OXFORD STUDIES
IN ISLAMIC ART

XV

The publication of this volume has been made possible
through the continuing support of
THE BRITISH INSTITUTE OF PERSIAN STUDIES
THE IRAN HERITAGE FOUNDATION
MARYAM AND FATEMEH KHOSROWSHAHI
THE BOARD OF THE FACULTY OF ORIENTAL STUDIES,
UNIVERSITY OF OXFORD

The series acknowledges with thanks
the continuing support of the BARAKAT TRUST,
through its purchase of one hundred copies of each title as gifts
for distribution to libraries of the Muslim world.

ISL R TAN

PERSIAN STEEL
The Tanavoli Collection

JAMES ALLAN AND BRIAN GILMOUR

PUBLISHED BY OXFORD UNIVERSITY PRESS
FOR THE BOARD OF THE FACULTY OF ORIENTAL STUDIES,
UNIVERSITY OF OXFORD
AND THE BRITISH INSTITUTE OF PERSIAN STUDIES

Series Editor
Julian Raby
Lecturer in Islamic Art & Architecture, University of Oxford

Editorial Board
James Allan
Keeper, Dept. of Eastern Art, Ashmolean Museum, Oxford
Robert Hillenbrand
Professor in Islamic Art, Dept. of Fine Art, University of Edinburgh
Oliver Watson
Keeper, Dept. of Ceramics, Victoria & Albert Museum, London
Jeremy Johns
Lecturer in Islamic Archaeology, University of Oxford
Luke Treadwell
Samir Shamma Lecturer in Islamic Numismatics, University of Oxford

Copy Editor
Alison Effeny

OXFORD
UNIVERSITY PRESS

Great Clarendon Street, Oxford OX2 6DP
Oxford University Press is a department of the University of Oxford.
It furthers the University's objective of excellence in research, scholarship,
and education by publishing worldwide in
Oxford New York
Athens Auckland Bangkok Bogotá Buenos Aires Calcutta
Cape Town Chennai Dar es Salaam Delhi Florence Hong Kong Istanbul
Karachi Kuala Lumpur Madrid Melbourne Mexico City Mumbai
Nairobi Paris São Paulo Singapore Taipei Tokyo Toronto Warsaw
with associated companies in Berlin Ibadan

Oxford is a registered trade mark of Oxford University Press in the UK
and in certain other countriess

This volume © 2000 Oxford University Press

All rights reserved. No part of this publication may be reproduced, stored in a retrieval system,
or transmitted, in any form or by any means, without prior permission in writing of Oxford University Press
or as expressly permitted by law, or under terms agreed with the appropriate reprographic rights organisation.
Enquiries concerning reproduction outside the scope of the above should be sent to the
Rights Department, Oxford University Press, at the address above.
You must not circulate this book in any other binding or cover
and you must impose this condition on any acquiror

British Library Cataloguing in Publication Data
Data available

Library of Congress Cataloging in Publication Data
Data available

ISBN 019–728025–0

Printed in Great Britain by PJ Print

CONTENTS

Preface — 7
Foreword — 11

IRON RESOURCES AND MANUFACTURING CENTRES IN ISLAMIC IRAN — 19
by James Allan

THE DEVELOPMENT OF IRON AND STEEL TECHNOLOGY IN SOUTHERN ASIA — 41
by Brian Gilmour

THE IRON- AND STEEL-WORKING INDUSTRY — 80
by James Allan

THE TRADE IN STEEL BETWEEN THE INDIAN SUBCONTINENT AND IRAN — 113
by James Allan

CATALOGUE — 123
by James Allan

Steel at war and the chase

 Arms and armour (A.1–49) — 125
 Belt fittings (B.1–26) — 211
 Horse fittings (C.1–13) — 226
 Hawk stands (D.1–2) — 247
 Standards (E.1–8) — 253

Steel and Islam

 Iron and steel in architectural settings (F.1–5) — 283
 Religious objects (G.1–13) — 304

Steel from the bazaar

 Bells (H.1–2) — 323
 Butcher's implements (I.1–3) — 328
 Balances, weights and related equipment (J.1–23) — 331
 Drawing equipment (K.1–28) — 341
 Tools and implements (L.1–56) — 358

Steel in the home
 Barbers', medical and surgical instruments (M.1–13) 393
 Locks and padlocks (N.1–38) 402
 Household objects (O.1–23) 421
 Fire implements (P.1–31) 435
 Cosmetic implements and mirrors (Q.1–19) 459

TECHNOLOGICAL INVESTIGATION OF OBJECTS
by Brian Gilmour 475

APPENDICES
One: List of steel-workers by nisba 519
Two: Inscriptions 527
Three: Firmans relating to mining in Iran 533
Four: Account of steel-making by Massalski 535

GLOSSARY 541
CONCORDANCES 561
BIBLIOGRAPHY 569
INDEX 597

Preface

If one metal had to be chosen for its particular association with Iranian mythology and beliefs, it would have to be steel. The many references to this metal found in Iranian cultural and literary traditions attest to its importance among the Iranian people throughout the various phases of their ancient history.

The word *pulad* (the Persian equivalent for 'steel') itself is of ancient origin that can be traced back to the earliest extant text. Many references to *pulad* are found in the Avesta, the sacred book of the Zoroastrians, where it is mentioned as a precious metal, worthy of gods, kings and heroes. The chariot of Mehr (Mithra) is reported to have contained 1000 battleaxes, each of them equipped with two steel blades. It is also reported that Kiyumars, the first man and the first king in Iranian mythology, built himself seven fortresses, one of which was made of *pulad* and stood on the slopes of Mount Alburz.

The difference between iron and steel was well known to the earliest Iranians, who considered them separate metals. The death of Kiyumars as narrated in the *Bundahishn* reveals the Iranians' familiarity with the two metals: 'When Kiyumars was struck with illness, he fell on his left side and there oozed out of his body – lead from his head, tin from his blood, silver from his brain, iron from his leg, zinc from his bone, glass from his fat, *pulad* from his arm, gold from his departing life … and death from his small finger.' When they mention weaponry, these same sources specify whether an article was made of iron or steel. Firdausi, author of the *Shahnameh*, named Jamshid, the great-grandson of Kiyumars, as the person who discovered the technique of smelting iron and the art of manufacturing the helmet (*khud*) and body armour (*zereh*). Jamshid devoted 50 years of his life, say the sources, to the task of perfecting the smelting technique, after which he taught it to his people.

Leaving the domain of mythical history behind, archaeological excavations clearly indicate that the Iranians were one of the earliest people to have worked with iron. They appreciated its value, treating it like precious metal from the beginning and using it in the manufacture of personal ornaments and jewellery. Some iron bracelets found in Luristan and dating back to the first millennium BC display an exquisite craftsmanship which is on a par with the best ornaments made from more

precious metals. Daggers from this same period have handles adorned with finely detailed motifs in relief. In museums and private collections there are many iron artefacts, shaped like swords, daggers and similar weapons, which date back to the Achaemenian, Parthian, and Sasanian periods, indicating the continuation and development of the blacksmith's craft in pre-Islamic Iran. These artefacts have all been classified under the general label of 'iron' and await further scientific examination to distinguish those made of steel.

Nor did the desirability of steel wane after the advent of Islam. Historical allusions to kings and generals – not to mention their arms and armour – all point to the importance of the metal. Likewise, in religion and folk practice steel was put to new uses. Doors to mosques and other sacred places, doorknobs and plaques began to use steel. The grillwork surrounding the tombs of the shrines was made with steel, which was burnished by the constant rubbing of pilgrims' and supplicants' hands. Among the devotees of steel were sufis and dervishes. Although these people owned little more than their ceremonial bowls (*kashkul*) and hatchets (*tabarzin*), their preferred material was steel and they attached great importance to its use. Nevertheless, relatively few iron or steel articles remain from the earlier Islamic periods.

Then in the 16th century, with the establishment of the Safavid dynasty, the picture changed dramatically and steel once more came into prominence, reaching its zenith in the course of Iranian history. The founders of the Safavids, who were devout Shiite sufis, attributed a religious aura and function to articles that were made from steel. An examination of a few such ornamental articles clarifies the reasons for the flourishing steel industry during the Safavid period. One such is the *'alam* (literally, a 'banner' or 'standard'). *'Alams* made of steel bore the sacred names of God, the Holy Prophet and the Imams, which were cut on the metallic surface amidst delicate floral scrolls, exerting a magical influence on the viewer. Whenever an *'alam* was taken out of a mosque or a *hoseiniyyeh* (a place of assembly where the martyrdom of Imam Husein is mourned every year), people of the local community followed, going where the *'alam*-bearer went. The *'alam* worked wonders in mobilising troops and was the most symbolic item on the battlefield. The Ottomans, who were well aware of the *'alam*'s spell, considered it a worthy trophy, not so much for its material value but for the power it exerted. When an *'alam* was seized in battle, the military unit fighting under it would just disintegrate. Some *'alams* are still to be found in Turkish museums.

Other articles made from steel included items of male apparel such as the amulet (*bazu-band*) and belt (*kamar-band*). The Safavids paid special attention to the physical fitness of their followers, encouraging them to engage in martial arts and physical exercises which produced qualities of valour and chivalry, best manifested in the person of 'Ali, the first Imam. A lion motif, which symbolises the bravery of 'Ali,

and the sacred names of God and the saints were often engraved on the amulet, so that their power might fortify the wearer and give him 'an arm of steel'. The belt also had its hidden religious resonances. The Safavid sufis considered themselves as begirded servitors of 'Ali and his clan, and when they tied or tightened their belts, it was with the avowed intention of serving this clan. Safavid belt buckles, which are often adorned with the names of the Imams and verses from the Koran, reflect the religious fervour of their owners.

In addition to these items, men carried other metallic objects such as knives, daggers, swords and flint-strikers which were almost always made entirely of steel or were reinforced with steel. The Safavids' love for steel objects stimulated the steel industries in several other fields, such as steel tools for various guilds or steel harness for horses. With the passage of time, more mundane household items such as mirrors, vases, ewers and ornaments for doors and chests became a part of the industry and the tradition continued well up to the end of the Qajar period: full sets of steel utensils, including ceremonial ewers and washbasins which were once a part of royal households up to the last Qajar kings, have survived. From the latter decades of the 19th century, however, the steel industry went through a dark period. The large-scale arrival of foreign goods devastated steel artisans. Unable to compete in the market with imported swords, rifles and other machine-made products, they watched helplessly as their workshops went out of business. All that remains of their industry these days is the odd bazaar that still sports their name: a 'Steel-makers' Bazaar' here, a 'Swordsmiths' Bazaar' there, a 'Gunsmiths' Bazaar' elsewhere.

Although the field of Iranian studies has made great strides in the examination of Iranian metals, it has continued to ignore steel. Fortunately, the efforts of Professor James Allan, as presented in this book, fill this vacuum. My acquaintance with Professor Allan was an important event in my life's ongoing quest for Iranian steel. Of course, I was aware of his valuable and extensive work on Islamic metalwork, but the day I went up to Oxford to meet him and to ask for his help and cooperation in making Iranian steel better known, my respect for him grew even greater. For in spite of his crowded schedule and previous commitments, he fell in love wholeheartedly with Iranian steel when he examined the specimens that I had brought along. From then on, in the course of our numerous meetings and our field trips to various parts of Iran, I have felt ever more sure that the job has been placed in very capable hands. The importance of James Allan's work in this book lies in its multi-dimensionality. Not only does he review the history of steel-making in Iran and explain one by one the various uses to which the metal was put in tools and other objects, but he also looks farther afield and locates mines described by historians and travellers in Iran. He casts light on the import of steel from India, and paints a picture of the last few steel-makers in Isfahan.

The other stroke of good fortune is Brian Gilmour's work on the scientific analysis of about 70 pieces described in the book. Comprising a solid foundation for the study of iron and steel in Iran, this will serve as a guide and inspiration to generations of students and researchers.

The efforts and energy of James Allan and Brian Gilmour in *Persian Steelwork. The Tanavoli Collection* have shed light on a formerly obscure Iranian art and paved the way for further study of the importance of this metal to the Iranian people.

Parviz Tanavoli
London 2000

Foreword

James Allan

The study of Islamic metalwork has always suffered from the disproportionate emphasis placed on brasses and bronzes. This is understandable, for these inlaid objects are often of the greatest beauty and hence beloved of collectors, and often bear inscriptions and hence of particular interest to historians. Yet steel, as this catalogue vividly demonstrates, played a major role – perhaps even the most important – in the history of Iranian metal-working, a role that deserves to be brought to the attention of the public and the scholarly world.

The one group of steel objects which has been studied and published, and is therefore an exception to this general pattern, is arms and armour. Here, however, the problem has been a lack of overlap between art historians and weapons experts. Books and articles on weapons have rarely reached the desks of art historians; those by art historians are equally unread by weapons experts.

Conscious of my own lack of knowledge about steel, and my inexperience in the field of arms and armour, I was therefore immensely excited when Parviz Tanavoli offered to lend his collection of Iranian steel objects to the Ashmolean Museum. For the last few years I have been in the privileged position of learning about the industry from firsthand acquaintance with this rich and varied collection. In the delightful company of Parviz, and with practical help of all sorts from him, and with financial help from the British Institute of Persian Studies, I have also been able to visit Iran on a number of occasions during this period. There I was able to study the steel objects in the Iran Bastan Museum, many of which came from the shrine of Shaikh Safi in Ardabil, to see the *'alam* ('standard') still in the Ardabil shrine, to meet one of the last surviving cutlers of Zanjan, to see the steel objects on show in the museum of the Shrine of Imam Riza in Mashhad, and to visit Isfahan to meet craftsmen who still manufacture steel objects in the traditional way.

I have been further encouraged in this study by Dr Brian Gilmour. Without him the pioneering technological side of this volume could never have been written.

A full study of Iranian steelwork depends on controlled use of the various sources and resources available. Some are relatively straightforward. Thus, the European travellers' accounts of their experiences in Iran are virtually all available for study

at the Bodleian Library in Oxford. Some travellers mentioned steel objects because of their social interest; others noted them because they were curious about their technical details. Whatever their motives, though, one can put together a remarkably broad picture of the industry through systematic use of this resource. Occasionally the information provided by one traveller contradicts that of another, but that is a very rare occurrence, for such visitors to Iran had little to gain by disguising the truth about the steel objects they saw in different towns. When comments on Iranian arms and armour were deliberately written with a political audience in mind, the motives are usually obvious. Hence, one may be confident that the overall picture is an accurate one.

Not all such resources are so easy to use, however. Language, for example, can prove a drastic hindrance. Thus, the Dutch East India Company records for the years 1624–82 have been edited by Chijs under the title *Dagh-Register gehouden int Casteel Batavia vant passerende daer ter plaetse als over geheel Nederlandts India: 1624–1682*. There are thirteen volumes in this series and individual volumes may run to 1500 pages. There are no indices, and the volumes are all in Dutch! There must therefore be a time when an author draws a line, and leaves further research to other, better qualified scholars. The same is true for whatever Persian sources are omitted in this study. They will no doubt be fully utilised by Iranian scholars in the future, and I am delighted that Mrs Monfared is even now working on a group of 30 articles on Iranian arms and armour for a Persian encyclopaedia, to be published in the coming months in Tehran. Future scholars will be better equipped than me to draw all this material together. For the same reason, this book does not offer any detailed discussions of the Persian names used for the objects. That is a work for scholars in Persian and for lexicographers, some of whom no doubt will be swift to publish their views.

What we have attempted here, however, is to establish appropriate English usages in the field of steel-working, so that future English-language studies will not be hindered by confusion of nomenclature. The most notorious rogue word is, of course, 'damascening', which is discussed below (see pp.76–79). When it refers to the pattern in the steel produced by etching the crystalline structure, we have abandoned the word in favour of 'watering'. The only times it is used in our text is in quotations from other authors who themselves used it.

Certain other limitations were imposed on this study. In the first place, there is the problem of survival to contend with. Early Islamic steel from Iran is extremely rare. We have elsewhere discussed this problem in the context of mirrors, where the lack of survival of early mirror types is almost certainly due to the fact that they were of iron or steel. After lying in the ground for more than a thousand years they are too badly corroded to be recognisable or valued by those who illicitly excavate

the appropriate sites. Re-use of steel because of its value is another factor in the shortage of early pieces. Hence, the overwhelming emphasis on the period from 1600 AD onwards in a book such as this should not mislead the reader into thinking that steel had not been used in quantity for many centuries before that.

Secondly, the Tanavoli collection is inevitably selective. Only collectors of literally unlimited means could afford to be otherwise. It is therefore good that we have been able to fill occasional gaps through the inclusion of individual items of arms and armour from the Ashmolean Museum, together with the Ashmolean's set of steel tools in a lacquer case.

Thirdly, depictions of steel-workers, either in manuscript illustrations or photographs, have proved very difficult to come by. The situation is further confused by the fact that descriptions in catalogues of unillustrated miniatures are not always accurate. Thus an illustration in a Bodleian manuscript supposedly shows the shops of a potter and a metal-worker:[1] in reality, however, one is a baker's shop and the other appears to be a soup kitchen. In the case of photographic records, those that exist are often unidentified, and the whereabouts of many possibly important archives – for instance, that of Hans Wulff – are at present unknown to us.

Fourthly, in spite of all the research that has gone into the making of this book, many of the objects illustrated here remain very elusive in terms of their provenance or date. Although it seems unlikely that any of them came from India, there are many steel objects in museums and on the art market which could be from either country, and a certain judgement is not always possible. Similarly, there are numerous objects in this catalogue which can only be dated in the vaguest terms to the period between 1600 and 1900 AD. This is very unsatisfactory from an art-historical perspective, but at present there seems no sure ground for dating such objects more accurately, and it would be false to claim otherwise. Let others try!

Fifthly, there is the problem of limited technical understanding. At a very basic level we have often been unable to identify precisely what material we are dealing with. Is it an iron, or a steel? If it is an iron is it cast iron or wrought iron? If it is a steel, was it produced by the bloomery or the crucible method? The identification of the metal or metal alloy is a laborious business (only watered steel can be identified by eye), and the number of samples that could be taken and photographed under a microscope, or analysed, proved to be very small. The results of these analyses show such a variation in material that we considered it potentially misleading to identify every item as steel, since the casual reader might conclude that the identification was proven. For this reason we have omitted any such specific identification in the captions, and simply cross-refer to the Appendix of

1. MS Elliot 149 fol.11a; Robinson (1957) p.109.

analyses if a particular object has been analysed. On the other hand, the likely alloy of non-ferrous objects illustrated in the figures is indicated.

Manufacturing techniques can be equally difficult to identify. For example, the technical notes that accompany the entries for the pieces of steel in the Freer Gallery catalogue show that two objects which look similar are not necessarily made in the same way. Thus one openwork plaque seems to have been made using drills, saws and files, the other using only a drill and files.[2] Particularly problematic is the extent to which steel objects were cut, rather than forged into, shape. The key to the craftsman's ability to cut, chisel and chase the steel lay in his ability to soften the steel that was to be shaped and decorated, and to harden the implements he used. It is no surprise to find in a 16th-century German treatise on iron and steel that one of the seven chapters is indeed entitled 'how to make steel soft enough to be cut'.[3] Indeed the other chapter headings show the range of concern of the pre-industrial iron and steel-worker: 'how to temper iron and draw it again', 'how to temper steel', 'how to solder, and first how to solder iron cold', 'how to etch in steel or iron or upon armour', and finally a chapter on how to apply gold and silver.

In many ways the iron and steel-working traditions of medieval and Renaissance Europe were very different from those of the Islamic world, and especially of Iran. A medieval decorative technique developed in Europe for wrought iron was stamping, striking the hot iron into prepared dies as wax is pressed into a seal. This reached its peak in 13th-century England in the wrought-iron screens and railings of many cathedrals including Lichfield, Chester, York, New Windsor, Oxford and Westminster, all seemingly the work of Thomas de Leghtone. By the 16th century, European steel craftsmen had also developed the use of embossing to give raised decoration, the equivalent of the repoussé work so common in other base metals. There is no evidence of either of these techniques being used in Iran.

In 14th-century France, craftsmen were extremely proficient at working wrought iron into shape: they sawed it, filed it, chiselled it, even carved it out of the solid. Whether Iranian craftsmen were able to work wrought iron or steel in this way is very difficult to discern.

The literary sources of the Islamic world, although they include a small number of important texts on swords and the production of steel, provide very limited information on technical matters relating to the manufacturing industries. An important exception is Abu'l-Fazl's *Ain-i Akbari*. However, as he was writing for the Mughal court, the extent to which his infomation is accurate for the Nearer East is at present uncertain. Thus, a niello-type black composition used in Mughal India is mentioned by Abu'l-Fazl,[4] and no.189 in the Tanavoli collection has a chiselled inscrip-

2. Atıl, Chase and Jett (1985) nos 28–29. 3. Williams (1935) pp.68–69.

tion against a black ground. However, this has yet to be analysed, and may be either a bituminous substance, a type of niello, or a colouring of the steel. It is also the case that more detailed studies of crafts were made by the British in India than by any foreign travellers to Iran. As a result, the best descriptions of inlaying and overlaying, for example, come from the former source.[5] Again, whether these descriptions would apply equally precisely to the Iranian industry is unclear.

Other techniques were certainly used but occur so rarely, or are referred to so rarely, that their actual importance is difficult to gauge. Thus, because steel rusts, it is sometimes tinned, and two examples of this – two comb backs in the Freer Gallery of Art[6] – have been published. To these may now possibly be added the ramrod in the Tanavoli collection (no.13). However, the only reference to tinned iron or steel known to me is provided by Ibn Battuta, who writes that the dead son of the sultan of Maghnisiya was placed in a wooden coffin with a tinned iron lid.[7] Did others follow this example?

Likewise, etching steel to give a design in low relief is a common technique in this century, but its history is almost impossible to trace. The earliest dated example known to me is a set of armour in the Royal Armouries dated AH 1201 (AD 1786–87).[8] After that, the lack of other datable examples, or of textual evidence, leaves the history of this technique completely in the dark.

Inevitably, too, research leads to new questions. The widespread use of brass as a solder for steel, the use of brass rivets, and the use of brass for decorative purposes opens up the question of the relationship between brass-working and steel-working. This has been addressed in the past,[9] but we seem no nearer understanding it.

Finally, time is not infinitely extendable. Brian Gilmour in particular was working under considerable constraints. There is a physical labour involved in taking samples, mounting them in perspex, photographing them under a microscope, and making prints of the photographs, and all this has to be done before the structure of the steel can be studied. Brian's part was also limited to what could be achieved alongside the daily round of research work for the Royal Armouries. Moreover, the book took its final form during my own sabbatical leave from Oxford University, which provided my last opportunity for undertaking such a project for the foreseeable future. At a particular moment in time, therefore, both of us had to draw our work to a close, even though more research could well have yielded further important results.

The book's length meant that full catalogue entries could not be included.

4. Abu'l-Fazl (1894) vol.3 p.316.
5. For inlaying see Egerton (1968) p.69, for overlaying see Hendley (1892) p.7.
6. Atıl, Chase and Jett (1985) pp.203–204 no.32, and pp.205–206 no.33.
7. Ibn Battuta (1958–71) p.447.
8. Royal Armouries, Leeds, acc. no.XXVIA.163.
9. Allan (1996).

Instead it was decided to put important information in the main text, and give basic technical details in the captions. The latter also give the likely provenance (if known) and date of the object, together with the collection number.

ACKNOWLEDGEMENTS

Particularly thanks are due to Laure Soustiel, who undertook all the cataloguing of the collection when it first arrived at the Ashmolean, and pioneered much of the research into the different groups of items. Without her thoroughness and patience, the study would never have got off the ground. Almost as important are the contributions of Manijeh Bayani, who spent many precious hours working on the texts and translations of the Persian inscriptions, and Alison Effeny, our excellent copy-editor. I would also like to thank the following individuals: Stefano Carboni, John Carswell, Anna Contadini, David Edge, Robert Elgood, 'Ali Gheissari, 'Abdallah Ghouchani, Norman and Rina Indictor, Ernst Kläy, Jean-François de Lapérouse, Bashir Mohamed, Mrs Monfared, Anthony North, William Robinson, John Tuddenham, Dan Walker, Rachel Ward; my colleagues at Oxford, especially Teresa Fitzherbert, John Gurney, Jeremy Johns, Julian Raby, Donald Richards and Luke Treadwell; Ken Hylson-Smith for providing writing space in the winter of 1996–97; Keith Bennett for providing the maps and re-drawing the diagrams; Sue Godard for the drawings of standards and perches; Michael Dudley and David Gowers for the photography; my secretary, Janet Partridge; and, of course, Parviz Tanavoli. My family – Jennifer, Virginia, Philip, Caroline and William, have been brilliant! And I am happy to own the Oxford University motto, *Dominus illuminatio mea*. He is indeed.

 JWA

I would like to acknowledge the generous support of my former employers, the Royal Armouries (formerly at the Tower of London but now based in Leeds) for this project in its earlier stages, particularly for allowing most of the microscopy to be carried out. I would also like to thank my colleague Chris Salter of the Science-based Archaeology Group of the University of Oxford, Department of Materials, for carrying out the electron-probe micro-analysis and for reading through parts of the draft, discussing technological problems and making various valuable suggestions and corrections. The micro-analysis was carried out in the University, partly at the Research Laboratory for Archaeology and the History of Art, for access to which I have to thank the Director, Mike Tite, and partly at the Department of Materials, Science and Business Park, Begbroke, for which I must thank the Head of the Department, Professor Brian Cantor. Georgina Herrmann and Ann Feuerbach allowed me to study and photograph the Merv ingot.

ACKNOWLEDGEMENTS

Thanks are also due to various friends and colleagues with whom I have had valuable discussions on aspects of the work as it progressed, in particular, Dr Robert Elgood, who also donated material relevant to the background research. Last, but by no means least, I would like to thank my wife, Lauren, for her continued support and interest in this book from the beginning of the project.

BJJG

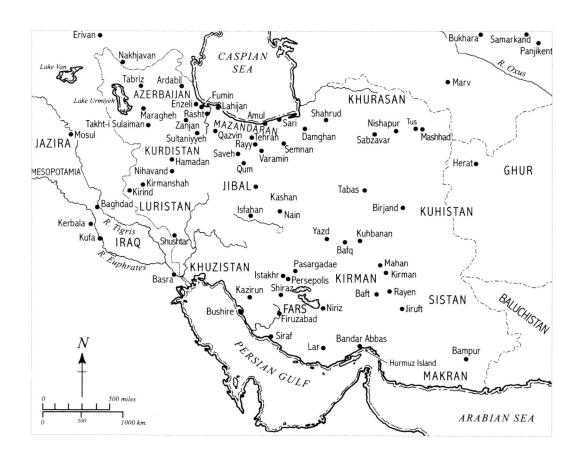

FIG. 1 Iran

Iron resources and manufacturing centres in Islamic Iran

James Allan

Until recently virtually all the raw metal used to make iron objects in Iran was mined there, as this chapter will make clear. The source of steel, however, is less certain. The texts agree on the importance of Indian steel and Indian swords in the history of Iran,[1] but there is also evidence for local manufacture of steel within Iran itself. The nature of this local industry and the details of the different processes used are discussed in the following chapters. Here it should be noted that the iron produced in the localities identified below would always have been used for local products made of cast or wrought iron, but only sometimes for local steel ones. At other times imported Indian steel would have been used.

In his survey of the iron resources of modern Iran, Ladame suggests seven areas of importance: south-west of Nikhbeh, i.e. the Zanjan region; the Saveh–Qazvin–Tehran area; Kashan–Yazd–Bafq; Bafq–Narijan; south-east Khurasan; the Persian Gulf; and western Baluchistan.[2] Historically, however, the evidence for iron mining is more particular, and the following regions merit consideration: the Karadagh district of Azarbaijan; the Alburz mountains; the Niriz area between Kirman and Shiraz; Khurasan; and the island of Hurmuz. Before looking at these areas in turn, one point should be made, and this is to do with Transoxiana. Transoxiana was, of course, closely linked with the rest of Iran in early Islamic times, and it cannot be ignored in a discussion of metal resources and exploitation. It was, in fact, the richest in iron of all regions of greater Iran, as for virtually every other metal. Ibn Hawqal was probably not exaggerating when he claimed that in Transoxiana there were veins of iron whose exploitation exceeded the demands of commerce, and his comments on the province of Farghana emphasise the riches buried under ground: 'the iron extracted there is so malleable that one can ply it into any desired form, and artisans rack their brains to invent strange objects.' At Minak and Marsmanda, in Ushrusana, he continues, were made iron instruments

1. Marco Polo (1929) p.93–94 n.
2. Ladame (1945) pp.248–67; see also Harrison (1968) pp.496–500.

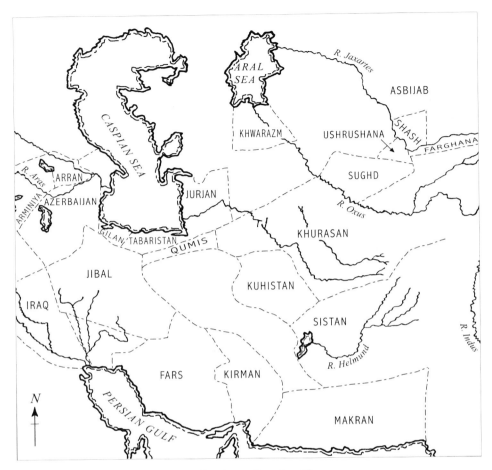

FIG.2 Provinces of medieval Iran

which were found all over Khurasan and even spread to Iraq.³ According to al-Qazvini, there were also iron resources near Shash,⁴ and al-Muqaddasi says that scissors were manufactured there.⁵ So too were padlocks.⁶ Farghana itself was the centre of sword and arms manufacturing, and other manufacturing centres occurred in Asbijab, to the north, and in the neighbouring province of Khwarazm.⁷ It is also possible that Transoxiana produced swords made from its own steel.⁸ The resources thus gave rise to an equally important manufacturing industry.

AZARBAIJAN

This catalogue is limited to the area of modern Iran, however, and that must be the focus. Starting in the north-west, the first detailed report on the iron resources of the Karadagh district seems to be that contained in Morier's account of his journey of 1810–16.⁹ 'Ahar is the chief place of the Karadagh … Iron is known to exist in its surrounding mountains, and the Prince has it in contemplation to explore the mines, and establish furnaces in the most eligible places for working their produce. The ore is in such great abundance that it may literally be called, "A land whose stones are iron, and out of whose hills thou mayest dig brass" *Deut.viii:9*.' Elsewhere, he includes a report of Capt. Monteith of the Madras Engineers, who was sent on an expedition to decide on the best place to establish iron-works.¹⁰ In his narrative of the journey from Ahar to Nakhjavan, Monteith writes of a village which he transcribes as Dombré, two miles beyond which there was the most productive iron mine. 'The ore is found around a foot below the surface and yields 50% metal, and is of dusky red colour. The Persians work it in a very rude manner, by first burning the whole substance in a furnace; they then hammer the earth and dross from each other, and the metal is afterwards made into horse-shoes &c.' Further on, the expedition visited a village transcribed as Masarood, near which was another iron mine.¹¹ 'Although the quality of the stone be good, yet its distance from fuel, and the badness of the roads leading to it, render it less available than the one at Dombré. The colour of the ore is of a dark grey. In no other part of the world, did we conceive it possible that a greater abundance of iron ore can exist, than in this range of moun-

3. Ibn Hawqal pp.464 and 506, trans. pp.447 and 485. He also singles out Nasya as a source of iron, p.515, trans. p.492. The author of *Hudud al-'alam* para.5.4 also notes the iron wealth of Transoxiana.
4. al-Qazvini vol.1 p.362.
5. al-Muqaddasi p.325.
6. Yaqut vol.4 pp.511–12.
7. al-Muqaddasi p.325. Narshakhi's record of an iron plate on the door of the palace at Bukhara, giving the name of its renovator, and his story of the way mirrors were used by the 8th-century rebel, Muqanna', to delude his followers, emphasise the abundance of iron products in Transoxiana; Narshakhi pp.23 and 73.
8. See below, pp.192–93.
9. Morier (1818) p.235.
10. Morier (1818) p.409.
11. Morier (1818) p.411.

tains. For many fursungs [*sic*, i.e. *farsangs*] the soil appears to consist of no other stone.'

Another early 19th-century traveller to Iran was Drouville, whose main interest was in armaments. He discussed the emptiness of the Iranian arsenals and their need to found artillery pieces and to manufacture the necessary projectiles for them. 'Be it for political or other reasons, they have never founded these munitions except in very small quantities at a time, so that the Persians lack grape-shot, shells, flints, and fuses, although all these objects are abundant in India and cost the earth in Persia. They ought to construct forges in Azerbaijan where iron mines are widespread. The environs of Aker [*sic*] overflow with first quality minerals ... It appears without doubt astonishing that in a country where the mineral can be 85–90%, one is obliged to make use of projectiles of copper, which are far from having the effect of iron, and cost an exorbitant price, since the bullets of 12 and the shells of 6 inches, the most common calibres in Persia, each cost 50 francs. Grape-shot, lacking iron, is of lead, thus by its weight and malleability lacking the principal merit, the ricochet. Powder is made very badly, in small quantities, and in a dangerous way'[12] Morier is more positive: 'In the first yard [of the Arg at Tabriz], we saw a range of guns and all the accompaniments of artillery. A numerous body of carpenters and wheelwrights were at work with European tools, superintended by a European mechanic. Farther on was the blacksmith's forge, worked with charcoal for want of coal. Then in another yard, were piles of shot, with men filling cartridges and other lesser employments. We were led through a suite of apartments, in which were sadlers and workers of leather, store-rooms neatly arranged, and conveniences of every sort.' The Crown Prince, 'Abbas Mirza, was a frequent and enthusiastic visitor: '[His] principal delight is a machine for boring cannon, which is worked by a buffalo, enabling him to make guns of any description.'[13] A powder mill, worked by water power, had also been built near Tabriz.[14]

Curzon adds to this picture by quoting a report on the mines of Karadagh, then being worked by Sir H. Lindsay-Bethune, which was sent by a Dr Riach to Sir J. McNeill in 1837. 'He wrote of the entire district that "it seems to be one enormous mass of the most valuable minerals, whole mountains being apparently composed of ores, perhaps the richest in the world – viz., iron, tin, and copper." '[15] Macdonald met at least one of the British workmen at these mines, a Scot by the name of Allen Roberts, when he visited Tabriz on his way out of Iran. He and 13 others – engineers, miners, moulders and founders, had been brought to Iran by Lindsay-

12. Drouville (1825) vol.1 pp.37–38.
13. Morier (1818) pp.226–27. In Safavid times the arsenal in the north-west of the country had been situated at Erivan; Minorsky (1943) p.136.
14. Morier (1818) p.231.
15. Curzon (1892) vol.2 pp.514–15 n.1.

Bethune,[16] and were paid by the latter for the first two years of their contract. Subsequently, their pay was in the hands of the Iranian government, which had failed to discharge its obligation, and mining ceased. 'They had, before they struck work, been getting on in first-rate style, had found plenty of coal and iron ore in the country, had their furnace and steam-engine going, and had commenced to cast guns, and shot and shells.'[17] Other references in the European travellers' accounts, like those of Johnson,[18] Lumsden,[19] Fowler,[20] Stuart[21] and Mitford[22] seem to refer exclusively to copper mining in this area, and by implication the founding of bronze or brass rather than iron cannons.[23] Johnson in fact specifies brass for the few pieces of artillery he saw. This was also the case in the exploitation under Amir Kabir between 1848 and 1851.[24]

There is little doubt that it was upon these resources that the towns and cities of Azarbaijan depended. They would therefore have been of fundamental importance in the early days of the Safavid dynasty. In the 14th century Shaikh Safi had received financial and political support from groups of craftsmen who included blacksmiths, though these may have made little more than agricultural implements.[25] Under Shah Isma'il I (1501–24), however, we know that Tabriz was a centre for the production of arms, for armsmiths were included among the 3000 families of craftsmen taken back to Istanbul by the Ottomans in 1514.[26] How the city was repopulated after this event, and how far the craft industries revived, is impossible to tell. The lack of information about smithing in Tabriz during the rest of the 16th century could be read in a number of different ways. There is a strong likelihood, however, that there was a major steel-working industry in Tabriz during Tahmasp's reign (1524–76): not only was it the capital, but located so close to the Ottoman frontier it must needs have supplied equipment for the Safavid army. The range of *'alams*

16. A brief outline of Lindsay-Bethune's career in Iran is given by Busse (1972) p.234 n.
17. Macdonald (1859) p.276.
18. Johnson (1818) p.213.
19. Lumsden (1822) p.141.
20. Fowler (1841) p.106. In his Appendix, pp.324–26, Fowler gives translations of the firmans issued by Fath 'Ali Shah, 'Abbas Mirza and Mahmud Mirza in AH 1245 (AD 1830), providing permission for the development of these mines by Lindsay-Bethune.
21. Stuart (1854) p.142.
22. Mitford (1884) vol.2 p.7.
23. The problems of casting iron cannons are discussed by Rostoker (1986), and their introduction into Mughal India by Khan (1999). Bronze or brass cannons tended to split if they became over-heated, but cast iron cannons could burst, with catastrophic results for the gun crews. J.Bell, *Travels from St Petersburg in Russia, to various parts of Asia, in 1716, 1719, 1722 &c.*, in Pinkerton (1808) vol.7 p.307, says that the 20 cannon he saw in 'the grand court before the palace gate' in Isfahan were of brass, and p.311: 'In the market-place [of Rasht] I saw about eight pieces of cannon, mounted on sorry carriages; among them was a neat brass field-piece, with the name of that noted prince the Duke of Holstein Gottorp upon it: it seems to have been left here accidentally by the ambassadors of that Duke to the then Schah of Persia.'
24. Issawi (1971) p.296 quoting Adamiyat.
25. Keyvani (1982) p.154, quoting an unpublished manuscript of the *Safvat as-Safa* of Ibn Bazzaz.
26. Osborne (1745) vol.1 p.728.

depicted in Tahmasp's *Shah-nameh*, produced in his royal atelier there, also points in the same direction (see p.255, FIGS 38a–b).

There are three pieces of information which indicate the possibility of Ardabil as an additional steel-working centre. First there is a clue in Struys's description of the mausoleum of Sultan Oljeitu at Sultaniyya. He writes: 'In entering this Sepulchre one must pass thro three very high Gates all made of *Indian* Steel, very neatly polished, and as smooth as Glass, this being the same Metal of which the Damaskin, or Ardebil Scymitars are made, and is preferred before any other Steel that is used.'[27] This strongly implies a swordsmithing industry at Ardabil at some period under the Safavids. Secondly, there is the Ardabili *nisba*, which is known from the signatures of two craftsmen (see Appendix One), one of them the maker of the strut for the Tanavoli standard (see E.4). Thirdly, Tanavoli and Wertime propose Ardabil as a locksmithing centre in the later period,[28] though they propose other Azarbaijan centres, too.[29]

With the abundance of its metal resources and the Russian frontier so close, and the great number of foreign travellers who passed through the city, it is not surprising to find evidence of the importance of Tabriz as an iron- and steel-working centre under the Qajars. It was probably at its peak under the dynamic Crown Prince, 'Abbas Mirza (1789–1833). Drouville claims that it was the only arsenal in Iran containing actual workshops, and records that it included, in addition to foundries, artisans making everything necessary for the clothing, arms and equipment of the soldiers.[30] This is confirmed by Morier's report, quoted above.[31] Von Kotzebue notes the existence of a cannon foundry set up by 'Abbas Mirza,[32] and Lumsden mentions the city's gun-smithing industry.[33] Johnson, on the other hand, was far from impressed by what he saw in the 'ark' there: 'We found [the artillery] in a very miserable state. A few small six-pounder amusettes ... and a few nine or twelve pounders, all of brass' and 'the iron work of the carriages is very inferior to ours of India.'[34] Towards the middle of the 19th century, Fowler found workshops for the manufacture of fire-arms and noted the quality of the swords produced there.[35] According to Wagner, however, these were not as good as Shirazi swords.[36] The lack of evidence for major manufacturing in Tabriz during the second half of the 19th century probably reflects the trading crises from which it suffered from the late

27. Struys (1684) p.302.
28. Tanavoli and Wertime (1976) pp.144–45. The same shape has also been attributed to Europe; see, for example, Eras (1957) fig.60 p.47, where one is described as Spanish.
29. Tanavoli and Wertime (1976) p.93.
30. Drouville (1825) vol.2 p.141.

31. Morier (1818) pp.226–27.
32. von Kotzebue (1819) p.162.
33. Lumsden (1822) p.141.
34. Johnson (1818) p.212.
35. Fowler (1841) p.264.
36. Wagner (1856) p.105.

1830s onwards. Swamped by foreign imports, the livelihoods of many of its traditional craftsmen were probably destroyed.[37]

There were probably other towns in Azarbaijan manufacturing steel objects. The only other record which has so far come to light, however, concerns Maragheh, which is mentioned by Mirza Husain Khan in the late 19th century as a centre for the manufacture of the *qama*, a type of dagger.[38]

THE ALBURZ MOUNTAINS

The riches of the Alburz mountains are first mentioned by the anonymous author of *Hudud al-'alam*, who wrote that Samar, near Sari, towards the eastern end of Mazandaran province, produced much iron, antimony and lead.[39] In the latter part of the 13th century al-Qazvini noted Rasht, in Gilan, as a source of iron, and a centre for iron-working, and commented on the rich iron resources of the mountains of Zanjan, which must also indicate the Alburz range to the north of the town.[40] In 1618 the English trader Thomas Barker recorded iron mines 'at Guyland' (i.e. Gilan),[41] which probably included those named by Olearius: 'There are indeed certain Forges, at Masula [sic], and Keintze [sic]; but the best iron comes from Masula, where it is so soft and tractable, that it is malleable, and yields to the Hammer without heating.'[42] Chardin simply noted iron mines in Hyrcania.[43] In the early 19th century, the Gilan mines furnished the raw materials for a widespread industry, as noted by Fraser: the province was 'full of large villages which produce things, but Rasht, Lahajan [Lahijan], Fomen [Fumin] and Enzellee [Enzeli] in particular make cutlery and arms.'[44]

Interest in further developing the Mazandaran iron resources of the Alburz appears in the 18th century, and Hanway fills out the picture a little: 'Near this place [Amul] are mines well furnished with iron oar [sic], where the SHAH [i.e. Nadir Shah] had his chief foundery for his cannon, ball, and bomb-shells, as also forges for horse-shoes; and supposing the PERSIAN marine would also succeed, they

37. Issawi (1971) pp.105–108 and p.259 records the 1844 petition of the merchants of Tabriz to the Crown Prince to prohibit European imports 'on the ground principally of the ruin Persian manufactures are reduced to by the constant and immense importation of foreign goods'. See too de Rochechouart (1867) p.232.
38. Floor (1971) p.107.
39. *Hudud al-'alam* para.32.23.
40. al-Qazvini vol.1 pp.190, 256. The author of *Hudud al-'Alam* para.32.20 says that iron is extracted from Mt Damavand, but the background to this may be mythical rather than factual.
41. Ferrier (1976) p.208.
42. Olearius (1669) p.233. The identity of Keintze is uncertain.
43. Chardin (1988) p.163. According to Curzon (1892) vol.1 p.357 n.1, Hyrcania comprised the Gurgan plain as far as the Atrek, Astarabad, and the greater part of Mazandaran. According to Cordier, the steel mines of Niriz are also mentioned in the *Jihannuma* of Hajji Khalifa Katib Chelebi (1609–57); Marco Polo vol.1 p.92 n.3.
44. Fraser (1826) p.356.

intended also to make anchors.'[45] These are no doubt the iron mines in Mazandaran noted by John Malcolm in 1801, and by Hommaire de Hell in the middle of the 19th century.[46] In 1848 Abbot made a visit to the iron works in the district of Nur, near Amul, and provided a uniquely detailed report. For this reason it is worth quoting in full:

'The iron ore is procured chiefly from the bed of the streams, or, when the supply there fails, it is dug from near the surface in the sides of the Ravine. It consists of stones from the size of a mere pebble to one of many pounds weight – of a brown or reddish brown colour and close grain. I was told, but consider this an exaggeration, that 100 Parts of ore yield about 40 of Iron.

'The ore is first heated in a furnace with charcoal in alternate layers, after which it is broken with a hammer into small pieces and thrown into a second furnace with Charcoal as before in the proportion of one men of ore to 3 of charcoal. A blast is effected by means of a large bellows worked by a water wheel and when fused the metal is allowed to run out in a pool and is taken up in long wooden ladles and poured into shot moulds, or it is run into short bars. The Cannon shot are sold by the villagers at 30 Tomans per 1,000 of 4 sizes, namely 6, 9, 12, and 18-Pounders, and 100 6-Pounder Shot or 50 of the above four sizes can be cast daily at each furnace. Iron for common use is sold at Amoul for 15 to 20 Sahib Kerans per Kherwar of 40 Tabreez Mens and when Russian Iron is scarce there at 25 to 30 Kerans even.

'There are 16 Shops or Furnaces scattered over the district on the three streams I have already mentioned and the names of the villages at which they are found are:

Alesherood	possessing 4 Furnaces
Anessitoorood	possessing 1 Furnace
Nâpelâ	possessing 2 Furnaces
Vaz	possessing 2 Furnaces
Lavejerood	possessing 3 Furnaces
Goolunderood	possessing 2 Furnaces
Meeanbund	possessing 1 Furnace
Kherse	possessing 1 Furnace

'The furnaces each require 20 or 22 Men and are worked only during 6 to 9 months of the Year. When I visited Nâpelâ in November it was just the season for resuming the work after the return of the Inhabitants of the Villages from their

45. Hanway (1754) vol.1 p.196.
46. John Malcolm, *The Melville Papers*, in Issawi (1971) p.263; Hommaire de Hell (1854) vol.3 p.239.

Summer quarters but having been oppressed by the Chief of the district they had abandoned the works and were proceeding in a body to lay their complaints before the Prime Minister. They stated that during the preceding year they had cast 175,000 Cannon Shot for the Government.

'I did not find that Coal had been discovered near any of the Iron works but a seam is reported to exist at the village of Yâloo in Yâlrood, three days journey from Âmoul ...'[47]

It must have been soon after this that Amir Kabir tried to encourage Iranian development of the Masule mines, in Gilan, and the mines in the district of Nanich, in Mazandaran. The former, as Olearius had noted in the 17th century, produced a relatively soft iron, which was used for gun-barrels and other arms.[48]

Abbott's report was not accessible to Curzon, who specified Naij, near Amul, as the site of the mines. He also observed that the combination of the area's rich deposits of coal and iron, and their proximity to the capital, had led to greater exploitation than elsewhere in the country, and drew attention to the fact that part at least of the purpose of constructing the Mahmudabad–Amul railway was to allow the export of these raw materials.[49] It was no doubt the move of the capital to Tehran by Agha Muhammad Khan, the founder of the Qajar dynasty, that provided the greatest stimulus to developing the Alburz iron mines, but Qazvin and Zanjan too would have had a long-standing interest in their resources.

There is surprisingly little textual information about the metal-working industries of these latter two cities. The *nisba* Zanjani is not found among the signatures of surviving steelworkers, and Qazvini only occurs once (see Appendix One). In the late 18th century, Ferrières-Sauveboeuf records the fame of its sword blades,[50] but early in the 19th century Drouville records that Qazvin had not long before had an excellent arms industry, which no longer existed.[51] This is contradicted by Fraser who says that Qazvin manufactured swords and other arms,[52] and by later visitors: de Rochechouart mentions the type of watering for which Qazvin blades were known,[53] Murdoch Smith includes Qazvin alongside Isfahan and Shiraz as a centre for sword-smithing,[54] and at the turn of the century Landor noted among the chief manufactures of Qazvin iron-wares and sword blades 'which are much appreciated by Persians'.[55] Zanjan was known for its padlocks,[56] and today it has the last remains

47. Quoted by Issawi (1971) p.284.
48. Issawi (1971) p.296 quoting Adamiyat.
49. Curzon (1892) vol.2 p.515.
50. Ferrières-Sauveboeuf (1790) vol.2 p.44.
51. Drouville (1825) vol.2 p.207.
52. Fraser (1826) p.355.
53. de Rochechouart (1867) p.229.
54. Murdoch Smith (1885) p.60.
55. Landor (1902) p.77.
56. Tanavoli and Wertime (1976) p.16.

of a once flourishing cutlery industry.[57]

Of Tehran very little is recorded. In 1800 it had 'no manufacture of consequence except that of sheep and lamb-skins',[58] but a few years later Sir William Ouseley describes its arsenal, located near the citadel gate, where he noted craftsmen constantly employed in cleaning and repairing muskets, pistols and the swivel guns used on camels; heavy cannon were also kept there.[59] Wagner noted a sword-smithing industry in the middle of the century,[60] and the growth of an arms industry during the 19th century is clear from the records of Thomson, the British Minister in Tehran between 1872 and 1879. In an estimated population of 100,000, Thomson reckoned there were some 5,000 shopkeepers who were also artisans, such as carpenters, gunsmiths, saddlers, tailors, watch-makers, bookbinders, glaziers, coppersmiths, blacksmiths, dyers, printers, cotton-spinners, goldsmiths, curriers, painters and farriers. He also gives numbers of artisans employed in Tehran with their occupations: 'blacksmiths 52 *ustadhs* ['masters'], 156 *shahgirds* ['apprentices']; gunsmiths 20 *ustadhs*, 78 *shahgirds*; nail-makers 12 *ustadhs*, 24 *shahgirds*; saddlers 30 *ustadhs*, 90 *shahgirds*; farriers 70 *ustadhs*'.[61] Curzon noted that the city had an arsenal and an iron foundry, and shops for the manufacture of belts, straps and saddlery and 'common swords for use on the parade ground and in the streets, the better blades being of Russian steel'. The quality, however, did not impress him.[62] Tehran is also known to have had a locksmithing industry.[63]

FARS AND KIRMAN

Further south, the provinces of Fars and Kirman are both mentioned by the early geographers and travellers as sources of iron,[64] and sometimes particular areas or places are specified: for example, in Fars the mountains near Istakhr,[65] and Saha and Qutra in the district of Istakhr,[66] and in Kirman province the Bariz mountains near Jiruft,[67] and Kuhbanan.[68] Niriz, on the road between Shiraz and Kirman, may

57. Author's observation.
58. John Malcolm, *The Melville Papers*, in Issawi (1971) p.262.
59. Ouseley (1819) vol.3 p.119; the arsenal is also mentioned by Drouville (1825) vol.2 p.141.
60. Wagner (1856) p.105.
61. Floor (1971) p.19.
62. Curzon (1892) vol.1 p.602–603. According to Binning (1857) vol.2 p.227, the blacksmiths of Tehran and the workers in the arsenal used the excellent coal mined in the Alburz mountains in preference to charcoal.
63. Tanavoli and Wertime (1976) p.16.

64. For Fars see al-Istakhri p.155, Ibn Hawqal p.300. For Kirman province see Mas'udi para.256; Marco Polo pp.90–96.
65. *Hudud al-'alam* para.29.2; al-Istakhri p.155; Ibn Hawqal p.300, trans. p.195.
66. Ibn al-Balkhi text pp.125, 128, trans. pp.24–25, 29.
67. al-Istakhri p.165; Ibn Hawqal p.311, trans. p.305; al-Idrisi p.442; al-Dimashqi p.176.
68. Marco Polo p.125.

have been of longer term importance than other localities.[69] In the early Islamic period its iron is mentioned by al-Muqaddasi,[70] and, although there appear to be no literary references in the intermediate period, it probably continued as a mining centre, for in the 17th century Olearius noted: 'The steel of which they [Qum sword blades] are made comes from the City of Niriz, within four days journey of Isfahan.'[71] Struys makes precisely the same point, adding that at Niriz 'are several mines'.[72] The abandoned iron mine at Parpa, near Niriz, was recorded by St John in 1876, and Houtum-Schindler said that in his day it was called *ma'dan-i fulad*, or 'steel mine'.[73] In the 1960s, the Tal-i Iblis expedition recorded the remains of extensive workings in the area of Baft, south of Kirman,[74] and iron deposits at Hanaskh, north-east of Pasargadae,[75] suggesting that over the centuries iron-working moved around as convenient lodes became exhausted and new lodes were discovered.

That in fact seems to have been the way many medieval mining operations worked, with many smaller deposits having had a significance in earlier periods of history out of all proportion to their size. Wertime, for example, mentions magnetic ores as occurring at isolated points around the rim of the central Iranian desert, not only along its southern fringe but also at places such as Saman and Kashan, and the latter area is indicated by other authorities who record iron deposits in a triangle between Isfahan, Kashan and Na'in.[76] Perhaps it was from such isolated iron ore

69. Curzon (1892) vol.2 p.518 perhaps goes too far in asserting the importance of Niriz: 'Between Kerman and Shiraz at Parpa, near Niriz, are the iron mines of which Marco Polo, Tavernier, and Chardin spoke as steel mines, and which were extensively worked in ancient times.' None of the authorities he cites mention Niriz or Parpa by name.
70. al-Muqaddasi p.443.
71. Olearius (1669) p.194.
72. Struys (1684) p.309.
73. St John (1876) p.107; Houtum-Schindler (1881) p. 491. Parviz Tanavoli and the author visited the site of these mines on 19 April 1997. They are located 4km south of the Niriz–Sirjan road, some 10 or 15km west of the Gol-i Gawhar copper mine and the Khairabad police station. The village of Parpa is on the west side of two small ranges of hills, both of which run north–south. The western range, which is the smaller of the two, has recently been quarried for stone, and these quarries may have destroyed earlier workings. There were no signs of any tunnels, however, and it seems most likely that the mining was opencast. This is also suggested by modern mining at Gol-i Gawhar, which is all opencast, the hills are so rich in iron. The wide areas of gullying on the Parpa hill would be the result of the ore extraction, although, having acquired a light covering of vegetation, and with weathered rocks, they are difficult to distinguish from their surroundings. Other such gullies are visible in the eastern range of hills. A second village, Kal Cheshmeh (literally, 'the spring of the wild goats' home'), is to be found nearby which suggests that the presence of a spring may have made these two villages the focus for mining over a fairly extensive area around. No signs of smelting were to be seen in the immediate area of the hills, but there was no time for a thorough search. There are today very few trees in the area, but in previous centuries there may have been more, or soda plants may have been used. Alternatively, the purest ores may have been transported by camel to Niriz for smelting. It is interesting that today the Gol-i Gawhar mine produces the purest iron, even though Bafq has the largest iron mine.
74. Caldwell p. 389; St John *et al.* (1976) also mentions the iron resources of Kirman.
75. Caldwell pp.321, 338, 388.
76. Curzon (1892) vol.2 p.519; Schindler p.114; Stahl 1 p.1910; Fateh p.31.

deposits that the Sabzavar blacksmiths, noted for their heart-shaped spades, derived their raw materials.[77] Smaller deposits are also found in Baluchistan,[78] though whether they were ever used is doubtful.[79]

The importance of the Fars-Kirman area for iron production, however, is fundamental. Al-Kindi records Fars swords made from Fars iron as well as others made from imported Sri Lankan steel.[80] Ibn al-Faqih says that the province of Fars was famous for its marvellous iron implements, and he specifies large cauldrons, padlocks, mirrors and compartmented boxes, together with an arms industry comprising swords, coats of mail and breastplates.[81] There can be little doubt that it was focused at Shiraz, though there were also localities producing their own specialities: for example, Ibn al-Balkhi says that the iron from Saha, or Chahak, was made into Chahaki sword blades,[82] while in the late 19th century the village of Bunat manufactured engraved and inlaid steel stirrups and bits.[83] In Shiraz itself, in the 13th century, al-Qazvini records the manufacture of knives and sword blades, and says that its excellent padlocks were carried to the rest of the world.[84] Timur's steel coffin made by a Shirazi craftsman, 'a most skilled master of his art', by the order of Khalil Sultan in AH 807 (AD 1405) suggests the continuing importance of Shiraz as a steel-working centre in the 14th century.[85]

Moving on to the Safavid period, in the early 16th century an anonymous Italian merchant wrote of the army of Isma'il I that 'sometimes [their harness] was of the fine steel of Shiraz.'[86] Then in 1611 Cartwright records of Shiraz: '…it is one of the greatest and most famous cities of the east, both for traffic of merchandize; as also for most excellent armour and furniture, which the armourers with wonderful cunning do make of iron and steel, and the juice of certain herbs, of much more notable temper and beauty, than are those which are made with us in *Europe*: not only headpieces, curiasses [*sic*], and compleat armours; but whole caparisons for horses, curiously made of thin plates of iron and steel.'[87] A number of swordsmiths with a Shirazi *nisba* are known (see Appendix One), but only one is approximately datable, Muhammad Kazim Shirazi, who seems to have worked *circa* 1700. Under Karim Khan Zand (1750–79) there was certainly a flourishing industry, witness a splendid

77. d'Allemagne (1911) vol.3 p.145.
78. Hughes (1877) p.22.
79. According to E. Sykes (1898) p.239, forges and blacksmiths were unknown in Baluchistan.
80. See below, p.57, pp.192–93.
81. Ibn al-Faqih pp.205, 254.
82. Ibn al-Balkhi (1962) p.125, trans. pp.24–25.
83. Murdoch-Smith (1885) p.71.
84. al-Qazvini vol.2 p.140: *nasl*, pl.*nusul*, can mean 'arrow' or 'spearhead' as well as sword blade.
85. Sanders (1936) p.245. The importance of Shiraz as a metal-working centre in general is emphasised by Ahmad ibn Arabshah's mention of two of the greatest goldsmiths of Timur's reign being Shirazi craftsmen – see Sanders (1936) p.313 – and by the evidence of the possible impact of the Shirazi style on Timurid metalwork – see Allan (1991a) pp.157–58.
86. Thomas and Roy (1873) p.207.
87. Osborne (1745) vol.1 p.744.

dagger (*khanjar*) in the Freer Gallery of Art dated AH 1191 (AD 1777), signed by a craftsman, Taqi or Naqi, who says in the inscription that he made it in Shiraz.[88] The sword-cutlers' bazaar is mentioned by Hasan-i Fasa'i,[89] and sword production at this period is described by Scott Waring: 'The swords which they make in Sheeraz, are manufactured from steel which they purchase in cakes at Hydrabad, and which I learn, is brought out of the Rajah of Berar's country.'[90] The industry remarkably survived the death of Karim Khan Zand and the resulting decline of manufacturing in Shiraz. Sir Robert Ker Porter was an eye-witness: 'With the death of its protector ... its numerous manufactories perished for want of purchasers; two, however, have survived the wreck, and are prosecuted with sufficient diligence and success; one is making glass ... the second is the formation of sword blades and daggers, which are deemed excellent for general use.'[91] This to some extent confirms the information given by Malcolm in 1801 that 'the chief manufactures of Shirawz are guns, pistols, swords and other military arms ...'[92] Fraser noted that Shiraz manufactured arms and cutlery and comments: 'its damasked steel knives and daggers are still esteemed ... [but] all its manufactures have declined since it ceased to be the capital of the country.'[93] Hasan-i Fasa'i mentions two steelworking craftsmen who took part in a rebellion in Shiraz in AH 1255 (AD 1839–40), one Haji Asad, a sword-cutler, and one Riza, a musket-maker,[94] indicating the continuation of the arms industry there. And, in the middle of the century, Polak and Wagner noted the quality and reputation of the watered blades of Shiraz.[95] Wagner gives an interesting description of their quality and style: 'Of all the Eastern provinces, Schiraz yields the most solid articles, including, especially, sword blades of remarkable beauty, and very high price. I was shown blades of splendid workmanship, into whose steel, ornaments and arabesques of gold, containing occasionally passages from the Koran, were inserted, and which were valued at 200 tomans, or Persian ducats.'[96] Indeed they continued to be considered the best.[97] In the early 20th century, d'Allemagne seems to suggest a broader steel industry in Shiraz, which included watered dervish axes and axe handles.[98] At this period it was also a centre for padlock production;[99] so too, it seems, was the town of Abarquh (see p.409).[100]

Of the manufactures of Kirman less is known. In the 13th century, according to Marco Polo, Kirman was famous for its swords, arms, spurs and horse-fittings, while

88. Atıl, Chase and Jett (1985) pp.214-19, no.35.
89. Busse (1972) p.48.
90. Scott Waring (1804) p.49.
91. Porter (1821–22) vol.1 pp.714–15.
92. John Malcolm, *The Melville Papers* in Issawi (1971) p.262.
93. Fraser (1826) p.354.
94. Busse (1972) p.265.
95. Trans. in Issawi (1971) p.273; Wagner (1856) vol.3 p.104.
96. Wagner (1856) vol.3 pp.104-5.
97. Mitford (1884) vol.2 p.10.
98. d'Allemagne (1911) vol.1 p.135.
99. Tanavoli and Wertime (1976) p.16.
100. Tanavoli and Wertime (1976) p.96.

Kuhbanan was famous for its steel mirrors,[101] but how long these industries survived is uncertain. Paulus Jovius, Bishop of Nocera, wrote in the 16th century that Kirman was celebrated for the fine temper of its steel in scimitars and lancepoints, and that they were eagerly bought at high prices by the Turks.[102] Its fame continued in Europe into the early 18th century, when Moxon noted the quality of Kirmani steel and the weapons made from it, and the ability of a Kirmani sword to cut through an (iron) helmet.[103] No blade signed by a craftsmen with a Kirmani *nisba* has survived, and Elgood suggests that the destruction of the industry in Kirman itself was the work of Agha Muhammad Qajar (1779–97), who had all the city's male inhabitants blinded or killed when he captured Kirman from the Zands in AH 1209 (AD 1794–95).[104] That seems highly likely. Certainly, in the early 19th century Fraser makes no mention of swords, instead noting matchlocks, which were 'in request all over Persia'.[105] Curzon merely notes the reputation of Kirman for the manufacture of arms, adding, 'but this, like that of Mashhad, is a thing of the past'.[106] Of the ironworking of the rest of central southern Iran there appear to be no records, with the exception of Fraser's information that Yazd manufactured ironware.[107]

ISFAHAN AND QUM

The importance of the iron from Fars goes beyond the province itself, however, for Fars must also have been the source of the iron used in the major cities of central and western Iran, like Isfahan and Qum, and possibly others further afield, like Hamadan and Kirmanshah.

The earliest mention of Isfahan as a steel-manufacturing centre appears to be in the *'Aja'ib al-Buldan*. There, al-Qazvini, who died in AD 1283, says of Isfahan: 'The talent of the armourers is also praised for the manufacture of steel, and the art of damascening – an art in which they have no equals.'[108] Apart from this, all our information on Isfahan comes from the 17th century or later. As a result of Isfahan becoming the capital of the Safavid empire, large quantities of craftsmen would have been attracted to the city, particularly in the hopes of royal patronage. Not surprisingly Chardin noticed that the *kar-khaneh* maintained by the king in Isfahan

101. Marco Polo (1929) pp.90, 125; on p.96 n.4 the editor, Yule, notes the phrase 'Kirmani blade' being used in poetry by Marco's contemporary Amir Khusrau of Delhi.
102. Marco Polo (1929) p.96 n.4.
103. Moxon (1703) p.59.
104. Elgood (1994) p.2; Busse (1972) p.61.
105. Fraser (1826) p.354, (1834) p.87.
106. Curzon (1892) vol.2 p.245.
107. Fraser (1826) p.354.
108. Quoted by Murdoch Smith (1885) p.29. Murdoch Smith appears to have found the information in L. Langlès' editorial addition to Chardin's information on Isfahan, Chardin (1811) vol.8 p.153. However, it does not appear in the published text of al-Qazvini, and one can only assume that the statement appears in a manuscript of the latter in Paris which Langlès consulted.

included a 'maison des arms', or arsenal, where the armourers employed by the king worked.[109] The Director of the Arsenal, according to Kaempfer, had among his subordinates locksmiths, cutlers, makers of arrow-heads, and makers of gunpowder.[110] Cartwright, in 1611, gives a more detailed description of the arms manufactured there: 'After he [Shah 'Abbas] has viewed his horses, he passeth into this armory, certain buildings near unto his palace, where are made very strong cuirasses, or corselets; head-pieces and targets, most of them able to keep out the shot of an harquebusier, and much more to daunt the force of a dart. Here also the king furnisheth his soldiers, not only with curiasses [sic], head-pieces, and targets; but with bows and arrows, poutdrones, and gantlets; and with launces made of good ash, armed at both ends; with scymetars and shirts of mail, most finely and soundly temper'd; wherewith both themselves and their horses are defended, in time of war.'[111] It was in the heart of this great city that the most famous of all Iranian swordsmiths, Asadallah Isfahani and his son Kalb'ali, lived and worked.

In the city Chardin also saw ironmongers, mirror-makers, and general steel-workers (*ahangaran*), who made edged-tools, as well as locksmiths, makers of agricultural implements, other mechanical arts, and chains.[112] Struys noted the 'mechanics' working in full view on the east side of the Maidan-i Shah,[113] who were presumably the forgers of scythes, hammers, pincers, nails and other things, with some cutlers, recorded by Tavernier outside the porticoes of the Maidan-i Shah on the side of the Lutfullah Mosque. He also noted file-cutters and makers of saw blades in the bazaar.[114] According to Kotov the street in Isfahan where the swordsmiths were located had over 200 shops, though other traders including slipper-makers and tent-makers also had their shops in that particular street.[115]

Keyvani has managed to put together a list of the guilds in Isfahan in the 17th and 18th centuries, from which the full spectrum of iron- and steel-working activities is clear. The list details the armourers' guild, who included arrow-makers, needle-makers, and gunsmiths; a guild comprising swordsmiths, cutlers, scissor-makers, and chainmail-makers, and the steel-workers who made helmets, Qur'an cases, shields, and special items like the upper parts of *qalians* and saucers for coffee cups; and the blacksmiths' guild, which included locksmiths, makers of horse-shoes, farriers and foundrymen.[116] Under the Shah's private barber's supervision

109. Chardin (1811) vol.7 p.329.
110. Minorsky (1943) p.136.
111. Osborne (1745) vol.1 p.736.
112. Chardin (1811) vol.7 pp.341, 368 and 393, though 'miroitier' could mean mirror-dealers rather than mirror-makers; Chardin's text is also unclear as to whether the mirrors were of steel or glass.

113. Struys (1684) p.316.
114. Tavernier (1970) pp.59, 63.
115. Kemp (1959) pp.18–19.
116. Keyvani (1982) pp.50–51, nos 10, 16 and 19. The list of *bashi*s (government-appointed officers over each guild) who assembled for a ceremony at Shah Husain's court, given by Asaf and quoted by Keyvani (1982) p.84, includes *bashi*s for chainmail-

were the razor-blade makers[117].

Despite the ravages suffered by Isfahan and its population as a result of its capture by the Afghans in 1722, the city was destined to remain the largest iron- and steel-working centre in Iran for a further 200 years. Its continued production in the later part of the 18th century is suggested by the existence of two swordsmiths, Muhammad 'Ali and Muqim, who used the *nisba* Isfahani, and the extraordinary number of known swordsmiths with the same *nisba* who probably lived in the 18th and 19th centuries testifies to the city's unique position in the industry (see Appendix One). The literature is equally positive. In 1801 Malcolm recorded among its manufactures 'saddles, swords, and other arms, all utensils in gold, silver, iron, steel and brass'.[118] In 1813–14 Kinneir noted that a foundry had been established by the French general, Gardane,[119] probably early in 1808, though it may well have been for brass as opposed to iron cannons. Morier recorded sword blades among Isfahan's manufactures,[120] so too Fowler, who commented on their superb quality: 'A good Ispahan blade, if well welded, will, it is said, cut through a half-inch bar of iron, a bale of cotton, or a silk handkerchief thrown into the air; and this is by no means a Persian extravaganza.'[121] Lady Sheil noted the manufacturing of arms.[122] However, it is Binning who, in the 1850s, provides the clearest information. He says that the sword-cutlers of Isfahan formerly enjoyed great celebrity, and that in his own time large numbers of swords were still being manufactured there. The best blades, he affirms, were all made of Indian steel imported in the form of small round cakes, and the forgery business was in full swing – Asadallah's name was regularly added to ordinary swords.[123] Wagner was of the opinion that Isfahan blades were inferior to those of Shiraz,[124] and by the last decade of the century decline had set in. According to de Windt: 'the trade of Isfahan has sadly deteriorated … The sword-blades manufactured here are, in comparison with those of Khorassan or of Damascus, of little value.'[125] Binning had also noted the manufacture of daggers (*khanjars* and *kards*),[126] as well as firearms, gunpowder and, by implication, steel gunpowder primers.[127]

Comments on the quality of the watering come from Wills: 'The "pulad" or damascened steel, is beautifully veined, and much of it is ornamented with work *à jour* and inlaid with gold. But the most prohibitive prices are asked for this pulad work

makers, swordsmiths, arrowsmiths, locksmiths, general smiths and blacksmiths.
117. Keyvani (1982) p.55.
118. John Malcolm, *The Melville Papers*, in Issawi (1971) p.262.
119. Kinneir (1818) p.520; Shadman (1944) p.30.
120. Morier (1818) p.156.
121. Fowler (1841) vol.1 p.264.
122. Lady Sheil (1856) p.288.
123. Binning (1857) pp.127–29.
124. Wagner (1856) p.105.
125. de Windt (1891) p.149.
126. Binning (1857) p.130.
127. Binning (1857) pp.130–31.

and the constant demand for export render[s] it very expensive.'[128] Benjamin noted Isfahan as the centre of the metal-working industry in Iran, though other cities in Khurasan vied with the capital in the production of steel blades.[129] Murdoch Smith ascribed most of the steelwork he purchased for the then South Kensington Museum to Isfahan,[130] and lists Isfahan with Khurasan, Qazvin and Shiraz as a sword-blade manufacturing centre.[131] Curzon noted the way Isfahan had formerly been famous for its armour, but that a certain amount was still being manufactured in imitation of the old,[132] while Mirza Husain Khan lists guilds of swordsmiths, chainmail-makers, helmet- and breastplate-makers, and cutlers in the city in the last decade of the 19th century.[133]

D'Allemagne records a substantial body of information about the iron- and steel-workers to be found in Isfahan early in the 20th century. Describing the Isfahan bazaar he writes:

'If one continues to turn always to the right, one penetrates into the bazaar of the locksmiths and armourers ... The Persian smiths are of a surprising ability, and they manage with the help of a hammer and anvil alone to forge animals, notably pheasants and rabbits which they cover with gold and silver incrustations: one meets so many specimens of these works on the European market, that they are little sought by collectors. Also made in this bazaar are reproductions of ancient arms, such as cuirasses, bucklers, helmets etc. ... For 20 to 25 francs one may have a complete set of armour, of well finished workmanship. The most interesting part of the armourers' bazaar to visit is that where Martini guns are made. The local workmen are able to copy these arms with extraordinary exactitude, and, in order to delude the purchaser completely, they have manufactured dies allowing them to strike [onto their products] the number and name found on pieces imported from Europe. Unfortunately the material they use is utterly inferior, and the arms thus made are of very little use.'[134]

The inferior quality of the steel is explained by Allemagne elsewhere. After commenting that the steel used in Iran comes from Russia and India, he continues: 'The Persian cutlers also use ... an amalgam which they obtain by founding together, once they have become useless, their files, chisels and other tools made of steel, which come from Europe. However, this metal does not please them, for they find it

128. Wills (1883) pp.189–90.
129. Benjamin (1857) pp.302–303.
130. Murdoch Smith (1885) p.58.
131. Murdoch Smith (1885) p.60.
132. Curzon (1892) vol.2 p.42; *cf.* Pollington (1867) p.249.
133. Floor (1971) p.107, 109, 110.
134. d'Allemagne (1911) vol.4 pp.91–92.

too fragile and that it does not give the finest designs.'[135] Axes and maces too were produced in Isfahan: 'It is in the bazaar of this last city [Isfahan] that are made those large axes with two blades, richly encrusted with silver, or those maces in the form of a bull's head imitating the capitals at Persepolis, which are sent to Europe to be sold to people who are looking for oriental objects of bad taste and cheap price.'[136] The accessories of both defensive and offensive arms were also still to be found in the bazaars of Isfahan when d'Allemagne was in Iran, and one has the strong impression from the way he writes that they were actually manufactured there.[137] Finally, d'Allemagne noted that the Isfahan locksmiths also made shutter handles and scissors.[138] Chal Shutur near Shahr-i Kurd, south-west of Isfahan, was also a locksmithing centre early in the 20th century.[139]

Mirza Husain Khan gives further information on the range of other iron or steel objects made in Isfahan late in the 19th century, in his list of the items sold by local haberdashers. These include garment pins, chains, tongs, tweezers, locks, trowels, tailors' scissors, percussion-cap holders, knives with bone handles, beams of balances, sugar hammers, bridle bits, bells, door keys, cheese-scrapers, saws, shears, screwdrivers, packing needles, stucco trowels, sharpening-steels for scrapers, belts (presumably with metal fittings), kitchen knives, compasses, goldsmiths' scales, barbers' razors, and tailors' irons.[140]

The 17th-century travellers are unanimous in praising sword blades made in Qum. Chardin is brief and to the point, saying that there are no more excellent sword blades than in this city.[141] Kotov offers a little more information: 'Here they make good swords and armour and chain mail and all kinds of damask steel work.'[142] Olearius writes: 'The principal Trading of the Inhabitants consists in earthen Pots, and Sword-blades. Those blades which are made in this City are accounted the best in the whole Country, and are sold sometimes at twenty Crowns a piece. The Steel of which they are made, comes from the City of *Niris*, within four days of *Ispahan*, where there are found in the Mountain of *Demawend* very rich mines of Iron and Steel.'[143] He adds: 'The Inhabitants of this City are somewhat light-finger'd, and apt to find anything lies in their way. We had hardly alighted, but our Pistols were taken away, and what was not lock'd up immediately vanish'd.' Struys had a similar experience. 'Qum is a place very considerable in regard of Traffic this

135. d'Allemagne (1911) vol.2 p.91.
136. d'Allemagne (1911) vol.1 p.135.
137. d'Allemagne (1911) vol.2 p.108. Curiously he says that the belt buckle on illustr. opp. p.108 top centre is 'Indo-Persian work': perhaps he means that it is of a type of work found in India too.
138. d'Allemagne (1911) vol.4 p.97. For the locksmiths, see also Tanavoli and Wertime (1976) p.16.
139. Tanavoli and Wertime (1976) p.16.
140. Floor (1971) pp.119–120.
141. Chardin (1811) vol.2 p.481.
142. Kemp (1959) p.15.
143. Olearius (1669) p.194.

being eminent for Swords, Knives, Armorers and Cutlers Works. Some of our Company bought here Scymiter Blades, for which they paid to the value of 20 Crowns a piece, yet were not those of the best sort. The Steel they have from Niris near Ispahan where are several Mines … The Inhabitants are sociable and friendly enough to converse withall when you have not much to loose, but we were warned to look well about us, for they say that they are brought in to the World with the Fist doubled. My Patron lost here 2 new Scymiters he had lately bought, and I a Tobacco box.'[144] The fame of Qum blades is attested by Bell in the 1720s,[145] and seems to have continued into the 1780s,[146] but 30 years later Drouville commented that the manufacture of sword blades, though once well-known, had not been practised for a long time,[147] and Ker Porter in the 1820s confirms the decline, saying that the industry at Shiraz had entirely superseded that at Qum.[148] Hence, Ussher's information that sword blades were still being traded in Qum in the middle of the 19th century must refer to trade, not to manufacture:[149] certainly, no other 19th-century records of the Qum industry are known to me. The reason for the decline is uncertain, but it may have been a combination of earthquake damage, recorded by Ferrières-Sauveboeuf, who visited Qum in the 1780s,[150] and the rise of Tehran.

Towns like Rayy, Hamadan and Kirmanshah may also have derived their iron from Fars, though this is less certain, since there were alternative sources in the Alburz and Azarbaijan. Jibal itself may have had resources, for Pettus's report of 1618 says that there were iron mines in the region of Hamadan.[151] Rayy produced scissors.[152] Hamadan is mentioned by Ibn al-Faqih as a manufacturing centre for iron mirrors, spoons, censers and gilded drums,[153] and in more recent times had a locksmithing industry.[154] Kirmanshah is mentioned by Ker Porter, in the early 19th century. He says that it was famous for an excellent manufactory of firearms.[155] The nearby town of Kirind is also known to have had a flourishing firearms industry in the late 19th century,[156] and was famous for its puzzle- and combination-locks.[157]

KHURASAN

There was also extensive iron production in Khurasan. The mountains near Tus and Nuqan were rich in all sort of metals, including iron,[158] and there were abun-

144. Struys (1684) p.309.
145. J.Bell, *Travels from St Petersburg in Russia, to various parts of Asia, in 1716, 1719, 1722 &c.*, in Pinkerton (1808) vol.7 p.298.
146. Francklin (1788) p.60.
147. Drouville (1825) vol.2 p.224.
148. Porter (1821) vol.1 p.715.
149. Ussher (1865) p.608.
150. Ferrières-Sauveboeuf (1790) vol.2 p.42.
151. Ferrier (1976) p.208.
152. al-Tha'alibi p.111.
153. Ibn al-Faqih p.253.
154. Tanavoli and Wertime (1976) p.16.
155. Porter (1821–22) vol.2 p.201.
156. Murdoch-Smith (1885) p.71.
157. Tanavoli and Wertime (1976) p.16.

dant veins of iron in Guzgan,[159] and in the region of Kabul.[160] On the basis of these resources there were various important manufacturing industries. Khurasan was known in the 9th century for its swords, some made of local iron, others of imported Sri Lankan metal,[161] and in the 10th century for its weapons and breastplates.[162] Al-Hamdani noted Tus as a source of coats of mail, which were made from local iron,[163] and Tus iron would also have formed the basis of the Nishapur iron-working industry, notably the manufacture of needles and knives.[164] Ghur is singled out by al-Jahiz for the manufacture of breastplates, and by the author of *Hudud al-'alam* for coats of mail, breastplates, and good arms; al-Jahiz adds that Ghur breastplates were exported all the way to Iraq.[165]

More important, however, is the fact that there is evidence of the actual production of steel in Khurasan, both in Merv and in Herat. Merv has been investigated by the International Merv Project since 1992, and, in the old urban area vacated in early Islamic times, the archaeologists have brought to light evidence of the production of crucible steel in the late 9th and early 10th centuries.[166] The significance of the methods used is discussed elsewhere (see pp.50–55). Merv is also known from Yaqut to have had a locksmithing industry.[167] The evidence for steel production in Herat is literary rather than archaeological, and comes from al-Muqaddasi and al-Biruni. From these authors it is clear that Herat was known for its production of steel cakes, which were exported to Multan and Sind to be made into swords.[168] It seems highly likely that Herati cakes also provided the basis of the arms and armour industry in neighbouring Ghur.

At a much later period Khurasan was mentioned by Kaempfer as a source of iron,[169] and continuing evidence for a Khurasani steel industry is provided in the late 18th century by Ferrières-Sauveboeuf, and in the early 19th century by Hasan-i Fasa'i and Scott Waring. Ferrières-Sauveboeuf comments of Khurasan: 'The swords of that province are distinguished by a valuable kind of steel; one blade costs up to a thousand *tomans*, which is almost thirty thousand *livres*; they are very sought after by the Persians who prize them, more or less, for their antiquity; the sturdiest armour and the best coat of mail in use in war cannot resist their cutting edge.'[170] Hasan-i Fasa'i notes that in AH 1229 (AD 1813–14), when a new ambassador to Russia

158. Ibn Hawqal p.434, trans. p.419–20.
159. *Hudud al-'alam* para.23.51.
160. Ibn Hawqal p.450, trans. p.436, though Kabul is strictly speaking not in Khurasan.
161. Khurasani *sarandib* and Khurasani *muwallad* swords, according to al-Kindi pp.10–11.
162. Ibn al-Faqih p.316.
163. al-Hamdani fol.25a.
164. Muqaddasi pp.324, 326.
165. *Hudud al-'alam* para.24.1.
166. Herrmann, Kurbansakhatov *et al.*(1994) pp.70–71; Herrmann, Kurbansakhatov *et al.* (1995) pp.42–45.
167. Yaqut vol.4 pp.511–12.
168. al-Muqaddasi p.324; al-Biruni pp.254, 256.
169. Quoted by Minorsky (1943) p.177.
170. Ferrières-Sauveboeuf (1790) vol.2 p.9.

was appointed, he took presents to the Russian Emperor which included 'swords from Khurasan'.[171] Scott Waring, like Ferrières-Sauveboeuf, is more specific about their quality and value: 'The arms of the Persians are very good, particularly their swords, which are highly prized by the Turks. They are full of jouhur or what is called damask, which however does not express the meaning of the word, for the jouhur is inherent in the steel. Tavernier says that none but Golconda steel, can be damasked; but in this he is mistaken, as the Khorasan swords are more valuable than any others, the blade often alone costing 20 or 30 guineas.'[172] Fraser adds one particularly interesting comment on the industry, noting that various towns and large villages in Khurasan exported swords and firearms. Perhaps this accounts for the use of the *nisba* Khurasani by certain swordsmiths. Fraser also specifies the two most important towns – Mashhad for the manufacture of sword blades and armour, and Herat for manufacture of sword blades.[173] Mashhadi does indeed occur as a *nisba* among swordsmiths in the 18th century, but curiously Haravi does not (see Appendix One).

The later European travellers are generally less informative, though Mitford is an exception. He writes of Mashhad as follows: 'There are a great many armourers' shops, and at the present time they appear particularly active; they told me that they had large demands for arms from Herat; swords seemed to be most wanted, and of these they are sending off large numbers: the Khorassan swords are not equal to those made at Shiraz, and no two are of the same size or shape, but all more or less curved.'[174] Otherwise comments are very general. According to Ferrier, the arms manufactured in Mashhad, particularly swords, 'have a great reputation',[175] a fact affirmed by Polak.[176] Later in the century, S.G.W. Benjamin cited the cities of Khurasan, such as Mashhad, Astarabad and Damghan, as vying with Isfahan in the production of steel blades,[177] and de Windt confirms their high quality.[178] Murdoch Smith says that the most famous watered steels were those of Isfahan, Khurasan, Qazvin and Shiraz, but gives no more details of Khurasani products,[179] while Curzon affirms that the manufacture of watered sword blades had long been a trade in Mashhad, having originally, it is said, been introduced by a colony transported for the purpose by Timur from Damascus. 'Now, however, that rifles and revolvers have taken the place of swords and daggers, there is not the same demand for the new blades.'[180] Eastwick noted that there was an arsenal at Mashhad, but was more interested in describing the water-powered gunpowder factory run by an English-

171. Busse (1972) p.147.
172. Scott Waring (1804) p.61.
173. Fraser (1826) pp.355–56.
174. Mitford (1884) vol.2 p.47.
175. Ferrier (1857) p.125.
176. Trans. in Issawi (1971) p.273.
177. Benjamin (1887) pp.302–303.
178. de Windt (1891) p.146.
179. Murdoch Smith (1885) p.60.
180. Curzon (1892) vol.1 pp.166–67, vol.2 p.526.

man, Colonel Dolmage, 10 miles west of the city.[181]

It was presumably from Khurasan that the craftsmen of another town, Birjand, in Kuhistan, derived their raw materials. At the turn of the last century Landor observed of Birjand: 'Among the shops there are a few silversmiths', some blacksmiths', and some sword and gunsmiths'. The latter manufacture fairly good blades and picturesque matchlocks.'[182]

OTHER SOURCES

Al-Dimashqi's comment on iron coming from the Persian Gulf is vague.[183] However, given the extensive iron deposits on the island of Hurmuz, it may well be that by about AD 1300 these iron resources, having hitherto been neglected, were also being exploited. At a much later period, in the early 20th century, the iron oxide from the Gulf islands was the only mineral being exported from Iran apart from petroleum.[184]

It is clear that there were both major and minor sources of iron in earlier and later Islamic Iran. The major sources, such as Niriz, no doubt utilised quite a number of small local mines, since there were obvious limitations on the depths medieval miners could take their galleries compared to modern mines. The minor sources probably consisted of small mines which were themselves exhausted after a few years, or which used up the local supply of firewood for smelting, and therefore had to be abandoned until the latter had regrown.

181. Eastwick (1864) vol.2 pp.198–99.
182. Landor (1902) vol.2 p.97.
183. al-Dimashqi p.166.

184. Issawi (1971) p.259; Houtum-Schindler (1910–11).

The development of iron and steel technology in southern Asia

Brian Gilmour

EARLY IRON PRODUCTION: THE 2ND TO 1ST MILLENNIUM BC

The beginnings of the Iron Age in Iran *circa* 1400 BC seems to have coincided with the emergence of Persian-speaking peoples, who entered Iran from the north-east and spread slowly westwards and then southwards until, in the early 1st millennium BC, they emerged as two powerful groupings, the Medes in the area of Hamadan, and the Persians further south in Fars. Until the establishment of the crucible-steel industry in Iran – possibly in the later 1st millennium BC – all iron and steel produced in this region was almost certainly made using the bloomery iron-smelting process, exploiting scattered but generally plentiful, if small-scale, sources of iron ore. Hardly anything is yet known of the technological development of the industry in this area from its beginnings to relatively recent times, and even where material evidence of such development exists, very little has been the subject of metallographic or elemental analysis.

The exception is the analytical work that has been carried out on some of the well-known iron swords from Luristan in western Iran. An early dating, of the 12th–10th centuries BC, has been argued for these swords and it has been suggested that the Persians brought them to the area of the Zagros mountains in this period.[1] Maxwell-Hyslop and Hodges dismissed the three Luristan swords they examined as 'a mess' in terms of the smithing skills demonstrated, and concluded that they were the work of incompetent smiths who were unaware or incapable of hammer-welding, and were unable to control the process of carburisation.[2]

A re-appraisal of their evidence, with that from the previous examination of twelve other iron swords from Luristan, suggests that these weapons were actually the products of highly skilled smiths. Until recently it has usually been assumed in

1. Maxwell-Hyslop and Hodges (1966) p.170–75. Their dating has been supported more recently by the results of accelerator radiocarbon dating of samples from two other Luristan swords, which placed their likely date of manufacture as approximately mid-12th to mid-11th century BC: Rehder (1994) pp.13–14.
2. They assumed that one of the two swords examined metallographically (No. 2) had been almost totally converted, inadvertently, to a high-carbon steel before being extensively decarburised, again accidentally, to produce a blade with a largely high-carbon steel core: Maxwell-Hyslop and Hodges (1966) pp.168–69. See also the report by Bird in the same article, pp.175–76.

archaeological publications that early steel was made by the solid-state carburisation of plain bloomery iron, although there has never been any real evidence to support this assumption, and the theory ignores the fact that solid-state carburisation is not easy to achieve, even intentionally.[3] In fact, because so little material has been given detailed metallographic examination, it has been impossible to track the developments, either in early iron- or steel-making, of the ways in which early ironsmiths worked these or any other ferrous alloys. Much the most obvious conclusion from the mixed, uneven carbon compositions reported for many of the Luristan swords covered in Rehder's survey is, as he concludes, that they were made of partially steeled iron blooms.[4] Far from being the incompetent product described by Maxwell-Hyslop and Hodges, the high-carbon steel-cored sword blade seems more likely, along with many of these blades, to have been skilfully forged from fairly well-consolidated, partially steeled blooms, possibly to demonstrate that these higher-carbon parts could be separated from what in many cases may have been a bloom generally much lower in carbon. Evidence is slowly beginning to accumulate elsewhere for the existence of steel billets (or blocks) made from what can only have been the intentionally steeled parts of iron blooms produced as part of the bloomery process.[5]

The sword hilts were forged as separate pieces which then interlocked – when accurately made – and were finally pinned together, demonstrating the skill of the ironsmith in making shapes that were more suited to the cast bronze designs from which they had developed. Also, the failure to notice obvious welds in the few objects examined does not mean that these early ironsmiths were not perfectly capable of hammer-welding. Solid-phase welding is such a fundamental part of the process of consolidation of the spongy slag and cinder-rich bloom after smelting that ironsmiths can be expected to have mastered the basic technique of hammer-welding from early in the Iron Age. Forge-welds have been observed in at least some of the Luristan sword blades already examined, and in certain cases these appear not to have been noticed by previous researchers.[6]

All the Luristan sword blades examined so far seem to have been slow-cooled after final forging, so as to leave the steel in the softest possible state, and in some cases it would appear that this aim was furthered by the use of an additional spheroidising, annealing heat treatment. There is no reason to suppose that the smiths

3. Some form of pack-carburisation process in a separate or sealed reducing atmosphere is needed: see Rehder (1989) pp.17–21.
4. Sword No. 2 is likely to have been made of directly reduced bloomery steel, or at least from a partially 'steeled' bloom – one where localised reducing conditions in the smelting furnace favoured the extensive absorption of carbon: Rehder (1994) pp.18–19.
5. Salter (1997) p.102.
6. Rehder (1994) p.15.

making these swords were not aware of the advantages to be gained by quenching, which produced harder steel and was clearly often employed. The drawbacks of quenching, such as increased brittleness, must also have been obvious to them: in the case of the Luristan blades, the irregularly steeled composition would have made distortion a very real danger if quenching were attempted, which may be why slow-cooling or related treatments were used for these weapons. The relative softness of the Luristan iron swords, together with the comparative mechanical weakness of their complex riveted hilts, may suggest that they were made mainly for ritual, display or prestige purposes rather than as practical weapons.[7] The symbolic importance of the swords may have consisted in part in their demonstration of smithing skills and the ability to choose and use iron and steel of relatively high quality.

From the evidence of the Luristan iron swords we may conclude that the knowledge of iron technology, including at least an awareness of the existence and potential of steel-making, was well advanced in western Iran by *circa* 1000 BC, but its development during the 1st millennium BC is uncertain. Some indication of the skill of the Achaemenid ironsmiths of the late 5th century BC is provided by a spearhead from Deve Huyuk in Syria. In section this spearhead reveals a fine, inhomogeneous layered structure which is probably indicative of the extensive forging of a block of iron (with an original, irregular carbon content and the additional accidental presence of an impurity in the iron, such as phosphorus, which would have inhibited the diffusion of carbon through the iron), probably combined with folding, welding and forging out again, possibly repeated several times (piling). This banded effect is well known in low- to medium-carbon steels with an irregular dispersion of certain elements like phosphorus,[8] and seems much more likely to have been responsible for the laminated structure of the Deve Huyuk spearhead than the welding together of many layers of thin, partially carburised iron plates, as previously suggested.[9] This in no way detracts from the skill demonstrated by the ironsmith, however, and in fact the extensive forging and possible piling would tend to suggest that the smith was aware of the variability of the metal and was ensuring a better dispersion of carbon and whatever else was present in it. When part of this spearhead was mounted, polished and etched, it revealed the relief-map effect[10] of a layered structure which has been both distorted by forging and partially ground away at a slight angle. Structures like this have the potential to produce a decorative, patterned effect, given suitable grinding, polishing and etching of the surface, and it seems not unreasonable to suggest that this might be a very early example of a pattern-welded structure. Evidence for pattern-welding in Europe is thought to date from about this time

7. Rehder (1994) p.15.
8. Rollason (1973) p.170.
9. Coghlan (1956) p.115.
10. Coghlan (1956) plates II and III.

(see below)[11] and, whether or not the Deve Huyuk spearhead can be reliably said to represent pattern-welding, it would seem likely that early surface patterns like this may well have led to the development of both the various forms of pattern-welding seen in the 1st millennium AD in Europe, and the watered crucible steels, the early development of which is still largely unknown.

IRON AND STEEL IN LITERATURE: 4TH CENTURY BC TO 8TH CENTURY AD

Additional information on this early period is rare. It is possible that Indian iron was famous or sought after as early as the 4th century BC, as has been claimed by some authors[12] – mostly based on the account of the 1st-century AD Roman historian Quintus Curtius Rufus, who recorded that Alexander the Great, when campaigning in the Indus region, received a gift of 100 talents of 'white iron' (*ferri candidi talenta C*).[13] Again, according to Herodotus, the Indians in Xerxes' army at the battle of Thermopylae in 480 BC had cane arrows tipped with iron.[14] Both these references suggest that Iranians would have known of Indian iron, but little more. On the other hand, the Delhi wrought-iron pillar, standing over 7 metres tall and weighing about 7 tons, which probably dates from the 5th century AD, illustrates the very advanced technology of India in this field,[15] and it is perfectly possible that Iran utilised Indian imports under the Achaemenids and their successors.

Unfortunately, references to iron- and steel-working in the Parthian period are non-existent, and are extremely sparse for the Sasanian period. Roman references to Indian iron again suggest that it was a regular part of Indian Ocean trade, but until recently no scientific investigations had ever been undertaken into Sasanian steel. In practice, our knowledge seems to be limited to the four different words for iron craftsmen which occur in Sasanian times: *ahengar*, a man who evidently made spades and axes; *ahen-paykar*, literally, a man who cast, moulded or forged iron; *chalangar*, a worker in small iron artefacts; and *palawud-paykar*, a 'steel smith'.[16]

The Iranians' knowledge about their own metal-working heritage seems to have been almost as vague. Few of those writing about iron and steel before the appearance of Muhammad recorded anything, except perhaps to quote some pre-Islamic poetry mentioning the watered pattern on a sword blade. The usual starting-point was the Qur'an. Al-Biruni, for example, begins his discussion of iron with the words of sura 57, verse 25: 'We revealed iron, wherein is mighty power and (many) uses for

11. Pleiner (1993) p.117 no.68: the structure shown in fig.12 looks likely to have been an early form of pattern-welding.
12. For example, Maryon (1960).
13. Curtius Rufus (1954) pp.646–47. For comments on this passage see Bronson (1986) p.18.
14. Mahmud (1988) p.18.
15. Mahmud (1988) pp.20–21.
16. Tafazzoli (1974) pp.193–95.

mankind,' a quotation which continued to be popular in later times.[17] In practice, references to iron are rare in the Qur'an, but al-Biruni also quotes two verses that implicitly justify the manufacture of armour: 'And we made the iron supple unto him [King David], Saying: Make thou long coats of mail, and measure the links (thereof)' (sura 34, verses 10–11) and 'And coats (of armour) to save you from your own foolhardiness' (sura 16, verse 81).

Most Iranians were probably more interested in the *Shah-nameh* as a source of information, or more particularly as a source of the mythology associated with iron and steel. There, Hushang is credited with the first separation and extraction of iron from its parent rock, and with the invention of the smithing crafts for the making of axes, saws and mattocks. Jamshid, on the other hand, was the first ruler to be able to forge iron into arms and armour – helmets, mail, laminated armour, missile-proof vests, swords and horse armour – and he is occasionally picked out for special treatment in illustrated manuscripts of the Timurid and Safavid periods. Thus, he is depicted in a Herati *Shah-nameh* of AH 833 (AD 1429)[18] and in a Herati manuscript of al-Tabari's *Annals*, dated AH 874 (AD 1469),[19] and a drawing of his craftsmen survives in the Diez Album.[20] The continuing popularity of the theme is indicated by its appearance in the *Shah-nameh* of Shah Tahmasp.[21]

The legendary importance of the blacksmithing trade is also enhanced in the *Shah-nameh* by the story of Kaveh's revolt against the tyrant, Zahhak. Kaveh fastened a piece of leather on the end of his spear, of the kind which blacksmiths wear to protect their legs, and this apron was adopted as the royal banner of Iran by the new king, Faridun. Called *durnfah-i Kava*, it was supposed to have been captured by Sa'd ibn Abi Waqas and sent to the Caliph 'Umar.[22] The *Shah-nameh* incident, however, is only occasionally illustrated, for example, in a mid 15th-century manuscript in Tashkent.[23] Rarely do other references to iron and steel in the text receive illustrative treatment.[24]

In the 1st century AD Pliny stated that 'Seric' iron was the best, with Parthian iron said to be second best.[25] In this case 'Seric' is often thought to refer not to China but to an intermediate source for which Ferghana, north-east of Iran, and India have

17. It is found on the 14th-century pierced iron door plaque in the Homaizi Collection: *Art from the World of Islam 8th–18th century* (1987) no.165.
18. Tehran, Gulistan Library; Pope (1938) pl.872B.
19. Dublin, Chester Beatty Library; Pope (1938) pl.880.
20. Lentz and Lowry (1989) no.63. For other 15th-century examples see Norgren and Davis (1969), under *Jamshid Teaches Crafts*.
21. Dickson and Welch (1981) no.11, fol. 2v.

22. Gordon (1896) pp.136–37.
23. Norgren and Davis (1969), under *Kaveh Carries his Standard*.
24. A picture of Gushtasp working as a blacksmith was recently on the art market (Christie's, 24 April 1996, lot 86), and 15th- and 16th-century illustrations of this event are also known: Norgren and Davis (1969), under *Goshtasp Seeks Work in Rum with the Smith Burab*; Titley (1977) no.117 (44).
25. Pliny (1952) vol.9 p.233, 34.145.

been suggested.[26] In the 2nd century AD the *Periplus of the Erithraean Sea* mentions the Red Sea trade in 'iron and steel'[27] at a time when Roman trade with India was at its height,[28] and such references imply that Iran was at least involved in the trade, if not the actual manufacture, of good-quality iron and steel.

CRUCIBLE-STEEL MAKING IN PRE-ISLAMIC IRAN

Indeed, the earliest evidence so far recovered for the making of artefacts from ultra high-carbon (crucible) steel comes from Taxila, now in the north-east corner of Pakistan, where two sword blades and an adze-head were excavated.[29] One complete double-edged sword (No.57) was from a Parthian context of the 1st century AD,[30] as was the adze (No.116), a carpenter's tool.[31] The date of a fragmentary second sword (No.58a) is less certain although it is reported as being 'probably 5th century'.[32] Information on these three objects is not sufficiently complete to enable the manufacturing techniques to be identified, but the carbon content and general descriptions could well refer to objects of crucible steel. Sword blades with such high carbon contents would have been far too brittle for use and would have to have been forged in such a way as to render them practical.[33] There remains the tantalising possibility that these objects might represent evidence of the early crucible-steel industry in an area under Iranian influence in both the Parthian and Sasanian periods.

A later account of the 'tempering' of Indian iron, by the Alexandrian alchemist Zosimos, makes it clear that crucible-steel making was taking place in the region by the 3rd century AD.[34] Zosimos is quite specific in saying that this technique came to

26. Warmington (1874) p.257.
27. Huntingford (1980) p.22; Casson (1989).
28. Craddock (1995) p.279.
29. Marshall (1951) vol.2 p.536–38 and 544–45.
30. It was found to be made of steel with a carbon content in the range 1.3–1.5% and mean hardness 240 HV. Its structure is described as consisting of 'small slightly elongated grains of ferrite and spheroidal carbide, the result of the decomposition of the pearlite. The grains are outlined by cementite. Traces only of decarburisation round the outer surface. Non-metallic inclusions fairly small and comparatively few.'
31. The adze was only examined away from the edge (i.e. the body). It is reported as consisting of high-carbon steel, with 1.23% carbon, but no other details are given.
32. This sword had a carbon content in the range 1.5–1.7% and mean hardness 243 HV. Its structure was similar to the first but with 'cell walls of cementite thicker and grains larger and more elongated'. It is also said to have slight traces of decarburisation at the surface, and to contain a comparatively few, small, non-metallic inclusions similar to those seen in the first sword.
33. The hardness values given are consistent with, although possibly rather low for, the spheroidal – decomposed pearlite – carbide structure described. This structure sounds similar to the steely matrix found for many, much more recent, watered crucible-steel objects. It would have been necessary to disperse, at least partially, the cementite reported as outlining the grain boundaries (see note 30), but no mention is made of the presence of free spheroidal cementite (iron carbide) particles which should be present if the objects had been forged in this way.
34. 'Take soft iron, 4 pounds, and cut it up into small pieces; then taking the husk of the fruits of the palm tree, called *elileg* [i.e. date skins] by the Arabs, 15 parts by weight, and 4 parts by weight of *bellileg*,

the West from Iran, and it is likely to have been in use in Iran at this time even if it was invented in India, as Zosimos states. A passage in the Babylonian Talmud of the 4th or 5th century AD records that the sale (by Jewish merchants) of iron ingots to other nations was forbidden because of the likelihood of this material being used by the wrong people to make weapons, whereas the export of Indian iron to the Iranians, as protectors, was allowed.[35] That this Indian iron is described as iron bars made as ingots suggests that the reference is to crucible steel.

Two pre-Islamic Iranian references to what may have been watered-steel blades reinforce the idea that crucible-steel making had become well established in Iran by the 6th century. The poet Imru'ulqais (d. *circa* 540 AD) refers to a blade having wavy marks like the tracks of ants, while his younger contemporary, Aus ibn Hajar, describes a blade as follows: 'It has a water whose wavy streaks are glistening … it is like a pond over whose surface the wind is gliding … the smith has worked out in it a grain as if it were the trail of small black ants that had trekked over it while it was still soft.'[36] These descriptions match the surface appearance of much more recent (16th-century and later) watered crucible-steel blades more closely than the surface appearance of contemporary pattern-welded blades,[37] which are, as far as we know, predominantly Western European. We cannot be sure that the sword blades mentioned in these pre-Islamic descriptions were not pattern-welded but what evidence we have seems to suggest that these swords are more likely to have been watered blades of a crucible origin, and at least one 6th-century Iranian sword is now known to be made of crucible steel.[38]

TRADE IN IRON AND STEEL BETWEEN IRAN, CHINA, INDIA AND SRI LANKA: 1ST CENTURY BC TO 11TH CENTURY AD

As yet we have no evidence of when the crucible-steel industry was established in

likewise cleaned, of the insides, i.e. the husk again, likewise 4 parts of *ambileg*, likewise cleaned, and the glassworker's magnesia mentioned above [probably manganese dioxide], 2 parts. Grind all this up, not too small, and mix with the 4 pounds of iron. Then place in a crucible and ensure that the crucible is well placed before heating; if you do not do this, to prevent it [i.e. the crucible] from being moved, you will have difficulty when casting. Then place the coals and force the fire [i.e. apply a forced draught, probably with bellows] until the iron melts, and the [above mentioned] materials have joined with it. The 4 pounds of iron will require 100 pounds of charcoal. Note that if the iron is very soft it will not need any magnesia, but only all the other materials; this is because the magnesia makes it extremely dry and it becomes brittle. But if it is soft, only it alone is needed, as said above; because this accomplishes all. This is the first and foremost operation, that which is now being studied, and with which the most marvellous swords are manufactured. It was discovered by the Indians and made known by the Persians, and it is through these that it came to us.' Berthelot (1888) III p.332.
35. Bodenheimer and Rothenberg (1996) pp.10–11.
36. Smith (1960) p.14.
37. Gilmour (1996) p.119.
38. Craddock (1998) p.48; Lang *et al.* (1998) p.10.

north-western Iran, although it would seem likely that the arrival of cast-iron technology from China, where it had developed in the 6th–5th centuries BC,[39] and the trade links between Iran and China that grew following the establishment of the Silk Route four centuries later, would have had some influence on the later development of the industry in Iran. There seems to be written evidence, however, that certain types of iron or steel may have been imported into China in pre-Tang times – 6th century AD or earlier.[40] This consists of a late 16th-century quote from a much earlier Chinese work, the *Pao Tsang Lun*, now lost but known to have been finished by AD 918 and to include some material which is thought to be as early as the 3rd or 4th century AD. The quote lists five types of iron, two of which concern us here. 'Steely iron (*pin thieh*) comes from Po-Ssu, hard and sharp, it can cut gold and jade … Hard iron (*kang thieh*) comes from the rocks of the mountains among the aguish south-western seas, and in appearance it is like veined purple quartz. Water and fire cannot hurt it; it will cleave pearls and cut through jade.'[41] The 'mountains' or 'mountain lands' of the 'south-western seas' would seem most likely to refer either to Sri Lanka or to the Indian mainland, and the hard iron could refer either to *wootz* (see below) produced in southern India and Sri Lanka, or to a form of ultra high-carbon steel, possibly in an unprocessed form similar to the *tamahagane* (the central steel part of the bloom) produced in the comparable *tatara* furnaces of Japan.[42] *Pin*, a Chinese word for steel, is suspected to be a loanword from one of the Turkic or Iranian languages, transliterated into Chinese, and might refer specifically to *wootz*.[43] If these speculations are correct, and *pin* is a Chinese adaptation of a word for a specific kind of steel, possibly *wootz*, it would seem to add weight to the argument that Po-Ssu (or Possu) is to be identified with Persia.

Iran seems to have been largely unknown to the Chinese before Chang Ch'ien's exploratory mission to the regions beyond China's western frontiers in 128 BC and his return to China two years later. Another 15 to 20 years elapsed before the Silk Road was established, by which time Parthian domination had extended beyond the River Oxus as far as the Aral Sea. Persia (or Parthia) was then known to the Chinese as An-hsi after its capital, Antioch-Merv, before the opening of the Silk Road in the late 2nd century BC,[44] after which time iron-casting appears to have been introduced to Central Asia.[45] In about 110 BC the Chinese writer Ssuma Chhien says of the people living in the area from Ta-Yuan (Ferghana) to the east, and An-Hsi (Parthia) to the west: 'Those countries produced no silk or lacquer, nor did they know of the technique of casting iron for pots and pans and all kinds of useful imple-

39. Wagner (1993) p.406.
40. Needham (1958) p.46.
41. Needham (1980) p.538.
42. Kapp *et al.* (1987) p.65.
43. Needham (1980) p.539.
44. Yarshater (1983) pp.541–42.
45. Needham (1974) pp.219 and 238.

ments ... When some deserters from the retinue of a Chinese embassy had settled there, however, they taught them to cast weapons (of iron) and many other useful things.'[46]

Metals did travel in antiquity and the early Middle Ages, often in the form of pigs or cakes (i.e. ingots), as well as finished objects. Seric or Chinese iron moved westwards, while Iranian brass, Indian *wootz*, 'Damascus' steel (see below) and various other metallic products are listed as tribute in the Chinese dynastic histories. Arabic sources also record the use of *hadid al-Sini* ('Chinese iron') for mirrors.[47] If the identity of An-hsi as Parthia is correct then there were also seaborne links between Iran and China as early as the 3rd century AD. Once this trade route had become established, transport by ship would have been a more convenient and less costly way to carry heavy materials like the 'steely iron' mentioned in the Chinese accounts. Under the Sasanian dynasties of the 5th and 6th centuries AD, Iran was a dominant maritime trading force at least as far east as Sri Lanka. The presence of a Nestorian Christian community at Qal'ah (the Syriac QLH) would suggest the presence of Sasanian merchants somewhere on the Malay peninsula by the early 7th century, in a place which became an important trading centre in the medieval Islamic period.[48] On balance, such evidence as exists appears to support the identification of Po-Ssu with Persia until at least as late as the 8th century AD.[49] It is perhaps significant that Qal'ah is mentioned by al-Kindi, writing in the first half of the 9th century, as a producer of an 'ancient' (meaning high-quality) form of *fulad*, a term by which he usually refers to crucible steel.

Sources such as al-Kindi also mention the export of lesser quality *fulad* from Sri Lanka to the sword-making centres at Khurasan and Fars in Iran, Mansura in southern Pakistan and the Yemen;[50] al-Kindi also reports that *fulad* was made there for local sword production. Evidence from archaeological investigations at Samanalawewa, unknown until recently, would suggest that Sri Lanka was a major centre for specialised, non-crucible iron and steel production between the 7th and 11th centuries AD. The metal was smelted in wide-mouthed, wind-driven furnaces which relied on the dry monsoon season winds of that part of south-western Sri Lanka. Ancestral remains of the industry have been found, and its origins can be traced back (from archaeology and field survey) to as early as the 4rd century BC.[51] The Sri Lankan industry appears to have reached its peak in the 9th century and to have ceased operating sometime during the 11th century, most likely a victim of the

46. Needham (1974) p.219.
47. Needham (1974) p.238.
48. Whitehouse and Williamson (1973) p.48. Qal'ah (Kalah) may be an Arabised form of Kalang, an ancient port near Kuala Lumpur: Fatimi (1964), pp.211–15.
49. For a detailed discussion, see Whitehouse and Williamson (1973) pp.46–48.
50. al-Kindi pp.9–10; Hoyland *et al.* (forthcoming).
51. Juleff (1996) p.62; Juleff (1998) p.153.

disruption caused by Chola invasions from southern India, which eventually brought about the end of the Sri Lankan Dry Zone civilisation under which this particular large-scale development of iron production had prospered. In the 12th century AD crucible-steel making seems to have taken over; there seems little reason to doubt that crucible steel (or *wootz*) had been produced in Sri Lanka for some centuries earlier although, so far, the material evidence for this is restricted to unstratified finds of crucible fragments as well as some actual pieces of crucible steel.[52] None of the production sites has yet been identified.

Although crucible-steel making appears to have continued in Sri Lanka after the 11th century, subsequent imports of this material to Iran seem to have come from India.[53] Al-Kindi describes Indian crucible-steel swords as of high quality, although he does not mention the export of Indian crucible steel. India continued to be famous as a centre for specialised (presumably crucible) steel and associated sword production, whereas Sri Lanka is not mentioned by most later writers, and its industry eventually died out in the mid- to late 19th century.[54]

CRUCIBLE-STEEL MANUFACTURE IN MEDIEVAL IRAN: THE EVIDENCE OF MERV

Recent investigations at Merv and Fergana have produced the first evidence of early steel-making in this region. Fieldwork and partial excavation at Merv brought to light a steel-making workshop dated by associated pottery to the late 9th–early 10th century AD.[55] Two phases of furnace plus fragmentary remains of associated crucibles were found scattered in this area, although until very recently no traces of crucible charge or steel ingots had been identified. To the north-east, across the River Oxus in the area formerly occupied by Transoxiana and Fergana, evidence of crucible-steel making dating between the 9th and 12th centuries has also been found recently.[56]

The Merv crucible fragments were made of thin-walled refractory clay and, in

52. These have been dated to the 9th–11th centuries by radio-carbon determination: Juleff (1997); Brown and Rehder (forthcoming).
53. In this final phase of crucible steel production in Sri Lanka the crucible charge consisted of a piece of plain bloomery iron with small pieces of wood (*cassia auriculata*) which – with small variations such as the addition of leaves, or the substitution of rice husks for wood – is the same as the crucible charge recorded for nearly all the variations in the crucible steel (or *wootz*) industry recorded in the 19th century for the Mysore region of south-west India and in Tamilnadu in the south-east. This is in contrast to the plain (bloomery) iron/cast-iron crucible charge recorded for the large-scale industry in the 19th century in the Hyderabad region of central India and for the northern Iranian industry recorded by Massalski (1841). See also the section on *wootz* below.
54. It was rediscovered, recorded, and briefly reconstructed, in 1904: Coomaraswamy (1908).
55. Herrmann *et al.* (1996) p.16.
56. Papachristou and Swertschkow (1993) pp.122–31.

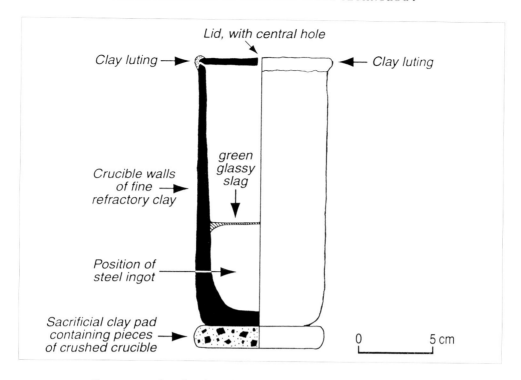

FIG.3 Reconstructed section through one of the larger Merv steel-making crucibles (based on information from A. Feuerbach and D. Griffiths)

addition to the remains of slag towards what would have been the lower part of the inside, small particles or prills of both steel and cast iron were found embedded on the inner walls of the crucible fragments.[57] Sufficient fragments were recovered to allow a reconstruction drawing of at least one crucible to be made.[58] The lid of this crucible, which had been luted (sealed with a clay slurry) onto the main body, consisted of a disc of similar refractory clay with a single central vent hole. The material from Fergana also consists mainly of the remains of crucibles of varying sizes, including lids in which a central hole seems to have been usual, sometimes with additional smaller holes, presumably for venting, nearer the sides. Overall the reconstructed Merv crucible was comparatively large, measuring approximately 22 centimetres high with an external diameter of 8–9 centimetres (FIG.3), and would have produced a steel ingot about 5 centimetres high with a maximum diameter of about 7 centimetres, weighing approximately 1.3 kilograms. The remains of smaller crucibles were also found.

57. Herrmann *et al.* (1996), pl.VIII and III; Merkel *et al.* (1995) p.44; (1996) p.17.

58. Merkel *et al.* (1996) p.17 and fig.12.

FIG.4a Corroded remains of an egg-like crucible-steel ingot found near the 10th-century steel-making workshop at Merv. Ingot measures approximately 5 cm across.

An ingot like this would seem to match the 'refined steel in the shape of ostrich eggs' which is described in Jabir al-Hayyan's *Kitab al-hadid* ('Book on Iron') of the 8th–9th century and quoted in a commentary by al-Jildaki (*circa* 1340). Jabir says that these egg-shaped ingots were used to make swords as well as helmets, lance-heads and all kinds of tools and it may be no coincidence that 1.3 kilograms is about the weight of ingot needed to forge a single watered-steel sword.[59] It would seem highly likely that this particular site represents one of a number of crucible-steel workshops operating in Merv during the 9th and 10th centuries, producing crucible-steel ingots varying in size from approximately 0.25 to 1.5 kilograms, depending on the use to which they were to be put. They may have been turned out mainly for the production of arms and armour, given that Merv was an Arab military headquarters in this period.[60]

One of a series of unpromising iron lumps found at the site of the steel-making workshop at Merv has now been identified as a crucible-steel ingot (FIGS 4a–d). Its surviving structure[61] is a key to understanding what remains of a sword found dur-

59. Some allowance must be made for loss due to oxidation during forging: it is not yet clear what proportion would have been lost in this way, but possibly half of the original metal.
60. Herrmann (1995) p.33.
61. Although now highly corroded it is very roughly egg-shaped, measuring approximately 6 cm long by 4 cm wide. Metallographic examination of a sample from near one end identified it as an unused ultra high-carbon (hypereutectoid) steel ingot or cake with a carbon content of approximately 1.2–1.4%. Uncorroded metal shows up in one place (FIG.4b, top right). At higher magnification, a pale grain boundary network of iron carbide (cementite) shows up clearly against a darker (pearlitic) steely background matrix. Also visible were pale, spiky needle-like formations of iron carbide. Elsewhere in the darker areas metal corrosion has been more or less complete but must have progressed slowly, leaving a recognisable imprint or 'remnant' network of the original metallic structure still visible (FIG.4c). In some places, however, fragments of iron carbides survive in an otherwise corroded background (FIG.4d). We are indebted to Ann Feuerbach and Dr John Merkel of the Merv Project for generously allowing us to examine and report on this material in advance of their own publication, and to use some of their initial photomicrographs.

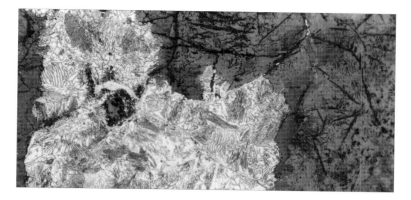

FIG.4b Section of ingot in FIG.4a: hypereutectoid structure with dark, steel grains outlined with pale cementite, which also shows up as 'needles' within the grains. Magnification x 50; etched 2% nital.

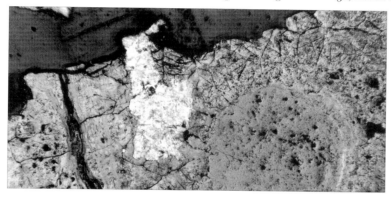

FIG.4c Section of ingot in FIG.4a: boundary between surviving metal and corroded areas, where the hypereutectoid structure continues in relic form. Magnification x200; etched 2% nital.

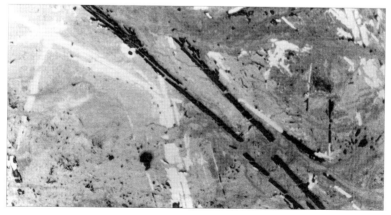

FIG.4d Section of ingot in FIG.4a: partial survival of needle-like cementite in an otherwise corroded area showing relic outlines of other cementite needles. Magnification x 400. Photo: Ann Feuerbach

ing archaeological excavation at Nishapur, about 150 miles (250 km) south-west of Merv, in the late 1930s (FIGS 5a–b).[62] Its style would suggest this sword is approximately late 8th- or 9th-century in date,[63] and analysis suggests that the metal for the blade came from a crucible-steel making workshop roughly contemporary with that found at Merv, and conceivably from the same workshop, although Herat, approximately 160 kilometres (100 miles) south-east of Nishapur and the known steel-making centre for this time, may be a more likely source for the metal. In any case, there seems little doubt that the Nishapur sword is a product of the crucible-steel industry of this region.

One might ask why an ingot like this was left on the site, although the curious circular patch visible in the totally corroded central part of FIG.4b might provide a clue. It would appear that the metal here was different and may represent a piece of plain iron that had failed to become absorbed into the surrounding liquid steel while the crucible was still in the furnace. This may therefore represent a failed ingot or reject that was put aside to await a return to the furnace that never came. There is little doubt that it is a rare surviving example, probably dating to the 9th century AD, of one of the egg-shaped ingots of the kind described a century or two later by al-Biruni (see below). Apart from the Merv ingot, few or no traces of metal relating to whatever crucible process was being carried out at Merv, or sites further east, have been found, although some metallic remains can be expected from further fieldwork.

62. New York, Metropolitan Museum of Art: Allan (1982) pp 56–58, 108–109.

63. Until now nothing has been known about the structure of its blade. However, the Metropolitan Museum has recently collaborated with the Ashmolean Museum, Oxford, in an attempt to identify the metal used to make the blade. A small sample confirmed that the blade is now almost totally corroded with little or no metal left. Slow corrosion in the ground had left some remnants of the structure intact, in shape at least, although the structure was less easy to see than in the surviving Merv ingot. There was none of the former grain boundary network of iron carbide visible in the Merv ingot and typical of an as-cast ultra high-carbon steel structure. There were, however, traces of what had once been a needle-like structure of iron carbide (cementite) scattered across the section. In its original state this would have left the blade quite brittle. In one area the pale remains of iron carbide 'needles' still survived (FIG.5b). The needle-like structure is closely similar to that visible at higher magnification in the Merv ingot, although in the case of the Nishapur blade it must represent iron carbide which formed during the last heating cycle when the blade was being forged. Also surviving in this area of the blade was a scattering of small, pale spheroidal particles, absent in the Merv ingot but which are typical of an ultra high-carbon steel which has been extensively forged. The small dark spheroidal spots also visible here are likely to mark the positions of other similar iron carbide particles, now totally corroded away. The overall pattern of corrosion was aligned parallel to the main (flat) plane of the blade, suggesting that this blade may once have had a layered structure similar to that found in later watered-steel objects, particularly swords. Varying sized iron carbide particles are also typical of watered steels and the presence of these strongly indicates that the blade of the Nishapur sword was made of watered steel with a typical carbon content of approaching 1.5%.

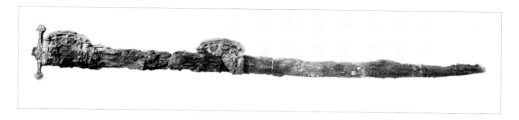

FIG.5a Slightly curved, single-edged sword found in 9th-century archaeological levels at Nishapur. Length of blade 71.5 cm. Photo: Metropolitan Museum of Art, New York

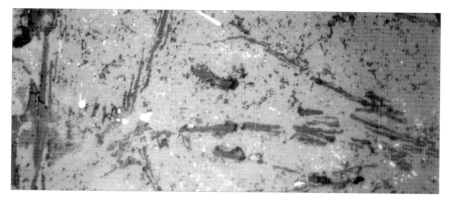

FIG.5b Section of sword in Fig.5a: relic hypereutectoid structure with surviving traces of cementite 'needles', and dark spots formerly occupied by spheroidal cementite particles. Magnification x 400.

The area of Merv lacked any obvious iron ore deposits, and all the raw materials for crucible-steel production may have been imported. This was made possible by Merv's key position on the Silk Route. In any case, the crucible-steel making carried out here must have been a secondary process (i.e. not involving the primary smelting of ores to produce the metal). This process seems almost certain to have involved a crucible charge of which the main constituents were plain (bloomery) iron and cast-iron pieces, perhaps imported from more than one source, probably mixed with slag-forming minerals and vegetable matter. This procedure was described by al-Biruni as that used by the ironsmith Mazyad ibn 'Ali of Damascus (or al-Dimashqi, see below), and must predate al-Kindi's treatise of the earlier 9th century; and it may have been the same process that is referred to in Jabir al-Hayyan's *Book on Iron*. It seems perfectly possible that Merv was one of a number of sites responsible for the Khurasani production of *fulad* referred to by al-Kindi.

ISLAMIC AUTHORS ON STEEL-MAKING: 9TH CENTURY AD ONWARDS

Although before the Islamic period there are few written descriptions which refer directly to cast steel or the watered blades made from it, it seems clear from the surviving texts that by the 9th century AD two methods existed for making steel in small clay crucibles. The earliest record of these is the description by Zosimos,[64] in which bits of bloomery iron and organic matter were mixed together in the crucibles and heated until enough carbon was absorbed for the metal to melt. Depending on the proportion of carbonaceous matter a cast steel or a cast iron resulted, although the temperature required for a cast iron was lower than that for a cast steel. The second method involved mixing bits of bloomery iron and bits of cast iron in crucibles and heating to produce an iron alloy with an intermediate composition. We have yet to find out the extent to which either or both of these methods was used in medieval Iran, but one Chinese chronicle, the *Ko-Ku-Yao*, describes the winding lines that were visible on the surface of Sasanian steel imported from Iran, which suggests that this was watered steel of crucible origin.[65]

From the 9th century, writers give much more detailed accounts of the Iranian industry. The first of these is al-Kindi (*circa* AD 801–870) who, in a letter to al-Mu'tasim, the Abbasid Caliph of Baghdad (r. AD 833–41), described different types of iron and steel as well as their use in making the various types of sword. The three main types were *narmahan*, 'soft iron', *shaburqan*,[66] 'hard iron' and *fulad*, 'steel'.[67] The accompanying descriptions suggest that *shaburqan* and another term, *dus*, may both have referred to cast iron, at least in some instances. *Shaburqan* also referred to steel and other iron alloys of a non-crucible origin. While it is difficult to be sure what is meant when al-Kindi uses one or other of these terms, there seems to be no doubt that *fulad* means steel, and it is clear from most descriptions that steel of a crucible origin is being referred to. Al-Kindi differentiates between 'mined' and 'unmined' iron, clearly referring on the one hand to iron or steel which is smelted directly from its ores, and on the other to iron or steel which is produced by secondary processing. *Fulad* appears only in the unmined category. Al-Kindi briefly mentions it as being

64. See note 34 above.
65. Wulff (1966) p.7.
66. 'Iron (*hadid*) from which swords are forged is divided into two categories: mined (*madani*) and unmined (*laysa bi-madani*). And the mined is divided into two categories: the *shaburqan*, which is masculine, hard and able to be quenched during its forging, and the *narmahan*, which is feminine, soft and not able to be quenched during its forging. [Swords] may be forged from each [type] of this iron alone, and also from both put [i.e. welded] together. So there are in all three types of mined swords: [those] that are made from *shaburqan*, [those] that are made from *narmahan* and [those] that [are] made from a compound of the two …'
67. 'The iron which is unmined, is steel (*fulad*), by which is meant purified. It is manufactured from mined iron by throwing onto it during the melting something which purifies it and makes its softness strength, so that it becomes firm, pliable, able to be quenched and its watering (*firind*) appears on it.' al-Kindi pp.5–6; Hoyland *et al.* (forthcoming).

produced as a liquid, which for a secondary process can only really mean a crucible steel. He does not discuss the manufacture of mined, or directly smelted varieties of iron, which seem likely to have included (white) cast iron that could also have been produced as a liquid, but goes to some lengths to emphasise the distinctive nature of unmined steel 'which [once it is made] is not mixed with anything else, [un]like the *shaburqan* and the *narmahan* … the *shaburqan* and the *narmahan* are single invariable metals without anything ever having been introduced into their essence that would change them for better or worse.'[68]

Al-Kindi goes on to describe, in detail, two main types of swords: those made from mined iron or steel, fairly clearly of bloomery origin, and those made of unmined iron, that is, crucible steel or *fulad*. He describes Indian steel swords as being of ancient origin and it seems likely that these and the crucible-steel ingots that were probably used to make them were imported to Iran from well before the 9th century right through to the 19th century. Perhaps of more relevance to crucible-steel processing in Merv in the 9th century is the type of steel sword referred to by al-Kindi as 'modern'. One sub-group of this type is called *salmani*, which seems to refer to swords, and possibly steel as well, made in the main iron-producing area of Transoxiana, north-east of Iran beyond the River Oxus. The main sub-group, *Serendibi* or Sri Lankan, splits into four groups: swords made in Sri Lanka; swords made in the Iranian province of Fars from Sri Lankan steel cakes, presumably imported by sea; swords made in Khurasan on a Sri Lankan model;[69] and swords made at al-Mansuriyya, the capital of Sind, which occupied the southern part of modern-day Pakistan, around the delta of the River Indus. Al-Kindi does not say what kind of steel was used to make this last group, although imported Sri Lankan steel is implied, and would in any case seem likely for this coastal area.[70]

More of a puzzle is another of al-Kindi's sub-types which refers to swords from Fars and Kufi as *baid*, for which 'white' (or 'polished') seems to make best sense, although 'eggs', a possible reference to a crucible origin, could also be meant.[71] Al-Kindi does not describe the making of crucible steel but he does refer to it as *murrakab*, a compound material, which he says is made by mixing *narmahan* (soft iron) and *sharburqan* (hard iron) which, in this particular case, would seem to refer to cast iron.

An approximately contemporary account of cast-iron and crucible-steel making is given in Jabir al-Hayyan's *Book on Iron*, which is quoted in al-Jildaki's 14th-century

68. al-Kindi p.8.
69. Oak or tamarisk charcoal appears to have been used to make the steel for these swords, which implies Khurasani production of crucible steel cakes, though imported Sri Lankan cakes may also have been used.
70. The steel was most probably in the form of crucible cakes but may have been the raw steel from the wind-powered furnaces which we now know were operating on a large scale in Sri Lanka at this time: see Juleff (1996) pp.58–60) and note 50 above.
71. al-Kindi p.9.

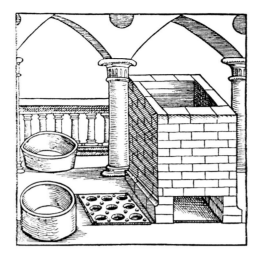

FIG.6 A furnace possibly of the form used for the production of crucible steel in medieval Iran, illustration from Jabir ibn Hayyan (1686)

commentary from Cairo. One passage gives instructions for making white cast iron:

'Learn, brother, that it is your comrades who found (literally, from *yaskubun*, 'founding') iron in foundries (especially) made for that purpose after they have extracted it (i.e. the ore) from its mine as yellow earth intermingled with barely visible veins of iron. They place it in the founding furnaces designed for smelting it. They install powerful bellows on all sides of them after having kneaded (*yaluttun*) a little oil and alkali into the ore. Then the fire is applied to it (i.e. the ore) together with cinders and wood. They blow upon it until it is molten, and its entire substance (*jishmuhu wa jasuduhu*) is rid of that earth. Next, they cause it to drop through holes like (those of) strainers, (made in) the furnaces so that the molten iron is separated, and is made into bars from that earth. Then they transport it to far lands and countries. People use it for making utilitarian things of which they have need.'

Another part of the text describes the making of steel in crucibles:

'As for the steel workers, they take the iron bars and put them into the founding-ovens (*masabik*) which they have, suited to their objectives, in the steel works. They install firing equipment (*akwar*) in them (i.e. the ovens) and blow fire upon it (i.e. the iron) for a long while until it becomes like gurgling water. They nourish it with glass, oil and alkali until light appears from it in the fire and it is purified of

much of its blackness by intensive founding, night and day. They keep watching while it whirls for indications until they are sure of its suitability, and its lamp emits light. Thereupon they pour it out through channels so that it comes out like running water. They then allow it to solidify in the shape of bars or in holes made of clay fashioned like large crucibles. They take out of them refined steel in the shape of ostrich eggs, and they make swords from it, and helmets, lance heads, and all tools.'[72]

The second part of this passage has been interpreted as representing a third early steel-making process linked to crucible production, this time involving the refining of the cast-iron bars mentioned in the first part of the description, but different to the two crucible methods known to have been used in this period.[73] One problem with this interpretation is that the existence of a new process seems to be unsupported by any other clear evidence. A slightly different translation of the passage in al-Jildaki's version of Jabir's description has been proposed, which reads like a variation of the process involving the mixing of pieces of plain iron and cast iron:

'As for the iron makers, they take bars of iron which they place in the smelters which they have according to their design for the production of steel. Then they place bellows upon them and blow on the fire for a long time to render the metal as boiling as water. They feed it with glass, oil and alkali until a light is released in the fire and a large proportion of its darkness is lost through the intensity of the melting, over the space of a day and a night. They do not cease from watching the signs, until they are sure of its quality and it lights like a lamp. They then pour it along ducts so that it leaves like flowing water and solidifies into bars or into sealed (?) clay holes like large crucibles. They then remove the purified steel in the form of ostrich eggs, and they make swords, helmets, lance points and other armaments from them.'[74]

72. al-Hassan (1979) pp.36–38; al-Hassan and Hill (1986) pp.252–53.
73. al-Hassan and Hill (1986) p.254.
74. Ragib and Fluzin (1997) pp.68–69. Not all the other surviving early descriptions specify that different forms of iron were used in the crucible charge but it is clear from their general agreement in other respects that this is most likely to have been the case. The addition of both organic and inorganic materials was normal and a process involving melting would have to have been carried out in crucibles even though these are not mentioned in the first part of the report. The reference to 'sealed clay holes like large crucibles' makes little sense. Sealed clay crucibles, however, would be the containers in the first part of the process. The clay lids luted on to the bodies of the 9th–10th century crucible fragments recently found at Merv were described for various of the crucible-steel making processes still in use in southern India in the 19th century, and the boiling noise was noted in 1841 by Massalski in the crucible-steel making process he observed at Bukhara (see below and Appendix Four), starting when the cast iron melted and continuing until the fusion between the two types of iron was complete and the contents of the crucible were completely liquid.

There seems no reason why it should not be simply an incomplete or garbled version of that process, which can also be regarded as a cast-iron refining procedure.

It would appear from Jabir's description that the heating cycle of this crucible-steel making process took approximately 24 hours, within the range found in the 19th-century southern Indian processes, which typically lasted between 6 and 24 hours for the heating part of the cycle, although longer times were reported.[75] In these processes the completion of liquefaction was sometimes judged by shaking the crucibles, while in at least one case it was observed through a hole in the lid. This may well have been one purpose of the central hole in the Merv crucible lids. Either could have applied in the case of Jabir's description, although the passage 'They keep watching while it whirls for indications until they are sure of its suitability, and its lamp emits light' most likely suggests that liquefaction was carefully observed through a central hole in the crucible lid.

In Jabir's account, once the iron was seen to be fully liquid (i.e. the fusion process was completed and a homogeneous steel produced) it was poured out, via channels, into bar- or crucible-shaped moulds. Sometimes the steel may have been allowed to cool slowly in the crucibles and was only broken out later, a variation that may have been important in the eventual production of watered-steel objects and is likely to have applied to much of the metal used for arms and armour, especially swords, if not necessarily for tools. All of these seem to have been among the likely end products of the crucible steel made according to Jabir's description.

Two hundred years after al-Kindi, al-Biruni (AD 973–1048) provided the earliest specific description of two entirely different types of patterned sword blades, those with welded patterns and those whose pattern is inherent in the steel from which they are made.[76] He says that the Rus (referring either to Russians, Vikings or other northern Europeans who occupied the Novgorod region) manufactured pattern-welded swords with patterns resembling mixed 'threads' consisting of *narmahan* (soft iron) and *shaburqan* (hard or steely iron), in contrast to Eastern blades, strongly suggesting that the latter were made from non-welded iron or steel. He also says that blades made of *fulad* (a clear reference to crucible steel) cannot withstand the cold of the Russian winters, in which they are liable to break. Brittle stress fracture is much more likely to have been a problem with the ultra high-carbon steels (of approximately 1.5–2.0% carbon) which are now known to have been the basic material used for watered blades made from some variant of the *wootz* type of crucible-steel ingots.

Like al-Kindi before him, al-Biruni used earlier sources for some of what he wrote, many or most of which are now lost. He mentions a book describing swords,

75. Bronson (1986) p.38.
76. '(True) *Farand* (on the other hand) does not occur in such work by intent, nor does it come as desired; it just happens.' al-Biruni p.254.

attributed to Mazyad ibn 'Ali or al-Dimashqi (i.e. of or from Damascus), specifications for which were included in al-Kindi's letter on their attributes.[77] According to al-Biruni, this work began with the origins of *fulad*, the making of crucibles and their shapes, and a description of the clays and their special attributes, and then goes on to give a recipe for steel.

> 'He ordered 5 *ratl* of mules' shoes and nails made of *narmahan* [soft iron] to be put into each crucible, together with 10 *dirhems* [by] weight of each of the following: antimony, golden marcasite [iron pyrites], and powdered magnesia [probably manganese dioxide]. He ordered the crucibles to be coated with clay, and then put into the furnace, the furnace [then] to be filled with [char]coal, and the crucibles then to be blown with [Byzantine] Greek bellows, each bellows worked by two men, until the contents melted and mixed. He also used to prepare bags, each with *myrobalans*, pomegranate skins, the salt of dough [i.e. edible salt], and mother of pearl [oyster shells] in equal quantities. One bag was placed in each crucible, the crucibles to be blown upon strongly and continuously for one hour, then left until cold, then the cakes to be extracted from the crucibles.'[78]

He recorded that the area of Herat was especially noted for crucible-steel ingots and that these were called *baidat* (eggs) because of their shape. His description goes on to say that the eggs were long and round-bottomed, following the shape of the crucibles, and that from them Indian swords and others were fashioned. About a hundred years later al-Tarsusi also described the ingots as *baidat* in one of his crucible-steel recipes. These egg-shaped ingots must be the same type as 19th-century examples of flat-topped ovoidal *wootz* ingots (for which, see below). Al-Biruni also mentions that in Herat, according to the smith al-Dimashqi, cakes were made in crucibles by melting together *dus* (by which white cast iron would appear to be meant) and *narmahan* ('soft' or bloomery iron).[79] Herati *fulad* was of two types, one which did not produce a watered pattern and was consequently used for objects such as files, and another which did produce a watered pattern or *farand* that was

77. Ragib and Fluzin (1997) p.67. Mazyad ibn Ali's book is mentioned by al-Kindi and appears to have been old in his time. All that now survives is al-Biruni's quotation. Mazyad ibn Ali's identity is uncertain: he may have been a well-known ironsmith and steel-maker operating in Damascus in late Byzantine or early Islamic times.
78. al-Biruni p.256. The author would appear to have slightly muddled this recipe, in that presumably the bags of organic matter and salt would have been placed in the crucibles before they were sealed to provide the carbon necessary to carburise the soft iron and produce the steel cake, in this case a procedure not involving cast iron, despite the reading of this passage by Said (1989) p.219.
79. al-Biruni p.256. He describes *dus*, the Persian *asteh*, as a sub-type of *narmahan*, which precedes iron in reaching a fluid state and is white, hard and (presumably in appearance) something like silver: al-Biruni p.248.

used to make sword blades that were much sought after. This method for making *fulad* (crucible steel) is described in detail.

'As for the compound of *narmahan* and its water, the latter being the first to become fluid in the purification process, it is *fulad*. The area of Herat is specially noted for *fulad*, and it is called *baidat* ['eggs'] on account of its shape. These eggs [or egg-shaped cakes] are long and round-bottomed according to the shape of the crucibles [in which they are made] and from them Indian swords etc. are fashioned. According to its composition *fulad* is of two types. Either the *narmahan* and its water [presumably white cast iron] in the crucible melt equally and unite so that one cannot distinguish one from the other, in which case it is good for files and the like. From this one reaches the opinion that *shaburqan* [a more general word for hard iron or steel] is of this type and that it has been tempered [i.e. made hard] by natural means. Or, alternatively, the melting qualities of the substances in the crucible vary, so that they do not mix completely but, on the contrary, are separate in their parts from one another, and each part of their two colours [i.e. light and dark] is seen individually. This is called *farand*. Men vie with one another for sword blades composed of it.'[80]

Both these types of crucible steel were made of *narmahan* and 'its water', probably *dus*, which seems most likely to mean a mixture of bloomery and cast iron. Elsewhere al-Biruni mentions crucible charges including mule shoes, nails and organic and inorganic materials, so it appears that both the main crucible-steel production methods (those involving plain iron plus organic matter containing carbon, and that in which plain iron was mixed with cast iron) were used in this region during the period.

Al-Biruni referred to various types of crucible-steel ingot or the objects – usually watered sword blades – which they were used to make. He says of an Indian steel, *pularak*, that in the pattern the lighter of two colours stands out against the darker.[81] A type called *zhuna* is reported as being made in Multan from Herati *baidat*, and a type called *maun*, also made in Multan, from Herati cakes. These cakes are of three types, called *umrani* (or possibly *imrani*). *Maun* is said to closely resemble *pularak*, although the black is more dominant in its watered pattern. The finest and most sought after is *harmaun*, to which he likens the steel of Yemeni swords. He says a half-blue and half-black type is similar, as is a type called *bakhra* which is said to be of three colours. For another kind, *makhus,* he describes a particular forging method being used.[82] He also notes that some swords are not watered and these are included

80. al-Biruni p.252.
81. al-Biruni p.254.

under the *bakhra* type, which includes three colours.[83] Al-Biruni does not say whether or not the non-watered swords were polished to a bright mirror-finish and the possibility remains that these plain blades were nevertheless etched to give what is referred to as a coloured finish, possibly differing according to the particular etchant recipe used.

One probable Iranian sword of this period, a Saljuq sabre blade thought to have been made at Herat in Khurasan in about AD 1200, has been recently analysed and found to consist of a watered crucible steel.[84] It is by far the earliest clearly identified watered-steel sword blade (although the complete 9th-century sword from Nishapur discussed above is the earliest known curved Islamic sword, and its corroded remains strongly suggest that it, too, once had a watered-steel blade).

About 1200 AD, al-Tarsusi added further information on crucible-steel making, giving four recipes for *fulad* apparently obtained from an Alexandrian armourer.[85] Three of these were for 'true' *fulad*. The first of these calls for *narmahan*, the better

> 'if it comes from the heads of old nails ... 17 *dirhems* of *myrobalan* from Kabul and the same quantity of *belleric*, should be cast upon it. The iron should be placed in a pot, which should be cleaned well with water and salt. The above mentioned preparation should be mixed with it, and the whole placed in a crucible, which should be dusted with a *dirhem* and a half of crushed magnesia [probably manganese dioxide]. The foundry fire should then be blown upon this until it melts and is collected as a cake (or egg). This is over several days. Then allow this to cool and make a sword from it; this is a mortal poison [i.e. a deadly material].'

The second involves

> '3 *ratl* of *narmahan* [soft iron] and half a *ratl* of *shaburqan* [hard iron]; place the whole in a crucible and throw upon it 5 *dirhems* of magnesia [manganese dioxide] and a fistful of the husks of sour pomegranates. Blow upon the foundry fire to cause it to melt; and it turn into a ball [or ovoidal egg] shape; then remove it and make the sword.'

The third method uses

> '1 part male magnesia [manganese dioxide], 1 of *sunbad* [coral], 1 of borax. Break

82. 'The *baidat* [egg-shaped cake] is beaten on its head until it spreads like a dish. Then they cut it like a pipe and flatten its circular form until it is level. Then they forge out the sword from it.' al-Biruni p.255.
83. Said (1989); al-Biruni p.255.
84. Haase *et al.* (1993) pp.186–87.
85. Cahen (1947–48) pp.106–107 and 127–28.

up the whole then set it aside. Take a *mann* of soft iron filings in the pure state, place them in a crucible, and pour over them two *uqiya* of the aforesaid mixture. Blow on the fire to cause it to melt and make it soft enough take up a round shape in the crucible. Then take 1 part of (Syrian) rue (*peganum hamala*), 1 of gall nuts, 1 of acorns [or possibly almonds], 1 of aloes, together with a quantity of cantharides equal to all these. Make the whole into a powder, and of this mixture cast 2 *uqiya* on to the *mann* [1 *maund* = 2 *ratl*; OED] of iron, blow on the fire until what appears to be a rainbow rises out of the crucible. When it has reached this state, allow it to cool, then forge it to make whatever you want.'[86]

A fourth recipe was for *fulad slimani* (or *salmani* crucible steel), from which he says that *slimani* sabres were made, and which may therefore refer to *salmani* swords from Transoxiana or elsewhere in the region to the north-east of Iran in the late 12th or early 13th century.

'Cultivated myrobalan, 20 *dirhem*; magnesia [manganese dioxide], 7 *dirhem*; scammony, 5 *dirhem*. Reduce all to a powder. Cast this preparation onto 3 *ratl* of *shaburqan*, and blow the fire to make it melt in a crucible with a lid pierced with a hole so that one can see into it, and examine the iron until it is seen and felt with an iron (rod) to melt. Then remove it from the furnace, allow the crucible to cool with it, and make of it what you will. And strike a 20 *ratl* iron bar: with Allah's help it will cut it.'[87]

An anonymous fragment of manuscript from Berlin included one of al-Tarsusi's recipes with another apparently for Indian steel,[88] about which very little seems to be known despite the evident fame of early Indian iron and the likelihood that the Indian crucible-steel industry may have been several centuries old by the time of Zosimos' description in the 3rd century AD.

86. For all these recipes, see Cahen (1947) p.106. The approximate weight equivalents are 1 *ratl*=12 *uqiya* (ounces)=144 *dirhams*=0.75 lbs=0.3 kg; 1 *mann* (probably)=1 *maund*=2 *ratl*s; 1 *bacheman*=6 *livres* (Russian pounds)=5.5 lbs=2.5 kg.
87. Cahen (1947–48) pp.106–107 and 126–27; Ragib and Fluzin (1997) p.68.
88. 'Take soft iron and an equal quantity of steely iron [or more probably *shaburqan* meaning white cast iron]. Break them up into smooth pieces. Place them in a crucible and throw upon them 1 *dirham* of manganese [dioxide], 2 of myrobalan nuts, 5 of *andarani* salt and a weight equal to the whole of nitre of Hurasan, together with a fistful of screened orange peel mixed with egg white. Blow upon it until (the metal) melts. Allow it to cool. Then you make what you want, such as Indian blades.' Ragib and Fluzin (1997) p.68.

HEAT TREATMENTS, POLISHING AND ETCHING

Medieval Islamic sources show that from an early date their authors were aware of other metal-working procedures, such as quenching, and their importance. In the 9th century, al-Kindi wrote that 'moderation of quenching is an aid to sharpness, for quenching, if intensive, causes the severing of a blade in adversity';[89] in other words, that too sudden quenching, as in cold water, made the blade too brittle. It is clear from al-Kindi's text that true tempering – reheating a quenched steel to relieve stresses and make it less brittle – was also clearly understood and practised by his time,[90] and in another passage even implies that there were local differences in the tempering process in Sri Lanka, Khurasan and Baghdad.[91] His text illustrates how difficult it was to control the whole production process to result in a finished object with entirely predictable physical properties, including the pattern on its surface.

In addition to his recipes for crucible-steel making, al-Tarsusi described several procedures for quenching sword blades. (Although tempering is mentioned, quenching is clearly meant.)

'Take the mushroom which is known as 'serpent's mushroom', so-called because it is fatal if eaten, and which is the same as mountain celery [*sic*]. It frequently grows especially at the foot of large olive trees or in asses' dung. Grind it up, collect the juice of Persian alkali and the jujuba, and vine lees, sea foam, sal ammoniac, cantharides, the juice of the tender henbane, grind the solid parts to a powder and mix them with the liquid, place them in a bottle stoppered at the top, and bury in manure for 40 days until completely dissolved. Then take felt, soak it for three days in old urine, dry in the shade, and sprinkle the abovementioned liquid upon it. Bring the sabre to red heat in the fire and spray it, using wool, as is done

89. al-Kindi p.14.

90. He discusses how the structural properties of two particular sword blades can be judged and improved: 'The treatment, in order to improve it [the pliability of a blade], is to stretch out the ashes of charcoal after hours of the day have gone over these ashes and have tempered its fire [i.e. it has cooled down]. Then insert the sword in the ashes and pay close attention to it. And when it gets a peacocky [blue] colour [approximately 300° C] a bit of oil should be put on the two blades. After that it should be left until it is cooled off in a place where neither wind nor water can reach it. Because if it is reached by wind it will bend, and it will not be safe from breaking.' al-Kindi pp.20–21.

91. These differences were based on the various types of charcoal used to forge Sri Lankan blades, or the blades made using a Sri Lankan form of steel. In Sri Lanka charcoal from *khilaf* (a type of willow) was used, in Khurasan, the charcoal of oak or *ghada* (a type of euphorbia). In Baghdad a more severe tempering or annealing procedure was adopted: 'They surely wanted to purify its essence [by means of] *marjuh*. And the meaning of *marjuh* [tempering/annealing] is: they placed it in the ashes of hot charcoals until nothing of the quenching was left, except the hardest part. Then it was polished and a medicament [chemical etching mixture] was thrown onto it. After that a good *ferend* [watered pattern] would come out, and that if not they called it the *atlas*. And the *atlas* has an essence that has not settled. It is not wide, and the colour is dark inclining to yellow.' al-Kindi p.29.

for sabre iron. When it has drunk, cool it, cover it to protect it from dust. It will cut anything, and if a saw is made of it, it will cut through glass like another will cut through wood; this is a noble tempering.'

'Of the tempering [quenching] which is less good than the above, there is this one: Lead, 1 part; yellow sulphur, 1 part, all ground together, powdered gall nut, 1 part. Mix all together, and set aside in an available vessel. Take the iron which you wish to temper. Clean it and sharpen it. Make a pan of clay with 2 saddles in the shape of a terrace or a vault of clay, and make a low door in it, and place the blade in this opening. Light a gentle fire of olive wood beneath to bring it to red heat, taking care that it is not touched by any smoke or flame. Then take the blade and plunge it in the aforesaid liquid, delicately tempering the cutting edge, wetting it and allowing it to cool. The sabre obtained cuts well.'

'Another procedure: Take one part of sulphur and pour over it three parts of wine vinegar, place in the sun for seven days, purify the vinegar and throw away the residue, and add three times its volume of horseradish water. Bring the sabre to red heat, pour dissolved sal ammoniac upon it, and then the aforesaid liquour. The sabre obtained will cut well.'

'Another procedure: 1 part of filtered colocynth, pour onto it its own volume of water, or, if it is not fresh, three times its own volume; temper [quench], the strength of which is in the throw [presumably a reference to how rapid a quench the solution or mixture will allow].'[92]

Al-Tarsusi omitted to mention the polishing and etching that these blades would have undergone, but al-Kindi made it clear that an entirely different group of people – the sword polishers – were responsible for the final surface treatments, even if some selective polishing and etching may have been carried out earlier during procedures such as quenching and tempering. He credited sword polishers with producing various surface effects, including certain colour variations and the watered patterns that were achieved on different types of blade, and explained that many of the terms and descriptions used for the qualities and appearance of different sword blades were those in use by the sword polishers.

'As for the ground (*ard*) of a sword, they call it ground according to its state, I mean the area of iron with no *firind* [watered pattern]. So they say 'red of ground', 'green of ground', and 'dark of ground'. But when you find me saying in this book of mine 'white of iron', 'yellow of iron' or other descriptions of the iron, I am referring to the sword, and I mean the watered pattern. And if I say 'before

92. Cahen (1947) p.107.

throwing' (*tarah*) or 'after throwing', I am referring to the medicament [chemical etching mixture] which is 'thrown' onto the sword, that is, the *dawa* that is thrown onto the sword to make the watered pattern appear. And if I say the sword is red, I am referring to the clarified [polished] area on which the medicament has not yet been thrown, for the polishers call this medicament the red clarification [presumably that which produces a red background effect]. I have not used these names without (first) explaining to you so you know their meanings in their expressions and so that nothing escapes you of their matter.'[93]

Al-Biruni mentioned the use of an etching chemical called *zaj*, now known to be impure iron sulphate which was probably generally derived by decomposition from the plentiful sulphide mineral, iron pyrites.[94] He describes *zaj* as the basis for certain etching compounds used to produce the watered effect on sword blades after final heating or heat treatments and polishing.[95] The use of *zaj* as an etching material has been mentioned at various times by other medieval authors.[96]

These same heat treatments, surface preparations and etching compounds would appear to have continued in use until comparatively recently: iron sulphate or something similar seems to have been the main active chemical ingredient employed. The most complete record of the heat treatment of a watered-steel blade was made in 1816 by Barker, who reported the re-finishing in Aleppo of two watered-steel sword blades. This process included the reheating, quenching, tempering, polishing and etching of each blade.

'The work was begun before sunrise to ensure even re-heating to the correct temperature, which was judged by eye. The heating was carried out in a charcoal bed and the temperature of the blade raised until an even level of cherry-red heat [approximately 750–850 °C] was reached, at which point the blade was slack-quenched in a mixture consisting of equal quantities of *surege* [sesame oil], mutton

93. al-Kindi pp.14–15.
94. It has been identified by the analysis of more recently collected samples of this material: Jacquin (1818) pp.571–72; Zchokke (1924) p.660.
95. '*Farand* [watering] is called in Khurasan "*jawhar* [a jewel] of the sword" and it may be hidden by heating and polishing. When the Indian wants to make it obvious [visible] he coats it with yellow *zaj* [iron sulphate] from Bamiyan or with white *zaj* from Multan. The surplus [superiority] of the Bamiyani *zaj* means [is the reason] that it is transported [exported] to Multan. In tempering [meaning quenching] they coat the blade of the sword with hot clay, cow dung and salt, [a preparation] like *mulghamat* and test the place of tempering, [and] clean the two edges [of what is presumably a straight, double-edged sword] with two fingers. Then they heat it up by blowing [with bellows], the *mulghamat* boils, and they plunge the sword blade into the water. They then remove the coating from the surface of the blade and [after polishing and etching] the *jawhar* [watered pattern] appears. *Zaj* can be mixed with the salt.' al-Biruni 193–203.
96. These include al-Khwarizmi in Wiedemann (1911) pp.92 and 97; al-Dimashqi p.80, and al-Qasvini I pp.225–26, 233.

suet, virgin wax, and Persian *naft* [naphtha], in which it was left to cool. Each blade was then tempered by laying it on the hot charcoal bed, but only reheated until the greasy surface residue of the quenching oil stopped smoking [Barker seems to have been unaware of tempering colour temperatures which most competent smiths can be expected to have exploited.] At this point it was removed from the charcoal bed and allowed to cool, and the material still adhering to the surface was gently scraped off. One blade was slightly bent after the heat-treatments and was now straightened. Each of the blades was then polished using emery powder and oil, and was burnished with a piece of iron. All traces of oil were cleaned off using alkaline materials, firstly slaked lime [presumably as a paste] followed by tobacco ashes in water, a perfectly grease-free surface being essential at this stage. An etching solution was prepared by dissolving *zagh* [again iron sulphate; in this case apparently produced by a mineral spring near Ghazir, in the Druzes mountains] in pure water. This was wiped rapidly up and down the blade to ensure even coverage, then the excess was washed off and the process repeated until the watered pattern stopped developing. The temperature of the water for this etching solution was clearly of some importance: it was necessary to take the chill off if the operation was carried out in winter. After etching the blades were wiped dry and oiled.'[97]

The whole procedure compares closely to various aspects of the less complete medieval descriptions which do survive and it seems probable that the methods used in medieval and post-medieval Iran (and probably earlier as well) are unlikely to have been much different. In his description of the heat treatment and etching given to sword blades made in northern Iran in the earlier 19th century, Massalski reported that the crucible-steel blades were slack- or slow-quenched in boiling hempseed oil from between red and white heat. The blades were then reheated until hot enough to set light to wood and the surfaces rubbed to remove residual burnt oil. This seems to have been intended as a tempering treatment and it can only be assumed that the temperature was judged by the colour of the blade in much the same way as that described by al-Kindi ten centuries earlier. The blades were then cleaned with sand, polished with emery (silicon carbide), and 'mottled' by pickling with a solution of iron sulphate.[98] Abbot reported much the same procedure for the more-or-less contemporary watered-steel sword-making at Jullalabad in Pakistan, in the Gujerat area near Lahore. There blades were slack-quenched in 'common' oil, edge first, then tempered over a slow charcoal fire. They were then burnished,

97. Elgood (1994) pp.111–12; see also Smith (1960) p.267, n.29.

98. Massalski (1841) p.302.

ground and carefully cleaned of any grease using wood ashes (i.e. the alkali, potash). Finally, the pattern was revealed by rubbing the surface, except the edge, with white vitriol (zinc sulphate).[99]

WOOTZ AND EUROPEAN ACCOUNTS OF LATER CRUCIBLE-STEEL PRODUCTION

The enthusiasm of al-Biruni in the 11th century and of Fakhr-i Mudabbir in the 13th century suggests that Indian swords were the finest available in the medieval Islamic world.[100] In the 12th century, al-Idrisi wrote that 'the Hindus excel in the manufacture of iron, and the preparation of those ingredients along with which it is fused to obtain that kind of soft iron which is usually styled Indian steel. They also have workshops wherein are forged the most famous sabres in the world. It is impossible to find anything to surpass the edge you get from Indian steel.'[101]

From the 18th century the steel used for the manufacture of Indian swords and other specialised arms and armour from the region became known as *wootz*. The term first appears in European accounts in 1795, to describe ingots of Eastern, and more particularly Indian, crucible steel, when Robert Pearson reported that specimens of *wootz* had been sent from Bombay for examination at the Royal Society in London.[102] *Wootz* is a corruption of an Indian word, *ukku* (pronounced *wukku*),[103] and although *ukku* may have been a more general term for steel, *wootz* took on the quite specific meaning of the very high-carbon steel made in small clay crucibles, either in India or the surrounding regions, the manufacture of which died out progressively during the 19th century with the imposition of British rule and the introduction of more modern and cheaper steels. Between 1795 and 1908 several accounts were written by European observers on the production of *wootz* or crucible-steel ingots as well as analyses made of several *wootz* ingots. Some of these accounts were not first-hand and appear to be an unreliable mixture of other people's unacknowledged records and further details which cannot be traced to a source.[104] Subsequent writers sometimes overlooked these earlier errors, which consequently became established as part of the literature of *wootz* and watered crucible-

99. Abbott (1847) p.417.
100. Allan (1979) pp.69–71.
101. Bronson (1986) p.20.
102. Pearson (1795) pp.322–46. Dr Helenius Scott, who dispatched this material from Bombay in 1794, may have been the originator of the term *wootz*, which he mentioned in a letter now in the collection of the Royal Society.
103. *Ukku* means 'steel' in Telugu-Kannada, a Dravidian, non Indo-European language of central, southern India: Thelma Lowe, personal comment. *Wootz* is a mispronunciation of *ukku* (which should sound more like 'wooku', with a very short final syllable), which was absorbed into English; OED.
104. Bronson (1986) pp.13–51 gives a comprehensive summary and critical analysis of these 19th-century accounts.

steel production.¹⁰⁵ (The most prevalent of these misunderstandings, the attribution of watered-steel sword blades to Damascus, is dealt with separately below.)

The accounts of Western travellers make it clear that from the 17th to the 19th centuries the traditional centres for the production of *wootz* were in southern India. *Wootz* was also produced to a lesser extent in Iran, and perhaps in Sri Lanka, during this period, but European investigations concentrated on India and seem to have established two main methods by which *wootz* ingots were produced.

The first of these was the carburisation, in sealed crucibles, of one or more small pieces of bloomery iron with organic matter, nearly always dried wood, the mixture usually being covered with leaves (FIG.7). Two of the earliest and most informative accounts of this process are those given by Benjamin Heyne and Francis Buchanan, who each saw two separate examples of *wootz* manufacture in the Mysore region of south-west India. In both of the processes seen by Heyne in 1795 and one of the processes seen by Buchanan in 1802, leaves were placed on top of the mixture in the crucible. These three descriptions also mention that the crucible mouth was then sealed with clay. Buchanan's description of a process in 1800 does not mention leaves, nor sealing the lids of the crucibles, although other accounts would suggest this might be an error of omission. Between 14 and 59 crucibles were packed together in the furnace with charcoal and (according to Buchanan) were fired using two bullock-skin bellows. In three of the processes the firing time varied between four and nine hours; in the second procedure observed by Heyne, firing continued until the crucible contents became liquid. Buchanan reported that the *wootz* ingots were cooled fairly rapidly by taking the crucibles from the furnace, breaking them open and removing the steel cake. Heyne recorded that in one process the *wootz* ingots were cooled with water but his second account does not describe cooling. In the two processes seen by Buchanan the *wootz* ingots varied in weight between approximately 270 and 400 grams (9 ½ –14 ounces); Heyne's first description gives the weight of the *wootz* ingot as approximately 230 grams (8 ounces) and the second, approximately 330 grams (11 ½ ounces). Buchanan reports that in some cases fusion was not complete, resulting in poor-quality *wootz* ingots in which some of the original wrought-iron lumps remained.¹⁰⁶ Most later accounts of the making of *wootz* across southern India and Sri Lanka are much briefer and less detailed, although in general they confirm the basic method and give useful additional information.¹⁰⁷ For example, see the accounts by Heath;¹⁰⁸ CVB;¹⁰⁹ and Coomaraswamy.¹¹⁰

105. For example, Maryon (1960) pp.52–59.
106. Heyne (1814) pp.358–61; Buchanan (1807) I pp.174–75 and 119–23.
107. The crucible charge usually contained one or two pieces of bloomery iron mixed with dried wood – nearly always *cassia auriculata*, a tannin-containing plant used in south India by dyers – and was often covered with leaves: Bronson (1986) p.37.
108. In Tamilnadu in south-east India, several pieces of iron from a broken-up bloom smelted at

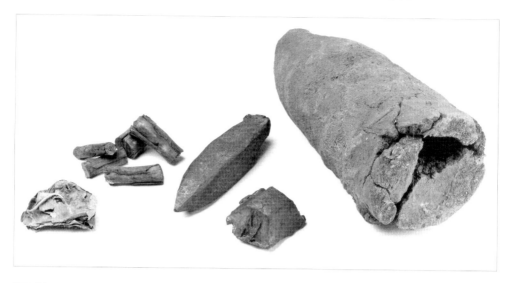

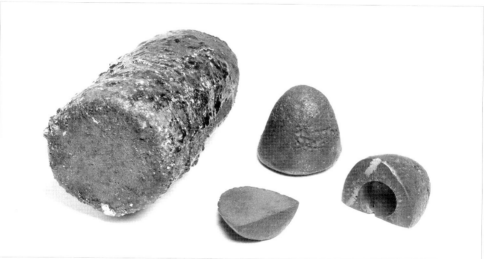

FIG.7 Collection of pieces related to *wootz*-making in Tamilnadu, brought to England in the late 19th century by Thomas Holland: (top) wad of dried leaves, wood pieces, two small lumps of plain (bloomery) iron, and an unfired crucible; (bottom) fired, hence glazed, crucible and two *wootz* (steel) ingots, one of which has been sectioned for metallographic examination.

The second method of *wootz* manufacture involved the carburisation, in sealed crucibles, of pieces of bloomery iron with pieces of cast iron. This process was less widely reported but according to Henry Voysey, who made repeated visits to see it, in this case the crucible charge consisted of a mixture of bloomery iron and white cast iron. Voysey described a process which was carried out at Konasamundram in the Nirmal district of Hyderabad on the Deccan plateau of central southern India.[111] On his 1820 visit to the *wootz*-making site, Voysey met a trader, Haji Hosyn of Isfahan, who was there buying *wootz* ingots and who told him that this crucible-steel making process was familiar to the Iranians, who were unsuccessful at it. This may well be indicative of a decline in the Iranian crucible-steel industry since it had been observed by Chardin in the later 17th century. Some crucible-steel manufacture does seem to have taken place in Iran even towards the mid-19th century, however, although it may have been restricted to the more inaccessible north-eastern region towards Russia.

Massalski reported on an Iranian crucible-steel making process – quite similar to that described by Voysey – in which the crucible charge was wrought iron and white

the same site were mixed with one tenth the weight of the same wood, chopped and dried, plus leaves. When fusion was completed perfectly the top of the cake was covered in striations radiating out from the centre, with no holes or rough projections (see the top of the ingot in FIG.8a); when less than perfect the surface of the cake had a honeycombed appearance and often contained projecting lumps of iron, still in a malleable state. Imperfect cakes were returned to the crucibles and the process repeated. Heath estimated the iron in the crucible charge as weighing between 230 g ($^1/_2$ lb) and 920 g (2 lb), the latter being rather higher than most other versions of this process. The resulting *wootz* ingots would have been a similar weight. After smelting, the cakes of steel were annealed for several hours in a charcoal fire blown with bellows. This may also have been done intentionally as a method of controlled partial decarburisation. Unlike Voysey in his more-or-less contemporary description (see below), Heath did not mention the use of a protective clay coating during annealing, which would seem to be necessary to prevent uneven and excessive decarburisation at the surface, giving a *wootz* cake of uneven composition. Heath (1839) pp.392–93.
109. This anonymous account adds that the crucibles and charcoal charge were fired to a 'white heat' (approximately 1200–1400° C). The firing took nine hours, after which the furnace was sprinkled with a little water and the crucibles were removed, laid on the ground, covered with sand and cooled with water, then broken open and the *wootz* ingots recovered. Out of 54 crucibles in this process, about 20–30 were reckoned to contain usable steel while the other, semi-fused pieces were returned to the furnace in the 'same manner' (presumably in sealed crucibles). In this process a bar of consolidated bloomery iron 10 cm long by 3 cm in diameter was used in the crucible charge and yielded a *wootz* ingot weighing approximately 570 g (1 lb 4 oz). CVB (1820) p.442.
110. At Mawalgaha in Sri Lanka the crucible charge was one 350 g (12 $^1/_2$ oz) piece of iron with 140 g (5 oz) of *cassia auriculata* chips. In this process the crucibles were covered with clay lids perforated to allow the escape of gas. The crucibles were shaken to check liquidity and returned to the furnace until it was achieved, after which they were laid down on the ground to cool. A bar of steel weighing 280–420 g (10–15 oz) was then removed. Coomaraswamy (1908) p.192. (Coomaraswamy only witnessed demonstration firings with just six crucibles in the furnace.)
111. Pinecone-shaped crucibles of different sizes were used depending on the objects to be made – swords, knives – and the crucibles were sealed with a clay lid with one hole in it, presumably for venting. The crucible charge consisted of a flux of a few

THE DEVELOPMENT OF IRON AND STEEL TECHNOLOGY

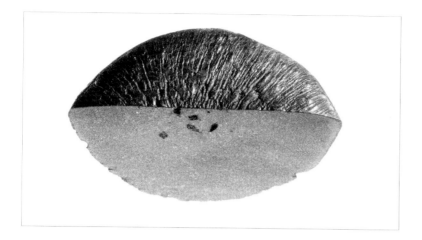

FIG.8a Detail showing the radiating cast macro-structure showing on top of one of the south Indian *wootz* ingots, as well as a section (oblique view) through the ingot.

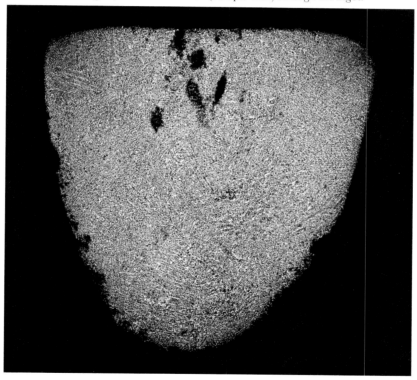

FIG.8b Section through *wootz* ingot in FIG.8a: overall impression of microstructure, with hints of a dendritic pattern, left from the casting, in places. Magnification approximately x 2.5; etched 2% nital.

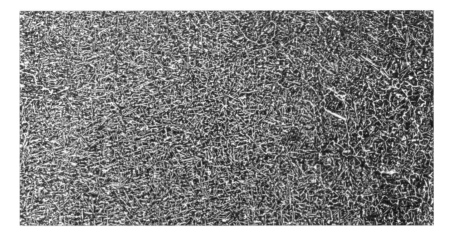

FIG.8c Section of *wootz* ingot in FIG.8a: pale cementite, in needle and grain-boundary network form, contrasts with a steely, pearlitic background matrix. Magnification approximately x 3, etched 2% nital.

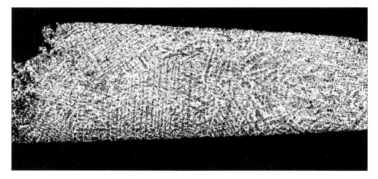

FIG.8d Mounted section of *wootz* ingot in FIG.8a: dense but even scatter of cementite needles visible against a dark pearlitic matrix, this microstructure being overlain by a dendritic (firtree-like) macrostructure demonstrating the cast origin of the ingot. Magnification x 6, etched 2% nital.

cast iron, with a little silver, in the ratio of one part cast iron to three parts wrought iron.[112] Massalski's account has not appeared in English before: it is included here,

small pieces of fused glassy furnace waste together with two pieces of white cast iron from Mirtpalli to three pieces of bloomery iron from Kondapur. Firing lasted 24 hours, much longer than for the method of *wootz* production using wood. After firing the furnace contents were cooled slowly and one crucible is described as producing a steel cake weighing approximately 680 g (1 ½ lb), and another a cake weighing approximately 1260 g (2 ¾ lb). The cakes were covered in clay and annealed in the furnace for 12–16 hours, then taken out, cooled and the annealing treatment repeated, sometimes three or four times until the metal was soft enough to be worked. Voysey (1832) pp.245–47.

112. The silver was added to the molten mixture (possibly to remove impurities such as sulphur) after the two kinds of iron had fused, then the furnace was sealed and allowed to cool slowly over two or three days. Massalski (1841) pp.297–300.

in Appendix Four, because it contains much important detail about the crucible-steel making process that was still being carried out in Bukhara in 1840 (see also FIG. 110).

The brick box-like furnace described by Massalski bears a striking resemblance to an illustration accompanying a late medieval manuscript on the *Works of Geber* (Jabbir al-Hayyan; see FIG.6) a translation of which appeared in English in 1678. Apart from the total number of holes the layout of smaller and larger holes appears to match closely the grid-like base of the crucibles for the Bukhara furnace illustrated by Massalski, in which the bigger holes support the crucibles and the smaller holes in between allow the hot gases to rise through the furnace. This would appear to provide a good basis for Hassan and Hill's identification of the manuscript illustration as representing a steel-making furnace. There seems to be no particular reason to suppose that the furnace seen by Massalski was greatly different to those used several centuries earlier, particularly given that his description of the making of sabre-blades closely matches that given by al-Biruni 800 years earlier.[113]

A description of *wootz* manufacture in Tamilnadu says that only iron was used in the crucible charge, suggesting that here too, a mixture of bloomery iron and cast iron was used.[114]

These descriptions can be compared to earlier Islamic accounts for crucible-steel making. Both al-Biruni in the 11th century and al-Tarsusi in the early 13th century described methods involving the mixing of plain soft bloomery iron with cast iron, although only one of al-Tarsusi's recipes gives the proportions – one part cast iron to six parts plain iron. It would seem from these accounts that a method of *wootz* manufacture using a crucible charge of mixed bloomery iron and cast iron was used, at one time or another, between the 11th and 19th centuries, as far afield as Egypt, Iran and south-eastern India.

Before the last half of the 19th century there was no suggestion that iron ore replaced metallic iron in the crucible charge. Several more recent writers have suggested that *wootz* was produced in closed crucibles charged with powdered iron ore and charcoal.[115] These accounts, however, seem to be based on that by Cecil Ritter von Schwarz, which is not an eyewitness description and may therefore be unreliable.[116] Indeed, much of Schwarz's information is likely to have been derived from Voysey's 1832 account, although Schwarz seems to have substituted details such as the use of iron ore and charcoal for cast iron and bloomery iron in the crucible charge.[117]

113. See note 82.
114. Wood (1893) p.179. Wood adds that these *wootz* ingots weighed approximately 910–1350 g (2–3 lbs), similar to but slightly heavier than those described for the first method using bloomery iron and wood.
115. For instance, Belaiev (1918) and Richardson (1934).
116. Schwarz (1899) pp.96–99.
117. Bronson (1986) p.45.

Hunter also mentions that iron ore was used with leaves as the crucible charge for making steel,[118] but again it is possible that he was not accurate in his description and his report is not substantiated by any other reliable account. As yet, there seems to be no convincing evidence that *wootz* was regularly produced by the direct smelting of iron ore in a crucible. Conceivably this method was tried out (possibly at the suggestion of European observers) in the late period when the ancient industry was dying out, but as yet there seems to be no firm evidence that it was used earlier.

DAMASCUS STEEL: A CLARIFICATION

Much of the recent interest in the early south Asian crucible-steel industry has focused on the origins of the metal used to make the watered-steel sword blades which feature so prominently in various Western collections of Oriental material. Until recently this steel was popularly but misleadingly known as 'Damascus', 'damasked' or 'damascene' because of the misguided notion that it was made in Damascus, despite the fact that the vast majority of the objects that survive have been identified as being of Iranian or Indian origin, and none as from Damascus. Nevertheless the term has been widely misused to refer to a variety of decorative surface effects on sword and dagger blades,[119] such as those on early northern European swords, and even those on Western gun (mainly shotgun) barrels, which are mostly of the 19th century.

The northern European swords in this group, dating mainly to the 1st millennium AD, were in fact made using a decorative welded construction now more accurately known as 'pattern-welding'.[120] The results of recent research make it clear that pattern-welding played an important part in the development of these weapons, at least in north-west Europe, and strongly suggest that the welded patterns developed originally either as an accidental by-product of bloom consolidation, or from the welding together of different pieces of metal during the manufacture of early iron blades.[121] It is not known where the technique was first exploited, although some findings suggest that its use in sword-making in northern Europe may date from as early as the 5th century BC,[122] but more certainly it was being used for its decorative effects by the 1st century AD.[123]

The patterns on the blades of such weapons, at least of those from the 5th–11th centuries, derive from combinations of different iron alloys welded together,

118. Hunter (1875) pp.45–48.
119. For instance, Baldwin-Brown (1915).
120. Pattern-welding was introduced as a descriptive term by Herbert Maryon only in 1948, to differentiate between blades showing weld patterns and those whose patterns derived from the use of Eastern crucible steel, in particular *wootz*.
121. Gilmour (1991) p.220.
122. Pleiner (1993) p.117.
123. Gilmour (1996) p.114 and figs 1 and 2.

whereas the patterns of watered blades made from Eastern crucible steel, in particular *wootz*, derive from a dispersion of cementite particles in an ultra high-carbon steel. The two types of pattern are sufficiently different to suggest that the technologies that made them developed and were practised quite separately for the most part (pattern-welded sword construction is known in the area of Malaysia which was also the probable source of the *fulad* swords of Qal'ah mentioned by al-Kindi), although the appearance and supposed qualities of Western pattern-welded swords may have had some influence on the types of pattern produced by Eastern steelsmiths. Al-Kindi's description of sword types makes it quite clear that Western techniques of sword manufacture, including pattern-welding,[124] and the swords themselves were well-known in Iran by the early 9th century AD. Very little archaeo-metallurgical work has so far been carried out on medieval or earlier iron from this region, but as we have seen, there are enough clues to suggest with some confidence that the production of watered-steel swords and the associated crucible-steel industry were in place sometime in the early 1st millennium AD, if not earlier.

In European minds the association of Damascus with swords can be traced back to 1432, when the French traveller Bertrand de la Broquière wrote that 'Damascus blades are the handsomest and best of all Syria.' He described 'their' method of burnishing sword blades, in which a block of iron was rubbed up and down the blade to remove all inequalities, after which it was 'tempered and polished'. He reported that the blades had a mirror finish with perfect 'temper' and cut excellently.[125] It is fairly clear from this description that the swords described had polished rather than watered blades. Surviving swords of Syrian type which may have been made in Damascus are identifiable by the inlaid patterns and inscriptions on their blades,[126] and those sword blades that did come from the Damascus region are likely to have been notable for their inlaid and highly polished blades rather than for any watered patterns.[127] There is, however, no convincing proof, either historical or with reference to known swords, that Damascus was ever a major sword-producing centre at any period.[128] Only one (non-watered) blade signed as having been made in Damascus, and dated AD 1608–9, is known, and a sword acquired by Broquière is most likely to have been made in India, based on the similarity of his report to other descriptions of polished swords of Indian origin.[129]

This region seems to have been better known for iron production in the 10th–12th centuries,[130] if not earlier, although some local, late medieval iron production is indicated by the mention of an iron mine and three furnaces near Bayt Shabab, in

124. al-Kindi pp.12–14.
125. Alexander (1984) p.132.
126. Alexander (1984) p.133.
127. For a contrary claim, see Maryon (1960) p.53.
128. Elgood (1994) pp.103–109.
129. Elgood (1994) p.103.
130. Hassan (1978) p.41.

the mountain ranges between Beirut and Damascus. Movements of iron and steel around the eastern Mediterranean must be assumed, and one 14th-century description records the shipping of steel from Beirut to Cairo,[131] but, apart from its undisputed role as an arms-trading centre, there is only one reference to suggest that watered-steel swords may once have been made in Damascus, perhaps well before the 9th century. Among the medium-quality group of swords made of the kind of steel referred to as *fulad*, al-Kindi mentioned one as being linked to 'Dimashqi' or Damascus and having been made in ancient times.[132] Two hundred years later al-Biruni, aware of al-Kindi's text, was more specific in referring to an earlier ironsmith called al-Dimashqi (identified as Mazyad ibn 'Ali, see above),[133] although it is uncertain whether the name referred to the city or simply to an ironsmith who had been well known, probably long before al-Kindi's time. In other Islamic texts watered-steel sword blades are never referred to by the word 'damascene'. Watered steel was known in post-medieval Iran as *poulad jauherder* or *bulat* and the watering itself was still called *ferend*, as it had been known by al-Kindi eight centuries earlier.[134]

The term 'damascene' continued to be misapplied to non-welded watered steel in Europe throughout the 17th century. In 1679 Jean-Baptiste Tavernier reported from his travels in Iran that the steel susceptible of being 'damasked' came only from the kingdom of Golconda in central south India, east of Hyderabad,[135] while in 1711 the Chevalier Chardin reported that the Iranians called both Indian steel and their own by the same name: 'poulad jauherder – wash'd (or wavy) steel, which is that we call Damask'd steel to distinguish it from the steel of Europe.'[136] Chardin gives no details of manufacture and his account is likely to refer to watered blades traded in Damascus but not necessarily made there.

In the late 17th century, two early fellows of the Royal Society in London, Robert Boyle and Joseph Moxon, took an interest in 'Damascus steel'. In 1678 Moxon reported in his *Mechanick Exercises* that an expedition led by Boyle had been unable to discover the steel's source, although it did identify the coastal Iranian province of

131. Elgood (1994) p.104.
132. Hoyland *et al.* (forthcoming).
133. Said (1989) p.219.
134. *Bulat* or *poulad* are also the terms by which watered steel was known further north, in Russia: Belaiev (1918) p.417.
135. 'For when the workman puts it in the fire, he needs no more than to give it the redness of a cherry, and instead of quenching it in water as we do, to wrap it up in a moist linen cloth; for should he give it the same heat as ours, it would grow so hard that when it came to be wrought it would break like glass … This steel is sold in pieces as large as our one sou (halfpenny) loaves and in order to know that there is no fraud involved, they cut it in two, each fragment being enough to make one sabre … I speak thus to undeceive those people who think our scimitars and cut-lasses are made of steel of Damascus, which is a vulgar error; there being no steel in the world but that of Golconda which can be damask'd.' Bronson (1986) p.23.
136. 'It is from this steel that they make their beautiful blades. They melt it down in a round loaf like the hollow of one's hand, and in small square rods.' Bronson (1986) p.24.

Kirman as a centre for the production of high-quality steel weapons.[137] Although Boyle's expedition failed to find any evidence of its production in Damascus, his description gives a lot of information about this crucible steel. Apart from the fact that it was obtainable in Kirman and was associated with the manufacture of high-quality weapons and tools, Moxon's account suggests that the steel was well known for being hard but not too brittle and had to be forged at a much lower temperature range than was normal for Western smiths.

> 'There is another sort of Steel, of higher commendations than any of the forgoing sorts. It is called *Damascus-steel*; 'tis very rare that any comes into *England* unwrought, but the *Turkish-Cymeters* are generally made of it. It is most difficult of any steel to work at the forge, for you shall scarce be able to strike upon a blood-heat, but it will *red-sear*; insomuch that these cymeters are, by many workmen, thought to be cast steel. But when it is wrought, it takes the finest and keeps the strongest edge of any other steel. Workmen set almost an inestimable value upon it to make punches, cold-punches, etc. We cannot learn where it is made, and yet as I am inform'd, the Honourable Mr Boyl hath been very careful and industrious in that enquiry; giving it in particular charge to some travellers to Damascus, to bring home an account of it: But when they came thither they heard of none made there, but were sent about 50 miles into the country and then they were told about 50 miles farther than that: So that no certain account could be gain'd where it was made. Kirman towards the Ocean affords very fine steel, of which they make weapons highly priz'd; for a *Cymeter* of that steel, will cut though an (iron) helmet with an easie blow.'[138]

It is clear that by the late 17th century some Western scientists were aware of the physical properties of Eastern crucible steel even if many people, in England at least, did not understand its manufacture or know its source. Most of the 'damascene' swords found in Europe are of Iranian or Indian origin and it seems probable that Damascus, with its site on the caravan routes from East and West,[139] was simply the market place for fine watered-steel blades produced further east.

137. Moxon (1703) p.59.
138. The red-heat range is approximately 700–900°C compared to the more usual white-heat forging temperatures of about 1000–1200°C. Moxon specifically says that this steel will 'red-sear' or break up above red heat, and it is clear from this that a hypereutectoid steel, one with a carbon content within the range 1–2%, is being referred to.
139. Stone (1961) p.202; Zaky (1961) p.23.

The iron- and steel-working industry

James Allan

To whichever period one turns in the history of Islamic Iran, it is clear that the impetus for the development of the iron and steel industries was the production of arms. It is no coincidence that our earliest Islamic source of information on steel is al-Kindi's letter on swords, written to the Caliph al-Muʻtasim in Baghdad. The trade with Sri Lanka and later with India was governed by the need for steel to equip successive caliphal and independent Iranian armies with swords. The development of local steel production in Khurasan, at Merv and Herat, would have been driven by the same motives, and a fascinating miniature painting in a Tabriz *Shahnameh* fragment of *circa* 1370 shows how iron or steel war-chariots might have been developed in Iran, had the possibilities of wheeled vehicles for the battle-field been seriously considered.[1] With the invention of firearms and artillery, it was yet again the need for armaments that dictated Iranian policy, particularly the preoccupation of ʻAbbas Mirza in the early 19th century with developing the Iranian metal resources of Azarbaijan. Although steel was used occasionally for other types of object, like mirrors, from early times, it was not widely used for non-military purposes until the Safavid period, with steadily increasing consumption of steel luxury goods through the 19th century.

Against that general background, the purpose of this chapter is to review what European travellers and local literary sources have to say about the Iranian iron and steel industry, its structure and development, its growth and decline, and about the craftsmen themselves. This will first be done in the context of the Safavid period (1502–1722), and then for the succeeding two centuries. It will be apparent that the information for the Qajar period (1779–1924) is more prolific than for the Safavids, but it will also be suggested that the situation of the industry in the Qajar period, and indeed the nature of the traditional industry in the 20th century, throw light on what went before.

1. Rogers (1986) pl.53.

IRON- AND STEEL-WORKING UP TO CIRCA 1700

From the literature a number of important facts emerge about the industry in the Safavid period. Although some of these have been noted in passing during our survey of metal sources and manufacturing centres, they need to be brought together here. First of all, Isfahan stands out as the key centre for the manufacture of metalwork, especially of iron and steelwork, a role it was destined to continue throughout the Qajar period. The bazaars of Isfahan were far more extensive than any others in Iran, and the variety of trades practised there is clear from the travellers' accounts.

Secondly, particular towns were famed for particular iron or steel products, which were then widely exported to meet the demand throughout Iran. The swords of Qum, Shiraz, Kirman, Mashhad and Isfahan are the most obvious examples, but scissors, mirrors, needles, and other goods which required specialised manufacturing skills would have fallen into the same category. Some of these centres, like Isfahan or Shiraz, were destined to retain their industry and importance over very long periods of time. Others, like Kirman, for political reasons, had much shorter lifetimes.

Thirdly, royal patronage played a major role through the setting up of royal workshops. This idea dated back at least to Mongol times, when Ghazan Khan set up armourers' workshops throughout the land.[2] According to Clavijo, Timur had a royal armoury in the citadel at Samarqand castle staffed by more than a thousand workmen,[3] while from Barbaro we know that Uzun Hasan (r. 1467–78) had his royal armouries located in five towns not far from Tabriz. The quality of their work was unrivalled.[4]

Under the Safavids too, artisans working in royal workshops had higher skills and qualifications than self-employed artisans – it is known, for example, that a craftsman who wished to be employed in the royal workshops had to produce a piece of work for presentation to the *bashi*.[5] Once in the royal workshop, they enjoyed a better social as well as economic status.[6] This in its turn attracted other artisans to enter royal workshops as opportunity arose. The number of royal workshops is variously given by the travellers. The *Tadhkirat al-Muluk* counts 33, Chardin lists 32, Kaempfer 50.[7] The royal *buyutat* undoubtedly included the country's major armoury. Despite the expansion of royal workshops in the Safavid period, however, the sources suggest that the royal court also patronised the Isfahan bazaar.[8]

Royal patronage was sometimes coupled with royal example. Thus Shah 'Abbas I was proud of his knowledge of several crafts, including steel-working. According to

2. Keyvani (1982) pp.28, 165.
3. Clavijo (1928) pp.289–90, 293.
4. Thomas and Roy (1873) p.66.
5. Chardin (1811) vol.5 pp.499–500.
6. Keyvani (1982) p.43.
7. Keyvani (1982) p.168.
8. Keyvani (1982) p.170.

Simon, a Carmelite priest who visited Iran in 1608, 'he enjoyed making scimitars, arquebuses, and bridles and saddle for horses … and, in short, with all mechanical crafts, if not perfect, he was at least somewhat conversant.'[9] This personal interest in steel-working may well have been instrumental in Shah 'Abbas's exemption of the Isfahan sword-makers' guild from taxation, though it was also apparently on account of the skill of Asadallah Isfahani (see below).[10] This exemption continued in the Qajar period.[11]

Patronage also affected local industries in the provinces, for some provincial governors also set up the equivalents of royal *buyutat* in their own governorates. Thus, a governor of Sistan under Shah 'Abbas I set up various workshops, including an arsenal and a goldsmith's workshop, and other governors are recorded doing the same.[12]

There was also the itinerant bazaar, which travelled on campaign with the Shah and his troops. This was already in use under the Turkoman rulers of Iran. For example, Barbaro describes the bazaar which followed the army of Uzun Hasan: 'Amongst the baggage are these things following, with their prices and owners. First, taylors, shoemakers, smiths, sadlers, and fletchers in great number, with all things necessary for the camp. Then are there victuallers …'[13] The same was true in the Safavid period.[14]

Finally, a key element in some at least of the steel implements produced in Iran was Indian steel. This was imported along two different routes, one by sea up the Gulf, and then northwards to Shiraz and beyond; the other by land through Sistan into Kirman province. The details of the trade in Indian steel are reviewed in the following chapter, so too the possible effects of wars or trade embargoes on supply.

THE 18TH AND 19TH CENTURIES

The damage inflicted on the iron- and steel-working industry of Isfahan by the Afghan sack of the city in 1722 is impossible to estimate, but must have been little less than catastrophic. Nor were Nadir Shah's policies in the 1740s, among which Ricks lists revaluation of the currency, excessive taxation, neglect of the merchant community, and harrassment of Armenian and Iranian trading families, likely to have helped its recovery.[15] The following decade offered scarcely more hope, with the Dutch leaving Bandar 'Abbas, the Dutch and English East India Companies closing

9. Quoted by Keyvani (1982) p.41.
10. Floor (1971) p.41.
11. Lambton (1954) p.2.
12. Keyvani (1982) p.172.
13. Thomas and Roy (1873) p.67. Contarini (*Ibid* pp.132, 134) describes similar bazaars accompanying the royal court, 'at which everything was to be had, but at a high price'.
14. Keyvani (1982) pp.64, 165.
15. Ricks (1973) p.117.

their trading houses in Kirman and Isfahan, and Iranian and Armenian merchants migrating to Baghdad, Basra and India.[16] And behind all this was a declining population – some cities may have lost as many as two-thirds of their inhabitants.[17] Nevertheless, the evidence of the following century is that the industries of Isfahan, including steel-working, did indeed survive all these problems.

Shiraz would no doubt have been affected in the same way as Isfahan by Nadir Shah's policies, but with the rise of Karim Khan Zand (1750–79) major changes took place. For, under his leadership, the craft industries were not only encouraged by the return of southern Iran to some sort of social and economic stability but more directly by the patronage of Karim Khan himself. True, many of its manufactories disappeared with the fall of Shiraz to the Qajars in 1779, but the steel-working industry at least is known to have survived. Kirman, on the other hand, appears to have completely lost its steel industry along with the eyes of its male population in the retributive fury of the first Qajar, Agha Muhammad (1779–97). The report of a Select Committee of the East India Company's directors in the 1780s showing that Iranian sword blades, spear heads, gun barrels and other manufactures of steel were still highly thought of, is an all too rare piece of evidence for the state of the industry at that period.[18]

Under Fath 'Ali Shah (1797–1834) the craft industries may well have picked up. The growth of trade between Europe and the East in the 18th century had been brought to a temporary halt by the Napoleonic Wars in Europe,[19] but at the same time there seems to have been a commercial and urban revival within Iran.[20] Fath 'Ali Shah had a desire for pictorial self-glorification which encouraged the expansion of the art of portraiture in oils and the carving of monumental rock reliefs, and if the portraits are accurate indications then other arts, such as jewellery, costume and all types of courtly furnishings received extensive royal patronage, although there has been woefully little systematic study of this period.[21] There is a small amount of evidence in steel objects: a cuirass bearing Fath 'Ali Shah's name is in the Wallace Collection;[22] a box made for him is in the Iran Bastan Museum;[23] and elsewhere in this book it is suggested that a group of flint-strikers of particular elegance probably date from this period (see p.446). Other indirect evidence for the revival of the arts under Fath 'Ali Shah comes from Mirza Husain Khan, who records in his

16. Ricks (1973) p.116.
17. Issawi (1971) p.13.
18. Issawi (1971) p.88.
19. Issawi (1971) p.258.
20. Hambly (1991) pp.547–48, who suggests that the number of mint towns in Iran under Fath 'Ali Shah points to increased demand for coin, and hence to commercial and urban revival.
21. See Khalili *et al.* (1996) pp.160–61 for a brief but good summary.
22. No.1572, dated AH 1224 (AD 1809–10); Laking (1964) p.44 does not mention the inscription.
23. Unnumbered; in store; 23.7 x 18.6 x 9.5 cm.

Jughrafiya-yi Isfahan a number of craftsmen who lived in his reign and remained in the folk memory of Isfahan.[24]

Again the details of the expansion of the industry, if such it was, are elusive, but, as in the Safavid period, royal arsenals may well have had a role as major centres for the manufacture of arms. For example, 'Abbas Mirza, Crown Prince of Fath 'Ali Shah, is known to have prepared for war against Russia by setting up military workshops and arsenals in Tabriz and Tehran.[25] In the later 1840s, Hommaire de Hell records three arsenals in Iran, at Tabriz, Tehran and Amul,[26] while Hasan-i Fasa'i also mentions one at Shiraz.[27] For the other crafts, proximity to the royal court in Tehran may not have been as significant as the living tradition of craftsmanship still to be found in provincial centres like Isfahan and Shiraz.

On the other hand, patrons could flourish and an industry could expand without wealth necessarily filtering down to the craftsmen. Scott Waring, a visitor during Fath 'Ali Shah's reign, comments of Shiraz: 'Some of the Artificers are ingenious able men, but their qualifications are actually misfortunes, as they are compelled to work for the principal people in the City, without the smallest hope of being recompensed for their labor, or being repaid for the expences they have incurred. This was really the situation of a very able Gun-smith, who made Pistols, nearly equal to those in Europe.'[28]

The period from the death of Fath 'Ali Shah to the end of the 19th century used to be thought one of decline. However, that simplistic view is far from adequate, and Seyf has recently described three phases in Iran's foreign trade during the 19th century which throw some light on the country's economy during the period.[29] The first, which ended with the Great Plague of 1830–31, saw trade with Europe restricted by the French Revolution and the Napoleonic Wars and by the loss of territory to Russia, but also included the beginnings of trade expansion through treaties with the European powers. The second phase, from the 1830s to the 1880s, saw trade expand, at first through silk, and then, after the collapse of the silk industry in the 1860s, through cotton and opium. The third phase, from the 1880s to the 1900s, had no precise pattern, but included the opening up of the Karun to navigation, concessions to British and Russian banks, growth in carpet exports, and increasing integration of the economy into the world capitalist system. Throughout the 19th century, however, as Seyf points out, with no proper infrastructure to support it and no institutional arrangements to facilitate it, trade was spontaneous and volatile.

24. See Floor (1971) p.99 Hajji Ibrahim the *giva*-maker, p.107 Husain the gunsmith, and p.111 Mahmud the cutler.
25. Issawi (1971) p.287 quoting Kuznetsova.
26. Hommaire de Hell (1854) vol.3 p.133.
27. Busse (1972) pp.271 and 336.
28. Scott Waring (1804) p.34.
29. Seyf (1996).

THE IRON- AND STEEL-WORKING INDUSTRY

It is impossible for the present to track movements in the manufacturing and trade of iron and steel products within Iran during the 19th century, and hence to assess the effect of these phases of trade on the industry as a whole. However, we can measure some of the changes that took place through the *Jughrafiya-yi Isfahan*. This text fleshes out something of the picture through its author's comments on the state of the iron- and steel-working crafts in Isfahan. Thus, the smiths in the bazaar next to the Maidan-i Shah seem to have been holding their own: their iron products included spades, pick-axes, ploughshares, harrows, handbarrows, tripods, tongs, braziers, nails, skewers and the like.[30] Locksmiths were also doing well.[31] General steel-workers were also managing to survive. They made the steel parts of other items, such as the tops of *qalian*s, sword-grips, saucers for coffee-cups, belts, lampions, Qur'an cases, helmets and the iron mountings of shields. The demand for their work was partly, at least, for export, to Turkey and Egypt. Needle-makers still had a market.[32]

On the other hand, the cutlers who had traditionally made the fine steel knives were in decline, with no customers except for the tribes and some villagers. They were now reduced to manufacturing ordinary knives and the large knives used by butchers and cooks. Penknives had also been discontinued as they were not as good quality as the European knives.[33] Scissor-makers, although they had modified their products to accord with European imports, were also in decline.[34] Swordsmithing had virtually come to an end,[35] as had chainmail manufacture,[36] and helmet and cuirass-making was in serious decline.[37] Iron or steel tools used by other craftsmen naturally depended on the viability of these other industries. Some, like the coppersmiths, prospered.[38] Others were in decline: gold and silver wire-drawers,[39] bookbinders,[40] farriers, goldsmiths and gold engravers,[41] *khatam*-makers,[42] carpenters,[43] and stone-cutters.[44] Yet others had moved elsewhere, for example, gunsmiths and gunhammer smiths, many of whom had gone to Tehran.[45] Occasionally, though, new crafts appeared, such as tinsmiths.[46]

The comments in the same text about haberdashery sellers are also informative. In the 1890s, as noted elsewhere, they were still selling local Isfahani iron and steel products: garment pins, chains, tongs, tweezers, locks, trowels, tailors' scissors, per-

30. Floor (1971) p.85.
31. Floor (1971) p.103.
32. Floor (1971) p.104.
33. Floor (1971) pp.104 and 110.
34. Floor (1971) p.110.
35. Floor (1971) p.107.
36. Floor (1971) p.109.
37. Floor (1971) p.109.
38. Floor (1971) p.105.
39. Floor (1971) p.88.
40. Floor (1971) pp.97-98.
41. Floor (1971) p.101.
42. Floor (1971) p.111.
43. Floor (1971) p.112.
44. Floor (1971) p.113.
45. Floor (1971) p.107–108.
46. Floor (1971) p.109.

cussion-cap holders, knives with bone handles, beams of balances, sugar hammers, bridle bits, bells, door keys, cheese scrapers, saws, shears, screwdrivers, packing needles, stucco trowels, sharpening steels for scrapers, belts (presumably with metal fittings), kitchen knives, compasses, goldsmiths' scales, barbers' razors, and tailors' irons. The percussion caps, needles, knives and scissors they sold, on the other hand, were imported.[47]

The complexities of the economic changes in 19th-century Iran are beyond the scope of this book, as are the wider details of such topics as trade and taxation. In Issawi's view, Iran's weak government, inefficient administration and archaic fiscal system, its social composition and geographical position, and the stultifying effect of Anglo-Russian rivalry, all led to comparative neglect by European capital and enterprise, and a far slower rate of development than other countries in the Middle East.[48] Keddie to some extent fills out this picture, providing a more extensive list of the factors involved in Iran's stagnation.[49] Gilbar sees the main features of the mid 19th-century Iranian economy as increased demand for European industrial goods, a resulting decline in Iran's traditional industries, and a consequent fall in the relative share of industrial goods in the country's visible exports. As a result the government tried to establish a few modern industries, and encouraged the production of raw silk and other agricultural products for export. However, the lack of improvement in the banking system or in transport, and the immobility of manpower and capital, prevented any serious development.[50] Pakdaman, on the other hand, takes a rather different view, suggesting that the domination of the 'peripheral' economies by the world order had far more complex consequences than those usually assumed.[51] He sees Iran's greater exposure to the world economy following the Treaty of Turkomanchai in 1828 as leading to increased trade with Europe much earlier than generally realised, bringing new products into Iran, bringing about new patterns of consumption within the country, and in the later 19th century leading to greatly increased production of carpets and opium for export.

That Iran was subject to a much slower rate of development than many of its neighbours, however, and that it remained relatively isolated, seems incontestable. Isolation, on the other hand, was not in every sense a disadvantage. For, if nothing else, it helped to prolong the life of the country's craft industries, because there was not the capital investment to build factories to provide mass-production. Moreover, the lack of a good transport system allowed towns which were remote from the main trading arteries to continue to produce many of their traditional goods. In that sense

47. Floor (1971) pp.119–120.
48. Issawi (1971); Issawi (1991) *passim*.
49. Keddie (1972).
50. Gilbar (1979) especially pp.205–209 on transport within Persia.
51. Pakdaman (1983).

Yazd was less badly hit than Tabriz. It is equally clear, however, that it was the import of mass-produced European goods that was the most important single element in the decline of the bulk of the country's traditional crafts. The Europeans themselves realised this. In 1915 Moore put it bluntly: 'Aside from [the saddle-cloths and leather-work in the saddlers' bazaar of Shiraz] there is not a single curious or beautiful object for sale, nothing but trash from Europe. Intercommunication has killed all local customs ... and has – with the aid of machinery – replaced by vulgar products of commerce the native handwork ...'[52]

European visitors to Iran in the 19th century give appropriate evidence of this phenomenon in the metal-working crafts. In 1801 John Malcolm noted that Iran imported from Russia 'cutlery of all descriptions';[53] some years later Stocqueler commented on the quantity of German, Russian and Italian manufactures in Tabriz, and the damage these imports, including cutlery, were doing to the local arts;[54] Fraser noted the demand for English hardware along with English textiles.[55] In the middle of the century Binning wrote: 'The imports from India consist of chintz and other cloths, tea, sugar, cotton, indigo, iron, and other metals; from England, France, and Russia, they comprise cutlery, firearms, cloth, glass, chinaware, watches, paper, and a few other articles.'[56] Cutlery and related ironmongery, English, Austrian, German and Russian, are frequently mentioned, especially in the context of the Tabriz and Tehran bazaars,[57] and the cheapness of the Russian goods was particularly significant:[58] the metal industry of Iran was clearly under attack from all sides. If the haberdashery seller in the Isfahan bazaar was not worried about the source of his wares, the craftsmen themselves certainly were.

Other aspects of the decline were technological. Thus, the invention of matches meant the end of the steel flint-striker industry (see p.448), and the invention of looking-glass the end of the steel mirror industry (see pp.470–71). The pride of Iranian steel-working, the swordsmithing industry, had no future with the arrival of guns, pistols and the modern rifle. Moreover, the arms industry was so much more developed in Europe that Iran could never hope to compete, except perhaps in hand-reproducing foreign guns for the local market.

Polak, in the mid-19th century, was perspicacious enough to notice another element of the problem – the high price of raw materials, due to the need to import

52. Moore (1915) p.387.
53. John Malcolm, *The Melville Papers*, in Issawi (1971) p.264.
54. Stocqueler (1832) vol.1 pp.154–55, vol.2 p.5.
55. Fraser (1834) p.292.
56. Binning (1857) vol.2 p.299.
57. Stuart (1854) p.276; Wagner (1856) p.102; Stack (1882) p.218; de Windt (1891) p.86; Sykes (1898) p.23; Curzon (1892) vol.1 pp.212–13; d'Allemagne (1911) vol.3 p.64.
58. Binning (1857) vol.2 p.298; Wills (1883) p.373; report by Consul-General Jones quoted in Issawi (1971) p.114.

them. 'The country's rich *iron mines* are also neglected, like the copper mines. Only insignificant quantities are supplied, by those of Mazandaran and Khurasan. All the remaining iron comes to Persia from the Urals, by way of the Volga, and the Caspian Sea; only the southern and southeastern parts of the country get part of their supplies from India ... Owing to the high price of iron, the use of tools and implements is naturally very restricted, which has an unfavorable effect on the whole of industry.'[59]

The problems facing local production were various, but huge distances and poor transport were obviously key elements in preventing the development of mining in the country at large. The fascinating picture of local mines in 1848 provided by Abbott is quoted in full elsewhere (see pp.26–27), and offers important insights into the industry and its problems – the scale of the industry, the source of the ore, the smelting technique including the use of water power, and of charcoal rather than coal, the production of shot, the variation in prices depending on the availability of imported iron, the seasonal working, the oppression by the local chief. These give a graphic picture of local mining conditions in 19th-century Iran, and though the technology might be different elsewhere, where water power, for example, was not available, or coal was, the other factors probably give a good reflection of the problems faced by all such small-scale industries.

In the first half of the 19th century there was a series of attempts to overcome the problem of foreign imports. These began with 'Abbas Mirza and continued during the middle of the century under Amir Kabir, chief minister of Nasir al-Din Shah (1848–52). 'Abbas Mirza used a two-pronged policy, one part of which was to develop the mines of Azarbaijan, the other to start manufacturing Iranian armaments. The mining he put in the hands of English engineers; the manufacturing side was partly dependent on imported founders, but also involved sending Iranians to England to learn the relevant trades. A similar approach was used by Amir Kabir, who again encouraged mining by Iranians in the Karadagh region of Azarbaijan, and further development of the iron resources of Gilan and Mazandaran.[60] In 1850 he also dispatched a group of artisans and craftsmen to Moscow and St Petersburg under the supervision of Haji Mirza Muhammad Tajir-i Tabrizi to work in factories there and learn new industries, including casting metals, and smithcraft. On his return, Haji Mirza Muhammad set up a cast-iron workshop at Sari. Sadly his enterprises were not pursued after his murder in 1851, and left no lasting impact on Iranian industry.

59. Trans. in Issawi (1971) pp.272–73.
60. Issawi (1971) p.296 quoting Adamiyat. In 1820 the Persian ambassador in London, Mirza Abu'l-Hassan Khan, was instructed to engage a superintendent of ironwork, two furnace men, and two miners; Issawi (1971) p.260.

In AH 1276 (AD 1859–60), at the time of the French military mission, a rifle factory was set up in Tehran designed to produce 1000 rifles a month. However, this was a purely commercial enterprise, the initiative of a French officer, and not part of Iranian government strategy. How long it flourished is unclear, but it was evidently not a success.[61] During the 1860s factories were also built in Tehran to produce gunpowder and percussion caps, but these do not seem to have been commercially successful either.[62]

A final attempt to develop the country's natural resources was made by Nasir al-Din Shah in 1872, when he granted Baron Julius de Reuter a concession which gave him exclusive rights over railways, tramways, mining, irrigation, water works and exploitation of the state forests for 70 years. This was cancelled the following year under pressure from within Iran and from Russia, but Reuter was eventually offered a new concession in 1889 giving him exclusive banking and mining rights for 60 years. His mining exploits, however, were no more successful than those of his British predecessors. The Persian Bank Mining Rights Corporation's prospectors had little success, and local hostility, lack of communications and inaccessibility of mining areas brought the company's life to an end just three years later.[63]

Despite these failures, the constant pressures of imports and expensive raw materials, and the increasing integration of the Iranian economy into the world capitalist system,[64] the Iranian manufacturing industry managed to keep going, albeit in a gradually contracting form. One method was import substitution, which was successfully practised in Isfahan by the makers of *orsi* ('Russian' shoes), by the chest-makers,[65] and indeed, as we shall see, in the steel-working industry.

The survival of manufacturing was also aided by the slowness of traditional transport, the wide geographical distribution of specialist artisans, and the strong traditions of local craftsmanship. This meant that specialised trades in specific localities continued to flourish well into the 20th century. Two or three examples might be cited. Kirind is a village near Kirmanshah which in the 19th century had a flourishing firearms industry,[66] was famous too for its puzzle- and combination-locks,[67] and still makes steel objects, for example, tongs.[68] Of Rayan, near Mahan, Ella Sykes wrote in the 1890s: 'The little town was evidently prosperous: every house was embowered in fruit trees, the crops appeared to be excellent, and the people carried on the arts of glass-blowing, cutlery, and such-like, being quite an independent com-

61. Issawi (1971) p.309, quoting Jamalzadeh. My thanks to Dr John Gurney for pointing out that Issawi has made an error over the date, ascribing it to AH 1267 instead of 1276.
62. Gilbar (1979) p.200.
63. Wright (1977) pp.102–104.
64. Seyf (1996) p.126.
65. Philipp (1984) p.406. See also Nashat (1981) p.66.
66. Murdoch Smith (1885) p.71.
67. Tanavoli and Wertime (1976) p.16.
68. Gluck (1977) p.153.

munity.'[69] Rayan still produces knives, carpet tools and *qandshakan* ('sugar choppers').[70] Likewise the village of Chal Shutur near Shahr-i Kurd in central Iran is still famed for its locks.[71]

Another significant force in preventing total decline was Iran's religious tradition. Of particular importance were the Shiite *ta'ziyeh* plays, requiring as they did traditional arms and armour, sword, helmet, shield, vambrace and so on.[72] Also important were the Muharram processions, with their *'alams*, flails, locks and other items of equipment, and the 'Id-i qurban ceremony in Isfahan with its numerous warriors, and the men accompanying the camel carrying their traditional steel objects.[73] Indeed the *ta'ziyeh* plays and Muharram processions have continued to support the industry to the present day. It is interesting to see, however, that Iranian craftsmen were also keen to exploit the tourist market with what were essentially objects with a religious focus. Thus, at the end of the 19th century, Collins writes of Isfahan: 'Armour is made of damascened steel, inlaid with gold. This is now used in the "Tazya", or religious play of the Sheahs. Some of it is always brought round for European customers.'[74]

It should also be pointed out that our main source for the late 19th century industry, the *Jughrafiya-yi Isfahan* of Mirza Husain Khan, was written specifically about Isfahan. The physical and commercial decline of Isfahan reflected its lack of political status.[75] It does not follow that other cities in the northern, dominant half of Iran,[76] in particular Tehran and Tabriz, witnessed similar decline in so many of their local industries. Indeed, Mirza Husain Khan's records of particular craftsmen moving from Isfahan to the capital (e.g. gunsmiths and gunhammer smiths)[77] indicates where the real market for manufactured goods lay, and hence the manufacturing centre of the country. Thomson's figures for the number of artisans in Tehran, quoted below, show what a large manufacturing centre Tehran had already become by 1870,[78] and Gilbar's estimate of an 11 per cent growth in Tehran's population between 1873 and 1891 compared to 4.4 per cent in Isfahan shows the ever strengthening role of the capital,[79] the more so since the growth in Isfahan was largely the result of expanding opium cultivation in central and southern Iran.

Turning to the standards of craftsmanship at different periods, in the mid-19th

69. Sykes (1898) p.163.
70. Gluck (1977) pp.142, 153, 155.
71. Gluck (2977) pp.156, 158, 159.
72. Collins (1896) p.184.
73. Floor (1971) pp.138–41.
74. Collins (1896) p.184.
75. Philipp (1984) 403–404.
76. Ricks (1973) p.118 emphasises the ascendancy of north Iran over the south of the country in the Qajar period.
77. Floor (1971) p.107–108. Others mentioned include wood-turners (p.88), silver brocade makers (p.89), and book-gilders (p.115). For the same reasons large numbers of money-changers had also moved to Tehran or Tabriz (p.97).
78. Floor (1971) pp.20–21.
79. Gilbar (1976) pp.149 and 151. The population of Tabriz grew only 1% during the same period.

century Polak is blunt about the decline. 'The damascene blades of Shiraz and Kirman still enjoy a good reputation,' he writes, 'but they cannot be compared with old blades and gun barrels, especially in the beauty of the gold inlay in the steel.'[80] Elsewhere, however, the picture is more confused. For example, Wills's comments on Isfahani watered steel in the 1880s suggest that quality was maintained: 'The "pulad" or damascened steel, is beautifully veined, and much of it is ornamented with work *à jour* and inlaid with gold. But the most prohibitive prices are asked for this pulad work and the constant demand for export render it very expensive.'[81] Yet he was not so complimentary of other metal-workers: 'Very beautiful carving, or rather engraving, on metal is still done in Ispahan … But that too is deteriorating; the good artists find it pays them better to do a quantity of coarse work for the exporting curio-dealers than finer and more delicate engravings, which are paid at a higher rate, but which tax their sight and skill to the uttermost.'[82] D'Allemagne at one point praises the steelworkers: 'The Persian smiths are of a surprising ability, and they manage with the help of a hammer and anvil alone to forge animals, notably pheasants and rabbits which they cover with gold and silver incrustations: one meets so many specimens of these works on the European market, that they are little sought by collectors. Also made in this bazaar are reproductions of ancient arms, such as cuirasses, bucklers, helmets etc. … For 20 to 25 francs one may have a complete set of armour, of well finished workmanship.'[83] Yet on another occasion he writes of inlaid axes and maces 'which are sent to Europe to be sold to people who are looking for oriental objects of bad taste and cheap price.'[84]

An increasing part of the steel-workers' efforts during the 19th century went into copying foreign imports. This process had already begun early in the century, as Lumsden and Fowler's comments on the gunsmiths of Tabriz, quoted above, make clear. Here standards seem to have been high, and so too were the standards in Shiraz and Isfahan: 'In Shiraz and Isfahan the English type of knives are made – a common, very low-priced product which is so well turned out that even the word London is not missing on the blade. I have seen a locksmith for whom this was a completely new kind of work make spurs with screws after a British model put before him; his copy was so good that, except for the quality of the iron, the Persian product was at least as good as the English, and moreover was one-third cheaper.'[85] But standards were not always maintained. The quality of the Isfahani imitations of English penknives did not impress Polak in the middle of the 19th century any more than the imitation foreign guns being manufactured there impressed d'Allemagne

80. Trans. in Issawi (1971) p.273.
81. Wills (1883) pp.189–90.
82. Wills (1883) p.332.

83. d'Allemagne (1911) vol.4 pp.91–92.
84. d'Allemagne (1911) vol.1 p.135.
85. de Gobinueau, quoted by Issawi (1971) p.38.

50 years later.⁸⁶ Stocqueler puts it rather harshly: 'The Persians ... regulate their expenditure rather with reference to what is cheap, than what is permanently useful. A bad knife at six piastres would find a readier sale than a good one at ten.'⁸⁷

The visual evidence supports this picture of variable quality workmanship. The steel mirror cases made for Nasir al-Din Shah, for example, are of superb quality. Yet there is an abundance of poorly designed and executed lesser objects which suggest hasty production and little attention to quality.

Figures provided by de Rochechouart concerning the prices of sword and daggers in the late 19th century point in the same direction.⁸⁸ He distinguishes three types of metal – watered steel, ordinary steel, and iron, and for each type of metal three qualities – very good, good and ordinary. The price differences are striking. Thus a watered-steel sword of the finest quality is priced at 2,400 francs, of good quality at 240, and of ordinary quality at 36, while the figures for an ordinary steel sword are 60, 18 and 6 francs, and for an iron one 24, 12 and 6. He provides similar figures for sword accessories, for the three common types of dagger (*kard*s, *khanjar*s, and *qama*s) and for lances.

Apart from the mention already made of the impact of Russian imports on Iran, there will be no attempt here to deal with the steel-working industry of Iran in relation to those of its more immediate neighbours. A few published steel items from Turkistan show that a similar style of steelwork was used, and presumably, made there – for example, a dragon-headed flint striker, and what is described as a honing steel, which, in its cut and pierced handle and partly decorated blade, is very like many of the tools from Iran in the Tanavoli collection.⁸⁹ In the case of India, its steel-working industry produced objects so similar to those of Iran that it is often difficult to be sure where particular items were made. This is particularly so in the arms and armour industry, where it would seem that craftsmen travelled between Iran and India, presumably in search of more profit for their labours. It is also visible, however, with flint strikers, where the same forms recur in both areas.⁹⁰ The information for a more detailed study, however, has still to be gathered.

CRAFTSMEN AND THEIR ORGANISATION

As will be clear from what has gone before, a great deal of the industry of Iran was local and specialised. Many towns produced their own speciality within a class of goods which was itself widespread. For example, Sabzavar was not unique in manu-

86. d'Allemagne (1911) vol.4 pp.91–92; trans. by Issawi (1971) p.271.
87. Stocqueler (1832) vol.2 p.6.
88. de Rochechouart (1875) pp.321–22.
89. Kalter (1984) ill.65.
90. A dragon-headed flint striker, which from the inscription seems to have been made for an Indian patron, is illustrated by Christy (1926) pl.203 no.495.

facturing spades; it probably was unique, however, in the form of spade it manufactured, and possibly in the quality of its products. Likewise, padlocks were made in many different centres in Iran, but each centre produced its own particular forms or designs. Fraser is particularly interesting on this front. He draws attention to the fact that the Khurasani industry was based, not just on Mashhad and Herat, but on various towns and large villages in the province which exported swords and firearms. In Gilan too he notes that it was 'full of large villages which produce things, but Rasht, Lahajan, Fomen and Enzellee in particular make cutlery and arms'. Writing about Azarbaijan, he does not specify iron- and steelwork, but certainly implies a similar type of industrial situation. Having noted that the province, including Tabriz, produced 'copper utensils, cutlery (a little) and arms', he comments: 'Tabreez is the chief town of this large province, but there are many others, as Ardebeel, Maragha, Khooee, Moraund, Erwan, Makshewan, which contribute to its exports, but I am not aware of any remarkable difference in their respective produce or exports.'[91]

It should be noted that as in any pre-industrial society, 'specialisation occurs in the product not the process'.[92] In general a craftsman in Qajar Iran made all the different parts of an object and assembled them himself. This was noted by de Gobineau in 1859,[93] and is confirmed by Mirza Husain Khan, author of the *Jughrafiya-yi Isfahan*, who comments that each European gunhammer-smith made a different part, while in Iran all the parts were made by one man.[94] The words 'product' and 'process' do, however, require tight interpretation in this quotation. For example, today in Isfahan most steel-workers do not do their own goldwork, but pass their products on to a gold-worker who then decorates them.[95] Similarly, Haji 'Abbas was the head of a workshop in which he specialised in the shaping of steel objects, leaving to others the chiselling and goldwork used to decorate them. The product to the Western eye is the combination of steel, chiselling and gold, but would not necessarily have been so to the craftsmen involved in its manufacture and decoration.

A similar division of skills was true of earlier times. Thus, the Timurid steel grille in the Museum of the shrine of the Imam Riza in Mashhad, dated to AH 817 (AD 1414–15), was the work of Ustad Shaikh 'Ali Khudgar of Bukhara, but the inscriptions mention at least two other craftsmen responsible for the gold inlay, Mawlana Shams of Tabas and Ustad Mahmud, and an additional inscription giving the name of Haj Muhammad ibn 'Ali Hafiz al-Isfara'ini may well indicate the engraver of the calligraphy.[96] Similarly, in the Safavid period, the unpublished pair of steel shrine doors dated AH 1110 (AD 1698–99) made by Kamal al-Din Nazuk also bear inscrip-

91. Fraser (1826) pp.355–57.
92. Floor (1971) pp.17–18.
93. de Gobineau in Issawi (1971) p.37.
94. Floor (1971) p.108.
95. Allan (1994) p.146.
96. Anon (n.d.) pp.31–33, no.59; *The Arts of Islam* (1976) p.204 no.245.

tions which give the engraver of the inscriptions as Muhammad Nishan Saz and the calligrapher as Muhammad Riza.[97] The texts for such inscriptions were evidently commissioned by the steel-workers from appropriate calligraphers, who would also have been used by other craft industries. Thus, the calligrapher Muhammad Riza is known from a steel plaque recently on the art market,[98] which bears the words *katabahu Muhammad Riza*, and is almost certainly the same calligrapher from whom the texts for a set of wooden panels in honour of the twelve Imams was commissioned in AH 1110 (AD 1698).[99] He may also be the same calligrapher as Muhammad Riza al-Imami, known from tilework texts on Safavid monuments in Isfahan and Mashhad.[100]

In the Qajar period, the steel grilles and steel door of the cage surrounding the cenotaph in the shrine of Sayyid Shafti in Isfahan point to the same conclusion. The door, dated AH 1260 (AD 1844), is the work of Haji Ghulam'ali Mubashir 'Abd al-Baqi, while its goldwork was done by Ustad Ramadan Talakub Isfahani. In AH 1322 (AD 1904–5), a new upper part was provided for the grille, and this bears inscriptions attributing the work to Ustad Yadallah. However, two calligraphers were also involved, Kazim Sharif for the *naskh* calligraphy and Fath Allah for the *nasta'liq*.[101] Again, the steel-worker was the manufacturer, but not necessarily the craftsman who did the surface decorations, and certainly not the designer of the calligraphy. And in a final example, the *ziyarat-nameh* in the Moser collection, the steelwork (*kar-i pulad*) was done by Mirza 'Ali, and the calligraphy by Muhammad 'Ali.[102]

Most craftsmen, at least in Isfahan, belonged to a guild. In the 17th and 18th centuries, there were some 33 main guilds, of which four included iron- and steel-working craftsmen, or closely related crafts. That of the armourers included also arrow-makers, bow-makers, makers of rifle stocks, needle-makers, rifle-makers and gunpowder-makers; that of the habderdashers included dealers in iron and steel goods; that of the sword-makers included also knife-makers, steel-workers who made steel helmets, Koran cases, shields, and steel items for other objects such as the upper parts of *qalians* and the saucers for coffee cups, as well as scissor-makers, and chain-mail makers; the blacksmiths also included locksmiths, makers of horseshoes, farriers and foundrymen.[103] Each guild or group had a *bashi* in charge of it.[104] Separate were the makers of razor blades and the circumcisers, who came under the supervi-

97. Cited in comments to Christie's sale 25 April 1995 lot 304.
98. Christie's, 23 April 1996 lot 224.
99. Fehérvári and Safadi (1981) p.230 no.157.
100. Hillenbrand (1986a) pp.787, 803, 837; for this and others bearing the name Muhammad Riza, see the index in Honarfar (1966) pp.977–78.
101. For the texts of these inscriptions see Honarfar (1966) pp.785–88.
102. Historisches Museum, Bern, Moser colln. MK 178; unpublished.
103. Keyvani (1982) pp.49-51.
104. Keyvani (1982) p.84.

sion of the Shah's private barber.[105] They were also privileged in being exempted from taxation.[106]

It is unnecessary here to describe all the functions of a guild, since these have been dealt with fully by Floor and Keyvani.[107] However, certain details of guild organisation bring alive the way the iron- and steel-working crafts might have worked. Crafts were normally, but not always, family businesses, in which a son followed his father' profession, starting in his workshop as a child doing elementary tasks such as running errands, and then becoming a full apprentice learning his father's trade. The age of apprenticeship varied but is assumed to have started in early teens. It may in fact have been earlier than that, for the contemporary Isfahani craftsman, Ustad Haj Akbar Bahman, started his training when he was seven. The number of years required in that role varied according to the individual situation.

The family tradition had two specific advantages. Firstly, it kept technical secrets within the workshop. Secondly, if the master craftsman was not well off it saved the expense of purchasing the tools and other equipment necessary for his son to pursue a different craft. The available evidence shows that family businesses definitely existed in the iron- and steel-working industries at different periods, though they are impossible to quantify since very few craftsmen actually recorded their ancestry on their artefacts. However, two families are known from the Safavid period.

The first is the Nazuk family: Kamal al-Din Mahmud Yazdi Nazuk is known from work in the shrine of the Imam 'Ali Riza in Mashhad dated AH 1015 (1606–7),[108] his son 'Ali Riza Nazuk from a leather-working knife in the Khalili collection datable to the reign of Shah 'Abbas II (1642–66),[109] and 'Ali Riza's son, another Kamal al-Din Mahmud, is known from a variety of objects, a plaque dated AH 1107 (AD 1695–96),[110] a *maqta'* dated AH 1108 (AD 1696–97),[111] and a steel shrine door dated AH 1110 (AD 1698–99).[112] A further member of the family, whose relationship to the above is unclear, was Shafi' Nazuk. His name, together with the phrase *bandeh-yi shah-i vilayat Sultan Husain*, appears on a pair of steel scissors recently on the art market.[113]

The second is a swordsmithing family. Asadallah Isfahani was the most famous of

105. Keyvani (1982) pp.55–56.
106. Keyvani (1982) p.109.
107. Floor (1971); Keyvani (1982). See also Philipp (1984) pp.395–401 for guilds in the late 19th century and the problems of interpreting the sources.
108. Karimzadeh Tabrizi (1985–91) vol.2 p.550 no.811, who, however, gives the name as Kamal al-Din Mahmud Yazdi Nazil.
109. Stanley (1997) p.122 no.T32. Atıl, Chase and Jett (1985) pp.196–97 read an inscription on a ruler in Cairo in such a way that it could suggest another possible son of Kamal al-Din; however, this is the name of the owner, not the maker, as Wiet (1941) p.16 no.33 and pl.IX makes clear.
110. Sotheby's, 30 April 1992 lot 137; Momtaz (1995) p.50 no.55.
111. Mayer (1959) p.55.
112. Cited in comments to Christie's sale, 25 April 1995 lot 304.
113. Drouot-Richelieu, 6-7 April 1998 lot 364.

FIG.9 Isfahani craftsman Haji 'Abbas (d. AH 1380/AD 1960–61),
with (inset) his father, 'Abd al-Vahhab
FIG.10 Isfahani craftsman Haj Muhammad Bayazi, 1993 (photo: J.W. Allan)

all the Safavid swordsmiths, and his two sons, Kalb'ali and Isma'il, are also known from surviving sword blades. This family is discussed in detail below. There is evidence of another family business in Isfahan which may also date from Safavid times, that of Muhibb 'Ali and his son, Sadiq (see Appendix One). However, as none of their objects bears a date, when exactly either of them lived is uncertain.

Towards the end of the 19th century, Wills recorded that work in watered steel in Isfahan was a monopoly of a particular family.[114] This must be wrong, however (see Appendix One). In the first place there is the testimony of the contemporary craftsman, Muhammad Bayazi (FIG.10). Early this century, according to him, there were three steel-workers in Isfahan specialising in animals and standards, his grandfather Haji 'Abbas (FIG.9), Haj Muhammad Hasan, who worked for the latter, and Mirza Isma'il, whose workshop was in the Bazar-i Chaqmaq. Moreover, there are a number of different steel-working families who are known by name from the 19th and early 20th centuries. One of these families included Haji 'Abbas. Along with his father, 'Abd al-Vahhab, his son, Haj Karim, and his grandson, Muhammad Bayazi,

114. Wills (1883) p.332, who adds that steel objects were subject to 'almost prohibitive' prices as a result.

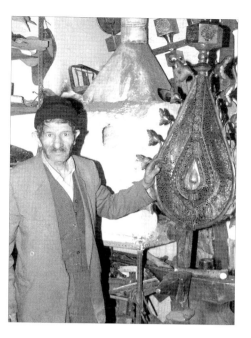

FIG.11 Isfahani craftsman Ustad Haj Akbar Bahman in his home, with standards made by him and his brothers, 1992 (photo: J.W. Allan).

FIG.12 Isfahani craftsman Haj Muhammad Sadiq Shirani in his workshop, 1993 (photo: J.W. Allan)

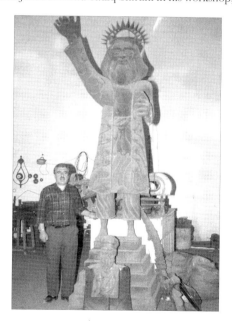

FIG.13 Isfahani craftsman Mr Jawhari in his workshop, with his steelwork statue of Moses, 1992 (photo: J.W. Allan)

he was part of a family business which continued to operate for at least half the 19th and most of the 20th century.[115] Another was that of 'Abbas *fuladgar*, whose son and grandson (FIG.11) continued the business, though his great-grandsons did not want to do so, hence the appearance of Haj Muhammad Sadiq Shirani (FIG.12). Another was the business of another standard-maker, 'Abbas, and his son, Haj 'Ali, and yet another in the 19th century was that of Ustad Haji Muhammad, who in AH 1264 (AD 1848) signed a *ziyarat-nameh* now in the Mashhad Shrine Museum, on which he records that he was the son of another Ustad, Haji Husayn. The now retired Isfahani steel craftsman Mr Jawhari (FIG.13) also claimed to be part of a family steel-working tradition going back to the Safavid period. There may well have been more.

Nevertheless, in Safavid times sons in the craft industries did not always follow their father's profession. Qadi Ahmad, for example, gives a number of examples of Safavid calligraphers whose fathers had been in other crafts.[116] Likewise, in more recent times, Haji 'Abbas's workshop also included craftsmen who were not members of the family, specifically Haj Tahir and Haj Muhammad Hasan. Another contemporary family of three craftsmen in Isfahan, the Bahman family, consists of three brothers who were apprenticed to a craftsman completely unrelated to them, Haj Muhammad Sadiq, and the latter had been apprenticed in his turn to another famous *ustad*, 'Ali Fuladgar, though the latter was the third of a family business (see Table 1, no.1).[117] Hence the lines are impossible to draw accurately, and must have varied from generation to generation, if not from year to year.

The published figures for masters and apprentices in different crafts in Erivan at the beginning of the 19th century also show the variations in the system. For example, the 20 blacksmiths had 45 apprentices, the 12 horseshoe smiths 10 apprentices, the six silversmiths 21 apprentices and the 40 general metal-workers three apprentices, suggesting no uniformity between metal-working crafts.[118] In 1870 Thomson produced figures for the number of artisans in Tehran which scarcely offer clarification. For here we find 150 goldsmiths with 300 apprentices, 52 blacksmiths with 156 apprentices, 40 coppersmiths with 80 apprentices, 30 gunsmiths with 78 apprentices, 12 nail-makers with 24 apprentices, and 70 farriers without any apprentices at all.[119]

115. Allan (1994).
116. Issawi (1971) p.291.
117. With two exceptions, the information on this table is derived from contemporary oral sources, in particular the Isfahani silversmith, Mr Aloghmand; Ustad Haj Akbar Bahman; Haj Muhammad Bayazi; and Mr Jawhari. The exceptions are the 'Abbas standard-making business (no.5), for which the information is derived from a tombstone in the Imamzadeh Ahmad, Isfahan, and the family business which produced the *ziyarat-nameh* in Mashhad. A complete line indicates a father–son relationship, a dotted line indicates a master–apprentice or master–employee, i.e. non-family, relationship. None of the craftsmen is known to have used the *nisba* Isfahani.
118. Issawi (1971) p.289.
119. Floor (1971) pp.20–21.

TABLE I RECENT STEEL CRAFTSMEN OF ISFAHAN

1. The Fuladgar standard-making business

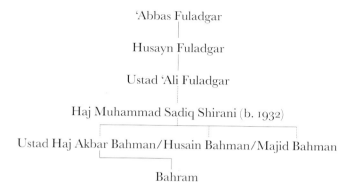

'Abbas Fuladgar

Husayn Fuladgar

Ustad 'Ali Fuladgar

Haj Muhammad Sadiq Shirani (b. 1932)

Ustad Haj Akbar Bahman/Husain Bahman/Majid Bahman

Bahram

2. 'Abd al-Vahhab (*circa* 1870–*circa* 1965): revived openwork, specialist in openwork boxes

3. Haji 'Abbas standard-making business

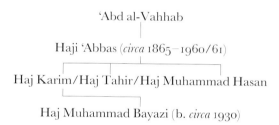

'Abd al-Vahhab

Haji 'Abbas (*circa* 1865–1960/61)

Haj Karim/Haj Tahir/Haj Muhammad Hasan

Haj Muhammad Bayazi (b. *circa* 1930)

4. Jawhari family: specialists in *ta'ziyeh* equipment

5. 'Abbas standard-making business

'Abbas

Haj 'Ali (1858/59–1939)

6. Mirza Isma'il (early 20th century), steel-worker making animals for standards in the Bazar-i Chaqmaq

7. A family business which produced the *ziyarat-nameh* in the Mashhad Shrine Museum

Ustad Haji Husain Isfahani

Ustad Haji Muhammad Isfahani

Beyond the stage of apprentice, there seems to have been a stage of deputy (*khalifa*). This qualified the craftsman concerned to act as his master's deputy when the latter was absent. To become an *ustad* itself required not only a long period of apprenticeship, but the acquisition of a certificate of mastership. This was subject to the approval of the master of the guild and to the endorsement of the government supervisor of guild affairs (*naqib*). The candidate's eligibility for mastership was then notified to another government official with authority over artisans and traders (*kalantar*), from whom a certificate was obtained. The transition from apprenticeship to mastership seems to have been marked by a ceremony at which the master was sometimes girded with a sash or belt. It is not clear whether a candidate for mastership had to present a fine piece of his own work for examination and judgement by the masters of the guild and the *naqib*, but this is possible.

The traditional image of an Iranian bazaar is of each master craftsman owning a shop in the bazaar alongside others of his craft. It is indeed likely that a specialised craft such as swordsmithing would have been concentrated in a particular part of the bazaar, and in support of such an image various travellers noted specific trades in the Isfahan bazaar: Chardin recorded iron-mongers', steel-workers' and locksmiths' bazaars,[120] Tavernier groups of file-cutters and makers of saw blades,[121] while at a much later date d'Allemagne recorded locksmiths' and armourers' bazaars.[122] However, this picture by itself is almost certainly too simplistic for Safavid and Qajar Isfahan. In the first place, more general iron-working crafts could well have had shops in the smaller bazaars in the *mahalleh*s ('city districts') or indeed been spread out all over the city. In addition, there seems to have been a large category of workmen who had no permanent shops, but were occupants of temporarily rented shops or booths. Workers in this category were called *muzdur* ('hired man') or *kargar* ('daily paid labourer'). The socio-economic system of the Safavid period promoted a multiplication of street artisans whose services were used mainly by the lower income groups in the cities and suburbs and by peasant families, because they could supply basic needs much more cheaply than their shop-owning counterparts in the bazaars. Chardin states that the artisans and vendors of this type who carried on their trades in the Maidan-i Shah of Isfahan rented spaces in the Maidan, or if more fortunate rented small shops surrounding the Maidan. Most of them spread their tools and wares on the ground in the square and were charged a small rent which they paid to the Shah's agents. Shah 'Abbas had designated a space for each trade. Among them were at least four groups of iron- and steel-workers – blacksmiths, armourers, saddlers and locksmiths. In the evening the

120. Chardin (1811) vol.7 pp.241, 368, 393.
121. Tavernier (1970) pp.59, 63.
122. d'Allemagne (1911) vol.4 pp.91–92.

members of these groups placed their tools and wares in chests which were left in the corners of the Royal Square, where they were guarded by watchmen throughout the night.[123] Tavernier records forgers of scythes, hammers, pincers, nails and other things, with some cutlers, outside the porticos of the Maidan-i Shah on the side of the Lutfullah Mosque.[124]

There were also groups of artisans, known as *khaneh-karan*, who had no shops and worked for hire at customers' houses. According to Chardin there were large numbers of these artisans in Isfahan, though he does not say whether they included iron- and steel-workers.[125] According to du Mans there were also artisans in Isfahan who lacked sufficient capital and other means to offer their products directly to consumers, and therefore sold them to established traders who had shops in the bazaar.[126]

The bazaar system automatically suggests specialisation of crafts, and the specific steel-working bazaars of Isfahan mentioned in the literature – those of the swordsmiths, the armourers, the makers of saw blades, the file-cutters, and so on – suggest that craftsmen confined their work to their particular branch of steel-working. However, craftsmen's signatures on particular objects indicate that this was not always the case. Thus, from his name Ustad Shaikh 'Ali Khudgar Bukhara'i must have been an armourer (*khudgar* means 'helmet-maker'), yet in AH 817 (AD 1414–15) he manufactured a splendid steel grille for the Shrine of the Imam Riza at Mashhad.[127] Similarly, the famous early 18th-century steel-working craftsman Faizallah Shushtari Isfahani was clearly an armourer, for a sword, a mace and two helmets by him survive. But he was also commissioned by Shah Sultan Husain to make sets of door plaques for the shrine of the Imam Riza, and a small steel orange and a steel ewer were made by him so that Shah Sultan Husain could donate them to the shrine.[128] In the 19th century one craftsman, Haji Muhammad, manufacturer of a dervish staff, betrays his gunsmithing or swordsmithing trade by stamping his name into the staff, a type of signature normally only found among these artisans.[129] Another craftsman who was probably a gunsmith by the name of Hasan made a clamp (1.7) which may have had a function related to guns but nevertheless shows how an artisan extended his range beyond his primary products.

The guild system and the ways craftsmen functioned in Isfahan was not necessarily true of members of the craft industries elsewhere in Iran. For example, in small villages the guild system probably did not exist, while in small towns the guilds that

123. Chardin 1811 vol.7 pp.339–40.
124. Tavernier (1970) pp.59, 63. See also Struys (1684) p.316.
125. Chardin 1811 vol.4 pp.91–93.
126. du Mans pp.194–95.
127. Mashhad (n.d.) pp.31–33, no.59, *Arts of Islam* (1976) no.245.
128. See Appendix One.
129. See Appendix One.

did exist were probably very few in number.¹³⁰ In addition there were itinerant individual day-labourers going from town to town, village to village, or house to house, providing a service wherever it was needed and could be paid for.¹³¹ There were also itinerant groups, such as the Kuli, the smithing gypsies, who travelled over the plateau buying scrap iron and forging it into rural implements, such as spades, ploughshares, forks, threshing blades, sickles and locks.¹³²

ASADALLAH AND KALB'ALI ISFAHANI

It is worth returning briefly to the guilds, and to the steel-workers of such cities as Isfahan, to discover whether there were ever individuals within the industry who could claim to have become famous through their craft. It is obvious that fame would be most likely in the most prized industry, namely swordsmithing, and here indeed we find one particular name, known from tens of objects: Asadallah Isfahani. Asadallah and his son, Kalb'ali Isfahani require more detailed comment here, since they pose a number of problems for the art historian. These were faced, but never resolved, by Mayer,[133] and have never been comprehensively considered since. Some scholars doubt whether Asadallah even existed, and one, in an encyclopaedia article devoted to him, wrote that 'nothing is known about the craftsman or craftsmen who according to Mayer p.26 is one of "the finest of all Persian swordsmiths."'[134] Other scholars are little more informative.[135]

Fortunately, however, there is independent evidence that both craftsmen did indeed exist. For, in his *Tadhkira-yi Tahir-i Nasrabadi*, begun in AH 1072–73 (AD 1661–62) and dedicated to Shah Sulaiman, the author, Mirza Muhammad Tahir Nasrabadi, talking of the poets who graced the court of Shah 'Abbas I, mentions Ustad Kalb'ali the sword-maker.[136] According to Nasrabadi, Kalb'ali recited a particular story which he had heard from his father, Ustad Asad, and also from two other men, Mulla Muhammad and Haji Husain. He goes on to emphasise Kalb'ali's skill as a raconteur. Furthermore, Keyvani has pointed out that a story told by Chardin, which is also part of the oral tradition of the Isfahan bazaar, relates how Shah 'Abbas I received a gift of a helmet from the Ottoman Sultan, who offered a sum of money to anyone who could break it with a sword. No one was able to do this until a swordsmith called Asadallah managed the feat. As a result Shah 'Abbas exempted the Isfahan swordmakers' guild from taxation, and Asadallah's tomb in

130. Fraser (1825) p.301.
131. Keyvani (1982) p.91.
132. Wulff (1966) p.49.
133. Mayer (1962) pp.26–27.
134. Melikian-Chirvani (1987).
135. For example, see Karimzadeh Tabrizi (1985) vol.1 pp.42–43.
136. Nasrabadi (1317) p.9. I am grateful for this important reference to Dr Sandy Morton.

the cemetery in Sichan became a place of annual pilgrimage for members of the guild, a practice still current as recently as 1937.[137] The tomb was engraved with a sword and was situated in the *takyeh-yi shamshir-sazan* (the *takyeh* of the swordsmiths), which collapsed *circa* 1950.[138] The tax exemption continued throughout the Qajar period, and was only reversed in 1921. Hence we may be sure that both Asadallah and his son Kalb'ali existed, and that their fame brought them into close contact with Shah 'Abbas I.

Shah 'Abbas died in 1629. Even if we suppose that Kalb'ali was young to be a raconteur at court, say 20 years old, and that he came to the Shah's notice late in his reign, say in 1625, he could scarcely have been born later than *circa* 1605. Equally, therefore, his father, Asadallah, is unlikely to have been born later than 1585. Those dates are important when we turn to swords which bear the names of the two smiths. For, in the case of Kalb'ali, the only dated sword claiming to be made by him which could possibly have been produced during his lifetime is that of AH 1092 (AD 1681) in the Victoria and Albert Museum, and if Kalb'ali was actually born earlier than we have suggested even this one is not by him.[139] The next dated example, a sword in the Moser collection claiming to have been made in AH 1120 (AD 1707), is too late.[140] A more likely candidate, perhaps, is another sword bearing his name in the Moser collection.[141] This is undated but was owned by Mir Karam 'Ali Khan Talpar, and must therefore have been made before AH 1127 (AD 1714–15). A second possible candidate is published by Figiel.[142] This has two deeply cut cartouches, one with Kalb'ali's name, the other with the words *Ya qadi al-hajjat*, 'Oh judge of needs', and the hilt is dated AH [1]103 (AD 1691–92). But neither attribution to Kalb'ali can be proven.

The problem of identifying swords by Asadallah Isfahani is even greater, since there are far more to choose from. Mayer's list gives the range of dated swords bearing his name as follows: AH 811 (AD 1408–9), AH 957 (AD 1550), AH 1018 (AD 1609–10), AH 1031 (AD 1621–22), AH 1085 (AD 1674–75), AH 1105 (AD 1693–94), AH 1115 (AD 1703–4), AH 1119 (AD 1707–8), AH 1121 (AD 1709–10), AH 1122 (1710–11) (?), AH 1123 (AD 1711–12), AH 1127 (AD 1715), AH 1181 (AD 1767–68), AH 1197 (AD 1783) and AH 1223 (AD 1808).[143] In addition there are swords bearing Asadallah's name claiming to have been made in the following reigns (numbers in brackets indicate the number of

137. Lambton (1954) pp.25–26.
138. Floor (1971) p.41, quoting Lambton (1954) p.25; Keyvani (1982) pp.193, 200, 202, and 204 n., who made personal investigations in the Isfahan bazaar and the Sichan cemetery.
139. Mayer (1962) p.46; also inscribed *bandeh-yi shah-i vilayat 'abbas*.
140. Historisches Museum, Bern, Moser collection; Zeller and Rohrer (1955) pp.112–13 no.69 fig.56 and Taf.XXIII.
141. Historisches Museum, Bern, Moser collection; Zeller and Rohrer (1955) pp.110–11 no.67 fig.54 and Taf.XXVI.
142. Figiel (1991) pp.46–47.
143. Mayer (1962) pp.26–29.

swords recorded by Mayer): Isma'il, 1502–24 or 1576–78 (1); Tahmasp, 1524–76 or 1722–31 (1); 'Abbas, 1587–1629 or 1642–67 or 1731–36 (many); Safi', 1629–42 (1); Sulaiman, 1666–94 (1); Sultan Husain, 1694–1722 (1); and Nadir Shah, 1736–47 (1). It is evident from the little we do know about Asadallah that the only dated swords which could be his work are those of AH 1018 (1609–10) and AH 1031 (AD 1621–22). There are, on the other hand, numerous swords bearing ascriptions to the reigns of 'Abbas or Safi which could be his work, though these ascriptions could equally well be later. One undated sword blade signed by Asadallah which could be genuine is that belonging to the Royal Asiatic Society and exhibited in the Victoria and Albert Museum. This is said to have been given by John III Sobieski to Laurence Hyde during the latter's mission to the Polish court in 1676, before being presented to the Society in 1845.

One other piece of information about this family of swordsmiths is noteworthy: the existence of a second son, Isma'il. He is not mentioned by Nasrabadi, and his name occurs on only two swords, a piece in Windsor[144] and another recently on the art market.[145] Along with his name, the Windsor sword bears the date AH 1186 (AD 1772). Given the dating parameters we have established for Asadallah this is impossible, and the inscription must be a later fabrication. In the case of the second sword, the inscription uses the word *valad* for 'son', which could suggest that Isma'il was illegitimate. On the basis of these two swords, therefore, it is perfectly possible that Isma'il existed, that he may have been an illegitimate son of Asadallah, and that his lifetime fell within the 17th century. More we cannot say.

The fame of another armourer, Faizallah Shushtari Isfahani, did not live on in the same way as that of Asadallah. There is, however, evidence of his fame in his own day, for, as mentioned above, Sultan Husain commissioned him to make steel objects for royal donations to the Shrine of the Imam Riza.

It is also noteworthy that of all groups of steel objects produced in Iran during the 17th to the 19th centuries the most often signed are sword and dagger blades. The manufacture of such blades was of course the peak of the steel-working industry, but the inlaying of craftsmens' names on those blades implies the fame of those craftsmen in the city in which they worked, and also one suspects among a much wider public.

Another craft in which fame was sometimes to be found was the manufacture of penknives, used by calligraphers for cutting their reed pens, and hence an adjunct to the most prestigious of all art forms. According to Mirza Husain Khan: 'Ahmad Isfahani was a famous cutler in Safavid times; his penknives lasted for more than 200

144. Royal Collection, Windsor Castle, no.1788; Mayer (1962) p.44.

145. Christie's, 13 October 98 lot 134.

years. There was one Mahmud in the beginning of the reign of the late Khaqan. His penknives were twins of the work of Ahmad ... even after being used one or two years they did not become dull. These penknives of Ahmad and Mahmud can be found in some old calligrapher families.'[146] Here fame depended on quality.

Occasionally other craftsmen in lesser branches of the industry became famous, especially locksmiths. Thus Sam Mirza, the Safavid prince, writing in the mid-16th century, describes Mawlana Ustad Nuri Quflgar as follows: 'He was among the great ones of his time and rare ones of his age. In the craft of lockmaking he was so outstanding that he made twelve locks of steel, [each one of which] would fit inside the shell of a pistachio nut. And there was a key for each of these locks.'[147]

But fame had not always come through such craftsmanship, as the story quoted in the chapter on locks makes clear (see p.417). It is worth relating again here. Yaqut records a locksmith by the name of Abu Bakr 'Abd al-Rahman ibn Ahmad ibn 'Abd Allah al-Marwazi al-Qaffal, who was a famous locksmith and legal scholar in 11th-century Merv. According to Yaqut's account, a Shash locksmith made a lock which, with its key, only weighed a *daniq* (one sixth of a *mithqal*). This work excited universal admiration and Abu Bakr, not to be outdone, made a lock which weighed a quarter of a *daniq*. His skill went almost unnoticed, however, and when he complained to his friends he was told: 'fame comes through knowledge of science, not padlocks.'[148] Two points are noteworthy: first, the low standing of craftsmen compared to religious scholars; secondly, the dependency of fame, at least in the locksmithing cases cited, on the extraordinary – the very small, rather than the beautiful.

FORGERIES AND FALSE ATTRIBUTIONS

Fame inevitably led to forgery, and the forgery business has certainly been a feature of the steel-working industry in Iran since the early 19th century, and probably goes back much earlier. One aspect of this business was the sale of steel objects which, according to the seller, had once belonged to some great figure of the past. Thus Sir William Ouseley writes of Tehran: 'I bought a very handsome *tabr* or battle axe, probably 300 years old, made of the finest steel, and ornamented with figures in relief, richly gilded; and examined a large mace likewise of fine steel, which was exhibited in a shop in the *bazar*, suspended by a chain; this weapon the proprietor denominated *Gurz-i-Rustam*, or "RUSTAM'S mace;" and affirmed that it had been wielded by that ancient hero; he even appealed to some pictures in a copy of the *Shahnameh*, as proof of his assertion, and the extravagent price which he demanded

146. Floor (1971) p.111.
147. Tanavoli and Wertime (1976) p.19.
148. Yaqut vol.4 pp.511–12, trans. p.532.

for it, was in proportion to its imaginary antiquity.'[149] Not surprisingly, this sales talk continued throughout the century. Orsolle, for example, relates some of the tales told to customers in the Tehran bazaar, how 'this old notched sabre is precisely the one with which Nadir Shah killed a Hindu Raja at the battle of Karnal', or how a battle-axe, sent with the last caravan by the makers of antiquities of Isfahan or Hamadan, was sold as 'the same that Rustam received from his grandfather, and with which he killed the White Div'.[150]

This type of attribution is of course the brainchild of the trader, not the manufacturer. But forgeries were also produced by the steel-workers themselves. Thus Sir Robert Ker Porter, who visited Shiraz in the second decade of the 19th century, wrote: 'The art of founding the metal in the superlative way that formed these ancient swords, poignards, knives &c. is now lost; which occasions so very high a value being set on them, when they are proved to be genuine; a fact of some difficulty to ascertain, modern artificers so well counterfeiting the appearance of the antique blades, it requires no little experience to detect the cheat at sight.'[151] Forgeries were also common in the gunsmithing business, as Fowler's description of what he saw in the Tabriz bazaar in the second quarter of the century makes clear (see pp.160–61).[152] And at the turn of the century, according to d'Allemagne: 'The most interesting part of the [Isfahan] armourers' bazaar to visit is that where Martini guns are made. The local workmen are able to copy these arms with extraordinary exactitude, and, in order to delude the purchaser completely, they have manufactured dies allowing them to strike [onto their products] the number and name found on pieces imported from Europe.'[153]

The forgery business was undoubtedly encouraged by the taste for antiques among the Iranian public and European visitors. That taste is exemplified by the title given to Haji 'Abbas's son, Haj Karim, *atigheh-saz* ('maker of antiques'), and is discussed by the first American ambassador to Iran, S.G.W. Benjamin. Having mentioned 'the very beautiful imitations of the ancient work which they now produce at Ispahan for the foreign market', Benjamin continues: 'For those who cannot find or cannot afford antique examples of the fine Persian metal work of former ages, it may be granted that these comparatively inexpensive imitations offer a tolerable substitute.'[154]

In order to enhance the antique appearance of his products, a forger would deco-

149. Ouseley (1819) vol.3 p.354.
150. Orsolle (1885) p.235.
151. Porter (1821–22) vol.1 p.715.
152. Fowler (1841) p.264.
153. d'Allemagne (1911) vol.4 pp.91–92. Contrast Mitford (1884) p.366: 'The Persians are ingenious workmen … they imitate our guns exactly; only failing in their attempts to copy the makers' names, by which they are easily detected.'
154. Benjamin (1887) pp.304–305.

rate them with inscriptions attributing them to famous craftsmen of the past, or naming past owners of the object. Thus, in the middle of the 19th century, Binning records how Asadallah's name was being forged on ordinary swords being produced in Isfahan,[155] and today museums and private collections contain numerous examples of this phenomenon.[156] Haji 'Abbas, the late 19th- and early 20th-century craftsman, boldly attributes one of his *kashkuls* to 'Haji 'Abbas, son of the late Aqa Rahim, armourer, in the year one thousand (and) fifteen of the Hegira'.[157] The Tanavoli *'alam* (E.2) bears an inscription attributing the piece to the famous steel-worker Kamal al-Din Mahmud Nazuk, but the date included in the inscription, AH 996 (AD 1587), is a century out, and shows that the attribution must have been a much later addition to the piece. A confusing object is a dagger (*kard*) in the Historisches Museum, Bern, which has an inscription on the back attributing the workmanship to Abu'l-Hasan Shirazi, a date on one side of the blade seeming to read AH 999 (AD 1590–91), and on the other side of the blade a cartouche inscribed with the name of the 17th-century craftsman, Kalb'ali Isfahani.[158] One wonders if any of this information is correct.

Numerous other objects bear inscriptions relating them to the reign of a particular Safavid ruler. Thus, for example, a sword signed by Sadiq and dated AH 1018 (AD 1609–10) in the Riza-i Abbasi Museum in Tehran,[159] and an axe dated AH 1017 (AD 1608–9) in the Moser collection,[160] both bear inscriptions ascribing them to the reign of Shah Isma'il (though without any indication of which Shah Isma'il). In the Moser collection is a sword bearing a cartouche with the inscription *bandeh-yi shah-i vilayat tahmasp*, and the date AH 112[0] (AD 1708).[161] The ascription and the date do not of course coincide, since 1120 was in the reign of Shah Sultan Husain. In the British Museum is a 19th-century helmet and vambrace purporting to have belonged to Shah 'Abbas,[162] and numerous objects in different collections bear the inscription *bandeh-yi shah-i vilayat 'abbas*.[163] Two steel mirrors,[164] and a cuirass, vambrace and helmet,[165] bear the title of Shah Sulaiman, but must also be late 19th-century creations. The vambrace and helmet are decorated with typically 19th-century

155. Binning (1857) p.129.
156. Mayer (1962) pp.26–29.
157. Allan (1982a) no.26; Allan (1994).
158. Mayer (1962) p.16.
159. Unpublished.
160. No. MW 614: Zeller and Rohrer (1955) pp.218–19 no.237.
161. No. MW 13: Zeller and Rohrer (1955) pp.112–13 no.69; Balsiger and Kläy (1992) p.94. Both works suggest the reading of the date as 1112, but it is very rare to find any numeral omitted in an Arabic or Persian date except the dot representing 0.

162. Barrett (1949) pls 38(b)–39.
163. For example, a bowl in the Iran Bastan Museum, Tehran, no.20290, diameter 16.7 cm, height 6.1 cm; a *qalian* base in the Iran Bastan Museum, Tehran, no.21875, height approx. 22.5 cm; a shield curiously dated AH 1122 (AD 1710), *Islamiske våben i dansk privateje* (1982) no.91.
164. V&A acc. no. 407-'76; Sotheby's, 20 October 1992 lot 164.
165. Muzeum Narodowe, Krakow: Żygulski (1979) pls 233–36, (1986) pls 62 and 64, (1989) pl.80.

projecting sun-faces, and the helmet is topped by a horned head. The cuirass has slight breasts and pronounced nipples, surely derived from pictures of Renaissance or Roman armour. The Qajar date is proven by the helmet's nasal, which has figures on it of conclusively Qajar character. Occasionally objects bear ascriptions to more than one reign. Thus a sword bearing the name of its maker, Isma'il ibn Asadallah, and a date, AH 1186 (AD 1772), also bears three cartouches in the same hand reading *bandeh-yi shah-i vilayat*, followed in turn by the names 'Abbas, Sulaiman and Husain.[166]

The inscriptions bearing the words *bandeh-yi shah-i vilayat* ('servant of the king of trusteeship', i.e. servant of the Imam 'Ali), and a name, may be interpreted in different ways. The words form one of a group of grandiose titles assumed by the Safavid rulers, which also included *shah-i din-panah* ('refuge of the religion') and *nusrat-e qur'an* ('supporter of the Koran').[167] Its particular importance as a royal title is shown by its inclusion in the royal seal of Shah 'Abbas I, impressions of which appear on an early 14th-century manuscript in the Khalili collection.[168] The same title appears on the numerous Chinese porcelain pieces dedicated by Shah 'Abbas to the shrine of Shaikh Safi,[169] and on the base of a jade bowl which was also in the same collection.[170] When, therefore, the phrase appears on a particular steel object to which it can be directly related, we need not doubt that it refers to the relevant Safavid ruler. Thus, for example, the *maqta'* made by Kamal al-Din Mahmud in AH 1108 (AD 1696–97) bears the phrase *bandeh-yi shah-i vilayat* followed by the name of Shah Sultan Husain.[171] Given Kamal al-Din Mahmud's importance, and our knowledge of other works by him of almost the same date, there is no doubt that this refers to the shah named.

Problems arise when such a phrase occurs on an object which is clearly much later in date than the ruler mentioned. Recently Melikian-Chirvani has described this formula as 'contrary to all known forms of Iranian usage on metal', and suggested that it is simply the standard Shiite cliché, 'the servant of the king of trusteeship', followed by the patron's name, whoever that patron might be.[172] That interpretation would be more convincing if any of the names attached to this phrase were not the names of Safavid rulers. As it is, if we follow his interpretation, we are faced with a situation where all known patrons of steelwork using this formula bore the names Isma'il, Tahmasp, 'Abbas or Sulaiman, which is surely unlikely. It therefore seems that the phrase, when it appears on many steel objects, is a usage of the Qajar period, based on the Safavid use of the title and designed to suggest that the

166. Kalus (1980) pp.46–49, no.20.
167. Keyvani (1982) p.153.
168. Stanley (1997) p.118.
169. Misugi (1981) vol.3 frontispiece and p.17.
170. Falk (1985) p.114, no.82.
171. Wiet (1935) p.18 no.38, pl.IX; Pope (1938–39) pl.1390F; Mayer (1959) p.55.
172. Melikian-Chirvani (1987).

object in question dates from the reign of the appropriate Safavid ruler. That the date sometimes added does not agree with the ruler's regnal years would not have worried a similarly ignorant prospective purchaser: the date's existence would have been enough to add more visual evidence of the piece's authenticity. This type of approach is not confined to Iran, but can be found elsewhere in the Islamic world. Thus, for example, a late 18th-century Ottoman blade bears an inscription inlaid in gold which claims that it was the gift of the Amir Muntasir billah in the year AH 799 (AD 1396–97)![173]

One is tempted to be cynical and see all such inscriptions as deliberate attempts to delude the uninformed public, but it is possible that this is unfair, at least in the case of Asadallah. There was probably such reverence for his skill and fame that the addition of his name to a sword was not meant to indicate that he made it, but rather to establish the sword as part of a tradition going back through generations of guild members to the great master himself.

CONCLUSIONS

Our research has brought to light a substantial body of information about the steel-working industry of Iran, and how it was structured. It would be wrong, however, to imagine that we have been able to answer all the questions we might have posed. A glance at the list of craftsmen with relevant *nisbas* in Appendix One and a sifting through of Mayer's rolls of metal-workers and armourers immediately raise many more. Why does the 18th century dominate? Is it one of the chances of survival? That seems unlikely, for had the Afghan invasions led to the destruction of most Safavid steelwork, the many objects still surviving dating from the reign of Shah Sultan Husain should also have disappeared. Or was it perhaps because the industry was much more tightly controlled under Shah 'Abbas I and his immediate successors, allowing less space for a craftsman to make and publicise his name? And was life much less controlled at the end of the Safavid period and under the Zand and Qajar rulers, so that the individual craftsman could impose his importance on his customers by signing his products?

Or, to pose another question, why have the works of some makers survived in quantity and others barely at all? Why, for example, are there so many surviving pieces by 'Ali Akbar, a late 18th- and early 19th-century craftsman, whose workplace remains unknown?[174] Then again, why are some smiths known from objects which cover a very short span of time? An example is Lutf'ali, whose six dated works span

173. Haase *et al.* (1993) no.127, pp.190–91.
174. (1) AH 1201 (AD 1786–87); *kard*; private collec-
tion; Haase *et al.* (1993) no.139. (2) AH 1215 (AD 1800–1); *kard*; Khalili collection, MTW 918; Alexan-

but five years between AH 1148 (AD 1735–36) and AH 1153 (AD 1739–40).[175] And finally, what is the significance of the title Ustad, and why do only some of the craftsmen use it? According to Ustad Haj Akbar Bahman, it is the fruit of popular recognition, and comes from achieving something new in one's craft. Many craftsmen, however, seem more concerned to include Haji than any other title. Does this suggest that, to their customers at least, their piety was more important than their qualifications?

An area we have not yet touched upon, but one brought out in the discussions of the different objects, is the practical relationship between steel-working and other crafts. There is, for example, a very obvious link between the plaques used by Safavid steel-working craftsmen to decorate the doors of important buildings and the bookbinding designs of their contemporaries. Although noted elsewhere, it deserves a brief additional comment here. In the Safavid period a whole range of designs travelled between different crafts. This phenomenon was particularly linked to the need for quality calligraphy in so many art forms, and the resulting impact of the arts of the book on other media. Here, however, it is important to understand that it was the steel-workers who made the dies for the bookbinders. In order to make those dies they needed copies of the designs used by the book-binders, which thus provided a direct channel for the transfer of those designs. In another case we see how wood-working influenced the steel-workers' techniques, in the imitating of tenon and mortise joints in the manufacture of shrine doors.

At another level, steel craftsmen typify all the craft industries of pre-industrial Iran. So many of the items illustrated in this book are perfect examples of the Iranian tradition of fine workmanship and ornate decoration that was lavished on even the smallest everyday object. This was noticed by d'Allemagne: 'In Persia every care is lavished on common small objects. Each item that contributes towards the achievement of an everyday act is treated with jealous care: one might say that the artists who made them and engraved them wanted in some way to rehabilitate their

der (1992) pp.142–43, no.83. (3) n.d.; *kard*; Historisches Museum, Bern, Moser collection MW 297; unpublished. (4) n.d.; sword dedicated to Nasir al-Din Shah (1848-96); Wallace Collection, London, acc. no. 1746; also signed Ustadh IsmaĒil; Mayer (1962) p.23. (5) n.d.; dagger; Victoria and Albert Museum acc. no. 814-1893; Mayer (1962) p.23. (6) n.d.; dagger; formerly Schulz collection; Mayer (1962) p.23.

175. (1) Signed Lutf'ali Ghulam; AH 1148 (AD 1735–36); saddle-axe; Poldi-Pezzoli Museum, Milan; Melikian-Chirvani (1979) pls 127–31. (2) Signed Lutf'ali Ghulam; AH 1148 (AD 1735–36); saddle-axe; whereabouts unspecified; Melikian-Chirvani (1979) pls 249–52. (3) Signed Lutf'ali; AH 1150 (AD 1737); body armour; Ashmolean Museum acc.no.EA1997.176; Sotheby's, 15 October 1996 lot 201. (4) Signed Lutf'ali; AH 1151 (AD 1738-39); body armour; Topkapı Saray Museum; Pope (193–39) pl.1408 D and E. (5) Signed Lutf'ali; AH 1153 (AD 1739–40); saddle-axe; Wallace collection; Melikian-Chirvani (1979) pls 139–41. (6) Signed Lutf'ali; AH 1150 (AD 1737–38); saddle-axe; private collection; Christie's, 19 October 1993 lot 217.

humble function by the exquisite care which they have brought to their decoration, to the point of making them true works of art.'[176]

And it is not simply in the decoration that this attitude is to be seen: to the craftsman, the form of an everyday object was just as important as its decoration. Thus the jeweller's hammer with a head in the form of a stylised bird (I.49), or a flint-striker with a most elegant neck and bird's head (G.7), two objects which incidentally betray an aspect of Iranian taste which often passes unnoticed – the liking for purity of form rather than abundance of ornament.

The interplay between steel-working and other crafts is perhaps more obvious if we turn the picture round. It was not so much that steel-workers depended on other crafts, rather that other crafts depended on steel-workers. Calligraphers and painters depended on fine steel tools for some of their most important activities: knives for sharpening their reed pens, and blocks on which to do it; compasses for drawing geometrical designs, and dividers for laying out the pages of text; rulers for drawing lines and margins; scissors for cutting the paper. And it is clear that the quality of the knife and scissor blades would have a very marked effect on the quality of the manuscript concerned, particularly if filigree work was involved. Wood-workers and intaglio-workers required steel tools too, saws, chisels, bradawls and the like, and the quality of the chisel blade which cut the designs of the wooden blocks in the hand of the textile printer would have had a direct effect on the quality of the textiles themselves. Other metal-workers, be they goldsmiths or coppersmiths, used a wide range of steel tools too – goldsmiths needed steel dies or matrices for their fine jewellery. The quality of the results would have been visible to all.

What people wore was also influenced by the tools available. The leather, boot and shoe industries had for centuries been important elements in the Isfahan bazaar. In the 1870s there were guilds of leather-workers, shoe-makers, boot-makers, makers of Georgian shoes, slipper-makers, and makers of shagreen shoes,[177] and all these craftsmen would have needed appropriate steel tools: laths, awls, needles and the like. As with all the craftsmen in the bazaar, the everyday lives of ordinary people were dependent on accurate steel weights and measures. The production of springy tweezers for picking up the smaller weights, the weights themselves, and a variety of sizes of scales, were part of the steel-workers' craft, together with textile measures and the much larger steelyards for weighing large quantities of materials and foodstuffs.

On yet other steel artisans depended success in times of war. The most obvious

176. d'Allemagne (1911) vol.2, p.53.
177. Issawi (1971) p.280, quoting the *Jughrafiya-i Isfahan* (Tehran 1342/1963). According to the author of the latter: 'Formerly the notables of Isfahan, men and women, wore shagreen shoes. Now very few follow the old way ...'

example is the swordsmith. As we have emphasised before, his craft was the peak of the industry, because more lives would be saved or lost as a result of the weapons he made than through any other single cause, excluding such natural calamities as plague. Increasingly important as time went by, though, were the gunsmiths. They had to produce, or have made for them, not only the steel barrels, but other crucial gun parts, like locks, triggers and rear ramrod pipes, together with a further range of objects needed for gun maintenance, such as worms, and multi-purpose instruments which combined hammer-heads with screw-drivers, picks and flint-strikers. And, until the middle of the 19th century, the importance of steel flint-strikers was paramount. Without them Iranians could not light a fire, light a lamp, smoke a pipe, or fire a matchlock or flintlock gun. High quality flint-strikers were therefore of the greatest practical importance in society.

In other words, the steel-working industry was not an optional extra. It undergirded virtually everything that was going on in the bazaar, and through that had a profound effect on society: it was fundamental not only to the luxuries desired by the shah and his court, but to the everyday lives of his subjects.

The trade in steel between the Indian subcontinent and Iran

James Allan

THE EVIDENCE

Trade in Indian iron and steel (type unspecified) goes back into antiquity. The earliest certain reference is in the anonymous *Periplus of the Erythraean Sea*, dating from the 2nd century AD, which mentions 'Indian iron and steel' being shipped from the inland part of Ariake, thought to be on the Arabian Peninsula, to Adouli and other ports on the Red Sea.[1] Two other 2nd-century references exist: one in the customs duties in the Laws of Marcus Aurelius and Commodus, which specifies 'Indian iron' as a dutiable article, and the other in Clement of Alexandria's warning against excessive luxury. 'It is quite unnecessary', he says, 'to use Indian iron when making a knife to cut meat.'[2] In the late pre-Islamic period references to Indian swords and Indian iron suddenly multiply in Arabian poetry. They become even more widespread in early Islamic literature, and the topic becomes of major interest to scientists such as al-Kindi and al-Biruni. There is little doubt, therefore, of a substantial trade in raw Indian iron and steel, and in Indian swords, westwards across the Indian Ocean to Iran and the Arab Islamic lands.

Details of that trade are more difficult to come by. In the 9th century, al-Kindi makes it clear that steel for the manufacture of swords was traded from Sri Lanka to the Yemen, Khurasan, al-Mansura in Sind, and to Fars, but gives no indication of quantities.[3] The 11th- and 12th-century Jewish Geniza documents from old Cairo include two letters from a merchant in Aden to one on the Malabar Coast of southwest India, both containing many mentions of iron. As Bronson points out, they show that Aden was largely dependent on imports of Indian iron, and that some of this metal was sent onwards to the Mediterranean. From the prices quoted in one letter it seems that this iron is unlikely to have been steel, for it had a very low value compared to the copper traded from Aden to India in return.[4] The only possibly Eastern metal object recorded in a contemporary archaeological context in the

1. Bronson (1986) p.18.
2. Bronson (1986) p.18.
3. al-Kindi pp.9–10.
4. Goitein (1980) pp.57–61. However, it is interesting to see that in 1615 copper traded into Iran was valued at 2 $\frac{1}{2}$ times the value of steel (see below).

Mediterranean, to my knowledge, is an iron or steel knife with a handle which may be of south-Asian origin. This was found in the Sirce Limani wreck.[5] Indian swords were almost certainly circulating, however, for they are commented on by both al-Idrisi and Ibn Hodeil, the latter writing in 14th-century Spain,[6] though other information for the 12th to the 15th centuries is extremely scarce. Indeed, the only other reference seems to be the assertion of the 17th-century traveller Struys that the grilles of the mausoleum of Oljeitu, built in the early 14th century, were of Indian steel (see below).

Information for the 16th century is still difficult to come by, though there are two important references to the trade between India and Iran in Duarte Barbosa. Of Goa he writes: 'The Ormus merchants take hence in their ships cargoes of rice (great store) sugar, iron, pepper, ginger and other spices of divers kinds, and drugs, which they carry thither: and in all their dealings they are by the order of the King our Lord [i.e. the King of Portugal] treated with greater mildness than by the Moorish kings [i.e. the Deccani Muslim rulers].' Of Bhatkal he writes: 'The ships come hither every year from Ormus to get cargoes of white rice (great store) and powdered sugar (of which this land has great plenty) ... They also take many cargoes of iron, and these three kinds of goods are the principal cargoes they get here.'[7] The trade is confirmed by Tome Pires (writing between 1512 and 1515), though not the origin of the traders.[8]

For the 17th century the information is plentiful. First of all there is the evidence of travellers to Iran who talked to the craftsmen and saw the Indian steel being worked. Thus Chardin wrote of Isfahan: 'Their scimitars are very well Damask'd and exceed all that the Europeans can do because I suppose our steel is not so full of veins as the Indian steel which they use most commonly. They have in their own country plenty of steel but they do not prize it so much as that and our steel still less than theirs, yet their steel is eager and very brittle.'[9] Elsewhere he comments on the Iranians' technique of mixing their own steel with 'acier des Indes'.[10] Tavernier is more specific about the origin of the steel: 'Their steel is brought from *Golconda*, and is the only sort of steel which can be damasqu'd ... This steel is sold in pieces as large as our one-sou loaves and in order to know that it is good and that there is no fraud involved, they cut it in two, each fragment being enough to make one sabre ... One of these loaves of steel, which would not have cost more than the value of five or six sous in Golconda, is worth four or five abbasis in Persia, and the further away one

5. Schwarzer (1988) p.26; Schwarzer and Deal (1986).
6. Bronson (1986) p.20.
7. Dames (1918) vol.1 pp.178 and 187–88.
8. Cortesao (1944) vol.1 pp.17, 21, 62.
9. Chardin (1988) pp.270–71.
10. Bronson (1986) pp.23–24.

gets the more expensive it becomes.'[11] The fact that Tavernier had actually visited Golconda makes his comments all the more telling.

Just how far Indian steel could travel within Iran is suggested by Struys's description of the 14th-century mausoleum of Oljeitu at Sultaniyya. He writes: 'In entering this Sepulchre one must pass thro three very high Gates all made of *Indian* Steel, very neatly polished, and as smooth as Glass, this being the same Metal of which the Damaskin, or Ardebil Scymitars are made, and is preferred before any other Steel that is used.'[12] Hence, it would seem that Indian steel not only reached Sultaniyya in the 14th century to be used for the grilles of the mausoleum, but it was also imported in the 17th century as far as the even more remote city of Ardabil for the manufacture of swords. Incidentally, Indian merchants were to be found there too.[13]

The import of steel continued, for in the early years of the 19th century Scott Waring recorded: 'The swords which they make in Sheeraz, are manufactured from steel which they purchase in cakes at Hydrabad, and which I learn, is brought out of the Rajah of Berar's country. One of these cakes is to be purchased for two rupees; at Bushire for about five. They each make one sword, and it rests entirely on chance how it may turn out. If they are full of Jouhur (*damask*) they are very valuable; but it is said that much depends on the skill of the artist.'[14] This is also confirmed by Pottinger[15] and Fraser,[16] though the latter suggests that metals came from India by land as well as sea. In the mid-19th century, the use of Indian steel is noted by Binning. In his day, he affirms, the best Isfahani blades were all made of Indian steel imported in the form of small round cakes.[17]

However, the circulation of Indian iron and steel within Iran seems to have been more restricted in the 19th century than it had been in earlier times. Polak defines the areas to which it was traded: 'The country's rich *iron mines* are also neglected ... Only insignificant quantities are supplied, by those of Mazandaran and Khurasan. All the remaining iron comes to Persia from the Urals, by way of the Volga, and the Caspian Sea; only the southern and southeastern parts of the country get part of their supplies from India.'[18]

In the 17th century, both the East India Company and the Dutch East India Company were involved in trading iron from the Kingdom of Golconda to southeast Asia, and sometimes to western India, from where it would have been traded

11. Bronson (1986) pp.22–23, who supplies details of Tavernier's text left out of the English editions.
12. Struys (1684) p.302.
13. Ferrier (1986) p.469.
14. Scott Waring (1804) p.49, who is presumably the source of the information provided by the editorial note in Chardin (1811) vol.8 p.425.
15. Pottinger (1816) pp.235–36.
16. Fraser (1826) p.370.
17. Binning (1857) pp.127–29.
18. Trans. in Issawi (1971) pp.272–73.

still further west.[19] The evidence for the export of steel from India is found in the Daghregisters of the Dutch East India Company. The Company was involved in the export of iron nails, iron bars, and 'hammer-steel' from southern India to Indonesia, and the weights of metal exported were substantial. Bronson has established that in 1682, Masulipatam and Pulicat, the chief Dutch factory on the southern Coromandel coast, shipped a total of 144.34 English tons of iron and steel to Indonesia, of which 49.43 tons were Masulipatam steel. The previous year the two ports had shipped 158.51 tons, including 15.01 tons of Masulipatam steel, to the same destination. Bronson concludes that the annual production of iron in India cannot have been far below that of Europe.[20]

THE QUALITY AND COST OF INDIAN STEEL

The details of the steel exported from India to Iran are more difficult to come by, but some information can be extracted from the same company records.[21] Unfortunately the published records of the East India Company cover only the years 1612 to 1617, while those of the Dutch East India Company which relate to Iran and are easily accessible only cover the years 1611 to 1638. However, they do bring to light some important details of the trade.

Firstly, steel came in a variety of forms and size of ingot. Thus a Dutch East India Company letter of 1624 requests '*stael van Masulipatan groote stucken*', an invoice of 1628 talks of '*1580 stx. lensen stael*', while a bill of lading of 1629 includes '*798 stucx ront stael*'. Sometimes they were packed in crates or barrels (*caskens*); at other times packets (*packens*) are mentioned. Sometimes they are listed by weight (in pounds), sometimes by the number of pieces.[22] In English ships steel was either packed in bales of 20 pieces, technically known as corges, but also referred to loosely as packs, or in barrels.[23] In 1617 a letter from Pettus, an East India Company representative in Isfahan, to the Company in London, talks of 'Steele, 100 cordge of the biggest sort, containing about 6 lbs. English the piece.'[24] Hence a bale weighed just over 1 cwt.[25]

19. Bronson (1986) p.22, based on Schorer and Methwold.
20. Thelma Lowe, in a personal communication, writes that having worked in the Dutch East India Company archives in the Hague, she has been able to document that as much as 28,000 pounds of *wootz* ingots were exported from Masulipatam to south-east Asian and Iranian markets in a single year. In the eleven years from 1670 to 1681, almost 150,000 pounds of steel alone were shipped from Masulipatam on the Coromandel coast to the Dutch entrepôt at Batavia. These figures are in fact much lower than Bronson's.
21. Dunlop (1930); Foster (1896). Further information will no doubt be found in the numerous, unindexed volumes, in Dutch, of Chijs (1887), but this was reckoned too inaccessible to yield up its treasures in the time available for the writing of this book.
22. Dunlop (1930) p.35 no.29, p.259 no.144, p.313 no.174, pp.509–19 no.256 etc.
23. Foster (1896) vol.1 p.336; vol.5 pp.194, 289; vol.6 p.75.
24. Foster (1896) vol.5 p.289.

However, the report of another Company representative in Iran, Barker, to London the following year talks of larger ingots of steel as weighing about 7 lbs,[26] so there must have been considerable variation.

In a letter of August 1617, from Nicholls in Achim to Berkeley in Bantam, there is a complaint that steel carried in barrels had been broken in transit, followed by a request that in future such steel should be packed in skins. This suggests that the pieces concerned must have been long and thin rather than round. The English words commonly used, 'pieces' and 'ends', do not convey a precise shape, but the occasional use of 'faggots' certainly suggests bars.[27] Certain documents, however, are more specific. Three East India Company agents at Surat, Kerridge, Rastell and James, wrote to the factors at Ahmadabad in 1619 asking them to provide steel for Iran in two forms, 'long gades called henselle' and 'round peeces called butt'.[28] Goods to be provided for Sumatra from Surat the same year included steel of various sorts: 'lickmapore' (Lakhimpur?), small, middle, and grand, 'henslaus' and 'butt'.[29] Another document, this time from Kerridge and Rastell at Surat to the factors at Masulipatam, in 1619, says: 'The iron you mention to be called looha boot is not heare knowne. A sorte of steele heare is called by that name, made up in another forme, wayinge 4 3/4 seare of 18 p[iece] the seare, and is worth at presente 24 m[ahmudis the] corge or skore … Heare is also another sorte of [steel] that is called hensta, which is drawne longer, in gads like the skoole ferrel, and weyeth neare aboute 2 1/2 seare the peece, worth some 11 m[ahmudis the] corge.'[30] According to Foster, 'looha boot' is an amalgamation of the Hindi *loha* ('iron') and *bota* ('lump' or 'piece'). The derivation of 'hensta' or 'henselle' is unknown. A 'seare' is a fortieth part of a maund, and at Surat in the early 17th century a small maund was equivalent to 27 lbs, and a large one to 32 1/2 lbs.[31] Hence the weight of these ingots was just over 3 lbs for the looha boot, and about 1 3/4 lbs for the hensta, if the small maund was meant, or about 3 3/4 lbs for the looha boot, and about 2 lbs for the hensta, if the large maund was meant.

Interestingly, Chardin adds details of the raw steel shapes he saw in Iran. Having commented that the Iranians mix their own steel with 'acier des Indes', he then remarks: 'They melt it down in a round loaf like the hollow of one's hand, and in small square rods.'[32] Tavernier, Scott Waring and Binning all talk of loaves or cakes. Barker also mentions steel 'in a flatt ovall form', but he seems to suggest that these

25. This is just over half the weight of a silk bale; see Ogilby (1673) who quotes the latter as 216 pounds.
26. Ferrier (1976) p.203.
27. Sainsbury (1913) p.88.
28. Foster (1906) vol.1 p.76.
29. Foster (1906) vol.1 p.94.
30. Foster (1906) vol.1 p.88.
31. Foster (1896) vol.1 pp.337–38.
32. Bronson (1986) p.24.

only came by the overland route from India.³³ This is certainly not true, for in 1622 Bell, Darrell, Purifie and Benthall wrote from Kuhastak, a small port on the Iranian coast about 40 miles south-east of Ormus, to the Surat factory: 'the round sorte of steele caled butt is indeed the sorte heere best requested.'³⁴

The Achim–Bantam letter of 1617 mentioned above specifies '6,000 of small steel at 4 rials of eight per hundred; the greater sort will be worth 4 tayle per hundred.' One of the East India Company's records of two years earlier states that there were 14 rials in a taylle.³⁵ Assuming their relative value was the same in 1617, and that the pricing of the large steel pieces was the same per unit of weight as that of the small steel pieces, the larger pieces of steel were 14 times the weight of the smaller pieces. Given that the larger weighed 6–7 lbs, the smaller must have weighed somewhere in the region of ½ lb each. However, Barker's report of 1618 suggests that the smaller gads weighed about 2 lbs, so again there must have been wide variations in the size of the pieces traded. Other steel pieces referred to by weight in the documents are gads weighing a mann; a mann seems to have been equivalent to anything between 10 and 15 lbs.³⁶

The second general point to emerge from the documents is that there were problems with the quality of steel traded across the Indian Ocean to Iran. As noted above, steel was sometimes broken in transit. This presumably meant that individual pieces were not large enough for the manufacture of a single item, such as a sword blade, and the value of the steel was correspondingly reduced. Steel could also be of poor quality in itself. Thus, in a letter to the Dutch East India Company's Governor-General in Batavia in 1632, Antonio del Court in Isfahan comments that the price for some of the steel he had imported would not be more than half an ory per piece because it was of bad quality:³⁷ it had been damaged *en route* by getting wet.³⁸ The outside might have started rusting but the inside would have remained undamaged, so one wonders why this made such a difference to the price. One can only conclude that the merchants who transported steel from Bandar 'Abbas to the cities of central Iran purchased it on the basis of the quality of its appearance, for fear that, if its looks were impaired, those to whom they wished to sell it on would refuse to purchase it.

Clearly steel was not always easily saleable. Thus, in 1633 Nicolaes Jacobsz., the Dutch East India Company's Overseer in Isfahan, complained to Amsterdam that nobody wanted to offer a price for the tin lying at Bandar 'Abbas or the steel lying in Isfahan. Both had been sent in the company's ship, the *Bueren*. A separate report

33. Ferrier (1976) p.204.
34. Foster (1906) vol.2 p.23.
35. Foster (1896) vol.3 p.109 no.278.
36. Foster (1896) vol.5 p.194. Contemporary reckonings on the weight of a mann are given in Foster (1896) vol.3 pp.326–27.
37. An ory was a tenth of a toman.
38. Dunlop (1930) p.391 no.212.

states that there were 9160 pieces of steel involved, and that their very poor quality probably accounted for the lack of a purchaser.[39] On another occasion the Company was forced to sell steel at a loss. One particular consignment of 8544 ½ pounds of 'rondt custstael' worth 6712 florins and 12 shillings in 1634, was unsold in 1635, and finally sold in 1636 for 3725 florins, just over half the original price.[40] This was probably due to over-supply.[41]

Some orders at least came direct from the royal court. For example, in 1626 Shah 'Abbas I's factor, Mulaim Beg, ordered 3000 pieces of Indian steel at one ory per piece, amounting to 300 tomans, and two years later an invoice from the Dutch East India Company to Mulaim Beg records 1580 pieces.[42]

Prices were very variable. The Shah's order of 1626 suggests the price of good-quality steel, but the 1628 order cost Mulaim Beg only a little over 12 tomans. Why it was so cheap is unclear. (In 1632 del Court wrote that poor-quality steel would fetch up to half an ory per piece.)[43] An important passage in an East India Company letter gives the relative values of commodities for sale in Iran in 1615:

'Tin is worth per mahan of 1200 drames 80 shayes.
'Lead worth per mahan 8 shayes.
'Steel worth per mahan 20 shayes.
'Iron worth per mahan 24 shayes.
'Copper worth per mahan 50 shayes.
'Pepper worth per mahan 40 shayes.
'Cinnamon worth per mahan 36 shayes.
'Cloves worth per mahan 55 abasses, being 16 dollars rials.
'Sugar worth per mahan 30 shayes.'[44]

How it was that iron was worth more than steel is unexplained. Prices in Iran were also affected by customs dues payable by the merchants *en route*. According to Barker in 1618, 'the gadd [of steel] that weigheth 7 pound payeth noe more customes at Surratt than that that weigheth 2 pound or lesse.'[45] Hence steel was treated in the same way as piece-goods. That was also true at Basra in 1640, where steel, though sold by the 'corge', was rated among the 'poz'd goods' for customs purposes,[46] and there may well have been a long history of this practice.[47] According to

39. Dunlop (1930) p.416 no.222, p.475 no.244.
40. Dunlop (1930) pp.509–10 no.256, p.529 no.261, p.567 no.279.
41. *Cf.* Dunlop (1930) p.416 no.222, p.475 no.244.
42. Dunlop (1930) pp.184–85 no.93, p.259 no.144.
43. Dunlop (1930) p.391 no.212.
44. Foster (1896) vol.3 p.178.
45. Ferrier (1976) p.203.
46. Foster (1906) vol.6 p.253.
47. At a seminar on 'Trade and Transformation in the Indian Ocean' held at London University in November 1996, Professor Rex Smith pointed out

a letter written by Cogan, Greenhill and Brown at Fort St George to the Company in 1642, however, this was not true of Masulipatam. There, all goods, including cloth and steel, paid both freight and customs according to weight.[48]

There is also evidence of a much lower profit margin in steel than in many other goods, though here again the evidence is sometimes conflicting. Re-ordering from Isfahan in 1617, Pettus asks London for Indian commodities, commenting: 'Cordge 100 of your bigger sort of steel, containing about 6 lbs English the piece, may here yield about cent per cent profit; but rather omit this than any the former commodities, in that you see by far it yields least benefit.'[49] In other words, he considered the 100 per cent profit to be a low one compared to the profits to be made on other items specified in the same document, such as English cloth, tin, quicksilver and vermilion, and Indies sugar, ginger, rice and soap. This conflicts with information provided by Barker the following year, however, who claimed that large steel ingots of 7 lbs would yield a profit of 400–500 per cent, compared to a 100 per cent profit for the smaller ones.[50] Equivalent information for other decades of the 17th century has unfortunately not been published.

Two details of the system of transport within Iran also come to light through these documents. A Dutch East India Company document of 1628 records that goods (including steel) brought to Bandar 'Abbas by frigate were then the responsibility of Iranian merchants for transport to Lar, Shiraz, Isfahan and beyond.[51] Even though goods could be trans-shipped from Bandar 'Abbas to Isfahan in a month, another document, of 1629, discloses that steel might take two or three years to transfer, presumably because of oversupply in the capital.[52]

MERCHANTS AND THE CONTROL OF TRADE

Control of the sea trade in steel at different periods varied. In the 16th century Iranian merchants were powerful in international trade,[53] as the quotes from Duarte Barbosa make clear. That there were still Iranian merchants trading in the early 17th century is evident from East India Company documents,[54] though the monopolies acquired by the European companies under Shah 'Abbas I suggest that the opportunities for native merchants were greatly diminished at this period, and that the bulk of the trade was transferred to European hands. In 1629, however, the state

that in Ayyubid and Rasulid Aden, iron was one of the only commodities, apart from cloth, to be taxed by the piece rather than by weight.
48. Foster (1906) vol.7 p.55.
49. Foster (1896) vol.5 p.234.
50. Ferrier (1976) pp.203–204.
51. Dunlop (1930) p.234 no.125.
52. Dunlop (1930) p.207 no.166.
53. Keyvani (1982) pp.216–17.
54. Foster (1896) vol.1 pp.299 and 327, both of which date from 1613.

monopoly on silk was abolished by Shah Safi' (1629–42). This led to some growth in the numbers of individual foreign merchants in the Isfahan bazaars, but also to an increase in the numbers of Iranian merchants. For example, Mirza Muhammad Tahir Nasrabadi names a number of enterprising Iranian merchants involved in the India trade at this period, including Mirza Amin, Mirza Ma'sum, and Haji Isma'il Khan,[55] while Fryer records of Mechlapatan: 'The Persians have planted themselves here through the Intercourse of Traffick as well as Arms, being all of them at the first coming, low in Condition; but inspired by the Court-Favour, and making one of their own Nation always their Executors, they arrive to Preferment. Nor are any of these so exempted when they grow too rich, to be deplumated by the same hand.'[56] The percentage of the trade actually controlled by the Iranians, however, probably remained comparatively small.

As regards foreign merchants in Iran, large numbers of Indians were certainly to be found there, particularly at Bandar 'Abbas, Shiraz and Isfahan. Among these the Multanis formed an extremely important and prosperous community, deriving most of their wealth from trading Indian textiles. They were particularly well established in the overland trade from India to Iran and Central Asia.[57] Whether they traded in steel is unknown. The other large group, the Banyans, were money-changers and brokers.[58] In the 17th century, however, the international sea trade was largely controlled by the European companies, and the regular mention of steel in the East India Company and Dutch East India Company records suggests that it was they who dominated the trade in steel between the Indian subcontinent and Iran throughout the century.

For the 18th century there is all too little published information, though the dominance of the Europeans almost certainly continued. For the period of Fath 'Ali Shah and the early 19th century, Henry Voysey's evidence may at first suggest a rather different situation. He found steel being made at '*Kona samundram*' in southern India, and described the trade: 'Export to Persia must be profitable as it is sufficient to bring dealers from that country, and to defray the cost and risk of travelling. We found at the village, in 1820, Haji Hosyn, from Ispahan, engaged in speculation; and it must have answered his purpose, as he was here again in 1823, having returned in the interval to Persia and disposed of the venture. He informed us that the place and the process are both familiar to the Persians, and that they have attempted to imitate the latter without success. Besides residing in the village, whilst making his purchases, he bore a personal part in the operation, weighing the proportions of the

55. Keyvani (1982) p.233.
56. Fryer (1698) vol.1 p.86.
57. Dale (1994) pp.55–64, 66–75.

58. Keyvani (1982) p.229.

iron, and testing the toughness of the steel himself.'[59] How far this scene depicted a more general trend, however, there is no way of telling, though it is interesting to note that in 1857 Binning observed that there was not a single Indian merchant left in Isfahan.[60]

Long-distance trade is inevitably subject to the vagaries of wars or trade embargoes from time to time. This was as true of the sea-borne Indian Ocean trade as of any other. Thus, Barker comments that a Portuguese prohibition on the import of steel into the Gulf in the second decade of the 17th century had made it expensive in Iran, though it had been met by an increase in overland trade,[61] probably through Multan.[62] A prohibition on the export of iron and steel from Iran to other countries seems to have been equally ineffective: Chardin noted that 'it is Exported notwithstanding'.[63] However, President Mathwold and his colleagues at Surat wrote to the Company in April 1636, saying that steel was so much dearer, owing to the Deccan wars and the difficulty of transportation, that its price was nearly the same as in England.[64] On another occasion, Mathwold recommended subterfuge. In a letter written earlier the same year to the captain of a particular ship due to pass through the straights of Hurmuz, he says that he had also addressed a letter to the 'Captaine Major of the Portugalls, who hath the charge of those straights', assuring him that the pinnace had no goods on board 'apperteyneing to any Moores or heathens, whereby the revenewes of the port of Muscatt should bee anywayes defrauded'. He goes on to tell the captain that, if necessary, he may be shown the invoice, 'the steele alone omitted, for that is a probitted comodety, as wee have since understood.'[65]

In the 19th century there were other problems. For example, in the 1860s the Government of India forbade the production of *wootz* in the Western Ghats, as the industry was causing deforestation on a large scale: it was from the hill tribes of the Western Ghats that Iran derived some of its best steel.[66] Hence, the regularity of the supply of Indian steel was never a foregone conclusion.

59. Voysey (1832) p.247.
60. Binning (1857) vol.2 p.140.
61. Ferrier (1976) p.204.
62. Chardin (1811) vol.7 p.360, vol.8 p.418, indicates that both Shiraz and Isfahan had a 'Caravanserai of the Multanis' and claims that all commerce of India to Iran came via Multan before European navigation of the Gulf.
63. Chardin (1988) p.282.
64. Foster (1906) vol.5 p.209.
65. Foster (1906) vol.5 p.185.
66. Elgood (1994) p.2.

Catalogue

James Allan

Arms and armour

ARMOUR

The pre-Islamic period

Although there have been outline surveys of the history of Iranian arms and armour,[1] a full study has yet to be written, and is certainly beyond the scope of this book. What follows will bring out the general trends: others will have to fill in the details.

The earliest armour fragments yet found in Iran come from the western part of the country and date from the late 2nd and early 1st millennium BC. From Tchoga Zanbil come bronze scales from a suit of scale armour,[2] from Marlik and elsewhere helmets of conical shape or of hemispherical form with a narrow brim, from Luristan an abdomen plaque of sheet bronze, from west and north-west of the country sheet-bronze discs probably used as body armour,[3] and from Hasanlu triangular pieces of bronze shoulder armour and a horse's chamfron.[4] These various finds suggest that in the Zagros area a soldier's armour probably consisted of heavy cloth with sheet-metal pieces sewn on to protect the more vital parts of the body, and it is possible that some of the objects described by authorities as shield bosses were in fact breastplates designed to be attached in the same way, or perhaps to be worn on straps like Assyrian ones.

The main evidence for the form of armour used under the Achaemenids comes from the Greek authors Xenophon and Herodotus. In his *Cyropaedia* Xenophon describes the guard of Cyrus the Great as having bronze breastplates and helmets, while their horses wore bronze chamfrons and poitrels together with shoulder pieces (*parameridia*) which also protected the rider's thighs.[5] He gives a similar description of the cavalry guard of Cyrus the Younger in 401 BC,[6] but Herodotus, in his description of the army of Xerxes which invaded Greece in 480 BC, suggests that the Medes

1. See, for instance, Gorelik (1979).
2. Ghirshman (1966) pl.55.4.
3. Moorey (1971) pp.249–57.
4. Dyson (1960) p.10; Littauer and Crouwel (1984).
5. Xenophon, *Cyropaedia* VI.4.1; VII.1.2.
6. Xenophon, *Anabasis* I.8.6.

and Persians were more lightly armoured, with iron scale armour for infantry and horsemen, iron helmets for the horsemen only and no horse armour.[7] The *parameridia* mentioned by Xenophon has been identified by Bernard with the armour for a horseman's leg shown on a Lycian sarcophogus, and the use of scale armour has been confirmed by finds at Persepolis which included numerous iron scales, some large enough to have been used for horse armour, and a few bronze and gold-plated iron scales.[8]

The most instructive evidence for the development of armour under the Parthians comes from Dura-Europos. There the excavators found depictions or remains of the following types of armour: laminated armour (vambraces and greaves of a graffito horseman); splint armour (body armour of graffito horseman); scale armour (numerous scales found on site, three housings found in Tower 19, chest armour of graffito horseman and his horse's trapper); mail (corselet found on site).[9] The depiction of the overthrow of Ardavan V by Ardashir near Firuzabad (*circa* AD 225) confirms that a wide variety of armour was in use at the time.[10] The Parthians are shown wearing laminated and scale armour, while the Sasanians wear mail body armour and vambraces, laminated greaves, and in one case a breastplate. The horses do not appear to have any metal protection but a description of an early 3rd-century cataphract given by Heliodorus confirms that the horses were often covered with an armoured housing together with chamfron and greaves.[11]

It is evident therefore that mail must have been introduced (from Rome) prior to AD 225, and it became more and more popular thereafter amongst the Sasanian cavalry. A cameo of Shapur I capturing Valerian shows that varieties of armour were still common in the later 3rd century, since Shapur here wears only a small breastplate, a short scale skirt and laminated thigh armour, but Ammianus Marcellinus's description of the Persian cavalry encountered by Julian's army in AD 363 suggests that mail was by then becoming more general.[12] It is certainly this form of armour which is depicted in such detail on the relief of Khusrau II at Taq-i Bustan: Khusrau wears a coat of mail and a large veil-like mail aventail, which hangs from the round helmet to the upper part of the coat of mail leaving only the eyes visible. The horse, on the other hand, has its head, neck and chest protected by lamellar armour, and its rear quarters quite unprotected. The great increase in the weight of armour carried by the Parthian and Sasanian heavy cavalry led to the introduction of a special

7. Herodotus VII.61–88.
8. Schmidt (1957) p.100 pl.77.13. Grancsay (1963) figs 13–14.
9. Baur and Rostovtzeff (1931–36), 2nd Season p.73, 3rd Season pp.78–84, 4th Season pp.216–20 and 6th Season pp.439–51.

10. Bivar (1972) figs 6,7, 10; H.R. Robinson (1967) fig.9.
11. Heliodorus, *Aethiopica* IX.15.
12. Ammianus Marcellinus, *Persian Expedition* XXV.1.

breed of horse, but at the same time there were modifications to give greater mobility by reducing the armour where possible: hence the substitution of poitrel, crinet and chamfron at Taq-i Bustan for the complete horse barding. Alternatively the metal bardings were replaced by housings of leather or felt as depicted on the Bahram II relief at Naqshi-i Rustam. The continuing use in later Sasanian times of different varieties of armour is illustrated by the discovery of a number of 5th- to 8th-century gilt bronze cuirass lamellae at Qasr-i Abu Nasr.[13] The five Sasanian helmets published by Grancsay suggest that the most common form was a rounded cone shape with iron segments and browband, and other bands and rivets of bronze. They probably share a common Near Eastern ancestor with the *spagenhelms* of the barbarian invasions of Europe.

The nature of the armour used in Iran in early Islamic times is by no means clear. According to Schwarzlose the Arabs at the time of the conquests wore a rather simple form of armour, either of leather or mail, and a full-length coat of mail evidently gave way to a shorter style early in the Islamic period.[14] Two coats of mail were occasionally used for extra protection. Helmets were either of metal plates or mail. Mail was riveted. Early Arab authors mention both Iranian armour, presumably that current in the late Sasanian period, and also armour from Soghd. The latter can be reconstructed from the Panjikent wall-paintings and a silver dish in the Hermitage. According to the paintings the Soghdian soldier dressed in a long armour coat, sometimes totally of mail, but more usually lamellar, with mail armour on the upper arm and a mail aventail. He also wore mail leggings and plate vambraces, and the close-fitting helmet was topped by a long spike.[15] The two soldiers on the Hermitage dish, on the other hand, have mail vambraces, shorter lamellar coats, laminated leg- and foot-armour, and plate hand-guards.[16] They also have round shields. A roughly contemporary shield fragment from Mug shows a horseman in a long coat of what must be lamellar armour with tubular plate vambraces.[17] Soghdian horses do not appear to have worn armoured bardings; nor did the Arabs during the conquests, when mobility was at a premium.

Body armour for men and horses

Against this background the meagre information on armour provided by texts and *objets d'art* of the early Islamic period becomes considerably more meaningful. For instance, it becomes quite plausible to interpret the costumes worn by horsemen on Iraqi 9th- to 10th-century lustre pottery as coats of mail or lamellar armour and

13. Grancsay (1963) figs 13–14.
14. Schwarzlose (1886) pp.322–56.
15. Belenitski and Piotrovski (1959) pls 7, 8, 16; Yakubovski *et al.* (1954) pl.25.
16. Orbeli and Trevor (1935) pl.21.
17. Yakubovski *et al.* (1954) pl.5.

pointed helmets.[18] In Iran there is one reasonably good surviving depiction of armour, on the late 12th-century *minai* dish in the Freer Gallery of Art,[19] where the picture of the battle scene includes four sets of armour lying on the ground, evidently stripped from fallen warriors as loot. All are in one piece, with a short skirt and long sleeves, and the drawing suggests that two are of mail, the third lamellar, and the fourth probably quilted. The helmets depicted on this dish are fairly flat with a slight central point, similar to those on a *minai* and lustre tile of the same period.[20]

A longer form of armour coat was also used by horsemen and those riding elephants, one which hampered movement on the ground.[21] Horse armour[22] and elephant armour[23] were also used. Horse armour in the early period appears to have been of mail, though by the 12th century it had probably been joined by lamellar armour. Another type of horse-armour consisted of mail lined with silk on the inside and covered with silk waste on the outside. The latter was glued on and concealed from sight by brocaded silk.[24]

Following the Mongol invasion and the influx of large numbers of Mongol warriors the fashion in armour followed Mongol taste. Mongol armour, according to the mid 13th-century Papal ambassador to the court of Kuyuk Khan, Carpini, consisted of a steel helmet, leather neck- and throat-guards, and leather or, more rarely, iron armour. The latter consisted of large numbers of strips measuring approximately 15 by 7.5 centimetres (6 by 3 inches) held by leather thongs and arranged one above the other. The text is worth quoting in full:

'They have also armed horses with their shoulders and breasts defenced, they have helmets and brigandines. Some of them have iackes [defensive coats], and caparisons for their horses made of leather artificially doubled or trebled upon their bodies. The upper part of the helmet is of iron or steel, but that part which compasseth about the necke and throate is of leather. Howbeit some of them have all their aforsaid furniture of iron framed in the following manner. They beat out many thin plates a finger broad, and a handful long, and making in every one of them eight little holes, they put thereunto 3 straight and strong leather thongs. So they join the plates one to another, as it were, ascending by degrees.

18. Pope (1938–39) pls 577, 579.
19. Atıl (1973) no.50.
20. Pope (1938–39) pl.706.
21. al-Juzjani (1864) p.55.
22. Melikian-Chirvani (1981) p.314. A discussion of the different pieces of armour used at this period, based on textual evidence, is beyond my competence, but well within the competence of others. See, for example, Melikian-Chirvani (1981 and 1983).
23. Bosworth (1963) pp.116-19; al-Juzjani (1864) p.55.
24. Melikian-Chirvani (1983); Melikian-Chirvani (1988).

Then they tie the plates onto the said thongs, with other small and slender thongs, drawn through the holes aforsaid, and in the upper part, on each side thereof they fasten one small doubled thong unto another, that the plates may be firmly knit together. These they make, as well for their horses caparisons, as for the armour of their men; and they skowre them so bright that a man may behold his face in them.'[25]

Such lamellar armour is common in miniatures of the 14th century, notably in the surviving illustrations to Rashid al-Din's *Jami' al-Tawarikh*,[26] and was evidently the standard form in Iran under the Il-Khans. Lamellar coats were sometimes fastened all the way up the front and sometimes only up to the waist, and the skirt had two slits at the back to make a flap for comfortable riding. During the rest of the 14th century the Mongol fashion was gradually modified and other forms of armour became more popular. The now dispersed Demotte *Shah-nameh*, for instance, contains miniatures depicting various soldiers or heroes wearing combinations of the following: plate helmets, lamellar coats and lamellar cuirasses. Plate vambraces also appear in manuscript illustrations in the second half of the 14th century. Fashion in the provinces may have varied somewhat from the metropolitan model – for instance, Shiraz manuscripts of the Inju period indicate the use of short mail and lamellar coats.

No horse armour appears in any of the published miniatures of the Il-Khanid period, although both Carpini and the Armenian historian Haithon claimed that Mongol horses wore armour. If it was not common during the early 14th century it certainly returned to popularity in the later part of that century, being depicted in Tabriz *Shah-nameh* fragments of the 1370s and in Shiraz manuscripts from the 1390s. Lamellar barding with a plate chamfron was apparently the norm. In early 15th-century Shiraz manuscripts laminated, studded and mail bardings are also shown, and the former appear in the Sultan Juki *Shah-nameh*, illustrated in Herat in about 1440, now in the Royal Asiatic Society. The elephants shown in the latter are not armoured. A superb barding with golden or brass studs is shown in a 1441 *Shah-nameh*, probably from Shiraz.[27]

For the next century or so our knowledge of Iranian armour continues to be largely dependent on miniature paintings. This raises problems since the illustrations may have followed earlier styles rather than contemporary fashions. The following features seem reasonably certain, however. By the end of the 14th century hand-guards had become part of the arm defence, attached to the vambrace, and by

25. Beazeley (1903) p.124.
26. Talbot Rice (1976).
27. Soudavar (1992) p.74 no.27 c.

the early 15th century armour for the knee joint had become more complex, with plate discs for the knees set in mail surrounds, as in illustrations for the *Shah-nameh* of Ibrahim Sultan in the Bodleian Library.[28] Mail aventails with plate ear-pieces attached to the plate helmets were also standard equipment by now, and surcoats commonly hid the body armour. Long mail coats are occasionally depicted. From Herat manuscripts of the early 15th century one might summarise standard Timurid armour as follows: plate helmet, mail aventail, plate ear-pieces, plate vambraces with hand-guards, short lamellar coat, plate knee-plates and greaves with mail joints, and plate shoes. Shields were either of cane or steel – the central boss of a shield with the name and titles of Ulugh Beg is in the Royal Armouries.[29] The only description of Timurid armour appears to be that of Clavijo, quoted in full below, which mentions 'plate armour, which is of the sort stitched on a backing of red canvas', and notes 'they wear a long shirt, made of a material other than that is plate-armoured, and this comes down so as to appear below, as might be with us a jerkin.'[30]

Laminated armour, unrecorded since pre-Islamic times except for horse bardings, also makes its reappearance in the early 15th century. It is depicted in the Sultan Juki *Shah-nameh*, where men are portrayed with metal plates encircling their bodies from armpits to waist, with mail above and below, the plates sometimes forming a coat, at other times a cuirass. This type of armour became widespread in the Islamic Near East and was particularly widely used in the Turkish and Mamluk states. In Iran it continued to be popular well into the 16th century,[31] and laminated horse bardings were also used.[32] The origin of this style is by no means certain, and an Iranian source cannot be proved.

Lamellar barding also continued to be used in the 15th century, and is described by Barbaro, who visited the Turkoman lands in the 1470s. 'Of the which there were ij ml [2,000] covered with certein armure of yron, made in little squares and wrought with gold and siluer, tacked togither with small mayle, which hanged down in maner to the grounde, and under the golde it had a frynge.'[33] Although grammatically Barbaro seems to be referring to the soldiers here, the description must in fact be that of horse armour; otherwise it would hardly have hung down to the ground or have had a fringe beneath it.[34] Barbaro ascribes this type of armour to Besthene or Beshkand, which is probably Kubachi.[35] The Caucasus had for long been known

28. Robinson (1958) pl.1.
29. Royal Armouries, Leeds, acc. no. XXVIA.127, see Kalus (1980) pp.20–25; it is set in a late 15th-century steel shield bearing anonymous, probably Aq Qoyunlu, royal titles.
30. Clavijo (1928) p.293.
31. See, for example, the Tabriz *Khamseh* of Nizami of 1525 in the Metropolitan Museum of Art, New York, f.279, in Gray (1961) p.128 and the Shah Tahmasp *Shah-nameh*, f.671, in Dickson and Welch (1981) vol.2, no.250.
32. See, for example, a miniature from the 1529 *Zafar-nameh* in Pope (1938–39) pl.1409 D, E.
33. Thomas and Roy (1873) p.66.
34. Later on the same page Barbaro says, 'the horsemen's armour is of the same sort before rehearsed.'

as a centre of arms and armour production,[36] and would have been an obvious source of arms for the Turkoman rulers, with their capitals in north-western Iran and eastern Anatolia.

Shah Isma'il I is recorded as having sent to Albuquerque a set of horse armour,[37] but what form it took is unknown. More important are the descriptions of two other Iranian sets of horse armour which used to be in Florence. Together with armour for their riders, they are reputed to have been given to the Grand Duke Ferdinand I by Shah 'Abbas I. The fullest descriptions of them date from 1631, and are to be found in the Florentine archives.[38]

'A horse of wood with barding of plates of iron, carved and decorated in gold, turquoise in colour, held together with mail and buckles of brass, with a fringe at the foot of the said barding, red and yellow, lined with red cloth, with a saddle of smooth red velvet, the saddle-bow of that saddle of iron, similarly carved, with stirrups of Turkish style, of iron embellished with gold, with a crest on the front of the horse, well used.

'A figure on the said horse, completely armoured with scale iron, all carved, with eyes of a peacock, of gold and grey appearance,[39] with hands and collar of iron mail, and for helmet a turban of white cloth with a point of wood above, the said turban embellished with gold with eyes of a peacock, with a gauntlet with a dart in (one) hand, and in the other hand a shield in the middle of which is depicted a head of Medusa all creeping (with serpents) by the hand of Caravaggio, with a scimitar of damascus steel in the Turkish style, with fittings of silver gilt, decorated with gold, both hilt and scabbard with shagreen, with a belt of ordinary leather and a purse of leather lined with red cloth.

'A horse of wood, with its barding of leather all embroidered with green velvet, decorated with brass studs, with a saddle of smooth green velvet garnished with fringes of green silk, with stirrups in Turkish style of iron with gold and green and above a figure with a small disk of turquoise velvet embroidered with green velvet and small white pieces of cloth, and the said figure all armoured with a white bust armour,[40] with etched arabesques, and a jousting lance all perforated and embellished with gold and green, with two plumes of feathers, one on the armour and one on the horse; well used.'

35. Minorsky, quoted by Alexander (1983) p.99.
36. Allan (1979) p.69. They continued to play an important role, see Porter (1821–22) vol.1 p.715.
37. Albuquerque (1875) vol.4 p.179.
38. Heikamp (1966) p.67.
39. This could indicate that the steel was deliberately greyed, as well as overlaid or inlaid with gold.
40. What precisely is meant by *una armatura biancha busta* is unclear to me. I would like to thank Mrs Lynes for correcting my translation of the Italian.

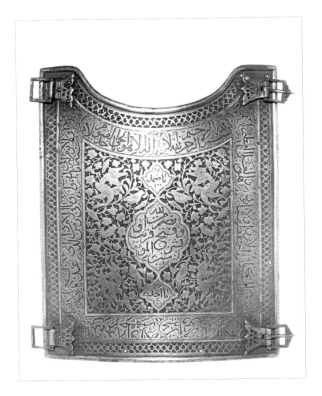

FIG.14a Body armour, one of a set of four; chiselled, pierced, chased and riveted; gold inlay and overlay; 21 x 16 cm; made by Lutf'ali, and dated AH 1150 (AD 1737); Ashmolean Museum acc. no.EA1997.176

Four other descriptions of these sets of armour are known. The first and earliest description of all is in a German manuscript of 1611: 'two Persian sets of horse armour, made only of leather, but impenetrable to shot.' Later, John Ray, visiting Florence in 1664, described the first set as 'a set of armour for a man on horseback, made of little scales of iron', while another German traveller's account of 1677 describes 'two horses which the King of Persia gave to the Grand Duke Ferdinand I, all embellished with armour plating in the same way as the two men that once used them; holding in their hand a lance as if they were about to rush at each other.' Finally, another 17th-century Italian record is of 'two sets of Persian armour, as much for the horseman as for the horse, most neatly carved according to that custom, which were given by the king of Persia to these Highnesses [the Grand Duke Ferdinand and his wife].'[41]

There are some discrepancies in the various descriptions, but the horse armour

41. Heikamp (1966) p.69.

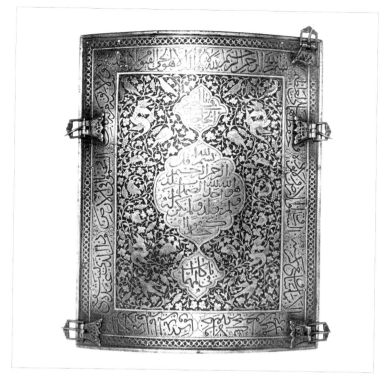

FIG.14b Body armour, one of a set of four; chiselled, pierced, chased and riveted; gold inlay and overlay; 27 x 20 cm; made by Lutf'ali, and dated AH 1150 (AD 1737); Ashmolean Museum acc. no.EA1997.176

appears to have been lamellar, in one case with iron scales, chiselled and inlaid or overlaid with gold, in the other case with leather scales. The dating of the sets of armour is uncertain, but given that they are both described as 'well used', and that the headdress of one of the horsemen was certainly a turban with a wooden baton in it, which was characteristic of the early Safavid period, it seems likely that all or part of the armour dated from the first half of the 16th century. Hence, lamellar bardings certainly continued in use into the 16th century, and possibly later.

The next important change in fashion in the armour of mounted warriors – the introduction of the *char-aineh* – probably occurred during that same century. Meaning literally 'four mirrors', this was most commonly a cuirass of four large curved plates, buckled round the wearer's body, above a mail shirt. It derived from the age-old use of breastplates. The latter are very rarely shown in manuscript illustrations, probably because they were often sewn into a soldier's clothing and were therefore invisible. H.R. Robinson has suggested that the circular plate shown in 16th-century miniatures is a convention representing the central plate of a cuirass, just as the rec-

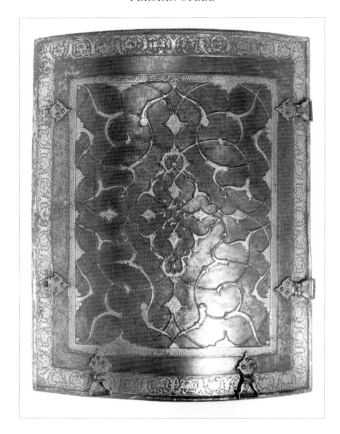

A.1 Body armour, second of a set of four; chiselled, pierced, chased and riveted; gold overlay; larger plates 29 x 22 cm, smaller plates 26 x 18.5 cm; 19th century; no.16

tangular or hexagonal plate shown in 17th-century miniatures represents the full *char-aineh* which was by then standard.[42] The relationship of the *char-aineh* to the Russian *zertsala* remains to be investigated.[43]

Surviving complete sets of such body armour are rare. The earliest dated example is that in the Royal Scottish Museum dated AH 1114 (AD 1702–3).[44] This has borders inscribed with verses from Hafiz, and two central cartouches bearing sura 11, verse 90.[45] Another dated 18th-century example is in the Victoria and Albert Museum.[46] Distributed around the borders of the four plates of this latter set are the first ten verses of sura 48, and the cartouche on one of the small plates gives the year AH 1140 (AD 1727–28). A further set illustrated by Egerton is associated with a helmet

42. Russell Robinson (1967) pp.34–38.
43. *Treasures of the Kremlin* (1998) p.5, no.2. *Zertsala* means 'mirror'.
44. Elwell-Sutton (1979) pls 8–11.
45. The other central cartouches remain unread.
46. Victoria and Albert Museum, London, acc. no. 638-1876; unpublished.

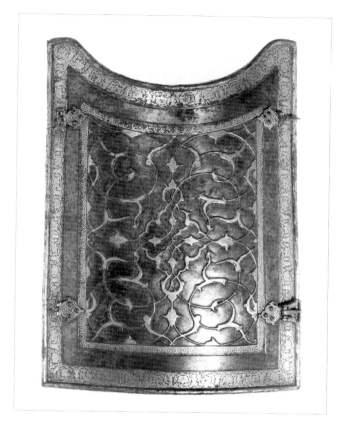

A.1 Body armour, second of a set of four; chiselled, pierced, chased and riveted; gold overlay; larger plates 29 x 22 cm, smaller plates 26 x 18.5 cm; 19th century; no.16

dated AH 1146 (AD 1734), and is decorated with sura 2, verses 256–59.[47] Two sets from later in the same decade also survive, both signed by the famous armourer, Lutf'ali. One, dated AH 1150 (AD 1737) is in the Ashmolean Museum (FIGS 14a–b);[48] the other, dated AH 1151 (1738–39), is in Topkapı.[49] Both are decorated with birds amid a jungle of foliage, and have borders of inscription which includes the 'Throne Verse' (sura 2, verse 255). These sets all testify to the popularity of Qur'anic inscriptions on armour during the first half of the 18th century. A set dated AH 1201 (AD 1786–87), which also includes helmet, one vambrace and shield, is in the Royal Armouries.[50] An undated set in the Royal Scottish Museum, bearing sura 2, verses 156–59, sura 40, verse 47, sura 61, verse 13, and suras 109, 110 and 113, is probably to

47. Egerton (1968) pl.V and p.52.
48. Ashmolean Museum, Oxford, acc. no. EA1997.176; Christie's, 5 October 1996, lot 201.
49. Pope (1938–39) pl.1408 D and E.
50. Royal Armouries, Leeds, acc. no. XXVIA.163.

be ascribed to the same century.⁵¹ A splendid set of body armour was presented by Fath 'Ali Shah (1797–1834) to the Prince Regent: 'a fine suit of chain armour (*zerreh*), with the breastplate and certain pieces, constituting what the Persians call *cheharaineh* or the 'four mirrors', of the most highly tempered steel; this armour had belonged to Shah Tahmasp, who ... died in ...1575.'⁵²

Although it is customary for body armour of this type to have rectangular plates, other forms do occasionally occur. Thus, in the Metropolitan Museum of Art is a cuirass consisting of two octagonal and two rectangular plates. Their central roundels are inscribed with Qur'anic verses, and their borders with the 99 names of God in quatrefoils.

A rather different style is represented by two cuirasses in the Victoria and Albert Museum,⁵³ a cuirass in the Wallace Collection,⁵⁴ another in the Metropolitan Museum of Art,⁵⁵ and one in the Musée de l'Armée in Paris.⁵⁶ Rather than four plates held together by leather straps, these consist of four curved plates hinged or clipped together to completely encircle the body. Both the Victoria and Albert sets have borders of inscriptions, and may be 18th-century in date. The Wallace Collection example bears the name of Fath 'Ali Shah and the date AH 1224 (AD 1809), but it has been suggested that it is an older cuirass reused and inscribed by the monarch. All the sets are decorated with projecting bird's heads, suggesting a link with other objects in this collection similarly adorned, and hence an Isfahani provenance. The Metropolitan Museum also contains a cuirass of this form made of painted leather, with iron or steel hinges overlaid in gold.⁵⁷ It is decorated in the style of a book cover, and the central cartouches and borders bear sura 48, verses 7–29.

A very late example of this style made of steel is in the National Museum, Kraków.⁵⁸ Despite being inscribed with the name of Shah Sulaiman, it is undoubtedly a late 19th-century piece of Isfahani work, akin to the helmet and vambrace bearing the name of Shah 'Abbas in the British Museum,⁵⁹ or the *kashkul* in the Nuhad Es-Said collection. Body armour is now only used for costumes of warriors in the tragedies (*ta'ziyeh*) of the Shiah martyrs, which are annually acted throughout Iran in the month of Muharram.⁶⁰

The four plates of body armour (A. 1) in the Tanavoli collection are decorated not with inscriptions but arabesques. These are in relief, are spaciously designed and

51. Elwell-Sutton (1979) pls 6–7.
52. Ouseley (1819–23) vol.3 p.373. The helmet of this set is illustrated in Pope (1938–39) pl.1415B.
53. Victoria and Albert Museum, London, acc. nos 636-1876 and 692-1889.
54. Norman (1968) fig.7; Norman (1982) pp.10 and 12, and p.15 pl.9.
55. Metropolitan Museum of Art, New York, acc. no. 48.92.1; unpublished.
56. Jacob (1975) p.74.
57. New York, acc. no. 36.25.342; unpublished.
58. Żygulski (1979) pls 233–36; (1986) pls 62 and 64; (1989) pl.80.
59. Barrett (1949) pls 38b, 39.
60. Murdoch-Smith (1885) p.38.66. Royal Armouries, Leeds, acc. no. XXVIA.242–3.

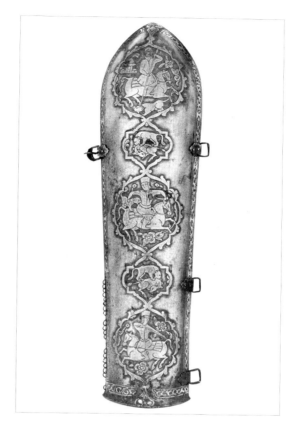

A.2 Vambrace; chiselled, pierced and riveted; gold overlay; ht 36 cm; w. 9.4 cm; late 18th to early 19th century; no.17

focus on a central cruciform figure made up of stems with four palmettes. Spacious arabesque designs, combined with an inscribed cartouche and an inscribed border, are found on a shield dated AH 1128 (AD 1714) and signed by Muhammad Riza.[61] The taste for space around motifs is also clear from pieces of armour dating from the period about 1700, which are decorated with inscriptions in cartouches. Some of these are noted above; others are vambraces dated AH 1103 (AD 1691–92), AH 1104 (AD 1692–93) and AH 1123 (AD 1711) in the Royal Scottish Museum.[62] Hence we may date other objects decorated with spacious arabesque designs, like the Tanavoli *char-aineh*, or a shield in the Royal Scottish Museum,[63] or a helmet, shield and vambrace in a Danish private collection,[64] to the early 18th century. A somewhat similar

61. Museo di Palazzo Fortuny, Venice, acc. no.546, *Eredità dell'Islam* (1993) no.282.
62. Elwell-Sutton (1979) pls 13–15.
63. Elwell-Sutton (1979) pl.20.
64. *Islamiske våben i dansk privateje* (1982) no.93.

style associated with Lahore is dated to the same period.[65]

A rather different, but also very plain, style of decoration includes chiselled 'eyes', sometimes with chevron bands. This abstract type of work is exemplified by a pair of vambraces in the Royal Armouries made by Faizallah Shushtari in AH 1120 (1708–9),[66] which also include, in exquisite chiselling, brief Qur'anic texts – part of sura 3, verse 126 (or sura 8, verse 10), sura 27, verse 30, and part of sura 71, verse 13.

Helmets and shields

A wide variety of helmets are depicted in Il-Khanid miniatures but from the late 14th century all are basically conical. Warriors' faces are almost without exception shown unprotected but there is evidence to indicate that a mail veil, part of the complete aventail, was often used. The changes in shape and design of helmets during the five hundred years between the coming of Timur and the fall of the Qajars have yet to be charted. Timurid manuscript illustrations show a variety of helmets: tall and squat, faceted and fluted.[67] Surviving helmets of the 15th century indicate that the Turkomans favoured a rather squat form with heavy emphasis on spiral fluting, often called a 'turban' helmet.[68] The Shah Tahmasp *Shah-nameh* suggests that in the following century the Safavids favoured a more elegant style, which may originally have been fashioned to imitate the tall, baton-topped turban favoured by the Qizilbash.[69] The commonest type illustrated is a tall helmet with a central spike surmounted by a plume or small pennant. The helmet may be faceted or fluted, often in bands, or sometimes decorated with arabesques. In some instances there is a single frontal plume and no central one; at other times both are shown. Sometimes a turban seems to have been wrapped around the outside of the helmet, and in one case the whole is surmounted by two plumes as well as a central baton. When the two-plumed helmet became widely used is unfortunately unclear from later manuscripts. It does not seem to occur in illustrations of the later Safavid period, and while it does appear in a Qajar miniature of 1810 most of the helmets depicted in that and related manuscripts are absolutely plain.[70] Surviving 17th-century helmets with their characteristic quadrangular spikes and plume-holders often retain their original aventails, which include a mail band round the upper face. Such helmets are also equipped with nasals. A splendid example which has unfortunately lost its spike, aventail and nasal, but is documented as early as 1621, is in the Kremlin.[71]

65. *Splendeur des Armes Orientales* (1988) fig.185.
66. Royal Armouries, Leeds, acc. no. XXVIA.242–3.
67. H.R. Robinson (1967) figs 18–19.
68. For example, Barrett (1949) pl.30; Bodur (1987) p.151 no.A.144; Alexander (1983) figs 2–5, 9.
69. Dickson and Welch (1981) vol.2 nos 23, 41, 78, 80, 97, 131, 133, 161, 181 etc. Soudavar (1992) p.150 suggests that a helmet in his catalogue, no.54, is early 16th-century Shiraz work.
70. Robinson (1976) p.247 no.1263.
71. *Treasures of the Moscow Kremlin* (1998) pp.2–3

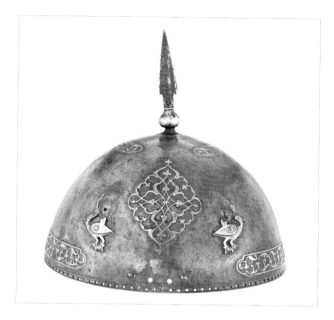

A.3 Helmet; chiselled, pierced, brazed and riveted; traces of gold overlay on the appliqués; brass rivets; ht 18.5 cm; d. 19.2 cm; late 18th century; no.15

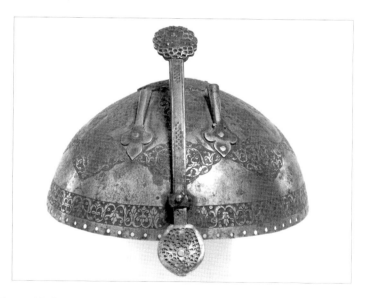

A.4 Helmet; chiselled, pierced and brazed; brass and steel rivets; edge pierced for a camail; spike missing; ht 9.7 cm; d. 19.5 cm; 19th century; no.14

The reduction in helmet size at this period may have led to the fashion of tying a scarf around the outside of the helmet to help defray the heat of the sun, replacing the greater quantity of internal padding possible on the larger, earlier models.

In the 18th century, under Nadir Shah, the top-knots of the helmets seem to have acted as identifying features for different groups within his army. According to Hanway, his 500 Giarkchies 'wore in their caps the beard of an arrow in brass', while his 800 Yesaul wore a brass knob and his 250 Nessakchi a feather in their caps.[72]

Helmet A.3 has lost its nasal, the bracket holding it, and the upper parts of its plume-holders, and the spike could well be a replacement as the disc around its base is missing (two rivet holes and the remains of a brass rivet are still visible). The base of the helmet is pierced for a camail, but it too is missing. The cruciform arabesque designs could indicate a Safavid date, but the narrow cartouches contain scrolling arabesques which can be related to those on a pair of scissors dated AH 1220 (AD 1805) in the Harari collection.[73] The latter show a tendency for the points of the leaves to break away and form separate dots, a feature which is not present on the helmet. Hence a date in the second half of the 18th century is most likely.

Helmet A.4 is in a strikingly different, rather baroque, 19th-century style. The pierced discs riveted to the nasal show the wide variety of uses to which these small ornamental pieces could be put. It too has an edge pierced for a camail, but the camail is missing, as is the spike.

From the late 14th century onwards, shields were usually circular, with a slightly convex profile, and made of cane. This was ideal for horsemen and was only replaced by a stronger material, namely steel, with the introduction of firearms from the 16th century onwards. Surviving Iranian shields are rare, but three 16th-century cane examples are to be found in the Livrustkammaren, Stockholm. Although originally Safavid, they must have been captured by the Ottomans before being taken from them by the Swedes. They all have central steel bosses, inlaid or overlaid with gold, and in one case with very fine openwork. All were enhanced by the Ottomans with gold plaques set with semi-precious stones.[74] A complete shield of watered steel dating from the late 16th century survives in the Kremlin Armoury in Moscow. It is incised, inlaid with gold, decorated with filigree, rubies, turquoises and pearls, and stamped with the name of the goldworker, Muhammad Mumin *zarnishan*. It entered the Tsar's armoury in 1622, but was probably in the hands of Prince Fiodor Mstislavsky as early as 1610–11.[75] Steel shields were included in lists of commodities felt by the English to be saleable in Iran in the mid-16th and early 17th century.[76] It

no.1. It bears the words of sura 61, verse 13: 'Victory from God and swift conquest. Give good tidings to the believers.'

72. Hanway (1754) vol.1 p.171.

73. Pope (1938–39) pl.1390C.
74. Livrustkammaren, Stockholm, acc. nos.[to do].
75. Loukonine and Ivanov (1996) no.200.
76. Hakluyt (1903) pp.66–7; Purchas (1625) vol.1

was probably firearms which led to the abandonment of horse armour at about the same time, since the amount of steel needed would have made the movement of horsemen in battle quite impossible.

Centres of production

Early texts suggest that in the pre-Mongol period most of the armour produced in Islamic Iran was made in Khurasan[77] and Transoxiana,[78] and the important role of Ghur in armour production is emphasised by al-Juzjani.[79] Rashid al-Din describes the industry under the Il-Khanids, indicating widespread manufacturing on a relatively small scale: Ghazan Khan set up workshops throughout the realm in which arrowsmiths, bow-makers, swordsmiths, chain-mail makers and others, working exclusively for the government, enabled it to equip 10,000 soldiers with full armour.[80] Under Timur, on the other hand, recentralisation focused on the north-east was evidently the official policy, as Clavijo and Barbaro show. Thus, Clavijo writes of Samarqand castle: 'Within its walls however Timur holds in durance and captivity upwards of a thousand workmen; these labour at making plate armour and helms, with bows and arrows, and to this business they are kept at work throughout the whole of their time in service to his Highness.'[81] Later he describes Timur's return from his seven-year campaign, and how he entered the castle to see what had been made:

> 'Among the rest they brought to show him 3,000 new suits of plate armour, which is of the sort stitched on a backing of red canvas. To our thinking this appeared very well wrought, except that the plates are not thick enough, and they do not here know how properly to temper the steel. At the same time an immense number of helms were exhibited, and these each with its suit of plate armour were that day many of them given as presents by his Highness, being distributed among the lords and nobles there in attendance. These helms of theirs are made round and high, some turning back to a point, while in front a piece comes down to guard the face and nose:– which is a plate, two fingers broad, reaching the level of the chin below. This piece can be raised or lowered at will and it serves to ward off a side-stroke by a sword. These suits of plate-armour are composed very much as is the custom with us in Spain, but they wear a long shirt, made of a material other than that is plate-armoured, and this comes down so as to appear below, as might be with us a jerkin.'[82]

pp.237, quoting Salbancke in 1609; Osborne (1745) vol.1 p.732, quoting Cartwright in 1611.
77. Ibn al-Faqih (1885) p.316; al-Hamdani (1968) fol 25a; al-Jahiz (1932), p.345; *Hudud al-'alam* (1962) para.24.1.
78. al-Muqaddasi (1877) p.325.
79. al-Juzjani pp.40, 47, 59.
80. Keyvani (1982) p.165.
81. Clavijo (1928) pp.289–90.
82. Clavijo (1928) p.293.

Later in the century Barbaro visited Tabriz, the capital of the Turkoman ruler, Uzun Hasan, and his armoury located nearby. He writes: 'Those armours of iron [for horses and horsemen] are made in Besthene [i.e. Besh-keuy, or 'five villages'], which in our tongue signifieth the 5 towns, being of two miles compass, and standeth on a hill where no man dwelleth but the craftsmen of that science. And if any stranger be desirous to learn it, he is accepted with putting in sureties never to depart thence; but to dwell there with the rest and apply that occupation. It is true that in other places like works are made, but nowhere so excellent.'[83]

The production of arms and armour in early Safavid times was hampered by the Ottomans and their regular assaults on Tabriz. Thus in 1514 the Ottoman sultan, Selim, captured Tabriz and is said to have 'carried away with him three thousand families, the best artificers in that city, especially such as were skilful in making of armour and weapons'.[84] How production fared for the remainder of the century is unknown, but from the time of Shah 'Abbas Isfahan became the key production city, including as it did a '*maison des arms*', or arsenal, where the armourers employed by the king worked.[85] The Central Arsenal of Iran was in fact situated in the ancient fortress there, and the Director of the Arsenal, according to Kaempfer, had among his subordinates locksmiths, cutlers, makers of arrow-heads, and makers of gunpowder.[86] Cartwright, visiting Isfahan in 1611, provides a more detailed description. 'After he [Shah 'Abbas] has viewed his horses, he passeth into this armory, certain buildings near unto his palace, where are made very strong cuirasses, or corselets; head-pieces and targets, most of them able to keep out the shot of an harquebusier, and much more to daunt the force of a dart. Here also the king furnisheth his soldiers, not only with curiasses, head-pieces, and targets; but with bows and arrows, poutdrones, and gantlets; and with launces made of good ash, armed at both ends; with scymetars and shirts of mail, most finely and soundly temper'd; wherewith both themselves and their horses are defended, in time of war.'[87] In addition there were provincial arsenals which must have had some sort of workforce attached to them to repair equipment, if not to manufacture new items as well. For example, Membré describes the munitions kept in the Arg at Tabriz, 'all in chests which they load two to a camel, all covered with leather; and in these chests are arrows, bows, swords and coats of mail, as I have seen.'[88]

Lesser patronage also played its part in developing local industries. Thus, some provincial governors also set up the equivalents of royal *buyutat* in their own governorates. For example, a governor of Sistan under Shah 'Abbas I set up various work-

83. Thomas and Roy (1873) p.66. Besthene, however, may signify Kubachi; see note 35 above.
84. Cartwright in Osborne (1745) vol.1 p.728.
85. Chardin (1811) vol.7 p.329.
86. Minorsky (1943) p.136.
87. Osborne (1745) vol.1 p.736.
88. Membré (1993) p.30.

shops, including an arsenal and a goldsmith's workshop, and other governors are recorded doing the same.[89]

Other cities, however, also provided sources of arms and armour for the troops. Cartwright again provides a description, this time of the products of Shiraz: '… it is one of the greatest and most famous cities of the east, both for traffic of merchandize; as also for most excellent armour and furniture, which the armourers with wonderful cunning do make of iron and steel, and the juice of certain herbs, of much more notable temper and beauty, than are those which are made with us in *Europe*: not only head-pieces, curiasses, and compleat armours; but whole caparisons for horses, curiously made of thin plates of iron and steel.'[90]

Despite widespread production at home, there was a continuing demand for foreign armour, as also for foreign weapons. Thus, Arthur Edwards, writing in 1567 to 'the right worshipfull Companie trading into Russia, Persia and other the North and northeast partes', notes that the Shah has requested the following:

'Three or foure complete harnesses that wil abide the shot of a handgun with 10. or 12. targets of steel, being good.
'Ten or twelve good shirts of male being very good or else none, that may abide the shot of an arrow.
'Twentie handguns being good, some of them with fire locks, and also six good dags, with locks to travel withall.
'Six stone bowes that shoot lead pellets.'[91]

And in 1609 Salbancke writes: 'These commodities are to be carried from *England* to *Persia*: Tinne, Copper, Brasil: as also … Dagges, and Pistols, complete harness, targets of steele, shirts of maile, stones bowes, brasse and yron Ordnance'.[92]

In the Qajar period, as under the Safavids, royal arsenals had a continuing role. 'Abbas Mirza, Crown Prince of Fath 'Ali Shah, prepared for war against Russia by setting up military workshops and arsenals in Tabriz and Tehran.[93] These probably formed the basis of the arms industry for most of the ensuing century, for in the 1850s Hommaire de Hell only records one additional one, at Amul.[94]

Traditional Iranian armour might look impressive on parade, or even on the battlefield, but the 19th century saw it come to the end of its useful life. By the 1880s, and probably much earlier, its only function, as noted above, was as costume for the

89. Keyvani (1982) p.172.
90. Osborne (1745) vol.1 p.744.
91. Hakluyt (1903) pp.66–67. A dag is a type of heavy pistol or hand-gun.
92. Purchas (1625) vol.1 pp.237; this is repeated almost word for word by Cartwright two years later, see Osborne (1745) vol.1 p.732.
93. Issawi (1971) p.287 quoting Kuznetsova.
94. Hommaire de Hell (1854) vol.3 p.133.

ta'ziyeh.⁹⁵ 'A set of armour consists of a helmet, a shield, and a guard for the other arm. The helmets are round, with a central spike. Chain-mail hangs down from the back and sides for the protection of the neck, and in front are two little holes in which feathers are inserted. The shields are circular, and the working and devices on some of them are most excellent.'⁹⁶ But this religious role for armour was not enough to keep the craftsmen in business. Mirza Husain Khan described the situation of the armourers in Isfahan *circa* 1890:

> 'The group of chain-mail makers. The making of chain-mail has fallen into disuse nowadays. Some of them have remained but are now engaged in other occupations. A few years ago they collected old chain-mail and went to Turkey, because there were buyers. Here and there they will make chain-mail at home, but it is not an important guild.
>
> 'The group of helmet and cuirass-makers. Formerly they formed a large group, but in recent years [their trade] fell into disuse. But since a number of years they found some buyers in Turkey and other countries. In Isfahan some people [still] make helmets and cuirasses.'⁹⁷

AXES

It is often difficult to distinguish military or ceremonial axes from dervish ones (see pp.316–17). However, three examples in this collection appear to be of the former category. The first (A.5) is an axe-head with a long, sharp blade and two sockets. It gives the appearance of having been heavily used and would have made an effective and unpleasant weapon. There is a good example of such an axe-head, but with three sockets, in a Tabriz *Shah-nameh* of 1524.⁹⁸ A smaller axe-head with a crescentic blade, in the Khalili collection, is also undecorated, and likewise almost certainly of military origin.⁹⁹

The second example (A.6) is a small axe-head with a crescentic blade and a pick. Although it shows relatively few signs of wear, the pick suggests that it was made for practical, military use, rather than for dervish adornment. On either side of the blade the terminations of the leaves have become separated from the arabesques surrounding the cartouches to form dots, suggesting an early 19th-century date.

The third example (A.7) is of a form called a saddle-axe (*tabarzin*). Saddle-axes were used by cavalry in both Safavid and later Iran and in Mughal India, and a

95. Murdoch-Smith (1885) p.38.
96. Collins (1896) p.184.
97. Floor (1971) p.110.
98. *De Baghdad à Ispahan* (1994) p.197.
99. Alexander (1992) no.57.

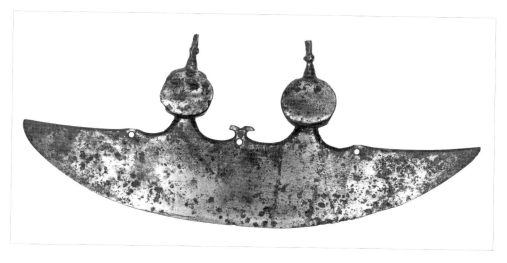

A.5 Axe head; pierced; l. 36 cm; w. 15.3 cm; 17th–19th century; no.155

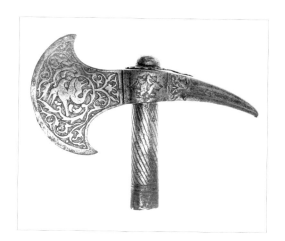

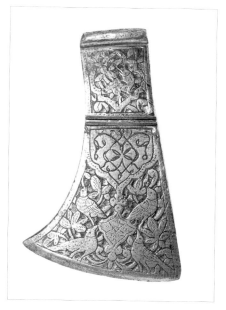

A.6 Axe head; chiselled, incised and drilled; brazed cap to shaft;
l. of shaft 10.6 cm; l. of head 15.6 cm; early 19th century; no.224
A.7 Saddle-axe head; chiselled, incised and punched;
l. 12.3 cm; ht 7.2 cm; 19th century; no.83

group of saddle-axes made by Lutf'ali Ghulam, who worked during the reign of Nadir Shah (1736–1747), have been published by A.S. Melikian-Chirvani, along with comparative pieces.[100] Melikian-Chirvani cites two axes in the Victoria and Albert Museum which he dates to the first half of the 17th century; two axes dating from the first half of the 18th century, one in the Victoria and Albert Museum, and one in a private collection; two axes probably dating from Fath 'Ali Shah's reign, one in the Metropolitan Museum of Art and one in Ingolstadt; three axes made by Lutf'ali Ghulam himself; a Hindustani forgery of a Lutf'ali axe, and a Hindustani axe, possibly of early 19th-century date, 'made at Lahore'. A further saddle-axe, unknown to Melikian-Chirvani, is in a Danish private collection.[101] It is signed by Muhammad Taqi, dated AH 1138 (AD 1726), and was made for Khudayar Khan Abbasi. Another, anonymous, piece has been published by Abolala Soudavar.[102] The Tanavoli axe-head is of one of the two forms illustrated by these axes, having one straight side to the blade rather than two curving ones. Each face of the Tanavoli axe-head bears a pointed cartouche containing an interlaced stem focused on a five-petalled flower. This shows virtually no feeling for, or understanding of, the traditional Iranian arabesque. Combined with the relative crudity of the workmanship and the lack of decoration on the rest of the head, it suggests that the axe-head is a 19th-century creation, and probably from the second half of the century.

DAGGERS

Iranian daggers caught the imagination of a number of European visitors to that country.[103] In the mid-17th century du Mans described the local (presumably Isfahani) custom of putting a small, well-made knife in one's belt, together with a slender whetstone, the two attached to each other by a small piece of bone.[104] Travelling through Isfahan in the middle of the 19th century, Binning noted two different types of dagger being worn, the *khanjar*, 'a curved double-edged dirk, stuck in the girdle on the right side', and the *kard*, 'a straight, single-edged pointed knife, worn on the left side'.[105] In the 1880s Wills noted daggers of a different type: 'As to arms ... the natives of the south of Persia and servants ... carry a kammer, or dirk ... The sol-

100. Melikian-Chirvani (1979). Another axe of Lutf'ali dated AH 1150 (AD 1737–38) was sold at Christie's, 19 October 1993, lot 217.
101. *Islamiske våben i dansk privateje* (1982) no.81.
102. Soudavar (1992) p.23.
103. Folding knives and pen-knives are dealt with elsewhere in the catalogue. Here the focus is on certain types of knives or daggers that would have been worn for ceremonial, military or hunting purposes in the period between *circa* 1600 and 1900. Here, as throughout the book, the traditional terminology for daggers is used; *kard* for a straight-bladed knife, *khanjar* for a dagger with a single-curved blade, and *pishqabz* for a dagger with a double-curved blade.
104. du Mans (1890) p.204.
105. Binning (1857) vol.2 p.130.

diery, on or off duty, always carry one of these "kammers", or their side-arms, sometimes both.'[106] He must here be referring to the *qama* or *kinjal* which was introduced from Daghestan in the 19th century.[107] It has a comparatively long, sharply pointed, double-edged blade. At the turn of the century Henri d'Allemagne commented: 'Every well-born Persian carries a long straight dagger', which implies a *qama*, but he couples this with a detailed description of the straight, single-edged knife, of which A.8–10 are all examples.[108]

Mirza Husain Khan's *Jughrafiya-yi Isfahan* mentions the changing popularity of the various types of dagger: 'Formerly the quma [*sic*] and broadsword (qadara) were not very much in use in Isfahan. A number of years ago they became quite popular and a great impulse was given to the making of qumas and qadaras; they were well-made, almost as good as the Maragha qumas. Nevertheless these goods became unsaleable, once more.'[109] Elsewhere he writes: 'Before European knives came into common use, they used to make steel knives in Isfahan; their shape was like the gizliks, something between a knife (kard) and a qum (poniard), with long bone handles and a short steel blade, which could not be bent.'[110] *Gizliks* are small Turkish sheath-knives.

A third passage from the same source concerns the knives made by the *kardgaran*, the *kard*-makers: 'The good antique steel knives which were used in Iran were all made in Isfahan. Now their products are not much in demand. They have no customers except for the tribes and some villagers.'[111] It was presumably these knives which were compulsory emblems of membership of the *lutis* ('men of noble qualities') in the 19th century.[112]

If Mirza Husain Khan's comments about *kard*s are correct, then we can attribute surviving examples with some confidence to Isfahan. That would seem to be supported by du Mans, whose description of Iran in 1660 was based primarily on his stay in Isfahan. Among the craftsmen he described were the *kardgaran*, whose extraordinary ability he extols: 'Here they work very well, to the point where some of them can join the two leaves [*alumelles*] of a knife so dextrously that their back and cutting edge [*coupant*] are double; assembled in the same handle, the cutting edge is single, and one is not aware of it in use, which demands great dexterity; to understand that, imagine one of our knives split precisely down the middle of its thickness from top to bottom.'[113] We have therefore attributed the *kard*s catalogued here to Isfahan.

106. Wills (1883) p.322.
107. de Rochechouart (1867) p.232.
108. d'Allemagne (1911) vol.2 pp.91–93.
109. Floor (1971) p.107.
110. Floor (1971) pp.110–11.
111. Floor (1971) p.104.
112. Arasteh (1961) p.48.
113. du Mans (1890) p.204. To see precisely how *kard*s are manufactured one would need to x-ray them.

Isfahan, however, was not the only manufacturing centre for daggers or knives. Shiraz too was famous for its products. As early as the 13th century al-Qazvini highlighted the city as a centre for knives as well as sword-blades,[114] and six hundred years later Sir Robert Ker Porter noted that the manufacture of daggers and sword-blades had survived the destruction of the Zand dynasty.[115] Fraser, too, mentioned that Shiraz manufactured 'damasked steel knives and daggers',[116] and Wagner alluded to the designs which decorated them: 'I was shown blades of splendid workmanship, into whose steel, ornaments and arabesques of gold, containing occasionally passages from the Koran, were inserted.'[117] Admittedly he is here referring to sword blades, but there seems every likelihood that the craftsmen would have decorated dagger blades in a similar style. Given the fame of Shiraz for its enamelling,[118] the number of *khanjar*s with enamelled hilts and scabbards which have survived,[119] a *khanjar* dated AH 1191 (AD 1777) with an inscription saying it was made in Shiraz,[120] and a number of published examples with gold-inlaid arabesques and inscriptions to decorate them,[121] it is tempting to see the *khanjar* as primarily a product of Shiraz, and the *kard* of Isfahan.

One must be wary, however, of trying to be too specific about provenance, for *kard*s or similar knives seem to have been produced further east, beyond the boundaries of modern Iran. Thus *kard*s almost identical in form to the Iranian ones seem to have been manufactured in Lahore,[122] while a longer version of the form was manufactured in Afghanistan[123] and a *kard* recently acquired by the Ashmolean Museum is probably Deccani.[124] One must also be cautious with the decorative argument, since a number of *kard*s (some mentioned below) bear inscriptions and arabesque work in gold, like the *khanjar*s. On the other hand, the fact that there appear to be no surviving *kard*s with enamelled hilts may support the proposition.

Structurally, Iranian *kard*s are different from their European equivalents. In Europe knives were constructed from a blade terminating in a narrow tang which fitted into the handle. That was also the technique commonly used for *khanjar*s in Iran. In these Iranian knives, however, and in the *pishqabz*, the blade was made of one piece with a flat steel tang of the same width as the complete handle and had a

114. al-Qazvini vol.2 p.140: *nasl* (pl. *nusul*) can mean 'arrow' or 'spear head' as well as 'sword blade'.
115. Porter (1821–22) vol.1 pp.714–15.
116. Fraser (1826) p.354.
117. Wagner (1856) vol.3 pp.104–105
118. See, for example, Waring (1804) p.48; Ussher (1865) p.512.
119. For example, *Splendeur des armes orientales* (1988) no.90; Haase *et al.* (1993) pp.206–7 no.146.
120. Freer Gallery of Art, Washington, DC, acc. no. 39.44a–b; Atıl, Chase and Jett (1985) pp.214–19 no.35.
121. For example, *Oriental Splendour* (1993) pp.204–5 no.144 (arabesques), Falk (1985) p.316 no.331 (arabesques and inscriptions).
122. Haider (1991) pp.153, 212.
123. Vianello (1966a) pl.25; Haider (1991) p.208.
124. Ashmolean Museum, Oxford, acc. no.EA1998.24.

T-section rim. The two ivory, or bone, scales fitted into this, one on each side, and were riveted in place through two holes in the tang.[125] Such a knife was thus extremely strong.

Of the history of Iranian daggers and military or hunting knives very little has been written. One of the rare authoritative articles on the subject is that of Ivanov, who grouped and dated the earliest surviving examples to the period from the late 15th to the early 17th century.[126] This includes the five pieces shown in the great Munich Exhibition of 1910,[127] plus a number of others from Moscow, St Petersburg and the Wallace collection. The blades of these daggers vary in shape, from the straight to the strongly curved, and also in length. Yet all those with inscriptions mentioning the weapon refer to it as a *khanjar*, presumably indicating that in the 15th and 16th centuries, at least, the name did not indicate a particular blade form. The broken tang of a blade in Vienna, which has lost its hilt, is of the type mentioned above used in later curved *khanjar*s.[128] (The fact that none of the early daggers has the tang typical of the later *kard* does not, of course, prove it was not used, only that it does not occur on the few extant examples.) When the three forms of knife or dagger known from the 18th and 19th centuries developed and became standardised is not clear.

These early daggers or dagger blades were almost certainly royal pieces, for they appear to be of the highest standard of steel-working, and bear the most sumptuous decoration, including arabesques and *nasta'liq* calligraphy of exquisite fineness. Technically, two pieces, from St Petersburg and Vienna, are outstanding. The first, in the Hermitage, would repay more detailed study. It is described in the Munich catalogue as showing 'a threefold damask i.e. it is welded together out of two dark and one lighter damasked [types of] iron'. If this is indeed so it is a unique example of Iranian pattern-welding using different qualities of watered steel. It is also described as having two different colours of gold inlay on the hilt and scabbard: again this is a unique feature.[129] The dagger in the Museum für Angewandte Kunst, Vienna, has a blade with an openwork centre and a beautiful contrast between those arabesques in gold inlay and those against a gold ground. The latter style shows that the use of a gold ground for decoration in the later period, round about

125. For a picture of a knife without its scales in position and the rivet holes visible, see d'Allemagne (1911) vol.2 pl. opposite p.92, and p.93.
126. Ivanov (1979). For an additional dagger in the Wallace collection see Melikian-Chirvani (1976) pp.24–25.
127. Sarre and Martin (1911) Taf.240 Nr.243, Taf.241 Nr.237–39, 256. They were also illustrated by Pope (1938–39) pls 1426C and 1427A–D. Two other 16th-century blades are in Danish private collections: *Islamiske våben i dansk privateje* (1982) nos 68–69.
128. Sarre and Martin (1911) Taf.241 Nr.238, previously in the F.R. Martin collection, now in the Museum für Angewandte Kunst, Vienna, acc. no.Ei 822; Ivanov (1979) no.3 pl.62.
129. Ivanov (1979) does not mention these features.

1800 (see below), was part of a long-standing tradition.

The importance of antique knives or daggers in the social life of Isfahan is indicated by the ceremony which took place there every year on 'Id-i Qurban. According to Mirza Husain Khan,[130] there was a group of men who accompanied the sacrificial camel on its tour of the *mahallas* each day during the month of Dhu'l-hijja until the eve of the day of sacrifice. This group consisted of two knife-bearers, a spear-bearer, two axe-bearers, two bearers of butchers' knives, two standard-bearers, a cup-bearer, a bridle-holder and a group of the royal brass band. Mirza Husain Khan describes 'two knife-bearers, each provided with three knives of old, valuable and strange design …', and he later comments that there were repeated conflicts between the heirs of these various offices, and that the cutting implements were regularly stolen either by locals, or 'by foreign thieves'.

The only indication of the relative value of the different types of dagger was provided in the mid-19th century by de Rochechouart.[131] In watered steel he prices the finest *kard*s ('*couteaux*') at 120 francs, the good at 18, and the ordinary at 6. *Khanjar*s, on the other hand, he prices at 70, 18 and 6 francs respectively, and *qama*s at 120, 24 and 10 francs. In ordinary steel the finest *kard*s cost 10 francs, the good 2.50, and the ordinary 1.25; *khanjar*s cost the same, but *qama*s cost 30, 2.50 and 1.25 francs. Finally, iron *kard*s cost 6, 3 or 0.75 francs, *khanjar*s cost 18, 1 or 0.75 francs, while *qama*s cost 10, 2 and 1.25 francs. These prices present obvious problems. For instance, watered-steel *kard*s and *qama*s were both priced nearly twice as high as *khanjar*s. On the other hand in the ordinary steel range, *qama*s were three times the price of the other two types of dagger, while in iron, *khanjar*s topped the list. De Rochechouart unfortunately provides no explanation. The assumption in these figures is that all the daggers were made in Iran itself, for the author adds that an exceptionally fine *qama* made in Daghestan would sell for 90 francs, incidentally a lower price than the finest Iranian ones.

Of the individual *kard*s in this catalogue, A. 10 is important in being dated to AH 1024 (AD 1615–16), in the reign of Shah 'Abbas I. Steel objects securely datable to this period are comparatively rare. A *kard* in the Moser collection is dated AH 999 (AD 1590–91),[132] but it bears two signatures, one of Kalb'ali Isfahani, the other of Abu'l-Hasan Shirazi, and the probability is that, even if the blade dates from this period, the decoration is much later. Nor is the decoration of a *kard* dated AH 1025 (AD 1616) and signed by Muhammad Karim much more convincing.[133] There seems little doubt however, that both the Tanavoli *kard* and its decoration do date from AH 1024, and that it is therefore the earliest dated example of a *kard* so far recorded.

130. Floor (1971) pp.138–39.
131. de Rochechouart (1867) pp.231–32.
132. Zeller and Rohrer (1955) no.169 pl.XLIV.
133. *Islamiske våben i dansk privateje* (1982) no.71.

ARMS AND ARMOUR

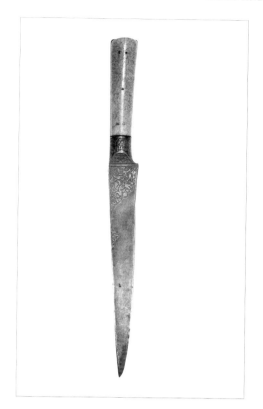 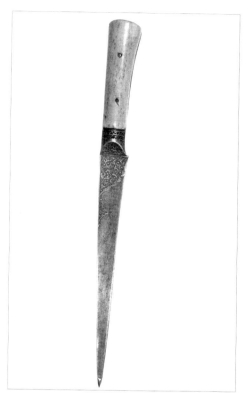

A. 8 Dagger; watered; chiselled; ivory scales; l. 37.5 cm; probably Isfahan, *circa* AD 1800; no.144
A. 9 Dagger; watered; chiselled and pierced; ivory scales; l. 38.9 cm; probably Isfahan, *circa* AD 1800; no.145

The inscriptions on the dagger are as follows. On the back of the tang are cartouches containing words from sura 61, verse 13: *nasr min allah wa fath qarib wa bashir al-mu'minin fi 1024* ('victory from Allah, and swift conquest. Give good tidings to believers. In [the year] 1024'). Sura 110 embellishes both sides of the blade: the text reads: 'In the name of Allah, the Beneficent, the Merciful. When Allah's succour and the triumph cometh, and when thou seest mankind entering the religion of Allah in troops, then hymn the praises of thy Lord, and seek forgiveness of Him. Lo ! He is ever ready to show mercy.' The emphasis on victory and conquest in the inscriptions suggests that the *kard* had a primarily military purpose. The use of inscriptions as sole decoration for the *kard* shows that the use of this style on 18th- and 19th-century *kards* goes back well into the Safavid period.

A. 8 has arabesque work which compares closely with that on two other published knives, both made by a cutler or swordsmith by the name of 'Ali Akbar. One, a *pishqabz* dated AH 1201 (AD 1786–87) is in a German private collection. The other, a *kard* dated AH 1215 (AD 1800–1), is in the Khalili collection.[134] Both have half-pal-

mettes designed in such a way that one leaf tends to end in a sharp point close to its tendril, sometimes giving the impression of whiskers. Another characteristic is the way some of the split palmettes end in a strongly emphasised dot, and free-standing dots are occasionally to be found on the ground of the design. Similar characteristics are to be found on A. 8, which can therefore be dated to *circa* AD 1800. A.9 has a ferrule decorated on each side with the phrase *nasr min allah wa fath qarib* ('victory from God and swift conquest') from sura 61, verse 13, and the words *ya subhan* ('O Most Holy One!'). Its decoration is otherwise so similar to that of A. 8 that it must date from the same period.

Contemporary with these three must be a *kard* made by Baqir and now in a German private collection.[135] The arabesque work is slightly different, as one might expect from a different workshop, but the combination of carved arabesque work and an inscription against a gold ground is precisely the same as on 'Ali Akbar's *pishqabz*, and similar to that on 'Ali Akbar's *kard*. A short-bladed knife signed by Musa and dated AH 1190 (AD 1776), in the Moser collection, has no carved arabesque work, but does have inscriptions and a small area of arabesque against a gold ground.[136] Similar work is also found on a *kard* in the Moser collection dated AH 1218 (AD 1803–4).[137] Another *kard* by 'Ali Akbar, dated AH 1218 (AD 1803), has no arabesque work of any sort.[138] Instead the bolster and ferrule are decorated with Qur'anic inscriptions against a gold ground. Another *kard* by 'Ali Akbar, decorated in the same style but undated, is in the Moser collection.[139] Finally, a *khanjar* dated the equivalent of AD 1770 has inscriptions against a gold ground, though in this case it also has cartouches and gold tendrils in relief,[140] while a *khanjar* signed by Muhammad Hadi and dated AH 1215 (AD 1800–1) has arabesques against a gold ground.[141] Hence, it would appear that the taste for inscriptions and arabesques against a gold ground was particularly prevalent between *circa* 1770 and 1810, a period which includes both the last years of the Zands and the early years of the Qajars.

The small knife, A.11, is of interest firstly for its fine watered-steel blade, and secondly for its grooved steel handle. The latter was evidently made of two parts – the

134. *Oriental Splendour* no.139; Alexander (1992) no.83. According to the catalogue entry for the former, the signature on the *pishkabz* should be read *'amal-i 'Ali Akbar Tabrizi*. However, the published photograph shows clearly that it should be read *'amal-i kamtarin 'Ali Akbar*. There is thus no evidence that 'Ali Akbar came from Tabriz. The decoration is virtually the same on the two knives; the signatures are very similar, but on the *pishqabz* the *kafs* have curious terminal wiggles.
135. *Oriental Splendour* no.135.
136. Moser collection no.325, length of blade 12.5 cm; unpublished. It is probably the remains of a *pishqabz*; this would account for the curve of the back.
137. Zeller and Rohrer (1955) no.209 pl.XLVIII.
138. *Islamiske våben i dansk privateje* (1982) no.76.
139. Zeller and Rohrer (1955) no.190 pl.XLV.
140. Falk (1985) no.331. The examples cited are the tip of an iceberg: see, for example, *Oriental Splendour* nos 144–45; Welch (1979) p.79.
141. Welch (1979) no.66.

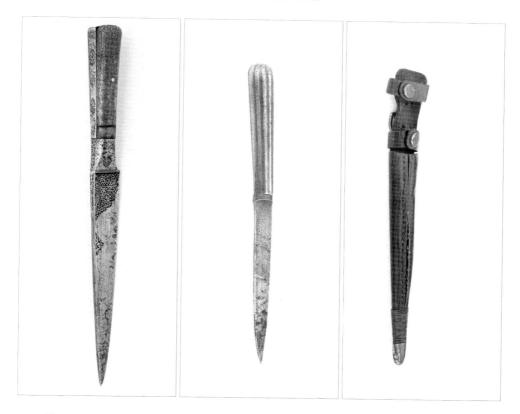

A.10 Dagger; chiselled; ivory scales; l. 33.5 cm; probably Isfahan, dated AH 1024 (AD 1615–16); no.345
A.11 Dagger and scabbard. Dagger: watered; cut and brazed; l. 24.1 cm; 18th–19th century; no.146

cylindrical body and the domical end – brazed together. Steel handles are sometimes found on larger knives and daggers, for example on a small number of 18th- and 19th-century *khanjar*s,[142] where they continue an earlier tradition exemplified by a 16th-century dagger previously in the Lamm collection.[143] These hilts are normally made in two halves and then fitted around the tang. Steel hilts are also occasionally found on *kard*s, witness two examples in the Khalili collection, one of which has a hollow hilt filled with eight small implements including files and picks.[144]

GUNS AND RELATED EQUIPMENT[145]

The earliest gun used in Iran was the arquebus. This had been developed in Europe in the 16th century, on the basis of the handgun, and utilised a slow-burning piece of

142. For example, *Oriental Splendour* no.145.
143. Sarre and Martin (1911) Taf.241 Nr.256.
144. Alexander (1992) nos 85–86.
145. Technical terms referring to guns and their

twine which had previously been soaked in saltpetre and then dried. The owner of the gun thus had a constant source of ignition. The most important improvement in the 16th century was the serpentine, a movable s-shaped clamp holding the smouldering slow-match, which was connected to a trigger. When the trigger was pulled the burning end of the match dipped into the priming powder, and the resulting flash ignited the coarse powder in the touchhole and discharged the piece. In the last half of the 16th century, for tactical reasons, the arquebus was replaced by the heavier musket. The musket, however, utilised the same matchlock mechanism.

When exactly firearms reached Iran is unclear. We know that the Venetians tried to send firearms to the Turkoman ruler, Uzun Hasan, in 1471, and cannons and matchlocks were used in the battle between Sultan Khalil and Ya'qub near Tabriz in AH 883 (AD 1478). Cannons were also used in Ya'qub's Georgian campaign of 1490. There is also evidence that Sultan Ya'qub had a bronze cannon cast at Mardin.[146] Firearms were therefore known and used in Iran by the end of the Turkoman era. However, firearms were probably first used on a large scale by the first Safavid Shah, Isma'il, who, after his defeat at Chaldiran, set about creating artillery and arquebus units of his own with the help of Ottoman deserters and the Portuguese. Thus, Afonso Albuquerque records a Portuguese diplomatic gift to Isma'il in 1515 which included one short cannon, one gun (*cao*) of metal and half a dozen matchlocks.[147] By the end of 1517 Isma'il had managed to equip 3,000–4,000 arquebusiers.

Sir Thomas Herbert attributed the first use of muskets in Iran to the Portuguese: 'The use of Musquets they have had only since the *Portugals* assisted King Tahamas [Tahmasp] with some Christian Auxiliaries against the *Turk*, so now they are become very good shot.'[148] There are a number of other references to their use from the 1520s onwards under Tahmasp,[149] though Frankish guns and cannons are also in evidence.[150]

From the second half of the century, the Iranians were casting their own brass cannons in quantity. According to Eskandar Beg Monshi, a cannon used by the Safavid troops at the siege of Tabriz in AH 992 (AD 1584) could hurl a ball weighing some 97.5 lbs, and when this was captured by the Ottomans the Iranians were able to cast a new one which could hurl a ball weighing over 163 lbs.[151] References to

parts recorded from an old gunsmith in the Shiraz bazaar were published by Wulff (1966) pp.59–60. They are not repeated here.
146. Minorsky (1957) pp.36, 51, 115–16.
147. Albuquerque (1975) vol.4 p.175.
148. Herbert (1677) p.298.
149. Elgood (1995) p.116; see also Minorsky (1943) p.33 quoting the *Ahsan al-tawarikh*; Eskandar Beg Monshi (1978) vol.1 p.164 says that Tahmasp gave the Emperor Humayun muskets decorated with jewels.
150. Eskandar Beg Monshi (1978) vol.1 pp.89 and 116.
151. Eskandar Beg Monshi (1978) vol.1 pp.452–53.

cannon-founding continue in the 17th century.[152] The Iranians also valued Ottoman or Portuguese cannons, and those captured from the Portuguese on Hurmuz in AH 1031 (AD 1621–22) were particularly praised by Eskandar Beg Monshi.[153]

Vincentio d'Alessandri makes it clear that the Iranians were also manufacturing their own guns, and comments both on the excellent quality of the barrels and their length: 'the barrels ... are generally speaking 6 spans long, and carry a ball of little less than 3 oz weight.'[154] Mannering, who accompanied Sir Anthony Sherley to Iran, also commented on the quality of the barrels,[155] and in the mid-17th century Manuel Godinho was amazed at their length – one he saw was no less than 15 spans long.[156] The fine damask on Iranian gun barrels was also noted by Kaempfer.[157]

Guns were already being depicted in Iranian miniature paintings of the early 16th century.[158] In most such paintings the scale is too small for a gun's identifying features to be included,[159] and where it is, in theory, big enough, there is no certainty that they will be shown.[160] However, one excellent illustration of a matchlock is to be found in a late 16th-century miniature in the John Rylands Library, Manchester depicting two soldiers of Shah 'Abbas.[161] Two more are to be seen in a drawing by Riza-i 'Abbasi.[162]

As to the quality of Safavid guns, Jean Chardin made some interesting comments:

'The Persians make also very well the barrels of Fire-arms, and Damask them as they do the Blades but they make them very heavy, and cannot avoid it: They bore[163] and scower them with a Wheel, as we do, and forge and bore them so even that they almost never burst. They make them alike strong and thick all along, saying that the Mouth of the Gun being weak, the Report shakes it, and communicates the wavering Motion to the Bullet. Thats the reason, that if their

152. Eskandar Beg Monshi (1978) vol.2 pp.835, 872, 902–3, 997.
153. Eskandar Beg Monshi (1978) vol.2 p.1204: 'among the captured weapons were several large cannon and siege guns of various sizes, cunningly wrought by skilled Portuguese craftsmen. Each one was a masterpiece of the art of the Frankish cannon founders.'
154. Thomas and Roy (1873) p.227.
155. Denison Ross (1933) p.222.
156. Correia-Afonso (1990) p.103.
157. Kaempfer (1977) p.255.
158. See, for example, Gray (1979) pp.149–50, dated 1510.
159. Such depictions are common in the late 16th century in Iran and India, e.g. in a manuscript of 1582 in Colnaghi (1976) no.24ii; and in an India Office Library Bukhara manuscript of 1593, Robinson (1976) no.910. See also note 16, below.
160. Luschey-Schmeisser (1981) pls 2 and 6 illustrate a Safavid tile-panel with hunters armed with unidentifiable types of gun.
161. Robinson (1980) no.820.
162. Pope (1938–39) pl.917A; for two other 17th-century examples see Grube (1967) figs 3–4.
163. According to du Mans they used a drill bit known as a *burghu*, or worm, to drill the gun barrel: see du Mans (1890) p.205.

guns be thicker, they carry the shot further and straighter. They soder the Breech of the Barrel with the heat of the Fire, and reject Screws, saying that a Screw Breach going in without Stress, may be thrust out by the Violence of the Powder, and it is not to be rely'd on.'[164]

Turning to gun mechanisms, Chardin continues his description of gunsmithing:

'They do not understand very well how to make Locks or Springs; those they put to their Fire-Arms, are very unlike ours; for they have no Steel, the Pan is very fast, being all of a Piece with the Barrel, the [missing word] which moves along a small rough Iron Branch, that comes out of the Inside of the Gun, and moves backward, that is toward the But-End, on the Pan, but quite contrary to it; the Pan is usually no bigger than the little Finger Nail, without Snap-hounce; and most Pans are rough within, like a File, that the Prime may stick the better to it. They do no understand how to Mount Fire-Arms, and do not observe the Rules of Staticks, but make the But-End small and light, which is the Reason that their Guns are light at the Breech, and heavy at the Muzzle.'[165]

A.12 is the trigger of a matchlock gun. Published examples of such triggers are on Turkistani and Indian matchlocks in the Moser collection,[166] and on an Indian matchlock in the Khalili collection.[167] A matchlock on display in the Ethnographic Museum, Tehran, shows that the Iranian style of trigger was similar. This is the form of trigger depicted on the guns in the painting of two soldiers of Shah 'Abbas, and in the drawing by Riza-i 'Abbasi, mentioned above. In contrast, flintlocks used a button-shaped trigger.[168] A.12, however, has had its original hinge broken off, and has been altered, probably to make it into a flint-striker. The present collection contains no examples of an Iranian flint-lock mechanism or trigger, but there was one in the d'Allemagne collection.[169] A.13 is the pan of a matchlock, but there is no way of dating it accurately. The taste for bird's-head ornament is once again seen, however.

The simplicity of the matchlock's design probably recommended itself to local craftsmen, and it continued to flourish in this part of the world long after it had died out in Europe. However, the matchlock had a number of weaknesses: rain could easily put the match out; sentries at night advertised their presence by the glow of

164. Chardin (1988) p.271.
165. Chardin (1988) p.271.
166. Moser (1912) pl.XXXVII nos 723 and 721, pl.XXXVIII nos 715 and 722. The Indian matchlock was evidently known by the term *turadar*.
167. Alexander (1992) no.116.
168. Moser (1912) pl.XXXVII nos 727 and 729, pl.XXXVIII nos 736, 738, 740, 741, 728 and 732.
169. d'Allemagne (1911) vol.2 p.109.

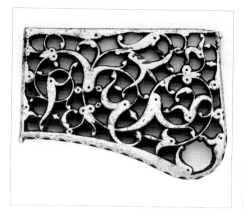
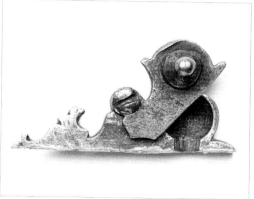

A.12 Matchlock trigger; cut, pierced and punched; l. 5.3 cm; ht 4.1 cm; 16th–17th century; no.196
A.13 Matchlock pan; cut; the lid held by a screw; l. 5.7 cm; 18th–19th century; no.529

the match; and lit matches are dangerous when there is gunpowder in close proximity. Early in 16th-century Europe came a radical improvement, the wheel-lock. Although wheel-locks were probably never used in the Near or Middle East, it is worth briefly describing the new mechanism. A serrated wheel revolved rapidly, striking a stream of sparks from a piece of iron pyrites, thus igniting the gunpowder in the adjacent pan. Along with this invention came the need for more elaborate tools, in particular a screwdriver and spanner combination for adjusting the mechanical parts, and for winding up the spring. The wheel-lock had none of the disadvantages of the matchlock, but it had its own problems, not least the expense and delicacy of the mechanism, and the relative softness and rarity of the iron pyrites.

Sometime in the mid-16th century the flintlock appeared in Europe, and, like the matchlock before it, travelled to the east (FIG 13). One of the earliest flintlocks was the miquelet lock, attributed to an Italian lockmaker who had gone to Spain at the invitation of Charles V. The two key elements in a miquelet lock were the cock, with jaws that gripped a piece of shaped flint, and the frizzen, an angled steel plate which covered the priming pan and intercepted the flint when the cock was released. The cock was pulled back against a powerful leaf spring and locked back by a 'sear' or cross-bolt. The frizzen was hinged forward, the powder sprinkled into the pan, and the frizzen then closed to protect the powder. Pulling the trigger released the sear, which allowed the cock to fly forwards, striking the flint on the flat face of the frizzen. Sparks flew, and as the frizzen was knocked out of the way the powder was exposed and ignited. A variety of flintlocks were developed in the 16th century, including the Dutch 'snaphaunce' lock, the English 'dog-lock', and similar Swedish and French locks, but the differences were in detail: the principle remained the

same. In Iran the matchlock gun continued to be used alongside the flintlock, despite the greater efficiency of the latter. George Curzon wrote: 'Conolly, Fraser, Eastwick, O'Donovan, and other writers who journeyed with the pilgrim caravans have left inimitable accounts of the perils and the panics of their pious companions … First would come the matchlock men blowing their matches, and either marching on foot or mounted on donkeys; then the genuine cavalry, with flint-locks and hayfork rests …'[170] How long the actual production of matchlocks continued in Iran is unknown, but in the early 19th century Pottinger and Fraser noted them as manufactures of Kirman. According to Fraser they were 'in request all over Persia'.[171] Pottinger is more explicit, stating that most of them were exported to Khurasan, Kabul, Balkh and Bukhara, though some also went to India, Sind, Arabia and the Red Sea. He adds that they were heavily taxed locally.[172]

Details of the manufacture of guns in the 18th century are somewhat elusive. According to Drouville, Nadir Shah was the first ruler to seriously adopt artillery, and with the help of French officers he founded pieces of various calibres.[173] He was probably well ahead of his predecessors and contemporaries in his siege artillery as a result. According to Hanway, Nadir Shah, in pursuit of naval ascendancy on the Caspian, established an iron foundry near Amul in Mazandaran, where he cast cannon-balls and bomb-shells, forged horse-shoes, and contemplated the manufacture of anchors for ships.[174] It may well be that the gunpowder factory at Astarabad, on the south-east corner of the Caspian Sea, also dates from this period.[175] Nadir Shah's naval ambitions were also probably responsible for the cannon foundry he established at Bandar 'Abbas on the Gulf.[176] It seems to have produced only two copper cannons, but it was intended to cast another three hundred. The cannon-founder who established it may have been a French engineer by the name of La Porterie.[177] Nadir Shah is also known to have had a corps of *jazayiris*, who were almost certainly armed with a long, locally produced musket, the *jazayir*, the ancestor of the *jazail*, still in use in Afghanistan in the 20th century.[178]

Though victory on the battlefield brought its own rewards in the form of captured guns and cannons,[179] it was too unpredictable to be a regular provider. The first half of the 19th century therefore saw regular Qajar attempts to persuade the Europeans to supply them with armaments, or draw on European expertise to help

170. Curzon (1892) vol.1 p.359.
171. Fraser (1834) p.87.
172. Pottinger (1816) pp.235–36.
173. Drouville (1825) vol.2 p.126.
174. Hanway (1754) vol.1 p.288.
175. Curzon (1892) vol.1 p.359.
176. de Planhol (1988) p.686.
177. Floor (1987) pp.49–50.
178. Elgood (1995) p.121.
179. For example, the five pieces of Russian artillery captured in 1827–28 by 'Abbas Mirza near Nakhchavan: Busse (1972) p.181.

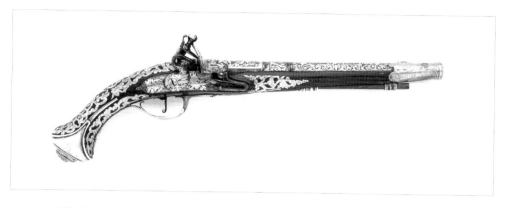

FIG.15 Flint-lock pistol; silver fittings, gold and silver overlays; l. 44 cm; dated AH 1224 (AD 1809); Ashmolean Museum, acc. no.EA1998.8

them in their production. Often this meant the use of European guns. In the forefront of this strategy was the Qajar Crown Prince, 'Abbas Mirza, who had himself studied under a French officer. He was appointed governor of Azarbaijan in 1799, and thereafter personally supervised all aspects of military affairs.[180] A French military mission in 1807–8, which included 70 artisans, master artisans, army instructors and engineers[181] was followed by a preliminary treaty with the British in 1809 and a full treaty in 1810 which offered British military equipment and armaments. When Price visited Tabriz in 1811, he found there an arsenal 'which was a miniature resemblance of a British arsenal; the cannons were numbered with English figures, and it was entertaining to see and hear English serjeants drilling the Persians in English and to hear their broken English in naming their respective guns.'[182] On that same embassy Sir Gore Ouseley presented the Iranian government with 3000 pieces of select English muskets, 20 pieces of artillery, and 40 cartridge wagons, as well as bringing with him 30 instructors and engineers. However, the treaty lasted only until about 1815. Again, in 1827 one Mirza Salih was despatched to England to secure arms, together with the payment of the arrears of the subsidy promised by the British.

Such initiatives inevitably meant the use of European guns. On his 1810–16 journey, James Morier noted near Tabriz a party of about 150 men, 'disciplined in the European manner, with English muskets and appointments [i.e. uniforms]'.[183] In the middle of the century Stuart recorded: 'The military stores [in Tabriz] are kept

180. The chronology of the various Iranian initiatives in matters military has been well compiled by Martin (1996).
181. Busse (1972) p.120.
182. Price (1825) p.62.
183. Morier (1818) p.301. Ouseley (1819) vol.3 p.443

in the arsenal under Nisbet's superintendence … The troops are chiefly supplied with English firelocks, stamped with "John Company's" lion [i.e. the East India Company's crest]; but some are armed with Russian muskets, which are longer, and smaller in the bore, than ours.'[184] In 1848 a London firm, Mills & Co., secured a large Iranian government order for 100,000 muskets.[185] The import of arms from abroad continued intermittently throughout the century, normally as a result of government orders, but also, especially in the 1880s and 1890s, through gun-running in the Persian Gulf. This latter activity proved a profitable replacement for the slave trade.[186]

Side by side with the import of foreign arms, however, went local production. Two gun barrels in the Ashmolean illustrate the late 18th-century industry. One, the barrel of a rampart gun, is signed in the gold-work by a craftsman called Abu 'Ali, for his patron, Muhammad Agha (FIG.16). The other is the barrel of a cavalry gun, and although anonymous is decorated in a style derived from that of the period of Nadir Shah (e.g. that on the armour made by Lutf'ali, FIGS 14a–b). Literary evidence also supports local production. Thus in 1804–1805 a royal decree ordered a hundred pieces of artillery from Azerbaijan and a hundred from Fars, which were duly manufactured and delivered.[187] Here too, however, there may have been substantial European influence. For example, when Morier visited the Arg in Tabriz, he found alongside guns, shot and cartridges, carpenters and wheelwrights using European tools superintended by Europeans.[188] Much local manufacture may therefore have been under European supervision.

An imaginative initiative of 'Abbas Mirza was to send craftsmen abroad to be trained by Europeans. For example, five students were sent to Britain in 1815 to study, among other technical matters, the manufacture of cannons, pharmaceutics and artillery drill.[189] A few years later Lumsden recorded: 'There is at Tabreez an European lady residing with her husband, a native of Persia, to whom she was married during his residence in England, whither he had been sent for his education by Abbas Mirza. He is a gun-smith, an excellent workman, and in other respects a man of considerable merit …'[190] Slightly later in the century, on a visit to the Tabriz bazaar, Fowler encountered the same phenomenon, perhaps even the same man: 'Beyond these were workshops for the manufacture of fire-arms, brought to very respectable perfection by one of the Persian youths sent to England to acquaint himself with the art. So ingeniously had he copied a rifle of one of the London makers,

noted several hundred English muskets and bayonets in use in the Iranian army near Erivan.
184. Stuart (1854) p.142.
185. Wright (1977) p.98.
186. Wright (1977) pp.70–71.
187. Busse (1972) p.109.
188. Morier (1818) pp.226–27. The arsenal is also described in Drouville (1825) vol.2 p.141.
189. Martin (1996) p.21.
190. Lumsden (1822) p.141.

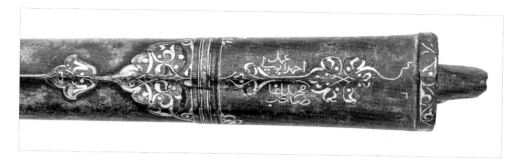

FIG.16 Gun-barrel (detail); inlaid with gold; signed *'amal abu ['a]li* (work of Abu 'Ali); total l. 114.5 cm; late 18th century; Ashmolean Museum, acc. no.EA1998.37

FIG.17 Gun-barrel (detail); cut and inlaid with gold; total l. 74.5 cm; late 18th century; Ashmolean Museum acc. no.EA1997.177

that I was completely taken in by it. He had engraved the name in steel letters, and, Persian like, had sold some of them as "London guns." This he related to me with great glee, quite unabashed. "Real London," said he, "although made at Tebreez".'[191] Yet another variant was the production of guns of mixed origins. In 1857 Robert Binning wrote of the Isfahan industry: 'The best gun-barrels are brought from Georgia, and they are fitted here with common English flint musket locks, and stocks of coarse walnut, or *cheet* wood.'[192] Elgood draws attention to the fact that many Iranian guns have Tower or East India Company flintlock mechanisms on Iranian stocks with Iranian barrels, and notes a magnificent flintlock carbine of mixed origin in the Iranian Crown Jewels with Parisian lock and mounts, Circassian walnut forestock, mounted with precious stones in the Iranian style, the gold, enamel and gem decoration being by an Iranian craftsman, Haji Muhammad Haft Khan.[193]

191. Fowler (1841) vol.1 p.264.
192. Binning (1857) vol.2 pp.130–31.

193. Elgood (1995) p.123.

Gunsmithing in Iran in the first half of the 19th century was not confined to Tabriz. Scott Waring mentioned a gunsmith in Shiraz who made pistols 'nearly equal to those in Europe',[194] and a gunsmith by the name of Reza was recorded there by Hasan-i Fasa'i in the year AH 1255 (AD 1839–40).[195] An unpublished cannon, the so-called *Tup-e Naderi*, now in the courtyard of the Foreign Ministry in Tehran, was made on Fath 'Ali Shah's orders by Isma'il Isfahani in AH 1233 (AD 1812), suggesting that Isfahan had a cannon foundry.[196] Another centre was Kirmanshah, though whether for matchlocks or flintlocks is uncertain.[197] When Tehran started producing guns is unclear. An unpublished cannon in the Military Museum, Shiraz, is dated AH 1258 (AD 1842), dedicated to Muhammad Shah Qajar, and is signed 'the work of Ustad Husain Tehrani'. In the 1860s Polak mentions guns being made in the arsenals of Isfahan, Shiraz and Tehran,[198] the latter centre confirmed by Windt near the end of the century,[199] and in the 1880s Murdoch-Smith cited Kirind, near the Turkish frontier.[200] Elgood notes how popular Iranian gun-barrels were in the Levant in the 17th to the 19th centuries, and how Iranian craftsmen were in demand from India to Turkey and Egypt,[201] indicating that the manufacture of guns may have been more widespread in Iran itself than these limited records suggest.[202]

Not all parts of the industry flourished, however, and Drouville was scathing about the quality of the arms industry when he visited Iran in 1812–13:

'The Persians still need to fill their arsenals, which are totally empty, to cast pieces of artillery, and to procure artillery projectiles from India, whence the English have sent them. Whether for political or other reasons, they have never founded these munitions except in very small quantities at a time. Hence, the Persians lack grape-shot, shells, flints, and fuses, although all these objects are abundant in India and cost the earth in Persia. They ought to construct forges in Azerbaijan where iron mines are widespread. The environs of Aker overflow with first quality minerals: one finds there a river, wood in abundance, but in spite of that forges have not been established … It is astonishing that in a country where the mineral

194. Scott Waring (1804) p.34.
195. Busse (1972) p.265.
196. Also called the *tup-e marvari* ('pearl cannon'), this cannon was said by Orsolle (1885) p.226 to have been captured by Shah 'Abbas on Hurmuz, while its more common name of *tup-e naderi* is based on the belief that it was captured in India by Nadir Shah. When Orsolle visited Tehran it occupied an elevated area between the fountain and the Nigar-i Khaneh arcade in the Maidan-i Shah.
197. Porter (1821–22) vol.2 p.201.
198. Polak (1865) vol.2 p.172.
199. Windt (1891) p.86.
200. Murdoch-Smith (1885) p.71.
201. Elgood (1995) p.119.
202. A list of towns with street names which include a bazaar of the gunsmiths, or a bazaar of the flint-makers, of which Hamadan is one example, would bring others to light.

can be 85–90% metal, one is obliged to make use of projectiles of copper, which are far less effective that those of iron, and cost an exorbitant price, since the bullets of 12 and the shells of 6 inches, the most common calibres in Persia, each cost 50 francs. Grape-shot, lacking iron, is of lead, thus by its weight and malleability lacking the principal merit, the ricochet. Powder is made very badly, in small quantities, and in a dangerous way …'[203]

For the earlier 19th century the only evidence of Isfahani gunsmithing is the cannon made by Isma'il mentioned above, though Morier noted the making of gunpowder there, which assumes a somewhat more wide-ranging industry.[204] However, of the Isfahan industry later in the century we fortunately know a considerable amount from two particular sources. First, from the middle of the century, there is a short but important description by Binning, of which part has already been quoted: 'Firearms are manufactured in Isfahan but not in any great quantity. The best gun-barrels are brought from Georgia, and they are fitted here with common English flint musket locks, and stocks of coarse walnut, or *cheet* wood. Long single-barrelled guns and pistols are also made here, but the workmanship is very coarse, and they are proportionately cheap. The percussion system is little known, except to a few of the higher classes, who are fond of English guns when they can get them.'[205] Binning's comments are illustrated by a 19th-century Iranian flintlock pistol with an Iranian barrel and stock, and English lock (signed 'Forsyth'), which was recently on the art market.[206]

For the end of the 19th century, a far more detailed description, focusing on the production of flintlocks, is provided by Mirza Husain Khan in his *Jughrafiya-yi Isfahan*, completed in 1891. He writes:

'The group of the gunsmiths (*tufang saz*). Formerly there was a substantial demand in Isfahan for gunsmithing; they have a special big bazaar in Isfahan. In the time of the late Khaqan there was a master called Husain; the guns from his workshop are famous. He was better than the old renowned Russian masters. There is for instance the gun that was made for the former governor of Isfahan, the late Hajji Sultan Muhammad Mirza. With regard to guns Hajji Mustafa was (also) very good and people used to compare and contrast the work of Hajji Mustafa with the above-mentioned gun. The work of the master Husain was considerably better, because for smoothness, perfectness, polish, lustre and art (*jawhar*)[207] his work

203. Drouville (1825) vol.1 pp.37–38.
204. Morier (1818) p.156.
205. Binning (1857) vol.2 pp.130–31.
206. Christie's, 13 October 98, lot 156.
207. *Jawhar* probably refers to the watering of the steel.

was better than a bullet and this gun especially was famous. Several other outstanding guns were made for some nobles and were not inferior to Hajji's work. He had apprentices who after his death made good work. There were and still are many other masters in Isfahan. Most of them work and do repair work in Tehran workshops now, because of lack of work here.

'The group of the gunhammer smiths (*chakhmaq saz*). There was a group of them in Isfahan when there were few European gunhammers and a lot of flint. There were many good English gunhammers brought to Iran and one of them cost 15000 dinars. Master Muhammad Isfahani, the gunhammer smith, sold one for 3 tomans in the time of the late Shahinshah. One has to take into account that in Europe the different parts of the gunhammer are made separately. There the hardening of the steel of the powder horn (*qur khalq*) and the hammer (*kaman*) is done by separate groups, while in Isfahan master Muhammad did all of this himself and the other masters did it in the same way. It is already some years ago since most gunhammer smiths left Isfahan for Tehran. Some chose to go to Khurasan, Kurdistan, Fars[208] and other places; only a few remained in their hometown. If there were a demand for their work they could still make good gunhammers. Their products are marketable in Iran only.'[209]

When he refers to 'the late Khaqan' the author means Fath 'Ali Shah. Sultan Muhammad Mirza was made governor of Isfahan in AH 1240 (AD 1824–25). Hence Husain was probably working in Isfahan during the first three or four decades of the 19th century. As regards 'the late Shahinshah', this must refer to Muhammad Shah: hence Haji Muhammad flourished *circa* 1840. Haji Mustafa sounds as though he was of the next generation. Benjamin also mentions two Isfahani makers of gun-barrels, Hasan and Haji Muhammad: 'the work of each bears the name of its maker. Those of Hassan are the more elaborate; but those of Hadgi Mehmet were superior in texture.'[210] They were presumably late 19th-century craftsmen.

An important description of the manufacture of gun barrels in Iran in the second quarter of the 19th century is provided by Massalski. Entitled 'The manufacture of banded mottled gun barrels', it is worth quoting in full (see also FIG.18):

'There was in Constantinople an armourer called Khadji-Moustapha, who became famous through his skill in making gun barrels of remarkable stength with elegant mottling in relief. This type of work was introduced into Persia some

208. Perhaps the aged gunsmith interviewed by Wulff in Shiraz had come from Isfahan; Wulff (1966) pp.59–60.

209. Floor (1971) pp.107–108.
210. Benjamin (1887) p.304.

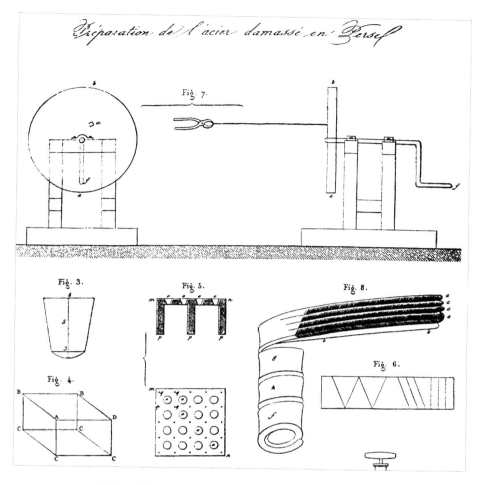

FIG.18 Massalski's drawing illustrating the manufacture of gun barrels.
After Massalski (1841)

200 years ago. This is what it consists of.

'Old horseshoes are obtained. These are drawn out into bars 2 lig. (0.0051 m) thick. These bars are welded together on their flat sides so as to form a uniform mass of sufficient size to make a gun barrel, that is approximately 1 inch (0.025 m) thick, 3 inches (0.076 m) wide and 10 inches (0.254 m) long. This mass is split lengthwise into rods which are hammered to a thickness and width of 3 lig. (0.0076 m), with a length of 13 or 14 inches (0.33 or 0.35 m), which are then turned into spirals. To do this the rods are first heated to red heat over one third of their length. The red hot end is placed in a hole **c**, approximately 3 lig. (0.0076 m) deep, made in a stone disk **ab**, [fig.7] mounted on an iron shaft, like a grinding

wheel. This stone is approximately 7 1/2 inches (0.19 m) in diameter. After placing the rod in the hole, it is seized with the tongs at the point where it ceases to be red hot, and is caused to turn by means of sleeve **f**, stone **ab** acting as a flywheel in this rotational movement. The red part of the rod then twists into a spiral. The second third of the rod is then heated to red heat and subjected to the same twisting as before, and so on until the entire rod has been shaped into a long pitch spiral which is then flattened somewhat on both opposite sides over its entire length. After four or five other rods have been prepared in the same way they are placed alongside each other, with their flattened sides together, and an iron bar of the same length as the rods, 2 1/2 lig. (0.0063 m) thick and 1 inch (0.025 m) wide. They are attached to this bar at three places by means of small iron clamps, and the whole is shaped into a spiral around an iron bar, removing the clamps as the spirals become welded to the bar. [fig.8] shows: **a**, the helicoidal rods placed on bar of iron **b**; **g**, **h** and **f**, the first three turns of the spiral. A spiral like this normally provides one third of the gun barrel. The three spirals are then welded together to form the entire gun. The work requires great patience and skill, particularly when welding the three spirals, because it is on that that all the strength of the gun depends.

'When the barrel has been forged, it is finished off using ordinary techniques. In Persia it is bored out by hand, in such a way that the bar of iron forming the inner surface of the gun to which the helicoidal rods were welded is almost entirely destroyed by the boring tool.

'After the barrel has been cleaned as much as possible, it is pickled externally with a solution of iron sulphate, as in the case of damascene blades. The pickling is repeated 3 times over 24 hours. Another clean is all that is required to reveal strong mottling in relief.

'If the iron is of good quality and the work is done with care, the guns, while being very strong, are also sufficiently thin to resound with every shot.

'The Persians sometimes make very large calibre guns; those of guns intended for the armament of fortresses go up to 15 lig. (0.0406 m). The iron bar and the rods welded onto it are in this case very much larger than those whose dimensions have been given.'[211]

Massalski's description shows that the use of iron for gun barrels was widespread. However, twisted steel rods were also used, giving the characteristic watering of many of the finest surviving pieces, for example, a barrel in the Tareq Rajab

211. Massalski (1841) pp.305–308; the translation here is by Graham Cross.

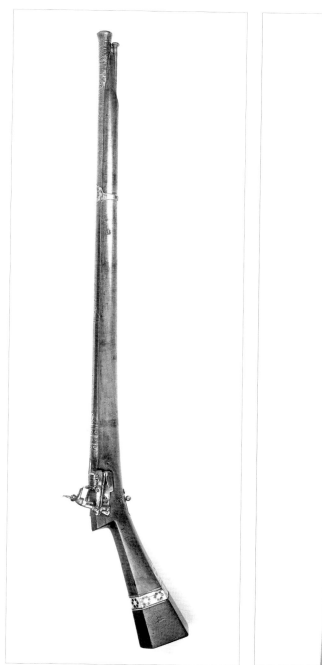
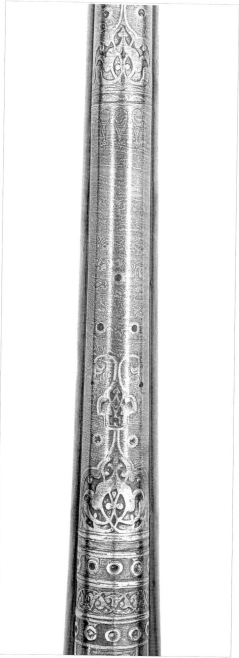

FIG.19a Flint-lock gun; Turkish stock; 17th-century watered Iranian barrel; l. 120 cm;
Ashmolean Museum, acc. no.EA1998.25
FIG.19b Detail of barrel of flint-lock gun in FIG.19a

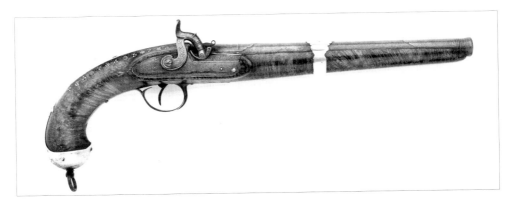

FIG.20 Percussion pistol; watered barrel with gold overlay; the lock signed by Ustad 'Ali Akbar, the barrel stamped Haji Mustafa, owner's name Husain Khan; l. 45.5 cm; late 19th century; Ashmolean Museum acc. no.EA1997.243

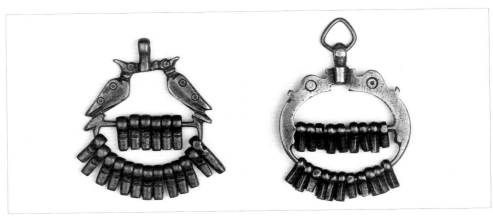

FIG.21 Two brass percussion cap holders; punched decoration; ht 6.6 cm; w. 5 cm (no.372); ht 6.5 cm; w. 5.1 cm (no.373); both late 19th century

Museum, Kuwait.[212] The mechanics of the manufacture of twisted steel barrels would have been virtually identical to those for twisted iron, though the gunsmith would presumably have begun with steel bars, thus saving a small amount of labour. Massalski's attribution of this type of gun manufacture to the Ottoman gunsmith, Haji Mustafa, is unproven, though possible. An example of Haji Mustafa's work is in the Askeri Museum, Istanbul.[213] A fine example of an Iranian barrel made of twisted rods, set into a Turkish gun, is illustrated in FIG.19a–b).

After the flintlock, the next major European development in gun technology was

212. Elgood (1995) fig.76.
213. Askeri Museum, Istanbul, acc. no.1373,
Elgood (1995) p.51.

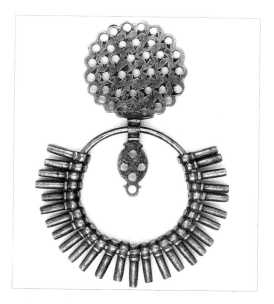

A.14 Percussion-caps holder; cut and pierced; ht 9 cm; d. of ring 5.3 cm; second half of 19th century; no.346

the percussion system, and a fine late 19th-century Iranian pistol of this type is in the Ashmolean Museum (FIG.20).[214] This technology is illustrated in the Tanavoli collection by a set of steel percussion-cap holders (A.14), which presumably date from the second half of the century. They are attached to a ring, and would have hung from a soldier's belt. Two brass percussion cap holders in the collection are also illustrated (FIG.21). Percussion caps are the result of the early 19th-century discovery and development of fulminating powder instead of gunpowder for exploding the charge in the gun: a fulminating powder detonates when struck. Mercury fulminate was first manufactured in 1800 by Edward Charles Howard, and was later refined by the Rev. Alexander Forsyth. Forsyth discovered that if mixed with potassium chlorate, mercury fulminate became sensitive enough to be set off by a flintlock cock but was not so powerful as to blow the gun apart. Forsyth also developed a suitable lock for it. Further development followed in about 1815, with the invention of the percussion tube and the percussion cap. The cap is like a small top hat. It fits over a nipple, exploding when struck, and sending burning gases down to the powder charge in the barrel. Guns using the percussion system gradually became more widespread in Iran. As the quote from Binning already cited makes clear, English percussion guns were beginning to find their way into the hands of the wealthy in

214. For another, see Christie's, 13 October 98, lot 155.

the 1850s, and by 1872, according to Mounsey, the Iranian infantry was armed chiefly with English percussion muskets,[215] while in 1892 Curzon noted percussion caps among the manufactures of Tehran. The factory had been bought in France, was run by an Austrian,[216] and had probably been set up as early as 1861–62 (see p.89).[217]

The lock in the Tanavoli collection (A.15) is probably from a percussion gun: it would certainly be unsuitable for a matchlock or flintlock. It is signed by Muhammad al-Isfahani, but whether this is the same craftsman as the one mentioned above is impossible to say. The lock must date from the later part of the 19th century.

By the end of the 19th century guns had been further developed in the West, and there was a steady demand in Iran for breech-loaded rifles.[218] Gordon writes:

'Their favourite weapon is the Martini-Henry, and there are many thousands in the possession of the nomads and villagers. This rifle, as the Peabody-Martini, was first introduced into the country during the late Turko-Russian War, when, being the Turkish army weapon, it fell by thousands into the hands of Russian soldiers, who sold them to the Persian sutlers and pedlars allowed to accompany the troops. The Persians ... sent the captured arms, which they purchased in large numbers, over the border into Persia, where they fetched good prices. A profitable trade in cartridges followed the introduction of the new rifle, and judging by the well-filled belts and bandoliers which I saw on the North-western frontier (Kurdistan and Azerbaijan), the business appears to be a well established one. In the course of time and trade this rifle found its way South to the fighting Bakhtiaris, Lurs, and Arabs, and the general vote in its favour brought about a supply of 'trade' Martini-Henry arms imported by way of the Persian Gulf, so that now in Persia what is known as the 'Marteen' has become the popular arm in private possession. The 'Remington' has its possessors and admirers among the Karun Arab tribes, who get their arms from Baghdad and Turkish sources. There is a brisk trade in ammunition for the breech-loader, and so keen is the desire to secure and supplement the supply that solid-drawn brass cartridge-cases, which admit of being used over and over again, with boxes of caps and sets

215. Mounsey (1872) p.142.
216. Curzon (1892) vol.1 p.602–603.
217. Issawi (1971) p.309, quoting Jamalzadeh.
218. It is unclear whether the rifle factory established in 1850–51 in Tehran ever achieved its projected output of 1000 rifles a month, and equally unclear how long it survived; Issawi (1971) p.308, quoting Jamalzadeh.
219. Gordon (1896) pp.49–50. Major Oliver B. St John's narrative of a journey in Baluchistan in 1872 contains an amusing passage on the problems of cartridges during hunting expeditions: '... There was the gazelle, walking quietly along, utterly unconscious of the presence of an enemy, and not fifty yards off. Of course I looked upon his head as good as in the British Museum, and resting the rifle, a double breech-loading express, on the rock, took a deliberate shot. Horrible to relate, the cap did not

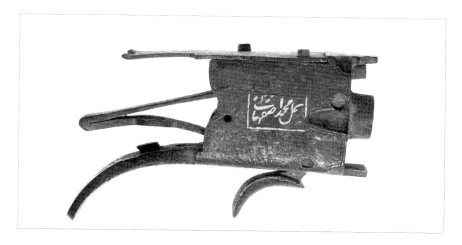

A.15 Gun block and trigger; cut, riveted and overlaid with gold; l. 8.8 cm; signed *'amal-i Muhammad Isfahani*; late 19th century; no.528

of reloading apparatus, are now in brisk demand.'[219]

Landor was struck by the fact that Martinis and matchlocks could both be purchased in the Isfahan bazaar.[220] Of more interest to d'Allemagne was the way demand for Martinis led to local manufacture there: 'The most interesting part of the [Isfahan] armourers' bazaar to visit is that where Martini guns are made. The local workmen are able to copy these arms with extraordinary exactitude, and, in order to delude the purchaser completely, they have manufactured dies allowing them to strike [onto their products] the number and name found on pieces imported from Europe. Unfortunately the material they use is utterly inferior, and the arms thus made are of very little use.'[221]

Fashion was changing fast by now, and in 1913 de Warzée recorded: 'There is an arsenal in Teheran, but no rifles are made there; the Persians generally use Lebel carbines, and the artillery are Schneider, Maxim and Hotchkiss. Some black powder is manufactured, and a little ammunition is loaded at the arsenal.'[222]

The death-blow to the local Iranian industry was in fact delivered by the country's own ruler, Riza Shah. Between 1925 and 1941, in his attempt to strengthen cen-

explode; the snap of the lock startled the antelope, which set off at a canter; and the bullet from the second barrel, as it always does in such cases, whistled harmlessly over his head. That the only *Boxer* cartridge I have had missfire should have been aimed at the only male *Gazella fuscifrons* I or any other collector have seen within shooting distance, was a coincidence that I cannot yet think of with any feeling of resignation.'

220. Landor (1902) vol.1 pp.319–20.
221. d'Allemagne (1911) vol.4 pp.91–92.
222. de Warzée (1913) p.163.
223. Wulff (1966) p.59.

tral power, he disarmed the tribes, and many townsfolk and villagers as well.[223] With virtually no market left for their products, and the inevitable competition of mass-produced Western arms for Riza Shah's own military forces, traditional gunsmiths were finally forced out of business.

Accessories

Ramrods had to be used for all muzzle-loaded guns. A ramrod would normally be carried under the muzzle of the weapon itself,[224] and the rear or tail ramrod pipe held the end of the ramrod nearest the trigger. A.16 is such a tail ramrod pipe from a pistol. A rather larger one in brass, suitable for a musket, is shown in FIG.22; this is of English design but made in India. Another unpublished steel example is on show in the Clive Museum of Indian Art in Powis Castle, Welshpool. Ramrods could also be carried on the belt, and A.17 with its hinged suspension ring is probably such an object. Similar ramrods are to be found in the Moser collection[225] and the Wallace collection,[226] and a late 17th-century painting showing a ramrod being used to load a matchlock is in the Hermitage, St Petersburg.[227] The importance of a ramrod in a muzzle-loaded gun cannot be overestimated: without it the gun could not be loaded.

Another piece of equipment of importance is the worm (A.18). This is a screw used for removing obstructions in a gun barrel, so that the gun can be reloaded and fired. This particular screw has two helices; another on show in the Science Museum, London, has three helices. There is a worm in one of the d'Allemagne collection sets of instruments.[228] A sportsman's companion described in the Bryant and May Museum catalogue has a worm combined with a fire-steel, hammer, screw-driver and corkscrew.[229]

Shot for sporting guns was loaded from a shot measure. Three types are shown here, and illustrate the way European equipment mixed freely with equipment of local, Iranian manufacture. One (A.19) is Iranian copying an English type; a second (A.20) is European but has an Iranian suspension ring attached. A third, although acquired in Iran, is English; it has an English weight ('1 ½ oz') and the words 'Sykes patent' engraved on it – Sykes was a famous English brand of shot measure (FIG.23). All of them have sprung hinged lids at both ends (though A.20 is missing one), but the spring mechanisms are inside the measure on FIG.23 and A.19, and outside on A.20. (Springs are also found on spring catches, see pp.218–20) Again, there are differences not only in the shape and size of the measures, but also in the divisions

224. Moser (1912) pls XXXVII and XXXVIII.
225. Moser (1912) pl.XXXIX, nos 787 and 788.
226. On display: nos 2036 and 2125A, the latter being suspended from a powder flask, no.2125.
227. Adamova (1996) pp.238–39, no.31.
228. d'Allemagne (1911) vol.3 p.61.
229. Christy (1926) p.35 no.450.

ARMS AND ARMOUR

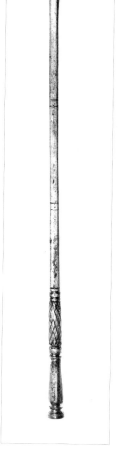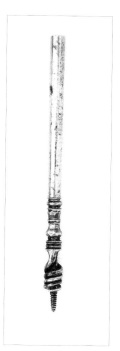

A.16 Tail ramrod pipe; cut and incised; l. 4.4 cm; 18th–19th century; no.395

FIG.22 Brass tail ramrod pipe; purchased in Iran; Indian; l.11.2 cm; 19th century; no.394

A.17 Ramrod; cut and incised; pierced and riveted handle; probably tinned; l. 41.4 cm; 18th–19th century; no.13

A.18 Worm; head with two intertwined helices twisted around a long central screw; cut; l. 12.2 cm; 18th–19th century; no.383

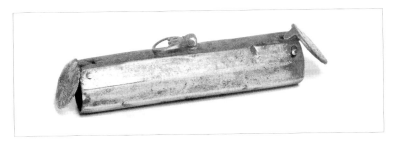

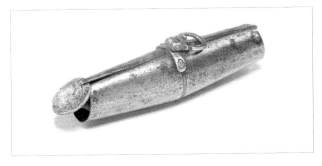

A.19 Shot measure; two riveted sprung hinged lids; pierced suspension ring; l. 9 cm; w. 2 cm; 19th century; no.216

A.20 Shot measure; two riveted sprung hinged lids, one missing; pierced suspension ring riveted to body; brazed; l. 7.5 cm; w. 2.2 cm; 19th-century European with Iranian suspension ring; no.217

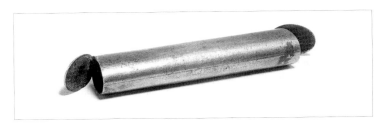

FIG.23 Shot measure; two riveted sprung hinged lids; brazed; l. 9 cm; w. 2 cm; English, Sykes, purchased in Iran; 19th century; no.52

within them. In the case of A.19 the measure is unequally divided, giving different quantities of shot at each end, whereas A.20 is divided equally. That in FIG.23 has lost its dividing wall. In all three cases the hinges work on rivets, and FIG.23 and A.20 are brazed down one side.

Powder was loaded from a powder measure. Both of the examples here have a sliding, graduated stem, enabling the powder to be measured in the desired quantity. Neither stem has its graduations specified, however: they are simply regular linear divisions. That of A.21 is divided into seven parts by a line incised across the stem, and each half is marked by a short line. That of A.22 is divided into five-and-a-

ARMS AND ARMOUR

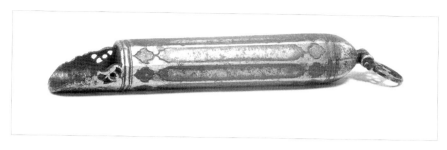

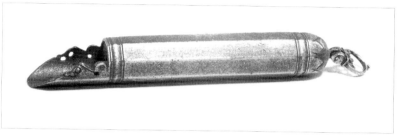

A.21 Powder measure; cut, pierced and incised; l. 13.3 cm; d. 2.1 cm; 18th–19th century; no.282
A.22 Powder measure; cut, pierced, incised and punched; l. 13.2 cm; d. 1.9 cm; 18th–19th century; no.281

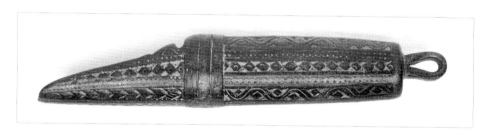

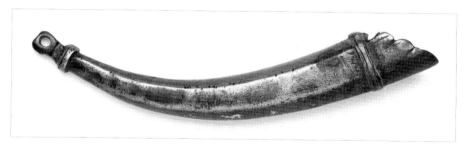

FIGS 24 and 25 Two brass powder measures; sheet metal; incised; l. 10.7 cm (no.283); l. 11.8 cm (no.284).

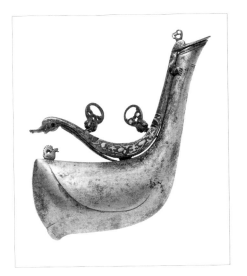 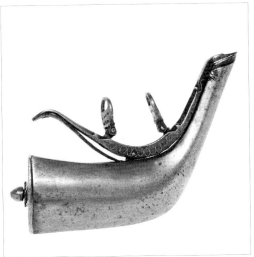

A.23 Bird-shaped primer; cut, pierced, brazed and riveted; gold overlay; spring valve;
l. 9.5 cm; ht 5.4 cm; late 18th–19th century; no.219

A.24 Primer; cut, pierced, brazed and riveted; gold overlay; spring valve and screw lid;
l. 11.7 cm; ht 6 cm; late 18th–19th century; no.51

half parts by a line incised across the stem, and each unit is divided into two parts by a short line, but each half also has a punched dot in the centre. The pierced designs on the edges of the pouring mouths confirm that both the examples illustrated are Iranian. In its design and details, including the graduated stem, A.21 is a much finer piece of workmanship than A.22, and is probably earlier. Another such powder measure was in the d'Allemagne collection,[230] two are in the Moser collection,[231] and another is in the Khalili collection.[232] In the Victoria and Albert Museum is an unusual tool which incorporates a powder-tester, a spanner and a powder-measure.[233] Brass powder-measures are also known (FIGS 24 and 25).

Containers for gun powder are commonly known in English as powder horns or powder flasks. However, strictly speaking, the name 'flask' should be confined to those used for charge powder, as the smaller containers used for carrying finer powder to prime matchlocks, wheel-locks and flint-locks are called 'primers'. Binning describes the apparatus carried by soldiers in Iran, and in the process distinguishes the two: 'The Persians usually carry the gun slung at the back; and all its apparatus is borne in a *keesa,e kemer* or waist girdle. This is a leather belt fastened round the middle, to which are attached two or three pouches for ball, shot, materials for strik-

230. d'Allemagne (1911) vol.2 p.109.
231. Moser (1912) pl.XL nos 833–34.
232. Alexander (1992) no.69.
233. North (1985) pl.15f.

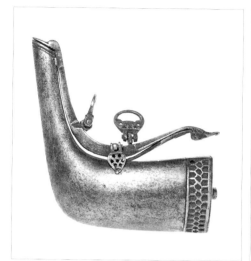 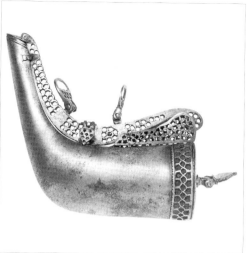

A.25 Primer; cut, pierced, brazed and riveted; spring valve and screw lid; l. 12 cm; ht 7 cm; late 18th–19th century; no.223

A.26 Primer; cut, pierced, brazed and riveted; spring valve and screw lid; l. 13.3 cm; ht 7.5 cm; late 18th–19th century; no.220

ing a light, and other odds and ends; a large powder-flask made of thick untanned hide as hard as horn; and a smaller flask, generally of metal, containing fine powder for priming. They make tolerably good powder but of coarse grain: bullet moulds are ordinarily constructed of stone: and shot is mostly imported from Europe, as well as flints.'[234]

Given Binning's final comment, a brief diversion on the subject of flints might be appropriate at this point. In the early 19th century, Drouville was as scathing on the topic as he was on Iranian firearms generally. Pointing out that there were three essential articles of war missing in Iran, projectiles, hemp and flints, he writes of the latter: 'one buys them dearly from the Armenians and Russians which traffic the length of the frontiers. It is pure negligence, for although the prince pretends that they are not to be found in Persia, I discovered an area of very good specimens in the environs of Kurdistan …'[235] The continuing inability of the Iranians to produce flints is demonstrated by the 500,000 flints included in a present from the British Government to Muhammad Shah in 1836,[236] and Binning's comment shows that the problem continued.

234. Binning (1857) vol.2 pp.130–31. The distinction is also clear from illustrations in Brydges (1834) between pp.44–45, and opposite pp.57 and 351.

235. Drouville (1825) vol.2 p.143.
236. Stuart (1854) p.312.

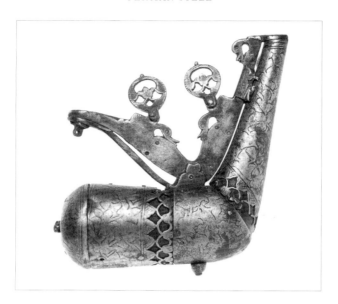

A.27 Primer; wooden with steel panelling; cut, pierced, incised and punched; steel and brass rivets; l. 15 cm; ht 10.5 cm; 18th–19th century; no.221

Returning to primers, one of the earliest and most widely distributed shapes was the horn, and the most beautiful of all surviving Islamic primers are perhaps the powder horns made of ivory, produced at the height of the Mughal empire.[237] Illustrated here are a group of rather different quality and shape: four steel, horn-shaped, primers (A.23–26), a fifth of the same shape which is of wood with steel mounts (A.27), plus two which in principle follow the horn shape but in practice take the form of a creature (A.28–29). The origin of this form is most likely to be the horn of some breed of sheep, though the fact that they all have an angled bend rather than the smooth curve of most natural horns suggests that they are a development of an earlier, more naturalistic form. No earlier Iranian examples, however, seem to have survived.[238] An example of the form in the Khalili collection, similar to the five illustrated here, is said to be of walrus ivory.[239] This seems unlikely in view of the strongly angled shape, which could not be carved from a normal, gently curving walrus tusk.

The narrower end of these primers, the nozzle, is closed by a valve hinged in the

237. See, for example, *The Indian Heritage* (1982) nos 439–40; Alexander (1992) no.115.
238. A possibly 19th-century Caucasian example of the naturalistic horn-shaped powder flask was published in *Splendeur des armes orientales* (1988) no.110. For two more Iranian examples of the angled form see Dexel (1991) pl.36.
239. Alexander (1992) no.71. This piece is said to be 'Ottoman, possibly 17th century', but in view of the many Iranian steel pieces of this form known, an Iranian origin is perhaps more likely.

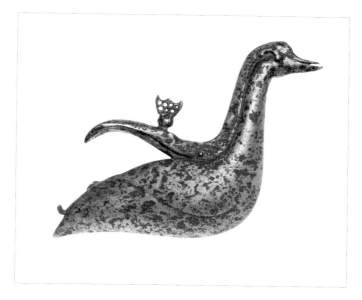

A.28 Bird-shaped primer; cut, pierced, brazed and riveted; spring valve and screw lid; l. 10.5 cm; ht 5 cm; late 18th–19th century; no.428

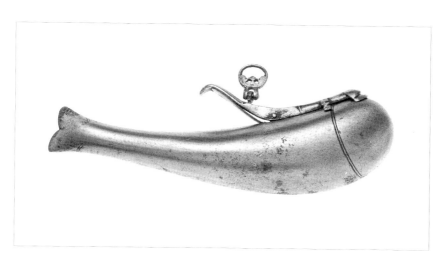

A.29 Fish-shaped primer; cut, incised, pierced, brazed and riveted; spring valve; l. 12.5 cm; ht 4 cm; 18th–mid 19th century; no.179

middle of the top of the flask and actioned with a spring underneath it, which reveals the aperture when the thumb-piece of the spring is pushed. The spring valve usually has one or more animal- or bird-headed terminals. A.23, 25, 26 and 28 have the valve terminals in the form of what appear to be long-beaked birds' heads. However, there are also two small projecting feet which give the creature a more lizard-like appearance. The other end is normally plain, though in one case it has a palmette terminal (A.25) and in another this has become dragon-like (A.23). That of A.29 is half-way between a bird and a dragon. A.27 is different, for although its spring valve is decorated with no less than five ducks, the terminals are both plain.

The form of spring valve may be an important indication of the origin of this style of primer, for it is found in 17th-century Russia.[240] Here the creature is a winged dragon, with a long reptilian body, its wings balanced by its forefeet. The Iranian craftsmen have moved the feet upwards and used them to ensure that the valve fits the aperture accurately, despite the fact that the substitution of a bird's head for the dragon's head makes such legs, and indeed the reptilian body, inappropriate. The fact that the lower terminal on A.23 has a dragon's head could also be a reflection of the Russian style, in which both ends have animal-head terminals, and the terminal on A.29 has an intriguing resemblance to the lower terminal on the Russian primer. In view of these comparisons, it seems reasonably likely that the form of primer exemplified by these steel examples was introduced into Iran through the wars with the Russians. If so, it provides a unique example of this phenomenon, despite the centuries of conflict between the two countries.

Onto the spring valves of the Iranian primers is hinged either a single or a pair of openwork suspension rings. Each horn-shaped primer also has a removable lid at the wide end to enable it to be filled easily. This lid is held in place by a screw. In the case of A.25 the screw has a screw head, and a screwdriver therefore has to be used. The screw on A.24 needs to be turned by hand, and that on A.26 has a hinged finial which makes this action very much easier. A similar lid, held by an ordinary screw, is to be found on the narrow back of the tail of the bird (A.28). The fish-shaped primer (A.29) has no such aperture and could only have been filled through the very small hole covered by the spring valve. As the latter opens a mere five millimetres, the practicality of this elegant piece is dubious. The same problem recurs in A.23. Here, however, the fact that the spring valve opens further and that the mouth is larger would have made refilling the primer possible, if difficult. All the primers are made out of one or more sheets of steel, and brazed along the joints.

Although A.26 is more elaborate than A.25, the two are so similar that they must be contemporary and from the same workshop. Two similar primers are illustrated

240. *Treasures of the Kremlin* (1998) p.50 no.30.

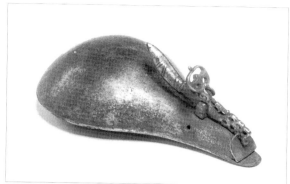

A.30 Primer; brazed; hinge and clasp with brass rivets;
ht 6.5 cm; w. 5.2 cm; 19th century; no.218

A.31 Primer; cut, incised, pierced, brazed and riveted; spring valve;
ht 10.8 cm; w. 6.5 cm; 19th century; no.222

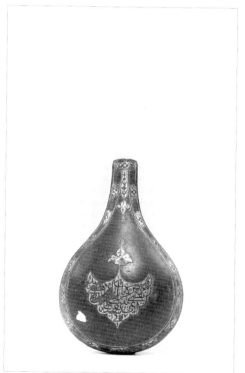
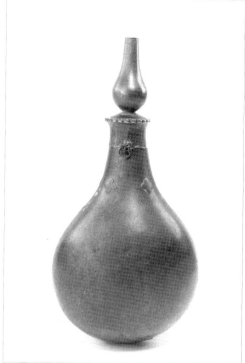

A.32 Front half of a primer; chiselled and inlaid with gold;
ht 13 cm; w. 8 cm; dated AH 1217 (AD 1802–3); no.371

A.33 Primer; watered; cut, pierced, chiselled, soldered, remains of gold overlay; small hinged valve;
remains of leather belt; ht 29 cm; w. 13 cm; 19th century; no.25

in the Moser Collection catalogue.[241] A.24 has piercing only on its suspension rings, and has a crude interlace overlaid in gold on its spring valve, but the close similarity of its form to that of the other two suggests that it is of similar origin.[242] A.23 and A.28 are both in the form of birds, though the first is so stylised as to appear at first sight to be horn-shaped. The great period of stylised birds in the manufacture of flint-strikers seems to have been the 18th to the mid-19th century (see p.446), and it may be that they belong to this period: so too the stylised fish, A.29, unless its functional problem should suggest a later date. Another primer in the shape of a fish is illustrated by Antony Welch, who unfortunately gives no reason for his mid 17th-century dating.[243] The relative crudity of the pierced work on A.25–26 makes it unlikely that they are earlier than the late 18th century. Hence A.24 is probably of the same date. The confused form of the spring valve of the flattened pear-shaped primer A.31 also points that way. A.27, on the other hand, although its workmanship is relatively crude, has a decorative emphasis on three-leaved palmettes, and could well be earlier in the 18th century. A similar Iranian primer is illustrated by Stone.[244]

A.30 is of quite different form, and has a rectangular belt-loop brazed to the back, and a hinged lid. It probably copies a European style. A.31 and A.33 are pear-shaped flasks with almost flat backs. A.31 is of similar size to the horn-shaped flasks. It has only one aperture. A.33 is much larger. Both are probably of 19th-century date.[245] A.32 is the front of a smaller flask of similar shape. Whether it had a flat or rounded back is not known. The steel appears to have been blued, and the piece is inscribed with a verse from the end of the Preface to Sa'di's *Gulistan*, and the date: 'Our [my] intention is to leave an impression behind [me]; / For I cannot see our [my] existence as eternal. In the year 1217 [AD 1802–1803].' This provides valuable dating evidence for objects with similar relief designs and gold inlays. A complete primer of very similar form, but with a rather different style of gold inlay and decorative design, is in the al-Sabah collection.[246] This latter piece bears a polylobed palmette which encloses half of the same verse from Sa'di, a verse which evidently provided an appropriate link between the gunpowder in the primer and the death which resulted from its use. The same verse occurs on a knife in the Khalili collection,[247] so it was presumably deemed suitable for a variety of weapons. A primer of related form, but rather slimmer and more elegant, is attributed to 19th-century India.[248]

241. Moser (1912) pl.XXXIX no.801, pl.XL no.802; see also Stone (1934) fig.660 nos 5 and 19 p.516; another was sold at Sotheby's, London, 10 October 90, lot 355.
242. A silver powder flask of similar form is illustrated in *Splendeur des Armes Orientales* (1988) no.109 p.69 where, however, it is described as 'Caucasian'.
243. Welch (1973) p.96 fig.68.
244. Stone (1934) p.516 fig.660 no.2.
245. See Stone (1934) p.335 fig.421 no.5 for a similar powder flask being worn on a belt with various pouches and loading implements.
246. It is attributed to 17th-century India: Atıl (1990), no.94 p.276.
247. Alexander (1992) no.86.
248. Alexander (1992) no.139.

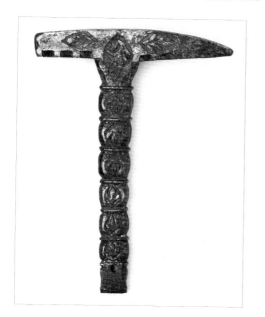 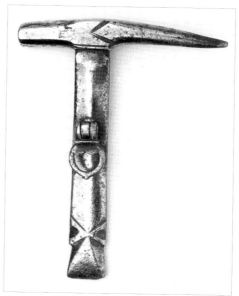

A.34 Multi-purpose instrument: screwdriver, pick and hammer; cut and chiselled;
l. 8.5 cm; 18th century; no.204

A.35 Multi-purpose instrument: screwdriver, pick and hammer, with suspension ring; incised;
l. 8.4 cm; 19th century; no.168

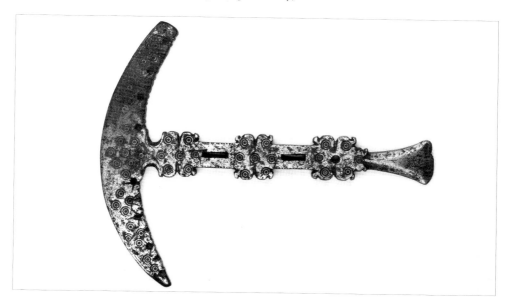

A.36 Multi-purpose instrument; screwdriver, pick and hammer; cut, incised, pierced and punched;
inlaid with punched brass rings; l. 15.3 cm; w. 12.5 cm;
perhaps Afghanistan, 18th–19th century; no.166

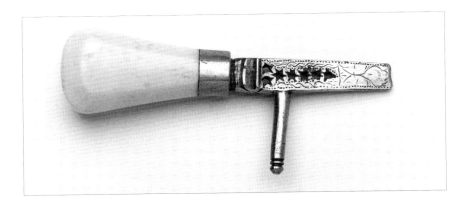

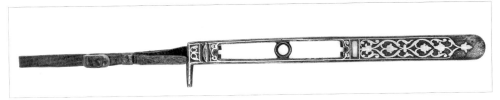

A.37 Screwdriver with pick; cut, pierced and chased; ivory handle and brass bolster; l. 9.2 cm; mid–late 19th century; no.404

A.38 Screwdriver and pick; cut, pierced and overlaid with gold; leather sling with brass fittings; l. of screwdriver 7.7 cm; mid–late 19th century; no.356

Many Iranian soldiers or huntsmen also carried a multi-purpose implement in the shape of a small hammer. The end of the shaft was often, though not always, manufactured to act as a screwdriver. The head end normally had a point balancing the hammer-head itself. A hole in the body, or a suspension ring attached to the body, enabled one of these implements to be slung on the belt. Where there is no sign of a suspension mechanism they were presumably carried in a pocket or pouch.

The hammer-head was probably designed for the breaking or shaping of the flint used in the flintlock gun; the screwdriver was for loosening or tightening the various screws which controlled the firing mechanism, or for refilling the primer; the pick, it has been suggested, was either for screwing a flint into a flintlock gun,[249] or for cleaning out the vent in the gun barrel, though they are often far too thick to have served this purpose. Perhaps they were for knapping the flint in conjuction with the hammer-head.

A.36 is very like an implement in the Science Museum, London,[250] and another in the Cacciandra collection.[251] Both of these are ascribed to Afghanistan, presumably

249. Christy (1926) p.36.
250. Chisty (1926) pl.205 no.505.
251. Cacciandra and Cesati (1996) pl.43 no.238.

ARMS AND ARMOUR

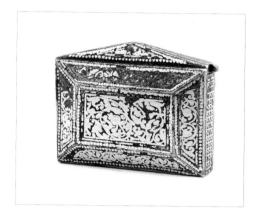 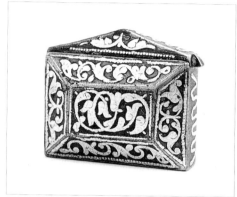

A.39 Grease box; sprung lid; brazed; silver inlay, gold overlay;
ht 3.3 cm; w. 4.2 cm; 19th century; no.341
A.40 Grease box; sprung lid; brazed and inlaid with silver; ht 3.6 cm; w. 4.2 cm; 19th century; no.342

because they were acquired there. The dating is uncertain but presumably 18th–19th century. The small plant motifs which decorate A.34 suggest an 18th-century date rather than a 19th-century one; A.35 is probably 19th-century.

A.38 is of a completely different form. It is long and rectangular, its rounded lower end has been filed down, and it has a pick projecting at right-angles from the top; its edges have been deliberately roughened by diagonal striations. This too is a screwdriver for a gun or pistol, combined with a pick, and its long sides would have been used for striking flints. Comparable pieces are to be found attached to a Caucasian leather belt in the Moser collection,[252] and in the Science Museum, London.[253] One of the latter is pierced with several large square and rectangular holes (apparently intended for use as nipple-screws) along its median line. Others of this type are illustrated by Gluck.[254] Nipple-screws would imply use with percussion caps, and hence a date in the mid- or late 19th century.

The star-shaped holes in A.37 could also have been nipple-screws. The imple-

252. Moser (1912) pl.XXXIX no.766.
253. Christy (1926) pl.203 nos 468 and 471, and p.36.
254. Gluck (1977) p.153 nos A–C.

ment clearly combines screwdriver and pick again, though here the ivory handle and brass bolster suggest a more wealthy clientele. A similar piece is on display in the arms section of the Pitt-Rivers Museum, Oxford.

Another necessary item of equipment for the more sophisticated guns was a grease box. Two grease boxes are included in the Tanavoli collection (A.39–40). They are virtually identical in form, though A.40 has three brackets on the back, and A.39 only two. Both have a narrow lid with a very strong steel spring to prevent the contents leaking out. Their identification is suggested by a small rectangular grease box attached to the Caucasian belt, already mentioned, in the Moser collection,[255] and that on the belt in the Tanavoli collection (p.225).

From all that has been said, it is clear that Iranian soldiers carried a wide range of equipment. Scott Waring gives a graphic description of an Iranian soldier *circa* 1800: 'The horses groan under the weight of their arms. These, consist of a pair of pistols in their holsters, a single one slung in their waist, a carbine, or a long Turkish gun, a sword, a dagger, and an immense long spear. For all these fire arms, they have separate ramrods tied about their persons, powder horns for loading, others for priming, and a variety of cartouch boxes, filled with different size cartridges ... I should really suppose, that their saddle and arms, would weigh about eighty pounds, an enormous addition to the horses burthen.'[256] Travellers' accounts also make clear the shortages and variations in equipment quality experienced by the soldiers. Drouville, noting the poor equipment of the army when 'Abbas Mirza took over, describes how the latter had to adapt bayonets to any guns that would take them and repair any old arms left by Nadir Shah. There were no cartridge pouches, so each soldier was given a little copper sack to hang from his belt to put his cartridges in, which was both dangerous and inconvenient.[257]

LANCES, SPEARS AND JAVELINS

Little is known of the history of lances, spears and javelins in Iran. Stocklein's summary of the evidence in 1938–39 has yet to be improved upon.[258] The earliest mention of lances among Western travellers seems to be that of Tenreiro in the 18th century. He writes: 'In time of war they wear ... half-lances which have tips like short

255. Moser (1912) pl.XXXIX. Anthony North at the Victoria and Albert Museum felt that these could not be grease boxes, but were more likely to be patch boxes for leather or cloth patches to put around a bullet. Others have suggested they are boxes for percussion caps, amulets or matches.
256. Scott Waring (1804) p.61.

257. Drouville (1825) vol.2 p.76.
258. In Pope (1938–39) vol.3 pp.2578–81, with editorial additions in the footnotes. See also al-Jahiz's comments on lances in his discussion of the Shu'ubiya movement: al-Jahiz (1366/1947) vol.3 pp.13–16.

ARMS AND ARMOUR

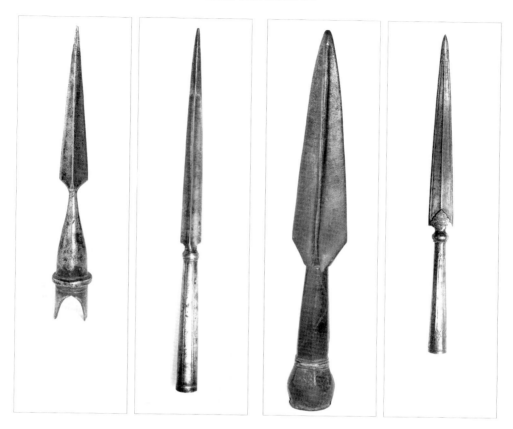

A.41 Lance head with cruciform blade; hollow ground; cut and brazed; langets broken;
l. 30.7 cm; 17th–19th century; no.20

A.42 Lance head with cruciform blade; hollow ground; cut, incised and brazed;
l. 45 cm; 17th–19th century; no.18

A.43 Lance head with cruciform blade; hollow ground; welded and incised; inlaid with brass band;
l. 46.5 cm; 17th–19th century; no.62

A.44 Spear head with double-edged blade; cut, incised and chiselled; brazed and riveted;
gold overlay; l. 39.6 cm; 17th–18th century; no.19

darts on shafts painted red and green, and small flags of coloured silk.' It is not clear from this description, however, whether the half-lances were short lances, or perhaps javelins (see below). The earliest surviving lance heads from Iran seem to be those in the Topkapı Saray, which are presumed to have been captured at the battle of Chaldiran in 1514.[259] These have round or polygonal sockets and cruciform blades, and the finest are overlaid with gold. A.41 is similar in form but undecorated, whereas A.42 is similar in its cruciform blade, but dissimilar in its cylindrical socket.

259. Pope (1938–39) pls 1429A–D, 1430B.

Neither A.41 nor A.42 has any decoration and they could date from any time in the 17th to the 19th centuries. A.43 is massive, extremely heavy and equally hard to date.

Later comments by European travellers are rare, with one notable exception, Drouville. Visiting Iran in 1812 and 1813, he described the Iranian troops. The irregulars had lances which were very light, with a pointed iron tip, a shaft usually made of flexible bamboo, thirteen to fourteen feet in length, of a hardness that could only with difficulty be cut by a sabre.[260] The regular cavalry had lances made on the European model, but lighter and longer.[261] The provincial cavalry carried guns, lances or javelins. The latter were of a single piece of iron, three-and-a-half feet long; one end terminated in a three-sided blade, like that of a very sharp lance, the other in two protrusions or buttons six inches apart. The Afsharids, he says, always carried two of these javelins in a case placed almost horizontally under the right thigh, and fixed to part of the saddle by means of a double strap. Drouville also described how they threw them, and how accurate they were with them.[262] A case containing a pair of 18th-century javelins, decorated with gold overlay, is in the Royal Armouries.[263]

Lances were carried by horsemen, whereas the pikes or spears were carried by foot soldiers. Spear heads are generally like knife blades. The double-edged spear head A.44 is very similar to one in the City Art Museum, St Louis, which is dated to the 17th century.[264] Another is illustrated in the Moser collection.[265] What remains of the chiselled decoration on the socket of A.44, and of the gold overlaid decoration on the upper part of the socket and the palmette-shaped base of the blade, suggests that the spear head is likely to be 17th- to 18th-century in date.

Two-pronged spear heads were also used by the Safavids, and are specifically referred to in accounts of the battle of Chaldiran. Again the only surviving examples of the Safavid period seem to be those in Topkapı Saray.[266] Three-pronged heads, or tridents, are also known. There are, for example, two 19th-century examples, overlaid with gold, in the Metropolitan Museum of Art, made by a craftsman by the name of Muhammad Hasan.[267] Others are to be seen in the Royal Scottish Museum and on the art market.[268] Whether they were actually used in battle, or made solely for ceremonial purposes, is unclear. A spear-bearer took part in the 'Id-i Qurban festival in Isfahan in the 19th century,[269] but again, whether his spear was

260. Drouville (1825) vol.2 p.89.
261. Drouville (1825) vol.2 p.113.
262. Drouville (1825) vol.2 p.95.
263. Royal Armouries, Leeds, acc. no. XXVII.23. Other javelins and spears, which may be Indian or Iranian, are illustrated by Haider (1991) pp.238–45.
264. Pope (1938–39) pl.1429E.
265. Moser (1912) pl.XXXV no.711.
266. Pope (1938–39) pl.1430A and C.
267. Metropolitan Museum of Art, New York, acc. nos 36.25.1934 and 32.75.289. They are just over 50.8 cm (20 in) long.
268. For example, see three sold by Ader Tajan, Hôtel Drouot, 7 novembre 1994, lot 166, measuring 54, 58 and 64 cm in length.
269. Floor (1971) pp.137–38.

more ceremonial than functional is difficult to say.

MACES

Another widely used cavalry weapon was the mace. References in the *Shah-nameh* suggest that maces were commonly of steel, and they were almost certainly solid in both shaft and head to give maximum weight and therefore breaking power. Indeed weight was in some ways synonymous with prestige, for Mahmud of Ghazneh was famed for his 60 *mann* mace, while Mas'ud's mace was so heavy (80 *mann*) than only he could lift it.[270]

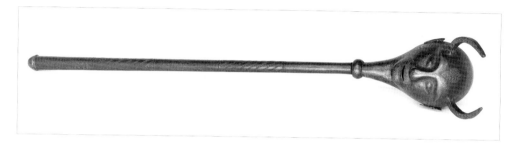

FIG.26 Mace; cut, etched and riveted; l. 84 cm; late 19th century; Ashmolean Museum, acc. no.EA1971.16

The forms of mace head varied considerably, from a simple sphere to an animal head with horns. A Soghdian mural shows a mace with a four-faced head,[271] a Saljuq silver dish shows at least three different styles, one apparently spherical, the other two more complex and asymmetrical,[272] and the *minai* dish in the Freer Gallery of Art shows on its reverse a mace with an oblong segmented head and another with a lion's head.[273] Later Iranian miniatures contain many and various examples, and the different Mamluk maces now in the Topkapı Saray may well represent types inherited from Turkish or Iranian traditions.[274] In addition, bull-headed maces are frequently specified in the *Shah-nameh* and elsewhere in Persian literature: in the *Shah-nameh* the bull-headed mace was the particular weapon of Faridun, with which he shattered the evil tyrant Zahhak's helmet.

The only iron or steel mace-head from early Islamic Iran to have been published is in the British Museum.[275] From the later period, a number of ceremonial examples are known.[276] In addition, numerous bull-headed maces have appeared in the

270. Bosworth (1963) p.120.
271. Belenitski and D'yakonov (1953) pl.7.
272. Orbeli and Trever (1935) pl.20.
273. Atıl (1973) no.50.

274. Stöcklein (1934) figs 2 and 14.
275. *The Arts of Islam* (1976) no.186, where I wrongly catalogued it as bronze.
276. Alfieri *et al.* (1974) pl.79, which is the same as

sale rooms. These, however, like the example in the Ashmolean Museum (FIG.26), and two in the Rijksmuseum,[277] seem to be late 19th-century reproductions made for the tourist market.

SWORDS

Although there is no complete Iranian sword in the Tanavoli collection, a book on steelwork with no mention of these objects is unthinkable. For centuries, indeed for millennia, they were the focus of the industry: on them was lavished the highest technical expertise. They were, literally and metaphorically, the cutting edge of the industry.

Swords and symbolism

Although swords were primarily weapons of war, many of them had a mythical or symbolic value which gave them importance far beyond their function. The most famous of all Islamic swords was Zu'l-Faqar, the sword of 'Ali. Because of its importance in the mythology of Shiite Iran it was regularly copied, as for example in Shah Isma'il I's Haydari sword, used by him at the battle of Chaldiran.[278]

Other swords had a symbolic value through their association with secular power. Some of them were presented to shrines, where they remained as evidence of the greatness of their owners. An example is the sword of Shah 'Abbas, which was still hanging in the Shrine of Fatima at Qum when Fraser visited the city in the early 19th century.[279] Other swords were passed from one ruler to the next, from conquered to conqueror perhaps, giving extra lustre to the latter's reputation. Thus it was presumably through being a prized trophy of the Qajars that the sword of Karim Khan Zand survived, complete with shagreen scabbard, and is now to be seen in the Pars Museum, Shiraz.

The sovereign's personal sword also seems to have played an important role as a symbol of legitimacy during Safavid and Qajar times. For example, on the day after the death of Shah Tahmasp, Sultan Haydar Mirza, heir apparent, placed the royal crown on his head, buckled on Shah Tahmasp's personal sword, and produced the late Shah's will.[280] In AH 1210 (AD 1795–96), the sword of Agha Muhammad Khan played an important role in the first Qajar coronation: 'the sword, which was imbued with the blessing of the shrine of Shah Safi at Ardabil, was girded round his waist. Since the time of the Safavids it was a custom to suspend the royal sword at

Vianello (1966) pl.34. An 18th-century example is in the Royal Armouries, Leeds, acc. no. XXVIC.72. For similar Indian examples see Haider (1991) pp.224–28.

277. Alfieri *et al.* (1974) pl.72.
278. Eskandar Beg Monshi (1978) vol.1 p.69.
279. Fraser (1825) p.140.
280. Eskandar Beg Monshi (1978) vol.1 p.284.

the sepulchre of Shah Safi for one night, whilst a group of sufis, during this night, offered continual praises and intercessory prayers on behalf of the king. On the following day a banquet was given, the shah girded this sword round his waist, and distributed alms among the poor.'[281] Three years after this event, in AH 1213 (AD 1798–99), 'Abbas Mirza was made Crown Prince and was given 'the robe of honour, due to the crown prince, which consists of a coat, sword, girdle, and dagger studded with jewels'.[282]

Pre-Islamic swords

Rock reliefs and surviving objects show that three types of sword were used by the Sasanians. The first was the long, straight double-edged sword with a quillon which occurs in most of the rock reliefs and which is interestingly contrasted with a Roman sword without a quillon at Bishapur.[283] This type of sword was worn on the left of the body and was supported by a single carrying strap worn round the waist (compare the Roman baldric, which hung from the shoulder across the chest). The strap was either buttoned onto opposite edges of the scabbard or attached to the scabbard by a bridge mount. The second Sasanian sword type was a short straight sword worn on the right of the body and supported in a similar way.[284] The third type is only depicted in the hunting scene at Taq-i Bustan and was a straight sword slung on the left side of the body and suspended from the belt by two separate straps, each leading to its own mount on the upper edge of the scabbard. A number of richly decorated swords of this last type have been found in northern Iran, including one short example with a very slight curve. Ghirshman[285] and Nickel[286] have shown that these swords are of a design typical of the Avar and Hunnish peoples of the Central Asian steppes. The rock reliefs suggest that this sword type was introduced into Iran late in the Sasanian period, a fact borne out by the appearance of a sword slung in traditional Sasanian fashion, and another slung in the latter fashion, in a wall-painting in the 7th-century monastery at Funduqistan in Afghanistan.[287]

A straight sword was also typical of the Soghdians, though it was by no means identical to any of the Sasanian varieties. Two main types are shown in the Panjikent murals – a very long slender variety hung on the left side of the body, and a short type attached to the front or front-left of the belt in an almost horizontal position. The longer sword was slung from the belt by a variety of means. In one mural a cord is shown running from the belt through an eye on the upper edge of the scab-

281. Busse (1972) p.68.
282. Busse (1972) p.89. A jewel-studded sword and girdle were sent to Mohamed Mirza when he was made Crown Prince in AH 1250 (AD 1834–35); see Busse (1972) p.228.
283. Ghirshman (1962) fig.197.
284. Orbeli and Trever (1935) pl.7.
285. Ghirshman (1963).
286. Nickel (1973).
287. Hackin *et al.* (1959) fig.199.

bard, then through another eye on the side of the scabbard slightly lower down, and ending at a third eye opposite the first.[288] In these cases it is not clear whether the rosette shown is the top of the scabbard or part of the hilt. In another mural the sword scabbards appear to have twin mounts, and one assumes that the cords were used to attach these to the belt as in the mural from Mug.[289] In other cases, where the swords are depicted with neither twin mounts nor eyes, and only a rosette where hilt and scabbard join, the form of suspension remains a mystery.[290] A Soghdian silver dish shows a scabbard with twin suspension mounts,[291] and such mounts seem to have been the rule for the short sword carried at the waist. Neither long nor short swords seem to have been equipped with quillons; on the other hand fairly elaborate hilts were often employed, some straight with a pommel, others plain but curved, still others curved and ending in an animal head.

Early Islamic swords

The first, and only, detailed account of early Islamic swords is that of al-Kindi in the 9th century.[292] Without going into the details of the different sword categories which al-Kindi develops, which will be discussed in detail in our forthcoming translation and annotation of his text, it is sufficient to draw attention to five particular Iranian sword types which he describes.

First are Khurasani swords made from Khurasani iron of a sort called *muharrar*, the manufacture and form of which are described as follows:

'that one is manufactured in Khurasan in the shape of the Qal'i. And it is covered with small knots side by side from top to bottom, made with a chisel, then polished with a polishing stone until smooth, and then lines show [in its knots] following each other as in the Qal'i sword. Its watering is black, and the widest of them is two and a half fingers wide, and the watering does not appear until the etching compound has been thrown onto the blade. In cases where some of the watering does appear before the etching compound has been thrown onto the blade you see that the iron is dark and soft following one another. Its characteristics are that its tang has been delicately pierced, that it is forged like a Qal'i sword, and that its price can reach 30 dirhams.'[293]

Second are the *salmani* swords, made apparently in Transoxiana. The most

288. Yakubovski *et al.* (1954) pl.36.
289. Yakubovski *et al.* (1954) pls 5, 10 and 12.
290. Belenitski and Piotrovski (1959) pl.7.
291. Orbeli and Trever (1935) pl.21.
292. The Arabic text was edited by Zaki; see al-Kindi (1952). A full translation and commentary, by James Allan, Brian Gilmour and Robert Hoyland, will be published as Oxford Studies in Islamic Art, volume XXVI.
293. al-Kindi (1952) pp.11, 33–34.

important *salmani* swords were *al-salmaniyat al-sughar* (the 'small *salmanis*'), which were long and slim, and had a watering which was curly and visible without the use of any etching compound. Both ends of the blade were the same width, the tip being a flat point as opposed to the characteristic Yemeni conical point, and the tang being like the Yemeni tang and therefore presumably square. The small *salmani* swords often seem to have been manufactured to look like either Yemeni or Qal'i swords, and their exact lengths and types of watering were adapted to this end. Wide *salmani* swords were known as *bahank* or *bahanaj*. These were four spans long, and weighed 3–3 $\frac{1}{2}$ *ratl*, but al-Kindi has differing opinions over their width, which he once gives as three to four fingers and once as four. The latter must be the correct figure since *ruthuth* swords were four fingers wide or just under. *Ruthuth* was another type of *salmani* sword, which was characterised by having a stamp on the tang giving the name of the manufacturer. These swords were four spans long, and had excellent backs, beautiful tips and wide tangs. Their weight was normally 4–4 $\frac{1}{2}$ *ratl* but occasionally 3 $\frac{1}{2}$. The removal of the maker's stamp and the addition of an etching compound to the surface enabled these swords to pass as Qal'i pieces among the polishers of Khurasan, Mawsil, Yemen and Jibal, such was their quality, though the Iraqi sword-polishers could evidently tell the difference.[294]

Another type of Khurasani sword was made on a *sarandibi* (Sri Lankan) model. Unfortunately al-Kindi does not give either the size or the essential characteristics of *sarandibi* swords, though it would appear that the Khurasani variety was distinguished by the use made of oak or tamarisk charcoal for producing the steel. The watering on all *sarandibi* swords was brought out by throwing onto them a suitable etching compound, and the resulting effect seems to have had yellow predominating. A further *sarandibi* type, the *farsi*, was made in Fars from Sri Lankan cakes, as was also the case with the *mansuri*, made at al-Mansuriyya, capital of Sind. From al-Kindi, it would also appear that some people in Fars used to take the swordsmith local pieces of ore from which *sarandibi*-type swords were then made. He adds that due to their being locally manufactured, some Fars swords had a wider watering (i.e. were of poorer quality) than good *sarandibi* swords.[295]

Another variety of sword produced in Fars is mentioned by al-Kindi, who associates it, and a related Kufan type, with a group distinguished by the term *baid*, which may refer to the colour ('white') or to the form of steel ingot used ('egg'). This Farsi variety was three fingers wide, and while the length of both Farsi and Kufan swords averaged about three spans and four open fingers, the Farsi type was three fingers longer than the Kufan. The Farsi type also had a longer, thicker, and wider tang,

294. al-Kindi (1952) pp.25–28. For Tarsusi's description of how *salmani* steel was made, see Cahen (1947–8) p.107, and above, p.64.
295. al-Kindi (1952) pp.10, 28–30.

and was usually about a third less in price for the same weight and length of sword. Its watering was wider but not so pure as the Kufan. The characteristic of the type as a whole seems to be that it had a slim tang narrowing towards the top, two holes pierced in the tang, and a blade with a sharp point which was in fact heavier than the end of the blade attached to the tang.[296]

Unfortunately, al-Kindi is the only writer to deal with swords in detail, and all other information has to be derived from less comprehensive sources. Even al-Kindi, it will be noted, does not give all the details, and on one important point – the question of whether there were any curved swords in his day – he remains silent. There is one possible allusion to curved swords in his *Risalat*: in talking about Yemeni swords, he refers to a type rendered by the editor of the text, Zaki, as *qaljuri*. al-Kindi describes it, again in Zaki's reading of the passage, as *haqal* – long and curved. The shape of a *qaljuri* sword was indeed long and curved, but the text is not as clear as one would like. The manuscripts use the following terms at this point – *uri, quyuri, 'unuri,* and *qubuzi*, and for the word *haqaf* read *khafaf*. The latter reading, meaning light in weight, is incidentally supported by al-Kindi's remark embedded in this part of the text that these swords weighed 2 *ratl* or less. On the other hand, as the Nishapur evidence makes clear, the long, curved cavalry sabre was already in use in the central Islamic lands in the 9th century, so the question of how to interpret al-Kindi's text remains open.

It is appropriate now to discuss the Nishapur sword in slightly more detail.[297] Discovered in the excavations carried out by the Metropolitan Museum of Art at the medieval site of Nishapur in 1941, the sword consists of a long, slightly curved, single-edged blade with cross-guard attached; the upper part of the hilt, two gilt-bronze mounts on the remains of the wooden scabbard, and a ring attached to a boss-like plate were also found. The grain of the wood of the surviving part of the hilt shows that the hilt was originally curved, and hence that the sword was a weapon for slashing rather than thrusting. The ring must have thus been for a leather wrist-strap. Comparison with swords found in the Altai, the Caucasus and Russia suggests that the Nishapur sword is of a form which spread westwards across Asia into Europe in the 8th and 9th centuries, possibly as a result of Avar migrations. The sword itself is likely to be 9th-century in date, and is thus important as the earliest archaeological evidence that the curved slashing sword was known in the Islamic world in the Abbasid period.

The pictorial evidence for the development of Iranian swords in the ensuing cen-

296. al-Kindi (1952) pp.31–32.
297. For a full discussion see Allan (1982) pp.56–58. Here I maintained that the blade was straight. However, the published photograph, and the chance to re-examine it in 1996, suggest that I was wrong, and that it is very slightly curved. For the quality of steel used see above, p.54.

turies is extremely limited, partly because until the 13th century there is so little pictorial evidence of any kind. Two basic observations may be made, however: twin suspension mounts became standard,[298] and by the 13th century curved swords were dominant.[299] The earliest illustration of a curved blade is in the 10th-century Nishapur wall-painting of a horseman, now in the National Museum in Tehran, and the shape's growing popularity is confirmed by the literary sources, particularly in the Ghaznavid period.[300]

The next datable blade after the Nishapur sword is a watered-steel blade in a private collection which can be attributed to Khurasan in the period *circa* AD 1200.[301] The slightly curved blade is single-edged, except for the part nearest the tip (roughly one quarter of the length), which is double-edged. This is the earliest example of the style recorded, and establishes the long history of this well-known sabre form.

Later Iranian swords

The curved sabre was destined to remain the dominant style of sword in Iran from Il-Khanid to early Safavid times. From the 17th century onwards, however, it was rivalled in popularity by the *shamsir* or 'lion's tail', which has a much deeper curve than the sabre. The earliest depiction of the *shamshir* is in a manuscript dated 1567,[302] but it seems to have become widely used only in the reign of Shah 'Abbas I, appearing in Isfahan manuscripts early in the 17th century,[303] and thereafter in a steady succession of 17th-century miniatures.[304] It is also depicted in 19th-century scenes, for example in a painting of the court of Fath 'Ali Shah of *circa* 1815.[305] In all these paintings, whether of men on foot or horseback, the *shamshir* is shown hung in the reverse direction to the earlier sabre, i.e. with the concave side of the blade facing forwards. The only exception is the 1567 miniature, suggesting that a change in suspension of the *shamshir* took place in the late 16th century. It presumably reflected a change in use, for the later *shamshir* was intended for the drawcut rather than for slashing.

The problem of forgeries among surviving swords and sword blades has been discussed elsewhere, but the consequence is that blades definitely datable to the Safavid period are very rare.[306] It is therefore worth drawing attention to a small number for which there is evidence of authenticity, as a basis for a future survey of

298. See, for example, Allan (1979) pl.8a.
299. Allan (1979) pp.88–89.
300. Allan (1979) p.90.
301. Haase *et al.* (1993) no.123, pp.186–87.
302. Wiest (1979) p.75 fig. at bottom right.
303. Stchoukine (1964) pl.XII, c.1600; Robinson (1976) p.200 no.1026, p.203 no.1047, both of 1604.
304. For example, Colnaghi (1976) no.46xxvi, of *circa* 1625; Titley (1983) pl.17, dated 1628, pl.19, mid-17th century; Stchoukine (1964) pls LV–LVI, dated 1648.
305. Soudavar (1992) pp.392–93 no.160.
306. For the problems of dating from the names of makers and from inscriptional evidence see pp.105–109.

the characteristics of Safavid swords. Thus, the only surviving 16th-century blade seems to be a heavy, cut-down sabre blade in the Victoria and Albert Museum, which bears the genealogy of Shah Tahmasp (1524–1576).[307] There are, however, rather more 17th-century blades, for example, three sabre blades, all of watered steel, in the Kremlin Armoury.[308] The first has a double-edged tip and a single fuller, and is documented in 1642. According to Levykin it must be Russian because it has no marks or Arabic inscriptions. That does not rule out an Iranian origin, however, and its general character and the gold decoration on the blade suggest that it could indeed be Iranian. The second, like the first, has a double-edged tip but no fuller. It was presented to the tsar in 1646, and is decorated with a lion in a roundel, a motif found on other Iranian blades, and an inscription which can apparently be translated 'the possessor will be illustrious'. The third, presented to the tsar in 1664, is signed by Rajab 'Ali Isfahani. Unlike the other two, it is of virtually uniform width throughout its length. Another blade recorded in the 17th century belongs to the Royal Asiatic Society, and is on show in the Victoria and Albert Museum. This is signed in gold inlay by Asadallah Isfahani, and is said to have been given by John III Sobieski to Laurence Hyde (later Earl of Rochester) during the latter's mission to the Polish court in 1676. It was given to the Royal Asiatic Society in 1845 by James Finn, Consul at Constantinople.

There is also a group of four swords in the State Hermitage which have Russian inscriptions on their blades stating that they were made in Iran in the 17th century.[309] All have fine watering, and all but the fourth, which has been cut down, have a double-edged point. Two have grooves designed to hold small steel pearls; three have one or more fullers. The length of the blade varies between 74.4 and 89.3 cm, and the greatest width between 3.1 and 3.4 cm. The first is a sabre with an archaic Russian inscription stating that it was made in Isfahan in 1652 'by the Shah's master craftsman Asazaman'. The craftsman's name is confusing, but is most likely a conflation of Asadallah Isfahani (see pp.102–104) and his pupil Muhammad Zaman Isfahani.[310] The second is a sabre bearing a Russian inscription which states that it was forged in Iran in 1698. The third is a *shamsir* decorated with a medallion bearing the Persian words *'amal-i Husayn Shirazi* ('made by Husayn Shirazi'). The blade also carries Russian inscriptions, one stating that it was made in Isfahan, another giving the year 1677. The fourth is a blade which has been cut down to form a dagger, and bears a Russian inscription stating that it was made in Isfahan in 1652. Finally, Miller records a sword in the Polish Army Museum, Warsaw, which bears a

307. Victoria and Albert Museum, London, acc. no.IS 3378; unpublished.
308. *Treasures of the Moscow Kremlin* (1998) no.21 pp.31–32, and no.36 pp.58–59; Loukonine and Ivanov (1996) no.216.
309. Miller (1979) illus. 148–49, 150–51, 152–53, 154–56.
310. Robinson (1949) fig.4c; Mayer (1962) p.78.

Polish inscription which says that it was made in Isfahan in 1663.[311] Who had such inscriptions put onto these blades, and for what purpose, is uncertain. Nevertheless, it seems likely that they are authentic 17th-century Safavid blades.

It is worth noting that not all swords used in the Iranian army in Safavid times were necessarily of Iranian origin. For example, Eskandar Beg Monshi records how, at the time of the Uzbek invasion of Khurasan in AH 935 (AD 1528), Shah Tahmasp's Shamlu and Zu'l-Qadar *qurchis* were armed with Egyptian swords, presumably because these Turkoman tribes had their origins in, and still drew their human resources from, lands much further west.[312] Such swords were most likely sabres of the form used in the late Mamluk period, exemplified by that of one of the last Mamluk sultans, al-Malik al-'Adil Tumanbay, now in the Islamic Museum, Cairo.[313]

The problems of identifying Zand and Qajar swords are rather different from those associated with Safavid swords. In the first place, almost no royal swords of the period – which might provide a yardstick for lesser works – have yet been published. An exception is a sword presented to Tsar Alexander II by Nasir al-Din Shah, which seems to have a blade made for Fath 'Ali Shah (1797–1834).[314] Secondly, there is the problem of faking. Ker Porter touched upon this in his description of the industries of Shiraz in the early 19th century: 'The art of founding the metal in the superlative way that formed these ancient swords, poignards, knives &c. is now lost; which occasions so very high a value being set on them, when they are proved to be genuine; a fact of some difficulty to ascertan, modern artificers so well counterfeiting the appearance of the antique blades, it requires no little experience to detect the cheat at sight.'[315] And writing of Isfahan in the middle of the 19th century, Binning commented that Asadallah's name was forged on common swords.[316] Such forgeries will indeed be examples of later Iranian workmanship, but not surprisingly they do not advertise their precise origin or date. Another form of faking made use of inscriptions attributing the blade to a Safavid ruler, Isma'il, 'Abbas and Sulaiman being the most popular (see pp.107–108). A third problem for the scholar is illustrated by a remark of Mitford in the late 19th century: 'the Khorassan swords are not equal to those made at Shiraz, and no two are of the same size or shape, but all more or less curved.'[317] Finally, according to Massalski, armourers frequently re-worked old watered blades. Blades that have been repeatedly sharpened eventually become too narrow for use, and their watered blades can be reheated, drawn out into a thin blade, the same width but twice the length of a normal one, and then

311. Miller (1979) pp.145–46 no.42.
312. Eskandar Beg Monshi (1978) vol.1 p.91.
313. Atıl (1981) pp.114–15 no.42.
314. Loukonine and Ivanov (1996) no.270.
315. Ker Porter (1821–22) pp.714–15.
316. Binning (1857) p.129.
317. Mitford (1884) vol.2 p.47.

welded to both sides of an iron blade.[318] Good steel was understandably far too expensive to throw away, but such a process makes the possibility of accurate attribution remote. Small wonder that no modern scholar has devised a way of determining the date or provenance of most surviving Qajar blades, or even of distinguishing the Iranian from the Indian.

Sword manufacture

There is no full description of how Iranian swords were made before the 19th century. Even then, such descriptions are uncommon, which makes Binning's of the mid-19th century all the more important.

> 'When the blade has been hammered out of the *koors* or cake of Indian steel, it is put in the furnace, and kept there all night, subjected to the action of a low fire. In the morning, it is taken out, smoothed, and filed into shape, and then heated red-hot, and immersed for a few moments in a trough filled with castor oil. It is next polished, sharpened and the hilt and scabbard fitted to it; and the last thing done, is to bring out the *jowher* or damask pattern. For this purpose, the blade is perfectly cleansed from oil or grease; and a yellow kind of stone (n. called *zaj ash-shami*; Syrian vitriol) is ground to powder, mixed with hot water in a cup, which must be of china or glass, not metal, and the solution laid on over the blade with a piece of cotton, two or three times; this exhibits the black *jowher* perfectly.'[319]

An even fuller description, however, is provided by Massalski:

> 'Cakes of Damascus have the shape of disks of different diameters, but a thickness of at least a ½ inch (0.013 m). When it is desired to make the blades, they are stretched out into bars in such a way that the underside of the disk, which is the better knitted of the two, forms the cutting edge, while the other side forms the back, and the external circumference forms the flat of the blade.
>
> 'To draw out a cake in this way it is placed on the hearth with the top down, and heated, turning it in the fire, to a light red colour. This heat lasts about seven and a half minutes. The steel is then removed from the fire and struck with a 6 pound (2.45 kg) hammer, to give it a uniform thickness throughout. The first working requires great care. If the steel withstands the first hammer blows, then the success of the remainder of the work is assured.
>
> 'Without allowing time for the piece of steel to cool, it is replaced in the fire and heated a little more than the first time. A start is then made on drawing out

318. Massalski (1841) p.305. 319. Binning (1857) vol.2 p.129.

the blade using the conventional method, taking care not to make a mistake about which side is intended to form the cutting edge.

'As an example of the ease with which the cakes of Damascus burst under the first blows of the hammer, I would quote a fact of which I myself was an eye witness. Out of six exactly similar cakes, three burst into pieces after the first heat. The other three were drawn out in 1 $^{1}/_{2}$ hours into bars 6 verch (0.27 m) long, one verch (0.044 m) wide and one quarter verch (0.011 m) thick. The bar is gradually cooled, first keeping it close to the fire, and then taking it further and further away, until it can be held in the hand. The soft iron which forms on the surface is then cleaned off, first with the file, and then with shears of best English steel. This operation frequently disappoints the maker's hopes, and sometimes in order to be able to bare the Damascene he has to file down the bar in such a way that instead of obtaining a blade from it, all he can make is a knife.

'The fact that the soft iron has been completely removed from the bar can be recognised either by the resistance which is experienced to the file, or above all by the lack of the metallic lustre of the iron on the black background of the Damascus. Again a small portion of the bar can be polished, cleaned with emery and chalk, wiped dry and coated with a solution of iron sulphate. If this test does not make the mottling appear on the bar, it can be concluded that there is still iron on the surface of it. In order to clean a polished bar, a small piece of partly efflorescent ferrous sulphate is taken, and dissolved over the fire in a small dish. A minute later the water takes on a dark orange colour. The solution is allowed to cool a little, a cloth is soaked in it and wiped over the bar several times, and finally the bar is wiped clean.

'Sometimes soft iron forms on the surface of the bars which can be cut into pieces. In this situation the bars take on a very irregular shape, and require a great deal of working to even them up and draw them out into a thin blade. This working is performed using ordinary forging techniques. Then the soft iron is removed once again, the bar is reheated, and is given the shape of the object which it is desired to obtain, keeping it at a strong red heat.

'If a sabre is required, only one of the sides of the bar is slightly cleaned up, in particular the one which will form the back of the sabre. Cakes which have many pores on their top should be avoided. Otherwise these pores will form deep holes in the back of the sabre. These the maufacturer knows well how to plug, but they greatly reduce the value of the sabre. The Persians fill up these holes by pushing ordinary needles into them. They perform this operation with great skill, but without great firmness.

'When the blade has cooled, it is quenched in boiling hemp seed oil. Some armourers add a little grease and bone marrow. The wooden tub which contains

the oil is sufficiently large for the blade to go in easily. The oil is heated by plunging two or three pieces of red hot iron into it. During this time the blade is given a heat between red and white hot, and then plunged into the bath. If it is a dagger it is held flat; if it is a sabre, it is quenched little by little, beginning by the end of the cutting edge, holding the latter towards the bath. This manoeuvre is repeated until the oil stops smoking, which proves that the blade has cooled. After quenching the blade is always soiled with burnt oil. This dirt is removed by heating it enought to set light to a piece of wood, and by rubbing with a rag from a bedsheet. It is at this time too that imperfections are corrected and the blade is straightened if it is out of true. After 5 or 6 heats the blade leaves the fire quite ready, i.e. it then only has to be cleaned with sand, polished with emery and mottled by pickling in iron sulphate.'[320]

A somewhat similar description is given by de Rochechouart, who, however, distinguishes the different craftsmen involved. Thus there were the makers of the ingots, the forgers of the ingots, the armourers themselves, and the polishers, all of whom had clearly defined roles in the production of the blade. De Rochechouart also noted that the armourer who made a blade always made the steel fittings for the hilt and sheath.[321]

Characteristics of Iranian swords

In the discussion above the importance of shape has been regularly emphasised, in particular the shallow curve of the sabre and deeper curve of the *shamsir*. Shape was not the only distinguishing feature of an Iranian sword blade. As al-Kindi makes clear, there were many others: weight, length, width, size and shape of tang and blade tip, holes drilled through the tang, makers' stamps and the watered patterns, for example. The problem with such illustrative material as survives, both for the early and later periods, is that, once again, it consists primarily of miniature paintings designed to illustrate books, and of a scale that by its nature excludes such details. Holes through the tang, or makers' stamps on the tang, would have been invisible even to the owner of the blade, unless he was willing to remove the hilt. There must indeed be numerous examples of tang holes and tang stamps on surviving swords which have yet to be discovered through the removal of the relevant hilt. The potential importance of such investigation is illustrated by an Iranian sword in the Kremlin Armoury, which has a tang stamped twice with the name of the 17th-century swordsmith, Rajab 'Ali Isfahani.[322]

320. Massalski (1841) pp.300–304.
321. de Rochechouart (1867) pp.229–31.
322. Loukonine and Ivanov (1996) no.216.

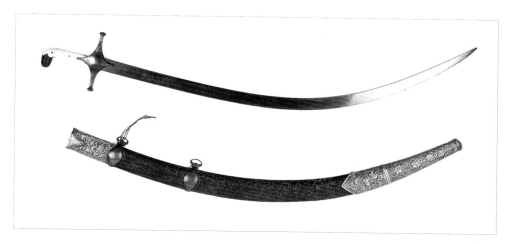

FIG.27a Sword; watered blade, quillon, hilt tip and scabbard lockets; remains of gold overlay; l. 91 cm; late 18th or early 19th century; Ashmolean Museum, acc. no.EA1997.196
FIG.27b Watering on blade in FIG.27a

Another characteristic of swords, which cannot be illustrated and receives almost no mention in the sources, is their monetary value. Information on this topic is exceptionally provided by de Rochechouart, who gives the relative prices of the different qualities of sword available in the mid-19th century. Thus, watered-steel swords fetched 2,400 francs for the finest, 240 for the good, and 36 for the ordinary; plain steel swords fetched 60 francs for the finest, 18 for the good and 6 for the ordinary; iron swords fetched a mere 24 francs for the finest, 12 for the good and 6 for the ordinary.[323] These figures leave no doubt as to the high esteem in which the finest watered-steel blades were held, and the extraordinary prices they commanded.

Al-Kindi's observations on the watered patterns require more detailed comment. It seems that the identification of any particular watering, and hence of any particular watered sword, depended on two qualities, pattern and colour. The first of these qualities, pattern (FIG.27b), was only used in the most general sense, for while it is

323. de Rochechouart (1867) p.232.

true that there is an infinite variety of patterns which can be produced by watering, it is equally true that the differences between them generally depend on a minuteness of design, often combined with a random distribution of lines, which is virtually impossible to describe or define in any meaningful way. Hence we find authors like al-Kindi and al-Biruni using only the most general terms in this context – broad, narrow, thickly decorated, webbed, like the track of ants, and so on. In two or three instances, however, a general description of a style of watering hides an important variation in the method of production, and these instances demand further comment. The first is in al-Biruni's *Mineralogy*, and concerns what the author calls 'plaited' watering: '… Plaited is similar to plaited brocade. The method used for these is that the cake is not beaten over its whole length but is beaten on its head until it spreads like a dish. Then they cut it like a spiral and flatten its circular form until it is straight. They then plait the sword from it. Then the plaitedness of the watering appears.'[324] The effect evidently depended directly on the way the cake of steel was forged into a sword, and the name seems to refer both to the physical structure of the blade and the crystalline structure. This method is mentioned by al-Biruni in connection with the Indian sword industry.

A second important variation in the way watered effects were produced is ascribed a Sindi origin by al-Biruni. 'A person who was in Sind told me that he sat and watched a blacksmith making swords. He looked at the swords closely and their iron was *narmahan*, and the blacksmith used to sprinkle on the iron a finely powdered medicament of reddish colour, then throw the sword [into water] and consolidate it by immersion. Then he used to take it out and lengthen it by hammering, and repeat the sprinkling and working many times. I asked him about its contents, and he looked up mockingly, and I understood from him that it was *dus* which he mixed with *narmahan* for edging and quenching [the sword].'[325] Here we have an example of the introduction of specks of iron into the steel blade for ornamental and other purposes, which would result in a very different effect from simple watering. There is no proof that this or the previous technique described above were used in Iran, but it is important to note their existence and the possibility that straightforward watering was not the only decorative art in use for early Islamic Iranian sword blades. It is also particularly important to note these two instances because modern scholars such as Smith have observed that there are certain patterns which appear on so-called watered blades which must be due to separate or additional processes of a quite different nature.

324. See Krenkow's edition of al-Biruni's text (1936) p.255. The recent translation by Said (1989) has not been used for this and subsequent translations. I am grateful to Donald Richards for his help in making direct translations from the text.
325. al-Biruni (1936) p.256.

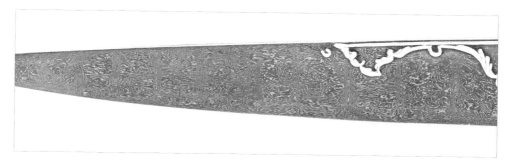

FIG.28 Muhammad's ladder watering on a 19th-century dagger blade; Ashmolean Museum, acc. no.EA1997.195

A third instance is a case of 'knotted' watering on a particular type of Iranian sword, described in some detail by al-Kindi, and noted above: 'The *muharrar* ... is covered with small knots side by side from top to bottom, made with a chisel, then polished with a polishing stone until smooth, and then lines show in its knots following each other as in the Qal'i sword. Its watering is black.' The term 'knots' is rather misleading. Elsewhere al-Kindi describes Yemeni swords as having a watering consisting of a ladder made up of equal 'knots', or better, 'rungs'.

Since no chiselling is mentioned in the Yemeni variety the laddering may simply have been due to the way the cake of steel was used, for example by making a radial cut in it, opening it out and hammering it flat, thus utilising the naturally occurring radial crystallisation pattern. But in the case of the *muharrar* sword, al-Kindi is almost certainly referring to a type of watering which has been the subject of particular study and debate in recent years and is generally called 'Muhammad's ladder' (FIG.28). Following on comments by Maryon, Smith and others, Panseri authoritatively identified the form of this watering and through his own experiments showed how it was produced. The characteristics of Muhammad's ladder watering, or *Kirk Narduban*, to give one of its more modern Middle Eastern names, are that it contains some 40 or so transverse 'bands', almost equidistant from one another, crossing the blade over its entire length. These bands are formed by more minute or dense watering patterning than the rest of the blade, a feature which clearly differentiates them from bands which appear on Malayan kris blades, which are of a more spacious watering than the surrounding areas. A glance at a later Iranian blade with Muhammad's ladder watering indicates why al-Kindi uses the term 'knotted', for due to the closeness of the weave of the watering at those points the bands do indeed look as though they have been created by watering lines being knotted together and pulled tightly towards one another. The fine weave of the bands is of great importance in identifying the method of manufacture. On the basis of work done by Massalski and De Luynes, Smith thought that the transverse markings probably resulted

from cutting shallow surface grooves in a nearly finished blade and then forging the surface flat, but Panseri showed that such grooves, if cut, would lead to transverse marks with a broader watering structure than the surrounding areas, as in the Malayan blades. Through deduction and experiment he showed that the transverse marks with a finer watering structure were produced by making a series of impressions with a chisel with a well-rounded end, grinding or filing down the areas between, and then hammering the blade flat, the effect being to condense and compress the structure of the watering at those points. This is indeed what al-Kindi describes.

Other watered patterns are found on surviving sword blades, but whatever Arabic or Persian names were used for them seem to have remained unrecorded. Examples are the so-called rose, or circle, pattern, which was usually combined with a single or double Muhammad's ladder pattern, and the zig-zag. An example of a rose and single-rung pattern made by Muhammad Kazim Shirazi, and one with a rose and double rung made by Bilal 'Ali, were both in the Figiel collection.[326] An example of a zig-zag is the blade in the Ashmolean Museum illustrated here (FIG.28).

The second quality of watering, used by early Islamic scholars for the classification of both watering and swords, was colour. Some colour will naturally be present in a watered sword blade due to the varying carbon content in the steel. However, the colours mentioned by medieval authors were in the main probably due to etching. This brings out the contrast between steel qualities through the differences in speed and form of reaction which take place, and depending on the acid or compounds used. Some of the different colours produced by the action of sulphuric acid on different quality irons and steels were described by the 18th-century Swedish chemist Sven Rinman. Al-Kindi describes the etching process in outline, giving important details of terminology, though he never reveals the exact substances employed.

> 'As for the *'ard* (of a sword) they call it *'ard* ("ground") according to its state. I mean the area of iron with no watering. So they say "red of ground", "green of ground", and "dark of ground". But when you find me saying in this book of mine "white of iron", "yellow of iron" or other descriptions of the iron, I am referring to the sword, and I mean the watering. And if I say "before throwing" (*tarh*) or "after throwing", I am referring to the medicament (*dawa*) which is thrown onto the sword, that is the medicament that is thrown onto the iron to make the watering appear.'

326. Figiel (1991) pp.84–87. For how the single rung and rose could have been produced see Figiel (1991) p.74.

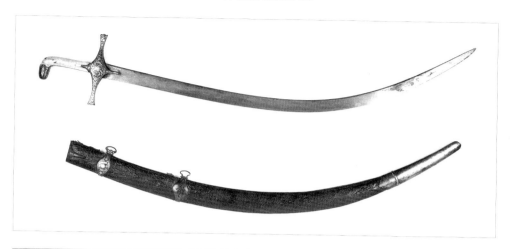
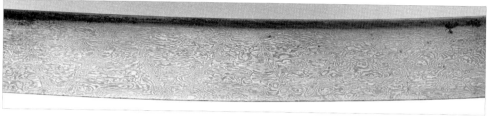

FIG.29a Sword; watered blade, quillon, hilt tip, scabbard lockets and scabbard tip; remains of gold overlay; l. 97 cm; late 18th or early 19th century; Ashmolean Museum, acc. no.EA1998.216
FIG.29b Zig-zag watering on blade in FIG.29a

Al-Biruni actually specifies the substance used as the *dawa* in India, and gives some more details of the process.

> 'When the Indian wants to make (the watering) appear he coats it with yellow Bamyani or white Multani *zaj* ... In the process of quenching (the sword) they coat the flat of the blade (*matn*) of the sword with hot clay, cow dung, and salt, like an ointment, and test the place of watering with two fingers on both sides of its blackness. They then heat it up by blowing, so that the ointment boils, and they then quench it. They then clean the coating from the surface of the blade and the watering appears. *Zaj* may be mixed with salt.'[327]

Analyses of samples of *zaj* collected in the East showed that this substance, as then marketed, was impure ferric sulphate, and this would also fit the descriptions of *zaj*

327. al-Biruni (1936) p.253. (See n.47.)

given by medieval authors such as al-Khwarizmi, al-Dimashqi and al-Qazvini. *Zaj* also seems to have been the name given to that very obvious, colourful and plentiful iron sulphide mineral, pyrites, from which the sulphate is formed by decomposition. Either the sulphide or sulphate would in fact have aided the etching process, producing, by strong heating and then immersion in water, sulphuric acid. In al-Biruni's Indian recipe the cow dung, containing amongst other things urea, would also have contributed to the desired process, and it is highly likely that such recipes as devised by different individual swordsmiths contained a wide range of other substances, some active, others totally inert. This is borne out by the fact that al-Kindi uses the term *dawa*, with its strong implications of a compound substance, to indicate what was used for etching, rather than the particular term *zaj*, which one would have expected if that had been recognised as the only essential ingredient.

A word used by both al-Biruni and Fakhr-i Mudabbir to describe particular swords is *bakhra*, but the precise characteristics of such a sword are unknown. Al-Biruni mentions it in his discussion of Indian sword manufacture: he first associates it with three colours or a third colour, unspecified, and then says that the name applies to any sword which has no watering.[328] Fakhr-i Mudabbir, on the other hand, says that most swords in Khurasan and Iraq were *bakhra* and seems to equate it with poor-quality watering and perhaps, too, with poor-quality swords: 'In Khurasan and Iraq most swords are *bakhra*, not having a good watering, but they are thick and break less in giving injuries and wounds.'[329]

It is worth drawing attention to one other aspect of colour in relation to Iranian sword blades. A section of al-Kindi's text already quoted, about the *muharrar* type of sword, says: 'it is made in Khurasan … Its watering is black.' Khurasani blades are cited by others for their black watering. Thus, in the early 19th century Sir Robert Ker Porter wrote: 'Nothing done here [in Shiraz] by even the best workmen can equal the old manufacture of Kerman and Khorasan, called the Kermanry and the Karkorasany; the wave, or *gishor* of the latter particularly, being large and black, on a steal so tempered as never to break, and to keep an unbluntable edge …'[330] The name he gives it is clearly an amalgamation of the Turkish *kara* ('black'), and the name of the province, Khurasan, emphasising the fame of its black watered patterning. According to de Rochechouart, Khurasani watering was very glossy and its patterns were black and gleaming.[331] Other colours are occasionally cited. Again according to de Rochechouart, Indian and Qazvini watering was very similar, being much yellower than Khurasani watering, with a sort of golden reflection. He

328. al-Biruni (1936) p.255.
329. Fakhr-i Mudabbir (1346/1967) p.259.
330. Ker Porter (1821–22) vol.1 p.714.
331. de Rochechouart (1967) p.229.

adds that the patterns were more compressed and generally formed a series of roundels.[332]

Blades manufactured in other centres were sometimes famed for rather different characteristics. Thus, Wagner, in the middle of the 19th century, writes of Shiraz: 'Of all the Eastern provinces, Schiraz yields the most solid articles, including, especially, sword blades of remarkable beauty, and very high price. I was shown blades of splendid workmanship, into whose steel, ornaments and arabesques of gold, containing occasionally passages from the Koran, were inserted, and which were valued at 200 tomans, or Persian ducats.'[333] This description accords with what we know of the decoration of Shirazi dagger blades (see p.148), and emphasises once again the prestigious nature of swords in Iran.

Sword fittings

Two swords in the Ashmolean and their scabbards (FIGS 27a and 29a)[334] show sword fittings in their appropriate locations. The scabbard is of wood covered with leather or gilt copper, and has two steel lockets. The scabbards are of wood covered with leather or gilt copper, and have two steel lockets. Both have steel quillons and steel pommel caps, while one has a steel scabbard tip. All the steel fittings are watered, and some of them bear the remains of gold overlay.

The Tanavoli collection contains a superb set of sword fittings (A.45–48) together with a single locket (A.50). Plain lockets of the same shape with openwork in the suspension eye are shown on two 19th-century scabbards in the Moser collection, one made in Kokand in Turkistan, the other from Bukhara.[335] Others, some plain and some more elaborate, are found on scabbards associated with Khiva in Uzbekistan,[336] while both plain and ornamented lockets decorate Iranian scabbards in the National Museum in Kraków,[337] and in the Hermitage, St Petersburg.[338] Scabbard lockets do not seem to have been studied in any considered way, but first impressions suggest that the Ottomans may have preferred a rather different style. For example, three of the scabbards associated with the straight swords in the name of the early Caliphs in Topkapı have oval or diamond-shaped lockets which emphasise the shape of the scabbard by pointing up and down it,[339] in contrast to the Iranian

332. de Rochechouart (1967) p.229.
333. Wagner (1856) vol.3 p.104.
334. Ashmolean Museum, Oxford, acc. no.1997.196, l. approximately 91 cm.
335. Moser (1912) pl.XIII no.14, with silver-gilt mounts decorated with turquoises, made in Bukhara and presented to Moser by the Amir of Bukhara, and no. 7, which has silver and niello mounts inset with turquoise, made in Kokand, Turkistan.
336. Abdullayev *et al.* (1986) nos 85, 94–98.
337. Żygulski (1979) figs 239, 244.
338. Ivanov *et al.* (1984) pls 92, 96–97 [63], 98, 100–101 [64], 103 and 107 [65], 109–10 [66], 131–32 [77].
339. Zaky (1979) figs 203–205.

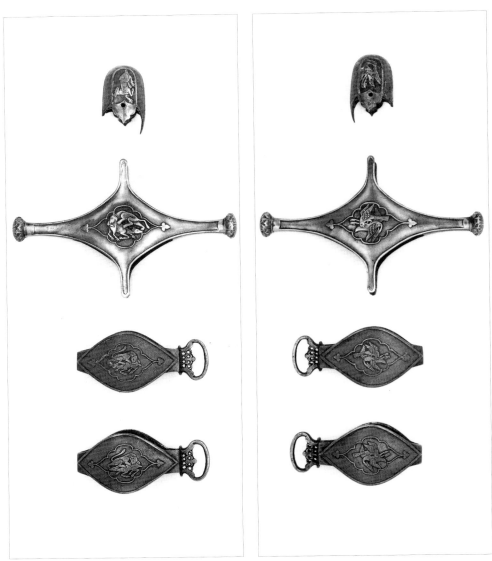

front back

A.45 Pommel cap; watered; cut, chiselled and chased; l. 3.8 cm; w. 2.3 cm; 18th–19th century; no.503
A.46 Quillon; watered; cut, chiselled and chased; ht 7.5 cm; w. 12.9 cm; 18th–19th century; no.500
A.47 and 48 Pair of lockets; watered; cut, pierced, chiselled and chased; l. 7.4 cm; ht 3.4 cm; 18th–19th century; nos 501–502

ARMS AND ARMOUR

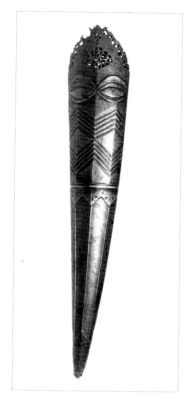

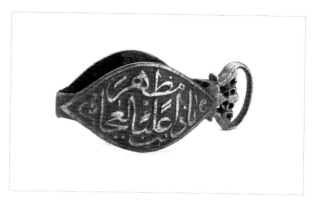

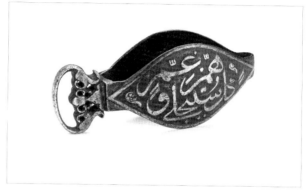

A.49 Scabbard tip; cut, pierced and chiselled; brazed; l. 25.7 cm; 17th century; no.164
A.50 Locket (front and back); cut, pierced and chiselled; l. 7.5 cm; ht 3.2 cm; 19th century; no.165

and Central Asian examples on which the ovals are laid the other way round. For the moment, however, such suggestions must remain very tentative.

The inscription on A.50 consists of two lines of a poetic prayer to 'Ali common on Safavid metalwork: 'Call to 'Ali, who causes wonders to appear. You will find him your help in distress. Every care and grief will be dispelled through your trusteeship. O 'Ali, o 'Ali, o 'Ali.'[340] However, they are not consecutive lines, but the first and third out of four. It is therefore likely that the second and fourth decorated the second sword mount (now lost), so that the lines read sequentially according to the side of the scabbard they ornamented.

The pommel cap (A.45), the pair of lockets (A.47 and A.48) and the quillon (A.46) all appear to belong to the same set, and must have been the fittings for an 18th- or

340. For example, on a mid 16th-century brass divination bowl; Melikian-Chirvani (1982) p.292 no.125.

19th-century sword and scabbard. Although they are not so early they may almost be compared in quality to the quite outstanding chiselled work on the pair of vambraces in the Royal Armouries signed by Faizallah Shushtari and dated AH 1120 (AD 1708–9).[341] The design of a lion attacking a deer, or of a bird of prey attacking a crane, is common on Iranian artefacts of the later Islamic period. It is highly likely that the belt piece (B.21) came from the same workshop.

This style of quillon is very common on surviving Iranian swords of the 18th and 19th centuries. A fine late 18th-century example, inlaid with gold, is in a private collection.[342] When this style developed is uncertain, though it certainly existed in the 14th century, witness an illustration of Mars in a Qazvini manuscript.[343] Another form had two dragon-head finials. Early examples of this style, in jade, date from the 15th century,[344] but steel examples suggest a continuing taste into the 17th century.

The decoration of the scabbard tip (A.49) is noteworthy for the chiselled 'eyes' and two bands of chevron pattern on each side. This abstract type of work is found on other pieces of Iranian armour, in particular a vambrace with similar oval motifs in relief illustrated in Stone's volume,[345] one in the Moser collection,[346] one in the Royal Scottish Museum,[347] and the pair of extraordinary quality made by Faizallah Shushtari in the Royal Armouries, mentioned above. Chevron patterns sometimes appear alone, as on a helmet in St Louis.[348] The 'eyes' are curious, and their origin is uncertain. On the Royal Scottish Museum vambrace there are six pairs in succession, forming a repeat pattern, but in some later instances they are to be found on helmets as fully developed eyes looking out over the nasal.[349] The design and quality of the pierced arabesque decoration suggest that A.49 is probably late 17th- or early 18th-century: the pair by Faizallah are dated AH 1120 (AD 1708–9).

341. Royal Armouries, Leeds, acc. no.XXVIA.242–3; unpublished.
342. *Oriental Splendour* (1993) pp.224–25 no.158.
343. Atıl (1975) no.56.
344. Pope (1938–39) pl.1428 C and E.
345. Stone (1934) p.108 fig.140 no.12.
346. Moser (1912) pl.VII, no.982.
347. Pope (1938–39) vol.6 pl.1410 fig.D; Elwell-Sutton (1979) p.15 fig.16. A similar vambrace was sold at Sotheby's, 16 April 1987, lot 178.
348. Pope (1938–39) pl.1414A, though here with the addition of openwork plaques.
349. Balsiger and Kläy (1992) p.103 centre.

Belt fittings

The history of belts in pre-Islamic Iran has been dealt with by Calmeyer and Peck,[1] and the history of early Islamic belt fittings has been surveyed by the present author in a previous publication.[2] The details will not be repeated here. The earliest dated or datable steel belt fittings from Islamic Iran appear to be those made for Shah Isma'il in AH 913 (AD 1507–8) and now in Topkapı Saray Museum, and a similar belt signed by Nurullah.[3] These are of astonishing workmanship, comparable to the finest dagger blades of the 16th century. How long the style they represent lasted is uncertain; there are no obvious successors among surviving belt fittings, but their popularity throughout the 16th century is indicated by their depiction in miniature paintings, for example a painting of *circa* 1530–40 in the British Museum,[4] and another from *circa* 1575 in the Bodleian Library.[5]

There are a variety of belt fittings in the Tanavoli collection, including buckles, suspension hooks, spring catches and swivel hooks. It should be emphasised that the hooks could have been used to suspend a variety of objects, and that it is not always possible to be sure of the precise function of a particular example.

Three distinct types of buckle occur. The first (B.1 and B.2) consists of two open-work rectangular plates, each attached to a cylinder, the two cylinders interlocking. One of the cylinders has a slightly smaller diameter than the other, and the larger cylinder has a vertical slit down one side. The smaller cylinder thus slides vertically into the larger, its rectangular plate sliding down the vertical slit. Nos 162 and 313 show the wide variety of such objects, both in terms of size and decoration. They can only be loosely dated to the 18th or 19th centuries, and the origin of the form, and the areas of Iran in which it was common, remain unknown. A gold-inlaid example '*d'un joli travail indo-persan*' is illustrated by d'Allemagne.[6]

A variant of this form is B.3. The linking mechanism is more like a tongue-and-

1. Calmeyer and Peck (1990).
2. Allan (1982) pp.28–30.
3. For Shah Isma'il's belt, see Sarre and Martin (1911) Taf.238–39 and Pope (1938–39) pl.1394B; for Nur Allah's creation see Pope (1938–39) pl.1394C and Mayer (1959) p.77.
4. Canby (1991–92) fig.1.
5. Robinson (1958) pl.XXXII.
6. d'Allemagne (1911) vol.2 p.108 and pl. on p.109.

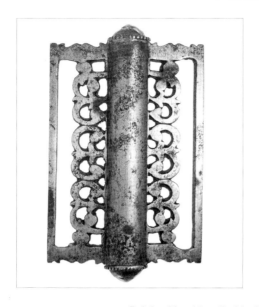 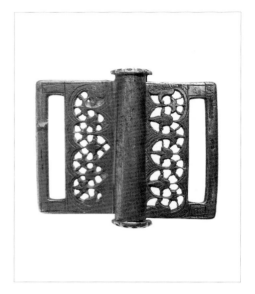

B.1 Belt buckle with cylindrical clasp; cut, pierced and brazed;
ht 10.3 cm; w. 6 cm; 18th–19th century; no.162
B.2 Belt buckle with cylindrical clasp; cut, pierced, punched, chased and brazed;
ht 4.5 cm; w. 5 cm; 18th–19th century; no.313

groove carpentry joint, but both tongue and groove are in this case slightly hooked, so that, held in place with the help of the vertical bar brazed to the front of the buckle, they cannot pull away from each other. The decoration is extremely fine. Four cartouches enclose an inscription in Persian which reads: 'From the side of the meadow blew the breath of good fortune / From the rose bush of hope blew the rose of benevolence / … which is from fair destiny and an auspicious horoscope / Your royal patent of favour for all arrived.' The inscription is worked in silver overlay and the background, both inside and outside the cartouches, is of five-petalled rosettes in gold overlay amid very fine stems and leaves in silver overlay. The back is covered with a squared pattern in silver overlay. The piece is probably 18th century.

The second type of buckle (B.5 and B.6), which is also found on belt B.4, has a large, slightly curving, rectangular plate. In both the free-standing examples in the collection a pierced sheet of steel has been attached to the body of the plate with brass rivets, though the five brass rivets on B.6 appear to be later replacements for numerous, originally steel, rivets. The buckle on B.4 is riveted with steel. A rectangular loop and a hook are attached to the back of each plate: in the case of B.4 and B.5 they are riveted on, in the case of B.6 brazed. The hook on B.6 is in the form of a stylised animal head. Both the free-standing buckles have beautiful decorative designs. That on B.5 is a centralised arabesque design; that on B.6 focuses on sura 61,

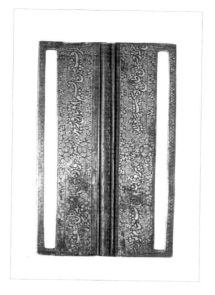

B.3 Belt buckle with tongue-and-groove clasp; cut, pierced and overlaid with silver and gold; ht 11.3 cm; w. 7.1 cm; 18th century; no.525

verse 13, *nasr min allah wa fath qarib* ('victory from God and swift conquest'), and around it is sura 68, verses 51–52: 'And lo! Those who disbelieve would fain disconcert thee with their eyes when they hear the Reminder, and they say: Lo! he is indeed mad; When it is naught else but a Reminder to creation.'[7] These inscriptions suggest that the buckle is from a military belt. The design of the buckle on belt B.4 is a finely worked pattern of interlacing stems and leaves. Both B.5 and B.6 are probably 18th-century, and a late 18th-century lacquer book-cover showing the poet Hafiz wearing such a belt buckle confirms the popularity of the style at that period.[8] The belt could be late 18th- or 19th-century. The origin of the pieces is uncertain, but it is interesting to note that the spacers and joints on the belt have chased decoration made by 'walking a scorper', a use of a particular tool which leaves a fine and closely worked line of curvilinear z-pattern. This is found on Ottoman brasses, but not to my knowledge on Iranian ones. It may be, therefore, that this belt is from north-western Iran, or perhaps even the Caucasus.

The third type of buckle is represented first of all by B.7–10. The most complete

7. A similar buckle plate sold at Sotheby's, 20 October 1994, lot 118, is decorated with sura 2, verse 255, the 'Throne verse', instead of sura 68, verses 51–52.

213

example (B.9) has an s-shaped clasp and two semi-circular rings, although, as the rings are not identical, it is probably a composite piece. The clasps of this piece, and of B.8, are dragon-headed, while those of the other two examples are bird-headed. The rings vary in shape too: those of B.7 and B.8 are rectangular, while those of B.9 and B.10 are slightly less than semi-circles. B.7 and B.8 also have in common the use of pierced plaques applied to each side of the centre of the clasp. In all cases these read 'O 'Ali', though one of the plaques on B.7 has been reversed. B.9 is of mild steel (see p.516) and therefore likely to be of 20th-century date.

Two belts in the Moser collection have bird-headed s-shaped clasps: one was made in Kokand in Turkistan, the other in Bukhara.[9] D'Allemagne illustrates two bird-headed s-shaped clasps, one with two semi-circular, the other with two flattened semi-circular, rings.[10] In all these examples the s-shaped clasp is closed around one ring but open wide enough to allow the other ring free access.[11] It is conceivable that such clasps were sword-hanger buckles, designed to attach a sword to its straps. Certainly their size suggests a much narrower strip of leather than the large rectangular buckle plates discussed above. However, for the time being it is impossible to be certain of the precise function of any particular example. As so often with small steel objects, they may have fulfilled different functions at different periods of their existence.

The origin of this style of buckle is difficult to establish. However, the existence of a number of dragon-headed s-shaped hooks of varying sizes in copper alloys, going back to Timurid and possibly Saljuq times,[12] suggests that the form may have been circulating in Iran for a number of centuries. Dating of the steel pieces is also difficult. A large and elaborate s-shaped clasp ending in a bird's head is illustrated in a painting of a footman, produced in Isfahan *circa* 1680–90, showing that the bird's head was already a popular adaptation of the dragon's head by this period.[13] The design of the pierced work on B.10 does not look Safavid, however, but its quality and articulation would be comfortable in an 18th-century context. This could also apply to B.9, which is rather less elegant. B.7 must be slightly later, and B.8 is probably 19th century.

A much larger example of the same style of buckle is B.11. Its s-shaped clasp has a bird's head, albeit small and ill-defined, at each end, but otherwise its appearance is

8. Robinson (1976) p.239 no.1232.
9. Moser (1912) pl.XIII no.14 and no.7. There are two similar pieces, made of brass with red and green glass dots, in the Khalili collection, acc. nos JLY975 and MTW572; unpublished.
10. d'Allemagne (1911) vol.2 fig. on p.108, and pl. on p.109.

11. d'Allemagne (1911) vol.2 p.109 also illustrates two s-shaped hooks, open at both ends, of uncertain function.
12. For example, Tanavoli (1985a) fig.38; *Islamische Kunst* (1986) no.231; Sotheby's, 25 April 1990, lot 282.
13. Colnaghi (1976) no.141.

BELT FITTINGS

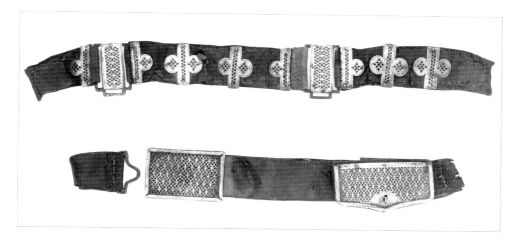

B.4 Leather belt with pierced and chased steel clasp, joints, spacers and purse lid; brass and steel rivets; w. of belt 5 cm; l. approx. 95 cm; 18th–19th century; no.163

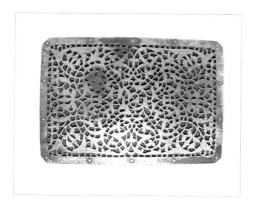 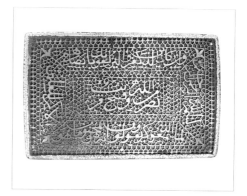

B.5 Belt-buckle plate; pierced and riveted; brass and steel rivets;
ht 7.2 cm; w. 10.1 cm; 18th century; no.159
B.6 Belt-buckle plate; pierced, riveted and brazed; edge overlaid with gold;
ht 7 cm; w. 10.5 cm; 18th century; no.311

quite different from those already discussed. The floral stems with their incised veining link the buckle with *kashkuls* like that in the Nuhad Es-Said collection,[14] and suggest a late 19th-century date.

The origins of the next two groups of objects, swivel hooks and spring catches, is uncertain. The earliest use of swivel hooks in Iran is impossible to establish, not least because they are so small that they could not be depicted in the standard early

14. Allan (1982) pl. on p.117.

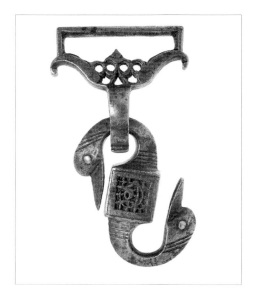
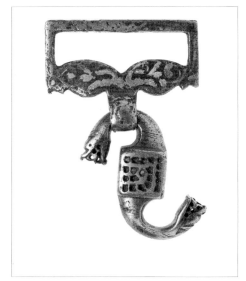

B.7 Belt-buckle plate and s-shaped hook; cut, incised, pierced and brazed; brass eyes; l. 6.5 cm; w. of loop 3.5 cm; 18th–19th century; no.298

B.8 Belt-buckle plate and s-shaped hook; cut, pierced, brazed and overlaid with gold; remains of turquoise inlay; l. 5.4 cm; w. of loop 3.5 cm; 19th century; no.314

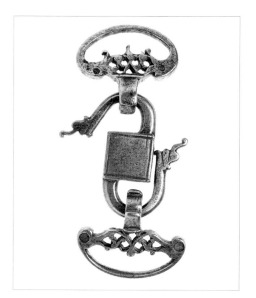
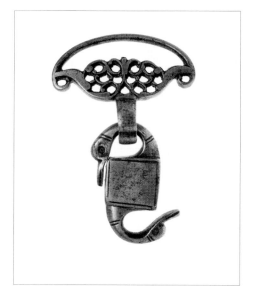

B.9 Belt buckle with s-shaped hook; cut, incised, pierced, punched and brazed; l. 7 cm; w. of ring 4 cm; 20th century; no.315

B.10 Belt-buckle plate and s-shaped hook; cut, pierced, punched and brazed; l. 5.4 cm; w. of ring 3.6 cm; 18th century; no.380

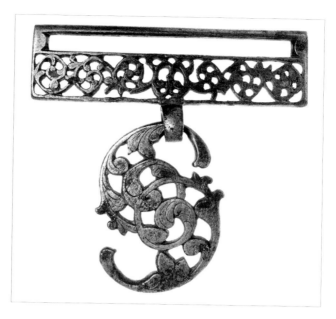

B.11 Belt-buckle plate and s-shaped hook; pierced, chased and brazed; ht 10.2 cm; w. of loop: 9.8 cm; 19th century; no.312

Islamic miniature painting. However, their use in the 15th century is confirmed by the appearance of what must be two swivel hooks in a painting of a warrior grooming his horse in the style of Siyah Qalm, now in Topkapı.[15] The horse is shown tethered to what may be an iron stake with a ring in it. A large keyhole-shaped ring is attached to the stake's ring, and to a small ring on the tether itself, by two swivel hooks with conical centres. The collar (C.12) and the tether (C.13) in the Tanavoli collection also include swivel hooks (see the section on horse fittings). In the case of the tether it is extremely primitive – a nail with a large head is inserted through a hole in the handle of the tethering stake, and its end is then bent through the last link in the chain. The origin of such a device could indeed be related to the need to prevent horses from tying their tethers in knots. Once invented, such objects functioned on a wide variety of objects. They were used, for example, by dervishes for *kashkul*s and by soldiers for weapons,[16] and indeed could profitably be used by anyone who wanted to hang objects from his belt. They were also used on balances.

The mechanism of B.12 and B.13–15 is just as simple as that on the tethering stake mentioned above. It is disguised, however, in B.13–15 by a series of pierced bands which revolve around the pin, and by the elaborate pierced decoration of the termi-

15. Ipsiroglu (1980) pl.35.
16. For example, on a processional axe illustrated in Moser (1912), pl.XXXIII fig.614.

nals. In B.12 the pin shape is varied to include a wide pierced section as its centre, and the larger ring has stylised bird's heads. In B.13–15 the pierced steel rings around the shaft alternate with brass discs, presumably to stop them sticking if they get damp and rusty. Similar swivel hooks occasionally appear on the art market.[17] These swivel hooks are most likely to be 19th century, for their pierced work has lost most of its articulation. However, B.12 is of mild steel and therefore likely to be of 20th-century date.

The date of the arrival of the spring catch in Iran is uncertain, but so too is the date of its invention. Spring catches formed an essential element of the carbine swivels which were known and used by European armies as early as the last quarter of the 16th century, where they allowed the carriage of arquebuses and carbines from broad shoulder belts. From Randle Holme's *Academy of Armoury*, dating from about a century later, *circa* 1680, comes a neat description: '... a belt over his left shoulder and under his right Arme: with a sweel or sweeth [i.e. a swivel] upon it which by the help of a spring in it takes hold of a ring, on a side bar, or iron rod screwd on the stock, the contrary side of the lock.' Michael Baldwin suggests, however, that such a spring catch, with or without a swivel, would have pre-dated military or other carriage of firearms by many years and may relate to the safe-keeping of keys or jewellery, or to falconry.[18] On the other hand, it could perhaps relate to the use of springs within the lock mechanism of firearms themselves, and the mechanical similarities between door locks and wheel-locks, as depicted by Leonardo da Vinci, may provide another pointer in this direction.[19] A 1471 manuscript of gunner Martin Mertz, who worked in the Palatinate, however, shows two designs for matchlocks including springs of two leaves, and the assumption must be that steel springs had been developed in Europe by the end of the 15th century.[20] Certainly they were standard parts of European gun locks by the early 16th century.

More uncertain is the ability of the Iranian steel-workers to make springs themselves. The only clue comes from Jean Chardin, who comments: '[Their steel] is as brittle as *Glass*; and as the *Persian* Artificers don't very well understand how to temper it, they have no Method among them of making Wheels and Springs, and other minute and delicate Pieces of Workmanship.'[21] From this it would appear that, at least during the 17th century, springs had to be imported from Europe. When the Iranian smiths first managed to manufacture them is unknown.

The two spring catches in the collection (B.16 and B.17) do not have swivels. Instead each was attached to the belt directly by a rectangular loop on its back. This

17. Sotheby's, Zurich, 10 June 1983, lot 352.
18. Personal communication from Michael Baldwin, Head of Weapons, Equipment and Vehicles at the National Army Museum, to whom I also owe the reference to Randle Holme.
19. Foley (1984) *passim*.
20. Foley and Canganelli (1990).
21. Chardin (1988) p.163.

BELT FITTINGS

B.12 Swivel hook; cut, pierced and riveted; ht 4.1 cm; 20th century; no.348
B.13 Swivel hook; cut, pierced, brazed and riveted; brass discs; ht 8.1 cm; 19th century; no.353
B.14 Swivel hook; cut, pierced, brazed and riveted; brass discs; ht 7.4 cm; 19th century; no.354
B.15 Swivel hook; cut, pierced, brazed and riveted; brass discs; ht 6.7 cm; 19th century; no.355

arrangement is also found on hook B.18, though in the case of the two other hooks B.19 and B.20 the rectangular loop forms the continuation of the body of the hook. B.16 has many similarities with the s-shaped buckle B.7 – the brass inlaid eyes and the chevron patterns made by the incised lines, for example – and must be contemporary with it. B.17 is finer and more elegant, with its three beautiful duck's heads, and is probably to be dated to the period of the most elegant flint-strikers, the 18th or early 19th century. B.16 is probably to be dated to the end of this period. Two spring catches of a slightly different form are illustrated by d'Allemagne. The hook in each case has a stylised bird's-head terminal, but the upper part of the body is flattened and instead of a bird's head has pierced decoration. The form of belt loop is uncertain. The dragon's heads of B.19 and B.20 are very different in form from those which decorate the flint-strikers, which makes any dating very difficult to establish. They do not have the dynamism of the early Safavid examples, nor the elegance of some of the later pieces. They would presumably come somewhere within a 17th- to 19th-century range. Two more such belt hooks are illustrated by d'Allemagne,[22] and others have appeared on the art market in recent years.[23] The

22. d'Allemagne (1911) vol.2 pl. on p.109. 23. Sotheby's, 11 October 1991, lot 403 shows a pair.

B.16 Spring hook; cut, brazed and incised; eyes inlaid with brass; riveted catch and spring; ht 8 cm; 19th century; no.279

B.17 Spring hook; cut, punched, brazed and chased; riveted catch and spring; ht 7.7 cm; 18th–early 19th century; no.379

feather pattern of the highly stylised bird's tail of B.18 recalls a composite flint-striker (P.15), which we have elsewhere suggested is probably 19th-century in date. (For other examples of springs see p.172 below.)

B.21 is evidently a junction mount, allowing a horizontal strap to be joined to a vertical one. Two sword belts in the Wallace collection have this type of ring,[24] and a similar junction mount occurs on a sword belt for an Indian *talwar* in Kraków.[25] An inscribed junction mount which would also function in this way is in the Khalili collection.[26] However, if B.21 were to be used for this purpose, the image engraved on it would appear the wrong way up. Perhaps it was used on a belt to hold the lower end of a shoulder strap: in that case the image would be the right way up. Another possible use for it is on a horse-harness. For example, the Karlsruhe 'Türkenbeute' includes a horse's breast-strap with a circular junction mount allowing a strap to be attached from above.[27]

24. Wallace collection, London, acc. nos 1403 and 1407.
25. Elgood (1979) p.234 no.244.
26. Alexander (1992) no.91.
27. Petrasch (1991) no.73 p.145 right.

BELT FITTINGS

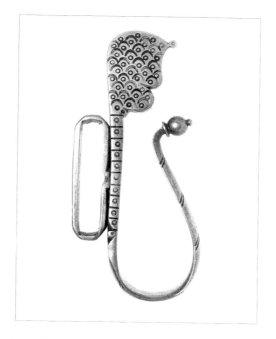

B.18 Belt hook; cut, incised, punched and riveted; ht 8.2 cm; 19th century; no.95

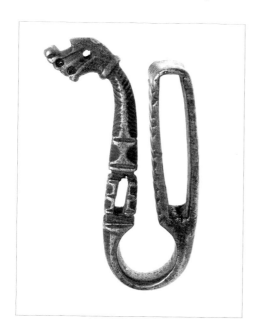
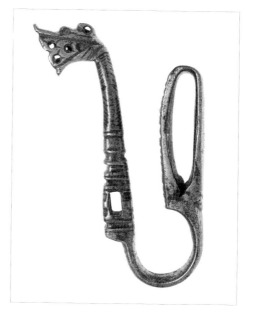

B.19 Belt hook; cut, incised and pierced; ht 6.2 cm; 19th century; no.96
B.20 Belt hook; cut, incised and pierced; remains of brass inlay; ht 8.8 cm; 19th century; no.280

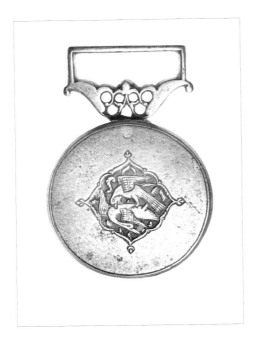 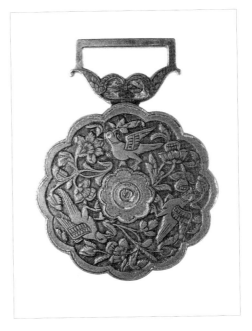

B.21 Junction mount; cut, pierced, chiselled and chased; riveted and brazed; ht 5.2 cm; w. 3.5 cm; 18th century; no.135
B.22 Junction mount; cut, chiselled, chased and brazed; remains of gold overlay; ht 6 cm; w. 4.2 cm; 18th century; no.505

The image of a bird of prey attacking a water bird is found on 18th-century Iranian saddle-axes:[28] A.S. Melikian-Chirvani suggests that the depiction is of a hawk attacking a heron, and that it is an allegory of royal triumph.[29] The two saddle-axes concerned are signed by Lutf'ali Ghulam, and one is dated AH 1152 (AD 1739–40). On the basis of this image, and the pierced arabesques of its loop, which recall the finest of the flint-strikers, an 18th-century date seems likely for the junction mount. The other junction mount, B.22, is at first sight in such a different style as to be of a very different date. However, comparison once again with the work of Lutf'ali dating from the 1730s, in particular armour made by him, suggests that it too is probably early 18th century.

B.23 and B.24 are a pair of terminals, which were probably attached to straps hanging down from a belt, a common style of decoration in Iran, at least since the 10th century. They both have rivet holes for attaching them to the leather. The late date of B.24 at least is indicated by the fact that it is made of mild steel.

28. Elgood (1979) figs 132–33 and 138–39.
29. Elgood (1979) p.124.

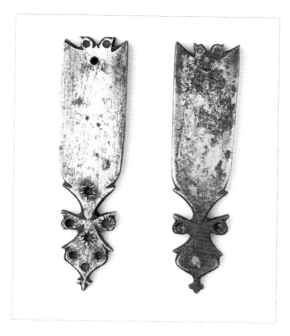

B.23–24 Pair of belt terminals; cut, incised, punched and brazed; l. 7 cm;
18th–19th century; nos 101 and 102

Of much greater fineness and importance are the set of belt fittings overlaid with silver and gold, B.25. These are all very small and must originally have been attached to a very narrow leather belt. They consist of five strap ends of elongated pointed form, five buckles and nine sliding ornaments of circular and rectangular form. The buckles have no tongues and depend on friction for their effect. One strap end, one buckle and one sliding ornament are larger than the rest, suggesting a narrow belt to which the three belonged, and four narrower pendant straps to which the rest of the pieces were fixed. In that case the function of the smaller buckles would have been as ornaments rather than as true buckles. This is confirmed by a 19th-century Kubachi *qama* in the Ashmolean Museum which has a belt joined by a larger buckle of this type and two pairs of pendant straps which are decorated near the top with the smaller buckles (FIG.30).[30] Each piece in the Tanavoli set is decorated with interlacing floral sprays in gold overlay and dotted borders in silver, and the strap ends and the sides of the fittings have criss-cross designs in silver. The decoration suggests an 18th-century date, and the comparison with Kubachi work suggests a north-west Iranian origin.

There is also a complete belt with a shoulder strap of this type in the collection,

30. Ashmolean Museum, Oxford, acc. no.1982.5.

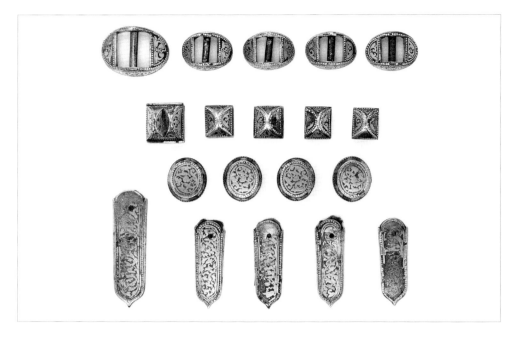

B.25 Set of belt fittings; overlaid with gold and silver; l. of largest strap end 4.7 cm; 18th century; no.374

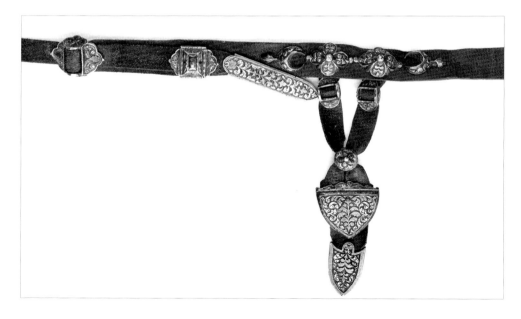

FIG.30 Detail of *qama* belt with nielloed silver fittings; l. of strap end (top centre) 6.2 cm; Kubachi, 19th century; Ashmolean Museum, acc. no.EA1982.5

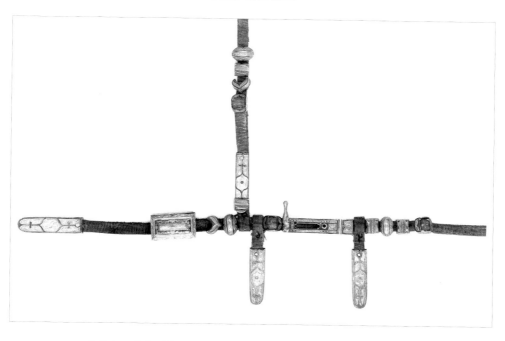

B.26 Belt and shoulder strap; fittings of silver, gilded and inlaid with niello; l. of belt 99 cm; l. of strap ends 5.5 cm; 19th century; no.397

B.26, though it is much simpler in concept than the Kubachi belt illustrated. The belt itself has four simple pendant straps, a grease box, and various other ornaments, and another group of small ornaments adorns the shoulder strap. The quality of the silver-gilt and niello workmanship suggests 19th- rather than 18th-century north-west Iranian workmanship. One of the buckles and one of the ornaments on the belt are wider than the rest, and appear to have no particular purpose. The set may thus be composite.

Horse fittings

STIRRUPS

The date of the introduction of the stirrup into the Middle East or into Europe is still debated. Bivar suggested that the stirrup evolved in Siberia not long before the 5th century AD, and that the cast-iron or bronze stirrup was perfected along the frontiers of China, and introduced to Europe by the Avar migration in the 6th century.[1] A more detailed discussion of the arrival of the stirrup in the Near East was offered by White.[2] He noted that the Iranians used the Arabic word *rikab* for stirrup, suggesting that it was introduced into Iran with the Arab conquests, but he also pointed out al-Jahiz's attribution of iron stirrups to the Azraqites. This seems to fit the evidence of al-Mubarrad, who claimed that stirrups were first made of wood but that iron ones were introduced by al-Muhallab, who in fact campaigned against the Azraqites in Central Iran. Against this he placed the traditional view that stirrups were known to the Byzantine armies in the 6th century or at least in the 8th – depending on the dating of a *Strategikon*, a treatise on strategy traditionally ascribed to the Emperor Maurice (AD 582–602) – and that they would therefore have been introduced into Iran before the Arab conquests through Byzantine–Sasanian contacts, or after the Arab conquests through the Arab attacks on the Byzantine lands.[3]

Since then other facts have emerged: these have been summarised by Herrmann.[4] First of all, the stirrup was known in north-east China in the 4th century AD.[5] Secondly, not only were stirrups regularly used in the late 6th century by the Avars, but they also occur on the 7th century wall-paintings of Panjikent, the Soghdian capital. More important for the history of the stirrup in Iran, Herrmann has pointed out an important feature of Sasanian saddlery. From surviving representations of horsemen, it is clear that the early Sasanians used a horned saddle, and the

1. Bivar (1955).
2. White (1962) pp.18–26.
3. See also Bivar (1955) and (1972) p.290.
4. Herrmann (1989) pp.770–72.
5. Yang (1984) seems to have brought together the most recent information on this topic. He notes that a single stirrup, perhaps for mounting, was also in use as early as AD 302 in south China, witness the finds from a tomb at Changsha.

artists show the rider's lower leg bent sharply back, with the foot continuing the line of the leg. A change comes about in the mid-4th century, however, for in later representations the riders are shown using a bow-front saddle, their legs hanging down relatively straight, and their feet often sharply flexed at the instep, at just the point where the stirrup might be. 'Without some such aid [i.e. stirrups]', she suggests, 'the replacement of the safe horned saddle by the bow-front version would appear to have been military folly.'[6]

The first depiction of stirrups in an Islamic context is in the hunting scene at Qasr al-Hayr al-Gharbi, probably datable to AD 724–27.[7] Since this particular painting is definitely of Iranian, not Syrian, inspiration, the Iranians must already have been using the stirrup by the beginning of the 8th century. Unfortunately, the actual form of the stirrup shown at Qasr al-Hayr al-Gharbi is uncertain due to the damage suffered by the floor-painting concerned.

Three detailed studies of early Islamic stirrups have so far been published. The earliest was that of Scerrato, who brought to public attention a group of Ghaznavid bronze stirrups. Broadly speaking, these have a flat rectangular tread, low, vertical sides, and a narrow, arched bow with a rectangular eye, and are decorated with combinations of birds and animal heads, and small bosses.[8] Scerrato also published a single example of another, much simpler form, with a flat rectangular tread, a narrow bow and rectangular eye.[9] Scerrato suggests that the first type is of Far Eastern origin, transmitted via Central Asia. He also draws attention to the way the angularity of its form suggests that it is a bronze copy of stirrups originally manufactured from forged iron.

The second study was that by Melikian-Chirvani,[10] who discussed a 13th-century style of Indo-Muslim bronze stirrup, and, ignorant of Scerrato's article, illustrated one of the Ghaznavid stirrups published by the latter as an antecedent. Such a stirrup form is also to be seen in the 13th-century *Varqeh and Gulshah* manuscript, written and illustrated in the Saljuq sultanate of Rum,[11] though it is not the only form indicated by the artist. Another pair of stirrups of the same style, and a related single piece, are in the Khalili collection.[12]

The third author, Ward, emphasises the loss of rope, leather and wooden stirrups, some of which may have been the source of more expensive metal forms. She draws attention to another group of bronze stirrups commonly found on the art market which have a flat or curved rectangular tread, and a flat pointed bow with a

6. Herrmann (1989) p.771.
7. Sourdel-Thomine and Spuler (1973) colour pl.XIII.
8. Scerrato (1971) tav.1–5. An almost identical pair were sold at Christie's, 19 October 1993, lot 303.
9. Scerrato (1971) tav.6.
10. Melikian-Chirvani (1982).
11. Melikian-Chirvani (1970) pls 6 and 20.
12. Alexander (1992) nos 18–19.

rectangular eye at the apex.¹³ Judging by the incised decoration, this group appears to be 11th- or 12th-century in date. She also contests Melikian-Chirvani's attribution of the previous group to the Ghaznavids, and suggests an Indian origin.¹⁴

Other bronze stirrup forms are known, such as a style with bells beneath the base,¹⁵ which is somewhat similar to the group published by Melikian-Chirvani. More unusual, though again related, is a bronze stirrup in the Tanavoli collection (FIG.31), which is oval in form and has two lotus-like leaf forms beneath the base. The strap attachment is slightly trapezoidal and is supported by a pair of peacocks, relating the piece to the major Ghaznavid group. The quality of the relief work also recalls the single Ghaznavid stirrup published by Scerrato. Another bronze stirrup in the Tanavoli collection (FIG.32) has a flat rectangular tread, a pear-shaped arch, and a rectangular eye with two projecting bird's heads. The confusion over attributing such objects is clear from the fact that one was sold as 17th-century Flemish.¹⁶ A related pair of *tombak* (gilt copper) Ottoman stirrups of the late 17th century are to be found in the Karlsruhe *Türkenbeute*.¹⁷ These have no bird's heads on the eye, but interestingly do have birds in profile at each corner of the square tread. Given the taste for such ornamentation in Iran from the Safavid period onwards, as this catalogue so clearly shows, it seems most likely that the Ottoman style is derived from an Iranian style, of which the Tanavoli bronze stirrup is an earlier example. A less common form of copper alloy stirrup from the Saljuq or Mongol period is illustrated in FIG.33.

For the development of stirrup forms in Iran we are largely dependent on the evidence of miniature painting, though it is often difficult to tell precise details from such a diminutive art form. The variety of stirrups in use at any one time is suggested by the *Varqeh and Gulshah* manuscript, in which at least three different forms are shown: the Ghaznavid style already discussed,¹⁸ a rounded form,¹⁹ and a form with triangular sides to the bow.²⁰ The 14th and 15th centuries appear to have favoured a rather plain, rounded form with triangular sides, witness a miniature of *circa* 1370 in Istanbul,²¹ miniatures in the *Diwan* of Khwaju Kirmani (1396),²² and the *Shah-nameh* of Ibrahim Sultan (*circa* 1432–35).²³ However, there is also some indication of the presence of a much heavier style with a large tread and broad triangular side-plates. The most striking example of this is to be found in a miniature from the

13. For example, Alexander (1992) nos 17, 20, 22; Tajan, 5 April 1993, lot 381; Tanavoli (1998) fig.35; Alexander (1996) pp.206–207 illustrates the same piece as Ward (1996) p.86.
14. Ward, like Melikian-Chirvani, seems to have been ignorant of Scerrato's article.
15. Alexander (1992) no.21.
16. Sotheby's, Zurich, 10 June 1983, lot 78.
17. Petrasch (1991) no.69.
18. Melikian-Chirvani (1970) figs 6, 20.
19. Melikian-Chirvani (1970) fig.25.
20. Melikian-Chirvani (1970) fig.39.
21. Ipsiroglu (1980) pl.17.
22. Gray (1961) pp.46–47.
23. Robinson (1958) pl.1.

Baysunghur *Shah-nameh* of 1430.²⁴ The stirrup shown also appears to have two protrusions (perhaps bells) beneath. It may be that this style is indicated by the triangular form shown in the *Varqeh and Gulshah* manuscript, and it could also provide some sort of origin for the later steel form illustrated by C.3 and C.4 (see below). The style was certainly in use in the 16th century, witness the mention in the two sets of armour supposed to have been presented to the Grand Duke Ferdinand by Shah 'Abbas I (see pp.131–32), in both cases iron embellished with gold.²⁵ It was also common in later Safavid times, appearing, for example, in a miniature of Shah 'Abbas hawking,²⁶ and in another contemporary Iranian album painting.²⁷ It also appears in Qajar miniatures, and one particular example from a *Khusrau and Shirin* manuscript suggests pierced side-plates like those of the Tanavoli pieces.²⁸ From the early 19th century, there is a plate in Drouville's first volume showing the Shah's horse with flat stirrups with solid but pierced arched sides.²⁹ The form is mentioned by Ella Sykes, who writes: 'The high-peaked saddle, though comfortable, lifts the rider too far above his horse to control it properly, and instead of a whip he kicks its sides with his big iron shovel-stirrups.'³⁰ An example in the Royal Scottish Museum, which, according to the accessions register, was purchased from M. Richard, Tehran, has its side-plates decorated with a tall cypress design, with pierced areas around. The sides are also decorated with gold wire work, and inset with what appear to be steel pins, with round heads of 2 mm diameter standing in relief.³¹ This is a type of decoration we have not seen on other objects, but could be a legacy of the use of small bosses as decorative motifs on Ghaznavid bronze stirrups.³² The shovel-stirrup style was to become particularly popular in the Ottoman lands, witness 17th-century examples in the Karlsruhe *Türkenbeute*,³³ and 18th-century *tombak* developments.³⁴ How it relates to the somewhat similar style of stirrup used in the Maghrib – in which the base plate is much shorter, being of the same length as the lower edge of the triangular sides³⁵ – is not clear, though one might postulate a common ancestor in the Near East in early Islamic times.

Much more important in the Iranian context, however, is a very different style,

24. Gray (1979) pl.94.
25. Heikamp (1966) p.67.
26. Colnaghi (1976) no.58.
27. Colnaghi (1976) no.142x.
28. Ferrier (1989) p.230 fig.8.
29. Drouville (1825) vol.I pl. opposite p.224.
30. Sykes (1898) p.210.
31. Edinburgh, Royal Scottish Musem, acc. no. 1888–94, width 17.5 cm, height 19.5 cm. I am most grateful to Jennifer Scarce for giving me the opportunity of studying this piece.

32. Scerrato (1971) tav.I–II, IV; Melikian-Chirvani (1982) figs 67–68.
33. Petrasch (1991) nos 68 and 70.
34. Sotheby's, 13 April 1988, lot 100.
35. Higuera (1994) p.107 illustrates a Nasrid pair, and p.109 such a stirrup in use. A pair of similar form but with a curved base-plate are in Edinburgh, Royal Scottish Museum, acc. nos 1905–570A and B.

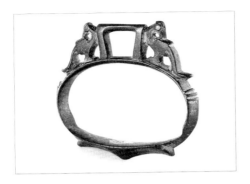

FIG.31 Stirrup; copper alloy; ht 9.7 cm; w. 11 cm; d. 2.4 cm; 11th–12th century (?); no.259

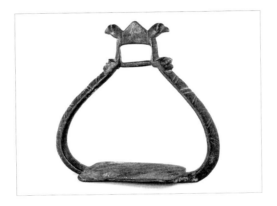

FIG.32 Stirrup; copper alloy; ht 13.5 cm; w. 14.2 cm; d. 5.2 cm; 11th–12th century (?); no.140

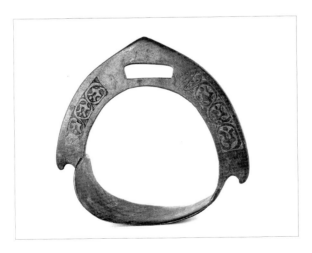

FIG.33 Stirrup; copper alloy; ht 15.5 cm; w. 16.5 cm; d. 4.9 cm; 11th–12th century; no.141

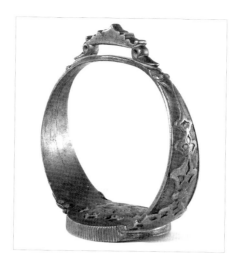

C.1 Stirrup; cut, milled and pierced; sheet brass sandwiched between sheets of steel; brass rivets; ht 15 cm; w. 14.7 cm; d. 7.3 cm; late 17th or early 18th century; no.12

represented in the Tanavoli collection by C.1.[36] The form is first picked up in painting in the work of Siyah Qalam, whose miniature of a mounted hawker provides many fascinating details of contemporary horse fittings and personal costume.[37] The stirrup shown here has a flat tread with a circular disc and central boss projecting below it. Its bow is slightly ogival, and runs elegantly into the rectangular strap attachment at the top. Another painting by the same artist suggests that the discs were often milled around the edge.[38] Of approximately the same date is a drawing in the Freer Gallery of Art showing a galloping horseman using the same stirrup form.[39] Of the earlier history of this form we know nothing, but this style of stirrup was destined to be immensely popular in Iran under the Safavids. It is standard in the Shah Tahmasp *Shah-nameh*, for example, and a number of different variations occur. First of all is the basic style following Siyah Qalam,[40] then a more elegant variant with an angled top for the strap attachment and a narrow cross-bar to strengthen the upper part of the stirrup.[41] What may be an inlaid style is also shown,[42] and finally among the gifts from Afrasiyab to Siyavush is a horse with most elaborate stirrups of this form: with bow and tread made up of curved, ogival elements, they must have been splendid works of art.[43] The stirrup type is

36. Published in Tanavoli (1998) fig.36.
37. Rogers (1986) pl.74.
38. Ipsiroglu (1976) pl.67B.
39. Atıl (1978) no.11.
40. See, for example, Dickson and Welch (1981) vol.2 nos 20 and 24.
41. Dickson and Welch (1981) vol.2 no.152.
42. Dickson and Welch (1981) vol.2 no.25.
43. Dickson and Welch (1981) vol.2 no.110.

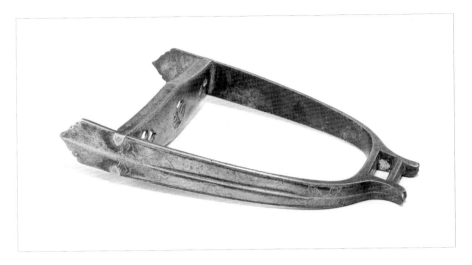

C.2 One of a pair of stirrups; cut, pierced, punched and chased; ht 21 cm; w. 13.8 cm; d. 4.3 cm; 18th century; no.11

shown regularly in later Safavid painting,[44] and certainly survived until recent times in Kazakhstan.[45]

C.1 in the Tanavoli collection, which is made of iron rather than steel (see p.513), is related to this stirrup form, in that it has a milled circular base.[46] However, instead of the bow being pear-shaped it is circular, and the strap attachment is much more elaborate. It may simply be a later development, it may be a mixture of this and another – so far unidentified – stirrup form, or it may have developed as a form in its own right at a much earlier date. The latter theory is supported by the existence of Ottoman parallels for the Tanavoli piece. Though virtually undecorated, and with an unmilled base, a *tombak* pair is to be found in the Karlsruhe *Türkenbeute*.[47] This shows that the form was already established, in the Ottoman empire at least, in the 17th century.

A quite different form of stirrup is represented by C.2.[48] This type is also found in Central Asia, for example in Bukhara,[49] in Turkistan,[50] and in Kazakhstan.[51] In the cases of Bukhara and Kazakhstan a palmette-shaped surround to the eye seems to be preferred, in contrast to the bird-headed Iranian piece; the Bukharan pair also have a more angled arch. Two examples in the Royal Scottish Museum indicate that the style must have been widespread and subject to a large number of varia-

44. For an Isfahan depiction of *circa* 1630–40, see Robinson (1976) no.1093, and no.1133 for an early 17th-century provincial (Astarabad) depiction.
45. Andrews (1981) fig.363 and p.114; Margulan (1986) fig. on p.169.

46. Published in Tanavoli (1998) fig.36.
47. Petrasch (1991) no.71, *cf.* no.34.
48. Published in Tanavoli (1998) fig.37.
49. Abdullayev *et al.* (1986) pl.91.
50. Kalter (1983) ill. 5e, 26 and back cover.

tions. One of these has a palmette-shaped surround to the eye, though the edges of the palmette are very reminiscent of birds' beaks, and a more flattened form of arch, while its tread has a central circular area, and is pierced and elegantly ornate; there are remains of gold work on the lower sides, which end in stylised leaf forms.[52] One similar to this is ascribed by David Alexander to Ottoman Syria or Anatolia.[53] The second has a rather different type of palmette-shaped surround to the eye, a more angled arch, and the open, circular area in its tread is filled by a stylised stem with four leaves. Its sides are inlaid with tall triangles of silver.[54] Perhaps it is a rather cruder Bukharan example. A miniature of Fath 'Ali Shah hunting shows that the form of stirrup was already in use in Iran in the early 19th century,[55] but its origin and the date of its introduction are uncertain.

It is now appropriate to turn to the dating of the various stirrups in the Tanavoli collection. C.1, with brass sheet sandwiched between sheets of iron and its bold sculptured form, is a superb piece of craftsmanship. It is also cleverly conceived, since the brass gives colour to the inside of the tread, under the rider's foot, and the outside of the arch. In both cases it forms the ground of palmette designs. Those on the tread form a rosette, which, lacking any details whatsoever, must be a formal derivative from a more precise and detailed style. Fortunately there are parallels for this form of rosette in Safavid ceramics, in particular in Gombroon ware. Here 'tassel' rosettes are very common motifs in the centres of bowls, and no less than four examples are to be found in the collections at the Ashmolean Museum,[56] while the same palmette motifs are sometimes used as pierced border designs.[57] This border also occurs in Safavid wares with a carved blue ground.[58] Gombroon ware is generally agreed to be of late 17th- and early 18th-century date, and this dating is also appropriate for the blue-ground wares mentioned. The parallel between the stirrup and the latter ware, colour-wise, is striking, for in the ceramic it is blue against white, while in the case of the stirrup it is silvery iron against yellow brass, giving the design as a whole the same effect of strong contrast. One may therefore conclude that the stirrup is indeed of the same period, late 17th- or early 18th-century.

51. Andrews (1981) fig.363 and p.114; Margulan (1986) top fig. on p.176. A Kirgiz variant is illustrated in Maksimov (1986), which has no page or plate numbers.
52. Edinburgh, Royal Scottish Museum, acc. no.1921.1409 (previously in London, Victoria and Albert Museum, acc. no.499-'76), height 24 cm, width 14 cm. I am grateful to Jennifer Scarce for permission to study this piece.
53. Alexander (1996) pp.206–207 attributes another, much more elaborate, example to the same source.
54. Edinburgh, Royal Scottish Museum, acc. no.1895.231A, height 26.5 cm, width 15 cm. The stirrup appears to be of iron, rather than steel, and the quality of the silver is poor. I am grateful to Jennifer Scarce for permission to study this piece.
55. Robinson (1976) no.1239.
56. Oxford, Ashmolean Museum, acc. nos X 1208, and 1978.1766, 1768, and 1769, all unpublished. For a published example see Lane (1957) pl.100.
57. Oxford, Ashmolean Museum, acc. no.1978.1766 and Lane (1957) pl.98B.
58. Lane (1957) pl.89A.

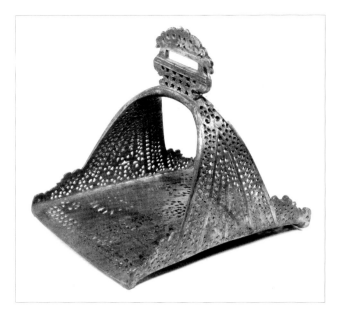

C.3 One of pair of stirrups; cut, pierced and punched; ht 17.5 cm; w. 13.7 cm; d. 17 cm; 18th–19th century; no.9

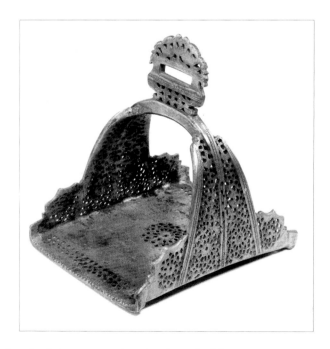

C.4 One of a pair of stirrups; cut, pierced and punched; ht 17.5 cm; w. 13.3 cm; d. 17.6 cm; 18th–19th century; no.10

C.3 and C.4 look at first sight unconnected with C.1.[59] However, they too have stylised bird's heads at either end of the strap holder, and they also are decorated with rosettes and borders made up of palmettes. There is therefore some stylistic link, even if technically they are totally different. They can scarcely be products of the same place as C.1, but they could perhaps relate in date, and be 18th-century workmanship – though one might prefer to put them into the 19th century on the basis of the relative crudeness with which they are worked.

The pair of stirrups C.2 has a quality more akin to C.1. They are essentially sculptural with little need for surface decoration. The pierced motifs on the base, however, lack any specificity, and point to a somewhat later date than C.1. We might therefore assign the pair to sometime in the later 18th century.

Records of places of manufacture for horse fittings are all too few. According to Murdoch-Smith in the late 19th century, stirrups, bits and other horse fitting of steel were made in the village of Bunat, in Fars, many of them ornamented with engraving or inlaying.[60] Unfortunately, none of these has yet been identified. Another record relates to Isfahan at the very end of the century. Landor, writing of the Isfahan leather-work bazaar,[61] comments on the 'clumsy silver or brass or iron mounted saddles', harness 'with silver inlaid iron decoration, or solid silver or brass', and 'its characteristic stirrups, nicely chiselled and not unlike Mexican ones. The greater part of the foot can rest on the stirrup, so broad is its base.' Such a description fits the shape, if not the decoration, of the shovel stirrups (C.3 and C.4). For the present more cannot be said.

The Iranians did not use spurs. Instead, they used the corners of the base plates of their shovel stirrups to encourage their horses forward, as noted above.[62] However, there was a brief experiment with spurs early in the 19th century. Drouville describes the regular cavalry, mounted on Arab or Turkoman steeds: 'They have kept their saddles, and only changed their stirrups, substituting hussar stirrups for the oriental ones. They also have been given spurs, which they did not know before, and with which they get impatient, because having no other manner of sitting than on their heels, and forgetting that they are booted, they stick the rowels into their thighs.'[63]

BITS

For practical purposes, there are two different types of horse bit. The first is the

59. They are published in Tanavoli (1998) fig.38; *cf.* Alexander (1996) pp.206–207.
60. Murdoch-Smith (1885) p.71.
61. Landor (1902) vol.1 pp.302–303.
62. See also Fraser (1834) p.468.
63. Drouville (1825) vol.2 p.113.

snaffle bit. Here the bit fits into the horse's mouth, lying over the tongue, with cheek-pieces at either end, to which the reins are attached. The cheek-pieces help steer the horse by pressing against the outside of the mouth. A snaffle bit may consist of a single piece of metal held at either end by the cheek-pieces (sometimes called a straight bar), or may be jointed in the centre (called a broken snaffle).

The second type of horse-bit is the curb bit. This works on the principle of leverage. The longer the cheek-pieces, the greater the leverage that can be applied by the reins, and as a result the greater the pressure that can be applied on the bars, and the tongue and poll of the horse. These bits are very severe compared to the snaffle, especially when spikes or sharpened edges are added, or a port, a raised curve in the centre of the bit which exerts pressure on the roof of the mouth.[64]

The use of horse bits in Iran goes back into prehistoric times, and the bronze bits of Luristan from the 2nd millennium BC have been extensively studied. In this early period they were snaffle bits of the same form as those used elsewhere in western Asia, with either a rigid or a jointed mouthpiece.[65] The particular interest of Luristan bits lies in the ornate variations on this theme which developed after about 1000 BC, and the adoption of very elaborate and heavy cheek-pieces. The first iron bits recorded from Iran appear to be those from cemetery 'B' at Tepe Sialk, dating from *circa* 850, 800–700 and 650 BC,[66] which have jointed mouthpieces and simple curved cheek-pieces. During the 7th century BC these bits were superseded by another form, which then spread throughout the Near East in the 6th century. This had plain cheek-pieces, each cast in one with half of the jointed mouthpiece. The two sections of the mouthpiece either interlock or are joined by a large ring. They are often covered with tiny spikes.[67] This was almost certainly the standard form of bit in Achaemenid Iran, and its cheek-pieces are visible on the various horses which adorn the Persepolis reliefs.[68]

Evidence for Sasanian bits and bridles is based on the Sasanian rock reliefs, and has been discussed by Herrmann.[69] She shows how two types of bit were in use during the Sasanian period. The first was a curb bit attached to a metal noseband/muzzle, though sometimes curb bits were used alone, witness a find in a late Parthian or early Sasanian grave at Noruzmahale in north-western Iran. From the rock-relief evidence, the curb bit and noseband were popular at least in the first half of the 3rd

64. For an excellent depiction of this bit and its effect on the mouth of a horse, see Cosmé Tura's painting, *S. Giorgio e il drago*, in Ferrara, illustrated in Probst (1993) fig.7.
65. Moorey (1971) pp.105–107; (1974) pp.65–66.
66. Ghirshman (1938–39) vol.2 p.51 and pls LVI S.803 a–c, and pl.LXVIII S.715 d,e; Potratz (1966) fig.53 a, b; for the dating of the cemetery see Moorey (1971) p.25.
67. Moorey (1974) p.66.
68. See, for example, Walser (1980) pls 13, 14, 19, 22, 26, 74.
69. See Herrmann (1989), from which the following details come.

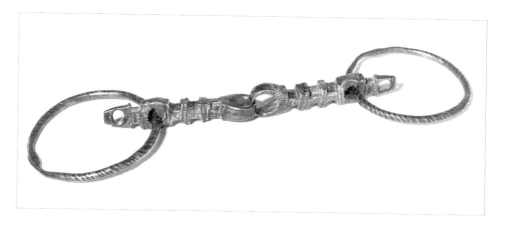

c.5 Horse-bit, broken snaffle; cut and chased; twisted rings;
w. 13 cm (mouth-piece); 18th–19th century; no.5

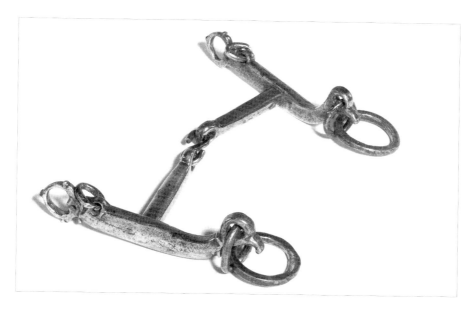

c.6 Horse-bit, curb bit; port missing; cut and pierced;
w. 13.5 cm (mouth-piece); 20th century; no.3

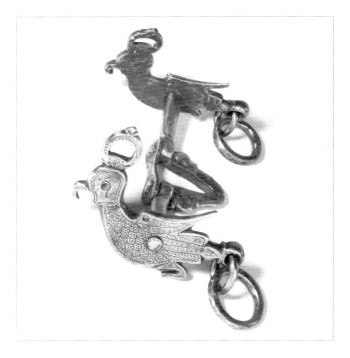

c.7 Horse-bit, curb bit; cut, punched, chased and riveted; w. 11.6 cm (mouth-piece); 18th–19th century; no.1

century, but possibly from the 1st century to the mid-3rd century, and again from the mid-4th to the 6th century. They were also used in Soghdia. The snaffle bridle regained favour from the mid-3rd to the mid-4th centuries. However, the significance of the change is difficult to assess, and Herrmann emphasises that the selection of a bit probably depended more on the character of the rider and horse, and the task for which it was being ridden, than on the vagaries of fashion. One further feature of the depiction of these bits needs to be noted. The horses shown wearing the curb bit and noseband/muzzle are shown with their mouths closed – the metal noseband made it impossible for them to open their mouths, and the bit was therefore doubly effective. Those shown with snaffle bits, on the other hand, have open mouths.

One other type of bit may have been used in the Parthian period in Iran. This is a ring bit, similar to a style used in Nubia in the 3rd to 6th centuries AD.[70] However, there is no evidence of its use in Iran in later times.

Representations of horses in early Islamic Iran are few and far between, and where they do appear, as for example in the fresco of a horseman from Nishapur,[71]

70. Littauer and Crouwel (1988). 71. Nicolle (1976) fig.20.

the visual evidence is by no means easy to interpret. However, the depictions of horsemen on *minai* and lustre ceramics of the pre-Mongol period suggest that the curb bit and noseband/muzzle combination continued to be popular. It occurs quite clearly on a lustre and *minai* tile, and on particular lustre and *minai* vessels,[72] and heavy nosebands on many of the more sketchily drawn horses suggest the same.[73] The depiction of the same bit on a cobalt relief-ware jar could point to its continuance into the Mongol period,[74] but the dating of this type of ware remains to be clarified. The curb bit and noseband were evidently popular throughout the rest of the Islamic Near East in this period, for they are depicted on a 12th-century ceramic figure of a horseman found at Raqqa,[75] in the illustrations of the Baghdad *Maqamat* of Hariri dated AH 634 (AD 1237),[76] in the illustrations of the 13th-century *Varqeh and Gulshah* manuscript, probably produced in the Saljuq sultanate of Rum,[77] and on the Baptistère de St Louis, the famous inlaid brass basin made in Mamluk Egypt or Syria soon after AD 1300.[78]

The impact of the Mongols on the traditional horse fittings of Iran may have been extensive. Certainly, 14th-century Iranian miniatures suggest that the curb bit and noseband were replaced. The harnesses shown in the AD 1314 manuscript of the *Jami' al-Tawarikh*,[79] for example, appear to include snaffle bits, though the precise system is confused by the fact that some of the horses are shown with double nosebands, cheek-straps and throat-lashes, while others only have single ones. The precise significance of this is uncertain, as is the way the double cheek-straps joined the bit. In one example, an additional rein is shown.[80] This extra rein is commonly depicted in the slightly later Demotte *Shah-nameh*,[81] where it appears to be attached to the left-hand side of the bit and the left-hand side of the horseman's saddle. It is presumably a leading rein, for Isfandiyar is shown holding it in a *Shah-nameh* page in Istanbul.[82] The snaffle seems to have continued to be popular into the 15th century, being shown, for example, on a miniature of Bahram killing a lion dating from *circa* 1400, and in the Baysunghur *Shah-nameh*.[83] It was still used at the time of Siyah Qalam, who depicts a falconer on horseback with a snaffle.[84] The horse here also wears the extra leading rein. Curb bits are also found, however, as in a miniature of a Shiraz school *Anthology* of AD 1420,[85] and in a painting of *circa* 1468 attributed to Bihzad.[86]

72. Pope (1938–39) pl.703B, lustre plate dated AD 1207; pl.705, *minai* bowl; pl.706, *minai* and lustre tile.
73. For example, Pope (1938–39) pl.667.
74. Pope (1938–39) pl.762.
75. Nicolle (1976) fig.58.
76. Ettinghausen (1962) pp.118–19.
77. See, for example, Melikian-Chirvani (1970) fig.39.
78. Rice (1951) pls VI–VII, XXIV–XVII etc.
79. Alexander (1992) figs 1, 3–5.
80. Alexander (1992) fig.4 left.
81. See, for example, Pope (1938–39) pls 839–40.
82. Gray (1979) pl.62.
83. Gray (1979) pls XXX, and 94.
84. Rogers (1986) pl.74.
85. Pope (1938–39) pl.863B.
86. Sakisian (1929) fig.58.

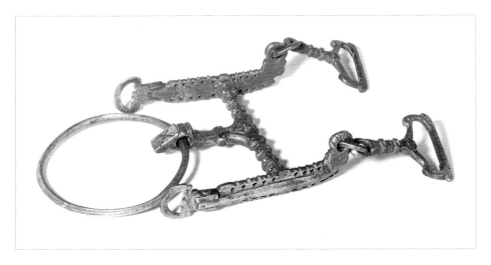

c.8 Horse-bit, curb bit; cut, pierced, punched and chased;
w. 10.5 cm (mouth-piece); 20th century; no.4

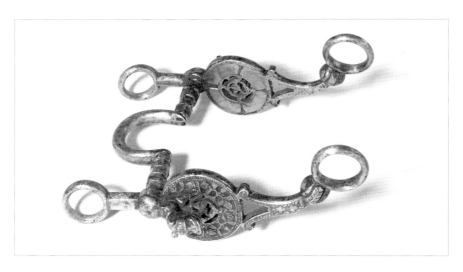

c.9 Horse-bit, curb bit; cut, pierced, chased and riveted; brass insets with red inlay;
w. 10.5 cm (mouth-piece); 18th–19th century; no.2

It is evident that snaffle bits remained in use in the 16th century. They are shown, for example, in illustrations to the Shah Tahmasp *Shah-nameh*. Good examples are to be seen in the depiction of the invading Turanians,[87] where the artist has also taken the trouble to draw most of the horses with their mouths closed. He evidently understood the difference between snaffles and the more elaborate 16th-century curb bits (see below), and the different effect they have on the way the horse holds its mouth. The artist's rendering of these bits also shows that snaffle bits were used with both a headband and a noseband. Snaffle bits with cheek-pieces in the form of a rosette are also shown.[88]

However, snaffles were by now far less common than curb bits, as the countless other depictions of horses in the Shah Tahmasp *Shah-nameh* vividly indicate. The most common style of curb bit has a shallow 's' attached to a cheek-piece in the form of a plain disc or rosette.[89] Normally the horse is shown with a cheek-strap and browband, but without a noseband, though occasionally nosebands are also shown.[90] Other variations are a more angular 's'[91] and a much finer 's' with strongly turned ends.[92] A simple curving piece of metal is also used.[93] In the latter case nosebands seem to be the norm. Along with these curb bits goes a different depiction of the horse's head and mouth. In earlier times horses' mouths had been firmly clamped shut by the use of a metal noseband/muzzle, but now there is no such restraint, and the artists regularly show the horses looking extremely uncomfortable, opening their mouths wide and lifting their heads as they try in vain to get away from the bit. How exactly this bit was constructed is uncertain, but it must have had a very high port which would have pressed on the roof of the horse's mouth.

Such published information as is available on Central Asia suggests that in recent years the snaffle has been most widely used. Maksimov illustrates two different broken snaffles used by the Kirghiz.[94] Snaffles are also documented for the Kazakhs,[95] Uzbeks and Turkmen.[96] The small collection of bits in this catalogue, however, shows that curbs as well as snaffles have been used in Iran in recent centuries. If earlier European travellers are anything to go by, the commonest form seems to have been the curb, in particular the style exemplified by c.8. Curzon quotes Sir Thomas Herbert's description of this type of bit: 'They curb their horses' mettle with sharp bits, a ring of iron helping them.' And Curzon then goes on to comment:

87. Dickson and Welch (1981) vol.2 no.77.
88. Dickson and Welch (1981) no.140.
89. For an example of the plain style, see Dickson and Welch (1981) no. 20; for examples of the commoner rosettes, see Dickson and Welch (1981) nos 28, 29, 74.
90. Dickson and Welch (1981) no.70.
91. Dickson and Welch (1981) no.151.
92. Dickson and Welch (1981) no.251.
93. For example, Dickson and Welch (1981) nos 232 and 257.
94. Maksimov (1986), with no page or figure numbers.
95. Margulan (1986) fig. on p.14.
96. Kalter (1984) ill. 5a and e.

'... there is no doubt that the same bit is in use now. It is shaped like the letter H, with a sharp projection upwards from the middle of the cross-bar. To this is attached a ring, which passes round the lower jaw and operates as the most effective curb that I have ever seen. If a horse has at all a tender mouth, the slightest touch will make him wince; while to rein him in tight, as the Persians are in the habit of doing in order to show off their horsemanship, must often cause the poor brute intense suffering.'

Ella Sykes also commented on the ferocity of the Iranian bit:

'The Persian rides his horse with an exceedingly heavy bit, his great object being to pull it up and turn sharply – the mouths of all young horses bleeding till they get hard and callous and their quarters being frequently strained from the same cause ... Towards the end of our stay at Kerman we had a little stud of ten horses, nearly every one of whom required many lessons from my brother to cure them of their tricks of flinging back their heads, "stumping", and taking exceedingly short strides, all attributable to the Persian bit, as were their hard mouths.'[97]

Curzon tried out an English snaffle but found it inadequate: 'It is utterly unlike the Persian bit, and a Persian horse does not understand it. If he is a crock it does not much matter, but if he is a mettled animal he runs away. It is better, on the whole, to employ the native bit, cruel though it be.'[98] Wills gives the Persian names of the two different types of bit: *ab khori* for the snaffle, and *danah* for the curb bit with the ring.[99]

This type of curb bit has in fact been very widely used in the Near and Middle East in recent times, not only in Iran, but in Iraq, Syria, and parts of Arabia, and in North Africa and Spain.[100] Dickson comments that all Arab horses ridden on these bits continually throw their heads up, to the great discomfort of the rider.[101] It is also seems to have been used occasionally in Italy.[102]

The Tanavoli collection contains one snaffle bit and four curb bits. The snaffle (c.5) is of the broken type, i.e. it is made up of two pieces, or 'canons', jointed in the centre. Each of the canons is ornamented with rather angled cutting, which would

97. Sykes (1898) p.210.
98. Curzon (1892) vol.1 p.54 and n.1. Gilmour (1994) p.76 quotes Curzon, on the basis of his experiences in Iran, advising later travellers to take, 'among many other things, ... an English military saddle, a snaffle and a two-reined bridle ...', which conflicts oddly with his comments quoted here. Stone (1934) p.115 is clearly mistaken in saying that the Iranians use snaffles.
99. Wills (1883) p.329.
100. Dickson (1949) p.389 makes the point that it is not used by the bedouin, who do not use bits of any sort. See also Stone (1934) fig.151 no.4, and p.115.
101. Dickson (1949) p.389.
102. Probst (1993) no.129.

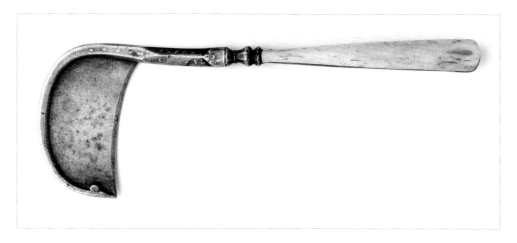

C.10 Miniature hoof knife; cut and riveted; overlaid with gold; ivory or bone scales; l. 13 cm; 18th–19th century; no.328

have been uncomfortable for the horse and would have helped the rider's control. A somewhat similar broken snaffle bit is on show in the museum at Firdaus, near Mashhad, where there is also a bit with a central ring joining the two canons. These were both part of a royal collection formed before the revolution, so their provenance is uncertain.

The Tanavoli curb bits vary in form. C.6 originally had a port, but as this is now missing its form is unknown. C.7 has an articulated port.[103] C.8 has a port with a large ring attached, which went round the horse's lower jaw.[104] C.9 has an arched mouth-piece. Artistically-speaking, this is the most splendid, with its handsome roundels inlaid with brass and a red inlay, and projecting lion's heads.

Snaffle bit C.5 is comparatively crude and could date from any time during the last two or three centuries. C.7 has an articulated port in the form of two stylised double-headed dragons, and cheek-pieces in the form of parrots with their crests made into strap loops.[105] It is probably 19th-century in date, though a slightly earlier dating cannot be ruled out. C.6 has cheek-pieces in the form of a stylised bird, its tail end in the form of a ring made up of two highly stylised half-palmettes.[106] These can scarcely be earlier than the 19th century. C.9 has an arched mouth-piece, and its canons terminate in projecting lion's heads; each of the circular cheek-pieces is inset with four chunks of brass which have then been chiselled and filled with red inlay. C.8 has canons in the form of two dragons, their heads grasping the port; each cheek-piece is also in the form of a stylised dragon, the fixed ring at its tail, and the

103. Published in Tanavoli (1998) fig.32.
104. Published in Tanavoli (1998) fig.33.
105. Illustrated in Gluck (1977) p.149.
106. Illustrated in Gluck (1977) p.149.

C.11 Horse ornament; cut and pierced; ht 8.2 cm; w. 7.6 cm; 19th century; no.160

free ring at its mouth. The dragons' bodies are decorated with stylised openwork palmettes. The design of C.9 allows no closer dating than the 18th–19th century, but C.8 is probably 20th-century since it is made of mild steel (see p.516).

OTHER HORSE FITTINGS

Horse-shoes are not represented in the Tanavoli collection, but are worth mentioning as they were an essential part of iron-working in Iran, as in the rest of the world, and indeed an essential part of military equipment in the pre-motorcar age. Hence Nadir Shah's establishment of an iron foundry near Amul which not only cast cannon-balls and bomb-shells, but forged horse-shoes.[107] The vast quantities which must have been manufactured in Iran in earlier times are vividly depicted in a photograph in the Fahie collection in the Bodleian Library, Oxford, which shows a horse-shoe maker (na'lchi) amongst his wares.[108]

The Iranian horse-shoe covers most of the surface of the horse's hoof, protecting it from stony ground,[109] a design which has been current for centuries.[110] Thevenot describes its varying qualities:

'Not only in *Persia* but all over the *Levant*, they have a better Hoof than in our Countries, whether it be because of the humidity of our Climate, or that we shoe

107. Hanway (1754) vol.1 p.288.
108. Oxford, Bodleian Library, no. 2061 d.24, box 2 no.16.
109. Sykes (1898) p.239.
110. du Mans (1890) p.202 and Kleiss (1990).

HORSE FITTINGS

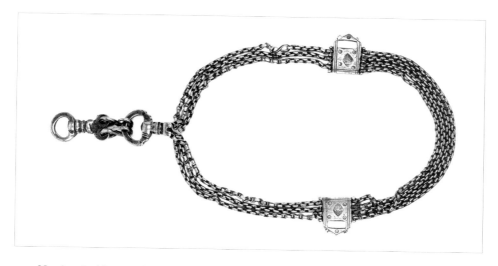

C.12 Noseband with two swivel rings and two cheek-strap buckles; cut, pierced, punched, chased and riveted; approx. l. 44 cm; 19th century; no.6

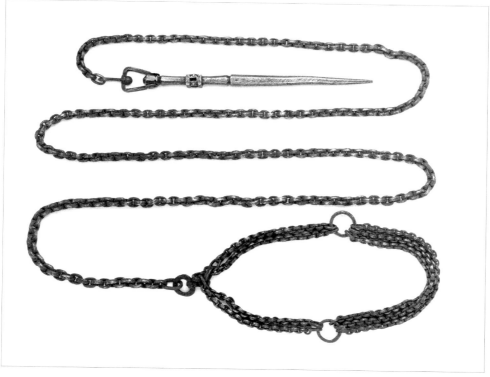

C.13 Tether: peg, chain and noseband; cut, pierced and chased; l. 23.4 cm (peg); l. 220 cm (chain and collar); 19th century; no.7

245

them to often. And indeed the *Persians* can shoe a Horse with the first Horse-shoe they find, putting it forwards or backwards as much as it is needful to fit it to the Foot, and they may nail it in all places of the Hoof. In *Persia* they make their Horse-shoes smooth and flat: so that they have not little turnings up as our have, which makes them continually slide upon Stones, and upon the Ground when it is but in the least wet.'[111]

Wulff describes how horses are shod, and illustrates the hoof knife used to smooth the sole of the hoof.[112] An actual hoof knife is to be seen in the Wallace collection set of instruments, which also contains a pair of pincers used by farriers for extracting old nails. C.10 seems to be a miniature version of such a hoof knife. Being too small to use, it presumably comes from some sort of presentation set of miniature implements, unless of course it is for shaving wood or leather, rather than hooves.

The collection also contains an ornament (C.11) which must have acted like an English horse brass, a noseband (C.12) and a tether (C.13). The noseband was being used on a mule when it was purchased, and stamped on each of the roko-type buckles is an inscription giving the name of the maker or original owner, 'Abd al-Husain. The buckles are designed to be attached to a head-strap on either side of the mule's or horse's nose. The tether too is attached to a noseband. There is an excellent depiction of a tether in use in a 14th-century miniature of a warrior and his horse in Topkapı Saray,[113] though here the tether is attached to a halter. Neither the tether nor the noseband show enough wear to be older than the 19th century, but both probably come from Yazd which was famous for its chains; the horse ornament could be 18th or 19th century and is of uncertain origin.

Iron or steel was also used in the construction of saddles. The first set of armour in the Florentine inventory, supposed to have been a present from Shah 'Abbas I, included a saddle with an iron saddle-bow, the latter ornamented in the same way as the horse's barding, in other words chiselled and inlaid or overlaid in gold (see p.131).[114] Hence, it is clear that in this instance the saddle-bow was extremely decorative, as well as structurally essential. Unfortunately, in his survey of Iranian crafts in the 20th century, Wulff did not record the work of the saddler, only the more mundane products of the packsaddle maker.[115] The history of saddles in Iran remains to be written.

111. de Thevenot (1686) vol.2 p.113.
112. Wulff (1966) pp.53–54, figs 76–78.
113. Ipsiroglu (1980) fig.35.
114. Heikamp (1966) p.67.
115. Wulff (1966) p.234.

Hawk stands

Whether falconry was developed in the Near East as early as in China is unclear, but it has certainly been a sport there for millennia. The earliest illustration so far recorded is on a 13th-century BC Hittite stele from Marash in Cilicia, which shows a scribe holding a jessed falcon on a block by its leash. A slightly later, 8th-century BC Assyrian stele from Khorsabad shows a falconer practising his sport.[1] Falconry's continuing popularity through the ensuing centuries is not easy to document pictorially, but from early Islamic times it became increasingly important as a symbol of royal authority. Specifically permitted in the Qur'an (sura 5, verse 4), falconry appears in numerous different artistic contexts: for example, on medals struck by rulers of the 10th and 11th centuries;[2] on wall-paintings such as that of the horseman from Nishapur;[3] on ceramics, especially on *minai* and lustre ware of the 12th and 13th centuries;[4] on metalwork, for example, the Bobrinski bucket of AH 559 (AD 1163);[5] in miniature paintings such as a fine example by Siyah Qalam in Topkapı;[6] and in textiles.[7] Its social importance in the Safavid period is shown not only by the number of single-page miniatures showing a youth or prince holding a bird of prey,[8] but also by the fact that Sadeler's engraving of the Iranian legate to Rome in 1605 shows him, presumably at his own request and with the intention of enhancing his image, with a hawk.[9]

1. de Chamerlat (1987) p.74.
2. Bahrami (1952) pl.I.
3. Wilkinson (1987) fig.2.40 on p.207.
4. See, for example, Pope (1938–39) pls 654 and 714. One has the impression that many of the mounted figures on *minai* ware shown with one hand raised are falconers with the falcon omitted – a sort of short-hand version.
5. Pope (1938–39) pl.1308.
6. Ipsiroglu (1976) pl.71. Another fine, late 15th-century painting in Topkapı showing a mounted falconer is 'signed' by Siyah Qalam in the style of Shayki al-Ya'qubi; see Rogers (1986) pl.74. An earlier depiction of falconers occurs in another Topkapı painting of *circa* 1330 for a now lost manuscript of the *Shah-nameh*; see Rogers (1986) pl.43. For a Safavid example in a manuscript of Jami's *Haft Awrang* (f.153v), copied in Mashhad for Ibrahim Mirza in AH 963–72 (AD 1556–62) and now in the Freer Gallery of Art (acc. no.46.12), see de Chamerlat (1987) p.205.
7. Allgrove McDowell (1989) p.164 pl.22. Pl.13 on p.157 shows a mounted falconer from what may be a Buyid textile.
8. See, for example, Grube and Sims (1989) p.212 pl.25.
9. de Chamerlat (1987) p.206.

Falconry was the subject of numerous treatises during early and later Islamic times,[10] and retained its popularity until the 20th century. Exactly how many birds a Safavid or Qajar ruler might have owned is uncertain – European travellers never had a chance to count. Abel Pincon's comments give the general flavour, however, when he writes of Shah 'Abbas as follows: 'He also takes great delight in the chase, and breeds more birds for hawking than I have ever seen elsewhere, falcons, tercels, vultures, merlins, with which they catch all kinds of birds that they meet: partriges, quail, pheasants, larks, rooks and others. By means of vultures they also trap a species of roe-deer which they call gazelles, which are very beautiful.'[11] More specifically, an indication of the size of an Indian maharajah's team of birds and falconers was given by the Maharaja of Bahonagar in 1960, when he told a French falconer that his father had had thirty sakers, fifteen peregrines, ten shaheen, twenty *luggar*s and fifteen goshawks, not counting eagles, *shikra* (Indian kestrels) and sparrow-hawks. He added that the birds were trained by 40 professional falconers, who additionally were in charge of ten hunting cheetahs.[12] The last major work on the subject in Persian is the *Baz-nameh-yi Nasiri*, written by Husam al-Daula Taymur Mirza, one of the sons of Husain 'Ali Mirza Farman-Farma, Governor of Fars, and hence a grandson of Fath 'Ali Shah. This work was composed in AH 1285 (AD 1868).[13]

The two perches (in Persian, *nishineh*) in the Tanavoli collection (D.1 and D.2) are of interest for a number of reasons. The first fact which needs to be emphasised is that they are perches, not blocks. Falconers recognise two types of bird of prey for use in hunting, long-winged and short-winged. The long-winged are the falcons proper (*falconidae*), like the peregrine. These have much longer wings relative to their tail length than the short-winged, which are the hawks (*accipitridiae*), like the goshawk and sparrow-hawk. Not only do they differ in their wings, and correspondingly in their method of attack (the falcons 'stoop' or power-dive to close with their prey, while the hawks catch their quarry by 'binding to' them after a short and level chase), but falcons and hawks have different perching requirements. In the wild, falcons live among cliffs and rocks, and perch on relatively broad surfaces. In contrast, the hawks are by nature forest birds, and perch on branches. Hence the falconer will have what are called 'blocks' for his falcons, and perches for his hawks.

I have not been able to find a description of an Iranian falconer's block. However, Burton, in his description of falconry in the Indus valley, describes a block as 'a truncated cone of solid wood about a foot high, with a small staple on the top as a resting place for the bird, and a broad base to prevent her overturning it'.[14] A slight

10. See A'lam (1994) and Danespasuh (1990).
11. Denison Ross (1933) p.163. For 'vulture' we should read 'eagle'.
12. de Chamerlat (1987) p.192.
13. Phillpott (1908).
14. Burton (1852) p.38. His English is not very

HAWK STANDS

FIG.34 Detail from miniature depicting Zal at Kabul, from the *Shah-nameh* of Shah Tahmasp, f.67v
FIG.35 Detail from an anonymous watercolour, 19th century

 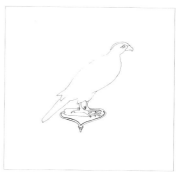

FIG.36 Detail from miniature depicting a Qajar prince, 1844–55
FIG.37 Detail from an engraving by Duhousset, *circa* 1860.
FIG.38 Detail from the spandrels of the Hasht Behesht Palace, Isfahan, *circa* 1670

suspicion hangs over this description, since it describes exactly the English block of the time, illustrated by Phillott in his translation of the *Baz-nameh-yi Nasiri*.[15] Hence Burton may be describing the block he was accustomed to, rather than those traditionally used by natives of Sind. Nevertheless, blocks were almost certainly made of wood to provide the broad surface suitable for a falcon, and wooden blocks are common to this day in the Gulf. The tops of these usually have a diameter of 15–20 centimetres and are padded to minimise damage to the falcon's feet. Since they need to be light their shafts are much thinner and are of turned wood: they can then be tucked under the falconer's arm as he rides.[16]

clear: he must mean that the block is the resting place, not the staple.
15. Phillott (1908) pl.XXIII.

16. Remple and Gross (1993) p.23; Allen (1980) pp.68 and 135, and illustr. opp. p.74.

Iranian paintings showing falconer's blocks are rare. One example is an album leaf of the second half of the 17th century by 'Ali Quli Jabbadar, now in St Petersburg.[17] This shows a falcon standing on the top of a circular block. This is evidently of wood, for its presumably leather cover is held on by a row of large-headed tacks. However, the painting shows just enough of the supporting stem to suggest that it was of metal, presumably steel. The only other evidence of metal shafts for such blocks is recent. A photograph from the Antoin Sevruguin archive shows a falcon on a block with a long, articulated steel shaft.[18] And in 1974, in a newspaper article about the revival of falconry in Iran, there was a photograph of falconers employed by the Department for Environmental Conservation.[19] This showed three falconers, two holding a perch, and the third holding a block. The block seems to be attached to a long, plain steel shaft.

Depictions of perches, on the other hand, are relatively common. An early Safavid example is to be seen in the *Shah-nameh* of Shah Tahmasp, in the miniature depicting Zal receiving homage from Mihrab at Kabul: there is one behind the corner of the carpet on which Zal is seated (FIG.34).[20] From a later period, a perch is shown in an early 19th-century painting in the style of Sayyid Mirza,[21] and another in an undated, 19th-century, watercolour (FIG.35),[22] while a bow-shaped perch is illustrated in a picture of a Qajar prince dating from 1844–55 (FIG.36).[23] A bird of prey on a bow-shaped perch also appears on one of the spandrels of the Hasht Behesht Palace in Isfahan, of *circa* 1670 (FIG.38). Perches also appear in Western books on Iran. For example, one is illustrated by d'Allemagne,[24] while Sykes, in his 1910 publication, reproduced a photograph of 'the governor's falcons': these latter rest on the right hands of three servants, who each hold a perch in their left hand.[25]

The two pieces in the Tanavoli collection are characterised by a rod or stem which directly supports the bar. This is the type of perch illustrated in the *Shah-nameh* of Shah Tahmasp (FIG.34), in the painting of the style of Sayyid Mirza, in the 19th-century water-colour (FIG.36), in d'Allemagne, and in the photograph of 'the governor's falcons' in Sykes' book. As a form it certainly seems to have been the most common, and it evidently spans the centuries. It also seems to have been the most popular style in India.[26] The surviving illustrations of Iranian perches show, however, that there were at least two other types as well. First there was a form in which

17. Akimushkin (1994) pp.108–9 and pl.64.
18. Washington, DC, Sackler Gallery, Antoin Sevruguin archive.
19. *Keihan International*, 10 April 1974.
20. S.C. Welch (1972) p.128 (f.67v.).
21. Robinson (1989) p.227 pl.4.
22. Christie's, 19 October 1993, lot 118.
23. Falk (1985) no.194.

24. d'Allemagne (1911) in a plate '*hors-texte*' at the end of vol.4. This plate reproduces a 19th-century watercolour, which shows a falconer by the name of 'Mohamed David-Khan'.
25. Sykes (1910) opp. p.52.
26. See, for example, Sotheby's, 1 December 1969, lots 143, 146; Christie's, 22 November 1984, lot 187; Dexel (1991) pl.VIII; Colnaghi (1976) nos 101, 133.

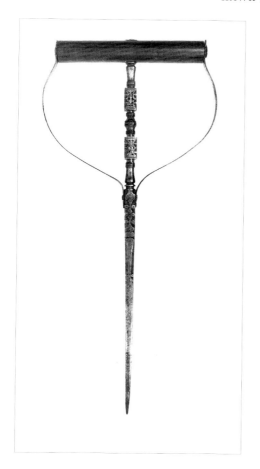 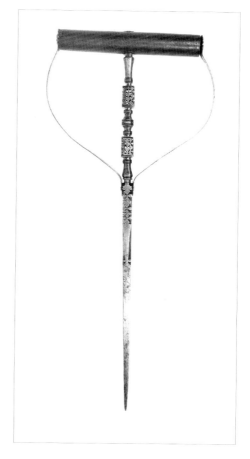

D.1 Falcon perch; steel structure with wooden perch; cut, pierced, punched, chased, riveted and inlaid with brass; ht 53.1 cm; w. 20.6 cm; made by Muhammad Husain; dated AH 1037 (AD 1627–28); no.526

D.2 Perch; steel structure with wooden perch; cut, pierced, punched, chased, riveted and inlaid with brass; ht 55.7 cm; w. 20.4 cm; early 17th century; no.21

the horizontal bar was supported only by the brackets. An example of this is to be found in an engraving by Duhousset (FIG.37).[27] Secondly, as noted above, there was a bow-shaped style, in which, likewise, the curving bar was supported only by the brackets (FIG.38). There seems little doubt, incidentally, that all the above were steel, though the colour of that illustrated in Shah Tahmasp's *Shah-nameh* suggests that royal perches would have been gilded.

27. Mr Tanavoli kindly provided a photograph of the engraving, but I have failed to trace its source.

The two perches in the collection are both of the type most often illustrated, and since they have so much in common – the form of the balusters and bosses, of the stem, the brackets and the rivets, and the style of brass inlay and punched emphases in the decoration – they must come from the same workshop. The quality of the incised design on the outside of the bracket of D.1 is less impressive than that of D.2, which is surprising given that the former is the signed and dated example: 'The work of Muhammad Husain, 1[0]37 [AD1627–28]'. This feature is a reminder that different craftsmen were working on different individual objects, and that they were by no means of uniform ability. There is a *nasta'liq* inscription on D.2, which reads: 'As the falcon of the kingdom of Ilkhan / Sits on top of the [bird] stand / The end of the [bird] stand will then / Sit on the eyes of his enemy.'

An unpublished steel perch, attributed to Mughal India, is on display at the British Museum.[28] The form of the stem is very similar to the two in this collection, though it is much more heavily decorated with gold overlay, and there are also significant differences in details such as the form of the lower terminals of the brackets, and of the rivets (or screws) and plates which attach the brackets to the bar of the perch. The floral design suggests an Indian provenance; the two rectangular bosses bear an unread Persian inscription. The similarity between the British Museum piece and the two in the Tanavoli collection indicates once more the close artistic ties between Iran and Mughal India in the 17th and 18th centuries.

28. Acc. no. 89.3-9 1: height 53.5 cm, width 22 cm. The cylindrical bar is of walnut.

Standards

Military, royal and religious metal standards can be traced back to early times in Iran. They occur, for example, among Luristan bronzes, and a number of depictions of Achaemenid standards exist, as well as textual evidence about their forms. Three Sasanian standards are depicted at Naqshi-i Rustam.[1] A legendary standard was that used by the blacksmith Kaveh in his revolt against Zahhak, which was captured at the battle of Qadisiyya in 637 and is said to have been burned by the caliph 'Umar.[2] None of these seems to have had any lasting impact on Iranian taste, though the total lack of evidence for early Islamic times may hide some sort of continuity. In a later Islamic context, steel or brass standards (*'alam*s) have been in use at least since the 14th century, and from the 18th century onwards a relatively large number survive. For their origin and early history there is much to be gleaned from surviving miniature paintings.[3] Attention should be drawn to the particular forms of standard associated with the Ottoman empire and the Shi'ite communities of India.[4] They will not be further discussed here.

The Saljuq Turks appear to have been responsible for the introduction into Iran of the *tugh*, or yak's tail, which can be seen hanging from the spears of so many warriors in 14th- and 15th-century painting.[5] But it is clear that very soon after the Mongol invasions, and certainly by the early 14th century, other items were being added to the tops of poles as totems or standards – for example, quatrefoils,[6] knobs and

1. Shahbazi (1994).
2. Khalegi-Motlagh (1994).
3. The evidence of miniature painting has sometimes suffered: a number of depictions which originally projected beyond the frame of the miniature have been lost through cropping and rebinding of the relevant manuscript; editors have omitted others from reproductions of particular paintings, presumably because they feel a painting is only what is inside its frame!
4. For Ottoman standards and banners see Zygulski (1992) pp.1–99, and Tezcan (1991); for the standards used in Hyderabad see Naqvi (1987), especially pp.7–14 and 19; for those used in Golconda, see Safrani (1992); and for those used in Lucknow see Frembgen (1995). For *'alam*s used in Muharram observances in Trinidad see Korom and Chelkowski (1994) pls 3, 7 and 14.
5. See, for example, Talbot Rice (1976) pl.38. For the *tugh* under the Ottomans, see Żygulski (1992) pp.69–99.
6. Binyon, Wilkinson and Gray (1933) pl.XXII.

crescents,[7] and paired dragon's heads facing the spear point.[8] Although dragon-headed quillons, jug handles and candle-holders are usually associated with the Timurids and assumed to have come into fashion in the 15th century, the pictorial evidence suggests that dragon's heads as ornaments predate the 15th century. Indeed A.S. Melikian-Chirvani cites a 13th-century text mentioning a banner bearing a dragon to show that this emblem was already used in Saljuq times,[9] though as yet no example of a Saljuq dragon-headed standard, or pictorial representation of such a thing, is known.

By the second half of the 14th century a central ornament above a pair of inward-facing dragon's heads was evidently an important, possibly royal, type of military emblem. In a miniature of *King Minuchihr killing a Turanian* it surmounts the royal banner.[10] However, it was by no means the only form of standard: a pair of late 14th-century miniatures in Topkapı Saray gives equal prominence to a standard in the form of a stirrup, and two rather plainer types are also illustrated.[11] Just before the turn of the century, in a Shiraz manuscript dated AH 800 (AD 1398), the name of God appears as a finial.[12] It also occurs in a Herati manuscript of AH 845 (AD 1441)[13] and in a Shiraz manuscript of the same date: the stirrup form is more elaborate in the latter case, and bears a reversible calligraphic design of the word 'Allah' at the top.[14] In a Shiraz *Shah-nameh* of Ibrahim Sultan of 1420, a very broad pointed oval appears,[15] and in a *Khamseh* of Nizami written for Shah Rukh in Herat in 1431, we find a long-necked serpent, an equally long-necked dragon, a lion's head, and a single, spear-shaped leaf, or trefoil with a crescent around its base.[16] By the mid-15th century standards with long projecting leaves also appear in Shiraz manuscripts. This design may be related to the cypress tree,[17] or possibly the palm tree;[18] for identification purposes it is hereafter called after the cypress. Provincial manuscripts suggest the likelihood of regional variations. For example, the *Shah-nameh* produced in Gilan in AH 899 (AD 1493–94) shows standards with a small central sphere and a pair of dragon's heads facing outwards either side of it, surmounted by a finial in the shape of a spear-head.[19] This also suggests that some provincial designs may have changed relatively little since Mongol times.

Sometime in the mid-15th century, however, the design destined to dominate

6. Binyon, Wilkinson and Gray (1933) pl.XXII.
7. Talbot Rice (1976) p.180.
8. Talbot Rice (1976) pl.5.
9. Melikian-Chirvani (1984) pp.124–25.
10. Ipsiroglu (1980) pl.20.
11. Ipsiroglu (1980) pl.19.
12. Pope (1938–39) pl.857.
13. Gray (1979) pl.116, dated AH 845 (AD 1441).
14. Lentz and Lowry (1989) no.46.
15. Binyon, Wilkinson and Gray (1933) pl.XLA.
16. Adamova (1996) p.105.
17. Robinson (1980) p.86 no.422. One might compare the cypresses shown in a rather later miniature from Shiraz, *circa* 1590, in Robinson (1976) pl.XII.
18. Arberry *et al.* vol.3 (1962) pl.17, an example dating from AH 987 (AD 1579).
19. Lowry (1988) pp.100–103.

standard styles for the next thousand years was introduced – a pear-shaped centre, an ornamental point, and double dragons with their heads turned outwards rather than inwards. In a miniature from the 1475–81 *Khamseh* of Nizami, produced in Tabriz and now in Topkapı Saray, there are no less than 13 examples of this type of standard:[20] it was clearly the style of the Turkoman rulers and their armies.

Further east, fashion was different. Bihzad's painting of the battle between Darius and Alexander the Great, added to a manuscript of the *Khamseh* of Nizami dating from *circa* 1493, shows a very different approach: a beautiful, cruciform, arabesque design.[21] Its continuing popularity in the east is confirmed by its depiction in a 1553 Bukhara manuscript in the Bodleian Library.[22]

Returning to Tabriz, it is worth noting in passing the use of dragons as handles and ornaments in drawings and paintings associated with Siyah Qalam,[23] and there is evidence that illustrates how rich was the variety of standard designs current in Tabriz under Shah Isma'il and Shah Tahmasp. The Shah Tahmasp *Shah-nameh* illustrates at least 30 different varieties (FIGS 39a–b). The pear-shape with a pair of dragons facing outwards, surmounted by three cypress branches, is by far the commonest, but it now includes examples pierced with arabesques and inscriptions.[24] Others are pear-shaped and have pairs of dragons, but bear a variety of other finials.[25] Dragons multiply in variety and prominence.[26] The name of God still remains in vogue.[27] Flaming haloes become popular,[28] so too lions.[29] The Sun appears,[30] while arabesque designs, presumably based on the eastern tradition, are common.[31]

Qazvin painting of the 1570s and 1580s suggests a continuing development. Long-necked, single dragon's heads are still popular,[32] the trident design continues,[33] and circular or pear-shaped plaques with paired dragons and a variety of finials are widespread.[34] An all-over, probably pierced, arabesque design on a pointed oval disc appears to be a new introduction.[35]

20. Gray (1979) pl.134.
21. Titley (1983) pl.8.
22. Robinson (1958) pl.XXIII.
23. Ipsiroglu (1976) pls 56A and B.
24. Dickson and Welch (1981) vol.2 nos 41, 42, 44, 45, 77, 78 (pierced), 85, 97, 99, 108 (pierced arabesques), 128, 147 (arabesques), 162 (inscription) and 173 (inscription).
25. Dickson and Welch (1981) vol.2 nos 79 (trefoil), 85 (rhomb), 101 (flames), 127 (disc and cypress branches).
26. Dickson and Welch (1981) vol.2 nos 113, 128, 160, 209.
27. Dickson and Welch (1981) vol.2 nos 160, 161.
28. Dickson and Welch (1981) vol.2 nos 128 (two different varieties), 139, 151, 157, 161.
29. Dickson and Welch (1981) vol.2 nos 138, 140, 160, 177.
30. Dickson and Welch (1981) vol.2 nos 139, 188, 251.
31. Dickson and Welch (1981) vol.2 nos 148, 150, 177, 261.
32. Lowry and Beach (1988) p.114 no.130, p.115 no.137, p.183 no.209.
33. Colnaghi (1976) p.121 no.19xv.
34. Lowry and Beach (1988) p.111 no.120, p.114 no.130, pp.183–86 no.209.
35. Colnaghi (1976) no.19xx.

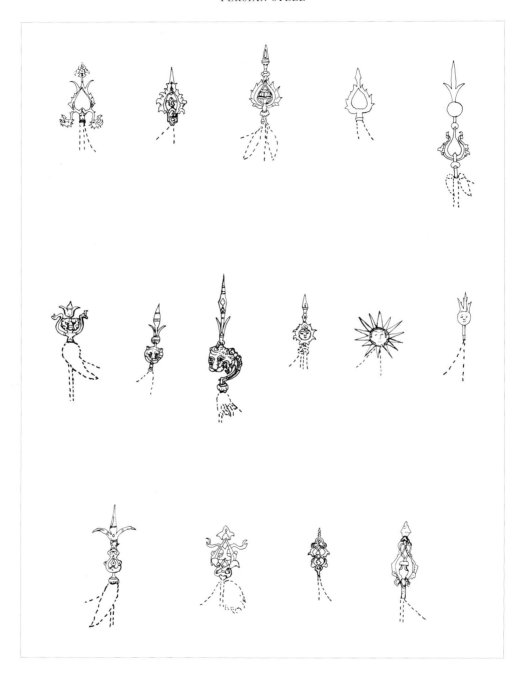

FIG.39a Drawings of standards after miniature paintings in the Shah Tahmasp *Shah-nameh*

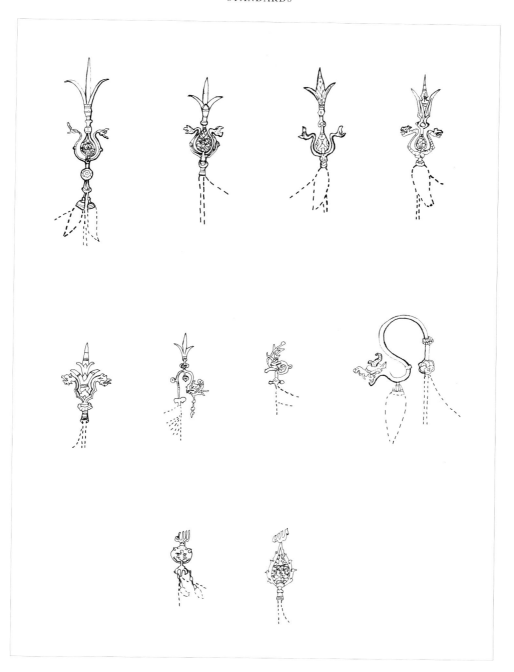

FIG.39b Drawings of standards after miniature paintings in the Shah Tahmasp *Shah-nameh*

Certain provincial centres of the 16th century also show a wide variety of designs. For example, 16th-century Shiraz miniatures illustrate wide variants of the disc, dragons and spear-head design;[36] disc, dragons and cypress-branch design;[37] flat pear-shaped standards topped by cypress branches;[38] and what appear to be three-dimensional pear-shaped or spherical objects, sometimes decorated with arabesques, topped with a variety of finials.[39] A variant of the first group has the dragons replaced by half-palmettes.[40]

Visual evidence in miniature painting of the first half of the 17th century is much rarer, probably due to the reduced numbers of royal commissions of luxury manuscripts, and the increasing taste for single-page drawings or paintings. From the middle of the century onwards, however, there is some evidence, notably in a group of manuscripts in the Chester Beatty Library – a *Shah-nameh* of *circa* 1650[41] and a history of the Safavid dynasty of *circa* 1670,[42] for example. From these it seems that interest in the designs of military standards was on the wane. Most pennants are topped with plain spear-heads, and a couple of stylised traditional forms plus a thin-leaved cypress design are the only more elaborate varieties.

The pictorial evidence outlined above demonstrates the use of standards in battle and as indicators of the presence of the sovereign. This is also indicated by textual evidence. Thus Barbaro observed: 'Where the Prince rideth there go before him v horses and more; which have also their scouts before them with certain square ensigns, which crying make room, make room! to whom all men give way.'[43] Eskandar Beg Monshi describes Shah Tahmasp's personal banner at the battle against the Turks near Vastan on Lake Van in AH 941 (AD 1534–35) as being surmounted by a gilded globe,[44] and five or six years later Membré gives a detailed description of the banners which went in front of the king: 'In front go the banners, which they call *'alam*, which are lances covered with red broadcloth, with two points, and on the top of the lance a circle, and, inside the said circle, certain letters of copper, cut out and gilded, which say, "*'Ali wali Allah; la ilah illa Allah; 'Ali wali allah wa Allahu Akbar*". That is what the words say. They are carried in the hand on horseback ... As many standard go as there are kingdoms, and below the said letters are armozeens of red silk with double points ...'[45]

36. Guest (1949) pl.5; Robinson (1980) p.187 no.608.
37. Guest (1949) pl.39; Robinson (1976) p.130 no.394, p.131 no.397; Robinson (1980) p.193 no.615.
38. Guest (1949) pl.46B.
39. Guest (1949) pls 11, 37A, 42B; Robinson (1976) p.82 no.237, p.95 no.277; Robinson (1980) p.175 no.591.
40. Guest (1949) pl.21.

41. Arberry *et al.* vol.3 (1962) MS. no.270. The relevant miniatures have not been published.
42. Arberry *et al.* vol.3 (1962) MS. no.279. The relevant miniatures have not been published.
43. Thomas and Roy (1873) p.68.
44. Eskandar Beg Monshi vol.1 p.114.
45. Membré (1994) p.24.

STANDARDS IN RELIGIOUS USE

By the early 17th century, if not earlier, however, standards had assumed a religious role as well.[46] Kotov, in Isfahan in 1624–25, writes: 'In the mosque [unspecified] lie poles with flags, [which], like our church banners, are not used for anything except to be carried on festivals with the ikons, and among them these poles are carried on festivals and in front of the dead. And these poles are vine rods, long and thin, about 20 *sazhen* in length, and when they lift them the poles bend; and tied to the tops of them long narrow streamers about 5 *sazhen* long hang half way down the poles and on top of the poles there are iron things like scissors or like a stork's beak and on other poles there are wicker crosses and spikes.'[47] And in another passage he writes about the Ashura festival: 'the procession carries coffins decorated all over with strips of copper and tin and glass ... in front of those same coffins they carry the long poles described above; and in front of these coffins they lead horses with complete harness, and they bear helmets and armour, bow and quiver, sword and lance.'[48] Pietro della Valle, de Thevenot and Francklin also testify to their use.[49]

There is also the evidence of Olearius. In the 1647 edition of his book there is an engraving of a firework display at the Shrine of Shaikh Safi in Ardabil.[50] This shows what must be the 'standard of Shah Isma'il' on a tall pole held by a courtier. The standard appears to be circular, with a central circular hole surrounded by a series of roundels, and is surmounted by some sort of pointed finial with a pair of dragons facing outwards, one either side of it. Olearius discusses its origin: 'it is reported, (it) was made by the daughter of Fatima, who caus'd the iron work to be made of a horse-shoe, which had belonged to one of the horses of 'Abbas, Uncle to Mahomet by the Father side, which Schich Sedredin, the son of Schich-Sefi, had brought from Medina to Ardabil. They say that this banner shakes of itself, as often as they pronounce the name of Hossein, during the sermon which is made in honour of him, and that when the Priest makes a recital of the particulars of his death, how he was wounded with seventy two Arrows, and how he fell down from his horse, it may be seen shaken by a secret agitation but withall so violent, that, the staff breaking, it falls to the ground. I must confess, I saw no such thing, but the Persians affirm it so positively that they think it should not in any way be doubted.'[51] Whatever the true origin of the standard, its religious importance in the 17th century is clear.

46. At burials, according to Membré (1994) p.40, 'on a spear they put certain branches, like a tree, and place [on them] many red oranges.' One wonders if this is meant literally, or whether he is referring to some sort of standard.
47. Kemp (1959) p.25. According to the translator, p.x, in the early 17th century a *sazhen* was approximately 5 feet long, but this figure makes nonsense of this passage.
48. Kemp (1959) p.31; for the history of this procession see *Encyclopaedia Iranica* vol.7 fasc.1, 'Dasta'.
49. della Valle (1663–70) vol.2 p.180; de Thevenot (1686) p.109; Francklin (1788) p.100.
50. Morton (1975) pl.Ic.
51. Olearius (1669) p.175.

How early the religious use of standards developed is not so certain. There is an interesting miniature in a Shirazi manuscript of the *Zafar-nameh*, dated AH 929 (AD 1523).[52] This shows a tower built of human heads in the form of a contemporary Iranian minaret. Towers of human heads have a regular place in the epic of Timur's endless battles and conquests, but the text never mentions a minaret made in such a way. In the miniature painting it is surmounted by a standard – of the disc, double-dragon and spear-head-finial variety. This image raises the important possibility that such standards were used on 16th-century minarets, and that they therefore had religious connotations long before the period of Shah 'Abbas I. It also raises the possibility of a connection between the standards under discussion and those which adorned, and still adorn, the tops of domes in Iranian architecture. The only manuscript which shows a large number of such finials is the 1431 *Khamseh* of Nizami in the Hermitage, but these are all of one type with a fluted sphere surmounted by a spear-like point.[53] Those still in use include the standard which surmounts the dome of the Masjid-i Shaikh Lutf Allah in Isfahan. This appears to be similar to Type A standards (see below), though without the dragons. However, no systematic study has ever been made of Iranian dome finials, so any relationship must for the moment remain conjectural. Another possible connection is with parasol finials,[54] but this too remains to be researched.

In the later Safavid period, the standards used at religious festivals identified the different guilds or town quarters taking part. According to Keyvani, they were made and decorated on a cooperative basis, and different parts of the emblem poles would be made by different guilds, such as ironsmiths, coppersmiths, braziers, steel fretworkers, sword makers, locksmiths, engravers, metal embossers and gold beaters.[55] The guilds kept their standards in their *char-suq* (public building complex), and the town quarters kept theirs in the local *bazarcheh* in their own *mahallas*.[56]

The various designs of standard raise the question of their symbolism. The royal symbolism of the dragon has been discussed by Melikian-Chirvani;[57] its significance in the eyes of a contemporary craftsman is mentioned below (p.263). The lion has obvious royal overtones, but is also the symbol of 'Ali, and hence strongly Shi'ite in its imagery. The sun is found elsewhere in the Islamic world as a royal symbol, and should probably be read the same way here.[58] The flame design could be a different

52. British Library, Add. 7,635; Guest (1949) pl.28B. For the English translation of the text see Yazdi (1723).
53. Adamova (1996) no.1, pp.138–39, 142, 144, 146–47, 148, 150–51, 152.
54. See, for example, Adamova (1996) no.3 f.90a on p.173, an illustration from a *Khamseh* of Nizami dated AH 948 (AD 1541).
55. Keyvani (1982) pp.145–6.
56. Keyvani (1982) pp.142–43. A late Safavid *'alam* still surviving in one of the local *mahallas* of Isfahan is described below.
57. Melikian-Chirvani (1984) pp.323 ff.
58. See, for example, the discussions in Allan (1982a) *passim*, and Hillenbrand (1986).

way of rendering the sun, or it could be the flaming nimbus associated with Muhammad, 'Ali, or other religious figures in Iranian miniature painting.[59] The symbolism of the style of standard shown at the Ardabil shrine in Olearius's engraving will be discussed below.

One other type of standard deserves mention at this point, even though it does not seem to appear in manuscript illustrations, nor indeed have steel examples so far been published: the standard in the form of a hand. It is recorded by Drouville being used for military purposes in the reign of Fath 'Ali Shah: 'The Persian flags and standards carry the coat of arms of the country, which consists of a lion lying in front of a rising sun, with this legend: Sultan son of Sultan Fath 'Ali Shah Qajar ... The flags are red, surmounted by a silver hand, that of 'Ali; the standards are blue, surmouned by a gilded lance, as sharp as those of the *houlans*.'[60] There is a fine silver example in the Victoria and Albert Museum which is thought to be Iranian,[61] but could be Indian, and a number of other silver examples are known.[62] Standards in the form of a hand occur among the Shi'ites of Central Asia,[63] were very popular under the Ottomans,[64] and are also widely used by the Shi'ite communities in India.[65] Ella Sykes noted poles with metal hands at the top as symbols of 'Abbas, standard-bearer at the battle of Kerbala.[66] Naqvi, on the other hand, sees the hand as a symbol of protection, but nothing more.[67]

STANDARD-MAKING IN CONTEMPORARY IRAN

Today the manufacture of standards in Isfahan is a very small industry. One of the only two businesses left is that of the Bahman family. Ustad Haj Akbar Bahman (FIG.11) is the eldest of three brothers, all of whom were until recently involved in the production process. He, however, is the only one with the title Ustad, which in his case identifies three different skills or trades – gold incrustation, piercing and calligraphy, all of which are essential features of standards. Akbar's two brothers, Husain and Majid (FIG.40), used to do the smithing in their workshop in the bazaar, but Akbar's son, Bahram, now helps him. In the workshop they store sheet steel of varying qualities, and varieties of steel pipes and tubes. From the larger tubes are

59. See, for example, Soucek (1975) fig.25 ('Ali); Guest (1949) pl.20 (Muhammad), pl.2 (al-Khidr and Ilyas), pl.44A (Yusuf). The significance of the rayed nimbus in Islamic art is fully discussed by Hillenbrand (1986).
60. Drouville (1825) vol.2 p.118, illustrated on p.119.
61. Safadi (1978) no.134.
62. For example, Sotheby's, 20 October 1994, lot 119.
63. Nikolaycheva (1970) figs 1–2.
64. See, for example, Lewis (1976) fig. on p.203; Frembgen (1995) Abb.9; see also Zygulski (1992) pp.50–54 for a discussion of the symbolism of the hand.
65. Frembgen (1995) Abb.8, 10–12.
66. Sykes (1898) p.163.
67. Naqvi (1987) p.14.

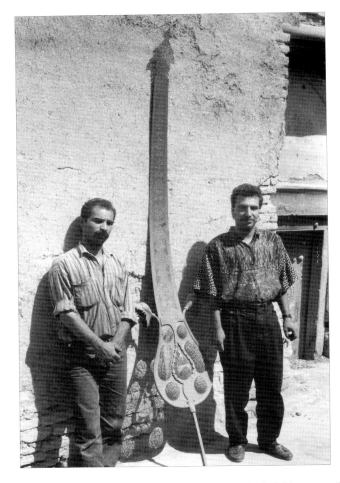

FIG.40 The Bahman brothers Husain and Majid with one of their standards, Isfahan, 1992. (Photo: J.W. Allan)

forged the round bodies of the various three-dimensional elements of the standards – birds, animals, vases. From the smaller tubes are made other important elements, in particular the edging for the pierced sheets of steel which form the heart of a standard's construction. The designs are then drawn onto the sheets for piercing and holes are drilled with an electric drill in each small area to be removed. The area concerned is then cut out with a fretsaw with a very high-quality blade. When Wulff saw steel fretworkers plying their trade in the 1940s some still used files rather than the newly introduced fretsaw, but this is no longer the case.

Etching is another important part of standard manufacture. The inscription to be left in relief is painted with lac and alchohol, and the steel is then dipped into acid. The result is an inscription in low relief, and a slight texturing of the background.

The gold incrustation Akbar Bahman does at home. He makes very fine cuts in two directions on the surface and then hammers onto them extremely fine gold wire which he has himself drawn from much thicker gold wire. Spatial incrustation is achieved by laying the wires side by side, a very laborious activity which in part explains the relative rarity of such spatial work in contemporary pieces. With such incrustation it is necessary to be very accurate with the hammer as damage to the nearby surfaces will prevent a smooth finish. Akbar Bahman smooths his gold and steel surfaces with a jade-headed polishing tool.

The Bahmans' standards are of various forms. The most common in their workshop has a pear-shaped body with openwork inscription, a large projecting dragon's head either side, and a tall blade surmounted by a polylobed finial. They also make standards with projecting dragon's heads all round, and *'alam*s of ogival form. An essential part of their work is manufacturing animals, birds, vases, axes and other objects to stand on the long crossbar of the more elaborate standards.

The symbolism of the various items adorning contemporary standards is not always clear, but Husain Bahman said that the dragon's heads around the central pierced and inscribed sheet are there to protect the Qur'anic verses by their fiery breath. The animals and birds he related to Solomon, who was master of all living creatures. He also said that the very tall, thin sheets, which bend backwards and forwards as the standard moves along, symbolise modesty, bowing to each other when two Muharram processions approach one another.

In the Bahman home stand the various elements of a magnificent standard, perhaps 30 feet high when assembled, and designed to be decked with 1001 ostrich feathers. This was commissioned by the last Pahlavi empress for the Muharram processions in Shiraz. Sadly it was unfinished at the time of the Revolution. Another Bahman standard is in the main room of a local house. This room acts as a Husainiyyeh, and the standard provides the focus when the room is fulfilling its religious function. It is also under a standard that important local or inter-family discussions are held, for example on marriage proposals, or similar topics or problems. Since many of the *'alam*s used in Muharram processions are extrememly heavy, they have to be carried by men of considerable strength, who are often wrestlers. For this reason they may be kept in the local *zurkhaneh* (gymnasium), though some, for religious reasons, may be the property of the latter.[68]

TYPOLOGY OF STANDARDS IN THE TANAVOLI COLLECTION

The standards in the present catalogue occur in a number of different forms:

68. Baker (1997) p.75 and n.18, and pl.XVIa.

Type A

First is the flat, almond-shaped standard on a steel shaft (E.1 and E.2).[69] At the top of the shaft is an ornamental sphere, and the body of the standard has an ornamented blade rising above it between two projecting leaves or cypress branches. A dragon's head projects from either side of the body, and the decoration of body, blade and sphere is pierced. The pierced inscriptions of E.2 are as follows: in the top medallion, *Huwa* ('He is'); in the scalloped medallion, *Ya fatah* ('O Opener'); and in the central panel, *Allah wali al-tawfiq* ('God, the one who grants success'). Those on E.1 read: in the trilobed palmette, *Huwa Allah subhanahu* ('He is God, praise be to Him'); in the pointed medallion the word is uncertain; in the small trilobed medallion, *Ya fatah* ('O Opener'); and in the central panel, *Allah Muhammad 'Ali* ('God, Muhammad, 'Ali').

E.2 bears an inscription in gold inlay around the top of the staff which reads: *'amal Kamal al-Din Mahmud Nazuk fi sana 996* ('made by Kamal al-Din Mahmud Nazuk in the year 996 [AD 1587]'). The standard was therefore theoretically made at the end of the reign of Muhammad Khudabandeh (1578–88). The name of the maker, Kamal al-Din Mahmud Nazuk, however, directly conflicts with this date, for the same name appears on objects dated almost exactly a century later – a plaque for sharpening pens (*maqta'*) in the Harari collection, dated AH 1108 (AD 1696),[70] an openwork door plaque sold recently in London and dated AH 1107 (AD 1695–96),[71] and an unpublished door of a shrine grille dated AH 1110 (AD 1698–99). The door plaque gives a more complete version of the maker's name, Kamal al-Din Mahmud ibn 'Ali Riza Nazuk. The inscription on the standard is in gold inlay, in a free-flowing hand, quite different from the signatures on the two openwork pieces and the grille doors, and, moreover, quite different from the rest of the pierced decoration on the standard. One is forced to conclude that the inscription has been added at a later date, to give the standard an attribution to a famed artisan, and that the attributer was misled about the period when Kamal al-Din Nazuk actually lived.

The correct dating of the standard is probably closer to the lifetime of Kamal al-Din Nazuk than to the date in gold inlay. Although comparison of the designs on the sphere and in the small cartouche between the dragon's heads with those on brass and tinned copper objects seems to suggest a late 16th- or early 17th-century date,[72] the pierced inscriptions against a scrolling stem with flowers and leaves has much more in common with base-metal objects from later in the 17th century.[73] Hence the

69. A piece closely comparable to no.58 was sold at Christie's, 26 April 1994, lot 389.
70. Pope (1938–39) Vol.6 pl.1390F.
71. Sotheby's, 30 April 1992, lot 137; Momtaz (1995) no.55.
72. *Cf.* Melikian-Chirvani (1973) pp.106, 116, 118; (1982) no.146.

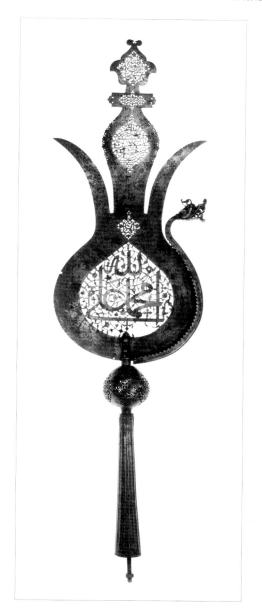 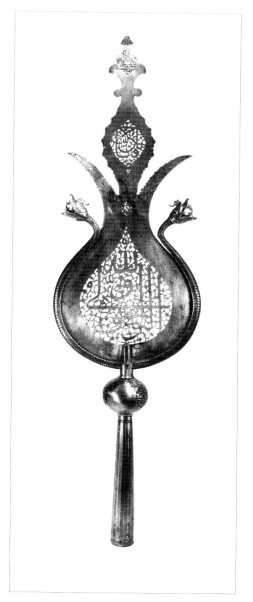

E.1 (left) Standard; pierced, riveted, and incised; eyes inlaid with brass; ht 96.5 cm; w. 28 cm; second half of the 17th century; no.58

E.2 (right) Standard; pierced, riveted, and incised; maker's inscription inlaid with gold; ht 95.5 cm; w. 26.5 cm; second half of the 17th century; no.59

E.3 Standard ornament; pierced and brazed; ht 9 cm; d. 9.4 cm; mid-16th century; no.65

standard probably comes from the second half of the latter century.

E.2 is a complete piece, but E.1 has suffered slightly during its working life. Not only is one of the steel edgings with its dragon's-head terminal missing, but the outer cover of the shaft has split and been crudely repaired, and the sphere is loose. It is likely to be the original, however, since the disc which prevents it falling down the shaft does not appear to have been replaced. The form and pierced designs of this standard and its sphere are so similar to those of E.1 that it must come from the same centre at the same period.

The steel sphere from another standard of this type (E.3) has a somewhat broader, openwork, cruciform palmette design. Cruciform palmette patterns were a legacy of the Timurid past and died out by the end of the 16th century. This example probably dates from the middle of the century.[74]

A variety of standards made of bronze or brass in forms related to this are known. There is a particularly splendid example in the Ardabil group, now in the Iran Bastan Museum in Tehran,[75] but most of the surviving pieces are of lesser quality and will not be discussed here.[76] More important for comparative purposes is a group of

73. See, for example, Melikian-Chirvani (1982) nos 155, dated AH 1089 (AD 1678–79), and 166, in which the third number of the date must be a 9, not a 4, and hence dates the object to the AH 1090s (AD 1680s).
74. Cf. Melikian-Chirvani (1982) fig.59a, nos 122–23.
75. No. 66/429. I am grateful to 'Abdallah Ghouchani for enabling me to study and photograph the 'alams from the shrine, now in the Iran Bastan Museum.
76. For example, Sotheby's, 22 November 1976, lot 126; 15 October 1985, lot 222; 14 October 1987, lot 473; von Folsach (1990) no.368; and three in the Tanavoli collection, nos 137–39.

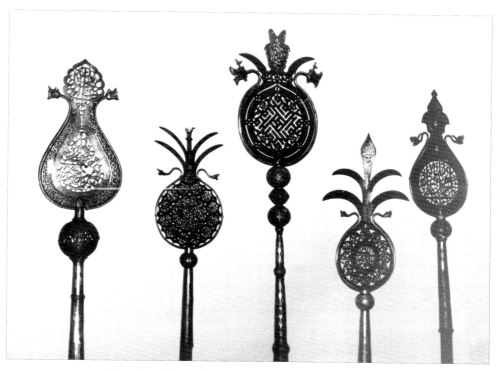

FIG.41 Type A and B standards in the Topkapı Saray Museum, Istanbul, 16th–17th century (Photo: J.W. Allan)

at least 25 steel standards in the Topkapı Saray Museum, Istanbul (FIG.41).[77] Four of those seen by the author have round or almond-shaped bodies with projecting dragon's-heads and a variety of leaf and/or medallion finials, while the fifth is of Type B (below). These are of the greatest interest, for they are clearly Iranian, and with their explicitly Shi'ite messages – two appear to be decorated with the names of the Twelve Imams, while others include the name of 'Ali along with those of God and Muhammad – are hardly likely to have been gifts from Safavid rulers to the Ottomans. The probability is therefore that they were captured from the Safavids in war. Most famous of all the battles between the Ottomans and Safavids was the battle of Chaldiran (1514), in which Isma'il I was so badly defeated by Sultan Selim that he even lost the royal harem, including two of his wives. However, this was not the only encounter between the rival empires. Suleyman the Magnificent's Grand Vizier, Ibrahim Pasha, briefly captured Tabriz in 1534. It was again captured in the Ottoman campaign of 1548, yet again during the Turko-Iranian war of 1578–90,

77. Two were published in Pope (1938–39) pl.1433. Dr Ludvik Kalus generously sent me photocopies of photographs of some 25. These deserve a separate publication in the future.

and for the last time in the war between Murad IV and Shah Safi' in 1635. There were therefore numerous opportunities for the capture of Safavid standards, and the Topkapı examples could in principle date from any time in the 16th or the early 17th century. That said, however, a closer dating of some of the pieces illustrated is possible. For example, the standard bearing a circle of twelve roundels, enclosing what appear to be the names of the Twelve Imams,[78] has in the centre an openwork inscription in which the verticals of the *alif*s are strongly contrasted with the horizontals of the *yay*s. In greater Iran, this type of calligraphic style appears to be associated with the late 15th century,[79] suggesting that this is an early Safavid object. Similarly, the standard with a bold openwork design of geometric Kufic[80] has steel spheres on the shaft decorated with a cruciform palmette design typical of the early rather than the later 16th century.[81]

Mention should be made here of a small standard of a rather broader almond shape in the Royal Armoury in Stockholm.[82] This could be a finial from a more complex standard,[83] but given the socket at its base designed to fit the top of a pole it is probably a true standard. Formerly in the collection of Prince Sachovskoy in St Petersburg, it could have come from the Ardabil shrine, along with other treasures taken by the Russians in 1827. Its fine pierced arabesque work suggests a date in the late 16th or early 17th century.

Type B

Related to the almond forms are a group of more elaborate steel standards. With their heads visually divided into separate sections, they give the appearance of being made of a number of separate sheet elements held together by thick metal strips. In reality the head is made of one sheet, or two half sheets, and the different areas are delineated by riveted steel bands. Both E.4 and E.5 belong to this group. The head of E.4 is made of a single sheet, whereas that of E.5 was originally of two sheets, joined down the middle. A very fine example of the group is in the Topkapı Saray Museum (FIG.41, left). The projecting medallion of this standard bears in openwork the names of God, Muhammad and 'Ali, and its body the phrase *nasr min allah wa fath qarib* ('victory from God and swift success'; sura 61, verse 13). It probably dates from the 16th century.

Another is to be found in the shrine at Ardabil (FIG.42). This standard has two

78. Topkapı Palace Museum, acc. no.651. I am grateful to Dr Ludvik Kalus for supplying the accession number of this piece.
79. See, for example, Lentz and Lowry (1989) pp.272–73 nos 150 and 152.
80. Topkapı Palace Museum no.655. I am grateful to Dr Ludvik Kalus for supplying the accession number of this piece.
81. For instance, Melikian-Chirvani (1982) no.123.
82. *Arts of Islam* (1976) no.236; A. Welch (1979) pp.148–49 no.61.
83. *Cf.* Moser (1912) pl.XLII no.990.

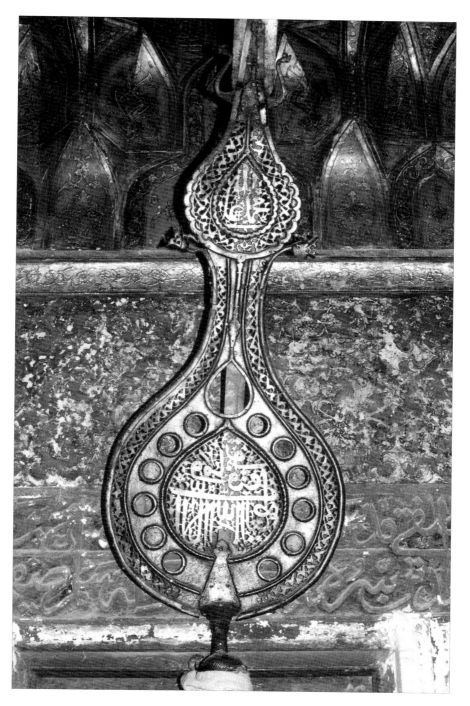

FIG.42 Type B standard in the Ardabil shrine, 16th–17th century (Photo: J.W. Allan)

additonal projecting dragons where the blade joins the upper openwork medallion, the latter in this case being almond-shaped. The upper medallion bears the names of God, Muhammad and 'Ali, while the openwork inscription on the body reads: *wa ma tawfiqi illa billah* ('My welfare is only in God'; sura 11, verse 88), followed by two epithets of God, the first concealed by the supporting bracket, the second reading, *al-'adhim* ('the mighty').[84] The border pattern may be compared to that on a late 16th- to 17th-century wine bowl in the Victoria and Albert Museum.[85]

Yet another example of this same group is illustrated in the Moser collection catalogue.[86] Like E.4 this has two projecting dragon's heads, but like E.5 it has a band of circular holes between the outer openwork and the central inscription. The almond-shaped body is surmounted first of all by a pointed oval medallion of openwork inscription and then by a tall blade. The inscription on this banner is in two parts. On the pointed oval at the base of the blade is *bismillah al-rahman al-rahim* ('In the name of God, the compassionate, the merciful'), and on the almond-shaped body *Allah nur al-samawat wa'l-'ard* ('God is the light of the heavens and the earth'; sura 24, verse 35). The delicacy of the inscriptions, the background ornaments and the border patterns all suggest an early 17th-century date for the piece.[87] A further example of the group is in the Army Museum in Istanbul.[88]

The piece sold at Christie's in London in 1990 may also be from this group.[89] It is not possible to tell from the photograph and description whether or not the body is all of one piece, but its similarity to the Moser standard, despite the lack of a band decorated with large circular holes, suggests that it is. Its simpler style of border design suggests a 17th-century date, rather than the late 16th-century one given in the sale catalogue.

E.4 does not have circular holes cut through its body in the intermediate band, like the Moser and Ardabil examples. Instead it has a magnificent set of openwork half-palmettes, culminating in a single palmette at the apex, forming a flaming nimbus. The vigour of this design, and the close relationship of the outer border pattern to that of the Ardabil standard, suggests that E.4 probably dates from the late 16th or very early 17th century.

E.5 is not of such fine quality. Its calligraphy is poor, its background scrolling stems uninteresting, and its outer border pattern highly simplified. It relies for effect largely on the circular holes in the middle band and the multitude of projecting dragon's heads. It would be tempting to put it into a later century, were it not for the

84. The two inscription panels face in opposite directions.
85. Melikian-Chirvani (1982) no.151.
86. Moser (1912) pl.XLII no.988.
87. Cf. the silverwork of the door of the Masjid-i Shah in Isfahan; Allan (1995) pl.XVIII.
88. *Askeri Müze* (1993) p.19. The reproduction is too small to enable one to make out the details of its inscription or arabesque work.
89. Christie's, 9 October 1990, lot 187.

STANDARDS

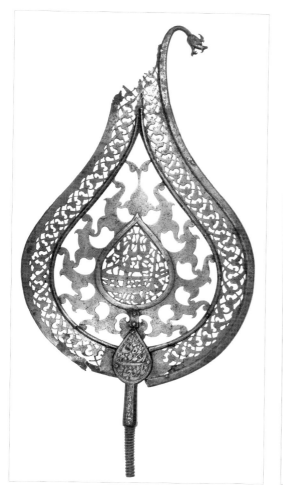
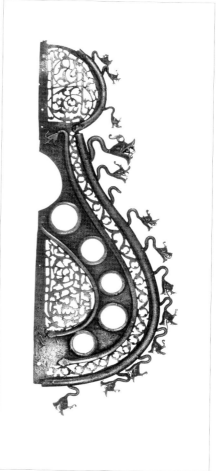

E.4 Standard; pierced, incised and riveted; ht 72 cm; w. 36.3 cm; late 16th to early 17th century; no.60

E.5 Half a standard; pierced and riveted; ht 55 cm; w. 21.2 cm; late 17th or early 18th century; no.61

E.6 Part of a standard blade; pierced; l. 30 cm; w. 7.2 cm; late 16th century; no.148

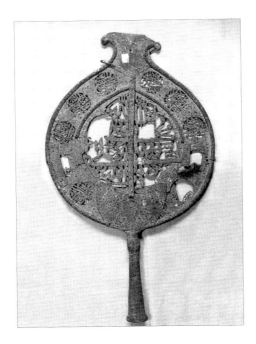 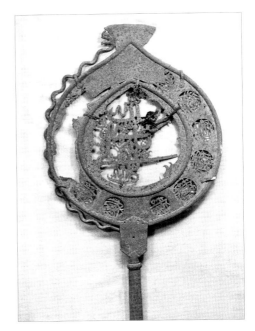

FIG.43 (left) Type B standard from the Ardabil shrine, 16th–17th century, ht 63 cm.
Iran Bastan Museum, Tehran, acc. no.25 (Photo: J.W. Allan)
FIG.44 (right) Type B standard from the Ardabil shrine, 16th–17th century, ht 73 cm.
Iran Bastan Museum, Tehran, acc. no.20 (Photo: J.W. Allan)

fact that the dragon's heads are of solid steel, not sheet steel, as they would have been in the later 18th and 19th centuries. It seems, therefore, that it is probably late in this series, perhaps from the late 17th or early 18th century.

A magnificent standard in Topkapı,[90] with a long pierced blade and pierced palmette-shaped finial, is probably a variation on this theme. The pierced inscription on the body bears the same inscription as the Moser collection standard: *Allah nur al-samawat wa'l-'ard*, while the finial bears the names of God, Muhammad and 'Ali. In date it is probably late 16th-century: one might compare the rhythm of the design on a brass torch-stand of that period in the Victoria and Albert Museum.[91] E.6 is part of a blade from such a standard, witness the thickness of the steel so that it would stand vertically, and the tapered form. The forms of the openwork flowers and leaves are closely comparable to those in the border of the body of the Topkapı piece, suggesting a similar dating.

A possible provenance for this group is suggested by various factors. First, the *nisba* of the craftsman whose name appears on the socket of E.4 is *Ardabili*. Secondly,

90. Pope (1938–39) vol.6, pl.1433B. 91. Melikian-Chirvani (1982) no.141.

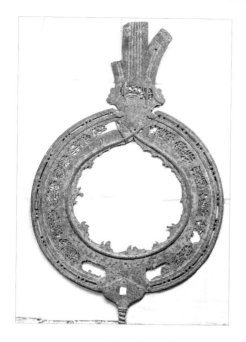 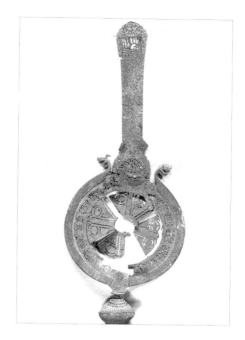

FIG.45 Type B standard from the Ardabil shrine, 16th–17th century, ht 77 cm. Iran Bastan Museum, Tehran, acc. no.19 (Photo: J.W. Allan)

FIG.46 Type B standard from the Ardabil shrine, 16th–17th century, ht 103.5 cm. Iran Bastan Museum, Tehran, acc. no.21 (Photo: J.W. Allan)

as if to back this up, one of the most notable examples of the style stands today in the Ardabil shrine. Thirdly, another group of such standards was discovered in the shrine at Ardabil and is now in the Iran Bastan Museum in Tehran. Of these, two are decorated with a central inscription and the names and titles of the Twelve Imams in surrounding circles (FIGS 43 and 44), one has lost its central inscription and has the names of the Twelve Imams in oblong cartouches instead of roundels (FIG.45), while a fourth has a rather different, highly stylised calligraphic design in the centre, and the names of the Imams in cartouches (FIG.46). Until these pieces have been cleaned, and studied in detail, it is not possible to date them more accurately than the 16th to 17th century. Fourthly, this appears to have been the form of the standard of Shah Isma'il I which stood in the shrine at Ardabil prior to its recent theft, and is illustrated in an engraving in Olearius of 1647. Finally, there is other evidence of a steel-working industry in Ardabil in the Safavid period (see p.24).

Tempting as it is, however, to attribute these standards to Ardabil itself, one should be cautious of this conclusion. In the first place, as is well known, *nisba*s do not necessarily prove a place of origin. Secondly, the maker's name on E.4 is not on the body of the standard, but on the top of the shaft, which may be a replacement.

Certainly, the style of the inscription which includes his name suggests a date well into the 17th century. Hence, although the standard may have been in Ardabil for much of its history, and repaired there at some stage, it need not necessarily have been made there. Thirdly, the number of pieces of this form associated with the Ardabil shrine may be an accident of history: by some good fortune, a group of standards of approximately the same age and from the same place of origin, were gathered there and have been preserved there. This is precisely what one might expect from a shrine which was a regular focus for pilgrimage throughout the period of the Safavid dynasty.

One might be equally inclined to attribute them to Tabriz. The appearance of such quantities and varieties of standards in Shah Tahmasp's *Shah-nameh*, which was being written and illustrated in Tabriz, suggests that the artists had a ready source of images in the city. As capital of Iran under Tahmasp, and with an obvious need to be an arms-manufacturing centre to provide the military equipment necessary for the wars against the Ottomans, Tabriz is indeed highly likely to have been a centre of standard manufacture.

On the other hand, it could equally be argued that they were made in Isfahan, given that this city had become capital under Shah 'Abbas, and the likelihood of many of the finest craftsmen from Azarbaijan following court patronage and settling there.

A further point about the style of this group of standards is worth making. The very tall Topkapı example mentioned above may be compared to a later example recently on the art market, and a finial probably from another such piece.[92] These seem to be an earlier version of the most common 19th- and 20th-century style of standard, still made today in Isfahan. But how and why the form became so popular and so widespread for the moment remains unclear.

Type C

Perhaps the most impressive types of standard, at least for their openwork inscriptions, are a group which are almond-shaped in form but unadorned by either dragon's heads or leaf- or blade-shaped finials.[93] E.7 is a fine example of the type with a revolving unit in the centre. It is signed by the craftsman Ibrahim, and dated to the year AD 1123 (AH 1711). The Qur'anic inscription reads: 'In the name of God, the Beneficent, the Merciful. Lo! We have given thee (O Muhammad) a signal victory, that God may forgive thee of thy sin which is past and that which is to come,

92. Christie's, 19 October 1993, lots 383, 384.
93. An apparent exception is that sold at Sotheby's, 16 April 1986, lot 184, but close study indicates that the dragon's heads on this are later additions, replacing the upper part of the original thick metal border on either side.

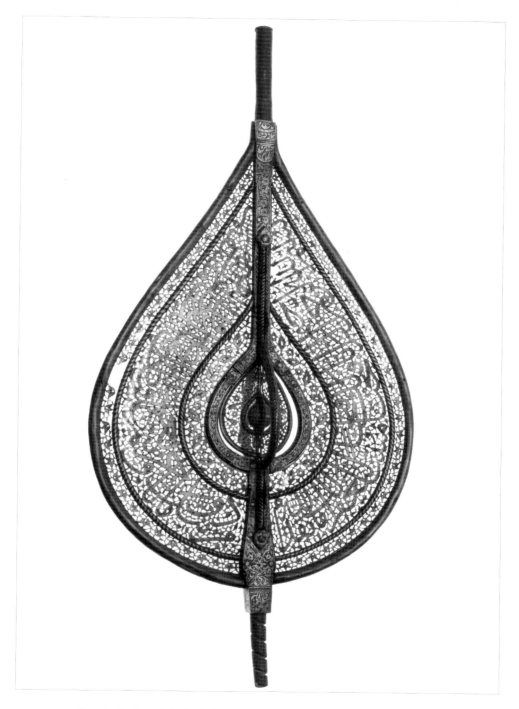

E.7 Standard; pierced, incised, chased and riveted; brass edging and central sphere;
ht 94.5 cm; w. 46 cm; work of Ustad Ibrahim, AH 1123 (AD 1711); no.57

and may perfect His favour unto thee, and may guide thee on a right path, and that God may help thee with strong help' (sura 48, verses 1–3).

This quotation appears on two other published examples, one dated AH 1124 (AD 1712), the other AH 1126 (AD 1714).[94] An inscription on an example in Stuttgart,[95] also dated AH 1124 (AD 1712), reads: 'In the name of God, the Beneficent, the Merciful. When God's succour and the triumph cometh and thou seest mankind entering the religion of God in troops, then hymn the praises of thy Lord, and seek forgiveness of Him. Lo! He is ever ready to show mercy' (sura 110). The remaining space is filled by the words *qasid allah al-'adhim* ('Messenger of God, the Almighty'), and the date. A piece dated AH 1112 (AD 1700–1),[96] and another dated AH 1124 (AD 1712–13) in the al-Sabah collection,[97] are inscribed thus: 'In the name of God, the Beneficent, the Merciful. Say: He is God, the One! God, the eternally Besought of all! He begetteth not nor was begotten. And there is none comparable unto Him' (sura 112). Part of another standard, now in the Metropolitan Museum of Art, bears sura 112, verse 4 and the first half of sura 68, verse 51.[98]

Another standard of this group in Topkapı is dated AH 1119 (AD 1707–8), and bears the inscription: *nasr min allah wa fath qarib wa bishr al-mu'minin ya muhammad ya 'ali khayr al-bashar mudad sana 1119* ('victory from God, swift conquest and the joy of the believers. O Muhammad! O 'Ali, best of men. During the year 1119 [AD 1707–8]').[99] Yet another standard of this group is in the Kunst und Gewerbe Museum in Hamburg.[100] It is dated AH 1125 (AD 1713–14), and bears part of sura 24, beginning *Allah nur al-samawat wa'l-'ard* ('God is the light of the heavens and the earth'; sura 24, verse 35).

A further example, dated AH 1203 (AD 1788),[101] bears a saying attributed to the Prophet. The full inscription reads: 'The Prophet, God bless him and his family and grant him salvation, said: "Whoever mourns for Husain is humble and [will enter] paradise." A true saying of the Prophet of God. In the year 1203.' Part of this inscription is found on another standard recently on the art market.[102] Here, however, both halves of the standard have the same extract, suggesting first of all that this is a composite piece, and secondly that this inscription was common.

94. Sotheby's, 20 April 1983, lot 313 and Sotheby's 16 April 1986, lot 184. The inscription on the earlier piece is in a slightly larger script in proportion to the space available, and consequently omits verse 3.
95. Kalter (1987) frontispiece.
96. Sotheby's, 17 October 1984, lot 182; 12 October 1989, lot 99.
97. Atıl (1990) no.92.
98. Metropolitan Museum of Art, New York, acc. no. 1982.435; unpublished.
99. Topkapı Saray Museum, acc. no.10414. I am grateful to Dr Ludvik Kalus for this information.
100. Unpublished; it was drawn to my attention by Laure Soustiel.
101. Sotheby's, 17 October 1984, lot 181; 25 April 1990, lot 117.
102. Sotheby's, 15 October 1986, lot 172.

Half of another quotation from the Qur'an occurs on a piece of pierced openwork, the shape of which suggests an original *'alam* of a form somewhere between the pieces in this group and the two of Type E following.[103] The whole inscription would evidently have contained sura 108, which reads: 'In the name of God, the Beneficent, the Merciful. Lo! We have given thee Abundance; so pray unto thy Lord and sacrifice. Lo! It is thy insulter (and not thou) who is without posterity.'

Certain technical features of these standards are worth noting. First of all they are constructed of a relatively large number of different pieces of metal, and these are not uniquely steel. In the most elaborate, there are three areas of pierced sheet steel in each half, separated by thick brass bands, together with a number of other thicker struts of steel forming the central structure of the standard. In addition, the central swivelling sphere may also be of brass, as in the Tanavoli example; the openwork pieces around it, like the main openwork areas of the standard, are made separately, and joined with brass or steel bands. Secondly, the pieces of thicker steel which form the central structure are decorated with designs quite different from those of the openwork areas. Their floral motifs and calligraphy are so different as to suggest that they were made by different craftsmen.

The example dated AH 1126 (AD 1714) mentioned above has on its central shaft an inscription giving a slightly later date of AH 1137 (AD 1725) signed by a craftsman named 'Abd al-Vahhab Isfahani.[104] Given the existence of a steel-working industry in Isfahan under the later Safavids, the most logical conclusion must be that this standard as a whole is Isfahani work. Given that E.7 bears the same inscription, with the date in figures inserted at the same place at the end of the text, and that many other aspects of its design and decoration are also extremely close, it too must be Isfahani work. So too the piece dated AH 1124 (AD 1712) sold at Sotheby's in 1983. The Stuttgart piece dated AH 1124 (AD 1712) is slightly different in detail, but could comfortably be the product of the same workshop, while the piece dated AH 1203 (AD 1788) shows the continuation of the style into the later part of the 18th century with no major modifications and a quite extraordinary closeness of detail.[105]

Standards of Type C all have sockets both above and below them on the shaft. This indicates that they decorated not the top but the shaft of a standard pole.[106] The lack of earlier examples of this phenomenon, and the relatively large numbers of surviving pieces dated to the early 18th century, might suggest that this was an early 18th-century fashion. However, the observations of Kotov quoted at the beginning of this section (see p.259) indicate that standards were used both half-way

103. Sotheby's, 20 April 1983, lot 314.
104. Sotheby's, 16 April 1986, lot 184.
105. Sotheby's, 17 October 1984, lot 181; 25 April 1990, lot 117.

106. The piece illustrated in the Moser collection volume, (1912) pl.XLII no.989, has a finial, but the style of this indicates that it is not original.

up and at the top of their supporting poles during religious processions in Isfahan in the 1620s.[107] His description of them as looking like scissors is also appropriate to the form of Type C standards, and their use in the mid-17th century, at least, is indicated by the existence of a piece of the closely related, but more elaborate, Type D (below), dated to AH 1069 (AD 1658–59). Taking into account the very different form and probable Azerbaijani origin of groups A and B, it also seems appropriate to ascribe group C to Isfahan.

Standards with a number of different elements attached to their supporting or surrounding structure survive, for example in the Ethnographic Museum in Tehran. None of them, however, includes a standard of the Type C form. This fashion may well, therefore, have died out sometime in the 18th century.

Type D

A more elaborate form of standard consists of two standards of Type C with a smaller ogival unit above, joined at right-angles to make a cruciform design. A fine example belonging to the mosque of a local *mahalla* in Isfahan is dated AH 1117 (AD 1705–6; FIG.47). The large band of pierced inscription which decorates it consists of sura 24, verses 35–36 and part of verse 37. The inner pierced band consists of suras 109, 112, 113 and 114. The standard surmounts a pierced cuboid unit, and is surmounted by a similar hexagonal one. Both these units have sides made up of steel sheets pierced with Qur'anic inscriptions. Their significance is discussed below.

Other examples have recently been on the art market. Of the first only half survives, but it is of particular interest as it is dated on the body to AH 1069 (AD 1658–59) and bears a *waqf* inscription on the finial dated AH 1108 (AD 1696–97).[108] The main pierced inscription consists of parts of sura 48, verses 1 and 4; the missing parts would have been on the other blades. The first three verses of this sura have been quoted above. The fourth reads: 'He it is Who sent down peace of reassurance into the hearts of the believers that they might add faith unto their faith. God's are the hosts of the heavens and the earth, and God is ever Knower, Wise.'

A second standard has a relatively large space in the centre, in which is positioned the representation of an openwork, cuboid building with an arched window containing a grill on each side.[109] Bold openwork *thulth* inscriptions on the blades of the *'alam* consist of blessings to the Twelve Imams, while smaller openwork *nasta'liq* inscriptions include phrases saluting the Prophet, 'Ali and Husayn, together with sura 61, verse 13, which reads: 'And He will give you another blessing which ye love: help from God and present victory. Give good tidings, O Muhammad, to believers.'

107. Kemp (1959) p.25.
108. Sotheby's 21 April 1996, lot 157. The illustration is reversed.
109. Sotheby's, 16 April 1985, lot 147.

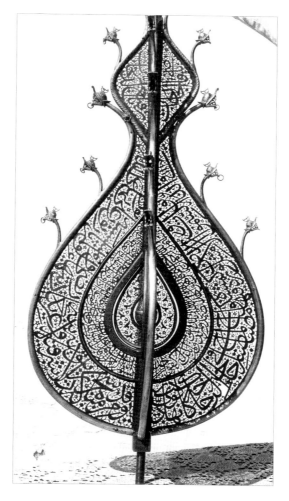

FIG.47 Type D standard from the mosque of a local *mahalla* in Isfahan, dated AH 1117 (AD 1705–6) (Photo: J.W. Allan)

The inscriptions above the doors and windows of the building read: 'O the innocent Imam Husayn, martyred in Kerbala, lead me to the Truth.' The piece is probably slightly later than the Isfahan example. Also later is a third piece, its central ornament missing, decorated with parts of sura 2, verse 255.[110]

A little more may be said about the small pierced steel items, cuboid, hexagonal, and building-like, attached to these standards, for it is surely from such an item that E.8 comes. There are a number of small rectangular plaques like it in other collections. For example, one was in the d'Allemagne collection,[111] and a group of four

110. Sotheby's, 20 October 1994, lot 117. 111. d'Allemagne (1911) vol.2 p.81.

made into a cuboid are in the Victoria and Albert Museum.[112] Two sides of the latter are decorated with the words *ya Muhammad*. However, it is clearly made up of disparate pieces, and must therefore be a relatively recent concoction. Another cuboid in the Victoria and Albert Museum, however, appears to be a genuine object.[113] It is 14.5 cm high and 17.8 cm wide, has four pierced sides and the remains of a hinge for a lid, and is held together with brass. The base plate has a circular hole in the centre some 5 cm in diameter. The four sides bear the words 'God! There is no God save Him, the Alive, the Eternal. Neither slumber nor sleep overtake Him. Unto Him belongeth whatsoever is in the heavens and whatsoever is in the earth. Who is he that intercedeth with Him except by his leave? He knoweth that which is in front of them and that which is behind them, while they encompass nothing of His knowledge save what He will. His throne includeth the heavens and the earth, and He is never weary of preserving them. He is the Sublime, the Tremendous' (sura 2, verse 255). In the centre of each side is a square plaque enclosing one of the following: *ya ridwan* ('O Delight!'), *ya burhan* ('O Proof!'), *ya daiyan* ('O Judge!'), *ya muhammad* ('O Muhammad'), though the latter seems to be a later replacement. E.8 has two rivet holes in the upper part, and the remains of solder on the back, around the edge of the other three sides. It was probably one side of a cuboid. Its inscription reads: *ya Muhammad* ('O Muhammad').

Such items are sometimes called lanterns, and indeed could have been used to hold candles or lamps on the *'alam*s to which they are or were attached. There does, however, seem to be a link with buildings. The second piece discussed above shows a cuboid building with an arched window containing a grille on each side, and its inscription suggests that it is there to remind the faithful of the mausoleum of Husain at Kerbala. And significantly too, perhaps, the cuboid piece on the *'alam* in the mosque in Isfahan has, in the centre of one side, a solid piece of metal incised in imitation of brickwork, suggesting another definite link with a building. One wonders whether they may relate to the models of shrines that are kept in some mosques of Husainiyyeh's in Iran and used in religious processions.

Another standard of Type D is in a private collection in Tehran. In the centre, instead of a miniature building, it has a smaller version of itself, and is surmounted by an almond-shaped standard decorated with two standing lions in an openwork ground. Above this are the remains of three tall blades. Both the main standard and the smaller one have numerous projecting dragon's heads. An early 18th-century date is also likely for this piece. The close relationship of Type D to Type C suggests that it too is a product of Isfahan during the Safavid period.

112. Victoria and Albert Museum, London, acc. no.M.36-1912, its sides measuring 9 by 10.5 cm.

113. Victoria and Albert Museum, London, acc. no. 533-1888.

STANDARDS

E.8 Plaque from a standard; pierced; 10.3 x 8.8 cm; 18th–19th century; no.332

Type E

Many 19th- and 20th-century Iranian standards are very different from those so far discussed, for they have not only a vertical axis, but also a horizontal one. On the horizontal bar stands an array of steel items, lions and other animals, birds, vases, axes and so on. An example in the Ethnological Museum in Tehran is dated AH 1341 (AD 1922).[114] How this idea came to Iran, and where it came from, is not yet certain. However, Żygulski noted the influence of the Central European *Schellenbaum* on Ottoman military standards,[115] and the influence of the *Schellenbaum* on the Iranian tradition, via the Ottomans, is a possibility,[116] the more so since Van Vloten's depictions of late 19th-century standards suggest that some of them were very much more like trees with pendant leaves, or perhaps bells, than 20th-century examples.[117] How early this style became popular is uncertain, though an observation made by Price in 1811 may be instructive. He writes of the Ashura festivities in Tehran: 'The next exhibition was what is termed *Took* [i.e. *tugh* or *'alam*]. It resembled a three-pronged fork with several devices round it in silk and precious stones; it was carried round the square followed by streamers.'[118] This description suggests the simpler, traditional style of standard. The tree-like variety, however, raises the question of the original use of the numerous steel animals which have survived, for many of them could have been made as decorations for these elaborate objects. Precise dating for the introduction of the *Schellenbaum* shape might also enable us to date these animals with more accuracy.

114. Gluck (1977) pl. on p.145.
115. Żygulski (1992) pp.96–97. For two excellent examples of *Schellenbaums*, now in the Musikinstrumentenmuseum in Munich, see Sievernich and Bude (1989) Abb.367.
116. Frembgen (1995) p.196.
117. van Vloten (1892) Taf.IX.
118. Price (1825) p.30.

Iron and steel in architectural settings

GRILLES

For centuries iron has been used for window grilles in Iran. The purpose of such grilles was primarily one of security, but they also enabled the viewer to see whatever lay within a building, even if he or she could not enter it. Ibn Battuta noted such grilles being used in mosques and mausolea on his travels through Iran,[1] and the mausoleum of Oljeitu at Sultaniyya had a number of magnificent grilles which will be discussed in detail below. There is 14th-century pictorial evidence, too, for their use in religious contexts. Thus, the manuscript of Rashid al-Din's *Universal History* now in the Khalili collection contains an illustration of Kushinagara, where the Buddha achieved Nirvana.[2] In the text it is described as a crystal edifice, and Sakyamuni could be seen inside it through its walls.[3] The miniature, however, shows it as a shrine with two windows, each with a metal grille, a depiction which must have been based on the artist's experience of equivalent buildings in Iran. Grilles would have allowed pilgrims to gaze on the contents of such a shrine, whatever those contents might have been.

In a secular setting, steel grilles were evidently used on both the ground and upper floors of Il-Khanid royal palaces. Examples of the former are to be found in illustrations from a 14th-century *Shah-nameh* in Topkapı Saray Library.[4] Their role was not simply to keep intruders out, but to allow the garden in – visually at least – and perhaps also to allow an enthroned ruler to be observed by people outside the building. The purpose of grilles on upper floors, on the other hand, was to allow the occupants to view the outside world without being seen. In Il-Khanid painting it is not always easy to be sure of the material used for these: often wooden *mashrabiyya* was probably intended, but in some examples the lattices are so bold that steel seems to be a more likely medium.[5]

The use of such grilles in palace architecture probably continued for centuries, and indeed the Sultaniyya grilles may well have served a secular purpose five cen-

1. Ibn Battuta (1958–71) vol.2 pp.314–17.
2. Blair (1995) fol.277b.
3. Canby (1993).
4. MS H.2153; see Atasoy (1970) figs 12–13.
5. For example, Grabar and Blair (1980) no.10.

turies later. For there is a suggestion in Johnson that Fath 'Ali Shah may have reused the steel grilles from Oljeitu's mausoleum for the harem of his own palace nearby.

> 'It is lamentable to observe that the servants of His present Majesty are destroying a work so venerable, for the sake of the brick and ornaments which are to be used in building a suite of confined rooms, termed a palace, with an enclosure, or keella (fort) for defence. This delapidation has been going on for the last seventeen years, so that only a small part of the original building is now in a complete state ... This pavilion, with the ornamented railing in the Chinese style, is mostly formed of enamelled tiles removed from the ruins of the tomb; and it has much the appearance of a prison from without, there being only two windows visible, and they are in the upper room to the eastward, covered with strong iron gratings, for the security of the select females who compose His Majesty's travelling haram.'[6]

Modest iron grilles were also used to protect free-standing tombs. A photograph of the tomb of Hafiz in the Fahie collection (*circa* 1860–90) shows it surrounded by a simple iron grille,[7] but this was later removed and a much more elaborate structure put up, described by one writer early this century as 'a kind of cage of iron bars, at the corners of which fly horrible iron pennons',[8] and by another as a 'high, spiked iron railing ... that forbidding cage'.[9] Another elaborate grille surrounded the tomb of Sa'adi within its small, lattice-windowed room, though whether it was of wood or metal is unclear.[10] When such protection was first used for the tomb of a famous or holy man in Islam is uncertain, though the practice may relate to the *rawda*, the railed enclosure around the Prophet's grave in Medina.[11] Be that as it may, the existence of magnificent steel grilles today around the tombs of the Imams and other Shi'ite saints, demonstrates their continuing popularity and artistic importance.

All too little is known about their history, however, even in the major architectural complexes of Iran. The reason is simple: the best examples were almost certainly located in the prime religious shrines of the country, those of the Imam Riza in Mashhad, and of Fatima, the daughter of the Imam Riza, in Qum. Both were forbidden territory to non-Muslim, European travellers. As a result, there are virtually no European descriptions of them. The fact that the mausoleum of Sultan Oljeitu at

6. Johnson (1818) pp.108–101.
7. Oxford, Bodleian Library, 2061 d.24 Box 1 no.147. The description of the tomb in Price (1825) p.12 suggests that in the early 19th century there was no surrounding grille of any sort.
8. Crawshay Williams (1907) p.139.
9. Norden (1928) pp.151–52, who illustrates it top fig. opposite p.150.
10. Crawshay Wiliams (1907) pp.140–41; photograph in the Fahie collection in Oxford, Bodleian Library, 2061 d.24 Box 1 no.158.
11. Blair (1984) p.74; Sauvaget (1947) pp.90–92.

Sultaniyya contained steel grilles is therefore of particular importance. As an ancient and decaying building with no continuing religious function, it was open to non-Muslims; that it lay on the main route taken by all overland European travellers to Iran was a further advantage, for it would have been a mean-spirited traveller indeed who would not have gone to see what stood beneath the great turquoise-tiled dome that dominates the Sultaniyya plain.

I have discussed the textual evidence for the steel doors and grilles of Oljeitu's mausoleum elsewhere.[12] My conclusions from the numerous but sometimes contradictory descriptions may be summarised as follows. The doors were a mixture of smooth sheets of steel, or steel-faced wood, alternating with areas of steel lattice work. There are no surviving examples of such a combination from the 14th century, but later examples are known, for example, the doors of the grille from the shrine at Mashhad made by order of Shah Rukh in 1414.[13] The latticework on the three gates evidently consisted of a geometric arrangement of bars joined by loaf-sized bosses, which in their turn enclosed smaller bosses the size of oranges. In addition there was a huge grille which separated the area containing the cenotaph of Sultan Oljeitu from the body of the mausoleum. The design of this grille was probably different from those of the three doors, for, according to one source, it was 'made in the form of big apples on a sword', with smaller lattices in the doors through the grille. The size and quality greatly impressed the travellers, as Olearius makes clear: 'the Barrs being about the bignesse of a mans arm, and so neatly wrought that the Junctures are hardly discernable.'[14] From the European descriptions it is also clear that the steel used for the grilles and doors was heavily decorated with gold and silver, although the precise details of the technique are not given. The only comment on the designs is that they included flowers. According to local tradition, recorded by Struys, Olearius and Kotov, the steel was Indian. It is extremely difficult to assess the quantity of steel imported from India for this project, but my own tally, based on three bars of steel to every one metre of grille in both directions, suggests as much as five tons of steel, or nearly 20,000 steel cakes: enough steel to provide all the equipment for an Il-Khanid army.

No other Iranian building received such careful study from such a variety of travellers. It is remarkably difficult, for example, to discover the details of the grilles which for centuries have surrounded the cenotaphs of the Imams, or of other members of the Prophet's family. This is largely because very few Westerners have ever been allowed to visit the major shrines, and those who managed to do so did not record in detail what they saw. Where travellers did describe the shrines, their

12. Allan (forthcoming).
13. *The Arts of Islam* (1976) no.245.

14. Olearius (1669) pp.250–51.

accounts were usually based on what they were told by local Iranians. Further complications have been caused through the plundering of the shrines by conquering warriors, and the restoration or replacement of the grilles by some ruler or other, who desired the *baraka* of the saint concerned. And there was always the possibility of reusing grilles taken from other sources.

First let us consider Mashhad. How early the cenotaph was surrounded by a grille is uncertain. Ibn Battuta's description suggests that there was none there in 1333–34, for his only comment on the tomb itself is that 'on the tomb is a sarcophagus of wood which is covered with silver sheets; and silver candle holders have been hung over it.'[15] This is probably the covering mentioned by Clavijo in his description of his mission to Timur: 'a sepulchre that is encased with silver and gilt'.[16] In the 15th century, however, there must have been one steel grille at least, for a small pair of doors survive in the museum at the shrine. They were commissioned by Shah Rukh, and are signed by a steel-worker called Ustad Shaikh 'Ali Khudgar Bukhara'i and dated AH 817 (AD 1414–15).[17] There is another inscription on them recording repairs and embellishments carried out in 1545–46 by Muhammad Beg Muslutar, the Turkoman, so they were still in use in the mid-16th century.

The next record seems to be that of 'Abd al-Karim, who left Delhi in 1739 with Nadir Shah's army and spent some 15 years in Iran before going on to Mecca. He describes three latticework screens around the tomb: the exterior one, in watered steel, had cost, it was said, more than if it had been made of pure silver; the second was of pure gold; the third, which immediately enveloped the coffin, was of sandalwood.[18]

At the beginning of the 19th century one or more grilles still surrounded the tomb. For, according to Burnes, 'the tomb [of the Imam Riza] is said to be shielded from the touch of the profane by railings of steel and brass, where plates of silver and wood, with blessings and prayers carved upon them, are suspended.'[19] Thirty years later Fraser records 'a railing of wrought steel, inside of which is an incomplete one of solid gold'.[20] In the middle of the century Ferrier was told that the tomb was surrounded by a massive silver railing, surmounted by gold ornaments.[21] However, according to Curzon, 'at different times the tomb has been surrounded with railings of gold and silver and steel. The first of these was originally set up by Shah Tahmasp, but in part dismantled and plundered by the grandson of Nadir Shah. The last was the gift of Nadir Shah himself.'[22] Another description, that of Bassett, was

15. Saadat (1976) p.24.
16. Clavijo (1928) p.185.
17. Anon. (n.d.) pp.31–33, no.59; *Arts of Islam* (1976) no.245.
18. 'Abd al-Karim (1797) p.72.
19. Burnes (1835) vol.3 p.70.
20. Fraser (1834) p.81.
21. Ferrier (1857) p.125.
22. Curzon (1892) vol.1 p.158.

not only based on what he was told locally, but also on drawings by local artists which he commissioned. He writes: 'The coverings of the tomb are each called a zerah. Of these there are three. One of silver, one of iron, and the third of steel. These have been changed in the course of years; for early writers mention an inner zerah of gold. The door of the zerah is fastened with a padlock of gold. The base of the zerah is solid silver.'[23] He also notes an extraordinary tradition of the local people: 'The steel of which the outer zerah is made was exhumed in nuggets within the sahn [mosque courtyard], at a place indicated by the oracle.'[24]

A different description is offered by Sykes. According to him, the cenotaph had three grilles around it: an outer one of steel, five feet high, a second of brass covered with gold, and an inner one of steel set with rubies and emeralds. The latter, according to an inscription, was a gift of Shah Rukh, grandson of Nadir Shah, who presented it in AH 1160 (AD 1747).[25] On the other hand, elsewhere he gives different information: an outer grille of steel, the one behind it, reputed to have been taken from Nadir Shah's tomb, of silver, studded with rubies and emeralds, and the inmost grating of steel inlaid with gold.[26] He also mentions a grating in the outer shrine made of steel covered with brass, and a second grating made of silver in the Dar al-Siyada, the latter presented by the father of the late Qawam al-Mulk of Shiraz.

A more recent detailed description is that of Donaldson. 'The tomb is protected by three steel gratings, one within the other. There is a sarcophagus of wood, plated with gold, that bears the name of Shah 'Abbas. Surrounding this is the first grating of plain steel, which is protected by a screen of copper wire to receive the gifts that are there deposited by devoted pilgrims ... The second steel grating is ornamented with gold and jewels and has an inscription that marks it as the gift of Shah Husain Safawi; and the third or outer grating, also of steel, is decorated with a delicate inscription of the whole of the Sura *Insan (Kor'an* lxxvi). The second and third gratings each have gold knobs at the corners ...'[27]

Donaldson's description, at least, seems to be reliable. The inscription on the wooden sarcophagus has been published, and does indeed name Shah 'Abbas.[28] Moreover, Shah Sultan Husain is known to have commissioned other steelwork for the shrine, for which references will be found under the names of Muhammad Kazim Shirazi and Faizallah Shushtari in Appendix One. But how long there have actually been three steel grilles there is no way of telling, unless there are historical inscriptions on the inner and outer grilles which have yet to be discovered. Today,

23. Bassett (1887) p.225.
24. Bassett (1887) p.226.
25. Sykes (1910) p.1144.
26. Sykes and Khan (1910) pp.248–50, 254.
27. Donaldson (1935) p.118 and fig.1.
28. Meshkati (1974) p.88.

FIG.48 Steel grille at the shrine of Sayyid Muhammad Shafti, Isfahan; mid-19th century and early 20th century (Photo: J.W. Allan)

IRON AND STEEL IN ARCHITECTURAL SETTINGS

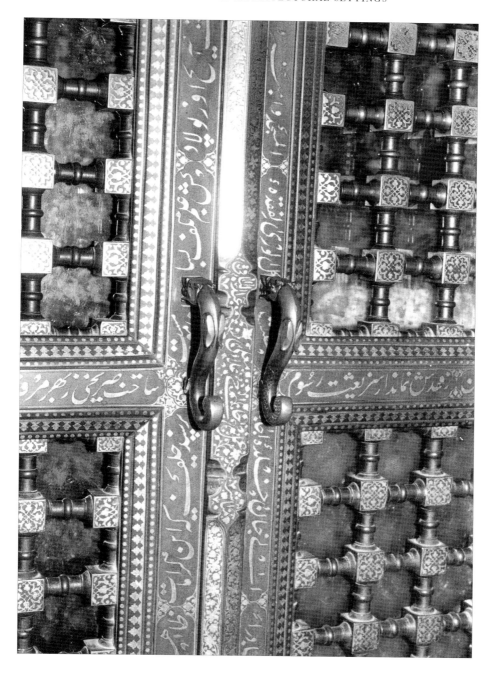

FIG.49 Door in the grille at the shrine of Sayyid Muhammad Shafti, Isfahan; signed by Haji Ghulam'ali Mubashir 'Abd al-Baqi and dated AH 1260 (AD 1844); upper part signed by Ustad Yadallah and dated AH 1322 (AD 1904–5) (Photo: J.W. Allan)

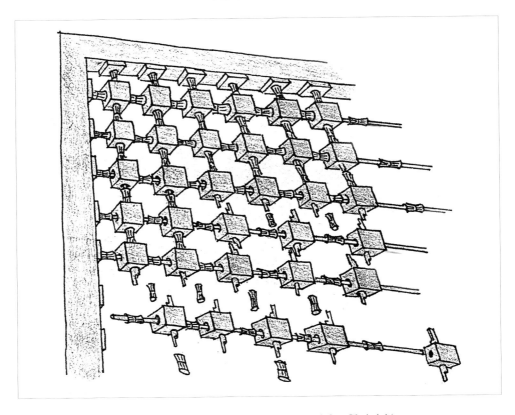

FIG.50 Structure of a grille; 17th century (after Christie's)

things are certainly different. For between 1962 and 1964 a new grille of precious metal was built, replacing at least one of the former steel grilles.[29]

Turning to the Shrine of Fatima at Qum, what little evidence there is starts by being unanimous. According to Ferrières-Sauveboeuf, writing at the end of the 18th century, the tomb of Fatima was surrounded by *'une grille croisée d'argent massif qui a seize pieds en quarré, & se termine en haut par de grosses boules'*.[30] In the early 19th century, according to Johnson, 'the cage-railing here is all of silver, and the wood pillars are covered with it.'[31] Morier too was told that the grille was of solid silver,[32] and Fraser was of the same opinion: 'The tomb is enclosed in a sandlewood box … and surrounded by a silver grate of massy cross bars, placed there by the mother of the present king.'[33] However, at the end of the century, Wills's informants told him that the

29. Saadat (1976) pls 32, and 35–36; Ghirshman *et al.* (1971) p.142.
30. Ferrières (1790) vol.2 p.42.
31. Johnson (1818) p.146.
32. Morier (1818) p.165.
33. Fraser (1825) p.140.

tomb had around it 'shawls of considerable value as carpets; then comes a wooden trellis-work, next a row of steel railings, inlaid with gold, and outside all a row of solid silver rails surround it; they are six feet high, and the thickness of a London area-rail.'[34]

Occasionally other, less important shrines could be visited. In the early 19th century Johnson recorded in some detail what he saw in the Imamzadeh Isma'il in Isfahan. The cage around the tomb measured ten feet by six feet by six feet, its frame was of wood with mosaic work and silver flowers, and the railings were all of solid silver.[35]

Today, steel grilles are to be seen in a number of small *imamzadeh*s, particularly in the area of Isfahan. For example, the mid 19th-century shrine of Sayyid Muhammad Shafti in Isfahan itself has a steel grille around the cenotaph (FIG.48). The door of the grille is signed by Haji Ghulam'ali Mubashir 'Abd al-Baqi and dated AH 1260 (AD 1844; FIG.49). The upper part of the grille is more recent, and is signed by Ustad Yadallah and dated AH 1322 (AD 1904–5). Another, unsigned and undated, steel grille is to be found in the small shrine of the Imamzadeh Ahmad.

Most grilles seem to be constructed in the same sort of way. They consist of a series of vertical iron bars onto which are slotted cuboid bosses. To the bosses are attached interlocking pieces of steel which make up the horizontal framework. Cylindrical sleeves are then added between the bosses, on the vertical and the horizontal, to cover up the iron or steel structure. The structure of a late 17th-century grille recently on the art market is illustrated here (FIG.50).[36] Some grilles at least seem to have had a decorative band of palmette-shaped panels around the top. A large number of examples are known and have been published.[37]

Related to the 17th-century grille illustrated in FIG.50 is a door for such a grille, made in AH 1110 (AD 1698–99) and signed by Kamal al-Din Nazuk.[38] The door measures some 144.3 centimetres in height and 39.7 centimetres in width, and is made of watered steel. Each flap consists of a rectangular panel between two square panels, and each panel contains grille-work. The panels are separated by bars of the same thickness as the surrounding framework. The grilles consist of plain cuboids (2.8 centimetres cubed) separated by twelve-sided cylindrical units. These have ridges around each end, and a central band. The most striking aspect of this pair of doors is their relationship to woodwork. Not only is the general layout typical of contemporary painted wooden doors, but the techniques used by the steel-worker to assemble the doors is based on wood-working, for the crossbars of the frame are joined to the

34. Wills (1883) p.387.
35. Johnson (1818) p.116.
36. This was also illustrated in Allan (1996), where Levantine and Egyptian window grilles are considered in more detail.
37. For a list, see Christie's, 26 April 1994, lot 387.
38. Private collection, unpublished; mentioned in Christie's, 25 April 1995, lot 304.

uprights by a form of tenon and mortise joint. The only difference is that, due to the nature of the material, it was necessary for the rear part of each mortise to project outwards in the form of a bracket. The joint is pegged with a cylindrical piece of steel just as one would peg a wooden joint with a piece of dowel.

DOORS AND DOOR PLAQUES

Probably the earliest record of iron or steel plaques decorating a door is that of al-Narshakhi, who mentions an iron plate on the door of a palace rebuilt for Bidun Mukhar Khudah, the ruler of Bukhara, just before the Arab conquest. This plaque evidently gave the name of the man appointed to undertake the renovation, and was still in position in AD 1128–29 when the Arabic text of al-Narshakhi's work was translated into Persian in a slightly abridged version by al-Qubavi. It was probably destroyed some ten years later by the Khwarazmshah's army.[39] Unfortunately al-Narshakhi gives no other details of the door.

The earliest published iron door facings are those of the Khatir gate in Yazd. They date from the 11th century. The gate had two leaves which were discovered at different times, but were both evidently constructed of two vertical planks to which were nailed a series of horizontal planks covered with rectangular iron plates. The iron plates were attached both horizontally and vertically, though mostly the former, and to them were attached iron cruciform designs. These consisted of a cross in the centre of a larger diagonal cross, the latter with semi-circular ends. Other applied iron ornaments included quatrefoils and discs, mounted archers, standing figures, lions, and elephants with armed riders. One of the plaques was inscribed, and named the patrons of the gate as the two Kakuwayhid brothers al-Mas'ud al-Bihishti Abu'l-Najm Badr and al-Muzaffar Abu Ya'qub Ishaq, who were also patrons of the Duvazdah Imam in Yazd. The plaque also dated the gate to the year AH 432 (AD 1040–41), and recorded the maker as the smith (*al-haddad*) Muhammad ibn Abu Ishaq al-Isfahani.[40]

Another gate with iron facings, of the same period, was erected in Ganja in Georgia, by the Shaddadid amir, Shavur ibn al-Fazl, in AH 455 (AD 1063). It was the work of the smith Ibrahim ibn 'Uthman ibn 'Ankawayh.[41]

The next earliest published door plaques of iron or steel are the two early 14th-

39. al-Narshakhi, text p.22, trans. p.23.
40. Pope (1938–39) fig.505; Blair (1992) pp.111–14 no.41 and figs 66–67. Blair (p.111) translates *al-haddad* as 'ironworker', and as 'smith' in the next inscription, and on p.133 gives the equivalent Christian date as AD 1041–42, rather than the correct one of 1040–41.
41. Blair (1992) pp.132–33 no.49. See n.37 (above).

century examples in the Homaizi collection, Kuwait.[42] One bears a Qur'anic inscription, *wa anzalna al-hadid fihi ba's shadid wa manafi lil-nas* ('We sent down iron, in which is great strength and profitable use for men'; sura 57, verse 25), the other the words, *hadha ahad abwab Dar al-Salam wa mahatt rihal al-rijal* ('This is one of the gates of Dar al-Salam and the place where men dismount'). Dar al-Salam was the name of Baghdad, and the plaques must therefore have ornamented one of the city's gates in the 14th century.

These plaques are rectangular in form, and the scanty pictorial evidence for Iranian door designs in the 14th century suggests that inscribed door plaques were normally rectangular and ran the width of the door leaf they ornamented. Examples may be seen in the Edinburgh manuscript of Rashid al-Din's *Jami' al-tawarikh*, in the depiction of the city of Iram,[43] and the Demotte *Shah-nameh*, in the scenes of Gulnar and Ardashir, and Bahram Gur and Narsi.[44]

Another form of door with iron facing is illustrated in the early 14th-century Edinburgh University and Khalili collection manuscripts of Rashid al-Din's *Jami' al-tawarikh*.[45] This is designed with purely defensive considerations in mind, and has broad iron bands held in place by nails with large heads. This was a standard form of door in early Islamic times,[46] and has continued to be made into the modern period;[47] it is still to be seen in Iran, for example, in the gates of the bazaar in Tabriz. A complete iron or steel door of the 14th century survives in the Imamzadeh-yi Darb-i Ahanin near Nurabad, between Kazerun and Khuzestan in Fars. The mausoleum is that of the daughter of the seventh Imam, and according to a Persian inscription on a stone tablet above the doorway it was reconstructed in AH 771 (AD 1369) by the Amir Farrukh Bahadur. The door has two leaves, and each leaf consists of a sheet of metal onto which are riveted vertical and horizontal bands, the latter forming recessed squares. Within each square are bands forming a diamond shape. A large rivet head decorates the centre of each diamond, and there is one in each corner of the square.[48]

A much more luxurious style of iron or steel door is to be seen in an illustration of Isfandiyar's chariot in an illustration from a *Shah-nameh* of *circa* 1370, now in Istan-

42. *Art from the World of Islam 8th–18th century* (1987) no.165. The panels are each 27 cm high and 77 cm in width.
43. Talbot Rice (1976) no.1.
44. Grabar and Blair (1980) nos 40 and 52. No.6 in the same publication shows a door with what appear to be horizontal plaques, but the depictions here and in Arberry et al. (1959–62), vol.1, pl.21(a), leave their precise nature uncertain. For a colour illustration of the miniature of Bahram Gur and Narsi see Falk (1985) no.23.
45. Talbot Rice (1976) no.38; Falk (1985) no.18, f.3r; Blair (1995) f.72a.
46. Allan (1979) p.140.
47. For example, at the fort built by Muhammad Shah at Tajrish; Binning (1857) vol.2 p.233.
48. Mostafavi (1978) pp.86–87, 259–61. It is possible that the doors are of wood and that the iron or steelwork is simply a facing.

bul.⁴⁹ Even if such a chariot was never built, the picture shows the style of steelwork which was probably current at the time. The doors follow the pattern of wooden doors, the tall, rectangular, central panel decorated with a large rosette with palmette extensions above and below.

Doors apparently clad in iron and decorated with gold appear in a number of later manuscript illustrations. Thus, in the Shah Tahmasp *Shah-nameh* the gate of the fort of Kalat, in the scene of Bizhan forcing Farud to flee, is silvery-black with two gold bands and a spaciously conceived, overall gold arabesque design.⁵⁰ It could represent a door faced with silver sheet, given the popularity of silver for this purpose under the Safavids,⁵¹ but iron facing is more likely in a fort.

In the early years of the following century there is another example in a miniature depicting Afrasiyab's capital, Bihisht-i Kang.⁵² The town is being attacked by Kai Khusrau, and the gates, firmly shut, are coloured silver-grey. Attached to each leaf, by gold or more probably brass nails, are two rectangular plaques. Their position, and the way they are depicted, suggests that they may well be covers for the panels of inscription which would have presumably ornamented each leaf of the door: such covers would have protected the inscriptions, and their talismanic qualities, from damage or destruction.

That gold inlaid or overlaid inscriptions did indeed ornament the iron-clad gates of forts or towns is clear from an observation of Johnson's during his visit to Tehran in 1817. He received a royal audience in the Arg, or fortified palace of the Shah: 'We proceeded thence through a gate in the principal wall, covered with plates of iron having on them sentences of the Koraun inlaid in gold. It was studded with gilt knobs of brass.'⁵³ Hence, we need not doubt the accuracy of the miniature painters.

There is also literary evidence that such plaques decorated the doors of religious buildings, for Johnson, describing the interior of the Imamzadeh Isma'il in Isfahan, writes: 'the doors and window-frames of the building are of wood inlaid with ivory and silver in mosaic, similar to the frames of the cage which encompasses the tomb. Of the same workmanship are all the folding-doors in the passages leading to the large folding-gates at the entrance into the tomb. These gates are covered with plates of iron and steel, inlaid throughout with very fine gold work in flowers, rectangular figures and compartments filled with monograms, and Arabic chapters or passages from the Koraun.'⁵⁴

Moving onto surviving metal plaques, there are a number of important published

49. Rogers (1986) pl.53.
50. Dickson and Welch (1981) no.141, f.234r, and colour pl.12; Falk (1985) no.52.
51. Allan (1995).
52. Enderlein and Sundermann (1988) p.152.
53. Johnson (1818) p.164.
54. Johnson (1818) p.116.

F.1 Half of a door plaque; cut and pierced; work of 'Ali Riza; ht 12.1 cm; w. 9.1 cm; 17th century; no.174

series in precious metal dating from the Safavid period. The best known is a series of eleven rectangular gold plaques, each measuring 88 by 20 centimetres, eight of them bearing Persian poetry in fine *nasta'liq*. The inscription on the other three indicates that the set was calligraphed by 'Ali Riza 'Abbasi, and was ordered by Shah 'Abbas I for the decoration of the Shrine of the Imam Riza in Mashhad.[55] The plaques are embossed: the decoration consists of the *nasta'liq* inscription set against a background of floral motifs within lobed rectangular medallions joined by quatrefoil medallions. Two different dates appear, AH 1011 (AD 1602–3) and AH 1012 (AD 1603–4). The plaques were clearly attached to a wooden ground, as they have nail holes round the edge, but whether they belonged to a door or in some other architectural context is not clear.

These are by no means unique. Not only are there other groups calligraphed by 'Ali Riza Abbasi in the Mashhad Shrine Museum,[56] but it also holds a much earlier, very large set of golden openwork plaques bearing the name of Shah Tahmasp and

55. Part of this series was exhibited at the 1976 World of Islam Festival exhibition at the Hayward Gallery in London: *Arts of Islam* (London 1976) no.247. See also Anon. (n.d.) pp.17–21 nos 3 and 5, which all seem to be part of the same set; this publication lists other examples of his work on both architecture and the minor arts.

56. Anon (n.d.) pp.19 and 21 nos 2, 4 and 5.

the date AH 947 (AD 1540–41).⁵⁷ This set consists of a long series of cartouches and cusped roundels (35 of each) containing the whole of sura 76, together with a long rectangular plaque bearing the historical inscription. The height of the plaques is 14 centimetres, and their total length is approximately 15.5 m. Given the length of the set, and the paradisical nature of the text, it is more likely that they were once nailed to wooden backing boards and placed around the walls of the mausoleum than attached to its doors: Donaldson's photograph of the interior in the early 1930s shows possible positions.⁵⁸

Such plaques are also known in steel. There is a fine example of this form in the Freer Gallery of Art.⁵⁹ The inscription in the cusped roundel reads, *ya muhayyi al-amwat* ('O, Bringer of life to the dead'), and that in the oval cartouche with cusped ends, *wa salla 'ala'l-imam al-Hasan al-majni* ('And pour thy grace upon the Imam Hasan, the victim'). Two other corner-pieces are in the Victoria and Albert Museum.⁶⁰ Judging by their dimensions and design, they must come from the same set, or be part of a very similar one. One reads, *wa salla 'ala'l-imam 'Ali al-murtada* ('And [God] bless the Imam 'Ali al-murtada') and the other, *wa salla 'ala'l-imam Musa al-kazim* ('And [God] bless the Imam Musa al-kazim') showing, as is to be expected, that the original inscription included the names of the Twelve Imams. Given that the height of the pieces is less than 8 centimetress, they are probably too small to have been used as door fittings, and are more likely to have come from a sarcophagus or box.

A relatively large number of steel plaques large enough to have ornamented doors have survived, however. They occur in a variety of forms, as follows.

(a) Ornamented rectangular, horizontal cartouches bearing inscriptions.

One set, which should be made up of eight such plaques, bears an Arabic poem in honour of the Fourteen Innocents. Six have so far been published.⁶¹ A plaque of the same design bearing the same part of this inscription as the Victoria and Albert

57. Anon (n.d.) pp.17 and 19 no.1, and figs on pp.22 and 24. Three different dates are given in this book: AH 949, when the inscription is said to have been calligraphed; AH 957, when it is said to have been put in position; and AH 947 in the historical inscription as quoted. The photocopy of the book from which I have had to work is not clear enough to be sure which date is actually on the historical plaque, and the source of the other two dates is not given.
58. Donaldson (1935) fig.1.
59. Atıl, Chase and Jett (1985) no.28, in which the inscription is completely misread.
60. London, Victoria and Albert Museum, acc. nos M.35 and 35A–1912; each piece measures 14.5 by 14.5 cm.
61. Sotheby's, 15 October 1985, lot 218; Sotheby's, 16 April 1986, lots 181–82, the latter now in a Malaysian private collection, see *Islamic Calligraphy* (1988) no.25; *Unity of Islamic Art* (1405/1985) no.96 (two), one of which is now in New York, Metropolitan Museum of Art, acc. no. 1987.14; London, Victoria and Albert Museum, acc. no. M 5.1919 in *Arts of Islam* (1976) no.234.

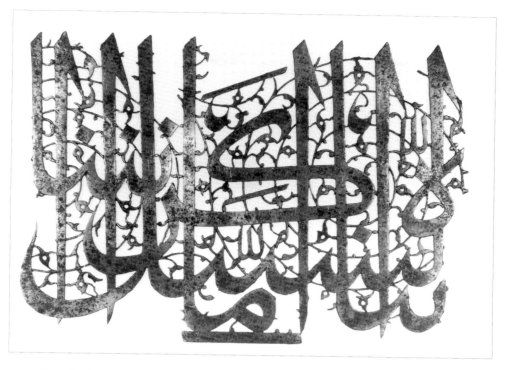

F.2 Part of a door plaque; cut and pierced; approx. ht 19 cm; w. 26 cm; 17th–18th century; no.23

example is in the David Collection, Copenhagen. This suggests that the poem was probably a standard inscription for the doors of Shi'ite shrines or mausolea.[62] The David Collection piece is set within a rectangular frame of steel sheets originally overlaid in gold, and has a larger, rectangular, gilt-copper backing sheet.[63] Hence, all such pierced inscriptions may have been designed to be seen against a golden ground. A slightly different Shi'ite inscription is found on an incomplete group of four plaques of the same shape, now in the Museum of Islamic Art, Cairo.[64] These are said to come from the Darb-i Imam in Isfahan. The Victoria and Albert Museum plaque was acquired in Shiraz and is said to come from the shrine of Shah Tahmasp.

(b) Ornamented rectangular, vertical cartouches, decorated with various pierced cartouches with

62. For an example from yet another set, see Lawton and Lentz (1998) pp.154–55.
63. My thanks to Kjeld von Folsach for information about this object.
64. Pope (1938–39) pl.1389; *The Arts of Islam* (1976) no.237. These plaques comprise four out of a probable total of eight, and refer to Muhammad *binabi 'arabi wa rusul madani*, 'Ali *alladhi yadrib bi'l-saif hukmin azali*, Hasan and Husain *wa bisibtiyi wa shibliyi huma najl zaki*, and Fatima and Khadija *wa zahra' butul wa b'umm waladatha*.

arabesque work or inscriptions.

There is an important example of this form signed by Kamal al-Din Mahmud ibn 'Ali Riza Nazuk and dated AH 1107 (AD 1695–96),[65] and the broken piece in the Tanavoli collection (F.1) bearing the words *'amal-i 'Ali Riza* is the remains of an example of very fine quality, possibly by Kamal al-Din Mahmud's father, 'Ali Riza Nazuk. There is one published piece decorated with cartouches of arabesque work only;[66] in theory this could be hung vertically or horizontally, but given the similarity of the layout of its cartouches to those on the plaque by Kamal al-Din Mahmud, a vertical format seems most likely.

(c) Quatrefoils, decorated either with central pierced arabesque work or with an inscription.

A number of different examples of the former are known.[67] Their use in a total scheme of door design is suggested by the two in Cairo, which are placed at the top and bottom of the inscribed set mentioned above, between the quarter-medallion corner plaques. However, since this set is incomplete its layout may not be reliable. Quatrefoils decorated with an inscription are represented by a piece recently on the art market, bearing the words *salla'llah 'alayhi wa alihi* ('the blessing of God be upon him and his family'), which refers to the Prophet Muhammad.[68]

(d) Quarter medallions used as corner plaques.

Two sets are known, one in Cairo, the other in St Petersburg.[69] They are plain except for a simple arabesque border in openwork.

(e) Horizontal, oval, cusped medallions with pierced inscriptions.

Two such plaques, supposedly from the same set, are in St Petersburg.[70] These bear sura 13, verse 24 and sura 10, verses 62–63. Two other plaques were recently on the art market. One bears the inscription, *la hawl wa la quwwat illa billah al-'ali al-'adhim ya qadir* ('There is no power and no strength except with God, the High, the Great, O Mighty One').[71] The other is inscribed with sura 13, verse 29.[72]

If we compare these four plaques, we find that the dimensions of the first three are very similar, whereas the fourth is slightly larger. The inscription on the third of these plaques is in a style very like the inscriptions on the two St Petersburg plaques, in that the letters of the words interlace with each other vertically, but the words are

65. Sotheby's, 30 April 1992, lot 137.
66. Sotheby's, 23 October 1992, lot 178.
67. Sotheby's, 23 October 1992, lot 179 (2); Harari collection in Pope (1938–39) pl.1389 (2); David collection, acc. no.9/1985 in von Folsach (1990) pl.349.
68. Sotheby's, 16 April 1986, lot 183.
69. Harari collection, Pope (1938–39) pl.1389; *Masterpieces of Islamic Art* (1990) no.91.
70. *Masterpieces of Islamic Art* (1990) no.91; one measures 35.3 by 24.5 cm, the other 34.5 by 26.8 cm.
71. Christie's, 19 October 1993, lot 382; width 34.8 cm.

F.3 Door handle plate; pierced; d. 35.5 cm; 17th century; no.22

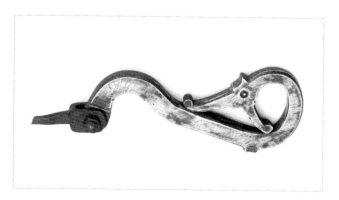

F.4 Door knocker; cut and incised; lg. 24 cm; 18th–19th century; no.152

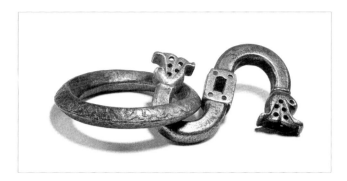

F.5 Ring and s-shaped hook; cut, pierced and chiselled; lg. 12.7 cm; d. of ring 7.4 cm; 19th century; no.56

all read from left to right in approximately horizontal bands. That on the fourth, however, is rather different, for here the words are divided visually into an upper and a lower band by the *yey* of *tubi*, but the words are read top right, bottom right, top left, bottom left. The fourth plaque is also different from the other three in that it is set within four inscribed steel corner-pieces on a gilded copper ground (though the others may originally have been like that too). Thus, while three of the four could come from the same set, the fourth, at least in style and size, appears to be from a different group.

Verses 18–29 of sura 13 are all appropriate to a shrine or mausoleum, since they emphasise the requirements for being accepted by God and entering Paradise. The fact that two of these plaques use verses from this group suggests that they were popular for this purpose. The four steel corner-pieces surrounding the last plaque bear in gold sura 3, verses 172–73. These refer to the Battle of Uhud, and suggest that the plaque comes from the shrine of a man killed in battle.

(f) Vertical oval cusped medallions with pierced inscriptions.

There are two published examples. One is in the British Museum,[73] the other was recently sold at auction.[74] On both, the inscription reads, *innahu min Sulayman wa innahu bismillah al-rahman al-rahim sana 1105 h* ('Lo! It is from Solomon, and lo! it is: In the name of God the Beneficent, the Merciful. The year AH 1105 [AD 1693–94]'). The Qur'anic quotation here is from sura 37, verse 30. This sura contains the story of King Solomon and the Queen of Sheba, and includes many details not found in the Old Testament. In this verse the Queen of Sheba starts to read to her noblemen

72. The piece measures 30.5 by 36.7 cm; unpublished.
73. *The Arts of Islam* (1976) no.235; Safadi (1978) p.37 pl.10.
74. Stuttgarter Kunst-Auktionshaus Dr. Fritz Nagel, 11 November 1995, lot 1207.

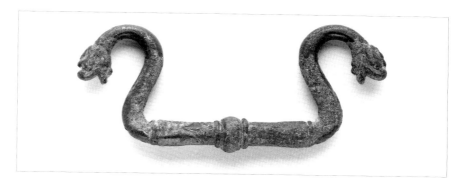

FIG.51 Bronze or brass shutter-handle; cast; lg. 12.5 cm; 17th–18th century; no.366

a message from Solomon demanding submission. It is difficult to imagine doors large enough to have been inscribed with the whole of this story, and difficult too to see the significance of inscribing a door with this story at all. It seems more likely that the medallions come from a pair of royal doors, and that the verse is used to allude to Shah Sulaiman I (1666–94). The two medallions are slightly different in size (one is 34.3 centimetres, the other 24 centimetres high), but are otherwise virtually identical. Shah Sulaiman was buried in Qum.[75]

(g) Cartouches in the form of a palmette with a pierced inscription.

Two plaques of this form are in the St Petersburg set; one has lost its trefoil finial.[76] The inscriptions on them read: *ya rafi' al-darajat* ('O Exalted of Ranks'), and *ya miftah al-abwab* ('O Key of the Gates').

(h) Cartouches in the form of a winged palmette with a pierced inscription.

There is a single example published of this elaborate form.[77] It bears sura 76, verse 13, with obvious allusions to Paradise, and indicative again that the piece came from a mausoleum.

(i) Irregular pentagonal plaques with a pierced inscription.

There are two published examples, bearing the words *ya qadir* and *ya ...(?)*.[78]

(j) Plaques of uncertain shape.

The fragment F.2 in the Tanavoli collection comes from a plaque of unknown shape

75. Meshkati (1974) p.225.
76. *Masterpieces of Islamic Art* (1991) no.91.
77. A. Welch (1979) no.59; Blair and Bloom (1991) no.13.
78. Sotheby's, 25 April 1996, lot 151.

and size, though the fragment of a base line suggests a plain rectangle. It bears part of sura 76, verse 3, *inna hadainahu'l-sabil imma shakiran wa imma kafuran* ('Lo! We have shown him the way, whether he be grateful or disbelieving').

The above analysis of the different shapes of steel plaques used on doors suggests a close link with bookbinding designs. The ornamented rectangular variety of cartouche alternating with quatrefoils occurs both in horizontal and vertical positions on the borders of many Iranian bookbindings, dating from the 16th century or later.[79] The oval cartouche in vertical format is the typical centre-piece of the main design on such bookbindings,[80] and is sometimes found with four corner-pieces.[81] The palmette-shaped and irregular pentagonal plaques are readily recognizable as being related to more complex geometric field designs on book-bindings.[82] In addition, of course, filigree work is typical of the book-binder's art, and all the steel plaques discussed here are pierced. Precisely how such a link between the two crafts functioned is impossible to say, but one element was undoubtedly the fact that steel-workers would have been responsible for the manufacture of the steel dyes used by book-binders (for examples, see L.41 and L.42).

Another aspect of the door plaques should also be mentioned. The set in St Petersburg demonstrates the interaction between this type of openwork design and that of the standards (*'alam*s) discussed elsewhere, for the two smaller pieces in the set could, if turned through 90 degrees, be used as standard finials. Hence there is an element of economy visible in the industry, in which a single item can fulfill more than one function.

OTHER ARCHITECTURAL SETTINGS

Two other pieces of door furniture should be mentioned. F.3 is the plate of a large door-handle, or possibly a door-knocker. Its openwork design of radiating palmettes and arabesques suggests a 17th-century date. The magnificent dragon door-knocker (F.4) is but the tip of an iceberg. Any traveller to Iran will have been struck by the sight of the knockers and knobs which decorate the outsides of houses in every Iranian town or city. Unfortunately, few have remarked on them. Binning noted them in Shiraz – 'a low door constructed of thick timber, embossed with large iron knobs, and having an iron knocker suspended above the keyhole'[83] – but his description gives no clue of the actual design of knob or knocker. They were probably so com-

79. Haldane (1983) pls 83–4, 104, 113. For such cartouches used in an illuminated border design regardless of direction, see Arberry *et al.* (1959–62) vol.2 pl.32.
80. Haldane (1983) pls 104, 113.
81. Haldane (1983) pl.83; Fu *et al.* (1986) no.47.
82. Haldane (1983) pl.83.
83. Binning (1857) vol.1 p.209.

monplace that travellers saw no reason to comment on them. One can only hope that the traditions of the different towns will be recorded before they all disappear.

The large ring and s-shaped hook, F.5, like the dragon door-knocker, is a fine example of the more massive type of steelwork produced in Iran for architectural settings. This particular hook could have been used to suspend a heavy chain, for example in the entranceway to a shrine. Such chains were common,[84] and many still exist in Iran, for example, in Isfahan in the entrances of the Imamzadeh Ahmad and the Masjid-i Sayyid, and in the doorway of the main room inside the Harun-i Vilayat.

D'Allemagne noted certain locksmiths in Isfahan who made door- and shutter-handles and scissors, as well as locks.[85] There are no examples of steel shutter-handles in the Tanavoli collection, but a bronze/brass example (FIG.51) gives an accurate idea of one of the most typical forms.

84. For example, Orsolle (1885) p.190 noted one in the entrance to the Friday Mosque in Qazvin.

85. d'Allemagne (1911) vol.4 p.97: for such handles, see the illustration by d'Allemagne (1911) vol.2 p.89.

Religious objects

Grouped together in this chapter are various objects with a primarily religious function. Some are fundamentally Shi'ite, such as the prayer plaque dedicated to the shrine of the Imam Husain at Kerbala, while others express a talismanic purpose in various ways – through invocations to God or prayers to 'Ali, through Qur'anic quotations, or by containing a copy of the Qur'an itself. Sufism is represented by items of paraphernalia associated with dervishes and dervish orders in Iran.

This does not mean that other steel objects in the Tanavoli collection have no religious function or message. On the contrary, as is shown in the relevant chapters, steel grilles and padlocks were both of primary importance in Shi'ite shrines, as well as being used in secular buildings and in everyday life. Numerous other objects were also decorated with Shi'ite or other sufi slogans. This chapter should therefore be read in the context of that wider horizon.

PILGRIMAGE PRAYER PLAQUES

An important piece in this collection is the *ziyarat nameh*, or pilgrimage prayer plaque (G.1). Dedicated to the shrine of the Imam Husain, it must have come from the famous Shi'ite shrine of the Imam in Kerbala, in Iraq. The main body of the text which it bears is in Arabic, but the heading, which is in Persian, suggests that it was manufactured in Iran and presented to the shrine for the benefit of Iranian Shi'ite pilgrims. In the bottom corners the maker gives his name, Muhammad 'Ali son of Abu'l-Qasim, and the date, AH 1197 (AD 1782–83), but unfortunately gives no clue as to his place of work.

It is instructive to provide a translation of the text of the prayer plaque in full. The inscription of the heading reads: 'The *mutlaqa* invocation to His Holiness Imam Husain, may peace be upon him. He is the God Who suffices me and He is the best Disposer of affairs. In the name of God, The Compassionate, The Merciful'. The main text reads: 'Peace be upon you, O servant of God. Peace be upon you, O son of the Messenger of God. Peace be upon you, O son of the Commander of the Faithful. Peace be upon you, O son of Fatima the Radiant One, mistress of the

women of the two worlds. Peace be upon you, O father of guiding and rightly guided imams. Peace be upon you, O quick to shed tears. Peace be upon you, O one possessed of allotted misfortunes. Peace be upon you, and upon your grandfather, and your father, and your mother, and your brother, and on the imams among your descendants. I testify that God has made the earth [of burial] sweet from you, and has clarified the Book through you, and has given religious merit liberally through you, and has made you and your father and grandfather and brother and mother and descendants an example to those who are intelligent. O son of the fortunate, the good, who recite the Book, I have directed my greetings to you, may God's blessing and peace be upon you, and He has filled the hearts of some men with love towards you. He shall not be lost who holds onto you and takes refuge in you.' A long section on the merits, benefits, various ceremonies and different prayers to be recited at specific stages and times when visiting the tomb of the Imam Husain is given in the *Mafatih al-Janan*, which deals with Shi'a religious observations and prayers.[1] Almost the last invocation to be recited inside the tomb sanctuary is the *ziyarat*, which is to be read while facing the Imam, meaning having one's back to the *qibla*.[2] The *ziyarat* is of two types: *mutlaqa*, which are not confined to a particular time; and *makhsuusa*, which are prescribed for specific occasions such as the birthday of the Imam. The *ziyarat* on the plaque is not included among the variants given in the *Mafatih al-Janan*,[3] but if its identification as *mutlaqa* is correct, one may assume that the plaque was fixed inside the sanctuary.

A number of other such plaques are in the Shrine Museum at Mashhad, though only one has been published.[4] This is in openwork steel with brass edging, and has a splendid handle in the form of the sun with a calligraphic face: the name of God is the forehead, the name of 'Ali twice in mirror-image the eyes, eye-brows and nose, and the name of Muhammad twice in mirror-image the cheeks and mouth. It bears a dedication to the Imam Riza as a heading, and a text similar in tone to the Kerbala one, greeting each of the twelve Imams in turn. In addition, however, it has a very important dedicatory inscription which says that it was given as *waqf*, or pious endowment, by Ustad Haji Muhammad ibn Ustad Hasan Isfahani, and that it is the work of Ustad Haji Muhammad. It is dated AH 1264 (AD 1848). This magnificent object bears eloquent testimony to the quality of openwork steel craftsmanship available in Isfahan in the mid-19th century. The other plaques in the Shrine Museum at Mashhad need further detailed study, but they include one dated AH 1200 (AD 1785–86), and another like it dated AH 1222 (AD 1807–8). These have their

1. Qumi (1984) pp.748–868. I owe this information to Manijeh Bayani.
2. Qumi (1984) p.770.
3. Qumi (1984) pp.772–87.
4. Anon (n.d.) no.61 fig. on p.78, dated 1294 (corrected to 1264 on postcards on sale in the museum).

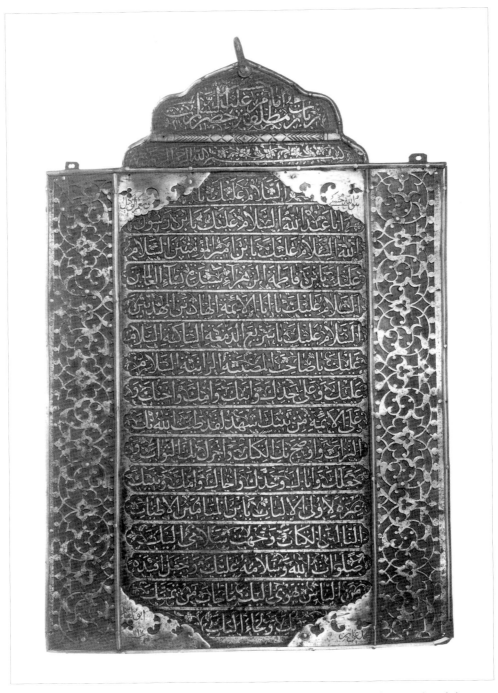

G.1 Pilgrimage prayer plaque; chiselled, pierced and chased; brass edging; brass and steel rivets; ht 43.5 cm; w. 29 cm; signed by Muhammad ʿAli ibn Abuʾl-Qasim, dated AH 1197 (AD 1782–83); no.301

texts and lines in gold, and the ends of the frame around each line are done in the same way as the piece in the Tanavoli collection. The frame is square in section and decorated with a stem-and-leaf pattern inlaid in gold. Three other examples are curved. They have square ends to the frame around each line, and inside the outer frame is an area of fine arabesque work. Another has a bracket-shaped top, a slightly tapered body and gold calligraphy. It is evident that there are a number of different forms and styles of pilgrimage prayer plaques. Until more of the Mashhad examples are published, however, little more work can be done on the group as a whole.

Such plaques were traditionally kept in the central chamber of the shrine of the Imam Riza, often hung upon the railings around the tomb. At the beginning of the 19th century, Burnes's informants, who described the tomb of the Imam Riza to him, mentioned them: 'the tomb is said to be shielded from the touch of the profane by railings of steel and brass, where plates of silver and wood, with blessings and prayers carved upon them, are suspended.'[5] Or, as another traveller put it: 'Before each of them [the plaques] a little group of the devout is posted, either to pray themselves or to repeat the petitions after the leader of their common devotions. This they do with cries and sobs, as though thus to open to themselves the gates of eternal bliss. It is indeed a singular and sublime spectacle to see how (they) ... kiss with unfeigned tenderness the fretwork of the grating, the pavement, and especially the great padlock which hangs from the door.'[6] In modern times they are offered to pilgrims by a mullah as they enter. The pilgrim then reads the text aloud, or if he or she is unable to read, the mullah reads the text on his or her behalf for a small fee.

Prayer plaques were not traditionally confined to the great shrines of Kerbala and Mashhad. Olearius, for example, notes their existence at the shrine of Shaikh Safi in Ardabil, and relates how they were there used as certificates of a pilgrim's visit and of the prayers said in the shrine. He also mentions their use as protective talismans.[7]

BAZUBANDS

Flat pieces of steel, curved to fit the shape of the upper arm, were used in later Islamic Iran for both decorative and talismanic purposes. G.2 (with no.331, ex-catalogue) forms a pair of purely decorative interest. Their attraction lies in their elegant shape and the beautiful watering of the steel of which they are manufactured. These aspects are enhanced by the pierced suspension rings (one on no.331 is a later replacement) and the brass rivets, the latter adding a subtle golden touch. The other

5. Burnes (1835) vol.3 p.70.
6. Eastwick (1864) vol.2 p.229.

7. Olearius (1669) p.181.

two *bazuband*s, on the other hand, have obvious talismanic content. Both G.3 and G.4 have central cartouches in which God's help is invoked in the phrase *ya qadi al-hajat* ('O judge of needs'), while G.4 in addition bears a poem calling upon the Imam 'Ali: 'You shall find him help in distress. Every care, every sorrow shall vanish, through thy care. O 'Ali …' The importance of calling upon 'Ali is stressed by G.5. Here 'Ali, as so often, is symbolised by the lion.[8] The presence of the sun adds strength to the lion through its astrological symbolism (the Sun in Leo), while the Qur'anic words (they do not appear to make up any coherent Qur'anic verses) and the two squares of magic letters further enhance the talismanic quality of the object.

Other materials apart from silver and steel were also used for *bazuband*s. For example, inscribed stones in metal settings (usually silver) were common, and among the published examples are to be found Shi'ite invocations similar to those inscribed on the steel *bazuband*s, including the prayer to 'Ali found on G.4.[9]

The precise history of *bazuband*s is uncertain. An early illustrated example, in a painting in the style of Siyah Qalam, is associated with Aq Qoyunlu Tabriz, but probably of Central Asian origin. Whereas most of Siyah Qalam's demons wear heavy metal torques of circular section, this painting shows a demon wearing armlets of what is probably black cord, each decorated with a golden quatrefoil medallion with two golden discs either side.[10] However, there does not seem to be any pictorial evidence for *bazuband*s of this type in Safavid miniature painting. Safavid costume with its loose, half-length or full-length sleeves did not lend itself to any tight ornament around the upper arm, and even in the 17th century a miniature of Shah 'Abbas receiving the Mughal ambassador at court betrays no evidence of their use.[11] In fact, on the evidence of paintings, it seems that the later Iranian fashion could well have originated at the Mughal court. In a lakeside scene of *circa* 1600–1605, for example, the Mughal prince, Salim, is shown wearing a pair of very delicate *bazuband*s, each apparently set with a single stone;[12] a very similar style is worn by the Emperor Jahangir in a portrait of *circa* 1605.[13] This type of *bazuband* evidently grew more elaborate, and in a portrait of *circa* 1640 Shah Jahan is shown wearing a narrow example consisting of a central oval dark stone with what is probably a large pearl at either end of it; a similar *bazuband* is shown in another of his portraits some ten years later.[14]

When this fashion reached Iran, if indeed it did come from India, is as yet uncertain, owing primarily to the lack of documentation for paintings of the Zand and Qajar periods. However, very elaborate *bazuband*s are commonly illustrated in

8. Tanavoli (1985) pp.23–28.
9. Kalus (1986) no.II.2.3 (III) pp.98–99, and II.2.5(I) pp.100–101, for example.
10. *The Islamic World* (1987) pl.63.
11. Falk (1985) no.100.
12. Robinson (1988) no.P16, colour pl.18.
13. Lowry (1988) no.69.
14. Colnaghi (1976) p.215 no.120, and p.217 no.121.

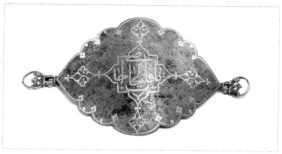

G.2 One of a pair of *bazuband*s; watered; cut; brass rivets; pierced rings; ht 5.8 cm; l. 17.9 cm; 17th–18th century; no.180

G.3 *Bazuband*; cut and overlaid in gold; steel rivets; pierced rings; ht 5.8 cm; w. 10.6 cm; 19th century; no.316

paintings of the Qajar era, pointing to their introduction sometime in the late Safavid or Zand period. Certainly, by the end of the 18th century such ornaments were extremely popular, for costume at the court of the first Qajar ruler, Fath 'Ali Shah, was resplendent with magnificent *bazuband*s encrusted with precious stones and held in place by strings of pearls.[15] They came in a wide variety of shapes and sizes, were used both by men and women, and the central stones were probably engraved with talismanic inscriptions.[16] A certain number of less exotic *bazuband*s of this variety have survived. There are, for example, five in the Ashmolean Museum which have either three or four separate stones, each engraved with talismanic inscriptions, in silver settings.[17] One group of settings is also enamelled. Such *bazuband*s remained popular in later Qajar times at court, despite the Europeanisation of costume, as the elaborate examples worn by Nasir al-Din Shah in a portrait dated AH 1285 (AD 1849) demonstrate.[18]

15. See, for example, Robinson (1976) no.1280 for a miniature painting, and Falk (1973) nos 15–16 for oil paintings of Fath 'Ali Shah himself.
16. Falk (1973) no.25, for example, seems to show engraved stones.
17. Kalus (1986) nos II.2.1–5.
18. Falk (1985) no.188.

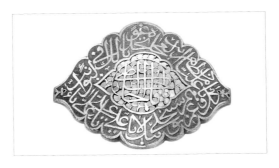

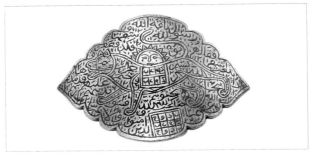

G.4 *Bazuband* medallion; cut, pierced and chiselled; two brass rivets remaining; ht 5.3 cm; w. 6.6 cm; 19th century; no.189

G.5 *Bazuband* medallion; cut and chased; two copper loops soldered onto back; ht 5.9 cm; w. 7.7 cm; 19th century; no.420

Steel *bazuband*s, however, are much less exotic, and were probably made for a rather different clientele, namely wrestlers (*pahlavan*s). In popular Shi'ite belief, 'Ali was a great wrestler: stone lions are used as tombstones for *pahlavan*s,[19] and steel *bazuband*s decorated with a lion (G.5) or inscriptions calling upon 'Ali (G.4) could well have belonged to wrestlers. An amusing description of a wrestling match is provided by Sykes, who also illustrates the Shah's wrestler wearing britches and *bazuband*s, though here the *bazuband*s appear to consist of three talismanic stones set in metal.[20] The great wrestlers were also compared with Rustam and Suhrab, and later depictions of the latter heroes often show contemporary *pahlavan*s. When wrestlers first used *bazuband*s is unknown, and the dating of the pieces in the Tanavoli collection remains difficult to determine. In terms of quality G.2 and its pair, no.331, are outstanding, in their weight of steel, in their form, and in their watered texture, and a 17th- or 18th-century date might be suggested. G.4 and G.5 are of much thinner steel, and probably 19th-century; so too G.3. There is no way at present of establishing their provenance.

19. Tanavoli (1985) p.29. 20. Sykes (1910) illustration opposite p.152.

RELIGIOUS OBJECTS

AMULET BOXES

From Safavid times onwards, small octagonal amulet boxes were made in a variety of materials, of which the most popular seem to have been silver and steel.[21] They usually had two suspension loops, one each side, so that they could be tied around the arm as a variation on the flat, *bazuband* theme. The boxes were designed to hold tiny copies of the Qur'an, and the remains of the leather cover of one such Qur'an is stuck to the inside of G.7. The inscriptions on the boxes vary, sometimes having a very simple talismanic content, like the *bismillah* on G.6, sometimes stressing the owner's dependency on God, as in the case of the quotation from sura 65, verse 3 on G.8: 'And whosoever putteth his trust in God, He will suffice him.' In yet other cases the box bears a statement of belief in keeping with its contents, as on G.7 with its quotation from sura 112, verses 1–3 around the lid: 'In the name of God, the Beneficent, the Merciful. Say: He is God, the One! God, the eternally besought of all! He begetteth not nor was begotten.' The invocation *ya qadi al-hajat* ('O judge of needs') in the centre of its lid refers to God; the inscriptions on its sides appear to be six invocations, but are illegible.

Technically, the boxes have some points of interest. Both G.7 and G.9 have their decoration applied to the lids. In other words, the inscriptions on G.7 and the roundel on G.9 are both openwork steel sheets which have been attached to the lids in question with either brass or steel rivets. G.6 and G.8, on the other hand, have inscriptions chiselled out of the lid itself. The use of brass on G.9 is also noteworthy, for it is employed not only for the rivets but also as a solder, thereby adding an effective touch of colour both to the rim of the lid and to the lower edge of the sides. Although it is likely, there is no absolute certainty that G.10 comes from an amulet box. The use of a somewhat similar pierced plaque in the Freer Gallery of Art, decorated with the *bismillah*, is also conjectural.[22]

To date these amulet boxes is difficult. However, a clue to the possible dating of G.8 is provided by a seal in the Ashmolean Museum, which is in the name of an Englishman, Nathaneal Wage, and is dated 1698.[23] The layout of the inscription and the deep curves of particular letters suggests that G.8 should be dated to a similar period, *circa* 1700. On that basis, G.6 may also be dated to *circa* 1700, for the *sin* letters in its inscription parallel the letter *sin* in the word *hasbahu* in G.8, while its flowers and the stem from which they spring are very close in design to those of the latter. G.10 may be late 18th century, while G.7 and G.9 are probably 19th century.

21. For silver amulet boxes, see Gandy (1995).
22. Atıl, Chase and Jett (1985) pp.198–99, no.30.
23. Kalus (1986) no.I.3.4.

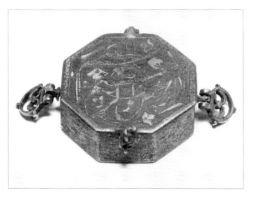 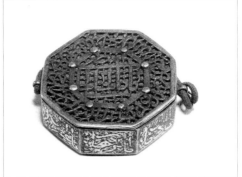

G.6 Amulet box; cut and brazed; chiselled lid with gold inlaid; pierced handles; brass and steel rivets; d. 4.4 cm; ht 1.6 cm; *circa* AD 1700; no.158

G.7 Amulet box; cut and brazed; applied pierced sheet on the lid, with steel and brass rivets; the sides overlaid with gold, with two brass loops; d. 4.2 cm; ht 1.5 cm; no.306

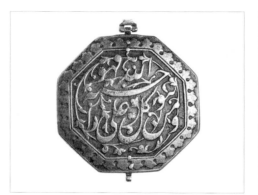 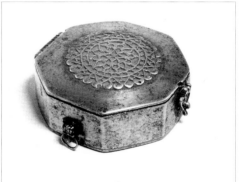

G.8 Amulet box lid; cut and chiselled; brass rivets; d. 4.1 cm; *circa* AD 1700; no.310

G.9 Amulet box; cut and brazed; pierced sheet applied to lid with brass rivets; pierced clasp and ring; one ring missing; steel rivets; d. 6 cm; ht 2.6 cm; no.307

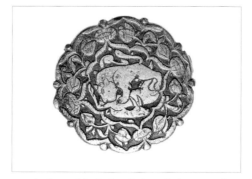

G.10 Plaque from an amulet box; chiselled and chased; d. 4.5 cm; late 18th century; no.136

DERVISH PARAPHERNALIA

Precisely what objects were associated with different dervish groups in Safavid times is not at all clear. A miniature in a manuscript of Sultan Husain Mirza's *Majalis al-'Ushshaq* of AH 959 (AD 1552) shows a troop of Qalandariyya dervishes:[24] between them they carry a horn, two flutes, a candlestick, a large boat-shaped basin, an equally large gourd or gourd-shaped vessel, a dragon-headed mace, and a tall *'alam*. The shaikh carries a staff with a spear-headed base and a knob finial. Kotov, who was in Isfahan in 1624–25, comments generally that dervishes carried staffs, spears and axes.[25] Kaempfer, who was in Iran in 1684–85, contrasts a number of different dervish groups largely by their clothing (or lack of it) and their headgear, but also mentions that Bektashis carried begging-bowls, Mavlavis a begging-bowl of light wood or pumpkin rind, and Haydaris a staff and a horn, while the Qazaq, who were wandering dervish players travelling on their own or in twos, carried axes, lances and staffs.[26]

By the 19th century, if one may judge by the accounts of European travellers, dervishes were carrying a great variety of objects: for example, axes of various different shapes; maces; knives; *kashkul*s; staffs, long and short, sometimes with flags on top; sickle-shaped pole axes; clubs; horns; and water-skins.[27] The axes were often inlaid. Wills writes: 'It is in his arms that the real dervish's fancy takes most scope. Bludgeons with portentous projections; clubs bristling with spikes or knife-blades; steel axes, single-headed or double-headed, at times beautifully damascened with silver or gold; maces of steel or iron, having the head like the head of a horned bull … With one or other of these curious weapons the dervish is sure to be provided.'[28] Late 19th-century depictions of dervishes and dervish paraphernalia emphasise, as do many of the surviving objects, that by then poverty was not of particular significance among the well-off, traditional dervishes. Hence a miniature of a dervish with a bejewelled *kashkul* and a crutch in the form of a bird, and another of the young dervish Nur 'Ali Shah with bejewelled accoutrements, both in the Pozzi collection.[29] A typical visitor's reaction comes from Ella Sykes: 'We were pestered for alms by two well-fed and well-dressed *dervishes*, clothed in white woollen garments, like nightgowns, with bare heads and flowing hair. They were young and

24. Bodleian Library, Oxford, MS.Ouseley Add.24 f.79b; Robinson (1958) no.783; illustrated Lewis (1976) p.11 no.6.
25. Kotov (1959) p.25.
26. Kaempfer (1977) pp.143–44.
27. d'Allemagne (1911) vol.1 pl. opposite p.136, shows a wide variety of dervish objects. See Sykes (1898) pl. opposite p.64 for a dervish with axe and *kashkul*; d'Allemagne (1911) vol.2 p.14 for a dervish with pole-axe. For a dervish with club and horn, see Binning (1857) p.229, describing a depiction of Hafiz in a Zand-period building in Shiraz. See Sykes (1898) p.247 for dervishes with staffs with flags, and water-skins.
28. Wills (1886) p.93; Sykes (1898) p.56 also comments on the inlaid axes.
29. Robinson (1992) nos 481 and 459 (pl.XXX).

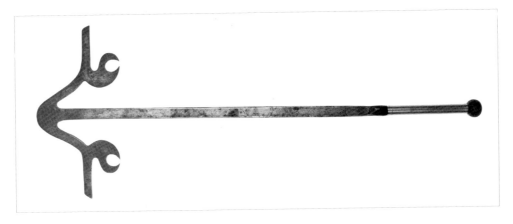

G.11 Dervish crutch; forged; the handle recently tinned; l. 67.7 cm; w. of head 27.4 cm; 19th century; no.4

strong, and carried handsomely inlaid battle-axes over their shoulders, and curiously shaped bronze boxes in their hands, in which to collect alms. These men live entirely by the proceeds of begging, and it has been hinted that they often attack and rob people in lonely places unless their demands are complied with.'[30]

Elsewhere in the manuscript of Sultan Husain Mirza's *Majalis al-'Ushshaq*, shaikhs are shown either with the staff with a spear-headed base and knob finial mentioned above, or with a staff with a spear-headed base and a diagonally-angled handle.[31] The size of the knob on such a staff obviously varied: an earlier Safavid manuscript of the *Khamseh* of Nizami contains an illustration of Jesus and the dead dog, in which Jesus holds a tall staff with a relatively large spherical head.[32] As in the 1552 miniatures, the base of the staff is apparently of metal, and fashioned like a spear head. In the 17th century, depictions of dervishes are relatively common, but depictions of dervish staffs and crutches are surprisingly rare. A drawing of 1622 shows a dervish holding a thin T-shaped staff,[33] while a picture of Jesus and the dead dog from another *Khamseh* of Nizami dated AH 1060 (AD 1650) shows Jesus holding a staff with a right-angled handle.[34] An early 17th-century depiction of a dervish by Riza-i 'Abbasi shows a crutch with a flat crossbar with straight, diagonally-upturned ends,[35] while a roughly contemporary Mughal example has a jade crossbar with a very shallow curve.[36]

When the more elaborate dervish staffs, or more often crutches, with handles in

30. Sykes (1898) p.56.
31. Fols 19b, 21a, 50b, 60b, 74b, 79b, etc.
32. Bodleian Library, Oxford, MS.Elliot 192, fol.22b; Arnold (1928) pl.XXVIII.
33. Bibliothèque Nationale, Paris, Sup.P.1572; Okasha (1981) fig.59.
34. Bibliothèque Nationale, Paris, Sup.P.1111, fol.102; Arnold (1928) pl.XXVIIa.
35. Colnaghi (1976) p.144 no.43 ix.
36. *The Indian Heritage* (1982) no.359.

the form of the name of 'Ali (G.11) developed is unclear. There is no trace of them in 17th-century miniatures, and one must therefore assume that they did not develop until the 18th century.

An undecorated steel crutch of a different form, with a crook-like top at right-angles to the shaft, is in Snowshill Manor, Gloucestershire (unpublished). Plain styles like this are virtually impossible to date, though it is presumably Safavid or later. However, its origin may be of some interest. In the 1483 Herat *Language of the Birds* manuscript in New York, there is a miniature of a rural scene showing a figure who appears to be a Buddhist monk. This figure has beside him a dragon-headed crook which appears to be the source of the later version.[37] It is therefore possible that Buddhist ideas, introduced from Central Asia, gave rise to at least one form of Iranian dervish crutch.[38]

For the true dervishes, some at least of the items they carried had a religious message. Thus, the dervish met by Lady Sykes in the Bampur plain carrying a furled white flag with a red fringe at the top of his staff was soliciting alms in the name of 'Abbas, Husain's brother, the standard-bearer at the battle of Kerbala. Water-skins too, she points out, recall 'an episode of the *Taziyeh* in which Abbas dashes for the well which is surrounded by hosts of enemies, and dies in the heroic attempt to get water for the miserable company of men, women, and children, who had been suffering all the agonies of thirst for three days under the scorching rays of the Arabian sun.'[39]

Other items may reflect the Iranian tradition of kingship, like the bull-headed mace, the emblem as well as the fighting weapon of Rustam in the *Shah-nameh* – though some writers suggest that the Persepolis protomes might have been the source of this design,[40] while others maintain that 'they symbolize power over demons and the evil in the human soul' and that 'the ox head is also to be seen as the devil's head'.[41] The club or cudgel was usually of knotted wood, though it was sometimes made from the long saw-like bone projecting from the upper jaw of the sawfish, which inhabits the Persian Gulf. Its significance is more difficult to gauge: in origin both it and the axe may have simply been for self-protection. The short dervish staff already mentioned (G.11) came to have its own symbolism through the elaboration of its form by the addition of the name of 'Ali. A fine, inlaid example of such a crutch is in the Victoria and Albert Museum.[42]

37. Lukens (1967) figs 29–30.
38. One would like to know whether the batons carried by the 900 'Chiaux' among Nadir Shah's forces in the 18th century were of similar form – they are described by Hanway (1754) vol.1 p.170 as 'a batton with a double silver crook on the end of it'.
39. Sykes (1898) p.247.
40. For example, d'Allemagne (1911) vol.1 p.135.
41. *Dreaming of Paradise* (1993) fig.65.
42. Victoria and Albert Museum, London, no number; length 57.5 cm, bearing two stamps in the

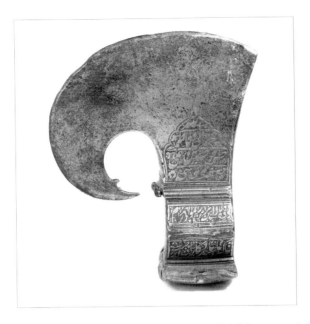

G.12 Axe head; forged and chiselled; made by Shah Najaf; l. 22.2 cm; ht 17.8 cm; dated AH 1201 (AD 1796–97); no.82

Dervishes could purchase their equipment in special shops which were to be found in most towns in Iran.[43] In these the full range of their paraphernalia – everything from items of clothing (such as hats and panther or leopard skins) to pieces of equipment (such as *kashkul*s and axes) – were exhibited. Such shops provided an unusual contrast to the normal type of shop in an Iranian bazaar, which was dedicated to the sale of the products of a particular craft. Dervishes also adopted ancient arms as their emblems. For example, d'Allemagne came across a dervish axe made up of a Bronze Age blade mounted on a damascened handle.[44]

It is not always easy to recognise which objects, particularly axes, were actually made for dervishes, and which had a primarily military function. One axe (A.7), for example, has been catalogued under weapons, as it is of a form called a saddle-axe, used by cavalry in both Safavid and later Iran and in Mughal India (see pp.127–29).[45] However, neither its shape nor its design rule out its ownership by a dervish, and though its hammer shows some signs of use, its blade shows relatively little wear.

name of Haji Muhammad. The *lam* was originally brazed on and has been refitted through the addition of the small unit between it and the stem of the staff.
43. Wills (1883) pp.45–46; (1886) pp.92–93.
44. d'Allemagne (1911) vol.1 p.135. The link with antiquity occasionally went further: d'Allemagne (1911) vol.3 p.87 shows a very interesting photograph taken by M. Césari, Inspector General of Customs, of the interior of the house of a dervish who was also an antique dealer.
45. Melikian-Chirvani (1979).

G.12, a large axe-head dated AH 1201 (AD 1786–87), is decorated with a range of inscriptions. In the lobed cartouche on one side of the blade is the following: 'God, Muhammad, 'Ali, Hasan and Husain, 'Ali, Ja'far, Musa'. The name of the fifth Imam, Muhammad, is missing. In the two panels on the same side is the following: 'This axe was endowed to the offspring [of 'Ali?] out of respect / So that [this] second [object] to be remembered [is there as a sign] of [the donor's] nobility and honour.' There was evidently another object endowed at the same time as this axe-head. On the other side, the lobed cartouche contains the following: 'God, 'Ali, Muhammad, 'Ali, 1021, Hasan, Muhammad. Through Your mercy, Oh You Who are the best of those who show mercy.' The panels read: 'For Isma'il, the victim (?), through affection and love / Haji Muhammad, the follower of the king of Najaf (i.e. 'Ali) endowed this. Isma'il (son of Qurban, or Isma'il the victim) is probably the name of a saint or a sufi to whose shrine this axe was endowed. There is an Imamzadeh Isma'il in Isfahan, dedicated to Isma'il ibn Zaid ibn Hasan ibn 'Ali,[46] and an Imamzadeh Sayyid Isma'il in Tehran;[47] there are no doubt other such *imamzadeh*s dedicated to saints by the name of Isma'il elsewhere in Iran. It is possible that the attribution *qurban* relates to the biblical Ishmael who, with his mother, was the victim of the jealousy of Abraham's wife, Sarah. According to local tradition his tomb may be in Iran. Other inscriptions on the axe-head are: *ya 'Ali madad* ('O 'Ali help!'); *ya 'Ali* ('O 'Ali'); ... *shafi* ... ('... the intercessor ...'); ... *[ba]shad bi-la'nat-e*... ('... be cursed...'); ... *Haji [M]uhammad 'Ali ibn 'Ali* ('... Haji Muhammad 'Ali ibn 'Ali'). The axe is too heavy to be used comfortably on horseback. It must have been made for a religious purpose by Shah Najaf, and purchased for donation to a shrine by Haji Muhammad. Its very worn and damaged hammer head, however, leaves little doubt that it was put to practical use in the institution concerned, or in some later context.

An axe with a head of the same shape is in a Danish private collection.[48] It was made by Muhammad Taqi for Khudayar Khan Abbasi in the early 18th century but, judging by the lavishness of its decoration, was evidently a ceremonial object designed to glorify its owner. Thus the same form of object may have been used to fulfil very different functions.

Although a wide range of axes are known from collections and the sale rooms, pictures showing dervishes holding axes are rare until the late 19th century. Indeed there seems to be no example prior to 1800. The earliest datable depiction is on a carpet dated AH 1221 (AD 1806), which shows the Ni'matullahi dervish and folk-hero Nur 'Ali Shah (d.1797), and single- and double-headed axes are also found on other

46. Honarfar (1344) pp.521–40.
47. Meshkati (1349) pp.195–96.

48. *Islamiske vāben i dansk privateje* (1982) no.80.

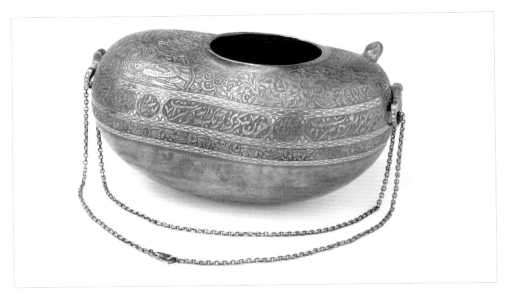

G.13 *Kashkul*; cut, pierced, chased and inlaid with gold; riveted handles; l. 24 cm; w. 14 cm; ht 14 cms; late 19th century; no.529

19th- and early 20th-century carpets.[49] An albumen print probably by Antoine Sevruguin, in the Freer Gallery of Art, shows a young dervish holding an inlaid axe with a single, crescentic blade and a hammer in the shape of a dragon's head,[50] while a young dervish, probably Nur 'Ali Shah again, shown on a painted papier-maché pen-box dated AH 1327 (AD 1909), appears to carry a smaller version of the same axe, though without the dragon's head.[51] Another photograph by Sevruguin shows a dervish seated cross-legged, his crescent-bladed axe across his knees. The top and bottom of the axe handle, and his *kashkul*, are inlaid.[52] A tile mural in the Takyeh Mu'avin al-Mulk in Kirmanshah, dating from 1917–20, shows dervishes and their paraphernalia, including a single-headed axe, while a photograph of *circa* 1920 of a dervish carrying an axe and *kashkul* is published by Tanavoli.[53]

Another religious use of axes – at the rituals associated with the camel sacrifice on 'Id-i Qurban in Isfahan – is perhaps worth mentioning here. Amongst the group of men who accompanied the camel on its tour through the *mahallas* from the first day of Dhu'l-hijja until the eve of the day of sacrifice were two bearers, each with an engraved steel axe. The comments made by Mirza Husain Khan, the author of the *Jughrafiya-yi Isfahan*, about the age and value of the knives held by the knife-bearers

49. Tanavoli (1994) nos 54–57.
50. Stein (1989) fig.18.
51. Falk (1985) no.173.
52. Durand (1902) opp. p.40.
53. Tanavoli (1994) figs 55–56.

in this ritual suggest that the axes, also, may have been old and special. His account also emphasises the religious association of such weapons, in their Isfahan context at least.[54]

A.S. Melikian-Chirvani has written a lengthy article on boat-shaped vessels in Iran, which includes a valuable body of material on *kashkul*s.[55] In the earliest known group of *kashkul*s the rounded, boat-shaped hull rises from a flat base to an inward-sloping shoulder with a wedge-shaped rim. The form is exemplified by a late 15th-century Turkoman piece in the Victoria and Albert Museum. Melikian-Chirvani also illustrates 16th- and 19th-century Iranian examples, and a possible example in a 17th-century miniature showing the continuity of this form into Qajar times. These vessels have no hanging mechanism, and it is suggested that, at least in origin, they may be wine-boats from which dervishes drank.

A second form of *kashkul* is exemplified by a piece in the Khosrovani collection, which has a high 'hull' rising from a narrow foot and a marked plunging curve. The tapering ends have dragon's heads with fitted suspension loops. Study of the inscriptions on a similar *kashkul* in Istanbul allowed the author to establish the mystical overtones of such vessels. 'The brass boat is metaphorically identified with the river- and sea-faring vessel, *safina*, seen by the prophet Musa (Moses) in his journey towards the Confluence of the Two Seas ([sura] XVIII, 60). In Sufi thinking, the Confluence of the two Seas is the receptacle of Being ... The lines ... designate the boat as a vessel holding the metaphorical wine of the access to God's presence.' Iranian verses on this and other *kashkul*s of similar form also point the link between boat and wine, as well as the theme of dervishes travelling the world seeking mystical illumination.

A third form of *kashkul* takes the form of half a coco-de-mer. This is an enormous nut which is traditionally swept across the Indian Ocean from its only known source on one of the Seychelles islands to land on the coasts of Iran and the Indian sub-continent. Half its husk formed an ideal bowl for wandering dervishes, and these were frequently carved with Persian poems which emphasise their function as drinking-vessels. The earliest example recorded by Melikian-Chirvani was carved in AH 1165 (AD 1752); it is also decorated with designs of mystical significance. It is this form which is followed by surviving steel *kashkul*s.

A number of steel examples are known. The two finest are in the Nuhad Es-Said collection and the Victoria and Albert Museum. In addition to a Persian mystical poem, the Nuhad Es-Said piece bears a written Hijri date equivalent to AH 1015 (AD 1606–7), and the claim that the maker was Haji 'Abbas, son of the late Aqa Rahim, the armourer. In fact it is a piece of 19th-century work convincingly designed to sug-

54. Floor (1971) pp.137–38. 55. Melikian-Chirvani (1991) especially pp.28–41.

gest a 17th-century origin.⁵⁶ The Victoria and Albert example bears the same poem, and is also signed by Haji 'Abbas.⁵⁷ There is also a group of stouter, less elegant steel *kashkul*s, similar to the piece in the Tanavoli collection (G.13), many of which also bear Haji 'Abbas's name. They include a piece in the Hermitage, St Petersburg, dated AH 1207 (AD 1792–93);⁵⁸ a piece in the Museum of Oriental Art, Moscow, dated AH 1296 (AD 1879);⁵⁹ a piece in the Gulistan Palace, Tehran;⁶⁰ a *kashkul* in the Nahman collection;⁶¹ and one on loan to the Ashmolean Museum.⁶² The Hermitage and Ashmolean pieces have the same inscription as the Tanavoli *kashkul*. It reads:

> '[This] rare *kashkul*, which is full of gold and watering
> As you observe, is like a precious stone
> Whoever drank a mouthful from it, said:
> It is a thousand times better than that of *tasnim* [a fountain in Paradise] and
> *kawthar* [a river in Paradise]
> It was completed by the efforts of the learned master
> 'Abbas, who is celebrated in every city and country.'

This inscription is written in the same style of rather coarse *nasta'liq*, and the decoration is so similar that, despite the date written on the Hermitage example, all must be of the same, late 19th-century origin. The Nuhad Es-Said, Victoria and Albert Museum and Gulistan Palace *kashkul*s share the use of a different poem,⁶³ and yet another is found on the *kashkul*s in the Museum of Oriental Art, Moscow, and the Nahman collection.⁶⁴ All three relate to the mystical nature of the dervish's search. Melikian-Chirvani suggested a dating for the Victoria and Albert Museum piece in the period of Fath 'Ali Shah. However, in 1885 Murdoch Smith was of the opinion that the piece, which was registered in the museum in 1876, was 'not more than ten or twelve years old', in other words, that it was new when bought.⁶⁵

56. It was first published by S.C. Welch (1972) vol.3, Appendix and A. Welch (1973) no.41, then by Allan (1982) no.26. The redating of the piece was acknowledged by the author in Allan (1994) p.146–47. See also Melikian-Chirvani (1991) pp.41–42; this volume was not actually published until 1993, and when it came to my notice it was too late for me to comment on it in my own article. Ivanov had also independently come to the same conclusion; see Loukonine and Ivanov (1996) no.253.
57. Victoria and Albert Museum, London, acc. no. 405-'76; Pope (1938–39) pl.1393C; Melikian-Chirvani (1991) p.41 and figs 85–86.
58. *Masterpieces of Islamic Art in the Hermitage Museum* (1990) no.118, where the date is on one occasion given as AH 1307; Loukonine and Ivanov (1996) no.253.
59. Maslenitsyna (1975) pl.70.
60. Pope (1938–39) pl.1394D.
61. Wiet (1935) p.18 no.37 pl.X.
62. Allan (1994a) p.11.
63. Allan (1982) p.114; Melikian-Chirvani (1991) p.41.
64. Melikian-Chirvani (1991) p.42.
65. Murdoch Smith (1885) p.59.

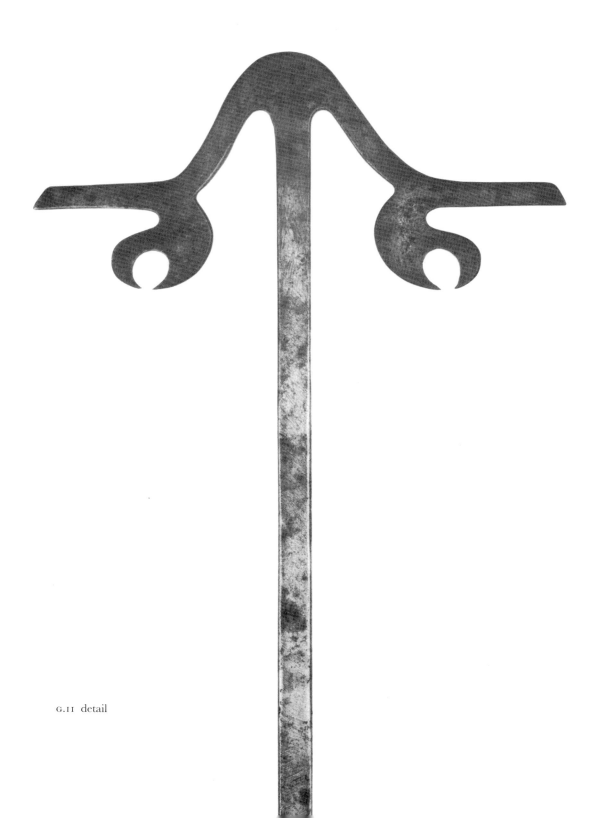

G.11 detail

Bells

It would be impossible to enumerate every possible use of bells in later Islamic Iran. At certain periods they may have been used as musical instruments,[1] but their prime function was as adornments for animals. Thus, in the 15th century, Barbaro described among the royal troops camels covered with bells, dingles and beadstones,[2] while in the great illustrated *Shah-nameh* of Shah Tahmasp we find bells attached to mules, war horses, camels and elephants, in the latter case in an unexpected variety of places – small bells on their legs, tusks, and by their ears, and large bells hanging from their necks.[3] At the turn of the 20th century, Landor described the shops in the Isfahan bazaar which sold bells for horses, mules and camels: 'Long tassels, either red or black, in silk or dyed horse-hair, silk or leather bands with innumerable small conical shrill bells, and sets of larger bells in successive gradations of sizes, one hanging inside the other, are found here. Then there are some huge cylindrical bells standing about two and a half feet high, with scrolls or geometrical designs on their sides. These are for camels and are not intended to hang from the neck. They are slung on one side under the lighter of the two loads of the pack.'[4] A few years earlier Lady Sykes had sympathised with the mules she encountered: 'Some of the mules carried enormous bells, one on each side, which emitted full, deep tones, and must have been most uncomfortable, as, besides being very heavy, they knocked against their ribs at each step.'[5] Horses were often covered with bells, too.[6]

In Safavid times bells were also worn by human beings. Describing the royal court, Chardin wrote, 'The king walks alone, surrounded by eight or ten very active footmen with plumes or aigrettes on the front of their head, and with grelots on their belts about the size of tennis balls … These grelots serve to keep the footmen always

1. For example, in the 15th century: see Ipsiroglu (1976) pl.62.
2. Thomas and Roy (1873) p.67.
3. Dickson and Welch (1981) nos 49 (mule), 41 (horse), 43 (camel), 38, 46, 51, 70, 108, 138, 147, 243 (elephants). For a Timurid depiction of a camel bell, see Ādahl (1981) fol.149r.
4. Landor (1902) vol.1 p.303.
5. Sykes (1898) p.33. Ferrier (1857) p.48 and Arnold (1877) vol.1 pp.157, 174 and 182 also mention mule bells, the latter almost obsessively.
6. Arnold (1877) vol.1 p.174.

well awake: the body of the grelot is cut like the teeth of a comb, thereby emitting a harsh sound.'⁷ This use of bells had already been noted, well over a century before, by Membré, in his account of his embassy to Shah Tahmasp.⁸ He did not, however, suggest that the bell was to keep the footman awake. 'When a Sultan rides to court,' he explained, 'there goes before him on foot a servant whom they call shatir … he has a little bell on the front of his belt.' The implied purpose of the bell was surely to warn commoners of the imminent arrival of the ruler. By Chardin's day the *shatir*'s activities had broadened, and he had become the Iranian postman. Quoting Chardin again:

> 'When those Expresses who are the Meanest and Wretchedest of Men, are hired to go a Journey; they run presently from Place to Place, and give Notice of their intended Journey, in order to get some Letters to carry, which they carry for as little as you please; they bow four times to the Ground to thank you for fifteen Pence, for carrying a Packet of Letters of three Ounce weight; they call those Expresses *Chatir*, which is the Name of Running Footmen, and of all those who can run well, and walk roundly; they are known in the Road by a Bottle of Water, and a Satchel they have at their Back, instead of a Knapsack, to carry Provision for thirty or forty Hours time, and to make the more Speed, they leave the High-Road, and cross the Country: They are known also by their Shoes and some Bells, like our Waggon Horses *Bells*, which stick to their Girdle to keep them Awake. They are bred up to that Business, and it goes on from Father to Son; they are taught to walk at a good round Rate with the same Breath at eight Year old.'⁹

In addition, bells were worn by dervishes. A single-page miniature signed by Muhammadi, dating from *circa* 1575, in the India Office Library, shows an elegant young dervish, Qur'an in one hand and spear in the other. From the left-hand side of his belt hang a variety of items, including dagger and begging-bowl. To the right, on a long chain, hangs a spherical cage bell.¹⁰ A similar figure, again with a cage bell on a long chain, is to be found in another late 16th-century miniature in the same collection.¹¹ Much later, in the early 20th century, we find such bells appearing as hanging ornaments in a tile mural depiction of dervishes in the Takyeh Mu'avin al-Mulk in Kirmanshah (1917–20). Below them hang other, open-mouth bells, small and large.¹²

7. Quoted by Murdoch Smith (1885) p.73.
8. Membré (1993) p.34.
9. Chardin (1988) p.283.
10. Robinson (1976) pl.V no.152.
11. Robinson (1976) p.68 no.208.
12. Tanavoli (1994) fig.56.

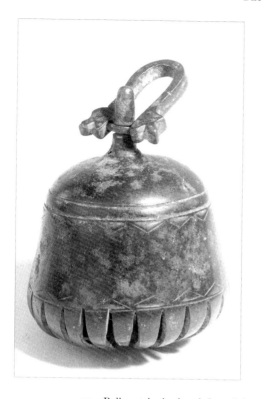 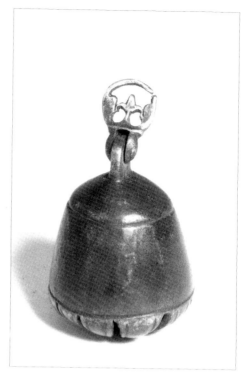

H.1 Bell; cut, incised and riveted; ht 11.2 cm; w. 7 cm; 17th century; no.44
H.2 Bell; ht 4.8 cm; w. 2.8 cm; 18th–19th century; no.344

Bells also had, and still have, a role in *zurkhaneh*s, traditional Iranian-style gymnasiums. A highly qualified wrestler (*pahlavan*) is given the title 'owner of the bell' (*sahib-e zang*), because the director (*murshid*) rings the bell when he enters the gymnasium.

Cage bells, or crotals, have a hollow spherical body completely closed except for one or more slits or perforations, and usually hold a pellet inside, rather than a clapper. Bronze examples are known from at least the 10th century BC in Iran, and a pomegranate-shaped crotal and a fig-shaped example from north-western Iran are in the Royal Ontario Museum, Toronto.[13] Very small examples of this type of bell are known from early Islamic Iran, appearing in the excavations at Rayy, Nishapur and Siraf,[14] almost all with a single slit in the base. However, an example made of copper alloy from Rayy,[15] and an iron example from Siraf,[16] are distinguished by their lower bodies, which have triangular pieces of metal bent inwards: a simpler

13. P. Price (1983) pp.57 and 59.
14. Allan (1982) pp.27–28, 60–61, nos 2–5.
15. Philadelphia, University Museum, acc. no.RH 6020.
16. No.S.68/9, 4558.

style of the piece in the Tanavoli collection. Two steel crotals from Safavid Iran have been published, one purchased by Friedrich Sarre in Tehran in 1899, now in the Museum für Islamische Kunst, Berlin,[17] the other, of no known provenance, in Kuwait.[18] The former has tapering, panelled sides, and is decorated extensively in gold overlay. It bears a verse from Sa'di:

'Emptiness is a picture that outlives us,
'For we do not see existence as permanent.
'Perhaps a warm-hearted man will one day [say a prayer] with compassion.'

The verse echoes the emptiness or hollowness of the bell and its sound.

Although both the Berlin and Kuwait bells have a similar mechanism for their handles, they look very different, and probably come from different manufactories. The Kuwait bell is almost perfectly spherical, and depends for its effect on the contrast between its diagonally fluted shoulder and the vertical lines of the prongs, though it does also have some gold decoration.

Another example of the tapering form, with panelling and gold inlay, is in the Khalili Collection.[19] Two much cruder examples are in the Victoria and Albert Museum.[20] The Tanavoli bells, like the latter, are both simplified versions of the Berlin example, H.1 being particularly close. It is of the same shape, its slightly faceted form picking up the articulated panelling of the Berlin piece, and its handle is constructed and attached in exactly the same way. Moreover, its dragon's-head terminals are simplified versions of the more naturalistic Berlin terminals. H.2 keeps the same form of body, but its hanging mechanism is altogether simpler, even though the pierced arabesque in the handle is carefully worked. It is interesting to see that its pellet has a hook attached and was therefore designed to be hung inside a bell. In this case no ring was available, so it was simply placed inside and the prongs were then bent over to close it in.

The crotal was not the only style of Iranian bell. Open-mouth or cup-shaped bells are found as early as crotals in Iran, and notable examples are depicted on the reliefs at Persepolis, where they adorn horses and camels. The Victoria and Albert Museum has a fine example of a later Iranian, steel open-mouth bell. Probably of 18th-century date, it is of ogival form and is decorated with four oval cartouches of

17. Sarre (1906) Abb.33 no.79, where it is catalogued as bronze; *Islamische Kunst. Verborgene Schätze* (1986) no.293, where it is catalogued, presumably correctly, as iron.
18. Qaddumi (1987) p.150; Atıl (1990) no.93.
19. Acc. no.MTW519.

20. London, Victoria and Albert Museum, acc. nos 410-'76 and 411-'76; Murdoch Smith (1885) p.89. Examination of these two bells suggests that the latter, which is decorated with three oval cartouches each containing a three-bloomed flower against a hatched ground, may well be Turkish.

openwork.[21] Also in the Victoria and Albert Museum is a fine open-mouth bell of a more domical style. It is also of steel and is inlaid with brass, and is described on its label as a camel bell.[22] However, bells of this size and shape also appear in the Kirmanshah mural of 1917–20 mentioned above, and it could therefore come from a *takiyah* rather than a camel.

21. London, Victoria and Albert Museum, acc. no.785-1889, ht 6.5 cm without the handle, diam. 7.7 cm.

22. London, Victoria and Albert Museum, acc. no.M.124-1916, diam. 17.5 cm. The various attachments are not original.

Butcher's implements

One of the meat cleavers in the Tanavoli collection (1.1) bears an inscription which reads 'From the eye-brow of the cruel [flows] the blood of the bier / From the dissection of the meat [comes] a tingling sigh'. (The 'cruel' must refer to the cleaver, the 'eye-brow' to its curve, and the 'bier' to the surface on which the meat is placed.) It is decorated on one side with a picture of a butcher's shop, in the lower part of which a butcher is using a cleaver to chop some meat. The reverse is decorated with a scene from the *zurkhaneh* (literally, 'house of strength'), the traditional Iranian equivalent to a gymnasium, in which two men are exercising with wooden club-weights. A second cleaver in the collection (1.2) is decorated on one side with scenes of the chase and on the other with two men wrestling.[1] Another example in Tehran, which is also decorated with scenes of the chase and gymnastics, is said to have come from Kirman.[2] Undoubtedly such objects were produced in many centres, but there is textual evidence only for Isfahan. In the late 19th century, Mirza Husain Khan noted that few of the knife-makers' guild were left, and went on: 'The greater part of their work consists of the fabrication of ordinary knives (*kard*) and large chopping knives (*satur*) for butchers and cooks.'[3] All the published cleavers are probably early 20th century, from a period when etching became more widely used as a cheap alternative to the much more laborious chiselling traditionally used to produce such pictures.

The butcher's sharpening steel (1.3) is of great elegance, and a fine example of the potential beauty of objects of practical use in the hands of an Iranian craftsman. Another such steel, signed by Khura, is in the Benaki Museum, Athens,[4] and another, signed by Rafi' al-Din Muhammad, is in the Harari collection.[5] The form of dragon's heads on the Tanavoli example, and the comparative confusion of the pierced design of its handle, suggest a 19th-century date.

1. Both cleavers are illustrated in Gluck (1977) pp.150–51.
2. *Iran: hommes du vent, gens de terre* (1971) fig.31. It is presumably in the Iran Bastan Museum (its acc. no.is given as 3130) though this is not stated.
3. Floor (1971) p.104.
4. Mayer (1959) p.54 and pl.VIII.
5. Pope (1938–39) p.2529; Mayer (1959) p.64.

BUTCHER'S IMPLEMENTS

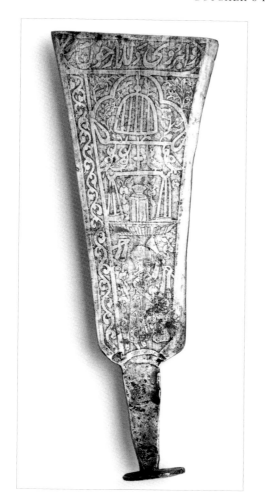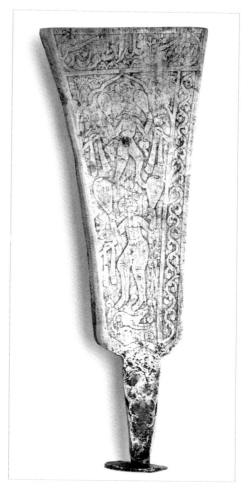

1.1 Meat cleaver; cut and etched; l. 40 cm; w. 14.5 cm; early 20th century; no.303

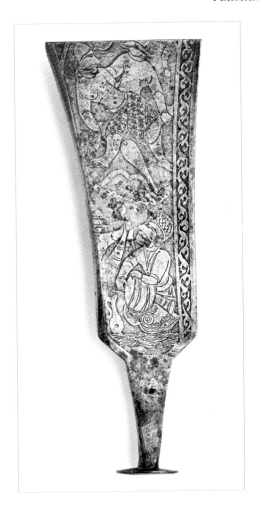
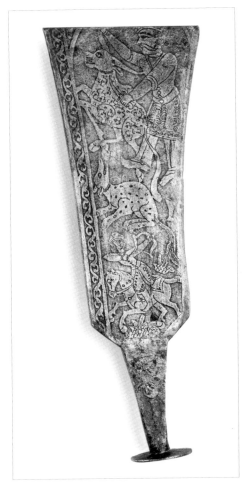

1.2 Meat cleaver; cut and etched; l. 39 cm; w. 13.6 cm; early 20th century; no.302

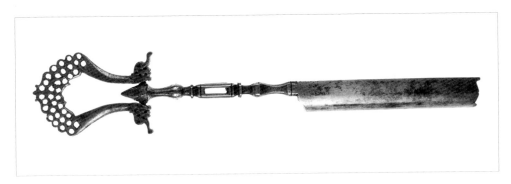

1.3 Sharpening steel; cut and pierced; riveted handle; l. 35 cm; 19th century; no.225

Balances, weights and related equipment

BALANCES, STEELYARDS AND BISMARS

Wulff describes two main types of balance in use in Iran in the first half of the 20th century: balances and scales with two equal arms and a central pivot, and balances with an unequal lever and moving weight (steelyard).[1] The first group he subdivides into those suspended from a fixed point (*mizan*), and those held by the hand when in use (*tarazu*). This subdivision reflects the size as well as the usage of the balances. The larger *mizan* is suspended from a rafter in the ceiling of a shop in a bazaar and will weigh up to about 300 pounds. The *tarazu* is the type of balance used by goldsmiths or silversmiths, small enough to be kept in a wooden box. A number of painted and lacquered papier-mâché boxes containing a *tarazu* and a set of weights are known, and will be mentioned in more detail below. The Tanavoli collection has one example of each sort of balance, J.1, a *mizan*, and J.2, a *tarazu*.

The *mizan* in the collection is not very large, but is certainly too long to fit into a goldsmith's box. It is decorated all over with inscriptions, one of which indicates the occupation of the person for whom it was destined: 'These scales are in the hands of the butcher, and I, astonished at his face. Come, O purchaser! Look at the Moon in the house of balance.' (For the other inscriptions, see Appendix Three.) The style of inscription may be compared to those on 17th-century Isfahan shrine locks (see p.410) and together with other features of the form and decoration points to a similar date and provenance. The *tarazu*, on the other hand, is of 19th-century date. One similar to it, but smaller, is in the Dar al-Athar al-Islamiyya in Kuwait.[2]

Quite different are the principles behind the steelyard (*qappan*) and a type of balance not mentioned by Wulff, the *bismar*. The steelyard is used throughout Iran for weighing very heavy weights.[3] Steelyards are levers with an immovable axis (fulcrum) which have a pan or hook, or both, attached to the shorter arm for holding

1. Wulff (1966) p.62. For the history of balances and their forms, see Kisch (1965) pp.27–56. Wulff's nomenclature for the different parts of balances differs from that of Kisch: in this catalogue Wulff's have been used.
2. Qaddumi (1989) p.32 no.17.
3. Wills (1883) p.221; Wulff (1966) pp.64–65, figs 93–94.

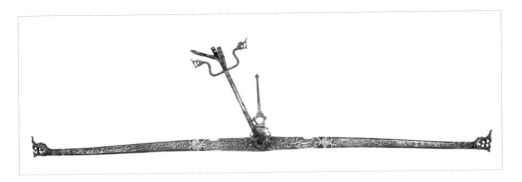

J.1 Balance; pierced, incised and riveted; l. 66.7 cm (beam); ht 21 cm; 17th century; no.40

the load and, suspended from the longer arm, a movable counterpoise. At the place where the counterpoise keeps the beam exactly horizontal, the weight of the object is indicated on an engraved or inlaid scale. The *bismar*, of which J.3 is an example, works slightly differently. The counterpoise is fixed to one end of the beam and the axis of the beam is then shifted, for example, by moving along the beam the loose loop of cord that supports it, thus changing the ratio of the lengths of the two arms of the beam. As soon as the beam is horizontal, indicating that equilibrum has been reached, the correct weight can be read on the beam from the position of the loop of cord. In other words, the steelyard works on the principle of immovable fulcrum and movable counterpoise, while the *bismar* works on the principle of immovable counterpoise and movable fulcrum.[4]

The *bismar* in the Tanavoli collection is relatively crude, but its swivelling suspension-ring recalls pierced steel hooks and rings. Hence, although it may be of quite recent date, it points to an earlier tradition of steel *bismars* of which no other example seems to survive. As with so many steel objects, their predecessors of the earlier Islamic period may well have been of bronze. An Umayyad bronze steelyard was recently on the art market,[5] and a medieval Islamic bronze steelyard is in the Dar al-Athar al-Islamiyya in Kuwait.[6]

BALANCE WEIGHTS AND TWEEZERS

The weights in the Tanavoli collection fall into six groups. Those in the first group (a) are characterised by their relatively tall, octagonal form and by their nipple-like finials (J.4–7). Those in the second (b) are also eight-sided but have four wide and

4. Kisch (1965) pp.56, 58–59.
5. Christie's, 26–28 April 1994, lot 304.
6. Qaddumi (1989) p.32 no.16.

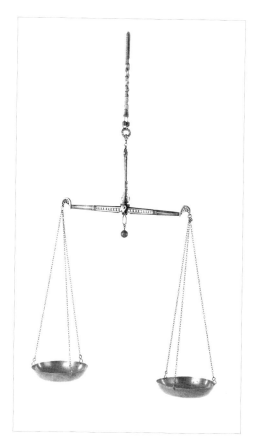 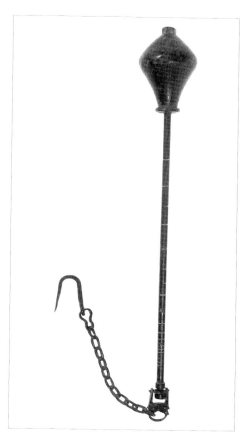

J.2 Balance; cut, pierced and incised; l. 25.9 cm (beam); diam. of pan. 11.6 cm; first half of the 19th century; no.270

J.3 Balance (*bismar*); l. 38.5 cm; 19th century; no.43

four narrow sides (J. 8–12). Only one has a nipple-like finial (J.8). The third type (c), of which there is only one example, is polyhedral, with eight flattened sides and a flat top and base (J. 13). The fourth group (d) consists of flat, octagonal weights (J.14–16). One of these weights also has an elaborate top which was originally brazed on and has a hole for a small finial. Another such top, with finial intact, but without the attached weight, is also in the collection (J.17). A fifth group (e) is represented by J.18, which is flat and has ten slightly concave sides. The sixth group (f) is represented by the sphero-conical weight J.19. This is decorated with palmettes.

There is no published study of Safavid and Qajar metal weights,[7] and the study of

7. *Cf.* Kürkman (1991) for the study of Ottoman weights and measures.

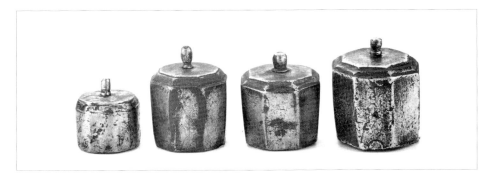

Group (a)
J.4 Octagonal weight with finial; ht 2.4 cm; w. 2 cm; wt 45.17 g; no.273
J.5 Octagonal weight with finial; ht 3.3 cm; w. 2.2 cm; wt 91.36 g; no.278
J.6 Octagonal weight with finial; ht 3.1 cm; w. 2.5 cm; wt 91.76 g; no.275
J.7 Octagonal weight with finial; ht 3.5 cm; w. 2.6 cm; wt 137.71 g; no.71

weights in general is complicated by the fact that different Iranian towns had different standards, and that the standards themselves varied over time.[8] The only fixed point was the weight of the gold *dinar*, or *mithqal*, which was established by the Umayyad caliph 'Abd al-Malik, and was the equivalent of 4.25 grams. In theory the silver *dirham* weighed seven-tenths of a *dinar*, or 2.97 grams, but in practice its weight varied. According to the figures given by Tavernier and Chardin, the *dirham* in Iran in the 17th century, at least in the cities of central Iran, was equivalent to approximately 3.2 grams.

The most important unit of weight in trade in Iran was the *mann*, but this varied greatly in its size. In the 10th century, according to the geographers, the *mann* ranged from 266 to 1040 *dirham*s, or from 833 grams to 3.33 kilograms. Under the Safavids the so-called *mann-i tabriz* ranged from approximately 2.7 kilograms to over 3 kilograms, while the *mann-i shah* ranged from 5.7 kilograms to 6.1 kilograms. In addition, at this and later periods, local towns and even local villages had their own *mann*. Discrepancies of weights and measures in different provinces and for different categories of goods endured throughout the Qajar period, until the introduction of the metric system by the 5th Parliament in 1925.[9]

That said, however, there does seem to have been some standardisation of weight from the 16th century onwards. Wills, for example, notes the Tabriz *mann* as 'the one standard weight of Persia, the other being the mithqal or sixth part of an ounce'.[10] On the basis of the available figures, Hinz computed the standard *mithqal*

8. Lambton (1953) pp.405–409; Hinz (1955) pp.1–2, 5–7, 17–21; Miles (1965).
9. Keyvani (1982) p.131.
10. Wills (1883) pp.220–21.

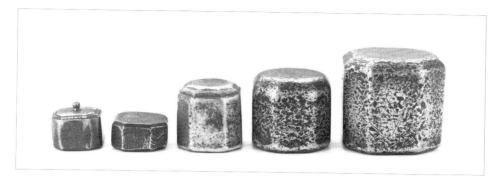

Group (b)
J.8 Octagonal weight with finial; ht 1.9 cm; w. 2.1 cm; wt 45.56 g; no.276
J.9 Eight-sided weight; ht 0.8 cm; w. 2.3 cm; wt 46.67 g; no.70
J.10 Eight-sided weight; ht 2.7 cm; w. 2.7 cm; wt 135.57 g; no.68
J.11 Eight-sided weight; ht 3.1 cm; w. 3.2 cm; wt 222.76 g; no.67
J.12 Eight-sided weight; ht 3.9 cm; w. 4 cm; wt 456.27 g; no.66

as 4.6 grams, and the *dirham* as 3.2 grams.[11] In his analysis of the weights in the Khalili collection, Stanley used the *shar'i mithqal* of 4.46 grams.[12] A figure of 4.6 grams is slightly too high for most of the weights in the Tanavoli collection, while a figure of 4.46 grams is slightly too low. The one exception is the sphero-conical weight J.19, which weighs exactly four times the *shar'i mithqal* of 4.46 grams. For the rest, it would seem that the octagonal weights with finials in the Tanavoli collection are approximately weights of 10 (J.4), 20 (J.5 and J.6) and 30 (J.7) units, and that the eight-sided weights in group (b) are weights of 10 (J.8 and J.9), 30 (J.10), 50 (J.11) and 100 (J.12) units. The flat octagonal weights are more problematic, since one of them (J.16) has a rosette which should be attached to it, suggesting that the others may have had such ornamental tops as well. However, with its rosette, this weight does not seem to relate to a *mithqal* of either 4.46 or 4.6 grams. Nor do the polyhedral weight (J.13) or the decagonal weight (J.18).

It is appropriate here to mention published or known sets of balances and weights in slightly more detail, since they were evidently part of the equipment of certain groups of traders in Iranian bazaars. The earliest set known was excavated at Takht-i Sulaiman in 1976, and must date from the Ilkhanid period. Although few details have been published, it appears to have contained weights and a balance and scale pans, and Huff suggests that it once belonged to a goldsmith or silversmith.[13] All the other surviving sets are much later. The most splendid of them is in the British Museum,[14] and, in addition to a set of 13 weights, it contains a balance and

11. Hinz (1955) pp.6–7.
12. Stanley (1997) p.124, using Hinz (1955) p.5.
13. Huff (1977) Taf.30.1.
14. London, British Museum, acc.no.1927.5-25.1.

scale pans, tweezers, a compass, pen, pair of scissors, penbox, and various containers. There is no indication of the name or trade of its owner, but its lock has a bell attached, so that anyone opening it would be heard, and the inside of the box also includes a secret compartment, suggesting that its owner kept money, valuable objects or valuable materials inside and was fearful of thieves. The mirror also acts as extra security for the items visible when the box is open. It seems reasonably likely, therefore, that it belonged to a trader or craftsman in precious stones or metals, most likely a goldsmith. Among other painted designs on its interior is a portrait of Nasir al-Din Shah, indicating that it was made at the end of the 19th century. This is important, for the decoration on the various steel implements is etched, a technique not found on earlier work for overall designs.

An earlier variety of the same type of box is in the Khalili collection.[15] This too must have belonged to a goldsmith or jeweller, for it has a number of security devices. Alongside a measure, four pairs of tweezers and three sets of weights, it contains three sets of scales which are stamped with the seal of the maker, Nasir, and the date AH 1235 (AD 1819–20). His seal is also stamped on two of the compartment lids.

A further set of weights and other implements is in the Science Museum, London.[16] It is labelled in the museum gallery as an Iranian accountant's official scales and weights for gold and silver, and contains a balance and scale pans, weights, a file, a straight edge, a pen and a compass. An unpublished set in the Musée du Louvre contains a balance, scale pans, weights, tongs and a textile measure. Another such set recently on the art market contains a straight edge, a bone spatula (perhaps a nibbing-block, see pp.356–37), a compass, a knife, twelve weights and two each of tweezers, files and brass and steel scales.[17] Yet another contains three sets of scales, ten weights, a pair of steel tweezers and other, unspecified items.[18] Wulff illustrates a set with two sets of scales and ten weights.[19] Finally, another set in the Khalili collection has two sets of scales and nine weights. Here the scale pans are stamped with the seal of the maker Mirza Baba, and a date read as AH 1265 (AD 1848–49).[20] There were evidently various different sets available, and one may surmise that each was designed for the specific requirements of the individual trader concerned.

The Science Museum set mentioned above includes a pair of tweezers similar to J.20 and J.21.[21] Tweezers and weights are also found together in the British Museum set, the Khalili set of AH 1235 (AD 1819–20), the Louvre set, and in the sets recently on the art market (all mentioned above). From this it is clear that such tweezers were

15. Stanley (1997) pp.124–25.
16. On loan from the Victoria and Albert Museum, acc. no.1936.348.
17. Sotheby's, 29–30 April 1992, lot 142.
18. Sotheby's, 29–30 April 1992, lot 143.
19. Wulff (1966) p.63 figs 90–91.
20. Stanley (1997) p.126.
21. London, Science Museum, acc. no.1940-61.

WEIGHING EQUIPMENT

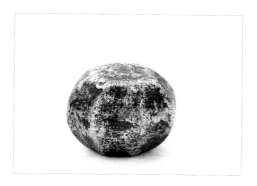

Group (c)
J.13 Polyhedral weight; ht 1.8 cm; w. 2.3 cm; wt 58.95 g; no.274

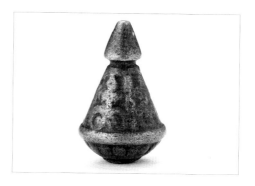

Group (f)
J.19 Sphero-conical weight; cut; ht 2.9 cm; wt 17.84 g; 18th–19th century; no.296

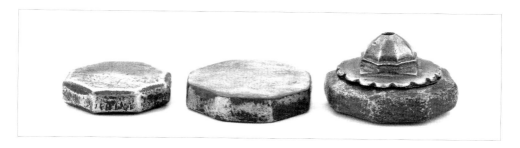

Group (d)
J.14 Flat eight-sided weight; ht 0.8 cm; w. 3.2 cm; wt 51.33 g; no.69
J.15 Flat eight-sided weight; ht 0.8 cm; w. 3.6 cm; wt 72.45 g; no.277
J.16 Flat eight-sided weight with applied rosette; ht 2.2 cm; w. 3.7 cm; wt 88.72 g (plus rosette wt 12.17 g); no.271

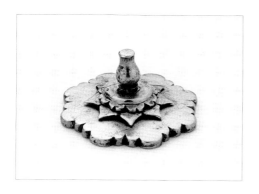

J.17 Top of a weight; cut and brazed; ht 1.8 cm; w. 2.2 cm; no.506

Group (e)
J.18 Flat decagonal weight; ht 0.7 cm; w. 2.5 cm; wt 27.86 g; no.272

used for lifting weights on and off balance pans. In practice, the opening distance of their arms limits their use. J.21 opens 1.5 centimetres, J.20 only 0.5 centimetres, and as a result they can only be used to pick up weights of a lesser diameter or thickness, or weights with a finial of much smaller size. Among the weights catalogued here, the only ones which can be lifted conveniently with the tweezers are those in group (a), all of which have small finials, and J.8 in group (b). However, the weights in the flat, octagonal group (d), may normally also have had finials. Certainly J.16 did, and J.17 is the top of another such weight. In all the sets of balances and weights containing tweezers mentioned above, the weights have finials too, emphasising the role of the finials in allowing the weights to be lifted easily with the tweezers. Whether the other weights in the collection originally also had finials is impossible to say. Four pairs of tweezers in the Khalili collection have also been published.[22]

The dating of the weights is for the most part uncertain: shape is perhaps the only guide. The group of weights in the late 19th-century set in the British Museum are cylindrical; so too those in the 19th-century set previously on the art market. Those in the Khalili sets, however, are eight-sided. One is tempted to suggest that the flat weights with ornate tops are earlier than the plainer forms. However, without accurately datable groups of weights of known provenance which can be used for comparison, it is very difficult to suggest a convincing dating for any of the weights in groups (a), (b), (d) and (e) narrower than the 16th to the 19th centuries. This of course raises the question of when forceps or tweezers began to be used to lift the weights. In the west their widespread use was the result of the need for exact measurement in laboratory conditions. Tweezers could therefore have reached Iran as a result of the import of sets of weights which had been manufactured in Europe for specific laboratory purposes. On the other hand, weighing precious items in small quantities – gold, gold dust, jewels – may well have brought about the use of tweezers long before.

The weight in group (c) is exceptional in its form and can be paralleled in brass or bronze weights of much earlier centuries. For example, five such weights, with 14, 26 or 34 sides, were found in the excavations at Nishapur.[23] One of these weighs 14.12 grams, the other two 28.85 and 28.87 grams respectively. The Tanavoli steel weight is thus just over twice as heavy as the larger Nishapur examples, and could well follow in the same tradition. A Mamluk bronze weight of this form, which weighs 58.36 grams, is in the Ashmolean Museum.[24] Two iron or steel polyhedral weights, for 50 *dirham*s and 20 *dirham*s respectively, are in the American Numismatic Society.[25]

22. Stanley (1997) pp.120–21, T27–30.
23. Allan (1982) nos 124–28.
24. Oxford, Ashmolean Museum, acc. no.EAX3243. For another of this type see Kisch (1965) fig.52, and for their influence on the Vikings fig.54.
25. Bates (1984) p.20 and fig.23.

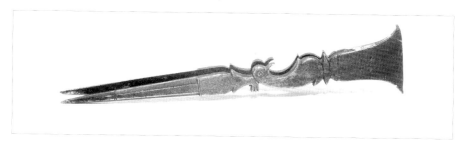

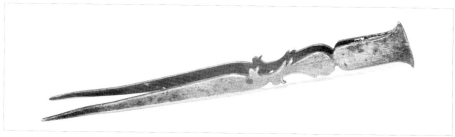

J.20 Tweezers; cut; l. 12.1 cm; 19th century; no.257
J.21 Tweezers; cut; l. 16.6 cm; 19th century; no.255

TEXTILE MEASURES

Chardin described the measures used in Iran as follows: 'There are two sorts of *Ells*, the *Royal Ell*, which is three Foot long, wanting an Inch, and the *Short Ell*, or *Gueze-moukesser*, as they call it, which is but as long as two thirds of the other ... The Carpets that are sold by the *Ell* are measur'd also by the *Square Ells*, Multiplying the Length by the Breadth, which the *Persians* call *Ell* by *Ell*: For Instance, if a Floor Carpet is twelve *Ells* long, and three broad, they say, three times twelve is six and thirty.'[26] On the basis of the measurements given by Chardin and Fryer, Hinz computed the royal ell or *gaz-i shahi* as approximately 95 centimetres, and the short ell or *gaz-i mukassar* as approximately 68 centimetres.[27] An alternative unit of measurement was the *zar'-shar'i* which was 49.88 centimetres, and the *zar'-i Isfahan* which was 79.8 centimetres.[28] The lengths of the textile measures in the Tanavoli collection (J.22 and J.23), 40.7 and 52.9 centimetres respectively, do not correspond to these, unless J.22 is perhaps half a *zar'-i Isfahan*. Rather, they raise the question as to whether cloth merchants in the bazaars used a local standard or their own personal one. A number of other textile measures are known: for example, there are three unpublished examples in the Khalili collection, measuring 52, 55 and 58.9 centime-

26. Chardin (1988) p.285.
27. Hinz (1955) p.62.

28. Hinz (1955) p.64.

J.22 Textile measure; cut and incised; l. 40.7 cm; 19th century; no.142
J.23 Textile measure; cut and incised; l. 52.9 cm; 19th century; no.143

tres respectively, and there is another in the Musée des Arts et Métiers in Paris, also unpublished, which measures 64.9 centimetres. Perhaps in due course enough examples will be known to establish the different standards in use.

Drawing equipment

PEN-BOXES

The earliest surviving metal pen-case from Islamic Iran appears to be a rectangular example, of copper alloy inlaid with silver, dated AH 542 (AD 1148), now in the Hermitage Museum, St Petersburg.[1] Pen-boxes from the end of the 12th and early 13th century are more numerous: these are of two specific shapes, a flat, pointed type, and a rectangular form with rounded ends. The fact that a craftsman called Shadhi signed examples of each form shows that the difference in shape was not a regional one, whatever else its significance may have been.[2] The latter style continued to be popular in copper alloys in the 14th and 15th centuries. A different form, consisting of a relatively tall, narrow, rectangular case for the pens and with an inkwell soldered to the outside near one end, appears in the early Safavid period. The one complete published example suggests that the pieces illustrated in miniature paintings may well have been of inlaid brass, though precious metal is also possible.[3] One particular illustration of such a pen-box, in a manuscript of the *Majalis al-'Ushshaq* of AH 959 (AD 1552), now in the Bodleian Library, shows the object with ornate legs at the inkwell end.[4] Such pen-cases were probably the origin of the beautiful Ottoman pen-case of later times, of which numerous examples in silver survive.[5]

Whether steel pen-cases were made in Iran earlier than the Safavid period is uncertain but likely, for the comments of the Mamluk historian al-Qalqashandi, who lived AH 756–821 (AD 1355–1418), about the pen-boxes used by Mamluk chancellery and treasury scribes shows that they had certainly been manufactured in Egypt and/or Syria in the 14th century, although they were evidently very expensive. He writes: 'Brass is the most used, steel less so on account of its rarity and costliness. It is the prerogative of the highest ranks of leadership, like the vizirate and

1. Gyuzal'yan (1968).
2. For the pointed type, see Falk (1985) no.265; for the rectangular form with rounded ends, see Herzfeld (1936).
3. Pope (1938–39) pl.1387A; Melikian-Chirvani (1982) nos 118–20. The boxes are shown in miniature paintings such as those in the *Khamseh* of Amir Khusrau, dated AH 963–64 (AD 1556–57) in the Chester Beatty Library; see Arberry *et al.* (1959–62) vol.3 pl.8 no.226.
4. Oxford, Bodleian Library, MS.Ouseley Add.24, dated AH 959 (AD 1552), fol.105a.
5. Hoare (1987) p.12.

similar ranks.'⁶ Certainly steel pen-cases were used in the later Safavid period, for du Mans records *davatkar* (pen-box makers) as workers in white iron (*fer blanc*).⁷

The pen-case shape with a sliding tray, represented in this collection by K.1 and K.2, is first recorded in the Safavid period. A 16th-century example is to be seen in a miniature of the Bodleian *Majalis al-'Ushshaq* mentioned above;⁸ a later Safavid example appears in a mid 17th-century drawing in the Riza-i Abbasi Album in the Freer Gallery of Art;⁹ and there are three 17th-century examples in the Khalili collection.¹⁰ It became extremely popular in the Qajar period, and was usually made in papier mâché decorated with elaborate painted decoration under a lacquer coating. The importance of such objects to the scribes who used them is emphasised by d'Allemagne: 'All clerks and members of the nobility … have at their service a *mirzar*, or masters of the pen. They each possess a pen-box which is an object of great luxury. Only the meanest object is not decorated with great care.'¹¹

Steel examples are much less common than papier mâché, though it is worth noting the existence of one in the Harari collection dated AH 1210 (AD 1795–96).¹² Its top is decorated with an unread Persian inscription in a long oval cartouche, and two smaller cartouches of flowers. K.1, with its undecorated polylobed medallions on the top and sides, is evidently an unfinished object: the criss-cross roughening of the surfaces of the medallions and the corners of the *qalamdan* indicates that these areas were designed to receive goldwork. K.2, on the other hand, is complete, with all its goldwork intact, even on the base. However, the designs of the gold ornaments used could suggest an Indian, rather than an Iranian, origin.

The illustration of this form of *qalamdan* in the mid-16th century manuscript of the *Majalis al-'Ushshaq* is of particular significance, for it is the only object shown in that particular miniature which is painted not in gold but in light and dark blue. This suggests that in early Safavid times, as in later Iran, such *qalamdan*s were made of papier mâché. The widespread use of papier mâché as opposed to metal for their manufacture, over a period of four hundred years, also suggests that the form is likely to have derived from a wooden rather than metal prototype. Wooden pen-cases were widely used in early Islamic times. Again, al-Qalqashandi gives us some

6. Qalqashandi vol.2 pp.431–32. The importance of pen-cases in medieval Iranian government circles is dealt with by Melikian-Chirvani (1986), but there is no comparable source about their materials and forms.
7. du Mans (1890) p.202.
8. Bodleian MS.Ouseley Add.24 fol.152b; Robinson (1957) p.101 no.813.
9. Atıl (1978) no.52.
10. Khalili et al. (1996) Part 1 pp.50–51 nos 21–23,

though these could be Indian.
11. D'Allemagne (1911) vol.1 p.81.
12. Wiet (1935) p.19 no.41 and pl.IX. Steel *qalamdan*s occasionally appear on the London art market: see Sotheby's, 2 May 1977, lot 251; Christie's, 19 October 1993, lot 160. Another, unpublished, example is in the British Museum, acc. no. 1957 2-27 1: it has a pair of scissors and a measuring-spoon inside.

DRAWING EQUIPMENT

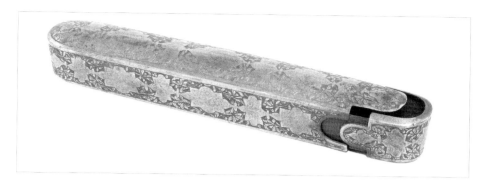

K.1 Pen-box; brazed, riveted, chiselled and chased; l. 20.7 cm; 19th century; no.239

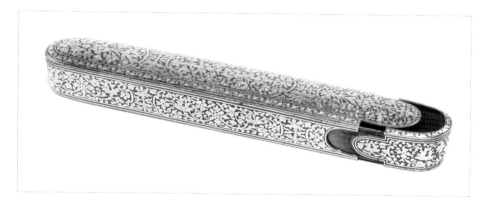

K.2 Pen-box; brazed and riveted; chased gold overlay all over the outside; l. 21.7 cm; Iranian or Indian, 19th century; no.429

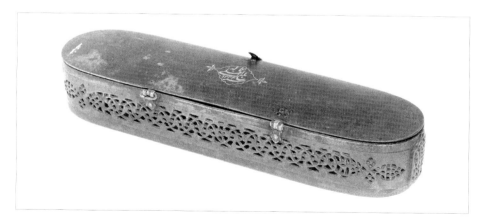

K.3 Paint-box; brazed, riveted and pierced; brass fitting inside; inscription in gold overlay; l. 20 cm; w. 5.1 cm; ht 3.6 cm; dated AH 1244 (AD 1826–29); no.238

343

important information. First he quotes an earlier authority, Abu'l-Qasim ibn 'Abd al-'Aziz: 'As for what is used [for making pen-cases] it is necessary to use the best wood and the most valuable, like ebony or sandalwood.' Then he comments: 'As for pen-cases of wood, they have been discarded [in favour of metal ones] except for ebony and red sandalwood. In our times they are used by judges and their clerks and by some government notaries.' Moreover, there is a very particular link between papier-mâché pen-cases and wood-working, for the pen-case maker traditionally uses wooden moulds for his products, one for the pen container and one for the cover, on which he builds his papier mâché.[13]

The earliest surviving Iranian wooden pen-case appears to be the piece in the Khalili collection signed by Mu'in Musavvir,[14] which dates from *circa* 1660. This is of boxwood, and has rounded ends but a lift-off rather than hinged lid. Given their small size and relative fragility, the lack of earlier surviving wooden examples may perhaps be no surprise, and they evidently gave way to papier mâché once the latter came into vogue. The close relationship between the Iranian papier-mâché *qalamdan* and the earlier rectangular form of pen-case with rounded ends in other media is evidenced by the late 16th- and early 17th-century papier-mâché examples of the latter form in the Khalili collection.[15] The idea of a sliding tray must have been introduced by the time of Mu'in Musavvir, but how much earlier there is no way of telling.

It is important, however, to see that the sliding tray never completely supplanted the hinged lid. This was not only true in lacquer,[16] but also in steel, for K. 3, which is dated AH 1244 (AD 1828–29), is of the latter shape. It is catalogued as a paint box, for its interior is divided into 15 separate compartments, which would most likely have been used for paints. However, the brass interior is so obviously different from the steel exterior that it must be a later insert, and originally the box was almost certainly a pen-case of traditional, hinged-lid, form. The inscription on the lid is obscure but the best interpretation of it, which reads *bikamalihi ballagha al-'ali sanat 1244* ('God communicates through its [the pen's] perfection. The year 1244'), supports that identification.[17] One assumes that the box is of the date inscribed on the lid, but the pierced arabesque work around the sides could well be late 18th century. Certainly the pierced steel patch at one end, which is inscribed *ya kafi al-muhimmat*

13. Wulff (1966) pp.238–39, though it should be noted that Binning (1857) vol.1 p.290 says that papier-mâché *qalamdan*s were moulded upon an iron mandril.
14. Khalili *et al.* (1996) Part 1 no.17 pp.42–43.
15. Khalili *et al.* (1996) Part 1 nos 15–16 pp.36–37.
16. For example, Khalili *et al.* (1996) Part 1 no.174 pp.220–21, dated AH 1225 (AD 1810–11) or AH 1252 (AD 1836–37).
17. I am grateful to my colleagues in the Oriental Faculty who on my behalf spent a coffee-break trying to decide on the most likely interpretation of this inscription.

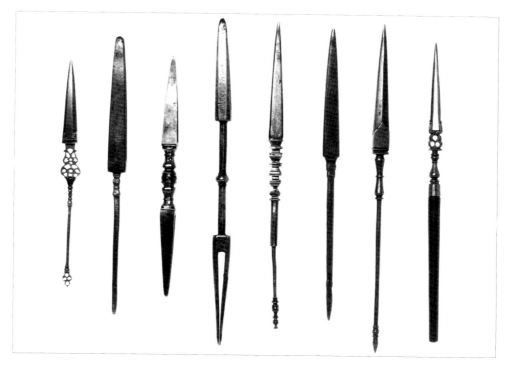

K.4 Ruling pen; watered; cut and pierced; riveted blades; l. 12.1 cm; 19th century; no.378
K.5 Ruling pen; cut and riveted; l. 14.7 cm; late 18th–early 19th century; no.249
K.6 Double-ended ruling pen; cut and chased; l. 12.7 cm; 18th–19th century; no.376
K.7 Double-ended pen; cut; l. 17.3 cm; 18th–19th century; no.251
K.8 Ruling pen; cut; l. 16.3 cm; late 18th–early 19th century; no.377
K.9 Pen; cut; l. 15.5 cm; late 18th–early 19th century; no.389
K.10 Ruling pen; cut; l. 17.5 cm; 18th–19th century; no.375
K.11 Ruling pen; cut, pierced and chased; wooden handle with brass band; l. 16 cm; 18th–19th century; no.390

('Oh thou who art sufficient for (our) needs') in *nasta'liq*, is likely to be scrap from an earlier object. A similar patch seems once to have adorned the other end.

PENS AND STYLI

In the medieval West the standard pen for writing or calligraphy was a quill; in the Islamic world it was a reed. From the quill developed the split nib of European 20th-century dip pens and fountain pens; the reed, on the other hand, has continued to be the calligrapher's pen in the Islamic Near and Middle East up to the present day. The appearance of European-style steel ruling pens in later Islamic Iran is therefore something of a surprise. Reed pens had presumably been used by early Islamic illu-

minators for ruling out and decorating the pages on which the calligraphy or occasional paintings appeared. When and why illuminators changed to steel ruling pens is not entirely clear. It was most probably due to the impact of European culture on Iran through the Dutch and British East India Companies in the 17th century, and the subsequent growth of the British Empire in the Indian sub-continent. That being so, it is unlikely that steel ruling pens were introduced before 1600. On the other hand, since there is one in the Moser collection set of instruments, they were certainly known and used by the end of the 18th century (see p.387).

Metal ruling pens go back to antiquity: the simplest were made of lead bent over, more elaborate examples were of bronze with twin blades and a movable ring to adjust the thickness of the lines drawn. Medieval Europe knew of steel pens, but it was in the Renaissance that the potential advantages of the Roman legacy were most fully appreciated. Pens with a pair of blades in the shape of a leaf or spade were used, relying on the inflexibility of the steel to keep the opening, and hence the thickness of the lines, constant. From *circa* 1700 pens were made with twin blades which could be adjusted to give the desired line thickness by the use of a wing or butterfly screw, and a hinged blade to allow the inside of the pen to be cleaned was common. Other variations developed – prickers were sometimes incorporated in the handle, some pens might have crayon-holders at the other end, and double-ended pens were also used. A major improvement came about *circa* 1800 with the introduction of fine milled thumb-screws in place of the wing-screws. Then, from *circa* 1840 onwards, further major improvements evolved based on the needs of cartography, the railways, and other forms of mechanical engineering: twin-line rail or road pens for drawing parallel lines, curved-blade pens for drawing against railway and other drawing curves, thick and thin line or double thick line pens for drawing borders on formal drawings, and so on.[18]

Structurally, the Iranian pens are very straightforward, with no mechanical elaborations. Whether they were used only for ruling is unclear: it is perfectly possible to write with them, and in the hands of a skilled practitioner high quality calligraphy could well have been possible. The finest were evidently designed for use in manuscripts (K.4 and K.11), whereas K.7 with its thick, rather round-ended nib could also have been used in some other craft industry. (The other end of K.7, incidentally, betrays the angle at which its owner liked to use it.) All of the pens bar two have nibs which are virtually closed at the point. The two exceptions (K.5 and K.9) have open nibs with parallel sides. These would have been used by the draughtsman holding

18. For the early history of pens in the West, from which these details are taken, see M. Hambly (1988) pp.57–73.

the sides of the nib and pressing them together to the required distance as he drew. K.8 shows signs of such use. In either case, the ink would have been put into the nib with a brush and would have been held there by capillary action.

Accurate dating of these pens is not possible at present. Pens of any sort are rarely shown in manuscript illustrations: the two reed pens shown in a mid 17th-century drawing in the Riza-i Abbasi Album in the Freer Gallery of Art are exceptional.[19] As the pointed steel blade does not seem to have become general in Europe until the 18th century it is unlikely that any of these pens date back to Safavid times, and much more likely that they are late 18th- or 19th-century. Certainly K.5, 8 and 9 are likely to be late 18th- or early 19th-century, for they closely resemble the pens in the Moser and Ashmolean sets of instruments. Given the latter examples, Wilson's comment in the 1890s that 'the steel pen is being introduced' is certainly incorrect.[20] The quality of the piercing on K.4 suggests that it is somewhat later than the others.

Technically, the pens are made in two different ways. Most (K.6–11) have nibs made of a single piece of steel, but some (K.4 and K.5) have the two points of the nib riveted to the central block. An example in the Ashmolean set of instruments, which has an open nib with parallel sides, has an inner nib made of a single piece of steel with another piece of steel soldered onto the outside of each blade.[21] The long handles are designed to balance the weight of the nib; some (for example, K.10) might have had a wooden or ivory handle around the cylindrical stick.

There is no example of a steel stylus in this collection, but they are known. One is in the Ashmolean set of instruments,[22] another in the Moser collection set. In form they are copies of simple reed pens, made of a hollow cylinder of steel.

RULERS

Iranian rulers or straight edges seem to have been made in various lengths. The longest example, which measures 43.4 centimetres, is in the Harari collection, now in the Islamic Museum in Cairo.[23] It bears the name of its owner, Muzaffar al-Murtada ibn Kamal al-Din al-Husaini, and is dated AH 997 (AD 1588–89). A much later example is in the Ashmolean set of instruments, and dates from *circa* 1830. It is 22.7 centimetres long, just over half the length of the Harari example. Another such ruler is to be found in the Moser tool set, dating from AH 1211 (AD 1796),[24] and another was

19. Atıl (1978) no.52.
20. Wilson (1896) p.284.
21. Oxford, Ashmolean Museum, acc. no.EA 1955.1M, length 17 cm. The Moser collection instrument set also contains a steel ruling pen.
22. Oxford, Ashmolean Museum, acc. no.EA 1955.1C, length 12.1 cm.
23. Cairo, Museum of Islamic Art, acc. no.15409: see Wiet (1935) p.16 no.33 and pl.IX; Pope (1938–39) pl.1390E; Atıl, Chase and Jett (1985) fig.67.
24. Balsiger and Klāy (1992) p.144.

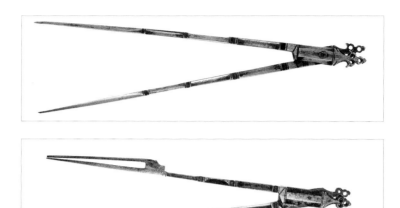

K.12 Dividers; cut, pierced and riveted; remains of brass solder around rivet;
l. 17.8 cm; 17th–18th century; no.193
K.13 Compass; cut and riveted; blade brazed; l. 16.3 cm; 17th–18th century; no.250

in the d'Allemagne collection.[25] The Ashmolean set also contains a shorter ruler, which is made of two parts designed to open out to produce a right angle. Its length of 10.3 centimetres is approximately half that of the longer ruler in the set. Another short ruler is to be found in the Wallace collection set.

From the surviving rulers it would appear that there were at least three different lengths made, and that these were approximately one unit, half a unit and a quarter of a unit in length. What that unit was is not so clear. The Iranian *gaz* in the Middle Ages was either the 'legal' cubit of 49.8 centimetres or the 'Isfahan' cubit of 79.8 centimetres. In the 17th century there was a 'royal' cubit of approximately 95 centimetres.[26]. The extant rulers fit none of these measurements closely, though failing anything else they might be considered approximately as a single, a half, and a quarter 'Isfahan' cubit. More likely, the actual lengths were not important since the function of these rulers was to provide a straight edge rather than a measuring tool.

COMPASSES AND DIVIDERS

Like ruling pens, compasses (for delineating circles) and dividers (for taking and transferring measurements) have been in use since antiquity: three sets of compasses formed part of a set of Roman instruments found in Pompei. Compasses remained

25. d'Allemagne (1911) vol.2 opp. p.68.
26. Hinz (1965); E. Bosworth (1993).

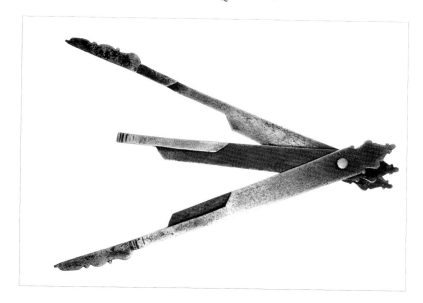

K.14 Dividers with three arms; cut, brazed and riveted; l. 21.6 cm; 19th century; no.242

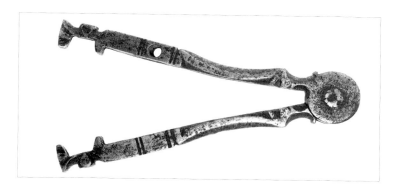

K.15 Wing-compass with sector head joint; cut, pierced and riveted; l. 11.2 cm; 19th century; no.244

essential tools for craftsmen in medieval Europe, especially masons and carpenters, but began to develop in quality and design from the 16th century, especially in Germany, where by 1600 compass-smiths were producing 'hand-compasses, hair-compasses, beam-compasses and bar-compasses'.[27] The 16th century was particularly important in seeing the introduction of crayon-holder or ink-point compasses, and hence the development of compasses as we know them today. The 18th century saw

27. For the history of compasses and dividers see M. Hambly (1988) pp.69–86, from which these details are taken.

the introduction of different forms of legs for compasses, and of the smaller 'bow-compasses', while the early 19th century brought tubular turnabout compasses and folding pillar compasses. Stanley's treatise of 1866, with its details of double-joint and turn-down joint compasses, of needle and spring points, of tubular compasses, single-joint and double-joint bows, spring bow points and parallel bows, and of Napier and pillar compasses, shows the rich variety of instruments available by the middle of the century.[28]

Of the instruments in the Tanavoli collection, the pair of compasses (K.13) and the pair of dividers (K.12) have so many features in common that they must certainly come from the same workshop. The artisan's use of bevelled edges for the design of the arms, and even more his use of concave surfaces on the arms of the compass, allows sensitive adjustment of the opening distance: it is thus practical as well as aesthetic in intent. Structurally, they are identical, and the compass may be viewed as a pair of dividers with the soldered addition (using brass solder) of the outer part of the pen nib.

There are a pair of compasses and a pair of dividers of very similar form in the Science Museum.[29] Another simple but elegant compass was in the d'Allemagne collection,[30] while a slightly more elaborate example, inlaid in gold and signed by a craftsman called Mahmud, is in the Harari collection in the Islamic Museum, Cairo.[31] The Ashmolean set of instruments also contains a pair of compasses,[32] as does the Moser collection set. The Tanavoli pair (K.13) is distinguished from the Ashmolean and Moser examples by a number of features. In the first place it is much longer – 16.3 centimetres as opposed to 13.8 centimetres for the Ashmolean instrument. This may be compared to the Harari pair of compasses, which is the longest at 18.5 centimetres. Secondly, its proportions are quite different. The overlapping part of the arms at the top, which forms its handle, is very short compared to the length of the arms themselves; on the Ashmolean and Moser examples the handle takes up over half the length of the arms. The proportions of the Harari pair are somewhere between the two, as are those of the d'Allemagne collection piece. The extraordinary quality and beauty of the faceting on the Tanavoli compasses and dividers do not appear on any of the objects in the late 18th- and 19th-century sets of instruments which survive, but are found on an unusual pair of scissors (K.23, see below) which are almost certainly Safavid. One is therefore tempted to conclude

28. W.F. Stanley (1866).
29. London, Science Museum, acc. no.V&A 1936-348.
30. d'Allemagne (1911) vol.2 opp. p.68.
31. Pope (1938–39) pl.1390D; Nasr (1976) fig.24. According to Pope's caption it bears the inscription 'the work of Mahmud, the slave of Shah 'Abbas', but the latter part is not apparent from the illustrations. For a discussion of the significance of attributions to the period of Shah 'Abbas see pp.107–109 in the present catalogue.
32. Oxford, Ashmolean Museum, acc. no.1955.1Q, length 13.8 cm. For all these groups of instruments see pp.383–87.

that these too are Safavid.

K.14 is much larger than the others, and its size and the width of its points suggests a use in a craft industry. The purpose of its third leg is unclear. Two pairs of dividers of similar form and size are to be seen on the workbench of a contemporary Isfahan astrolabe-maker, in a photograph published by Nasr.[33] Very different from all these is K.15. This is the body of a wing-compass which was originally also fitted with separate points. It was thus much more elaborate than the pieces detailed above, and its form and use of a sector head joint shows that it is closely dependent on a European model. Another example of this form of compass is to be seen in one of the trays published by d'Allemagne.[34] We have thus a minimum of five, and possibly six, different styles of Iranian compass surviving.

With the exception of K.15, these compasses, though apparently well-made, are relatively simple by mid to late 19th-century European standards: there are, for example, no knuckle joints, no sector head joints, and no replaceable points. Whether we can therefore assume that they predate the development of more elaborate mathematical instruments in mid 19th-century Europe, as certainly do those in the Moser collection (dated AH 1211/AD 1796) and those in the Ashmolean (*circa* 1830), or whether some may illustrate the continued use of simpler instruments in Iran in the second half of the 19th century is unclear. The use of a long joint rather than a sector joint may perhaps be significant. Long joints were used in 17th-century Europe[35] but largely given up in favour of sector joints in the 18th century. The Iranian instruments too have a long joint, but there is an important difference from the European ones, for the long joint on K.12 and K.13 is riveted not at the top, but halfway up its length. This is evidently a traditional Iranian joint, for it is to be seen in a pair of dividers illustrated in a miniature of Farhad and Shirin dating from AH 897 (AD 1492) in the Chester Beatty Library.[36] It may indeed be a traditional Islamic joint, for it also occurs in later Spanish compasses.[37] Another important characteristic of the joints in the later Iranian steel instruments is that the two arms interlock, the flattened shoulder forming the joint of one arm being set between two sheets which form the joint of the other arm. This too is presumably an earlier Iranian tradition.

PAPER SCISSORS

Various designs of steel scissors (*qaichi*) have survived from later Iran (see also pp.369–71). One style, with interlocking handles, is clearly designed to be narrow

33. Nasr (1976) pl.79.
34. d'Allemagne (1911) vol.3 p.255.
35. Hambly (1988) p.76 figs 59–60.
36. Arberry *et al.* (1959–62) vol.3 pl.14.
37. Sotheby's, Amsterdam, 14 December 1988, lot 137.

enough to fit into the standard form of *qalamdan* (K.16–21). This style is well-known, and there is an example in the Ashmolean set of instruments.[38] A second style (K.22) has distinct bows (finger holes) and shanks and is akin to typical European scissors. Two very similar pairs of scissors are illustrated by Pope,[39] one in the Beghian collection and one in the Harari collection, the latter dated AH 1220 (AD 1805). Another pair is in the Khalili collection.[40] Contemporary Ottoman scissors are somewhat similar, though they are easily distinguished by their narrow, elegant form, and are often characterised by the lack of pierced work on the blades, the use of obviously Ottoman designs in their goldwork, or the use of the words *Ya Fatih* ('O Opener') on their handles.[41] A third style, in which the bows and shanks form two halves of a single, openwork composition, is represented by K.23. No other examples of this style, to my knowledge, have yet been published. Their origin is for the moment unknown but it is interesting to observe that 18th-century Spanish shears have bows and shanks composed in a similar way.[42]

There is no reason to assume that the cutting of paper was restricted to the small *qalamdan* scissors. They were simply those paper-cutting scissors designed to fit into a *qalamdan*. Hence, although their shapes may vary, it is highly likely that the primary function of the other two pairs of scissors in this section was also cutting paper. This K.22, at least, does extremely well.

Paper was kept in a roll, and scissors were needed to cut a sheet off the roll to the required length.[43] However, there were other subtleties in the use of scissors, as du Mans makes clear: 'In their writing, when to be well set out the letters must follow curved lines, they cut the sides [of the paper] very straightforwardly with scissors, then, the paper having been made into a parallelogram, they cut off one of the corners, the lower right-hand corner, to make an irregular trapezium. The reason for this is that the rectangle is a perfect shape, and as perfection is not within our competence, it must not be attempted as if it were.'[44] He goes on to point out why paper was not cut into triangular shapes, since the latter had Christian (Trinitarian) connotations.

K.20 must be early 19th century, for the decoration on its shanks and upper blade is closely related to, though not quite as fine as, that on the scissors of AD 1805 in the

38. Oxford, Ashmolean Museum, acc. no.EA 1955.1J, length 13.8 cm. It should be noted, however, that the pierced designs on these scissors are so crude that they may be later replacements for an original pair which were lost. A pair with very simple pierced work which must date from the middle of the 20th century are illustrated by Wulff (1966) fig.81. See also T. Stanley (1997) pp.116–17 T14 and T16.
39. Pope (1938–39) vol.VI pl.1390A and C.
40. T. Stanley (1997) pp.116–17 T15.
41. For examples, see Pope (1938–39) pl.1390B; Bodur (1987) p.122; Sotheby's, 12 October 1982, lot 224, 11 October 1989, lot 361 and 25 April 1990, lot 144; T. Stanley (1997) pp.114–15.
42. Sotheby's, Amsterdam, 14 December 1988, lots 179–80.
43. Sykes (1898) p.178.
44. du Mans (1890) p.130.

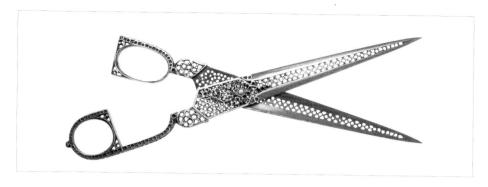

K.16 Pair of *qalamdan* scissors; hollow-ground blades; cut, pierced, brazed and riveted; l. 15.6 cm; second half of the 18th century; no.183

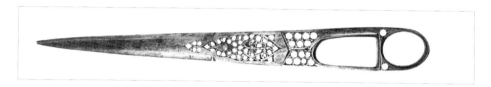

K.17 Pair of *qalamdan* scissors; hollow-ground; cut, pierced and riveted; l. 16.5 cm; 19th century; no.245

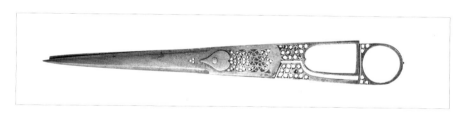

K.18 Pair of *qalamdan* scissors; hollow-ground; watered; cut, pierced and riveted; gold inlay; l. 14.4 cm; 19th century; no.246

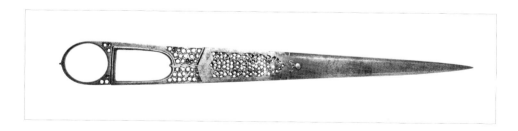

K.19 Pair of *qalamdan* scissors; hollow-ground blades; cut, pierced, brazed and riveted; inscription in gold inlay, *'amal Ibrahim* ('work of Ibrahim'); l. 16.5 cm; *circa* 1810–20; 19th century; no.248

Harari collection. Its inscription reads *ufawwid amri ila 'llah inna allah basir bi'l-'ibad* ('I confide my cause unto God. Lo! God is the Seer of (His) slaves' (sura 40, verse 44). The pierced arabesque on the shanks of K.22 is very close in design to that on the shanks of the 1805 pair, though technically they are very different, for the work on the latter pair is incised not pierced. The much more elaborate and fully detailed upper shanks and bows, however, suggest that K.22 is earlier, probably from the second half of the 18th century. Dates of 1796 for the pair of *qalamdan* scissors in the Moser collection set and of *circa* 1830 for the ordinary pair in the Ashmolean set help us to date the Beghian pair to sometime between the two, *circa* 1810–20. On that basis, K.19 must also be *circa* 1810–20. It bears the word *'amal* on one side, and *Ibrahim* on the other, in gold inlay: Ibrahim must have been an early 19th-century craftsman. The similarity of the pierced designs of K.16 to those of K.22, and the very elaborate nature of the workmanship, suggest that K.16 also dates from the second half of the 18th century. K.23 is exceptional, both because of its design and because of the robustness of its pierced arabesque work. The design of the latter suggests that the scissors are probably Safavid, and date from the 16th to 17th century.

The craft of the scissor-maker (*qaichi-saz*) has always been special. For example, al-Tha'alibi mentions Rayy as a scissor-making centre in the 11th century.[45] Mirza Husain Khan gives a brief commentary on the scissor-makers of Isfahan in the last decade of the 19th century: 'They make scissors for men's and women's tailoring, as well as paper-scissors of iron or steel. Formerly these had a special shape; the point was sharp and the hollow-ground blade was pierced out. They were priced from 2 qrans up to 2 tomans. Nowadays they are made quite simply, without any fretwork, and similar to the European shape. [However,] they last longer than the European ones and are sold for 3 to 4 qran each. These products are marketable all over Iran and are in all provinces; however, only few are [still] being made.'[46] Imitation also went the other way, for in the 19th century Sheffield is known to have been producing scissors of Iranian type with interlocking handles for export to Iran.[47]

Wulff's short paragraph on the subject is also worth repeating, as it emphasises once more the specialised nature of the craft: 'In many places in Persia some cutlers are fully ooccupied with the manufacture of a variety of scissors and are then referred to as scissor makers. Like the cutler, the [scissor maker] uses imported steel from car scraps for the forging of the scissor blades. The blades are carefully filed into shape, having a sharp cutting edge and nicely rounded backs. Most scissors have hollow ground blades. The finger holes are forged out and smoothed by filing.

45. al-Tha'alibi (1867) p.111. In his translation on p.129, Bosworth renders the word *maqarid* as 'shears', but 'scissors' seems more likely.

46. Floor (1971) p.110.

47. Himsworth (1953) fig.56 bottom left but one.

DRAWING EQUIPMENT

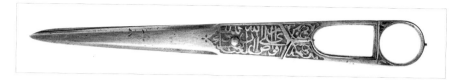

K.20 Pair of *qalamdan* scissors; hollow-ground blades; cut, chiselled and riveted; l. 15.3 cm; early 19th century; no.317

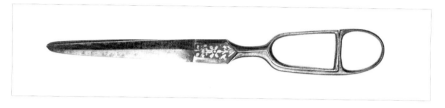

K.21 Pair of *qalamdan* scissors; gold overlay; riveted; l. 13 cm; 19th century; no.247

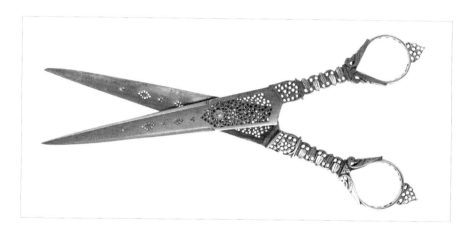

K.22 Pair of scissors; hollow-ground blades; cut, pierced, chased, brazed and riveted; l. 17.6 cm; late 18th century; no.182

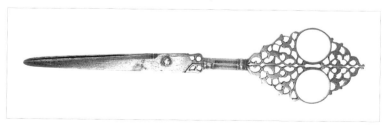

K.23 Pair of scissors; hollow-ground blades; cut, pierced and riveted; l. 18.5 cm; 16th–17th century; no.181

355

In the past a pair of fine paper scissors belonged to every writing set. The decoration of pierced work is drilled in with a fiddle drill and later shaped with a file.'[48]

INK SCOOPS

There are two ink scoops in the collection. They are part of the standard equipment of an Iranian *qalamdan*,[49] and small enough to fit easily into such a writing case. Their use is described by Wills, who says of *qalamdan*s that 'their drawer contains ... a tiny spoon for moistening the ink ... At one extremity is a small box of silver or brass containing a skein of silk, which absorbs a quantity of Chinese ink, and is wetted with the tiny spoon when it dries up.'[50] K.24 has fine pierced arabesque work at its neck; traces of the duck's-head motif, so common in Iranian steelwork, can be seen in the pierced design of K.25.

NIBBING-BLOCKS

The two steel blocks with ornate ends (K.26 and K.27) were probably nibbing-blocks (*qad-zan*), used in cutting the nibs of reed pens. Further west, in the Ottoman empire, such a plaque was called a *maqta'* (Arabic, *miqass*), and was normally made of ivory, walrus tusk, tortoiseshell or mother of pearl.[51] Only one from Iran seems to be recorded, an example in the Harari collection, of ivory with steel ends, the latter bearing the words *bande-ye shah-e vilayat-e sultan Husain 'amal-e Kamal al-Din Mahmud 1108[1696]*.[52] In more recent times Wills records ivory or bone nibbing-blocks in late 19th-century *qalamdan*s.[53] These were hard materials, but not hard enough to damage the steel blade of the nibbing-knife. The steel nibbing-blocks catalogued here would have been less friendly to the blade. K.28 is a handled implement of a rather different shape, but its thick steel body suggests that it could have been a nibbing-block, too. On the other hand, a somewhat similar object from Turkistan is said to be a honing- or sharpening-steel,[54] and this possibility should not be excluded. The worn arabesques at either end suggest a 17th- or 18th-century date. The two larger blocks are undecorated and, since one is of mild steel (see p.516), they are both probably 20th-century in date.

48. Wulff (1966) pp.56–57. The Persian technical terms have been omitted for brevity's sake.
49. See for example a 19th-century Kashmiri lacquer *qalamdan*, with its complete equipment inside, in the Ashmolean Museum, acc. no.1966.59; Robinson (1995) no.8.
50. Wills (1883) pp.288–89.
51. Hoare (1987) p.8; Pope (1938–39) pl.1390F. Grohmann (1967) vol.1 Taf.21, 1.a illustrates how they were used.
52. Wiet (1935) p.18 no.39 and pl.IX.
53. Wills (1883) p.288.
54. Kalter (1984) ill.65.

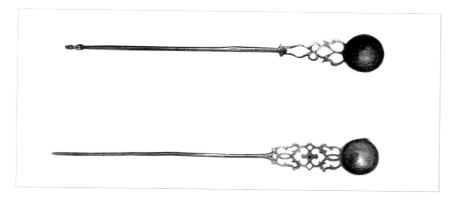

K.24 Ink scoop; cut and pierced; l. 12.2 cm; 18th–19th century; no.364
K.25 Ink scoop; cut and pierced; l. 11.9 cm; 18th–19th century; no.365

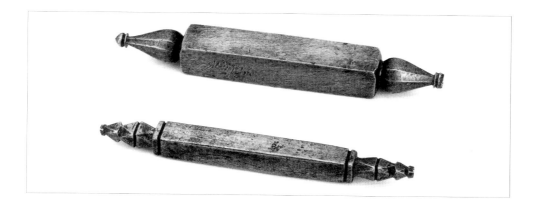

K.26 Nibbing-block; cut; l. 13.2 cm; w. 1.6 cm; 20th century; no.236
K.27 Nibbing-block; cut; l. 11.8 cm; w. 1 cm; 20th century; no.237

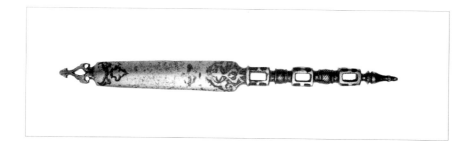

K.28 Nibbing-block; cut, pierced, chiselled and chased; l. 12 cm; 17th–18th century; no.340

Tools and implements

Many tool craftsmen specialised in making particular tools. Thus, in the Isfahan bazaar, Tavernier noted file-cutters and makers of saw blades.[1] Outside the porticoes by the side of the Lutfullah mosque he came across forgers of scythes, hammers, pincers, nails and other similar items, with some cutlers.[2] On the other hand, it seems likely that many other types of small tool, including some of those described in this section, could have been made by a single craftsman.

The tools and implements in the Tanavoli collection have been divided into the following groups: anvils and stakes; clamps; files; cutting implements; leather-working tools; other tools and implements. To these is appended a section which discusses the purpose, origin and dating of the various sets of tools and implements in the Ashmolean Museum (FIGS 55a–c), the Moser collection in the Historical Museum, Berne, the Chester Beatty Library, Dublin, the d'Allemagne collection (two different trays of implements, apparently from different sets), the Khalili collection, and the Wallace collection.

1. ANVILS AND STAKES

Large anvils or stakes were used, and still are used today, by a wide variety of metal-working craftsmen in Iran. For example, Wulff's illustrations of metal-working craftsmen and their tools show plain upright stakes being used by a bronze or iron founder's assistant cutting off risers, by coppersmiths beating and shaping copper vessels and planishing them, and by cutlers;[3] T-shaped stakes being used by a variety of silver smiths;[4] and a right-angled stake by Baluch blacksmiths.[5] Their long, pointed bases are normally set into the ground, or alternatively into wood. The variety of uses for a single type of stake makes it impossible to be sure exactly what the stakes catalogued here were used for. L.1, because of its size, must have been used for

1. Tavernier (1970) p.59.
2. Tavernier (1970) p.63.
3. Wulff (1966) figs 14, 19, 21–22, 27, 79–80.
4. Wulff (1966) figs 30, 36, 39.
5. Wulff (1966) fig.67.

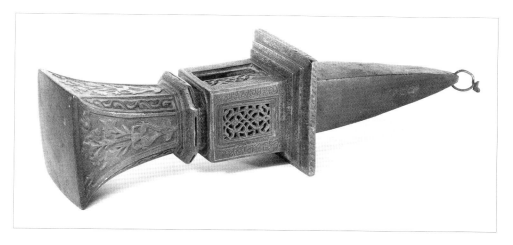

L.1 Large stake; brazed, pierced, chiselled and incised; ht 51 cm; w. 13 cm (top); dated AH 1199 (AD 1784–85); no.24

forming large metal objects, but more than that one cannot say. It is surprisingly ornate, given its size and weight. The faces of the upper part are decorated with vases of flowers, and its bevelled angles with undulating stems. The central part of the body has a square flange surmounted by a square lantern with three openwork windows and one door shutter. On the lower flange, around the windows, and on the upper flange, are incised inscriptions. These include sura 2, verses 255–56 and 61, verse 13, prayers for the Twelve Imams, and the popular prayer to 'Ali, and the date AH 1199 (AD 1784–85). The craftsman has signed the stake but his full name is unfortunately impossible to decipher. Inside is a brass oil container with three wicks. The pyramidal base has a suspension hole at the point, so that the stake could be hung up in the blacksmith's workshop.

The other three stakes (L.2–4) must all have been for small metal objects, and could well have come from jewellers' workshops. There is a beautiful, small T-shaped stake in the Ashmolean set of instruments, and another of similar form in one of the d'Allemagne trays. Like these, L.3 and L.4 are designed to fit into a socket on a bench or wooden table. Perhaps L.2 was held in some sort of vice.

2. CLAMPS (OR CRAMPS)

The three clamps (L.5–7), if compared with modern western clamps, are unusual for two reasons. First the adjustable jaw slides along the bar by means of a separate sliding head, the latter fitted to the end of the screw in such a way that there is play in it. A separate sliding head is found in the much larger joiner's cramp in carpentry, but is not normally found in other wood-working or metal-working clamps.[6] Secondly,

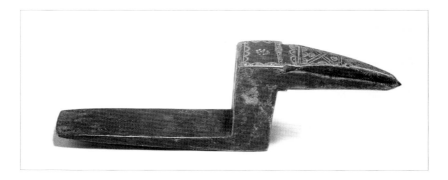

L.2 Stake; cut, incised and punched. l. 15.5 cm; w. 2.4 cm; 17th–19th century; no.26

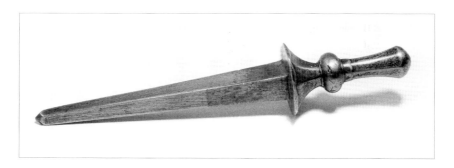

L.3 Stake; cut; l. 16.2 cm; 17th–19th century; no.27

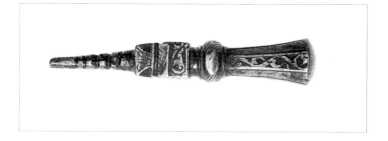

L.4 Stake; cut, chiselled and chased; l. 8.1 cm; 17th-19th century; no.385

the end of the bar curves round well beyond the line of the screw. At first sight this would make the use of the clamp awkward, since the object in the clamp would not be held at two opposite points and would therefore have a tendency to move. Where this design comes from is impossible to say. The precise use of such clamps is also disputed.[7] Clamps are a relatively modern invention in the West: Goodman's information on the history of the carpenter's bench suggests that vices and clamps are unlikely to have been in general use before 1800.[8] However, a clamp similar in form to L.5 and L.6, though missing its sliding head, is to be found in the Moser collection set of implements, dated AH 1211 (AD 1796), indicating that they were used in Iran in the 18th century. Another clamp of this form is to be found in one of the trays of implements in the d'Allemagne collection, and one similar to L.7 is in the Ashmolean Museum set. The decoration of L.5 and L.6 is so similar to that in the d'Allemagne collection that they must be of the same date.

The screws of these clamps are of some interest. L.6 appears to have a cast shank, with a diameter of $3/16$ inch, and a pitch of 25 threads per inch. The shank of L.5, on the other hand, has a diameter of $9/32$ inch, and a pitch of 22 threads per inch, and as the clamps give every appearance of being a pair, may well be a replacement for the original screw. L.7 has a much thicker, $1/4$ inch-diameter shank, and its 19 threads per inch is standard BSP for $1/4$ and $3/8$ inch diameter rod.[9] The screw therefore appears to have been made to the British standard with a chaser and imported $1/4$ inch rod. The manufacture of chasers needs milling equipment; otherwise the chaser would have had to be imported. This suggests a date after the middle of the 19th century. The comparable clamp in the Ashmolean set has an irregular, slightly flattened rod, and the thread has been made with a die. Its diameter is 2.27 inches and it has a pitch of 22 threads per inch.

On all three clamps the sliding loops have screwdriver terminals. These appear to be deliberate, and suggest an appropriate secondary function for the objects. In addition, L.7 has a hammer head for a handle. Given that it is stamped twice in a small oval with the name Hasan, and that such stamping is normally the custom of gunsmiths, it is tempting to see it as an adjunct for a gun, though the purpose of the clamp is then unclear.

The form of the two hand vices (L.8 and L.9) is typical of the small vices used by jewellers worldwide to hold small tools or objects.[10] Their decoration, however, is typical of Iran: their arms terminate in stylised animal's or dragon's heads, the

6. Salaman (1975) pp.165–70; Untracht (1968) p.67.
7. According to some authorities consulted by the author, the pair of clamps (nos 195 and 357) are of a type used for removing the main spring from a gun; one has to compress it to get it out. Others, however, dispute this.
8. Goodman (1964) pp.183–87.
9. For screw threads of the 19th and 20th century see Radco (1986)
10. Untracht (1968) p.439.

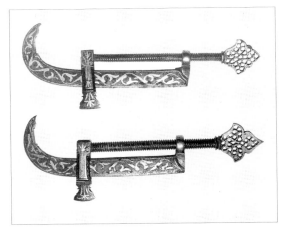
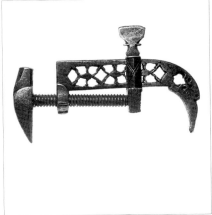

L.5 and L.6 Pair of clamps; cut, pierced and riveted; gold overlay; l. 10.9 cm;
late 18th–19th century; nos 195 and 357

L.7 Clamp; cut, pierced, punched and chased; screwdriver terminal; hammer handle; stamped *Hasan* on both sides of bar head; l. 7.5 cm; 19th century; no.211

upper part of their handles are of baluster form, and the chiselled work gives extra articulation to the arms. Almost identical hand vices are in the trays of implements in the Moser and d'Allemagne collections; an example in the Ashmolean set has an elaborate pierced roundel forming the body of the handle. The hand vices are likely to be late 18th- or 19th-century in date.

L.10, although it looks like a pair of tweezers, may also be a very small hand-vice used by a jeweller to hold tiny parts of the jewellery he was making. However, it could also perhaps be a pair of adjustable prickers used in the margin of a page to set the position of the lines prior to lettering. The same tool is to be found in one of the d'Allemagne trays of tools,[11] and in the Ashmolean and Chester Beatty tool sets, though none of these has a screw adjuster.

3. FILES

A great variety of files must have been used by woodworkers, jewellers and other craftsmen in the course of their work, and Wulff lists nine common forms of cross-section: flat, square, three-square, round, small round, half-round, knife-edged, cant, and tapered flat.[12] The four included here are thus but a sample. The finest is L.11, which is a work of art as well as a practical tool. It appears to be watered, and its pierced half-palmettes suggest a late Safavid date. L.12 is notable for its fine baluster

11. d'Allemagne (1911) vol.2 p.255. 12. Wulff (1966) p.58.

handle, and L.13 for its bird-headed end, while the end of L.12 has been made into a blade, probably at a later date. However, the illustrated files are more interesting for the pattern of lines created by the file-cutter. First the whole blade was cut with diagonal straight lines, then a second cutting was made of the central area of the file blade, at a much steeper diagonal angle. This obliterated or intermixed with the first set of lines and greatly increased the effectiveness of the tool. The same pattern of lines was used for files with half-round (L.14) or round blades (L.15), though here the width of each group of lines was inevitably less. L.11 was originally covered with two sets of straight lines, set at about 50 degrees to one another, though these have almost been worn away through centuries of use. L.13 is of mild steel and is therefore likely to be 20th-century in date (see p.516).

Both the Moser collection and Ashmolean implement sets contain files, four in each case: a small round single-ended file, a round or half-round double-ended file, and two files with wooden or mother-of-pearl handles, one flat and one half-round. One of the d'Allemagne trays also contains four files, a half-round double-ended file, and three files with mother-of-pearl handles, two flat and one half-round, while the Chester Beatty set still retains one double-ended example. Whatever the purpose of these sets of instruments (see below), the importance of files in the craft industries of Qajar Iran is clear.

Wulff describes the production of files in detail. First the blanks had to be forged to the required shapes, then cut by the expert cutter. 'He places the blank on a leaden base, holds it down with his big toe, and by striking a hammer onto a cutting chisel he produces a cut. During this operation his little finger rests on the blank, and with a rocking movement he shifts the chisel into the next position after each stroke. He uses hammers of varying weight for the different cuts. The cuts are surprisingly uniform in depth and evenly spaced.' The file has then to be hardened. Wulff continues: 'For hardening mild steel the ready-cut files are covered with a paste of salt and finely-ground horn meal, brought to bright red heat, sprinkled over again with the salt-horn-meal mixture – a process which is repeated about six times – and in the end quenched, thus obtaining a good surface hardening.'[13] As Wulff notes, this technique for hardening the steel is almost identical to that used by medieval European file-cutters as described by Theophilus.

To my knowledge, files are no longer made by hand in Iran. An aged cutler visited by the author in Zanjan in 1992 showed examples of his workmanship, but said that he had given up making his own files some time ago. He complained of the effects of the American embargo on Iran by pointing out that the Chinese files being imported were not nearly as good as American ones!

13. Wulff (1966) pp.57–59.

PERSIAN STEEL

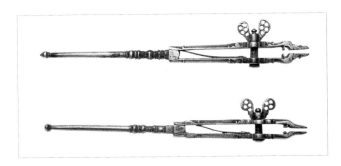

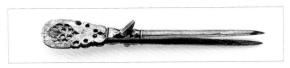

L.8 and L.9 Two hand vices; cut, pierced and brazed; riveted springs and screws;
l. 12.2 cm; late 18th–19th century; nos 194 and 384
L.10 Small hand-vice (?); cut, pierced and brazed; screw adjuster; l. 8.2 cm; 19th century; no.368

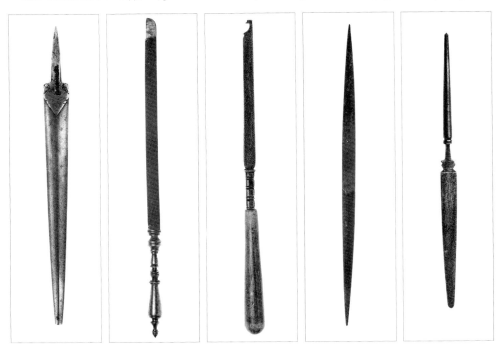

L.11 File; cut and pierced; half-round section, flat tang; l. 18.7 cm; 17th–18th century; no.530
L.12 File; cut; flat section; l. 20.2 cm; 17th–19th century; no.363
L.13 File; cut; flat section; wooden handle; l. 20.1 cm; 20th century; no.360
L.14 Double-ended file; half-round section; l. 16.4 cm; 17th–19th century; no.361
L.15 Double-ended file; cut; one end flat, one end rounded; 14 cm; 17th–19th century; no.362

4. CUTTING IMPLEMENTS

a. Knives

Penknives and knives in general pose a complex problem. In our own society knives can be used for a wide variety of jobs: for example, a sharp steel knife can be used equally easily for carving meat, for whittling a stick and for opening letters. Sometimes size precludes one such activity, but at other times it is quite impossible to be sure whether a particular knife has only one, or a variety of uses. The same is true of knives from the later period in Iran. In English the situation is often confused rather than clarified by the different names used for folding knives. Thus, a pocket-knife is a knife with one or more blades which folds into the handle for carrying in the pocket, a clasp-knife is a large knife the blade of which folds or shuts into the handle, and a penknife is a small knife, usually carried in the pocket, originally used for making and mending quill pens but now made with blades which fit inside the handle when closed. All three thus overlap, and we have here used the term 'folding knife' for all examples.[14]

We have described elsewhere in this catalogue the larger knives whose primary use was probably for hunting (see pp.143–56). Here we shall concentrate on the smaller knives, often folding knives, which amongst their many other possible uses could have been employed in cutting paper and reed pen nibs.

There evidently was a standard form of reed-cutting knife in the Ottoman empire.[15] It had a relatively long handle and short blade. For Iran there is at present no evidence for such a single-purpose instrument, though there is one knife in the collection which attracts that identification (L.16), with its short curved blade, rather longer handle and suspension ring.[16] A somewhat similar knife is in the Moser collection instrument set. Unfortunately, Iranian illustrations of the knives used for cutting reed pens are virtually unknown, and the only related evidence comes from Mughal India, in the Jahangir Album, dating from *circa* 1600–1610. This includes in its illumination a picture of a calligrapher at work at a low table, on which lies a knife.[17] It is smaller than an Iranian hunting knife but of similar proportions, and could indicate that Iranian calligraphers too used such knives. A knife of this form and appropriate size indeed occurs in the Moser collection instrument set, hence it could include two calligraphers' knives. Indeed the Moser collection contains a third, folding knife which could also have been used for cutting pen nibs. One of the

14. For English styles of pen and pocket knives see Himsworth (1953) pp.125–37.
15. Hoare (1987) p.6; Pedersen (1984) fig.27. Pedersen fig.6 shows the same type of knife being used in 19th-century Egypt.

16. Compare a knife shown on a calligrapher's table in a 16th-century Turkish manuscript; Safadi (1978) pl.93.
17. Pedersen (1984) figs 28–29.

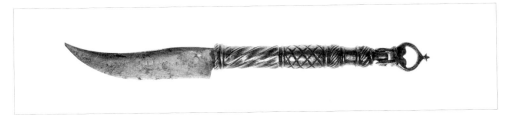

L.16 Pen knife; cut, pierced and chased; inlaid brass dots on blade; l. 12.8 cm; 19th century; no.426

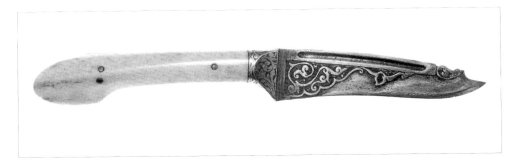

L.17 Knife; cut and chiselled; gold overlay; l. 17.5 cm; c.1800; no.513

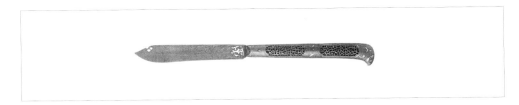

L.18 Folding knife; watered; cut, pierced and brazed; gold overlay; l. 5 cm; early 19th century; no.184

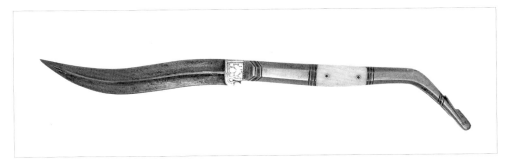

L.19 Folding knife; watered; cut, brazed and riveted; gold overlay; ivory scales; l. 13 cm; second quarter of the 19th century; no.424

d'Allemagne trays of instruments also contains a knife of the Jahangir Album form, but not the other types.[18]

It is also worth noting that a single form of knife could change its function over the years. Thus Mirza Husain Khan writes: 'Cutlers make the same type of pen knives now, but they are not used for sharpening pens, and their steel is not as well hardened as before ... The ones that are made now are women's utensils, who use them to cut the hair of their eyebrows.'[19]

In the Tanavoli collection knife L.17 is probably the remains of a hunting knife, but it has a very worn blade and could easily have been used for cutting nibs. Knife L.18 may also have been a calligrapher's knife, for although of a completely different form, its inscription hints at such an identification: 'And lo! those who disbelieve would fain disconcert thee with their eyes when they hear the Reminder, and they say: Lo! he is indeed mad; When it is naught else than a Reminder to creation.' These are verses 51–52 of sura 68, entitled *al-Qalam* ('The Pen'), and the text is otherwise inexplicable on such an instrument. A similar folding knife in the Ashmolean set has an inscription in Persian which must also relate to writing and show that this knife too was a penknife.

'Alas, there is no one in this world who is compassionate
[It is as if] I reveal my pain [grief] to the wall.
Whomever I reveal [my pains to] in this world
Is a sleeping enemy whom I awake.'

This relates to the Sufi understanding of pain as a purely Sufi experience, and its purpose is to remind the writer to keep that experience to himself, rather than lift his pen to write about it.

The only example with a reasonably clear date is L.18. Comparison of its form and pierced work with the folding knife in the Ashmolean instrument set suggests that they are roughly contemporary, though in view of the superior workmanship of the Tanavoli example it is tempting to put it slightly earlier, in the early 19th century. We have elsewhere dated a pair of scissors (K.20) to the early 19th century by comparison with a dated pair of scissors in the Harari collection (see pp.352–54). Those same scissors can be used to suggest a dating of *circa* 1800 for the very worn knife (L.17) with its bold arabesques punctuated by large dots. The Ashmolean set of instruments also provides a point of reference for dating 1.19, for the tiny bird's head on its shoulder is akin to that on the hooked end of the pair of Ashmolean callipers, and the gold work is of the same somewhat mediocre standard. It may there-

18. d'Allemagne (1911) vol.3 p.255. 19. Floor (1971) p.111.

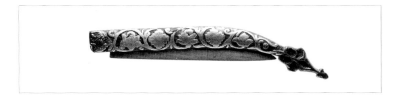

L.20 Folding knife; cut, pierced, brazed and riveted; gold overlay; l. 8.4 cm; 19th century; no.199

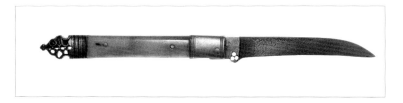

L.21 Folding knife; watered; cut, pierced, brazed and riveted; ivory scales; l. 11.7 cm; 18th–19th century; no.423

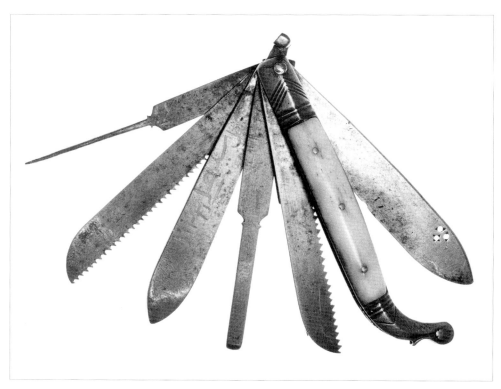

L.22 Folding set of implements; cut, pierced and riveted; gold (?brass) overlay; l. 21.4 cm; signed Shir 'Ali, dated AH 1221 (AD 1806–7); no.347

fore be approximately dated to the second quarter of the 19th century. The large blossoms on L. 20 suggest a 19th-century date, and L. 16 is probably 19th-century too. The shape of blade on L.19 is related to the curved dagger with double-curved blade (*pishqabz*) used in Iran. L. 21 has a fine watered blade, and probably dates from the 18th or 19th century.

It is appropriate at this point to mention a folding knife (L.22) which contains a number of different blades and other instruments. It is signed by the maker, one Shir 'Ali, and dated AH 1221 (AD 1806–7), and has seven implements in all: two blades, two saws, two picks and a screwdriver. Only the main blade, with its thumb-piece, opens on the concave side of the handle; all the rest open on the convex side. The set was presumably owned by a man interested in outdoor pursuits, not least in shooting (see p.184) and collecting firewood. The fact that the main blade has a thumb-piece suggests that it would have been used as a razor (see p.395). The bird's heads, subtly integrated into the curved end of the handle, are notable.

Isfahan produced penknives in the Safavid period, witness the evidence of Mirza Husain Khan: 'Ahmad Isfahani was a famous cutler in Safavid times; his penknives lasted for more than 200 years.'[20] Isfahan remained a manufacturing centre for folding knives in the Qajar period. Mirza Husain Khan continues: 'There was one Mahmud in the beginning of the reign of the late Khaqan. His penknives were twins of the work of Ahmad ... even after being used one or two years they did not become dull.' Polak describes them as follows: 'Cutlery, also copied from European models, is less successful, for example the Isfahan penknives which are put on the market. Persians are very keen on having good penknives; they show their own to Europeans and ask them if they are truly English make. Often when I visited the minister, he would take a penknife out of his shawl purse, to let me instruct him on its quality and value. In the novel *Hajji Baba*, an ambassador, asked by the king to describe the characteristics of the various European nations, says of the English: "That is the nation which makes penknives."'[21]

b. Scissors

A mid 17th-century drawing in the Riza-i Abbasi Album in the Freer Gallery of Art shows a cloth merchant with a large pair of scissors. These have rounded shanks and large bows, and must have been designed for cutting cloth. A crudely drawn pair of scissors of somewhat similar shape are to be seen in a Kashmiri manuscript dating from the mid-19th century, in an illustration of a bookbinder and his bookbinding instruments.[22] A similar pair of scissors was illustrated by d'Allemagne with the

20. Floor (1971) p.111.
21. Trans. by Issawi (1971) p.271. Other stories illustrate the same point: Wagner (1856) vol.3 p.32; de Windt (1891) p.71.

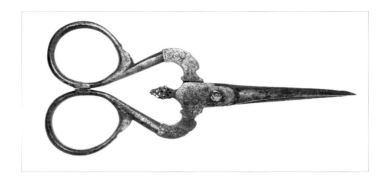

L.23 Large scissors; hollow-ground blades; cut, pierced, riveted and chased; l. 24.4 cm; 19th century; no.231

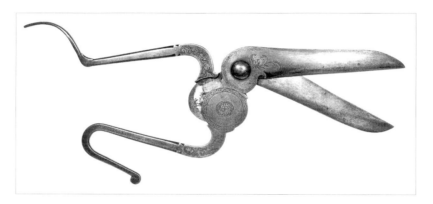

L.24 Tin snips; hollow-ground blades; cut and chased; l. 35.3 cm; w. 9.6 cm; 19th century; no.30

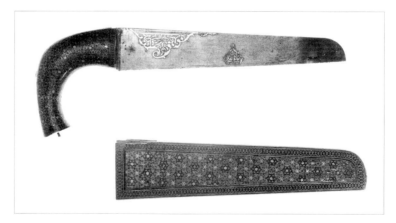

L.25 Saw; watered-steel blade; gold overlay; wooden handle and sheath decorated with marquetry work; l. 30.1 cm; the blade dated AH 1233 (AD 1817–18) and AH 1243 (AD 1827–28); no.304

comment that they were 'intended for master tailors, and particurlarly skin-dressers and furriers',[23] and yet another pair was illustrated by Wulff amongst the tools of a packsaddle maker.[24] Thus, there seems to have been a continuing use of such a style of scissors in textile, leather and allied crafts, and we may surmise that the scissors in this collection (L. 23) were also for use in textile- or leather-working. They have dragon's-head terminals for the handles, and bird's-head terminals for the grip, and are almost identical in form and decoration to those illustrated by d'Allemagne. The details of the dragon's heads point to a 19th-century date. D'Allemagne's collection also contained a fine pair of Chinese scissors of similar design,[25] begging the question of the origin of the form. There is no indication of where such scissors were made. Mirza Husain Khan's comment that the Isfahan scissor-makers made scissors for men's and women's tailoring as well as for paper unfortunately gives no indication of the style of the former.[26]

Metal-workers in Iran today still use large scissors similar to L. 24 for cutting sheet metal.[27] They are generally known in English as 'tin snips'. The author saw them in use among coppersmiths in Isfahan in 1992, Wulff saw them in use both by coppersmiths and silversmiths,[28] and Nasr reproduces a photograph of a master astrolabe-maker in Isfahan with a pair on his workbench.[29] His astrolabes were made of brass. The Tanavoli pair (L. 24) are probably 19th century, and are unusual for their ornithomorphic form: a glance at them immediately brings a pelican to mind.

Other forms of scissor are discussed above (pp.351–56).

c. Saws

The blade of the small hand saw (L.25) is decorated with two inscriptions in gold overlay. In the large cartouche is an inscription reading, *sahib Muhammad 'Ali 1233* ('[its] owner is Muhammad 'Ali, 1233 [AD 1817–18]'. In the small cartouche the inscription reads, *Allah ya 'Ali 1243* ('[O] God! O 'Ali! 1243 [AD 1827–28]'. Nearly a quarter of the smaller cartouche has been worn away through use and sharpening of the blade.

Muhammad 'Ali was most probably a wood-worker. His saw has the standard form of handle used by Iranian wood-workers.[30] It goes back at least till the 15th century, appearing in a painting of Siyah Qalam,[31] and another example is

22. Bosch, Carswell and Petherbridge (1981) col.pl.B.
23. d'Allemagne (1911) vol.2 pl. opposite p.97, top centre; the quotation is from p.96. A smaller pair of the same form is illustrated by d'Allemagne in the same pl., bottom centre.
24. Wulff (1966) fig. 326 on p. 234.
25. Janneau (1948) vol.2 pl.XVII.
26. Floor (1971) p.110.
27. Illustrated in Gluck (1977) p. 149.
28. Wulff (1966) figs.26 and 37.
29. Nasr (1976) pl.79.
30. Wulff (1966) figs 116, 118, 149.
31. Ipsiroglu (1976) pl.60.

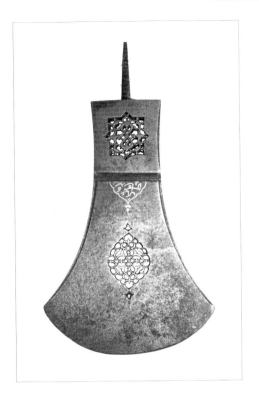 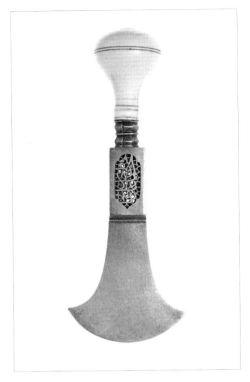

L.26 Half-moon knife; watered; pierced and brazed; gold overlay; shoulder enclosing a red ball; pommel missing; l. 13.3 cm; 16th century; no.171

L.27 Half-moon knife; watered; cut, pierced and brazed; shoulder enclosing two transparent red stones; ivory pommel; l. 14.5 cm; early 19th century; no.187

recorded in the Jahangir Album of *circa* 1600–10.[32] However, in view of the fact that the wooden sheath of L.25 is decorated with *khatam-kari* (inlay work), it seems most likely that Muhammad 'Ali was a *khatam-kar* or *khatam-saz*, an inlayer. Why there are two dates on the blade is unclear. One can only speculate that it was in some way renewed ten years after Muhammad 'Ali acquired it, leading to the second gold inscription.

Small saws of similar shape are to be found in the Ashmolean, Chester Beatty, Moser, d'Allemagne[33] and Wallace collection groups of instruments.

5. LEATHER-WORKING TOOLS

Cutting tools with a crescent-shaped blade, known in the trade as 'round knives' or

32. Pedersen (1984) fig.31. 33. d'Allemagne (1911) vol.3 p.255.

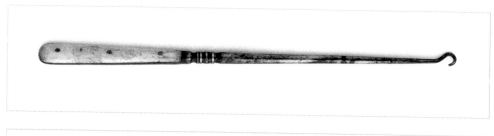

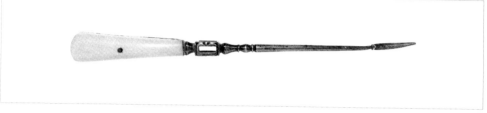

L.28 Hook; cut; ivory scales; l. 27.1 cm; 19th century; no.266
L.29 Awl; cut, pierced and chiselled; ivory or bone scales; l. 22.6 cm; 20th century; no.265

'half-moon knives', have been used for millennia by leather craftsmen. They occur in Egypt, for example, as far back as the 2nd millennium BC,[34] and have been in continual use in Europe to the present day.[35] Some authorities are dubious about their effectiveness: 'Why this particular form was evolved is something of a mystery. It cannot be said to fulfil any one specific purpose with distinction, although in skilled hands by gradually moving from one end of its curved cutting edge to the other (for instance, when cutting a long strap from heavy hide) a consistently sharp edge can be brought into play, while its broad flat surface held vertically serves as a useful directional guide.'[36] The same authority continues: 'This knife is used without a straight edge of wood or metal such as is sometimes employed along with a small knife, but it follows a guiding line marked on the surface of the leather with a blunt awl. Some workers also use it as a skiving knife, holding the blade more or less horizontally.'

The half-moon knife is found across the Islamic world. In the west, for example, it is used in the tanneries of Fez. There it has no handle proper, but is held with the pointed projection on the back between the tanner's fingers.[37] The Iranian half-moon knife is a more easterly Islamic type, and yet another Islamic variant with an angled blade is shown on a bookbinder's table in the Jahangir Album of *circa* 1600–10.[38] A number of Iranian half-moon knives are known: a fine example is in

34. Petrie (1917) p.50 and pl.LXII.
35. H. Osborne (1975) fig. on p.539.
36. H. Osborne (1975) p.540.

37. Guyot, Le Tourneau and Paye (1935) fig.4.
38. Pedersen (1974) fig.33.

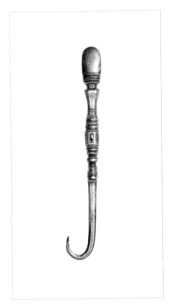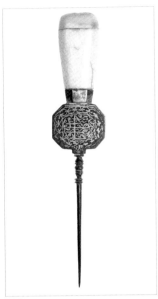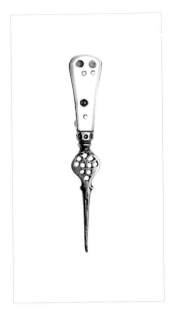

L.30 Hook; cut and pierced; l. 11 cm; late 18th–19th century; no.405

L.31 Awl; cut; gold overlay; brass bolster; stone scales; l. 15.5 cm; 19th century; no.267

L.32 Awl; cut, pierced and inlaid with turquoise; mother-of-pearl scales; l. 8.7 cm; 19th century; no.333

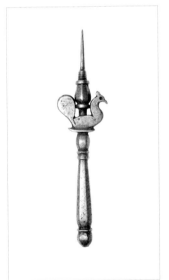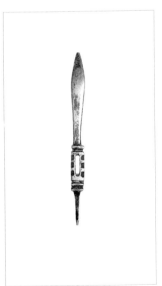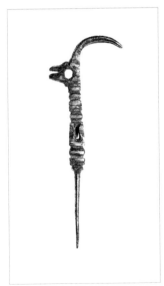

L.33 Awl; cut and punched; cap missing; ht 10 cm; 19th century; no.512

L.34 Awl; cut and pierced; l. 7.6 cm; 19th century; no.409

L.35 Ibex-headed awl; cut and chased; l. 9.8 cm; 19th century; no.406

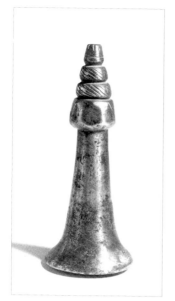 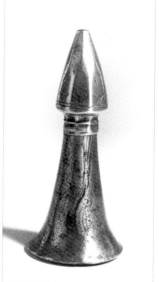 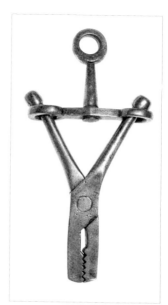

L.36 Paper burnisher or pestle; incised; ht 16.5 cm; diam. of base 6.3 cm; 18th–19th century; no.63
L.37 Paper burnisher or pestle; incised; ht 16.8 cm; diam. of base 6.8 cm; 18th–19th century; no.64
L.38 Stretching pincers; cut and riveted; ht 18.5 cm; w. 9.1 cm; 18th–19th century; no.33

the Freer Gallery of Art,[39] another is in the Walters Art Gallery, Baltimore,[40] two are in the Victoria and Albert Museum,[41] there is a space for one in the Ashmolean instrument set, and there is an example in the Wallace collection, d'Allemagne collection and Moser collection groups of instruments.[42] An angled example, signed by 'Ali Riza Nazuk, is in the Khalili collection,[43] and a Turkish example is illustrated by Bosch.[44]

The design and quality of the pierced work on L.26 suggests that it is a Safavid, 16th-century piece, but the gold inscription reading *bandeh Shah-i vilâyat 'abbas* ('the servant of the king of trusteeship, 'Abbas') looks 19th-century in style. It was presumably added by someone who felt that the tool was old and very fine, and wanted to record the fact (see pp.107–108). L.27, like L.26, has a fine watered blade, but here the pierced work provides an inscription rather than arabesques. The inscription reads, *al-khahesh 'Alijah Hasan Muhammad Quli Khan 'amal Salih* ('at the request of 'Alijah Hasan Muhammad Quli Khan. Work of Salih'). The form of calligraphy used, and the pierced background details to the inscription, suggest that it is contempo-

39. Atıl, Chase and Jett (1985) pp.200–203 no.31, where it is mistakenly described as an axe-head.
40. Pope (1960) pl.143 left.
41. Haldane (1983) fig.20.
42. d'Allemagne (1911) vol.3 p.255.
43. Stanley (1997) p.122 T32.
44. Bosch, Carswell and Petherbridge (1981) fig.4.

375

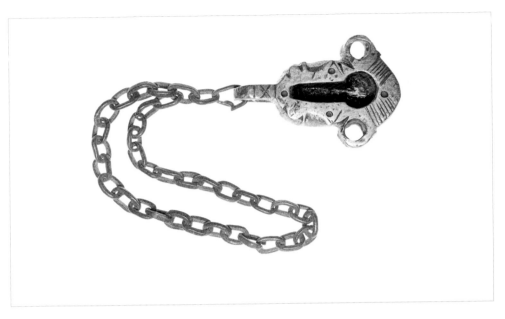

L.39 Palm; cut, punched and chased; l. 5.5 cm; w. 3.8 cm; 19th century; no.507

rary with penknife L.18, and hence early 19th century. This date also fits the design of its gold ornamentation. The craftsman's name, Salih, is not recorded on any published steel objects, and the patron is not otherwise known.

Another leather-working tool are the hooks (L.28 and L.30), which are used for pulling threads through the leather. Wulff illustrates such a hook among the tools of a packsaddle maker,[45] but implements such as this could have been used by other leather-workers, such as shoe-makers, so it is impossible to attribute them to a particular craft. There is another example in one of the d'Allemagne trays of instruments.[46]

Awls, like hooks, could have been used by numerous different leather-working craftsmen. Wulff illustrates an awl in the hands of a cloth shoemaker,[47] and in the past such implements would have been a vital part of leather shoe manufacture. Awls are also key instruments in bookbinding.[48]

The largest awl in the collection is L.29, with its fine baluster decoration, though the fact that it is of mild steel indicates a 20th-century date. There are also a number of smaller awls (L.31, L.32 and L.35). The size of the handle of L.31, and the form of its

45. Wulff (1966) fig.326.
46. d'Allemagne (1911) vol.3 p.61.
47. Wulff (1966) fig.318.
48. Haldane (1983) fig.20 illustrates a large awl which could well be for shoemaking; Bosch, Carswell and Petherbridge (1981) colour pl.B nos 9 and 13 shows the awls of a bookbinder in a 19th-century Kashmiri painting.

TOOLS AND IMPLEMENTS

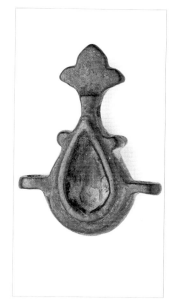 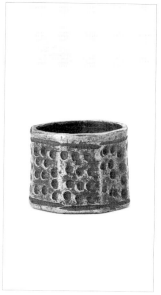 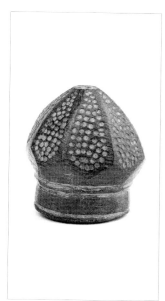

FIG.52 Palm; copper alloy; cast; l. 4.6 cm; medieval; no.509
L.40 Thimble; octagonal; ht 1.5 cm; diam. 2.2 cm; 17th–19th century; no.416
FIG.53 Thimble; brass; ht 3.1 cm; medieval; no.330

projecting octagon, give it the grip an awl needs. Its gold inscription is illegible. L. 35, though it looks too small, sits well between the index and second fingers of the hand, with the ibex horns gripping the second finger, and would be excellent for making small holes through a material like leather. L.32 is a more delicate instrument, but could happily perform a similar function. So too the small awls of similar design in the Wallace collection set, in one of the d'Allemagne collection trays,[49] in the Moser collection set, which has two, and the Ashmolean set, which has one with a hinge at the top of the blade. The distinction between a small awl and a cosmetic kohl stick is so fine that it is often impossible to make a positive identification of this type of object. L.33 and L.34 are such problem instruments. Another example in the present collection is catalogued under kohl sticks (Q.5; see p.460).

Another problem type of object is represented by L. 36 and L.37. Illustrations in a 1570–71 *Anthology* in the Topkapı Saray Museum,[50] and in the Jahangir Album,[51] suggest that they are burnishers for paper. But another possibility is that they are for working leather. A photograph taken in 1967, now in the Photothèque du Musée de

49. d'Allemagne (1911) vol.3 p.255.
50. Safadi (1978) fig.102.
51. Bosch, Carswell and Petherbridge (1981) fig.1, and colour pl.B no.14; also illustrated in Pedersen (1984) fig.34.

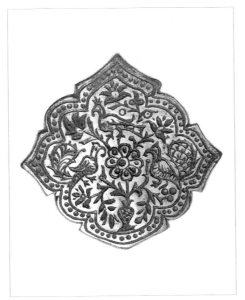 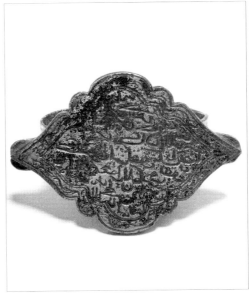

L.41 Leather stamp; cut, punched and chased; w. 8.8 cm; d. 0.6 cm; 19th century; no.207
L.42 Leather stamp; cut and chased; riveted handle; w. 9.3 cm; d. 0.5 cm; ht 6.6 cm (with handle); 19th century; no.253

l'Homme, Paris, shows such a pestle being used by a shoemaker to flatten the leather sole of the shoe.[52]

More straightforward is L.38 which is an implement for stretching leather. Stretching pincers, as they are normally called, are pincers with a sliding ring surrounding both arms, enabling them to grip the lower edge of a skin hanging from a perch and being pared with a half-moon knife. They can also be used to stretch skins.[53]

Another interesting object is a leather-worker's thimble, or, more precisely, palm (L.39). Wulff found such objects being used by packsaddle makers,[54] and, according to Lady Sykes, it was a normal item in the equipment of muleteers: 'A bag of yarn to do up the sacking, a leather case of packing needles, a curious steel instrument to protect the palm of the hand when using these latter …'[55] Such palms are also known in copper alloys (FIG.52): this example has the eyes at either side of the body at right-angles to it. Such palms presumably predate the steel examples. A thimble proper was also used in Iran: like the European type it fitted over the end of the finger or thumb. A copper alloy example is illustrated (FIG.53). Alternatively, a thim-

52. I owe this information to Laure Soustiel.
53. Salaman (1986) fig.11.30.
54. Wulff (1966) fig.326.
55. Sykes (1898) p.36.

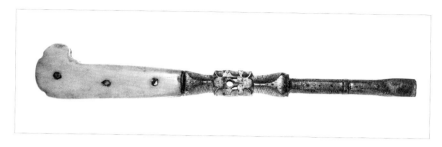

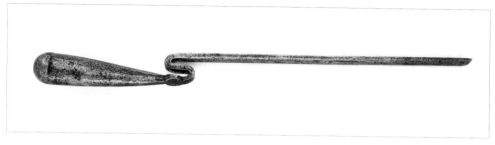

L.43 Chisel; pierced, cut and punched; brass overlay; ivory or bone scales; l. 26.6 cm; 18th–19th century; no.45

L.44 Chisel; cut and brazed; l.34 cm; 18th–19th century; no.46

ble in the form of a broad ring was employed (L.40). The example in the Tanavoli collection is octagonal and covered with shallow drilled holes so that the thimble can 'grip' the end of the needle.

Among the objects needed by bookbinders were metal panel stamps (L.41 and L.42). The first use of panel stamps to create a whole design or an important element in a larger design seems to have been in Iran in the late 14th or early 15th century.[56] However, simpler tools for stamping small, individual motifs, which had been standard in early Islamic bookbinding, were still used: an example with a rosette, ascribed to the 19th century, is in the Victoria and Albert Museum.[57] Panel stamps were made of either steel or brass. A number of examples, in both metals, are in the Victoria and Albert Museum,[58] and a further collection is in the Chester Beatty Library, Dublin.[59] Such stamps are of varying shapes, cusped ovals being particularly popular. They also include right-angled pieces for corner designs. Both L.41 and L.42 appear to be 19th century; the former stamp was presumably used to embellish the bindings of secular texts, the latter, with its Qur'anic verse (sura 58, verse 61, an extract from the sura of 'the Pen'), those of Qur'ans and other religious texts. Originally they would both have been used for impressing designs by ham-

56. Bosch, Carswell and Petherbridge (1981) p.68.
57. Haldane (1983) fig.22.
58. Haldane (1983) figs 1–2, 5, 9–11, 13, 14, 17, 18, 21.
59. Bosch, Carswell and Petherbridge (1981) figs 11, 13.

 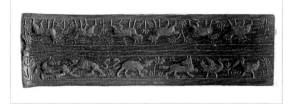

L.45 Jeweller's die; chiselled; l. 2.8 cm; w. 2.1 cm; d. 1 cm; 18th–19th century; no.209
L.46 Jeweller's die; chiselled; l. 2.9 cm; w. 2.3 cm; d. 1 cm; 18th–19th century; no.290
L.47 Jeweller's die; chiselled; l. 11.7 cm; w. 3.5 cm; d. 1.2 cm; 18th–19th century; no.208

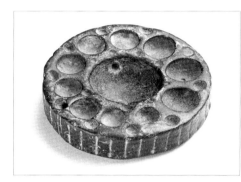 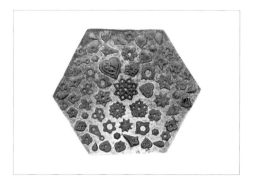

FIG.54 Dapping block; brass; d. 8.9 cm; ht 2 cm; medieval; no. 212
L.48 Jeweller's die; cut and chiselled; w. 6.8 cm; d. 0.3 cm; 17th–19th century; no.210

mering, and the steel handle of L.42 must be a later addition. It is worth noting, however, that not all leather stamps, at least in the 19th century, were of metal. Benjamin, for example, writing of book leather, says: 'Often, also, the design of the cover is stamped and beautified with various shades of gold. The stamping was sometimes done with engraved plates of metal; but singular as it may seem, it was usually produced by designs actually cut into sole leather of very fine quality, and attached to a block of wood. The leather to be stamped was thoroughly moistened, and the stamp was pressed down by heavy weights and left in position for days, until the under leather had, as it were, grown to the desired design.'[60]

Other tools not catalogued here were used for leather-work. For instance compasses and dividers were absolutely fundamental to the ornamentation of bookbindings,[61] and are to be found in the section on drawing instruments (see pp.348–51), while folding knives, which can be seen in one of Wulff's photographs on a packsaddle-maker's table,[62] are discussed on pp.365–69.

60. Benjamin (1887) p.292.
61. Bosch, Carswell and Petherbridge (1981) p.68.
62. Wulff (1966) fig.326.

6. OTHER TOOLS

Among these are two large chisels (L.43 and L.44). The ivory scales of L.43 are crude and ill-fitting and may be later replacements. The object is now so blunt that it looks more like a screwdriver. The pierced rectangular unit is reminiscent of those on the falcon perches (see p.251), and also relates this piece to an awl in the Victoria and Albert Museum.[63]

Tribal jewellery in Iran is characterised by the use of small silver pendants. The pendants are made of sheet silver, beaten into dies, and then the two halves are soldered together. The two dies (L.45 and L.46) are typical of this tradition. The larger die (L.47), with its friezes of animals moving in opposite directions, could have been used as the pattern for the body of a silver or gold bracelet. These three dies are probably 18th- to 19th-century. A large collection of brass dies for gold work, acquired in Afghanistan, is in Berne.[64] One is dated AH 1316 (AD 1898–99). Another type of die used by jewellers is a dapping block. This is a block of metal with hemispherical shapes cut into it, designed to act as a pattern for a variety of different-sized gold beads (FIG.54). Similar to a dapping block is die L.48 with its wide variety of designs carved into the steel plate. This would have provided the jeweller concerned with a large number of possible designs for individual elements in a composite piece of jewellery. It could date from the 17th century or later.

Other important tools for a metal craftsman or jeweller are his hammers. The collection has three examples. The most beautiful is L.49, with its superb bird's head and elegant handle. The other two (L. 50 and L. 51) have curving conical heads typical of a type of hammer common among metal-workers in Iran: Wulff, for example, shows similar types of hammer being used by embossers, engravers, signet-makers and wire-drawers.[65] The pointed end is good for finer work. A small hammer is to be found in the Ashmolean instrument set,[66] and another three in the Wallace collection set. One from a tray in the d'Allemagne collection has a head in the form of a bird very like that of L. 50, suggesting that the latter probably dates from *circa* 1800.

L. 52 looks very like a stake, but in view of the fact that its short, pointed end is hollow it must be a punch. Circular punches were commonly used in working sheet metal to give texture to the background of a traced or inlaid design.

There are two examples of carpet comb-beaters in the collection, L.53 and L.54. Both have a triangular body, a projecting handle, and a toothed edge. They are incised and punched with star-shaped motifs, zig-zag lines, and stylised flowers. Edwards, in his classic study of the Iranian carpet, distinguishes two different types

63. Haldane (1983) fig.21.
64. Berne, Historisches Museum, acc. nos G.R. 71.222.59-138; unpublished. I am grateful to Dr Kläy for the opportunity of seeing these objects.
65. Wulff (1966) figs 41, 44, 47, 55.
66. Oxford, Ashmolean Museum, acc. no.EA 1955.1, length 13.5 cm.

PERSIAN STEEL

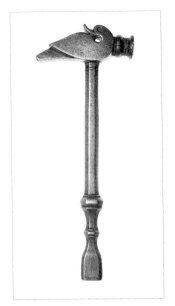
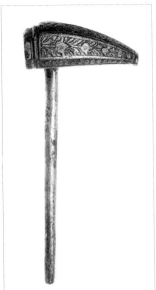
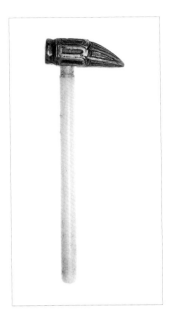

L.49 Jeweller's hammer; cut and punched; l. 12.5 cm; 18th–19th century; no.504
L.50 Chiselling hammer; cut and chiselled; l. 12.8 cm; w. 5.4 cm (head); 19th century; no.94
L.51 Jeweller's hammer; cut; brass inlay; ivory shaft; l. 10.1 cm; 19th century; no.359

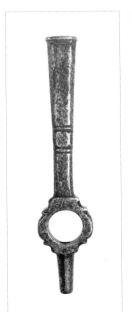
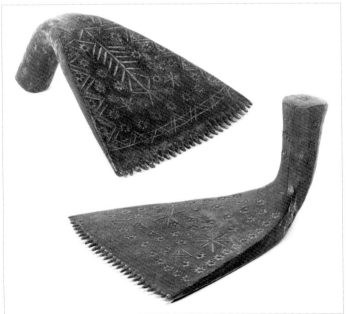

L.52 Punch; cut; hollow point; l. 9.1 cm; 18th–19th century; no.206
L.53 and L.54 Two carpet comb-beaters; incised and punched; l. of the larger 16 cm; nos 28 and 29

of comb-beaters: the old type with a heavy wooden body, an upstanding handle and long projecting iron teeth, and a later type made of a dozen thin strips of iron riveted together and splayed.[67] However, no detailed study of such combs seems to have been made, so it is impossible to say whether the pair in the Tanavoli collection, which is different in form from either of Edwards's types, represents a particular regional style or not. Other examples, of varying shapes, have been illustrated by a variety of authors.[68]

SETS OF INSTRUMENTS/TOOLS

Having established the identity of a range of tools and implements, it is now appropriate to consider a number of surviving sets of tools in painted, lacquered cases. The largest is that in the Ashmolean Museum (FIG.55a).[69] There is another in the Moser collection in the Historisches Museum, Bern,[70] an incomplete one in the Chester Beatty Library, Dublin,[71] and two trays of instruments, which may or may not come from a single set, were in the d'Allemage collection.[72] A further set was housed in a box in the Khalili collection, but only the spaces remain.[73] There is another, more specialised set in the Wallace Collection, London.[74]

The Ashmolean set occupies a flat, rectangular box, originally with a mirror under the hinged lid, and with two drawers. The large drawer has 21 steel instruments, one of which, the half-moon knife, is missing. It also contains a wooden comb, a small box, a role of string (?), a flat piece of mother of pearl with a hole in it, possibly the ink-well cover from a pen-box, a whetstone, and a pair of scales. The steel implements are as follows:

 a) barbers' tools: razors (2), circumcision knife, lancets (2), L-shaped knife
 b) cosmetic implements: tweezers (2)
 c) drawing instruments: ruling pen, compass, scissors (2), straight edges (2), stylus
 d) wood-working tools: saw
 e) file
 f) cutting tools: small *kard*, folding knife
 g) leather-working tools: half-moon knife (missing)

67. Edwards (1960) pp.24–25 and pl.13.
68. For example, Wulff (1966) fig.302. See *The Qashqa'i of Iran* (1976) pl.27 for one with much longer teeth.
69. Oxford, Ashmolean Museum, acc. no.EA1955.1, transferred from the Museum of the History of Science; Pope (1938–39) pls 1391–92; Robinson (1995) figs 1–3. The full dimensions of the box are 39.7 x 26 x 6.3 cm.
70. Balsiger and Klāy (1992) p.144.
71. Unpublished. I am grateful to the Director of the Chester Beatty Library for photographs of this set.
72. d'Allemagne (1911) vol.3 pp.61 and 255.
73. Khalili *et al.* (1996) no.90, pp.126–27.
74. London, Wallace collection, acc. no.OA 1737; unpublished.

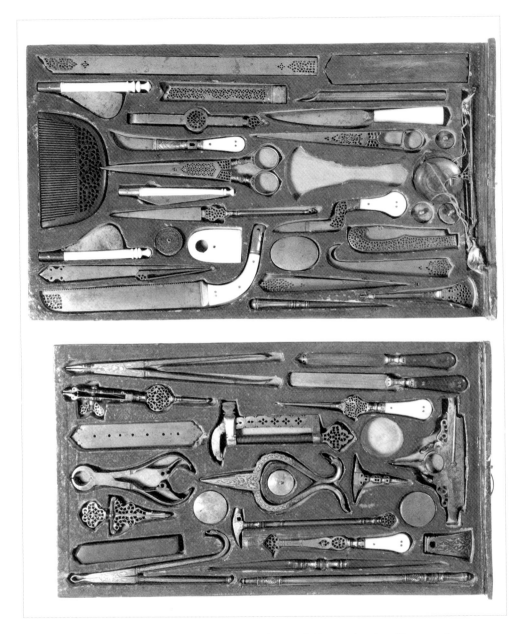

FIG.55a Set of tools in two drawers: papier-mâché box, painted and lacquered; probably Isfahan, *circa* 1830, Ashmolean Museum, acc. no.EA1955.1

FIG.55b Interior of cover of papier-mâché box, painted and lacquered (see FIG.55a)

The small drawer, which fits into the larger, has part of the scales, together with 16 implements, three small boxes (one missing) and a whetstone. The steel tools are as follows:

a) medical tools: forceps (2)
b) wood-working tools: saw, small adze
c) jewellery tools: stake, hammer
d) files (3)
e) gripping tools: pliers, pincers, hand vice, clamp
f) unidentified (3)

The Moser collection set is designed to hold a mirror inside its lid, and has the same sort of mixture of instruments. So too the incomplete Chester Beatty Library set and the two trays of implements illustrated by d'Allemagne. Variations include a flint-striker (in one of the d'Allemagne drawers), worms (in the other d'Allemagne drawer and the Moser collection set), a hook and a screwdriver (d'Allemagne), and a

FIG.55C Back of papier-mâché box, painted and lacquered (see FIG.55a)

cosmetic implement with file and blade (Chester Beatty). The set once contained by the box in the Khalili collection was smaller, being contained in a single drawer, and consised of nine items. Judging by the shapes of the spaces, it consisted of a comb and a pair of scissors (which would have overlapped as they do in the Ashmolean set), two razors, two sets of tweezers of different shapes, a circumcision knife, a whetstone, and an unidentified object. One has the impression therefore of a set of instruments belonging to a specific trade, that of a barber-surgeon.

Quite different from these is the set in the Wallace Collection, which has three hammers, an adze, a *kard*, a hoof knife, a saw, two sets of forceps, farriers' pincers, an awl, a half-moon knife, a clamp, a pointed L-shaped implement a large file and a straight edge. This looks as though it could well be an ornate set of implements relating to a farrier-cum-saddler, and its military nature is emphasised by the inscription on the pair of pincers, which reads: *nasr min allah wa fath qarib* ('victory from God and swift conquest'). The decorative design on the tray is also very different from those

on the other sets, and is most closely related to Iranian lacquer work of the mid- to late 19th century.[75]

As regards the dating of the other sets, the earliest is the box in the Khalili collection, which is dated AH 1187 (AD 1773). Next is the box housing the Moser collection set, which is dated AH 1211 (AD 1796). The box holding the Ashmolean set has been dated by Basil Robinson to *circa* 1830, and the Chester Beatty box is decorated in such a similar style to the Ashmolean box that it too must be from that period. D'Allemagne unfortunately does not illustrate the box or boxes which housed his two trays, but the sets of implements are very similar to the Moser, Ashmolean and Chester Beatty ones, and we may confidently date them to the late 18th or early 19th century. Intriguingly, each of the published boxes is decorated with at least one scene derived from a Western Christian source, more specifically that of the Holy Family. The models for these were presumably introduced into Iran as book prints.

These various trays or sets of instruments raise interesting questions about their purpose. In the Safavid period a craftsman who wished to be employed in the royal workshops had to produce a piece of work for presentation to the *bashi*,[76] but this system would probably not have continued after the end of the dynasty. The Safavid court was also awash with presents with a more general purpose. Thus de Thevenot comments: '... all the *Chans* and other Lords, make them often presents, and amongst others, regularly once a year in the *Neurouz* of Spring.'[77] The system for valuing and taxing such gifts was unusual. Minorsky desribes it: 'The strangest fees were those collected on the presents offered to the King ... The duty of the Pishkash-nivis was to register in a special book all the offerings brought to the court, to estimate their price, and to lead those who carried them, to the King's presence. The donor had then to pay an additional sum of money evaluated as a percentage on the price of his gift ... The estimate was usually accurately made, for the donors did not want to pay more fees than they could help and, on the other hand, they were loath to depreciate the value of their gifts.'[78] One of the present-giving events of Nauruz at the court of Shah Sultan Husain is illustrated in a painting dated AH 1133 (AD 1721) in the British Museum.[79] Such gifts undoubtedly went on being an important part of court life under later dynasties, and it is possible that sets of tools of this sort could have been designed for such a purpose.

It is also possible that under the Safavids, and continuing into the Qajar period, mastership in a guild was subject to some sort of qualifying examination. If so a candidate may have been required to present a fine piece of his work for examination

75. Khalili *et al.* (1997) Part 2 no.243 (the base) dated AH 1266 (AD 1849–50), and nos 413, 433 and 436.
76. Chardin (1811) vol.5 pp.499–500. The *bashi* was the government-appointed officer over each guild.
77. de Thevenot (1686) p.100.
78. Minorsky (1943) pp.47 and 156.
79. Canby (1991–92) fig.3.

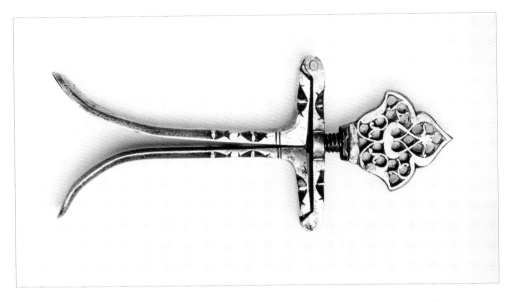

L.55 Speculum (?); cut and pierced; ht 8 cm; late 18th–19th century; no.358

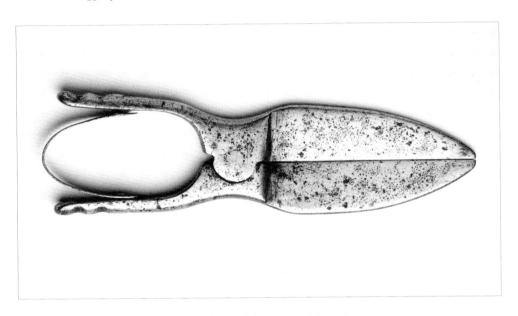

L.56 Implement; cut and riveted; ht 9.5 cm; 18th–19th century; no.233

and judgement by the masters of the guild. Again the sets might have fulfilled such a purpose.

Two of these sets, those in the Khalili and Wallace collections, do seem to have been made for a particular purpose, the former evidently being that of a barber-surgeon, the latter that of a farrier/saddle maker. The purpose of the others, however, remains enigmatic. A box with mirror and wooden comb and a range of implements covering woodwork, leatherwork, drawing, barbers' activities, guns and weighing activities cannot be the working tools of any particular craftsman. Moreover, although most of the tools are of steel, they are not exclusively so. Hence they do not represent one craft either. Since they bear no owner's name or dedication inscription, they are unlikely to have been made with a specific individual in mind, and because they bear no dedication to a ruler or other high official, they are unlikely to have been offered as a present to such a person.

The picture on the box housing the Chester Beatty Library set is an adaptation of a European scene of the Three Kings presenting gifts to Jesus, and could therefore suggest that the box was a present for someone. However, the very similar Christian scenes on the Ashmolean and Moser sets do not emphasise presents in the same way, except perhaps in the figure holding a bird on the left, and in the girl offering the seated prince food and drink on the inside of the lid of the Ashmolean set. Hence, there seems to be no obvious pictorial reference to their function. The most likely solution seems to be that these sets are tourist items from the Isfahan bazaar, items which foreign merchants or visitors would be encouraged to purchase, either as presents for family and friends, or as objects of trade: the mirror and comb to appeal to ladies, the range and variety of implements making an attractive display of craftsmanship, and the Christian scene on the lid to give it immediate appeal to a Western eye.

That they were produced in Isfahan, rather than in any other centre, is indicated by the following factors. First of all, the quality and variety of implements suggests that they must have come from a major steel-working centre. Secondly, we know from Ouseley that Isfahan in the early 19th century was the national centre for papier-mâché *qalamdans* (pen-boxes) and *sunduqchehs* (caskets).[80] Ouseley purchased a fine example of the latter with a picture of Fath 'Ali Shah on it. Thirdly, the inscription on the Khalili box says that the painting was the work of Muhammad

80. Ouseley (1819–23) vol.3 pp.62–64, 132–34, and pl.LXIV. Mirza Husain Khan makes an intriguing comment about the late 19th-century Isfahan papier-mâché business: 'Formerly the papier-mâché making of Isfahan was not as good as now, which is clear from old papier-mâché decorated by famous painters. Because of the inferior quality of former papier-mâché they took the initiative in Isfahan to transfer drawings, so that antique drawings of old masters could be transferred on new papier-mâché, and found a highly successful process.' Floor (1971) p.106.

Baqir 'in Isfahan, the seat of sovereignty'. Fourthly, Muhammad Sadiq, painter of the box in the Moser collection in the year AH 1211 (AD 1796), was at this point of his career in Isfahan. He had been trained in Isfahan, had moved to Shiraz, where he worked for Karim Khan Zand, but by the 1790s was back in Isfahan and was working for Agha Muhammad Khan, the first Qajar ruler, who died in 1797.[81] Robinson's suggestion that the paintings on the Ashmolean box are early works of Najaf 'Ali also fits this scenario, for Najaf 'Ali worked all his life in Isfahan.[82] Finally, although not all the known examples of lacquerwork with designs similar to the Wallace Collection tray are attributed, the piece dated AH 1266 (AD 1849–50) is almost certainly a product of Isfahan,[83] suggesting that this style may also be associated with the city. It is in any case related to the designs on the Khalili tray, as also are those on the Chester Beatty set.

UNIDENTIFIED TOOLS OR IMPLEMENTS

A small number of tools in the Tanavoli collection have an uncertain use. L. 55 might be termed a speculum or dilator, for the two curved blades open outwards and can be held in position by screwing the palmette-shaped handle downwards. Whether, however, it had a medical purpose or was used in one of the craft industries is unclear. Other examples are to be found in the Ashmolean set, and in one of the trays in the d'Allemagne collection.[84] L. 56 has two pivoting arms with a riveted U-shaped spring which holds the blades together when released. Another pair is to be found in the Khalili collection.[85] Its use is unknown.

81. Khalili *et al.* (1996) Part 1 pp.74–75.
82. Khalili *et al.* (1996) Part 2 pp.22–29.
83. Khalili *et al.* (1997) Part 2 no.243.
84. d'Allemagne (1911) vol.3 p.61.
85. Stanley (1997) p.118 T12.

Barbers', medical and surgical instruments

Jean Chardin was very impressed by the skill of Iranian barbers, of whom he wrote:

'The Mistery of Shaving, which they are perfect Masters of; they shave with a wonderful Dexterity, you can scarce feel them, especially when they shave your Head; they begin at the Top, and draw the Razor downwards, as if they only run it over your Head, and your Head is shaved in a Moment; but before they set the Razor to it, they rub it a great while, then they wet it; 'tis my Opinion, that long Friction that Facilitates the shaving, so that 'tis scarce felt; they use no hot Water for shaving, but cold, and set no Bason under your Chin; their Bason is a Cup, no bigger than a Parrot Cup; they wet their Hands in the Water that's in it, then wet the Face with it; they are likewise very cleanly in their Trade; for when they shave the Head, they throw all the hair in one Place; they wipe the Razor on the hair unshaved, so they never use a Razor Cloth, and never wipe it but with their Finger: I am perswaded, that the heat and dryness of the Climate are a great help to the Barbers in shaving: 'Tis their way after they have shaved one to cut also the Nails, both of his Hands and Feet, with a sharp Iron, like that Instrument, which the Chirurgeons call a Fleam; then they draw your Fingers and Arms, and handle your Head, and your Body, especially your Shoulders, to see, as it were, if every Limb be in its right Place, which affords much Ease and Pleasure; the Barbers go every morning to their Customers, to hold the Glass before them, which is commonly four Inches Diameter, with a Handle to it, they are not paid for that, but when they shave the Face and Head, they have three or four Pence given them; those who give them five Pence pay them nobly.'[1]

Olearius' comments on barbers in Isfahan were rather briefer:

'Near these Taverns or Drinking-Houses, are the shops of Surgeons and Barbers, between which Trades there is a great difference in *Persia* ... The former, whom

1. Chardin (1988) p.274.

they call *Tzerrach* only dress Wounds and Hurts; and the others, named *Dellak*, only Trim, unless they sometimes are employed in Circumcision. These Barbers are much taken up, for there is not a man, but is shav'd, as soon as any Hair begins to appear; but there is not, on the other side, any who carries not his Rasor about him, for fear of getting the Pox, which they are extremely afraid of, because it is very common among them, and very contagious.'[2]

From Chardin's comments it seems that barbers were itinerant, visiting their clients rather than being visited. Olearius, on the other hand, talks of barbers' shops and of the clients carrying their razors to the barbers. An observation by du Mans, 'de *dellaks* (saigneurs, barbiers), en nombre infini, un ou deux à chaque quarrefour',[3] supports Olearius rather than Chardin.

However, it is quite likely that both were right, for the same dichotomy persists in the accounts of later European travellers. Again, these are worth quoting at length as they give such flavour and colour to the instruments catalogued here. In the 1880s Wills described a local barber's shop:

'On the two takjahs, or recesses, were displayed all the various curious *armamenta* of an Eastern barber's art. There were the scissors, the razors, the fleams and lancets, the hand-mirrors, square and circular, the *one* pair of huge pincers with which all teeth are extracted, the small clamp and knife used for certain operations on the youthful male Persians; the branding-irons used for the actual cautery – a favourite remedy in Persia – a few well-made native combs of ebony – absolutely no brushes, these being unused by Persians.'

And yet Wills went on to describe the itinerant barber's equipment:

From this [the barber's] girdle ... hung the round copper water-bottle, the needful utensil of the peripatetic barber in a country where water is scarce; also his strap on which he sharpens his razors; and a small leather pouch, which holds a handy stock of the implements of his trade. In his bosom is a small mirror ...'[4]

Precisely the same view comes from d'Allemagne, who described a barber's shop in Tehran and the equipment of an itinerant barber in virtually the same terms.[5] He

2. Olearius (1669) p.222.
3. du Mans (1890) p.178.
4. Wills (1886) pp.133–34. A barber's shop in Herat visited by Forster in 1783, described in Pinkerton (1808) vol.9 p.285, was relatively plain. 'In the centre of it stands a small stone pillar, on the top of which is placed a cup of water, in readiness for operation, and the sides of the shop are decorated with looking-glasses, razors, and beard combs.'

BARBERS', MEDICAL AND SURGICAL INSTRUMENTS

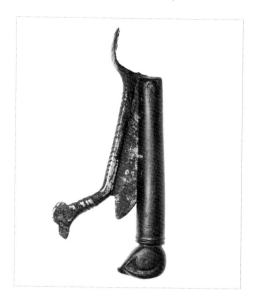 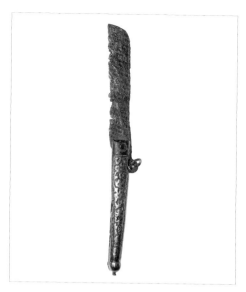

M.1 Razor; brass handle; hinged blade cut and incised; l. 10.6 cm; 19th century; no.185
M.2 Razor; brass handle; hinged blade; l. 8 cm; 19th century; no.325

also described how circumcisions were performed by barbers at the relevant boy's home,[6] showing again the itinerant nature of the barber's trade.

Be that as it may, a folding razor has obvious practical value, whether carried by the client or the barber. How early folding razors were introduced it is impossible to say, though simple folding (clasp or pocket) knives certainly have a long history. The slightly curving blade and thumb-rest make the identity of M.1 virtually certain: the straight blade of M.2 would not have made it so easy to use. The use of a thumb-rest is characteristic of Western razors,[7] but whether it was an introduction from the West into Iran is unclear. The use of brass handles for these two razors was presumably for reasons of economy. Two more Iranian razors of somewhat similar form are illustrated by Himsworth, though they both appear to have bone handles.[8]

The set of Iranian implements in the Ashmolean Museum (see p.384 and FIG.55a–c) has two folding objects which, with their slightly curving blades, must also be razors. However, the shape of their blades as a whole is rather different from the pieces in this collection. Their wedge-shaped form, with thick back, narrow edge

5. d'Allemagne (1911) vol.3 pp.197 and 254. See also Landor (1902) vol.1 p.309 for a similar description of a barber's shop in Isfahan, and vol.2 pp.71–72 for an itinerant barber in Naiband.
6. d'Allemagne (1911) vol.3 p.54.
7. See, for example, Bennion (1979) p.302 pl.16, a French razor of *circa* 1680; pl.17, a silver razor of William IV, 1830. See also Himsworth (1953) pp.141–48 for Sheffield steel razors.
8. Himsworth (1953) fig.49 nos 15–16 for two 19th-century Iranian razors of this form.

395

and concave ('hollow-ground') sides, suggests that they are copies of a typical late 19th-century European razor style. Indeed the blades may well be European imports, for their handles, with a groove along one side and a cut right through near the hinge, are clearly designed for circumcision knives (see below), suggesting that the craftsmen who made the handles were not previously acquainted with the form of blade. Other pairs of razors of similar form are to be found in the d'Allemagne and Moser collection sets. (For a blade which may have been used as a razor in a multi-purpose set of instruments, see L.22 in the section on knives, p.368.)

Barbers (*dellak*) were responsible not only for shaving their clients, but for other medical and surgical activities, which included blood-letting and circumcision. du Mans wrote critically of the former practice, beginning with a brief description of the implement used: 'Their lancets, pointed like the penants of the marshalls of our own country, do not go in easily because of their thickness and solidity.'[9] Such lancets were almost certainly made of steel, but in practice are difficult to recognize. A possible type of lancet is illustrated by M.3 and M.4. These are flat and pointed, with tapering sides, and an ogival, openwork design at the handle end. Whether the flat tapering object with a hooked end (M.5) has a similar function is unclear, though the fact that the two instruments appear next to each other in the Ashmolean set, and are laid out to balance one another on either side of a central instrument in the Moser collection set, suggests that they have related functions, or were at least used by the same people. It is tempting to see a similar function too for a small knife (M.6). This is somewhat akin to an object in the Ashmolean set which balances the circumcision knife (see below): although the cutting area of the blade is much greater in the Tanavoli example, the shape and general proportions are the same, and both have a cuboid knop in the bolster with a hole through it. In the Moser set a similar instrument is next to one of the razors: a medical use is therefore a possibility. The precise function of a knife with an L-shaped blade (M.7) is equally uncertain, though again a medical use is probable: the farrier's *trousse* in the Wallace collection, the instruments in the d'Allemagne collection, and the Ashmolean set each contain such an object. M.8 may also have had a medical, in this case ophthalmic, use, most likely for cataract operations.[10] That it was used for paring nails is suggested by a description of barbers in Pinkerton's *Travels*: 'after they have shaved a man, they cut the nails of his feet and hands, with a little iron instrument like a bodkin, sharp at the end.'[11]

9. du Mans (1890) p.177.
10. Bennion (1979) pp.136–44 pls 4–5, 7–8, 10–12, illustrates sets and individual examples of cataract and other ophthalmic knives from the 17th to the early 19th century. None of these is identical to no.415 but some are certainly similar, for example, pl.8 and fig.17 in pl.12. Another possible use for this instrument is suggested by an illustration in Bennion (1979) colour pl. opposite p.211, of a set of French dental scalers, *circa* 1800.
11. Pinkerton (1808) vol.9 p.206.

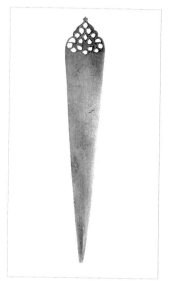 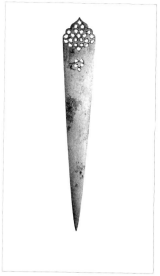 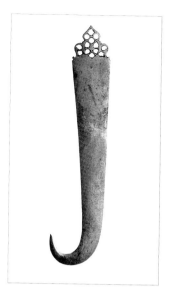

M.3 Lancet; watered; cut and pierced; l. 11.1 cm; 19th century; no.299
M.4 Lancet; cut and pierced; l. 9.7 cm; 19th century; no.329
M.5 Lancet with hooked end; cut and pierced; l. 10.7 cm; 19th century; no.335

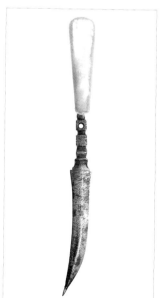 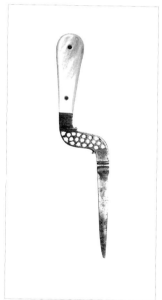 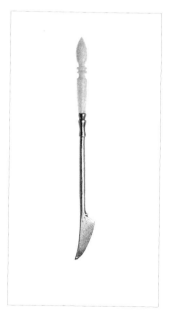

M.6 Surgical knife; cut and pierced; mother-of-pearl handle (probably not original); l. 12.7 cm; 19th century; no.411
M.7 Lancet; cut and pierced; handle with mother-of-pearl scales; l. 9.7 cm; 19th century; no.399
M.8 Lancet; cut; ivory or bone handle; l. 9 cm; 19th century; no.415

In the 17th century Herbert noted the use of scissors for circumcisions,[12] but later writers talk of knives. D'Allemagne describes these knives as *canifs*, that is, penknives,[13] and there are two small, folding knives in the collection, which are of a form traditionally associated with circumcision in Iran (M.9 and M.10). Both have blades which can be folded into their grooved handles, and would therefore have been appropriate for barbers who normally visited their clients at home for this purpose. The Ashmolean set of implements also includes such a knife,[14] as does the Moser collection set.[15] These are both virtually identical in the form of blade and handle to M.9, though the latter has finer pierced arabesque work. The inscription on the blade of M.10 is in four parts, two of them illegible, the third part reading *ya imam ya muhammad* ('O, Imam! O, Muhammad!'), and the fourth made up of a group of Roman capital letters including *OEGHAJZST*. The latter were presumably deemed to have some sort of magical quality.

Thus the Tanavoli collection contains, apart from razors, a variety of cutting implements which were, or could have been, used for medical or surgical purposes. A much wider range of surgical instruments was in fact known in the medieval and later Islamic world. The great early source for these is Albucasis' *On surgery and instruments*, for which the two illustrated Bodleian manuscripts, dated AH 670 (AD 1271–72) and AH 870 (AD 1465–66) respectively, are of prime importance.[16] While one cannot necessarily trust the artists' accuracy for the details of every implement, there is no reason to doubt the range of instruments cited in these manuscripts for use by medieval practitioners. This is confirmed by the existence of a small selection of such instruments of more recent date, now in the Museum of the History of Medicine in Tughluqabad, Dehli.[17] These correspond closely to examples depicted in the earlier manuscripts. No such instruments from later Iran have yet been recognised.

Also into this section falls an étui (M.11), probably made out of a sword scabbard chape, and designed to hold small instruments. European étuis tended to be oval or circular in section, to have compartmented interiors and hinged lids.[18] One Persian étui of this general style is known, a steel example with a fine pierced outer body and lid, now in the Walters Art Gallery, Baltimore.[19] This contains 17 small instruments

12. Herbert (1677) p.307. Scissors were also the preferred instrument of Abulcasis (d. AD 1013) for this operation; see Spink and Lewis (1973) p.396.
13. d'Allemagne (1911) vol.3 p.254.
14. Oxford, Ashmolean Museum, acc. no.1955.1L, length 17.3 cm.
15. Balsiger and Kläy (1992) p.144.
16. See Spink and Lewis (1973). Some of the illustrations from a manuscript of the text now in Berlin are reproduced in Brandenburg (1982) pp.188–89; see also Sievernich and Bude (1989) no.6/58 and Abb.760, and an illustration from a Paris manuscript in Hayes (1983) p.181.
17. Nasr (1976) fig.82.
18. Bennion (1979) pl.III for a silver étui 13 cm long containing three lancets, scissors, tweezers, spatula and probe, *circa* 1750, and p.278 pl.6 for a silver lancet case with six lancets, *circa* 1760.
19. Pope (1960) pl.143 right.

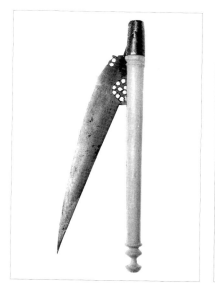 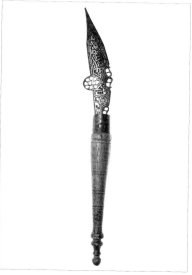

M.9 Circumcision knife; cut and pierced; ivory or bone handle; l. 10.5 cm; 19th century; no.327
M.10 Circumcision knife; cut and pierced; gold overlay; wooden handle; l. 10.4 cm; 19th century; no.326

including razor, knife, scissors, file, spoon and saw, and could well have been for medical use. It is also possible, however, that the Tanavoli étui was used as the case for a pair of spectacles, or pince-nez. Spectacle cases came in a variety of shapes in 18th- and 19th-century Europe, and usually, like étuis, had hinged lids,[20] but there is no reason why this particular object might not have been used in this way. The gold overlay suggests a 19th-century date.

As noted above, barbers not only shaved their patients but carried out surgical operations on them, and also extracted teeth. Two instruments in the collection (M.12 and M.13) may have been forceps for that very purpose. They may be compared to a pair of dental forceps with a similar s-shaped end to one handle, in the Wellcome Institute, which appear to be English *circa* 1600.[21] The use of such instruments for dentistry in the Islamic world is suggested by a group of these objects from the Aures mountains in Algeria, now in the Pitt Rivers Museum, Oxford, to which a dental function is also ascribed. Other uses cannot be ruled out, however. They could, for example, have been used for horses' rather than human teeth, or they could have been pliers for the use of wood-working or other craftsmen. The set of farrier's instruments in the Wallace collection contains a large and a small pair of

20. Bennion (1979) pl.VIII and p.236 pls 14 and 15.
21. Bennion (1986) p.51 pl.45.

M.11 Etui; brazed; gold overlay; ht 12.5 cm; w. 3.4 cm; 18th–19th century; no.241

forceps, the latter with the s-shaped handle end (see p.386–88). The dating of the two pairs of forceps in this collection is conjectural, but they are probably 19th-century. Although M.12 has a rivet on which the arms pivot, M.13 does not: the two arms function purely on the basis of their interlocking shapes.

On dentistry in Iran at the turn of the century d'Allemagne wrote:

'The patient who has seen an implement so richly decorated with inlaid gold introduced into his mouth cannot be insensible to the luxury displayed by the operator in his instruments of torture. One knows, besides, that Persian dentists – I'm talking about those of the old school – exercise relatively little gentleness in their relations with their clients. To avoid any attempt at rebellion, indeed, the latter must put themselves in the hands of three of their tormentor's assistants; once lying down, with his head slightly raised, the patient sees one of the servants of the dental artiste settle on his chest, and hold his mouth wide open, while two other acolytes immobilise his legs and arms. Under these conditions, it is not surprising that only in the last extremity do Persians decide to have recourse to the good offices of their country's Aesculapii.'[22]

Modern dental practice probably first reached Iran through British East India Company surgeons. The first dentures were manufactured in Iran in 1860 and the first denture workshop opened during the reign of Nasir al-Din Shah. The last decade of the century saw the appearance of Persian textbooks and of translations of relevant European books, but traditional methods of treating toothache continued until 1921, when all dentists had to be licensed by the Ministry of Education.[23]

22. D'Allemagne (1911) vol.2 pp.68–69; vol.3 p.59 illustrates a dentist at work, cf. the Fahie collection, Oxford, Bodleian Library, 2061 d.24 Box 2 no.122.
23. Sajjadi (1996).

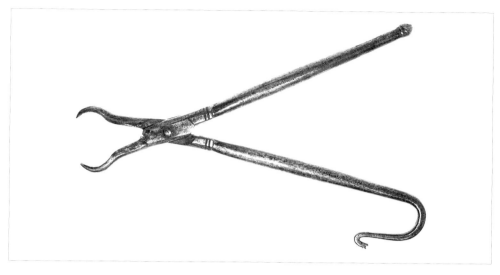

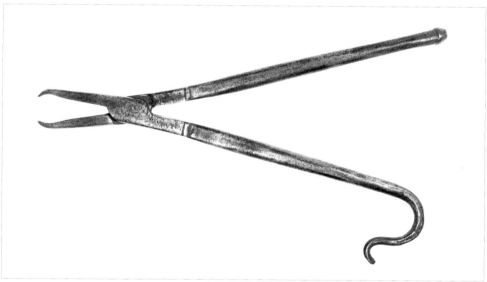

M.12 Forceps/pliers; cut and riveted; l. 20.8 cm; 19th century; no.34
M.13 Forceps/pliers; cut; l. 21.5 cm; 19th century; no.35

Locks and padlocks*

Whether for gates, doors, chests or boxes, the primary use of locks and padlocks has always been for security. Whereas most locks in contemporary use in Europe are fixed, however, fixed locks made of metal were rare in Iran before modern times.[1] Thus Jean Chardin writes: 'No Iron-work is to be seen in their Edifices, but a Pin with a hole in it, and a Chain and Padlock to fasten the Door with; the *Persians* do not use Iron Locks, their Locks are made of Wood, and so are their Keys.'[2]

The fixed lock in this collection (N.1) is therefore very unusual.[3] Its form at first appears to be that of a fish, and may be related to a fish which appears on a 9th-century piece of Iraqi blue-on-white ware in the Ashmolean Museum,[4] and to a small bronze flask in the form of a fish in the Bumiller collection.[5] However, the lock does not give the impression of being so old. Alternatively it may be related to the two fishes illustrating the sign of Pisces in an al-Sufi manuscript made in the 1440s for Ulugh Beg.[6] If this connection is real, then the lock could be Timurid. However, looked at vertically, the fish may also be interpreted as a *boteh*, the pear-shaped motif so common on Kashmir shawls, and hence Paisley designs. In that case it would be more recent, perhaps 17th- or 18th-century. One other Islamic fixed lock has been published. From India and dated AH 1242 (AD 1826–27), it is also in the shape of a fish, though in a quite different style.[7] Why the only two known fixed locks should both take this form is a mystery.

Because of their varying destinations, ranging from the great gates of caravanserais and the doors of private houses, to chests and tiny boxes, Iranian padlocks

* Tanavoli and Wertime (1976) is exhaustive on the subject of Iranian locks. It is impossible to repeat all their information here, and the interested reader is referred to their book for information about all known Iranian padlock forms, for the different mechanisms used, which are superbly illustrated, for more detailed discussions of the history of locks in Iran, and for Iranian locksmiths and the lock-smithing industry.

1. Fixed locks seem to have been rare, too, in other parts of the Islamic world. For two Ottoman examples, however, see Bodur (1987) p.149 A.139–40.
2. Chardin (1988) p.263.
3. Illustrated in Tanavoli and Wertime (1976) p.51 no.1.
4. Allan (1971) pl.6.
5. Bumiller (1993) p.76 Abb.27.
6. Gray (1979) p.160 and illustrations 97–99.
7. Stanley (1997) pp.374–75.

come in a wide variety of sizes. The largest illustrated here (N.2) is nearly 40 cm long, whereas the smallest examples are only some 3 cm square. The largest evidently had an architectural function, but the smaller varieties, although they could be used for fastening boxes and the like, had other uses, too. For, in Iran, padlocks have traditionally had great religious and folkloric significance.[8] For example, they are used, usually by women, as talismans, amulets or charms. In this case they are usually inscribed with magic letters or numbers (N.3). They are frequently attached to the grille of a shrine's tomb chamber by a pilgrim while making vows. And they are carried by mourners – piercing the skin of the chests of men and boys – during the procession of the Day of Ashura. The large padlocks which close the doors of tomb grilles in the shrines of the Imams also have more purpose than mere security, for they come in for special veneration. In his account of the grilles around the tomb of the Imam Riza in the shrine at Mashhad, Curzon describes how pilgrims 'kiss with unfeigned tenderness the fretwork of the grating, the pavement, and especially the great padlock which hangs from the door', while Sykes writes that 'every pilgrim, after holding and kissing the lock on his own account, must do likewise on behalf of his living relations and friends, whose petition to visit the shrine in person is thereby placed before His Highness.'[9]

Most small padlocks would have been the property of a single person. However, padlocks with multiple mechanisms and hence more than one key (such as N.18) could have been used not only by a single owner for greater security, but by multiple owners of a particular chest or box. This would have ensured that the item was only opened in the presence of all those who had rights to the contents.

The mechanisms used in Iranian padlocks are numerous: barbed-spring, bent-spring, helical-spring, shackle-spring, notched shackle, hook and revolving catch, notched shackle and rotating disks, and combination. To add further complication and deter thieves, many locks, as just mentioned, have multiple mechanisms. The various mechanisms have been fully described, and drawn, by Tanavoli and Wertime,[10] and the details will not be repeated here. One or several keys of different types (push, slide, screw or turn) are used to action the mechanism. The turn keys have one or two bits, and the screw keys have interior or exterior threads. Only a few locks in the Tanavoli collection work with a pin (e.g. N.4) and none in the collection has a keyless, letter-combination mechanism.

Small locks are very easy to carry and copy. As a result it is difficult to be sure where they were made, sometimes even in such broad terms as their country of ori-

8. Tanavoli and Wertime (1976) p.20; Torre (1984) pp.25–32.
9. Curzon (1892) vol.1 p.159; Sykes (1910) p.253.
10. Tanavoli and Wertime (1976) pp.30–46, who also illustrate many of the locks in the present book. See also the drawings in Torre (1984) pp.60, 79, 84, 98, 102, 132, 175, 177, 179, 183, 190 and 223, and Stanley (1997) pp.358 and 376.

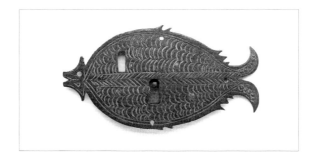

N.1 Fixed lock; pierced, incised, cut and riveted; l. 11.1 cm; no.531

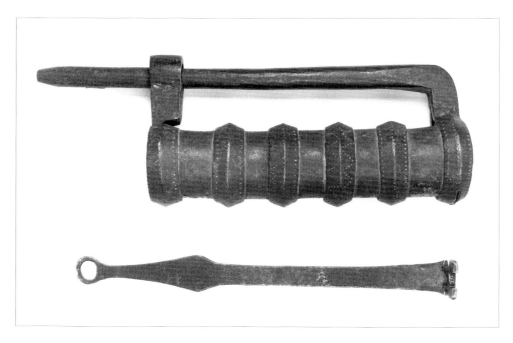

N.2 Massive padlock with barbed-spring mechanism; push key attached; pierced, riveted and punched; ht 14.5 cm; l. 39.5 cm; Azarbaijan, 15th–16th century; no.202

gin. There is indeed a wide distribution of specific types of lock throughout the world. For instance, the massive lock N.2 is ascribed here to Azerbaijan.[11] It is very similar, however, to one exhibited in the Science Museum, London, which was taken from the Old Wooden Gate of the City of Canton, demolished in 1911.[12] It can also be related to one from the Gate of Multan, in Pakistan,[13] and it is of the same shape as a 17th-century English lock used in the Royal Navy.[14] Pitt-Rivers suggests that this type of lock originated in the Roman period.[15] Similarly, spherical locks, like N.8–10, have been attributed to Europe as well as to the Middle East,[16] while locks in the form of a key have been attributed to Scandinavia as well as to Arabia.[17] As Wulff has already pointed out,[18] it is impossible at the present stage of knowledge to say with certainty where each type of lock originated and how it spread. On the other hand the more recent work of Tanavoli and Wertime has at least established likely Iranian centres for the manufacture of many of the known forms of lock, and it is assumed that the locks presented here are Iranian because they were acquired in Iran and because Iran is known to have had numerous centres producing a wide variety of locks over a long period of time.

Historically, almost every bazaar in Iran had a section devoted to lock-making. Tanavoli and Wertime noted the remains of such industries in a variety of centres: Chal Shutur near Shahr-i Kurd, south-west of Isfahan, had more than 30 locksmiths in the 1950s; the square in front of Shiraz's Shah Chiragh shrine was once dominated by locksmiths' shops catering for the pilgrim trade; handmade locks as a source of spare parts were still common in the old locksmiths' bazaar in Hamadan in the 1970s; in Tehran the locksmiths' bazaar was located in the small square in front of the Shah Mosque; in Zanjan, in the late 19th century, some 300 craftsmen are said to have been engaged in making locks for export to the rest of Iran; Kirind, a town west of Kirmanshah, used to be famous throughout Iran for its puzzle and combination locks.[19] In Isfahan, the locksmiths' bazaar was located next to that of the armourers.[20]

On the basis of the places where locks were acquired, Tanavoli and Wertime have ascribed particular forms to particular areas of Iran. Horse-locks are attributed to western Iran,[21] hence our ascription of N.12; a group of steel goat-shaped locks with bent-spring mechanisms, and a flat fish-shaped lock are ascribed to Isfahan

11. Tanavoli and Wertime (1976) no.134 p.93.
12. London, Science Museum, acc. no.1951.27.
13. Pitt-Rivers (1883) pl.VI figs 44c–46c.
14. Eras (1957) p.47 fig.61.
15. Pitt-Rivers (1883) p.19.
16. Hopkins (1928) p.92 fig.187; Eras (1957) p.32 fig.25; Sotheby's, Zurich, 7 May 1980, lot 106. For their manufacture in 18th-century France see

Duhamel du Monceau (1767) pl.XXXII.
17. Eras (1957) p.44 fig.54, p.46 fig.57.
18. Wulff (1966) p.66.
19. Tanavoli and Wertime (1976) p.16; Gluck (1977) pp.156, 158–59.
20. d'Allemagne (1911) vol.4 p.91.
21. Tanavoli and Wertime (1976) pp.59–63.

PERSIAN STEEL

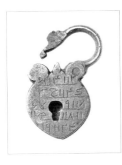 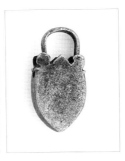 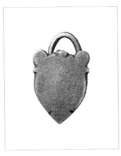 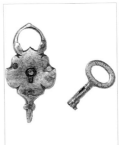

N.3 Padlock; bent-spring mechanism; pierced, incised and riveted; ht 4.4 cm; w. 2.7 cm; no.124
N.4 Padlock with barbed-spring mechanism (actioned by a pin key); cut and brazed; ht 3.9 cm; w. 2 cm; 18th–19th century; no.321
N.5 Padlock with barbed-spring mechanism (actioned by a pin key); cut and brazed; ht 3.2 cm; w. 1.8 cm; 18th–19th century; no.322
N.6 Padlock with bent-spring mechanism; cut, brazed and riveted; ht 3.8 cm; w. 1.9 cm; Isfahan or Shiraz, 17th–19th century; no.123

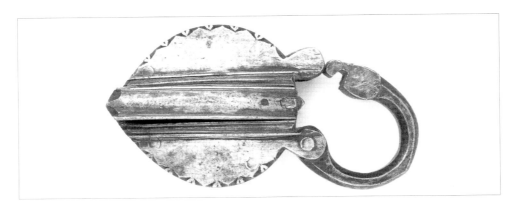

N.7 Padlock with bent-spring mechanism; cut, incised and riveted; ht 13.5 cm; w. 7.7 cm; Isfahan, 16th–17th century; no.118

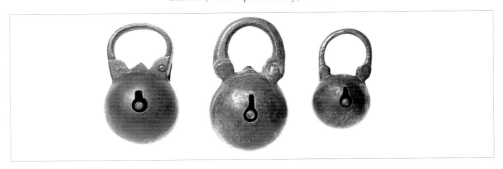

N.8–10 Three padlocks with bent-spring mechanism; cut, brazed and riveted; ht 6.8 cm; w. 3.9 cm (no.119); ht 6.3 cm; w. 3.7 cm (no.120); ht 5.2 cm; w. 2.9 cm; (no.121)

406

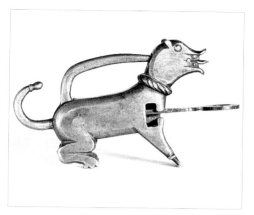 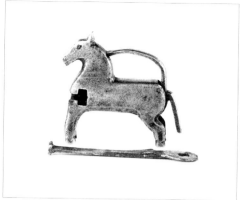

N.11 Padlock with barbed-spring mechanism; cut, brazed and riveted; overlaid with gold and set with semi-precious stones; ht 6 cm; l. 8.6 cm; Western Iran, 17th–19th century; no.318

N.12 Animal padlock with barbed-spring mechanism; cut, brazed and riveted; inlaid with brass; ht 5.5 cm; l. 5.8 cm; Zanjan–Qazvin area, 17th–19th century; no.132

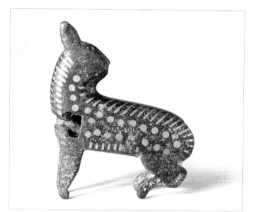 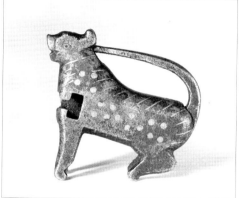

N.13 Animal padlock with barbed-spring mechanism (mechanism missing); cut, brazed and riveted; inlaid with brass; ht 5.9 cm; l. 4.6 cm; Zanjan–Qazvin area, 17th–19th century; no.100

N.14 Animal padlock with barbed-spring mechanism (mechanism missing); cut, brazed and riveted; inlaid with brass; ht 5.1 cm; l. 5.5 cm; Zanjan–Qazvin area, 17th–19th century; no.133

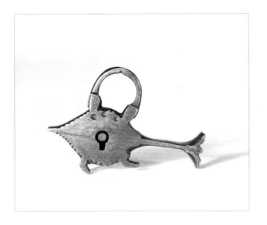
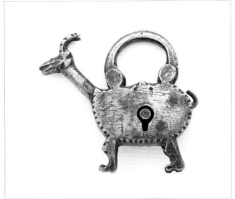

N.15 Padlock with bent-spring mechanism; cut, punched, brazed and riveted; ht 3.1 cm; w. 5.4 cm; mostly Isfahan or Shiraz, 17th–19th century; no.131

N.16 Padlock with bent-spring mechanism; cut, brazed and riveted; ht 5.1 cm; w. 5.5 cm; Isfahan or Shiraz, 17th–19th century; no.129

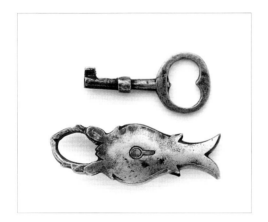
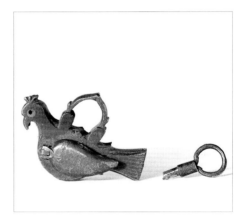

N.17 Padlock with bent-spring mechanism; cut, brazed and riveted; ht 5 cm; w. 1.9 cm; Isfahan or Shiraz, 17th–19th century; no.288

N.18 Padlock with multiple mechanism; cut, pierced, brazed and riveted; ht 3.8 cm; l. 5 cm; Shiraz, 17th–18th century; no.192

and Shiraz,²² hence N.15–17; three other goat-shaped locks with a side shackle inserted into the mouth of the animal's backward-facing head come from the Zanjan–Qazvin area,²³ hence our ascription of lock N.13, and with it N.11 and N.14; bird locks, particularly those with multiple mechanisms, are typical of Shiraz,²⁴ hence N.18; cradle locks probably come from central Iran,²⁵ hence N.19 and N.20; large barbed-spring locks are attributed to Azarbaijan,²⁶ hence N.2; locks which relate to art of the period of Shah 'Abbas either in terms of their shape, chiselled surface decoration or age, called 'Shah 'Abbasi' locks, probably come from Isfahan;²⁷ heart-shaped locks come from central and south-eastern Iran – Isfahan and Abarquh in particular,²⁸ hence our ascription of locks N.5 and N.7, though the mechanisms of these two are different from each other; locks with wheel-like plaques or pierced steel pendants seem to be Shirazi,²⁹ hence N.21; a group of helical- and bent-spring locks in the shape of half a pipe come from Fars, especially Shiraz,³⁰ hence N.22; a series of shrine locks from Isfahan,³¹ hence N.24 and N.23, N.25³² and N.26; a group of small steel locks with bent-spring mechanism from Isfahan;³³ a group of locks in the form of a dervish bowl or crescent from Isfahan and Shiraz,³⁴ hence N.27; puzzle locks from central Iran,³⁵ hence N.28 and N.29; kettle locks with notched-shackle, revolving-disk, and helical-spring mechanisms from Hamadan and central Iran,³⁶ hence N.30; ball, or spherical, locks from Fars³⁷ (but see below); octagonal locks from western Iran, mainly Zanjan,³⁸ hence N.31; a type of handbag lock from the Kashan area;³⁹ a form of lock with a horseshoe-shaped top shackle which appears to be connected to a small lock body through which a pipe runs, to Chal Shutur;⁴⁰ a lock in

22. Tanavoli and Wertime (1976) p.78. For other illustrations see Torre (1984) nos 174–77, 179–80, and Stanley (1997) p.378.
23. Tanavoli and Wertime (1976) p.78. For other similar animal locks see Torre (1984) nos.150–71, Stanley (1997) pp.370–74.
24. Tanavoli and Wertime (1976) p.72, and p.68 pl.IV; Torre (1984) nos 181–82.
25. Tanavoli and Wertime (1976) p.92.
26. Tanavoli and Wertime (1976) p.93. For two examples probably from India, see Stanley (1997) pp.366–67.
27. Tanavoli and Wertime (1976) p.94–95.
28. Tanavoli and Wertime (1976) p.96.
29. Tanavoli and Wertime (1976) p.100.
30. Tanavoli and Wertime (1976) p.104–105. Abdullayev *et al.* (1986) p.63 no.29 illustrates a lock of somewhat similar form, but fully cylindrical, and ascribes it to Kokand, 1882–83.
31. Tanavoli and Wertime (1976) p.106–109; other examples are illustrated by d'Allemagne (1911) vol.2 p.88; Torre (1984) no.7; Stanley (1997) pp.360–63.
32. A lock similar to no.104 is illustrated by Pitt-Rivers (1883), Pl. VI fig. 53C, and attributed to contemporary Myhere, India.
33. Tanavoli and Wertime (1976) p.110–11.
34. Tanavoli and Wertime (1976) p.112–13. For another example see Stanley (1997) p.378.
35. Tanavoli and Wertime (1976) pp.118–19 and for a drawing of the mechanism p.40 fig.21. For other such locks see Eras (1957) p.46 fig.57; Torre (1984) nos 148–49.
36. Tanavoli and Wertime (1976) p.120–21; Torre (1984) nos 144–46.
37. Tanavoli and Wertime (1976) p.122. For other examples see Stanley (1997) p.381.
38. Tanavoli and Wertime (1976) pp.128–29.
39. Tanavoli and Wertime (1976) p.134.
40. Tanavoli and Wertime (1976) pp.138–39; Gluck (1977) p.159.

the shape of a dumbell to Central Iran,[41] hence N.32; a rectangular style of lock with helical-spring mechanism to western Iran;[42] multiple-mechanism locks with pipe-shaped bodies and one or more tubular extensions coming out of them at right angles, from Ardabil,[43] hence N.33 and N.34.

A small amount of additional help in identifying the source of locks comes from the *Jughrafiya-yi Isfahan*, completed in 1891. According to its author, Mirza Husain Khan, there was in his time a group of locksmiths in Isfahan who made spherical locks (*quflha-yi qulva*) and screw locks (*miyan-i pich*), while others made locks for jewellery boxes, caskets and chests.[44] The 'spherical locks' are self-explanatory, suggesting that their manufacture was not confined to Fars, as implied above, but also extended to Isfahan, hence N.9 and N.10; the 'screw locks' are most likely to have been locks with helical-screw mechanisms, but more than that one cannot say.

The dating of the groups is highly tentative and highly subjective. We have followed Tanavoli and Wertime's datings except in the following cases. Among the animal-shaped locks, we suggest the more naturalistic animals are 17th- to 18th-century, while the less so are 18th- to 19th-century. On the basis of their decoration two of the Isfahan shrine locks almost certainly date from the 17th to 18th centuries. N.24 has an inscription relating the padlock to its function: 'By the truth of, "I testify that there is no god but God", may this threshold be ever open in felicity.' It is illustrated by Tanavoli and Wertime, who date it to the 16th to 17th centuries.[45] However, its calligraphy and border pattern suggest that the 17th century is more likely. So too with the palmettes and border pattern of N.23. The other two (N.25 and N.26) we have dated more broadly to the 17th to 19th century. The locks in the form of goats and fishes (N.15 and N.16) are dated by Tanavoli and Wertime to the 17th to 18th centuries. We would prefer to broaden that dating to the 17th to 19th centuries. A lock in the form of a dervish bowl (N.27) they date to the 17th century.[46] A later dating is preferred here. A broader dating is also preferred for the palmette-shaped locks (N.3 and N.6), the second of which was published as 18th-century.[47] The one example of a kettle lock with helical-spring mechanism (N.30) we date to the 19th century on the basis of its goldwork.

The slide keys in the catalogue (N.35–38) come from locks with barbed-spring mechanisms, and demonstrate the elaborate shapes that were devised for this pur-

41. Tanavoli and Wertime (1976) p.146 no.431; its mechanism is described p.39 fig.18.
42. Tanavoli and Wertime (1976) pp.140–43
43. Tanavoli and Wertime (1976) pp.144–45; Gluck (1977) p.160. The same shape has also been attributed to Europe e.g. Eras (1957) p.47 fig. 60, where one is described as Spanish.
44. Floor (1971) p.103.
45. Tanavoli and Wertime (1976) p.107 no.214.
46. Tanavoli and Wertime (1976) p.112 no.228.
47. Tanavoli and Wertime (1976) p.124 no.300. For others like this see Stanley (1997) pp.378–79.

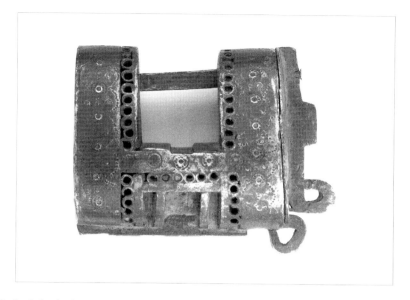

N.19 Padlock; barbed-spring mechanism; drilled, cut, punched, overlaid with copper, and welded; ht 8.5 cm; l. 10.4 cm; no.117

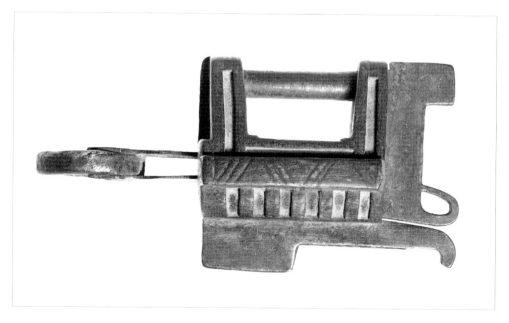

N.20 Padlock in the form of a cradle, with barbed-spring mechanism; slide key attached; cut, incised and welded; ht 8.5 cm; l. 10 cm; Central Iran, 16th–17th century; no.293

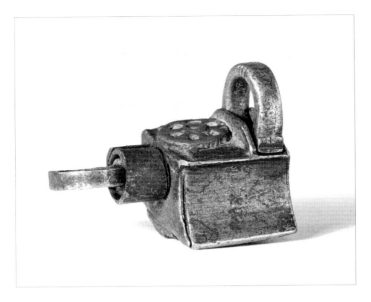

N.21 Padlock with helical mechanism; cut, pierced, brazed and riveted; ht 3.6 cm; w. 3.1 cm; Shiraz, 16th–17th century; no.122

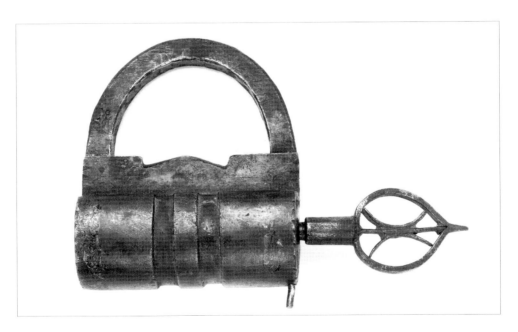

N.22 Padlock; helical spring mechanism; cut, welded and riveted; ht 13 cm; l. 11 cm; no.116

LOCKS AND PADLOCKS

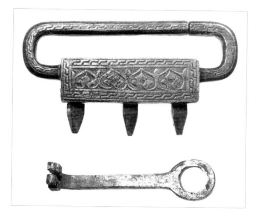
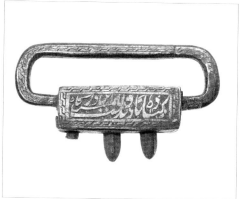

N.23 Shrine padlock with barbed-spring mechanism; cut, chiselled, incised, brazed and riveted; ht 6.7 cm; l. 11.8 cm; Isfahan; 17th century; no.291

N.24 Shrine padlock with barbed-spring mechanism; cut, chiselled, incised, brazed and riveted; ht 6.7 cm; l. 10.3 cm; Isfahan; 17th century; no.107

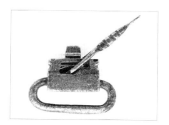

N.25 Padlock with barbed-spring mechanism (with slide key); cut and brazed; ht 2.5 cm; w. 3 cm; 18th–19th century; no.324

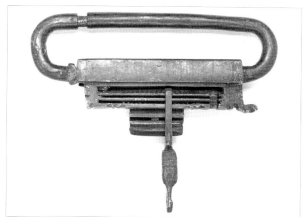

N.26 Large padlock with barbed-spring mechanism; slide key attached; cut, pierced, incised and welded; ht 14 cm; l. 27 cm; Isfahan, 17th–19th century; no.104

413

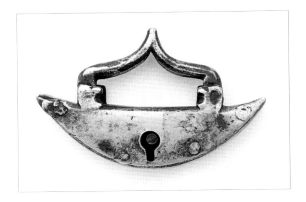

N.27 Padlock with bent-spring mechanism; cut, brazed and riveted; ht 4.4 cm; w. 6.8 cm; Isfahan or Shiraz, 17th–19th century; no.285

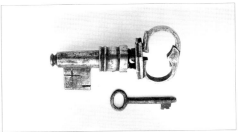

N.28 Padlock with notched shackle mechanism; cut, brazed and riveted; Central Iran, 18th–19th century; ht 6 cm; w. 3.4 cm; no.98

N.29 Padlock with notched shackle mechanism; cut, brazed and riveted; Central Iran, 18th–19th century; ht 7.3 cm; w. 3.3 cm; no.292

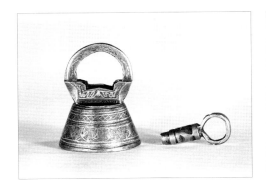
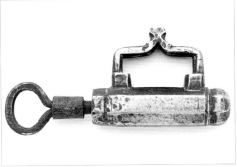

N.30 Padlock with helical mechanism; cut, brazed and riveted; overlaid with gold and silver; ht 3.8 cm; w. 2.8 cm; Central Iran, 19th century; no.320

N.31 Padlock with helical mechanism; cut, brazed and riveted; ht 4.8 cm; w. 6.3 cm; Western Iran, probably Zanjan, 18th–19th century; no.286

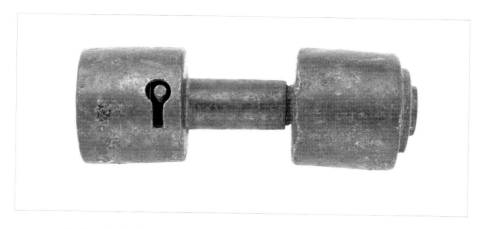

N.32 Padlock; helical-spring mechanism; cut and brazed; ht 4.5 cm; l. 12.5 cm; no.134

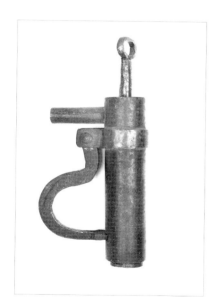 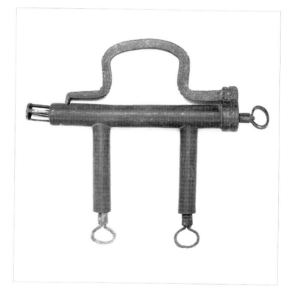

N.33 Padlock with multiple mechanism; cut, welded and riveted; ht 13.5 cm; l. 21.5 cm; no.112
N.34 Padlock; multiple mechanism, one barbed-spring and two helical-spring; three keys; cut, welded and riveted; ht 19 cm; l. 20.3 cm; no.115

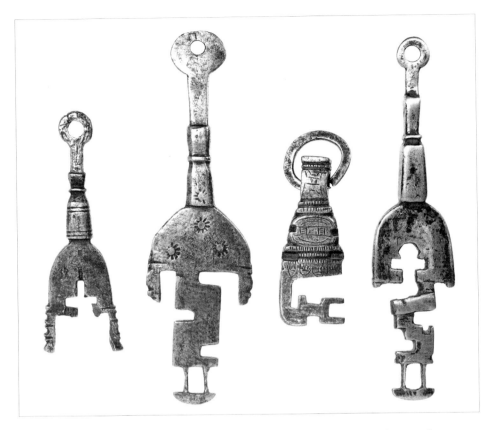

N.35–38 Four slide keys used for barbed-spring mechanism; cut and stamped;
l. 9 cm (no.111); l. 13.8 cm (no.108); l. 7.2 cm (no.110); l. 13.5 cm (no.109)

pose.[48] The origin of two of these keys (N.36 and N.38) is uncertain, for although acquired in Iran, they both bear stamps. The star-shaped stamps on N.36, in particular, are to be found on 18th- to 19th-century tinned copper objects of Ottoman origin.[49] Some at least of these may have been made in Ottoman Iraq, and these keys, and the locks that once went with them, could therefore have been imports. On the other hand, Iranian gunsmiths and armourers used stamps with their names cut in them, and there could have been a tradition for stamped designs in Iran as well.

Turning to the locksmiths themselves, according to the researches of Tanavoli and Wertime some produced nothing but locks, while others were blacksmiths who made other implements as well.[50] D'Allemagne noted the latter type in Isfahan, where he observed some who made door- and shutter-handles, and scissors, as well

48. Cf. the keys illustrated in Torre (1984) pp.240-43.
49. See Allan (forthcoming).
50. Tanavoli and Wertime (1976) pp.16–19.

as locks.⁵¹ Some locksmiths were so famous nationally that their names have been recorded for posterity. Yaqut, for example, records a locksmith by the name of Abu Bakr 'Abd al-Rahman ibn Ahmad ibn 'Abd Allah al-Marwazi al-Qaffal, who was a famous locksmith and legal scholar in Merv in the second half of the 4th century AH (10th century AD). According to Yaqut, a Shash locksmith made a lock which, with its key, only weighed a *daniq* (one sixth of a *mithqal*). This work excited universal admiration and Abu Bakr, not to be outdone, made a lock which weighed a quarter of a *daniq*. His skill went almost unnoticed, however, and when he complained to his friends he was told, 'fame comes through knowledge of science, not padlocks.'⁵²

Much later, in the mid-16th century, the Safavid prince Sam Mirza described a contemporary locksmith, Maulana Ustadh Nuri Quflgar: 'He was among the great ones of his time and rare ones of his age. In the craft of lockmaking he was so outstanding that he made twelve locks of steel, [each one of which] would fit inside the shell of a pistachio nut. And there was a key for each of these locks.'⁵³ Such fame is rare, however. The names of most locksmiths have remained unrecorded, though they have occasionally drawn attention to their skills. As the inscription on an Isfahan lock in the Mashhad Shrine Museum says: 'The fashioning of a lock like this requires effort and skill. All crafts when compared to lockmaking are nothing …'⁵⁴ D'Allemagne even records a musical lock.⁵⁵

The oldest padlock found in Iran, now in the Iran Bastan Museum, Tehran,⁵⁶ was excavated from a late Sasanian site, dated to the 5th to 6th century AD. It is of steel, with a small segment in the centre of the body of cast copper alloy. Its push key is entirely of steel. The padlock is rectangular, with a top shackle actioned by a barbed-spring mechanism. On the basis of this find, Tanavoli and Wertime suggested three other locks using the same mechanism, which could also be pre-Islamic in date – two of copper alloy, one of steel.⁵⁷ The top-shackle, barbed-spring lock was certainly a form well known and widely used in the Islamic period. For example, an important and very large 15th-century steel lock of this form, bearing the name of the Aq Qoyunlu ruler Hamza (1435–44), comes from the citadel at Mardin.⁵⁸ The roundel with two floral projections which embellish the body of this lock, and the division of the roundel into three parts, show distinct Mamluk influence, and it was most probably made in Mardin itself. On the other hand the Aq Qoyunlu ruled

51. d'Allemagne (1911) vol.4 p.97: for such handles see the illustration by d'Allemagne (1911) vol.2 p.89.
52. Yaqut vol.4 pp.511–12, trans. p.532.
53. Tanavoli and Wertime (1976) p.19.
54. Tanavoli and Wertime (1976) p.108.
55. d'Allemagne (1911) vol.3 p.190.
56. Tanavoli and Wertime (1976) p.53 ill.14.
57. Tanavoli and Wertime (1976) pp.55–57, locks no.3, 5 and 6.
58. Etem (1936), pp.141–47; Sözen (1981) fig.1. The lock weighs 6 kilos and is 53.5 cm long. For the significance of its design see Allan (1991a) pp.153–54 (for Edhem in n.6 read Etem).

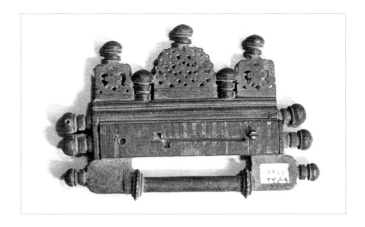

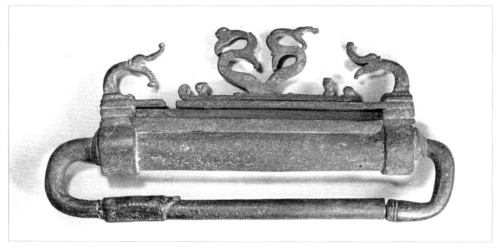

FIG.56 Padlock inlaid with brass bands; multiple mechanism; l. 19 cm; ht. 13 cm; Isfahan, 16th–17th century. Tehran, Iran Bastan Museum, acc. no.8349. (Photo: J.W. Allan)

FIG.57 Padlock, barbed-spring mechanism and slide key; l. 40 cm; ht. 20 cm; Isfahan, 17th–18th century. Tehran, Iran Bastan Museum, acc. no.8320. (Photo: J.W. Allan)

western and north-western Iran as well as eastern Anatolia, and there is little doubt that it represents a type of lock also in use in Iran at that period. The popularity of this form in the Islamic world, at least from the 15th century onwards, is established by the fact that Ka'aba locks were regularly of the top-shackle, barbed-spring type, beginning with a lock of the Mamluk Sultan Faraj dated AH 804 (AD 1401–2), and continuing with a series of Ottoman locks, dated AH 973 (AD 1565–66), AH 1002 (AD 1593–94), AH 1039 (1629–30), and AH 1056 (AD 1646).[59] The earlier forms of Ka'aba lock do not survive, but the numerous surviving Ka'aba keys predating the Ottoman period show that, whatever their design, they too used the barbed-spring

mechanism. These keys also establish the use of iron or steel for earlier locks, the earliest such steel key surviving being dated AH 555 (AD 1160) and signed by the locksmith Ilyas ibn Yusuf ibn Ahmad al-Makki.[60]

The Ka'aba locks also include what appear to be locks with barbed-spring mechanism and slide key, for example, two dated AH 915 (AD 1509) and one dated to the reign of Sultan Ahmed I (1603–17).[61] These are similar in mechanism and design to the Isfahan shrine locks, especially that made by Aqa Kuchek in the 17th or 18th century for the Shrine of the Imam Riza at Mashhad,[62] suggesting that there were accepted forms of lock for particular functions over a wider area of the Islamic world than Iran alone.

It is worth drawing attention here to two other Isfahan shrine locks now in the Iran Bastan Museum in Tehran (FIGS 56 and 57). One is similar in form and technique to Aqa Kuchek's lock for the Mashhad Shrine, but is decorated with openwork and brass strips. The designs of the two smaller pierced plaques recall a particular form of *alam*, and could well indicate a 16th- to 17th-century date. The other lock in the Iran Bastan Museum, with barbed-spring mechanism and slide key, is reminiscent of the second Mashhad Shrine lock illustrated by Tanavoli and Wertime,[63] which is dated AH 1064 (AD 1653–54), or possibly AH 1337 (AD 1918–19). It could equally well be 17th-century, or possibly slightly later.

Although pre-Islamic locks from Iran are few and far between, there are locks other than the barbed-spring variety mentioned above, which seem to pre-date the steel examples in this catalogue. They are of copper alloy, and take the form of horses, lions, goats or birds.[64] In some cases they bear decoration indicating a broadly Saljuq dating, to the 11th to 13th centuries. As a result, it seems that many of the surviving steel examples look back to earlier copper alloy prototypes, and consquently that steel locks only become widespread from Timurid or Safavid times onwards. It should not be assumed, however, that copper alloys were no longer used once steel had been introduced. An 18th-century brass bird with helical-spring mechanism,[65] and a 17th- to 18th-century brass goat with barbed-spring mecha-

59. Sourdel-Thomine (1971) nos 13, 16, 18, 20, 21; the lock dated AH 973 (AD 1565–66) is also illustrated in Rogers and Ward (1988) no.64 (which gives further references); the lock dated AH 1056 (AD 1646) is published in *The Anatolian Civilisations* (1983) vol.3 pp.259–60 no.E.263.
60. Sourdel-Thomine (1971) no.1; Ilyas may have been the decorator rather than the locksmith.
61. Sourdel-Thomine (1971) pl.VIII nos 14–15, pl.X no.19.
62. Tanavoli and Wertime (1976) p.108 illus.16.

This is probably the same lock as item no.107 in the Mashhad Shrine Museum catalogue, Anon (n.d.) p.52.
63. Tanavoli and Wertime (1976) p.109 illus. 17.
64. Tanavoli and Wertime (1976): horses pp.59–60 nos 13, 19, 28; lions pp.64–70 nos 40, 43, 49, 50, 54 (pl.3), 58; goat p.78 no.102; birds pp.72–73 nos 67, 70.
65. Tanavoli and Wertime (1976) p.75 no.90.

nism,⁶⁶ show that though they were less popular, locks continued to be made in non-ferrous metals.

Comparison of pre-Islamic Iranian, medieval Iranian, Mamluk and Ottoman padlocks with more recent examples produced in Iran, in whatever metal, emphasises the continuity of production in lockmaking in the Near East from pre-Islamic times to the 20th century. This in its turn explains why exact dating of what seem to be much later examples is often so difficult.

66. Tanavoli and Wertime (1976) p.80 no.108.

Household objects

FOOD AND DRINK

The Tanavoli collection contains a number of items relating to food and drink: a mouse-shaped hook, a pestle, a rice spoon, a cup, a saucer and a large number of sugar axes. Two meat cleavers and a sharpening steel are catalogued elsewhere, as butcher's implements.

The mouse-shaped hook (o.1) is included here because of the obvious association of mice with food. However, it is a somewhat enigmatic object, in that the hole in the mouse's back is shaped as though the item were to be hung horizontally, whereas the hook-shaped tail requires it to be hung vertically.

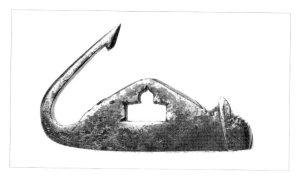

o.1 Hook; cut, incised and pierced; l. 5.4 cm; 17th–19th century; no.54

The cup (o.2) was probably used for coffee. Coffee was introduced into Iran sometime in the 16th century, and by the 17th century had become a normal part of Safavid court routine, being served both before and after meals.[6] It was drunk from small ceramic cups in metal holders, and large quantities of porcelain coffee cups were imported into Iran from the Far East by the Dutch East India Company. In the early 19th century Ouseley records a reception at which coffee was served on a tray in 'several fine china cups without handles, each in a filigree receptacle, silver or

6. For the history of the drink in Iran see Al-e Dawud (1992).

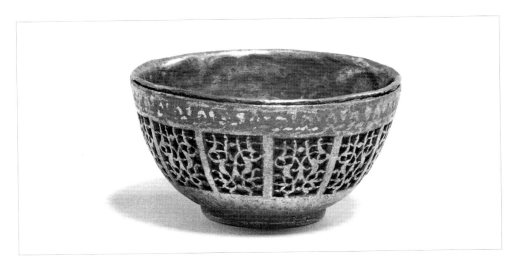

0.2 Cup; pierced, brazed and overlaid with gold; d. 5.4 cm; ht 3 cm;
late 18th–early 19th century; no.172

silver gilt, of the same form.'⁷ The Tanavoli object is both cup and receptacle, the two being brazed together, and was presumably made in imitation of the porcelain and silver combination. The cups mentioned by Ouseley must have had saucers, for the tea cups he saw were larger porcelain bowls 'but without saucers'. Whether 0.3 is a steel saucer is unclear. It is certainly too big to have belonged to a cup of the size of 0.2, but it must have been designed to hold another vessel of some sort for its pierced design makes it non-functional as a plate. A saucer with a cup or small bowl seated on it, probably enamel, is shown in a 19th-century miniature which appeared on the art market some time ago.⁸ Another such steel saucer, of almost identical size, is in Kuwait. It has a pierced plaque riveted in the centre bearing an inscription with the words *tawakhil 'ala 'llah fi kulii 'l-umur* ('rely on God in all matters').⁹ Like the latter, 0.3 is probably 18th-century, while 0.2 may be late 18th- or early 19th-century. Coffee-cup saucers of steel were made in Isfahan, according to Mirza Husain Khan, but he gives no indication of what they looked like. However, he does note that the makers of these and other steel items, who were members of the guild of steel-workers (*fuladgar*), were prospering, and that there was a demand for their work both inside Iran and in Turkey and Egypt.¹⁰

The spoon for serving pilau (0.4) has a handle so finely cut that it may well have been turned on a lathe. The shallow bowl of the spoon bears the words *subhar allah*

7. Ouseley (1819–23) vol.3 p.142.
8. Christie's, 24 April 1990, lot 137.
9. Jenkins (1983) p.136; d. 13.8 cm. For a similar pierced steel plaque in Washington, DC, Freer Gallery of Art, see Atıl, Chase and Jett (1985) no.30.
10. Floor (1971) p.91.

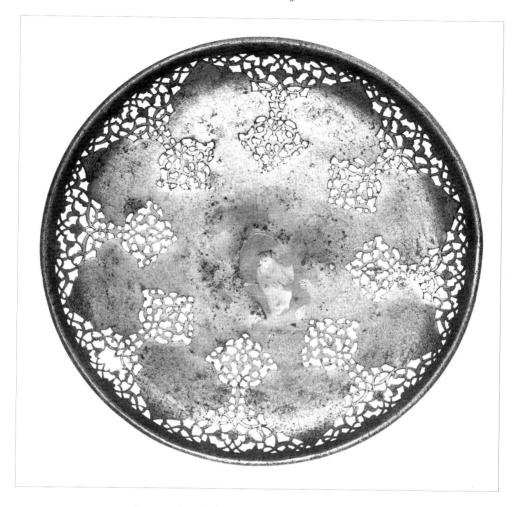

o.3 Saucer; pierced; d. 13 cm; ht 1.4 cm; 18th century; no.173

rabb al-'alamain ('Praise to God, lord of the worlds') in gold overlay. The style of the inscription points to a 19th-century date, and probably the later half of the 19th century. A 19th-century ladle is in the Victoria and Albert Museum.[11] There are two other, smaller spoons in the collection, o.5 and o.6. The former is almost flat, like the larger pilau server, but the latter has a much deeper bowl suitable for liquids as well as solids.

11. London, Victoria and Albert Museum, acc. no.407-'76, l. 27.9 cm, d. 13.7 cm; Murdoch Smith (1885) p.89.

The pestle (o.7) is heavily decorated with plants and arabesques, but also bears four seated figures in a frieze below the knop, and two more, alternating with the inscriptions, around the central bulge. One of the inscriptions gives the date AH 1207 (AD 1792–93), the other reads *'attar isfahani* ('Isfahani druggist') suggesting that the pestle was the property of an Isfahani dealer in perfumes and drugs, and was used for pounding his medicinal concoctions.

Two of the sugar axes (o.8 and o.9)[12] have extraordinary heads. That of o.8 is in the form of a naked, moustached man sitting on the top of the blade. He wears a top hat and is reading a book. A small dog is standing beside him, a clear sign of his not being a Muslim, and a small bird is emerging from between his legs, evidently representing, or in place of, his penis. On o.9 the man – also naked and wearing a hat – sits astride the axe blade, and his hands are missing, so it is not possible to tell whether he too was originally reading a book. The leaves of the book on o.8 are inscribed with four lines of numbers, not letters, suggesting that the book is some sort of ledger.

The man is clearly a Westerner, but his nationality is uncertain. Top hats were devised at the very end of the 18th century, and went through various styles during the 19th century. For example, the Wellington, whose crown was wider at the top and curved inwards towards the brim, was popular from the 1820s to the 1840s, while the stove-pipe, with its tall crown and more vertical sides, was popular in the mid-19th century.[13] The top hat on the sugar axes seems to be closest to a late 19th-century form.[14] About this time William Fogg visited Egypt and, purchasing a fez in the Cairo bazaar, commented: 'English travelers are everywhere the least inclined to adopt the costume or language of a foreign country and are made to pay accordingly ... Here the nationality of a stove pipe hat is recognised on sight.'[15] Hence, the figures on the sugar axes are presumably satirical representations of Westerners, but who produced them, who purchased them and precisely why they were manufactured remains unclear. The other sugar cutters (o.10–16) are all 19th- or 20th-century, and illustrate a few examples of the wide variety of designs used in different towns and cities in Iran.[16] Unfortunately no specific attributions are yet possible.

It is worth drawing attention to one spectacular steel object relating to food in the Khalili collection.[17] This is a sherbet spoon which, in its form, structure and pierced designs, copies the pear and boxwood sherbet spoons manufactured during the 18th and 19th centuries at Abadeh,[18] Kumaisha[19] and Istahbunat.[20]

12. No.50 is illustrated in Gluck (1977) p.155 as possibly a leather cutter.
13. Clark (1982) pp.38–40, 91.
14. Clark (1982) fig.29.
15. Fogg (1875) p.47.

16. *Cf.* Gluck (1977) pl. on p.155, which illustrates nos 50, 84, 86, and two additional styles.
17. Vernoit (1997) no.97 pp.158–59.
18. See Wills (1883) p.332; (1886) pp.147–50; Curzon (1892) vol.1 p.108; Collins (1896) pp.111–12;

HOUSEHOLD OBJECTS

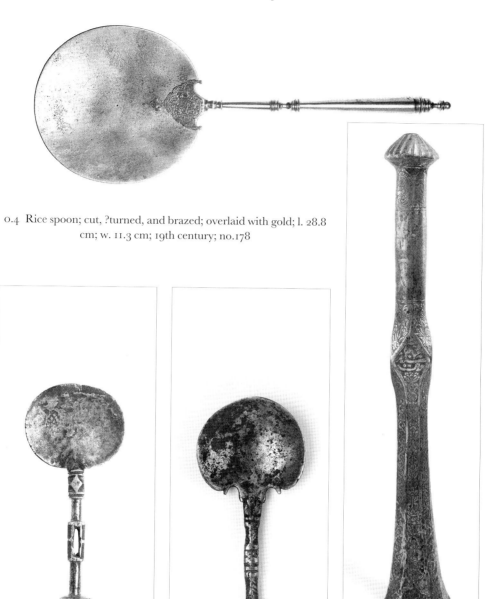

0.4 Rice spoon; cut, ?turned, and brazed; overlaid with gold; l. 28.8 cm; w. 11.3 cm; 19th century; no.178

0.5 Spoon; cut and pierced; l. 11.6 cm; w. 4.9 cm; 19th century; no.55
0.6 Spoon; cut; l. 10.5 cm; w. 5 cm; 19th century; no.226
0.7 Pestle; chiselled; ht 43 cm; diam. of base 6 cm; dated AH 1207 (AD 1792–93); no.41

425

Knives of varying forms are discussed elsewhere in this book, and types suitable for use at meals would have been produced in many different centres. The only record of local production comes from Mirza Husain Khan, who describes those of Isfahan in the late 19th century: 'They make knives with black bone handles for eating fruit, etc. The knives are sharp, of good quality and of an elegant form, both of cast iron (*ahan-i khushkeh*) and of steel (*fulad*).'[21] There are no examples of knives with black bone handles in the Tanavoli collection.

MISCELLANEOUS OBJECTS

Candle-snuffers like O. 17, which include both scissors for trimming the wick and a box for suffocating the flame, were probably introduced into Iran from Europe. On the reverse of this pair is an inscription in gold overlay, which seems to include the word *al-mu'minin* ('the believers'), and a possible date, AH 1240 (AD 1824–25).[22] A similar pair is in the Khalili collection,[23] and a slightly different style from Samarqand has been published.[24] Both the latter date from the 19th century.

O. 18 appears to be a pair of nutcrackers. The nut would have been placed between the ring shoulder of one arm and the disc-shaped shoulder with projecting screw head of the other. The precise use of the beaked bird's head, and the trough into which the beak dips when the nutcrackers are closed, is unclear. Some sort of de-stoning function for particular small fruits such as olives or cherries may have been intended, and indeed the nutcracking function ascribed to the arms may also have been for de-stoning.

Watch-cases are not represented in this collection, but deserve mention, as they seem sometimes to have been made in Iran of pierced steel. There is one in the Harari collection dated AH 1124 (AD 1712),[25] and a convex roundel recently on the art market may have been part of another.[26]

O. 19 could be the tail of a late 18th- or early 19th-century ornamental bird, but appears to have been used in more recent times as a shoe horn. The history of shoe-horns in Iran has to be written. Suffice it here to note that the Tanavoli collection also contains two copper alloy shoe-horns: one has a handle which appears to be in the form of a duck's head, the handle of the other is in the form of an eagle's head, and their dating is uncertain (FIGS 58 and 59).

Crawshay Williams (1907) pp.270–72.
19. Binning (1857) vol.2 p.7.
20. Ouseley (1819–23) vol.2 p.169; Binning (1857) vol.1 p.291.
21. Floor (1971) p.110.
22. It is conceivable that the figures should be read as AH 1204 (AD 1789–90).
23. Stanley (1997) pp.118–19, TII.
24. Abdullayev *et al.* (1986) pl.24.
25. Pope (1938–39) pl.1390G.
26. Christie's, 24 April 1990, lot 432.

HOUSEHOLD OBJECTS

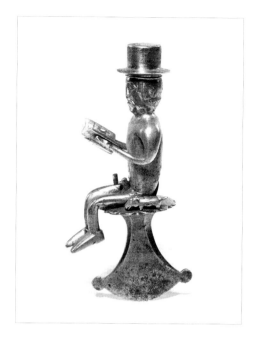

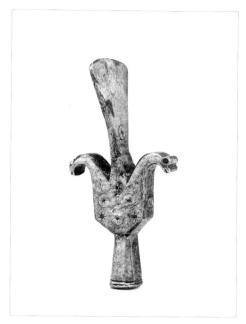

0.8 Sugar axe head; cut, chased and riveted; handle broken; ht 12.7 cm; late 19th century; no.50
0.10 Sugar axe head; cut, drilled and incised; remains of riveted handle shaft; ht 11.5 cm; 19th–20th century; no.84

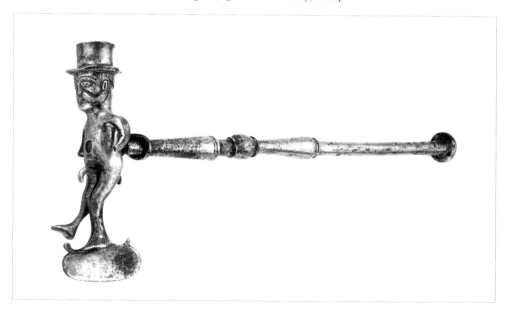

0.9 Sugar axe; cut, chased and riveted; screw handle; ht 11.5 cm; l. 27.3 cm; late 19th century; no.91

427

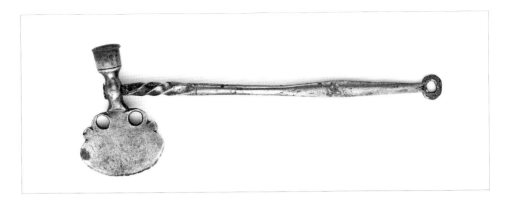

0.11 Sugar axe; shaft partly twisted; cut, pierced, brazed and riveted; l. 23.5 cm; 19th–20th century; no.87

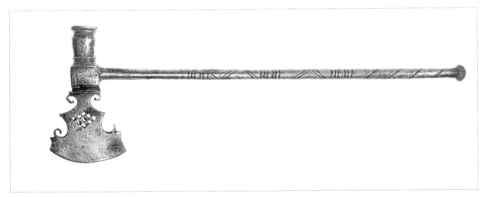

0.12 Sugar axe; cut, pierced and braised; ht 8.8 cm; l. 26.2 cm; 19th–20th century; no.89

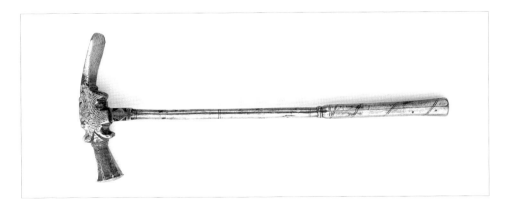

0.13 Sugar axe; cut and incised; head riveted on; ht. 11 cm; l. 26.7 cm; 19th–20th century; no.93

HOUSEHOLD OBJECTS

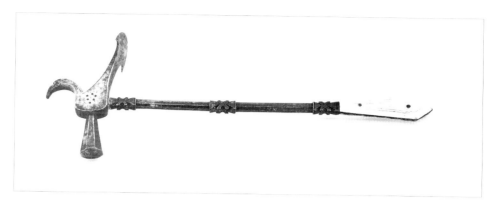

0.14 Sugar axe; cut, incised and drilled; ivory or bone bolsters; ht 11.5 cm; l. 32.5 cm; 19th–20th century; no.86

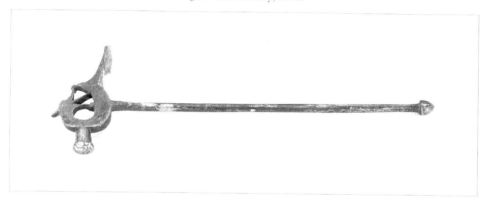

0.15 Sugar axe; cut, pierced and incised; head welded on; ht 8.8 cm; l. 27.2 cm; 19th–20th century; no.88

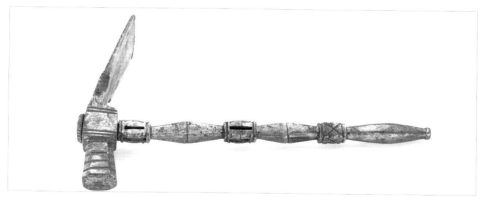

0.16 Sugar axe; cut, pierced, incised and riveted; l. 31.5 cm; 19th–20th century; no.92

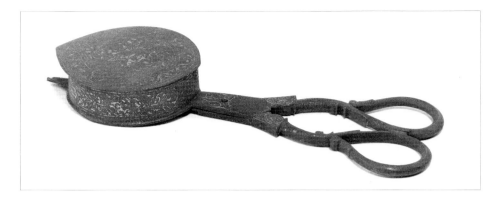

0.17 Candle-snuffer and wick-trimmer; cut, brazed and riveted; overlaid with gold; l. 20.8 cm possibly dated AH 1240 (AD 1824–25); no.268

DECORATIVE ORNAMENTS

During the second half of the 19th century, a new range of shapes became popular among both the steel-workers and their clientele. These included mirrors on stands, one of the finest examples of which is in the name of Nasir al-Din Shah (see pp.471–72); long-necked vases, some with stoppers, copying Western glass shapes;[27] elegant ewers and accompanying basins;[28] candlesticks with large domical knops half-way up the stem;[29] heavily decorated free-standing figurines in the shape of peacocks with oval or circular tails,[30] cockerels and geese,[31] ducks (FIG.60), birds of prey on perches,[32] deer with splendid antlers,[33] elephants[34] and camels;[35] lidded bowls;[36] lidded urns,[37] and so on. Many of these have continued to be made into recent times.[38]

Many of these were clearly influenced by Western taste, and were purchased and used by Europeans in Iran to put in their houses. Thus, in the Fahie collection there are photographs showing the interiors of the houses of Baron Norman and Dr Baker, both of which include rooms decorated with steel peacocks, elephants and

27. For example, Sotheby's, 20 October 1994, lot 162.
28. For example, Sotheby's, 20 October 1994, lot 164.
29. For example, Sotheby's, 20 October 1994, lot 162. These are also found in enamel, for example, Sotheby's, 28 April 1994, lot 231.
30. For example, Ward (1993) pl.96. A peacock signed by Hajji 'Abbas Isfahani is in the National Museum, Tehran; *An Anthology from the Islamic Period Art* (1996) acc. no.21871.
31. For example, Sotheby's, Geneva, 25 June 1985, lot 275; Sotheby's, 26 April 1982, lot 37.
32. For example, Balsiger and Klāy (1992) p.166;

Christie's, 23 April 1996, lot 121.
33. For example, Sotheby's, 30 April 1992, lot 140.
34. See a 19th-century piece bearing the name of Shah 'Abbas in the National Museums of Scotland, acc. no.1886-388.
35. For example, Sotheby's, 30 April 1992, lot 140.
36. Balsiger and Klāy (1992) p.165.
37. Christie's, 19 October 1993, lots 141, 143.
38. Gluck (1977) pp.146–47 illustrates two deer made in 1960, and a bird which won a handicraft prize in 1976.
39. Bodleian Library, Fahie collection, photographs nos 17, 83.

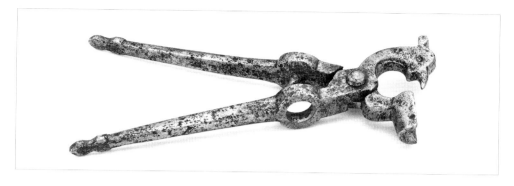

0.18 Nutcrackers; screw pivot; incised; l. 20 cm; 19th century; no.32

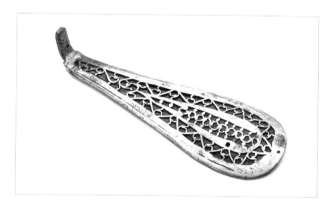

0.19 Shoe-horn; pierced and riveted; l. 13.2 cm; late 18th or early 19th century; no.261

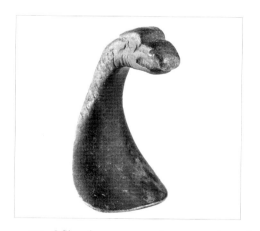 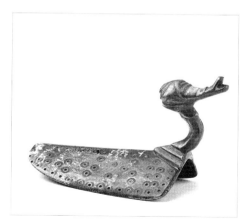

FIG.58 Shoe-horn; copper alloy; cast and punched; l. 10.7 cm; w. 5 cm; medieval or later; no.262
FIG.59 Shoe-horn; copper alloy; cast; l. 7.6 cm; w. 4.1 cm; medieval or later; no.260

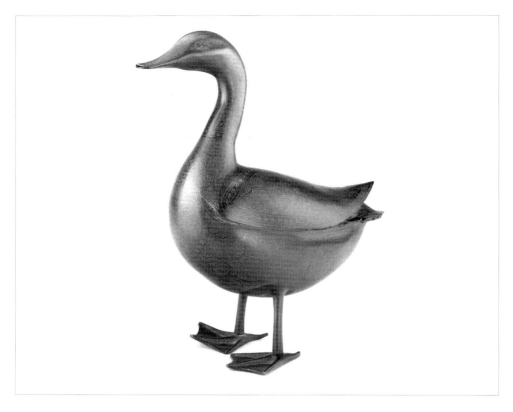

FIG.60 Ornamental duck; forged and overlaid with silver; inscribed: *bandeh-yi shah-i vilayat 'Abbas*; ht 30.6 cm; 19th century; Ashmolean Museum, acc. no.EA 1997.169 Gift of Dr J.K. McConica

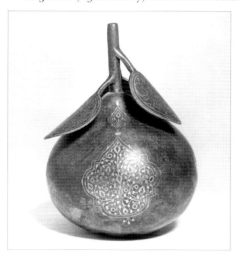 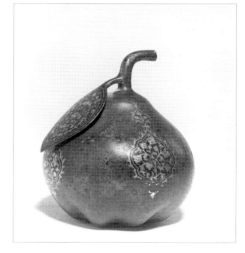

0.20 Pomegranate; cut, brazed and overlaid with gold; ht 15.7 cm; d. 11.5 cm; 19th century; no.200
0.21 Pomegranate; cut, brazed and overlaid with gold; ht 12 cm; d. 10.5 cm; late 18th century; no.201

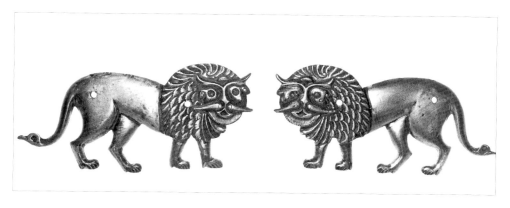

0.22 and 0.23 Pair of plaques in the form of a lion; cut and pierced; l. 11.9 and 12.2 cm; 19th century; nos 510, 511

the like.[39] Others, however, seem to have derived from the Iranian background, or at least were effectively integrated into the traditional side of contemporary Iranian culture. Pigeons,[40] for example, although they may have been used as free-standing ornaments, also played a part on the horizontal bars of Muharram standards, and are still made today to adorn the standards manufactured in Isfahan (see p.263). Equally, steel fruits probably derive from the fruits which were depicted on carpets in Safavid times and later.[41] The steel versions include not only pomegranates, but pears, apples and gourds.[42] How early such things were copied in steel is unclear. However, the style of the gold overlaid design of flowering plants on o. 21 suggests that it is earlier than o. 20, and probably late 18th century, so the idea may well have caught on in the early Qajar period. Cats, too, were popular among the Iranians. For example, a picture of the mother of Prince Khusrau, Lutf'ali Khan's eldest son, in Brydges' account of his 1807–11 mission to the Iranian court, shows her seated on a balcony with a cat in front of her.[43] The taste for steel cat figurines may therefore have been indigenous too.

The pair of lions (o. 22 and o. 23) appear to be plaques from a box of some sort, or possibly from a piece of furniture, to which they were attached by two nails or rivets. The significance of lions has been dealt with by Tanavoli, in particular their role as symbols of sovereignty, as the emblem of the Imam 'Ali, as symbols which extol the bravery of the dead, as talismans, and as guardians of tents and houses.[44] The extraordinary emphasis on their moustaches is noteworthy. Unfortunately, long mous-

40. For example, Balsiger and Klāy (1992) p.166.
41. See the 17th-century painting in the Chehel Sutun showing the audience of the ambassadors. See also *de Baghdad à Ispahan* (1994) no.58 p.267 (copied in 1787) and Robinson (1992) pl.XXXII for a 19th-century work.
42. For example, Blair and Bloom (1991) nos 43a–c.
43. Brydges (1834) opposite p.264.
44. Tanavoli (1985) pp.9–43.

taches were characteristic of many Iranian sovereigns from Shah 'Abbas I to Nasir al-Din Shah, and they do not help to date the plaques accurately. However, on the basis of the lion and sun motifs used in the Safavid and Qajar periods,[45] the fact that the lions turn their heads to face the viewer suggests that they are Qajar creations and therefore probably of 19th-century date.

45. Tanavoli (1985) p.37 Table no.1 f–i.

Fire implements

FLINT-STRIKERS

The creation of fire has been a primary need of man from earliest times. Until the 19th century, when matches were introduced, one of two basic methods had to be used: friction or flint. Once steel had been invented, the latter method normally involved hitting a piece of steel obliquely with the edge of a flint to create sparks.[1] The steel had to be of an appropriate quality, and of a shape that could be held securely in the hand.

Given these fairly broad requirements, it is no surprise that flint-strikers can take many different forms. The Bryant & May collection of fire-making appliances, now housed in the Science Museum in London, illustrates something of the variety possible, and displays a wide range of implements from Europe and the Middle East.[2] Most of them are based on the same principle of a long striking edge and a curved handle, and differ only in the details of their shape and decoration.

An early attempt to put order into the flint-strikers from Islamic Iran was made by d'Allemagne, who sorted them by shape into three categories.[3] The first included the numerous implements formed in the shape of a stylised animal, usually a bird or a dragon (*cf.* P.2–4 and 6–10). The long neck of the figure, used as a handle, curves around from the head and down towards the slender body, the edge of which is used to strike the flint. A point at or near the top of the curve, the hypothetical joint between neck and body, is often articulated in some way. The body is usually decorated on either side with the same design, but with slight variations in detail. There is sometimes a swivelled suspension ring attached to the back, so that the flint-striker can be hung from a belt (*cf.* P.7).[4] D'Allemagne's second category included similar flint-strikers, but with bodies finely pierced to make them lighter and easier to handle (*cf.* P. 11). His third category included those pierced with one or two finger holes (*cf.* FIGS 61 and 62). More recently, Cacciandra and Cesati have distinguished between medieval Islamic and later Iranian and Indian flint-strikers.[5] Cacciandra's

1. For illustrations, see Christy (1903) fig.XXXIX; O'Dea (1964) no.3.
2. Christy (1926); see also Christy (1903) figs XV–XXVIII.
3. d'Allemagne (1911) vol.2 p.54.
4. A point Jean Chardin noticed while travelling through Georgia: Chardin (1735) vol.1 p.63.
5. Cacciandra and Cesati (1996) pls 3 and 34–40.

collection also includes the only dated flint-striker so far published.

The size of the Tanavoli collection, and the variety of flint-strikers represented within it, should in theory make a more structured chronology possible. However, there are problems. In the first place, only one dated flint-striker is known, which forces the art historian back onto form and decoration to establish a chronology. In the second place, the evidence of decoration is not always available, for some of the best surviving pieces are almost completely plain, except perhaps for a bird's-head terminal and a single half-palmette. Moreover, even when, as on the finest examples, there is floral or animal decoration, there is no basic reference work on 18th- and 19th-century Iranian art to which the designs can readily be compared.

With these reservations, however, a limited chronological sorting of the flint-strikers in the collection can be attempted. P.1 appears to be the earliest piece, for its inscription, which is in Kufic script and reads *barakat wa surur li-sahibi* ('blessing and happiness to its owner'), points to an 11th-century date. It is by no means certain that the object was originally designed for this purpose, however. It is made of two separate items, the body bearing the inscription, and the ogival bracket (with ring handle) into which the body is fitted. The bracket could be of later date, and may have been added to allow this much older and valuable piece of steel to be used as a flint-striker. On the other hand, the body itself could have been designed as a flint-striker, for it bears a tolerable resemblance to the copper alloy examples with their paired finger holes (FIG.62), even though the holes in the steel are too small for fingers to be inserted. Moreover, the metal of the body is very similar to the metal of the ogival bracket. The original function of P.1 is further confused by the lion on the reverse, which could be the zodiacal sign, Leo, but is upside down compared to the inscription.

The two copper alloy flint-strikers both originally held pieces of steel, and both suggest themselves as early forms.[6] The lions on FIG.62 have highly stylised heads, but are close derivatives of Saljuq lions. The piece could therefore be 12th or 13th century. FIG.61 bears an inscription in *naskh* which reads, *al'izz al-da'im w'al-iqbal wa'l-dawla* ... ('continuing glory, prosperity, wealth ...'). This suggests a similar date. Another copper alloy example (FIG.63) is in the form of a stirrup, but is also similar in shape to P.1. It is probably of 11th- to 12th-century date.

It is worth noting the few examples of flint-strikers held in public collections. Some of these are of particularly good quality, and because they are heavily decorated offer some help with dating the plainer pieces. A gold inlaid, bird-shaped flint-striker now in the Freer Gallery,[7] for instance, displays a very finely worked scene of

6. Compare the medieval Islamic flint stikers illustrated by Cacciandra and Cesati (1996) pl.3, especially nos 14 and 12, which are of similar forms to nos 352 and 351 respectively.

7. Washington, DC, Freer Gallery of Art, acc. no.40.7: Pope (1938–39) vol.VI pl.1390 fig.J; Atıl, Chase and Jett (1985) no.37 p.226.

FIRE IMPLEMENTS

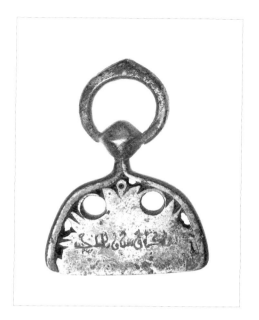 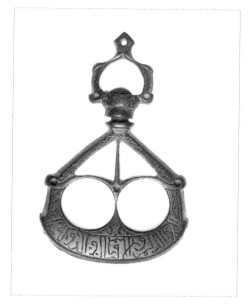

P.1 Flint-striker; pierced and incised; ht 6.4 cm; w. 4.6 cm; 11th century; no.349
FIG.61 Flint-striker; brass; cast and incised; swivel handle; remains of steel set in base;
ht 6.9 cm; w. 4.2 cm; 12th–13th century; no.351

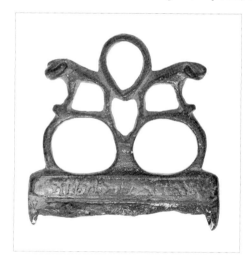 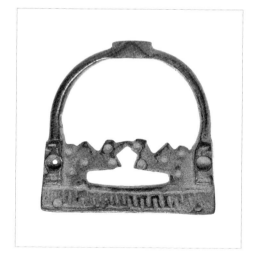

FIG.62 Flint-striker; copper alloy; cast and incised; remains of steel set in base; ht 5.9 cm; w. 5.5 cm;
12th–13th century; no.352
FIG.63 Flint-striker; copper alloy; steel missing; cast; ht 4.5 cm; w. 4.5 cm; 11th–12th century; no.350

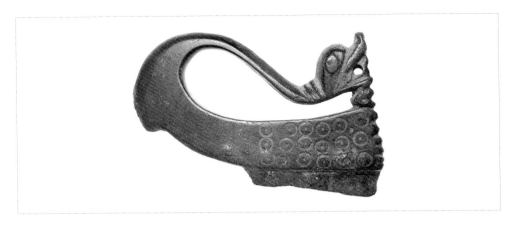

FIG. 64 Flint-striker; copper alloy; cast; incised; remains of steel set in base; l. 8.3 cm; 15th century; no.81

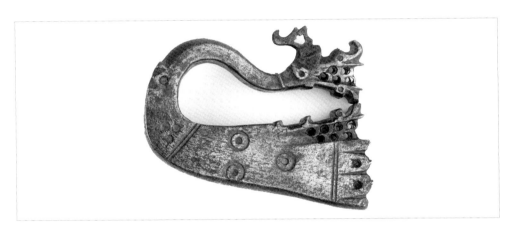

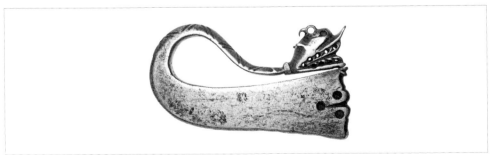

P.3 Flint-striker; cut, pierced, incised and drilled; l. 8 cm; 15th century; no.74
P.4 Flint-striker; cut, pierced, incised and drilled; l. 6.9 cm; early 16th century; no.75

FIRE IMPLEMENTS

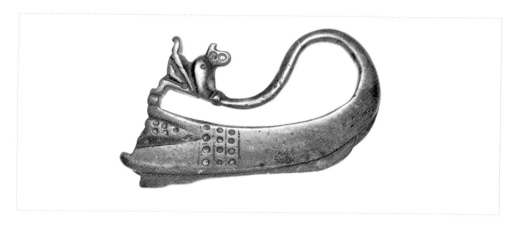

FIG.65 Flint-striker; brass; punched and incised; remains of steel set in base;
l. 10 cm; 15th century; no.80

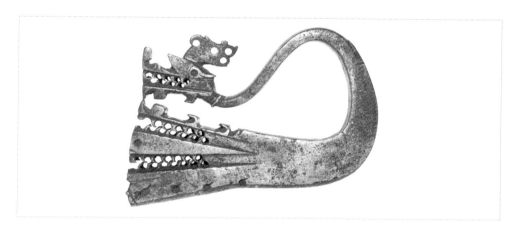

P.2 Flint-striker; cut, pierced, incised and drilled; l. 10.3 cm; 15th century; no.73

PERSIAN STEEL

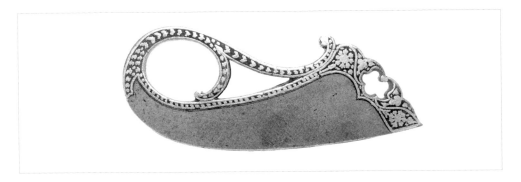

P.5 Flint-striker; pieced, cut and overlaid with gold; 19th century; no.527

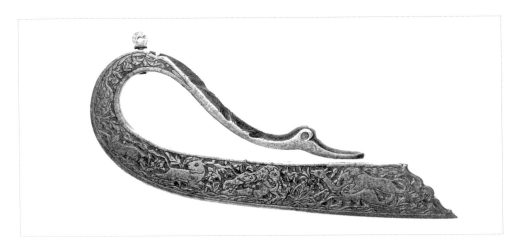

P.7 Flint-striker; cut, chiselled, incised, chased and drilled; l. 14 cm; late 18th–early 19th century; no.76

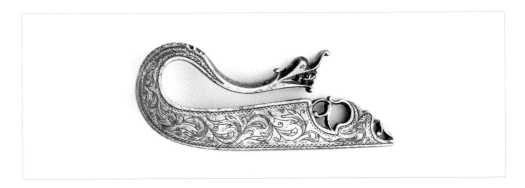

P.9 Flint-striker; cut, pierced and chased; l. 9.1 cm; 19th century; no.197

FIRE IMPLEMENTS

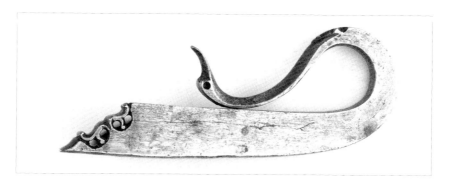

P.6 Flint-striker; drilled and incised; l. 10.2 cm; 18th–early 19th century; no.425

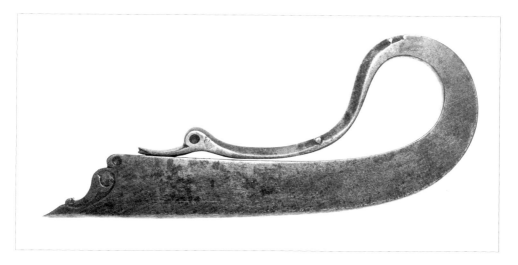

P.8 Flint-striker; cut, chiselled and drilled; l. 15.2 cm; late 18th–early 19th century; no.78

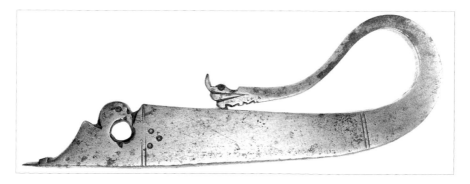

P.10 Flint-striker; cut, incised and drilled; l. 14.4 cm; 19th century; no.77

a hawk attacking a duck or goose. It has been attributed to early 17th-century India by comparison with a dagger made for the Emperor Jahangir, but the shape, the scene depicted and the variety of techniques used for the decoration are equally at home in Iran. Furthermore, the type of gold inlay work used on the half-palmette finial is typical of Iran in the period *circa* 1800. Another design featuring a dragon's-head handle, bought in Tehran in 1899[8] and now in the Berlin Museum,[9] is decorated with lions attacking gazelles. This has been given attributions ranging from 16th- to 17th-century Iran, to 18th- to 19th-century Iran, to early 17th-century India.[10] Our preference here is for Iran in the late 18th to 19th century, which seems to have been the period when heavily decorated flint-strikers were at their most popular.

Another example, in the Khalili collection, is decorated with nightingales amid flowering stems.[11] It is dated by Alexander to the 19th century. The second is an unpublished flint-striker in the Musée du Louvre, Paris,[12] this time decorated with human figures. On one side it has a battle scene and on the other mounted warriors and members of a mounted band. The hat of a foot-soldier with a gun over his shoulder is of a form typical of the late 18th to early 19th century, as illustrated in some early Qajar miniatures.[13] A third decorated flint-striker, closely related stylistically to the Louvre example, is in the Cacciandra collection.[14] This has a hunting scene on the broad part of one side, and a lion attacking a deer in a cartouche on the other, but is otherwise covered with arabesque or floral decoration. The lack of articulation in the form of the wide end, and the double half-palmettes which form the other terminal – both features shared with the Louvre piece – combine with aspects of the decoration to point to a late 18th- or early 19th-century date. Finally, an example in the Bryant & May Collection has a highly stylised arabesque design and an inscription overlaid in gold reading *bande-ye shah-e vilayat 'Abbas* ('servant of the king of trusteeship, 'Abbas'): it is likely to be 19th-century in date (see pp.108–109).[15]

Gold-inlaid P.5 has a terminal which is a simplifed version of the double half-palmette terminals on the pieces in the Louvre and Cacciandra collections. This, coupled with its relatively simple style of decoration, probably points to a 19th-century date. An 18th- to mid 19th-century date is likely for the elegant flint-strikers in the form of a bird. Justification for this dating is offered by P.7, together with the pieces in the Louvre and in Berlin mentioned above. Before being more specific, however, it is worth pointing out the background ornaments used in figural designs

8. Sarre (1906) no.160 p.55.
9. *Islamische Kunst. Verborgene Schätze* (1986) no.319 p.165.
10. See note 9 above; for the Indian attribution see Atıl, Chase and Jett (1985) p.227 fig.73.
11. Alexander (1992) no.93.
12. Département des Antiquités Orientales, acc. no.7022.
13. Robinson (1976) nos 1238 and 1245.
14. Cacciandra and Cesati (1996) pl.34.
15. Christy (1926) p.38 no.494 and pl.203.

FIRE IMPLEMENTS

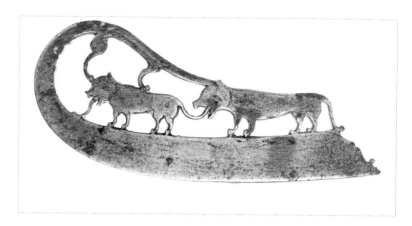

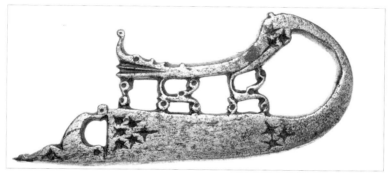

P.11 Flint-striker; pierced and incised; l. 11.5 cm; 18th–early 19th century; no.72
P.12 Flint-striker; cut, pierced, incised and drilled; l. 10.7 cm; 19th century; no.79

on Safavid metalwork. Figural designs from the 16th century are extremely rare, and in the early 17th century the figures were set against a spiral scroll decorated with four-petalled flower heads and numerous small pointed leaves.[16] This formalised treatment of the plants continued in the 1620s[17] and is still characteristic of designs in the middle of the century.[18] Living plant forms first appear in the late 1670s, superimposed over this type of background.[19] The type of plant forms found on P.7 and the Berlin flint-striker are therefore quite out of keeping with 17th-century Safavid art, at least in metalwork. Unfortunately virtually no dated copper objects of the 18th century have been published, so direct comparisons after 1700 are impossible to make. However, the free-standing plant forms on the Berlin piece,

16 Melikian-Chirvani (1982) no.147, dated 1602–3.
17. Melikian-Chirvani (1982) no.150, dated 1620–21.
18. Melikian-Chirvani (1982) no.153, dated 1643–44.
19. Melikian-Chirvani (1982) no.155, dated 1678–79.

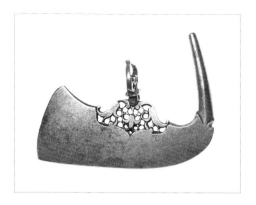 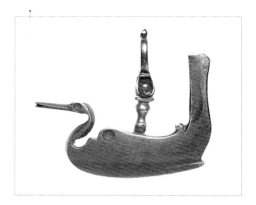

P.13 Flint-striker, blade and pick; watered; cut and pierced; l. 6.5 cm; 17th century; no.343
P.14 Miniature flint-striker and screwdriver; cut, pierced and drilled; l. 4.7 cm; 19th century; no.188

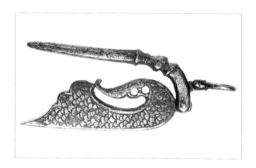 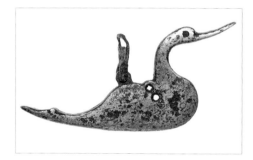

P.15 Flint-striker and screwdriver with hinged pick; cut, pierced and incised; l. 7 cm; 19th century; no.198
P.16 Flint-striker and screwdriver; cut, pierced and drilled; l. 6.5 cm; 19th century; no.177

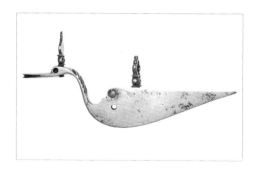 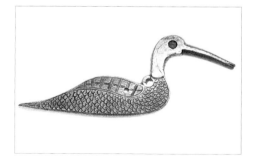

P.17 Flint-striker and screwdriver; cut, pierced, incised and drilled; brass rivets; inlaid with turquoises; l. 9.6 cm; 19th century; no.176
P.18 Flint-striker, screwdriver and pick; cut, pierced, chased and drilled; l. 8.8 cm; 19th century; no.401

FIRE IMPLEMENTS

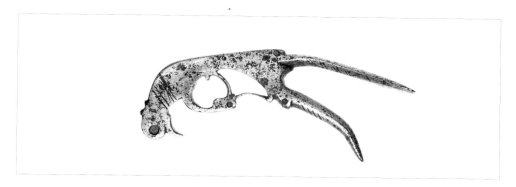

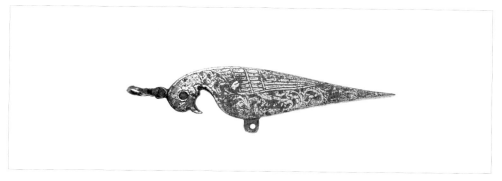

P.19 Flint-striker, screwdriver and pick; cut, pierced, incised and drilled; l. 9.4 cm; 19th century; no.427

P.20 Flint-striker and screwdriver; cut, chased and drilled; l. 8.7 cm; 19th century; no.170

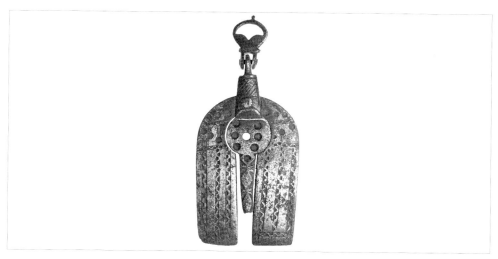

P.21 Flint-striker, screwdriver and pick (?); cut, incised, drilled and riveted; ht 8.3 cm; w. 3.4 cm; 18th–19th century; no.423

and the plants on P.7, have no place in the decorative repertoire of 17th-century Iranian metalwork, and must therefore be of the 18th or even 19th century.

The close relationship in general form between P.7 and the undecorated P.8, particularly in their heads and necks, suggests that they are approximately contemporary. Hence, early Qajar taste included not only the decorative but also the plain, as P.6 demonstrates further. Dragon-headed flint-strikers of the same form are presumably contemporary, hence P.9: the close resemblance of its neck design to that of P.6 is worth noting. P.10, though in the same tradition, is altogether cruder, and could be late in the series, perhaps mid-19th century.

More problematic are the dragon-headed group of a less elegant form which occur both in copper alloy and steel. The earliest appears to be FIG.64, whose dragon looks decidedly Timurid. One might compare the dragons fighting Bahram Gur in late 15th-century miniatures from the *Khamseh* of Nizami.[20] So too the rather tamer, and crest-less, FIG.63. P.2 and P.3 are totally different in character. P.2 in particular bristles with teeth, and both look extremely vicious. They are part of a group of heavily made, dramatically rendered, dragon-headed flint-strikers,[21] and comparison with 15th-century Turkoman paintings suggests that this is their origin. There we find aggressive-looking dragon's heads affixed to a variety of objects, many of them with crests; there we also find a tremendous emphasis on teeth as a sign of aggression.[22] P.4 has much more refined features, both in its head and in the symmetrical arabesque-shaped end to its body. It seems to be a synthesis of the Timurid and the Turkoman groups. As a result, we could perhaps date it to the early Safavid period.

Of the remaining flint-strikers, P.11, which shows two animals head-to-tail, is unusual in its design, though one of somewhat similar form with a single animal has been published.[23] It relates to the finer bird-headed flint-strikers both through the leaf in the shape of a bird's head, and through the bracket form made by the two half-palmettes which terminate the body. It is therefore likely to be contemporary with them. P.12 is very much cruder in its design. It has lost its sense of form, and, while it harks back to the dragon tradition, the dragon mouths themselves have become leaves between the neck and body of the piece.[24] It should probably be ascribed to the very end of the period of flint-striker manufacture, perhaps the third quarter of the 19th century.

As will be appreciated, the survey of the flint-strikers in this collection leaves a gap in the 17th century, which is somewhat surprising given the productivity of that

20. Lentz and Lowry (1989) p.282.
21. For another example see Christy (1926) p.38 no.496, and pl.205; also Cacciandra and Cesati (1996) pl.9 no.215.
22. See, for example, Ipsiroglu (1976) pl.56A and 54.
23. Cacciandra and Cesati (1996) pl.37 no.207.
24. *Cf.* two similar pieces in the Cacciandra collection; Cacciandra and Cesati (1996) pl.38 nos 210, 212.

period of Safavid culture. The gap can be filled by two unpublished pieces in a private collection, and confirmation of that chronology can then be provided by the one dated flint-striker mentioned above. Of the unpublished two, one is of a form close to P.4, but bears a *nasta'liq* inscription and floral motifs against a hatched ground, decoration typical of the 17th century. A second has a traditional dragon's head, but is shaped like P.7 and P.8. It too is decorated with *nasta'liq* inscriptions against a hatched ground. In their decoration both bear a striking resemblance to the Isfahan shrine locks (see p.413) Confirmation that these two flint-strikers are 17th-century is provided by the dated piece in the Cacciandra collection.[25] This too has a dragon's head, and a *nasta'liq* inscription against a hatched ground, the inscription including the name of the maker, Ibrahim Kashani, and the date AH 1135 (AD 1716). Here, however, the sweeping lower parts of the *waws* and *nuns* are much thicker, following a style typical of the 18th century, but thus confirming the correct dating of the two unpublished pieces.

In addition to the simple flint-strikers discussed so far, there is also a group of small composite flint-strikers which combine different functions. They are in fact gun accessories. While fire-making was their primary use, they also possessed a screwdriver, or a thick blunt spike that served to fix a flint firmly in the hammer of a flint-lock gun.[26] From their size, they were clearly intended to be carried, and are usually equipped with a small swivel suspension-ring on the back for attaching to the belt. They often have a very naturalistic shape, and the different parts of the creature concerned are used for different purposes – the tail or the spiked-shaped beak as a screw-driver, for example, when the object is bird-shaped. The dating of these composite flint-strikers is even more difficult than that of the simple ones, since there are no other decorated and published examples which can be used for comparative purposes. The most elegant is undoubtedly P.13, with an axe-shaped body and openwork ornament. This piece is in a class by itself, and one is tempted to suggest a Safavid date. P.14 has the character of the plain and elegant flint-strikers, and is probably late 18th or early 19th century. So, too, is P.15. P.16 and P.17 are also plain but do not compare in elegance, while P.18,[27] P.19 and P.20[28] are comparatively crude. One is tempted to date them all to later in the 19th century.

Another object, P.21, is worth citing here as it too may be a flint-striker. It was clearly meant to be suspended from a belt, and there is an illustration of what appears to be a similar object hanging from the belt of a camel-keeper in a painting by Shaikh Muhammad dated AH 964 (AD 1556–57).[29] This shape probably origi-

25. Cacciandra and Cesati (1996) pl.35.
26. Christy (1926) p.36.
27. For a very similar piece in London, Science Museum, Bryant & May collection no.499, see

Christy (1926) no.499 pl. 205; *cf.* also Cacciandra and Cesati (1996) pl.37 no.205.
28. *Cf.* Cacciandra and Cesati (1996) pl.37 no.206.
29. Atıl (1978) no.16A.

nates in the bow-handled style (FIG.62) or its variants (e.g. P.1). However, the identification is complicated by the fact that the points are worn, not the sides, suggesting use as a screwdriver, and by the fact that the two arms are riveted in such a way that they can be moved, releasing the area around the small implement in the centre – if such it be. Hence the object could have had a multi-purpose function, as flint-striker, screwdriver and spike.

Other objects, such as the multi-purpose implements described in the section on guns, could also have acted as flint-strikers (see pp.183–86). After all, the only real qualification for a flint-striker is that it be made of steel.

How tinder was carried is not clear. There are no extant steel boxes which seem to meet that need, so it was probably carried in leather pouches or purses attached to the belt, such as the leather purse on belt B. 4. In Turkistan a steel for striking flints was sometimes attached to a leather pouch containing spare flints and tinder. Dragon-headed flint-strikers, very like those of Iran, were also used.[30]

Having established the approximate dates of the various flint-strikers in the collection, we can now see something of their development. Although all-steel flint-strikers may have been in use as early as the 11th century, most medieval Iranian flint-strikers were probably of copper allooy, with a slot in the base into which a piece of steel could be fitted. A dragon form was probably introduced in the wake of the Mongol invasions, but this too was of copper alloy with a steel inset. It continued to be popular in eastern Iran in the 15th century, but the Turkomans adopted a vicious-looking, dragon-headed form made only of steel. The Safavids adopted this steel form, but modified its design. By the late 18th century bird's heads had become more popular than dragon's heads, and the flint-strikers were either plain or heavily decorated. Various other forms developed on the same general theme.

The later story of flint-strikers is linked to the development of Western technology, in particular the development of matches. Phosphorous friction matches were first produced on a commercial scale in Europe in 1833, and it is likely that they reached Iran soon afterwards. Flint-strikers would then have been progressively replaced by matches, and their manufacture is unlikely to have continued much beyond the third quarter of the 19th century. Over 80 years ago, d'Allemagne noticed their scarcity, and explained their rarity as due not to the interest they received from collectors, but because, no longer needed for their original function, they were used for sharpening knives, and thus became worn out.[31] An example of a flint-striker which has clearly been put to such a use is illustrated in the Bryant & May catalogue.[32]

30. Kalter (1984) ill.65.
31. D'Allemagne (1911) vol.2 p.54.
32. Christy (1926) no.488 pl.203; O'Dea (1964) p.5.

The change from flint-strikers to matches is documented in Mirza Husain Khan's *Jughrafiya-yi Isfahan*, completed in 1891. The author notes among the numerous objects available in Isfahani haberdasheries both local flint-strikers and imported European matches. He ends by commenting: 'The Isfahani haberdasheries have no more to offer (for sale) than this. Isfahani haberdasheries kept their ground, while in Tehran and Tabriz the European articles are in the majority.'[33] Clearly, flint-strikers had long disappeared from other Iranian cities.

FIRE-TONGS

Iron or steel were widely used in Iran for containing fire, in whatever form it came. Thus, Membré describes the torches used by Shah Tahmasp's army when travelling by night: 'And when the army intends to move and go to another place, or, as they say in their tongue, *urdu*, then in the middle of the night they load the camels and mules of the King with a kind of flaming torch, which they call *ishik*, which is a stout pole of wood, three fingers thick and half a rod long; and on the top of the said pole there is a round iron plate, one palm across, and around the said iron there is a fine iron grid, half a palm high, and on top an iron ring, within which they put rags of old cloth, soaked in a certain oil which they call *naft*, which is found in a well in Shirvan.'[34] Iron was also used for braziers,[35] and for chafing dishes, or portable grates. The latter were particularly useful when travelling, as they provided a source of hot charcoal for smoking. Binning observed them: 'From the forepart of the saddle hang iron chains, sustaining on one side a small iron chafing-dish, filled with burning charcoal, which hangs below the rider's stirrup, but a little way above the ground.'[36]

None of these objects is represented in the Tanavoli collection, but other iron or steel implements relating to fire and charcoal are. The two sets of long tongs have little in common except their function. P.22 is light, slim and elegant, with a screw adjuster, while P.23 is very heavily constructed, and the only function of the T-shaped fitting inside the handle is to prevent the handle from spreading too widely apart. P.23 has pierced rectangular units in the centre of each arm which are reminiscent of those on falcon perches. It also has decorative birds in evidence, two in the finial, and two on either side of the blades. P.24 and P.25 have similar wooden handles, but otherwise they have very little in common. The blade of P.24 is incised with flowers somewhat reminiscent of Kashmiri work. The function of P.25 is uncertain. All are probably 19th-century in date.

33. Floor (1971) p.120.
34. Membré (1994) p.23.
35. Bronze braziers are well known; see, for example, Pope (1938–39) pl.1379A–B.
36. Binning (1857) vol.2 p.177.

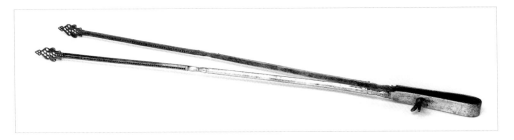

P.22 Large tongs; cut and pierced; screw adjuster; l. 65.8 cm; 19th century; no.37

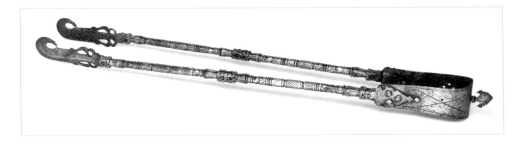

P.23 Large tongs; cut, pierced, incised and riveted; l. 70.7 cm; 19th century; no.36

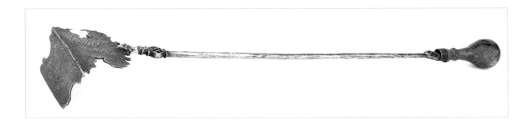

P.24 Fire shovel; cut and pierced; wooden handle; l. 56 cm; 19th century; no.38

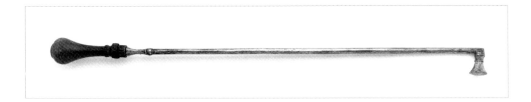

P.25 Fire iron; cut and milled; wooden handle; l. 61.6 cm; 19th century; no.39.

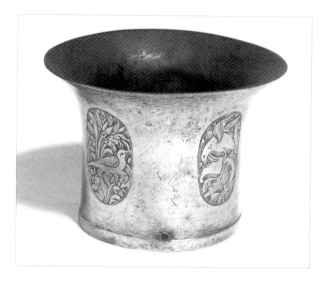

p.26 *Qalian* cup; chiselled and etched; four rivet holes; ht 6.2 cm; d. 8.6 cm; late 17th–18th century; no.421

TOBACCO- AND OPIUM-SMOKING EQUIPMENT

'The tobacco of Persia is known in every town and village in the western half of the Asiatic continent; and greatly to be commiserated is the European traveller or resident who, when either passing through or sojourning in that land is guilty of indifference to the exquisite solace of the Persian water-pipe, or *kalian*. Though I am no smoker, and derive little pleasure from the European modes of enjoying the weed, yet I never failed to succumb to the subtle influence of the Shiraz *tumbak*, a few perfumed inhalations of which are sufficient to fill the remotest cells of the brain with an Olympian contentment. This superb tobacco, whose agreeable qualities are in part due to the quantity of nicotine which it contains, in part to the manner in which it is prepared, being soaked, squeezed dry, and then placed at the top of the pipe under lighted charcoal, when its fumes are drawn through water to the smoker's lips, is grown chiefly in the districts of Shiraz, Kashan, and Tabbas, slightly inferior qualities being produced at Isfahan, Kum, Nihavend, Veramin, Semnan, and Shahrud ... The amount annually consumed in Persia alone has been estimated ... as 52,230 tons ... A second and different variety of tobacco, similar to that produced in Turkey, and used for smoking pipes and cigarettes, is grown in Kurdistan, near Urumiah, and on the Caspian littoral.'[37]

So wrote George Curzon. Benjamin added some additional details, for example,

37. Curzon (1892) vol.2 pp.497–98.

that the charcoal 'must be made from the root of the vine, or it would be extinguished by the dampness of the tumbâk', and the fact that the Turks preferred a serpentine stem for their *qalian*s, the Iranians short wooden stems. He also noted that 'it takes much time to light the pipe, and the care and cleaning of it is laborious and must be delegated to the charge of a servant. In Persia every gentleman's house has a pishketmêt [servant], whose sole business it is to prepare the refreshments and take charge of the kaliâns. The poorer classes generally have their daily smoke by resorting to a tea-house in the bazaars, or under the plane-trees in the centre of the village …'[38] Such was the love of smoking that *qalian*s were carried on journeys in special travelling cases, and used on horseback, the servant riding with the *qalian*, the master puffing at the mouthpiece.[39]

Very little has been written on *qalian*s in Iran. Laufer noted that the first description and illustration of them was in Neander's *Tabacologia*, published in Leiden in 1626, and was of the opinion that they were probably an early 17th-century Iranian invention – though he does admit that they could have been used earlier for hemp-smoking.[40] More recently, Keale has put together a fascinating, if tongue-in-cheek, theory that the medieval Islamic sphero-conical ceramic vessels are in fact *qalian* bases, and that the idea of a water-pipe originated, at a much earlier period than has previously been suggested, with coconuts. This would account for the fact that the Persian *nargil* derives from a Hindi, originally Sanskrit, word for coconut, and that the Yemeni-Arabic word for water-pipe, *mada'ah*, had the same original meaning. Since tobacco only appeared in Iran in the early 17th century, following its arrival in Europe from the New World, water-pipes would have been used previously for smoking something else – presumably hashish.[41]

Depictions of *qalian*s in Iranian miniature painting are uncommon. This is presumably due to the fact that the single-page miniature with amorous subject so popular in later Safavid times used wine, with its mystical overtones, as its symbol of intoxication: the effects of nicotine must have been too newly discovered to have entered the mythology of Iran.

The few depictions of Safavid *qalian*s which exist do seem to support this argument, for they show water-pipes in which the mouthpiece is attached, not to the body of the vessel, but to its neck: for example, a portrait of an Iranian lady by

38. Benjamin (1887) pp.410–11.
39. Ker Porter (1821–22) vol.1 p.253; Binning (1857) vol.2 p.177. For an illustration see Le Brun (1718) pl.112/1.
40. Walravens (1979) p.1521; the picture of the two Iranian water-pipes is reproduced by Brooks (1937) vol.1 p.12.

41. Rosenthal (1971) pp.42ff., 56–65, had previously suggested that hashish, although used as a narcotic as early as the 12th century in Iran, was eaten, not smoked.

FIRE IMPLEMENTS

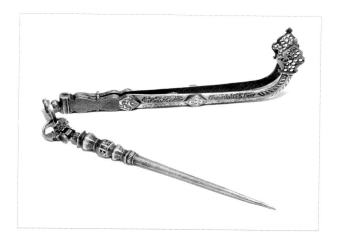

P.27 Ember tongs and pricker; cut, pierced, and brazed; pricker inlaid with turquoises, tongs overlaid with gold; l. 14.3 cm (tongs), 11.8 cm (pricker); late 18th–early 19th century; no.422

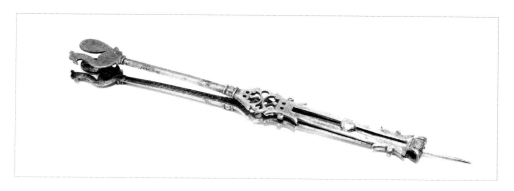

P.28 Ember tongs with sliding pricker; cut and pierced; l. 18.6 cm; 19th century; no.234

Muhammad Qasim-i Tabrizi, dating from *circa* 1640–50.[42] This suggests that the original method of manufacturing *qalian*s was to make a wooden or metal fitting which could be attached to the top of a coconut (or whatever vessel functioned as the water container), and it would also account for the popularity of the pointed ovoid shape used for water-containers in post-Safavid Iran. Certainly, coconuts were popular in some parts of Iran in the 19th century, for Murdoch Smith wrote: 'The bottles [of the *qalian*s] nowadays are usually of glass, but are also, especially in

42. Falk (1985) no.89; this and other illustrations are noted in Keall (1993) figs 4–6. For a miniature dated AH 1086 (AD 1675), which shows the version with pipe attached to the body, see Falk (1985) no.101.

453

the south of Persia, not uncommonly of carved and otherwise ornamented cocoa-nut shells, in which case the pipe is called *Narghileh*, from *Narghil*, a cocoa-nut. The heads are made of stone or earthenware, and those of rich men of silver, gold, steel, &c., and are not unfrequently of great value.'[43] Other scholars, however, believe that when tobacco was first introduced into Iran the long pipe (*chopoq*) was used exclusively and that the more complex *qalian* was a later invention. An Iranian physician in India, Abu'l-Fath Gilani, is said to have been the first to pass tobacco through a bowl of water to purify and cool it.[44]

Be that as it may, Moser had a number of pointed ovoid metal *qalian*s in his collection, including some fine enamelled examples,[45] and Benjamin illustrated a similar brass one,[46] apparently of late 19th-century date. Another, covered with turquoises and probably once the proud possession of Nasir al-Din Shah, survives in the Iranian Crown Jewels. In the same collection is an early 19th-century example of a water-pipe with an actual coconut as its body: the coconut has enamelled gold mounts, surmounted by a green nephrite neck and mouthpiece, and an upper neck and head also of enamelled gold.[47]

During the 17th century a number of other shapes seem to have developed. Some *qalian* bodies were completely spherical, some were adapted from tall bottles;[48] others developed from squat vessels, while yet others were made in more exotic shapes derived from contact with lands further east through the growth in Indian Ocean trade – for example, soft-paste porcelain *qalian*s in the shape of elephants.[49] In the 19th century, *qalian*s in the shape of bottles were common: a photograph in the Moser collection shows metal *qalian*s with enamelled decoration on sale in Bukhara,[50] while a rather different bottle-shape in brass was among Murdoch Smith's purchases in Iran.[51]

The only Iranian form manufactured in steel appears to be the ovoid type with the pointed projection on the base. These are comparatively rare. The finest published example, dating from *circa* 1870 and made by Haji 'Abbas, is now in the Victoria and Albert Museum.[52] Another late 19th-century pece, signed by Ghulam 'Ali, was sold in Paris in 1991.[53] That the manufacture of steel *qalian*s was not a late 19th-century introduction, however, is evident from the *qalian* mouth in this collection (p.26), whose decoration points to a late 17th- to 18th-century origin. It is impossible

43. Murdoch Smith (1885) pp.71–72.
44. Floor (1993).
45. Balsiger and Kläy (1992) p.163.
46. Benjamin (1883) p.311.
47. Meen and Tushingham (1968) pp.100–101 (ht 27 cm) and p.104 (ht 37 cm).
48. Allan (1991) nos 38–39.
49. Allan (1991) no.32.
50. Balsiger and Kläy (1992) p.122.
51. Murdoch Smith (1885) p.73.
52. Pope (1938–39) vol.VI pl.1393A.
53. Pierre Cornette de Saint Cyr, *Art Islamique, Asie Centrale et Iran*; Paris, 30 October 1991, lot 42.

FIRE IMPLEMENTS

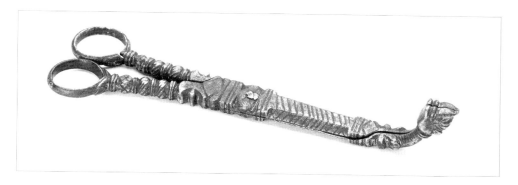

P.29 Ember tongs; cut, incised, riveted and brazed; l. 16.9 cm; 19th century; no.227

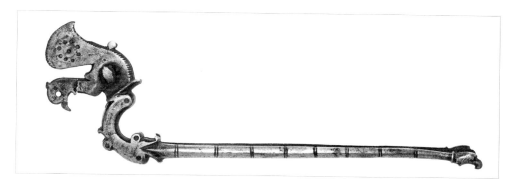

P.30 Ember tongs; cut, incised, punched and riveted; l. 18 cm; 19th century; no.235

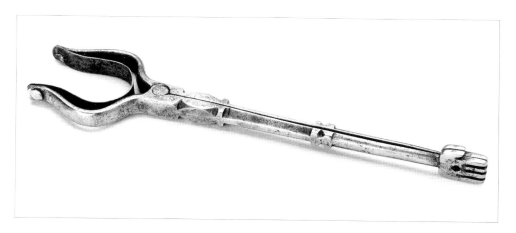

P.31 Ember tongs; cut, pierced and riveted; l. 16.1 cm; made in Rayen, 20th century; no.392

to say where this latter piece was made. European travellers praised Shiraz for its enamelled *qalian* bowls and stems:[54] Isfahan may have been the source of the steel piece.

In Iran, as noted above, tobacco smoking was not confined to *qalian*s: pipes (*chopoq*) similar to those used in Europe were also used. In the 19th century these were sometimes of precious metal studded with jewels, though more commonly of wood or ceramic.[55] No steel ones have been published. Nor was smoking confined to tobacco: opium smoking has for long been a popular pastime. According to Laufer, opium smoking followed tobacco smoking, and in the 17th century the Dutch were the first to prepare a mixture of opium with tobacco by diluting opium in water. The modern opium pipe was first used by the Chinese in Formosa in the 18th century.[56] A description of smoking opium in China is given by Theo Sampson of Canton. The smoker takes the pipe in one hand and the dipper in the other. Putting the sharp end of the dipper into the opium (which is treacly), he twists it round and round until a large drop adheres to the dipper. Still twisting it to prevent it falling he roasts it over the candle flame, every so often rolling it onto the dipper on the flat surface of the pipe bowl. When it is ready he gently heats the centre of the bowl, where there is a small orifice. He then quickly thrusts the end of the dipper into the orifice, twirls it round and withdraws it. If this is properly done, the opium (which is now the size of a grain of hemp seed) is left adhering to the orifice, and is ready for smoking. He puts the stem of the pipe to his lips and holds the bowl over the lamp. The heat makes the opium fizzle and the smoker then takes three or four long inhalations, using the dipper to bring every particle of opium to the orifice as it burns away. He then uses the end of the dipper to scrape away any residue.[57]

D'Allemagne noted how opium was smoked in Iran: the smoker broke the opium into small pieces, kneaded it in his hands, and having roasted it on a brazier, placed it above the small hole of the pipe and then inhaled it.[58] He also describes the pipes:

> 'Persian opium pipes are made of a thick hollow tube 25–30 centimetres long, most often of bamboo, at the end of which is a terracotta bowl; those little pots of glazed clay in which opium is currently sold are also used. The bowl or the pot is pierced with a hole 4–5 millimetres across, and it is in this hole that one places,

54. Binning (1857) pp.186–291; Curzon (1892) vol.2 p.101, though on p.526 he says that enamelling was still practised in his day at Behbahan and Isfahan as well as at Shiraz.

55. D'Allemagne (1911) vol.1 p.188 shows such pipes, and vol.3 p.13 shows one being smoked; see also *Persian Art* (1931) fig.51 for a modern Iranian oil painting showing a man smoking this kind of pipe.

56. Walravens (1979) vol.2, pp.1517–18 and pl.II no.5.

57. Holmes (1910–1911). A useful introduction to Chinese and Far Eastern opium pipes is to be found in Maveety (1979).

58. D'Allemagne (1911) vol.2 p.155.

with the aid of a long metal needle, a ball of opium weighing 15–20 centigrammes, which has previously been passed over the flame of a small lamp. This latter operation is very delicate, for if the ball is too warm it will completely block the hole and as a consequence inhalation will be impossible. If, on the other hand, the ball is not sufficiently warm, combustion will not occur and the operation has to be begun anew. A practised smoker knows how to select the right moment and, inhaling deeply, vapourizes the incandescent grain with a single puff.'[59]

An example of an Iranian opium pipe in the Pitt Rivers Museum, Oxford amplifies this description.[60] It consists of a hollow wooden tube with a Chinese porcelain jar attached to the end. In the side of the jar is a tiny, pierced aperture, and with the pipe come a pair of ember tongs and a very fine dipper, or pricker. The tongs have plain, palmette-shaped tips and are a plainer version of a pair illustrated by d'Allemagne.[61] The pricker is much finer than those attached to the tongs catalogued here (P.27 and P.28). This suggests that the latter were not used for opium, but for tobacco smoking,[62] where the pricker would be needed for cleaning the bowl of the pipe, while the tongs would enable the smoker to pick up the charcoal to light the tobacco. A 20th-century Iranian painting of opium smokers in a coffee-house, showing the opium pipes described above, recently appeared on the London art market.[63]

The two pairs of smoker's tongs with prickers published here show the variety possible in such implements. Structurally they constrast strongly with one another, for in P.27 the pricker is a separate implement joined by swivelling suspension rings, while in P.28 it is attached to a sliding head which acts as an adjuster for the tongs.[64] It can therefore be neatly stowed away when not in use. In form, too, they differ greatly, P.27 having curved arms,[65] P.28 straight.[66] The other three pairs of tongs (P.29–31) again emphasise this variety, for while P.29 has curved arms like P.27, its action is based on scissor designs, not on the sprung-arms principle. In P.30 the upward curve is at the handle end of the arms, while P.31 works on the opposite principle to the rest, the spring acting to hold the tongs closed rather than open.

The five pairs of tongs also show an extraordinary variety and richness of artistic elements. Animals and birds are common. The tongs and pricker of P.27 are

59. D'Allemagne (1911) vol.1 p.61.
60. Oxford, Pitt-Rivers Museum, acc. no.1915.14, 1–3; gift of C.S. Bompas. In total the pipe is about 33 cm long, the jar measuring 6 cm in height and 5.2 cm in diameter. The tongs measure 28.8 cm, and the pricker 13.2 cm.
61. D'Allemagne (1911) opp. p.68, second from right.
62. This has already been suggested by Wertime in Gluck (1977) pp.152–53.
63. Bonhams, 26 April 1995, lot 507.
64. Published by Gluck (1977) p.153 fig.H.
65. *Cf.* a decorated copper pair illustrated in d'Allemagne (1911) vol.2 p.69.
66. *Cf.* Gluck (1977) p.153 fig.F.

attached by swivel arms with rings ending in two small birds, the scissor-shaped tongs, P.29, have dragon's-head terminals, while the arms of P.30 come out of the mouth of a dragon with a peacock terminal, and have tips in the form of hooked bird's head. Peacocks also appear in P.28, where they form the striking tips of the tongs, but here there is also a human element, for the stylised palmette openwork in the centre of the arms has two human faces grinning at each other on each side. A human touch also appears in tongs P.31, which have tips in the form of human hands. It is interesting to see the remains of turquoise inlays in the openwork palmettes of the swivel rings of P.27, which suggest that other small openwork items may have been similarly decorated. The inscriptions on the two sides of P.27 read:

> 'My soul burned like a candle because of separation from you
> My bone marrow burned because of sorrow for you
> … your command is … on the top of a place
> … and burned my house and its belongings.'

> 'We [I] asked for the description of your face. He said:
> Along with the flame, my tongue burned
> The flame spread and the fire burned my tongue
> It burned everything of mine from the earth to the sky.'

The provenance and dating of only one is relatively certain: P.31 was made in Rayen in the 20th century.[67] However, if the sets of implements in lacquer boxes are Isfahani (see pp.391–92), then P.27 is probably Isfahani too, and likely to be of late 18th- or early 19th-century date. The others are all probably 19th-century.

Another item of equipment which was used by opium addicts was the *tiryak-dan*, an opium-pill box, which according to Wills, was 'as common as a snuff-box in England'.[68] Whether these were made of steel, or what indeed they looked like, remains unclear.

67. Illustrated by Gluck (1977) p.153 fig.G. 68. Wills (1883) p.181.

Cosmetic implements and mirrors

KOHL BOTTLES AND OTHER COSMETIC IMPLEMENTS

The larger of the kohl bottles in the Tanavoli collection (Q.1) and the pair of smaller ones (Q.2 and Q.3) are made in two halves soldered together, and are of *boteh*-shape. The *boteh* is a well-known motif in later Iranian and Indian art, especially in textiles, and through trade in textiles became the key element in Paisley shawl patterns. Given its relatively late popularity in Iranian art, it will initially come as no surprise that the *boteh*-shape does not appear among the three different forms of early Islamic kohl bottle excavated at the site of Nishapur,[1] nor among the vast numbers of early or medieval Islamic kohl bottles in a wide variety of shapes assiduously collected and catalogued by Bumiller.[2] A link with the past should not be dismissed so quickly, however, for a possible source for the *boteh* design in this particular context may indeed be found in earlier Islamic metalwork. This is suggested first by a group of small, bird-shaped dishes, also made for cosmetic purposes.[3] The shape of their bodies is precisely that of the *boteh*, although it is only a half-*boteh* in three-dimensional terms. The link is also suggested by a small kohl bottle, apparently found at Fustat, which is of the same shape as the steel kohl bottles but has what appears to be a fish's tail.[4] This latter feature may well be a rendering of the double tail found on one style of the small bird-shaped dishes. In either case there is a possible source for the steel shape in earlier Islamic bronzes, and the resemblance to a *boteh* is then by chance – but a chance which would have made the form all the more acceptable in Iran in the 19th century.

No other examples of this form of kohl flask have been published, to my knowledge. However, the Pitt Rivers Museum in Oxford contains an example used by the Kol women of Mirzapur in India, which was presented in 1892 and is therefore likely to be of earlier 19th-century date.[5] It also has three examples collected in Palestine which were presented more recently, and were probably imported from

1. Allan (1982) pp.38–39 and nos 85–87. These vary in height from 5.3 to 6.8 cm.
2. Bumiller (1993) pp.73–158.
3. Bumiller (1993) pp.47–71.
4. Awad (1980) figs 6–7. This bottle appears to have a screw fitting for a short kohl stick which has a trefoil handle.
5. Gift of W. Crooke 1892.

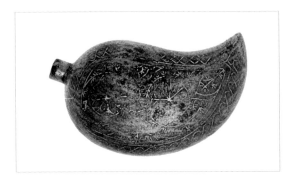

Q.1 Kohl bottle; brazed; screw socket; silver overlay; ht 6 cm; 19th century; no.386
Q.2 Kohl bottle; brazed; screw sockets; ht 3.8 cm and 3.5 cm; 19th century; no.387
Q.3 Kohl bottle; brazed; screw sockets; ht 3.8 cm and 3.5 cm; 19th century; no.388

India in the 20th century.[6] They are of brass with red inlay, and are decorated with Indian-style floral ornaments. They occur in two sizes comparable to the Iranian examples catalogued here. This form of kohl flask therefore seems to have been widespread in the Islamic world in the 19th and early 20th centuries.

Kohl sticks from early Islamic Iran, like kohl bottles, were of bronze. A common type has two pointed ends, and in many cases an ornamented area in the centre which acts as a grip. This grip normally consists of geometric faceting.[7] A rather different form of kohl stick had only one working end, and a handle end in the form of a bird[8] or some other device,[9] although such objects could also have been pins. The bird-handled form continues throughout later Iranian history, as two silver kohl sticks, also in the Tanavoli collection (FIGS 65 and 66), show. The double-ended kohl stick, on the other hand, does not seem to have survived into the later period. It was replaced by a single-ended design with a more or less elaborate handle of geometric (Q.4 and Q.5) or baluster (Q.6) design. Other implements, catalogued elsewhere in this book, could also conceivably have been kohl sticks, for example, the smaller

6. The larger one is numbered 1965.9, and the two smaller ones 1965.12.
7. Awad (1980) figs 1, 3, 8–9, 14; Allan (1982) p.38 and nos 83–84.
8. Awad (1980) figs 3, 6; Allan (1982) p.53 and nos 68–70.
9. Awad (1980) figs 6–7.

COSMETIC IMPLEMENTS AND MIRRORS

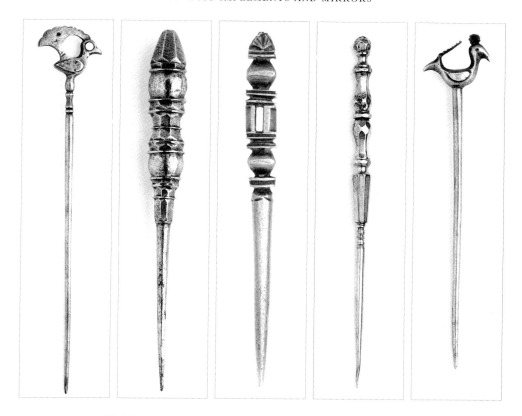

FIG.66 Silver kohl stick; pierced; peacock finial eyes inlaid with turquoise;
l. 11 cm; 18th–19th century; no.413

Q.4 Kohl stick; cut; l. 10.6 cm; 18th–19th century; no.269

Q.5 Kohl stick; cut and pierced; l. 9.2 cm; 18th–19th century; no.407

Q.6 Kohl stick; cut and gilded; pin and handle screw together; l. 10.1 cm; 18th–19th century; no.414

FIG.67 Silver kohl stick; slender cylindrical pin with peacock finial; l. 10.8 cm;
18th–19th century; no.412

awls (see p.374).

Tweezers are a very ancient form of cosmetic instrument, and at their simplest consisted of a piece of copper or bronze bent into a suitable shape. Iron tweezers of this type were found in 1st- and 5th-century contexts at Taxila,[10] but the later history of iron tweezers is unknown. The surviving tweezers from early Islamic times (found at Fustat, Siraf and Nishapur)[11] are all of copper alloy, and three out of the four are also distinguished by an adjustable sliding piece which allows the opening distance of the tweezers to be pre-set. The classical world knew of this more elaborate form of

10. Marshall (1951) vol.3 pl.167 nos 133, 134.
11. For the Nishapur tweezers, see Allan (1982) p.39 and nos 88–89. Those from Fustat and Siraf are unpublished.

461

instrument,[12] and, directly or indirectly, was presumably the source of the Iranian style. The later steel tweezers in the Tanavoli collection consist of a pair of the simpler form decorated with piercing and gold work (Q.7), another of the same type with pierced and incised work accompanied by four other small implements in a toilet set (Q.9, see below), and a pierced and incised pair with an adjustable sliding piece (Q.8). The form of Q.7 should be compared to similar tweezers among the groups of implements in the d'Allemagne collection and in the Ashmolean Museum set (see p.362). This, combined with the very plain style of pierced work on the Tanavoli pair, makes a late 19th-century date for them most probable. A pair similar to Q.8 is in one of the trays in the d'Allemagne collection. Two other small points are worth noting. Firstly, the piercing on them has not been filed smooth or otherwise finished off on the inside of the arms, suggesting that the drilling was done after the tweezers had been bent to their present shape. Secondly, the gold work on Q.7 shows that the adjustable style was not necessarily held in more esteem than the simpler form. As with kohl sticks, different uses, personal and medical, should not be ruled out for these instruments: in the Wellcome Museum, examples similar to Q.9 are catalogued as early 20th-century Punjabi dental forceps.

The toilet set (Q.9) represents a relatively common grouping of cosmetic instruments. Toilet sets of this type have been found in ancient Egypt, and continued in use throughout the centuries, in Europe[13] and in the Near East.[14] In the Pitt Rivers Museum, Oxford, are two more recent examples,[15] one said to come from Iran, the other from Huwaitat, Arabia, and silver Omani ones have been published.[16] Another Iranian silver set is in the Tanavoli collection (FIG.68). The identification of these toilet sets makes it likely that a number of the small implements published by Awad as surgical tools are just as likely to have been made for purposes of personal toiletry.[17] Q.9 is of mild steel (see p.516) and therefore likely to be of 20th-century date.

Q.10 is a dual-purpose cosmetic implement, combining a nail-file with a nail-cleaner. The file consists solely of deep cuts across the blade, and their regularity suggests that the implement is relatively modern. However, traces of lighter cutting at the neck end of the blade may indicate that the implement has been reworked and that it is therefore somewhat older than it may at first sight appear. Q.11 and Q.12 may also be cosmetic instruments, combining a knife for cutting nails with a nail-file, and in the case of Q.12 a nail-cleaner. It is also possible, however, that such tools were used by calligraphers (in which case the knife could have served as a nib-

12. Babelon and Blanchet (1895) no.1627.
13. Bennion (1986) p.137 pl.143 for a German toothpick, earscoop and tongue-scraper on a common ring, circa 1680.
14. See, for example, a set of toilet implements on a ring in London, Science Museum, Wellcome Museum, acc. no.A 634882.
15. Case L.51.A.
16. Hawley 1978 p.30 (unnumbered).
17. Awad (1980) figs 1–3, 7, 8, 12–13, 16.

COSMETIC IMPLEMENTS AND MIRRORS

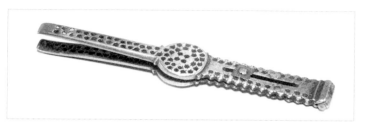

Q.7 Tweezers; cut and pierced; gold overlay; l. 9.9 cm; 18th–19th century; no.256
Q.8 Tweezers with sliding nail and brass plate; cut and pierced; l. 9 cm; 18th–19th century; no.367

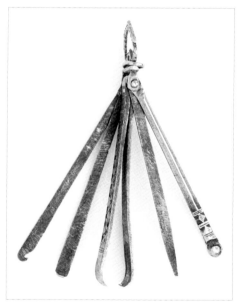
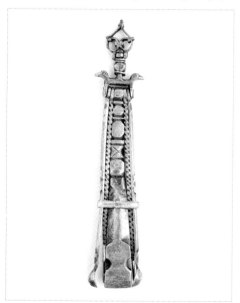

Q.9 Toilet set: tweezers, ear scoop and three picks; pierced and cut; l. 8.2 cm; 20th century; no.369
FIG.68 Silver toilet set; five implements hinged and held together by a slide loop;
l. 8.4 cm; 18th–19th century; no.370

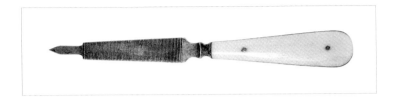

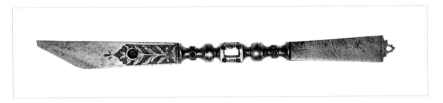

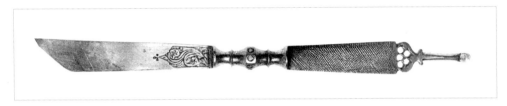

Q.10 Nail-file and nail-cleaner; cut; handle with ivory scales; l. 11 cm; 18th–19th century; no.398

Q.11 Knife and file combination; cut and pierced; ? once inlaid with semi-precious stones; l. 13.9 cm; 18th–19th century; no.381

Q.12 Knife and file combination; cut and pierced; turquoise inlay; l. 15.6 cm; 18th–19th century; no.382

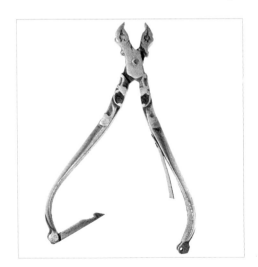 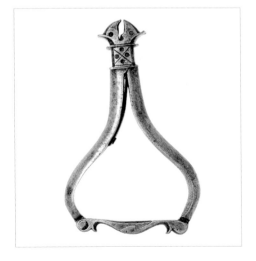

Q.13 Nail clippers (?); cut, riveted; once inlaid with semi-precious stones; l. 9.9 cm; w. 3.5 cm; 18th–19th century; no.48

Q.14 Nail clippers (?); cut, punched and riveted; l. 7.4 cm; w. 4.6 cm; 18th–19th century; no.49

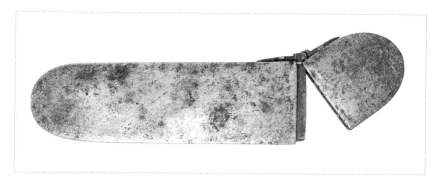

Q.15 Spectacle case; hinged lid; brazed and riveted; ht 12.5 cm; w. 3 cm; 19th century; no.240

cutter) or by other craftsmen. On both Q.11 and Q.12, the file has short cuts at right-angles to the blade along the blade edges, and groups of diagonal lines, at varying angles, over the rest of the blade.

One other type of cosmetic item made of steel, the comb back, should also be noted, even though it is not represented in this collection. Two examples are in the Freer Gallery of Art.[18] They are both arch-shaped, and are made of two sheets of steel soldered together. They have a sheath along the bottom into which a set of presumably wooden teeth could be inserted.

Two implements in the collection, Q.13 and Q.14, are of uncertain use. On the basis of 20th-century European parallels they could well be nail-clippers, and they are included here for that reason. This identification is also supported by the fact that Q.13 was once inlaid, probably with tiny turquoises, an appropriate embellishment for a pair of implements to be used by a well-to-do woman. Otherwise it is possible they had a use in one of the craft industries. Other examples are to be found in the Khalili collection,[19] one of which is also set with turquoises, and in one of the d'Allemagne tool sets.[20]

Q.15, with its hinged lid, is a spectacle case designed to hold pince-nez. Another possible spectacle case is mentioned above (see pp.398–99).

MIRRORS

The history of metal mirrors in early Islamic Iran has been dealt with by the author at some length elsewhere.[21] It may be summarised as follows. The earliest surviving Islamic mirrors are of what may loosely be termed 'bronze'. The few examples

18. Atıl, Chase and Jett (1985) nos 32 and 33.
19. Stanley (1997) pp.116–17, T17–19.
20. d'Allemagne (1911) vol.3 p.255.
21. Allan (1982) pp.33–37.

known seem to have been made of two different alloys sandwiched together, a highly reflective surface of high-tin bronze on one side, and a low-quality copper alloy on the back.[22] Handles of various forms may have been soldered to the centre of the back.[23] From *circa* AD 1100 there is an abundance of relief-cast bronze mirrors with central boss handles. The style of this latter group reflects Chinese prototypes, and their mass production the introduction of Chinese technology in the form of green-sand moulding.[24]

There is, however, a strong likelihood of another pre-Mongol tradition in Iran, of iron or steel mirrors. The evidence for this is various. First is the very small number of surviving metal mirrors datable to before AD 1100. This suggests that whatever mirrors existed must have been made of a material which does not survive well in archaeological contexts. Second is the fact that Ibn Faqih, writing in AD 902–903, ascribes mirrors to Hamadan and Fars, with an implied identification of their material as iron.[25] These mirrors almost certainly had long handles, for which there is evidence in bronze: some examples of the boss-handled pieces are decorated with a design which incorporates a space for such a fixture, while the Tanavoli collection actually contains a bronze mirror with a long handle (FIG.69). This must date from the late 15th century, indicating a continuing tradition for bronze mirrors long after one might have expected steel to be dominating the market. Another such mirror, ascribed to the 13th-century Saljuqs of Rum, is in a Turkish collection (see below).[26] More important, this is the form of the earliest surviving steel mirrors from the Islamic world, to which we now turn.

A number of early steel mirrors deserve mention. First is a Saljuq Anatolian mirror decorated with a falconer on horseback and a band of animals, sparingly inlaid with gold.[27] Second is a magnificent Mamluk steel mirror in the Topkapı Saray Museum made by Muhammad al-Waziri sometime before AH 746 (AD 1345), which is sumptuously inlaid with silver and gold.[28] From the following century come two mirrors in the name of the Mamluk sultan, Barsbay (1422–37), one in Izmir,[29] the other in Cairo.[30] Both are said to be of iron, and the Cairo mirror has traces of gilding. A steel mirror recently on the art market is decorated with large areas of gold overlay.[31] Comparison of the design with other Mamluk work suggests that this mir-

22. Allan (1979) p.48 and Table 21 no.44.
23. Allan (1982) nos 78 and 188 are both probably mirror handles.
24. Allan (1979) pp.61–62.
25. Ibn al-Faqih pp.205, 253–54.
26. Bodur (1987) p.99 A.30.
27. It is 21 cm in diameter, and 41.5 cm long with the handle: Rice (1961) figs 5 and 6; *The Anatolian Civilisations* (1983) vol.3 p.71.
28. It is 24 cm in diameter, but the length of its handle is not recorded: Rice (1950) p.370; Mayer (1959) p.74; Rogers (1987) no.109.
29. Riefstahl (1931) fig.228 and p.116 no.36.
30. It is 21.5 cm in diameter and 46.5 cm long with the handle; *Islamic Art in Egypt* (1969) no.81.
31. It is 20.1 cm in diameter and 43.3 cm long with the handle; Christie's, 19 October 1993, lot 314.

ror is much more likely to be of late 15th-century date than the 14th-century date ascribed to it.

Of similar date are the three mirrors in the Tanavoli collection (Q.16–18), which are characterised as follows. They have a mirror disc with slightly upturned sides, a neck of crude palmette form with a rectangular hole in the centre, and a handle with twisted shaft and pointed domical finial. In diameter they vary from 12.2 centimetres to 14.5 centimetres, and in length, with the handle, from 23.6 centimetres to 29.6 centimetres. Two have arabesque or geometric designs set within an interlace border, the third has an overall design of a lion attacking a deer amid formalised plants and flowers. Q.16 was published as 14th century;[32] however, although the interlaced star pattern which dominates its design is common in 14th-century Qur'ans and woodwork, the forms of the palmettes and rosettes which fill the interstices are very decadent compared to those of the 14th century. The use of simple geometry combined with a comparable decadence of motifs is to be seen in a late 15th-century brass lamp in Berlin,[33] and the mirror may also be attributed to the late 15th century. A similar dating for the other two, and a Turkoman provenance for all three, is clear from other features. The interlace borders of Q.16 and Q.17, the forms of blossom on Q.18, and the general form of the arabesques on Q.17, are characteristic of metalwork which we may now safely ascribe to the Turkoman dynasties.[34]

These three mirrors are part of a larger group which survive in both iron or steel and bronze. An iron or steel example, decorated with two confronted peacocks within an interlace border, inlaid with silver, is in Berlin.[35] Confronted peacocks were a popular Turkoman design.[36] Another similar mirror was sold at Sotheby's recently.[37] It has a lion against a foliate background, and an interlace border. A mirror from the Piet-Lataudrie collection, with the same interlaced border framing a geometric Kufic inscription, is illustrated by d'Allemagne,[38] and a similar piece bearing four repetitions of the name of 'Ali in geometric script is in the National Museum in Tehran.[39] A copper alloy example in a Turkish collection is decorated with a central cruciform arabesque design with three decorative bands, an inner

32. Tanavoli (1985a) fig.37.
33. von Gladiss and Kroger (1985) pp.129–30, no.316.
34. For the characteristics of Turkoman metalwork see Allan (1991). For more particular examples of those mentioned, see a lidded jar in the Victoria and Albert Museum in Melikian-Chirvani (1982) pp.253–54 no.112; a small plate in Sotheby's, 12 October 1982, lot 165; and various bowls, see Vienna (1895) pl.III and Sotheby's, 25 April 1990, lot 103.
35. It is 17.5 cm in diameter and 35 cm long including the handle; *Islamische Kunst Verborgene Schätze* (1986) no.213.
36. See, for example, Melikian-Chirvani (1982) p.243 fig.64.
37. With its handle it measures 26.7 cm; Sotheby's, 18 April 1994, lot 131.
38. d'Allemagne (1911) vol.2 p.74 illustrates two other examples, and yet another is illustrated on p.259.
39. *An Anthology from the Islamic Period Art* (1996) acc. no.8554. I assume the catalogue entry's description of this as silver is incorrect.

and outer one of interlace, and a middle one of leaves and stems.[40] The cruciform palmette and the interlace borders, combined with the form of handle, which is all but identical to the Tanavoli pieces, suggests that this is a 15th-century object, not a 13th-century one as published. So close is its form to the Tanavoli mirrors that it is tempting to suggest that it was cast in a mould used for both iron and copper alloys. However, technological investigations into the steel mirrors showed that they were forged not cast, so this suggestion must be discounted. An interesting steel mirror of this group is in the Victoria and Albert Museum.[41] It has had all the Turkoman decoration removed, and in its place has been added a gold inscription naming Shah Sulaiman. Far from being Safavid, however, the inscription is 19th-century work and shows the lengths to which dealers went to attract purchasers of antiques (see pp.105–109).

Where such mirrors were made is uncertain. The only post-Mongol reference to the manufacture of iron mirrors in Iran is that of Marco Polo, who praises the craftsmen of Kuhbanan in Kirman province for their steel mirrors of great size and beauty.[42]

The Tanavoli mirrors, although all attributable to Turkoman workshops of the late 15th century, are by no means identical. In size they differ significantly, and their handle necks are slightly different too. (A quite different, spade-shaped handle end occurs on the mirror in Berlin mentioned above.) Q.16 gives the misleading impression of an object cast complete with its decoration, although technological investigation has shown that was forged. Q.15 has its design incised with a sharp tool, and its background punched to give it texture, while the background of the design on Q.17 has been carved away, and the leaves of the arabesque have then been incised with groups of roughly parallel lines to articulate them. It is also interesting to note that Q.17 has a rosette punched at the base of the neck, which may perhaps be a maker's mark. These differences suggest that steel mirrors of this form were common, and that they were manufactured either in different places or over a substantial period of time, or both.

Steel mirrors must have continued to be popular in the Safavid period, though remarkably few have been published. A magnificent Safavid inlaid mirror is now in the Nelson-Atkins Gallery of Art in Kansas City.[43] It has a slightly pointed form and is inlaid with gold. It is decorated with a central medallion of arabesque work within a 'floating' arabesque band, and is bordered with a Persian inscription which may be translated:

40. Bodur (1987) p.99 no.A.30.
41. London, Victoria and Albert Museum, acc. no.407-'76. It is 27.7 cm long. The museum also has a 15th-century Turkoman steel mirror in its original form, acc. no.25-1889.
42. Marco Polo (1929) p.125.
43. It is 13.6 cm in diameter and 26.5 cm long including the handle; A. Welch (1973) no.44.

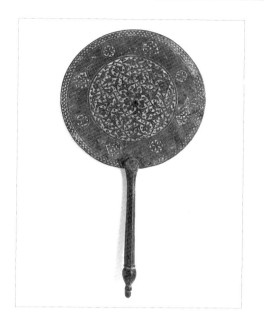
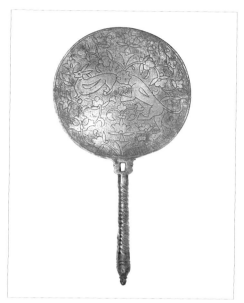

FIG.69 Mirror; copper alloy; cast handle; ht 27.3 cm; diam. 14.3 cm; Turkoman; late 15th century; no.151

Q.16 Mirror; ht 26.3 cm; diam. 13.7 cm; Turkoman; late 15th century; no.31

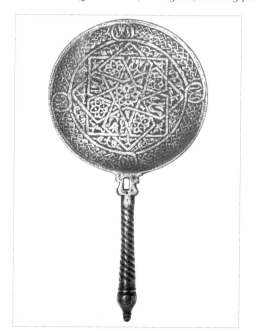
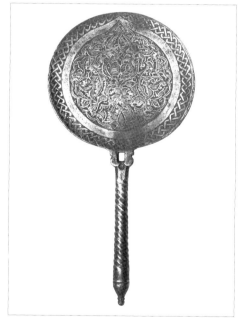

Q.17 Mirror; ht 23.6 cm; diam. 12.2 cm; Turkoman; late 15th century; no.149

Q.18 Mirror; ht 29.6 cm; diam. 14.5 cm; Turkoman; late 15th century; no.150

'Tell the mirror-maker: "Don't bother polishing it."
'The mirror will become unclouded when you look in it.
'You have loaned your face to the mirror.
'How else could it show your visage ?'

Steel mirrors were also popular at the Ottoman court.[44]

The later history of steel mirrors is obscure. They were still esteemed in the later 17th century, for Olearius records among presents from European ambassadors to the shah 'a very fair Steel Looking-Glass, polished on both sides, and embellished with several figures, grav'd by that famous artist, John Dresch'.[45] About the same time Herbert noted steel mirrors in use in religious contexts. One he saw hung by the brazen gate of the mosque of Lar; another hung in the shrine at Berry on the road from Lar to Shiraz. Their precise function is unclear. Of the latter one he writes: 'At the top of the Chappel is a Steel-mirrour, wherein these Lynx-eyed People view the deformity of their sins.'[46]

Steel mirrors probably died out some time in the late Safavid period as imported glass mirrors took their place. A method of backing glass with thin sheets of metal had been well known in the Middle Ages in Europe. Vincent of Beauvais, writing *circa* AD 1250, mentions such mirrors, and a guild of glass mirror-makers existed in Nuremberg as early as AD 1373. Using this method, small convex mirrors were made by blowing small globes of glass. While these were still hot, a mixture of tin, antimony and resin or tar was passed through the glass-blowing pipe. When the globe was completely coated with the compound, and had cooled, it was cut into convex lenses. These gave small but well-defined images. The major developments after this occurred in early 16th-century Murano, where the production of mirrors on a commercial scale gave the Venetians a monopoly in mirror-glass, and made them exporters on a vast scale until the middle of the following century. Here were perfected the tin-mercury amalgam necessary for good reflection ('silvering') and a more successful way of producing the glass itself. Brown glass cylinders were now used: these were slit, flattened on a stone, carefully polished and the edges frequently bevelled, before their backs were 'silvered' with the new amalgam. While Venice had been prospering, however, glass-makers in France and England had been further improving their own techniques, and in 1688 two Frenchmen, de

44. One dated *circa* 1520–30 is 14 cm in diameter and 30 cm in length with the handle; see *The Anatolian Civilisations* vol.3 (1983) p.158 no.E.81. For another, of steel but covered in gold and bejewelled, of late 16th-century date, see p.181, no.E.119.

45. Olearius (1669) p.211; he also notes (p.206) Indian dancing women wearing thumb-pieces with a piece of steel in place of a stone so well polished that it served them for a looking-glass.

46. Herbert (1677) pp.120, 125.

Nehou and Thevart, perfected a process for casting plate-glass by rolling molten glass poured onto an iron table. Previously the size of the blown glass sheets had been relatively small; the new technique made possible the manufacture of very large plates, and hence very large sheets of mirror. The Venetian mirror-glass industry thenceforward declined until, by 1772, there was only one glass-house still in operation.[47]

In the 16th and 17th centuries Venetian mirror-glass became a highly valued commodity in Safavid Iran, and it is noted among the gifts brought by embassies to the Safavid court. Thus, in 1666 the Muscovite ambassadors gave Shah 'Abbas II, amongst other things, 'Nine small Looking-Glasses of Christal, the Frames painted', while the French embassy did rather better, with 'Four Looking-Glasses of Christal five Foot high, three with a Frame of Brass guilt, the other with a Christal Frame'.[48] When the Iranians learned the art of silvering glass is not known. It was certainly not within their capabilities in Jean Chardin's day, for he observed: 'They do not understand to Silver their Glass over ... therefore their Glass Looking-Glasses, their Sash-Glass and their Snuff-Bottles are brought to them from *Venice*.'[49] However, the Iranian love of *a'ina-kari* ('mirror-work') in their architectural interiors must have exerted a considerable pressure on local craftsmen,[50] and silvering of glass was certainly practised in Isfahan at the end of the 19th century, though in this case the glass itself was foreign.[51] Be that as it may, the next stage in the development of mirrors for cosmetic use in Iran was to mount looking-glass in wooden or steel frames, and Qajar mirrors with circular, lidded steel covers, on a tall steel stand, are common in the salerooms today.[52]

A particularly fine example is in the Iran Bastan Museum. It was made for Nasir al-Din Shah (1848–96) by Muhammad Ibrahim in AH 1291 (AD 1874), and its dedicatory inscription and the signature of the artist are pierced against a red ground.[53] A second mirror made two years later by the same artist for the same patron was recently sold at Sotheby's.[54] Another, unsigned, mirror made for Nasir al-Din Shah is in the British Museum.[55] Its pierced inscription also has a red ground. These three

47. The details above are taken from Nesbitt and Powell (1910–11) p.101; Anon (1910–11) p.576.
48. Chardin (1988) pp.86 and 93.
49. Chardin (1988) p.275.
50. Sims (1985).
51. Floor (1971) p.110. Curiously Wulff (1966) pp.169–71 makes no mention of looking-glass in his discussion of glass-making.
52. Floor (1971) p.110 mentions the framing, but does not specify the material used. Frames were also made in *khatemkar*; see d'Allemagne (1911) vol.3 illustration on p.100.

53. Tehran, Iran Bastan Museum, acc. no.21879; it is approximately 55 cm high.
54. Dated AH 1293 (AD 1876); Sotheby's, 27 April 1995, lot 145. It appears, however, that the mirror back bearing the artist's and patron's names has been fitted into a mirror stand of inferior quality.
55. London, British Museum, acc. no.1967.7-18.1; it is 60.5 cm high. A much poorer quality mirror made for Nasir al-Din Shah was sold at Sotheby's, 12 October 1982, lot 235. Another of the same period, dedicated to Shah Sulaiman Safavi, was sold at Sotheby's, 20 October 1992, lot 164.

mirror-cases are of the finest workmanship, and show the extraordinarily high levels of craftsmanship reached in the late 19th century.

A different type of steel mirror-case is exemplified by another piece in the Iran Bastan Museum.[56] This is of a flat, rectangular form, hinged down the centre. It is made of watered steel, and is meant to be held in the hand, for it has no stand. The pierced inscriptions on each side, including a dedication to Nasir al-Din Shah, are backed by the reverse side of each mirror face. The words which include the name of the artist, *ya-nasir ya mu'in / 'amal-e kamtarin Ibrahim* (O, Giver of Victory! O, Defender! / the work of the most humble Ibrahim'), are in gold work, above and below the dedicatory inscription on the front. A further style of hand-held steel mirror-case is known from yet another object in the Iran Bastan Museum.[57] Here the lid is smaller than the body, and is hinged a centimetre or so in from the edge of the body, a style commonly found in lacquer, wood and ivory mirror-cases.[58] A rectangular mirror-case on an elaborate steel stand also occurs.[59]

56. It measures 18.5 by 12.7 cm. There is a plainer example of this same style in London, Victoria and Albert Museum, acc. no.504-1874.
57. Tehran, Iran Bastan Museum, acc. no.21879.

58. See, for example, an ivory mirror-case in the name of Fath 'Ali Shah in Oxford, Ashmolean Museum, acc. no.EAX1205; Raby (1999) no.135.
59. Bonhams 23–24 April 1996, lot 376.

Technological investigation of objects

Brian Gilmour

AIMS AND METHODOLOGIES

The overall purpose of this part of the present study was to identify the type of iron or steel used in each object examined, and more specifically, to find out in each case how the metal had been produced and subsequently processed. The objects were selected from across the full range of artefacts in the Tanavoli collection, and a broader aim of the technological investigations was to determine how the irons and steels used varied across the timespan represented.

Inevitably the chronological spread of material in a collection such as this is uneven, with the vast majority of objects belonging to the post-medieval period. Fourteen of the examined objects, however, belonged to medieval and earlier periods – that is, approximately 15th century AD and before – of which five were archaeological objects, of unknown provenance, all of which may be much earlier than the rest and belong to the pre-Islamic era, although this dating is only very tentatively suggested on the grounds of style.

In total 72 objects were subjected to metallographic examination. Given the wide variety of objects covered by the Tanavoli collection it was felt that the 72 examinations undertaken probably constituted about the minimum number from which to determine the different types of iron and steel used in Iran, at least in the later Islamic period.

Perhaps the most obvious omission in terms of the types of objects tested is that no swords are included in the collection. Although one of the aims of gathering this particular body of material was to show how iron and steel was used for objects apart from swords and other weapons, on which most attention has tended to be focused in the past, it had been hoped that it would be possible to examine one or more dated Iranian swords so as to forge a stronger link between medieval Islamic technological descriptions, which concentrate on swords, and the way in which iron and steel was used for a wide range of other objects. Unfortunately this was not possible owing to the constraints on time and on the availability of suitable securely dated blades for analysis.

A careful visual inspection of each object was first made, to look for surviving traces of the original surface appearance and to distinguish these from any effects

which are more likely to have been the result of subsequent corrosion or damage, such as that caused by wear and tear or cleaning. The subsequent detailed analysis of the material in the selected objects was carried out mostly by means of *in situ* metallography, which allowed the broad identification of the different types of iron and steel used. This involved the polishing, etching and microscopical examination of a small area on the surface of each object. To ensure the polished areas were flat, and to enable the easy demounting of each object without damage, a specific part of each object was set in mounting resin with release wax. In cases where the objects were composite, with more than one piece of iron or steel having been used or with non-ferrous alloys combined with pieces of iron or steel, each of the metal components was identified as far as possible. A summary of the results of the metallographic analysis is given here in Table 2.

In situ metallography does, however, have drawbacks compared to the examination of a mounted sample. It is much more difficult to achieve a perfectly flat, scratch-free surface on the mounted part of a complete object unless the object is small and easy to manage, which is not usually the case. The loss of resolution at higher magnification will inevitably makeit harder to identify some iron and steel structures, and a less well-prepared surface is bound to affect adversely the quality of any photo-microscopy that is carried out, although this will be less noticeable on photomicrographs taken at lower magnifications. One further drawback is that no micro-hardness tests can be carried out. Hardness testing is used to provide more information about the structure of a ferrous metal artefact, partly to confirm identifications made through the microscope when ferrous structures are difficult to resolve this way, partly to reveal or predict the presence of unseen additional alloying elements, and partly to provide a simple way of assessing the extent of heat treatments. Information like this allows the comparison of the physical properties of one ferrous object with those of another. Micro-hardness testing should therefore be carried out as part of a metallographic survey wherever possible. Nevertheless, on those occasions where *in situ* metallography is all that is possible, this approach can still yield much information important for identifying the type of iron or steel used.

It proved to be beyond the scope of the present work to carry out more than a very little detailed micro-analysis to look for trace impurities in the metal matrix or to analyse, and hence confirm, the types of non-metallic inclusions present, which could otherwise only be identified by their visual appearance. At the time of writing elemental investigation by electron-probe micro-analysis (EPMA) was being carried out on samples taken from the series of flint-strikers. These were chosen for more detailed work because they covered a period from the 11th to 19th centuries and could be dated with a fair degree of confidence, even if this, in most cases, was based on stylistic attributes. Also, judging by the obvious signs of wear they had quite

clearly been working objects, and their function as flint-strikers meant that a high-carbon steel could be expected, at least for the striker plate in each case.

Despite the limitations outlined above, the metallographic examinations produced enough information to show the scope – in the quality and types of materials used as well as the skills shown in forging, especially of ultra high-carbon steels – of earlier Iranian ironsmithing. It should, however, be stressed that the interpretations based on the results presented here can only be provisional.

THE IDENTIFICATION OF BLOOMERY AND CRUCIBLE STEELS

Steels produced by either the crucible process or directly smelted by the bloomery process will each retain some residues or impurities, however small in size or concentration, which are characteristic of the different manufacturing procedures. In the case of the crucible process, the residual slag associated with any bloomery iron or steel used as part of the crucible charge floats to the top as soon as the metal has melted and the only non-metallic residues that might be expected are those such as manganese sulphides or alumino-silicates which characteristically remain as very small particles – typically within the range 1–5 microns (0.001 millimetres) across – in suspension in the liquid steel.

It is clear from the surviving early recorded descriptions of the crucible steel-making process, spanning the 3rd to 13th centuries AD (see pp.46–47, note 34, pp.58–61, 64) that a distinctively reddish manganese mineral,[1] probably manganese dioxide, was a common additive to the raw materials in the crucibles. The very high temperatures that these crucibles had to reach, together with the overall reducing conditions present, would in most cases probably have been sufficient to reduce the manganese dioxide to manganese metal, which would immediately have reacted with any sulphur present to form small manganese sulphide inclusions, thereby converting any sulphur present to a harmless form. Sulphur otherwise forms at the grain boundaries of a steel leaving it brittle even at forging temperatures (hot shortness) and it seems most likely that we are here seeing an early forerunner of the modern practice in Europe, introduced during steel-making developments of the 19th century, where manganese was added as a way of removing sulphur, one of the unwanted by-products of using coke.

The greater reducing conditions and higher temperatures associated with the crucible firing, or with the smelting of the cast iron used as part of the crucible charge – which seems to have been a particular characteristic of Iranian crucible steel production – may also result in the partial reduction of small amounts of other

1. Ragib and Fluzin (1997) p.40 n.89.

metals such as chromium, manganese, titanium or vanadium, elements not normally found as significant trace impurities in bloomery metal. This is in addition to elements such as nickel and phosphorus which are more easily reduced and, therefore, also commonly found as impurities in bloomery iron or steel.

An important aspect of solidification in a crucible is that, on cooling, certain parts of an alloy will freeze first to give a characteristic dendritic effect (a firtree-like pattern visible on etching) which also results in the segregation of the minor or trace elements. The dendritic segregation of these elements, where they also control and promote the formation of cementite (iron carbide), plays a key role in the formation of the watered patterns when it persists through subsequent heating and forging operations. The presence of a watered pattern – recently shown to be dependent on this dendritic segregation of certain minor elements[2] – is, therefore, a good indicator of crucible origin for a steel (although non-watered steels may also be of crucible origin). A crucible origin may still be indicated even where these key minor elements are missing, although its identification will probably depend on the detection of characteristic non-metallic impurities such as manganese sulphide.

Bloomery steel, on the other hand, can be identified by the entrapped residual particles of non-metallic slag left over from the original smelting of the metal. These will consist mainly of iron silicate (fayalite), typically as small spheroidal inclusions (usually about 5–10 microns in diameter) or larger, more elongated, often ribbon-like inclusions. It should be noted that what appears as a spheroidal inclusion in transverse section – which effectively covers most of the objects examined in the present study – will often appear elongated when viewed in longitudinal section, along the direction of forging. An even microstructure is not necessarily a good guide to a crucible origin as this can be achieved from an uneven steel bloom by skilful reheating and forging as is still done by Japanese swordsmiths using the *tamahagane* steel from the *tatara* steel blooms (see below). Bloomery metal is generally very low in both sulphur and manganese and, therefore, the absence of manganese sulphide inclusions is a good guide to a bloomery origin for a steel.

RESULTS

Pre-Islamic period, circa *1200 BC–AD 650*

Three objects from the early Iron Age (*c*1200–700 BC) in this region, two armlets (R.1–2) and a horse-bit (R. 4), were examined and found to consist of plain iron with very little carbon. Both the armlets are closely similar to other armlets dated to this period.[3] These and the horse-bit all have skeuomorphic aspects to their design

2. Verhoeven *et al.* (1996), pp.20–21. 3. Muscarella (1988), pp.171–73 nos 272 and 275.

(copies forged in iron of late Bronze Age forms suited to being cast in bronze), which suggests an early date, and they are therefore tentatively dated *circa*1000–800 BC.

Of two other objects, also ex-catalogue, one is assumed to be a lynch-pin with a highly decorative iron head and a square-section shaft 0.8 millimetres across; it is 223 millimetres long in total, the shaft measuring 167 millimetres (R.3). It might be the surviving upper part of a mace although there is no obvious sign of a longer iron shaft having been broken or cut down and, although the head is of a similar size to Sasanian copper alloy mace-heads cast on to iron shafts,[4] the style and metal are different: the iron shafts of the maces are also thicker. Even if we assume that this object is a lynch pin, its date is still unclear; the Achaemenid to earlier Sasanian period, later 1st millennium BC to earlier 1st millennium AD, seems the best estimate so far. The iron shaft of this object and part of a second horse-bit (R.5) were both found to be made of steel, although their composition was mixed in both cases, varying between low- and high-carbon areas. Its resemblance to similar material would suggest a Sasanian date for this second horse-bit.

The plain iron objects consisted of ferrite with a variable grain size and containing many non-metallic slag inclusions. These inclusions were typical examples of the kind of entrapped residues which tend to be left in a piece of plain iron made by the bloomery smelting process. As is usually found to be the case the inclusions were seen to consist of a mixture of constituents of different shades of grey, paler iron oxide (wüstite) together with darker iron silicate (fayalite) with an additional dark grey glassy phase often visible as well. The overall proportion of this entrapped non-metallic slag was variable, as it always will be in iron of bloomery origin, for it is dependent on the skill and time spent on consolidating the primary product of the smelting furnace, the spongy iron 'bloom', to remove the non-metallic slag and cinders, the waste products of the smelting process. The variability of the grain size of the ferrite was a good indicator that the composition and distribution of minor and trace alloying impurities in the metallic iron were also uneven in different parts of the metal, although, unlike the uneven slag residues, this was the result of the variable conditions existing in different parts of the smelting furnace during the production cycle.

When etched with nital the horse-bit (R.4) and the two-piece bracelet or armlet (R.1) were found to consist of a varying, medium-to-fine grain ferritic structure whereas the one-piece bracelet (no.R.2) consisted mainly of a large-grain ferrite across which a fairly dense distribution of rod- or needle-like carbo-nitrides was also visible (FIG.70), again the probable effect of alloying impurities and a very low carbon content on the structure of the iron.

4. Overlaet (1998) pp 254–65.

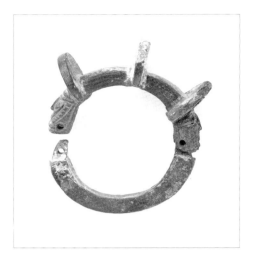 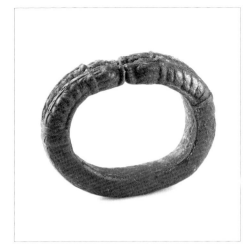

R.1 Armlet, d. 8 cm; 10th–8th century BC; no.518
R.2 Armlet, d. 8.5 cm; 10th–8th century BC; no.519

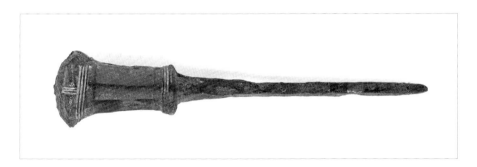

R.3 Axle pin(?), l. 22.4 cm; 7th century BC–3rd century AD; no.517

There seems to be no particular reason to doubt the dating of the earliest three among these objects, which indicates that they must have been made from bloomery iron, as no other iron-production methods were available in the earlier Iron Age in Iran. The metallographic analyses support this assessement. The picture seems no less clear for the two pre-Islamic steel objects attributed to this period (R.3 and R.5). In both these objects there was a very wide variation in carbon content between mainly ferritic areas with less than 0.1% carbon and high-carbon steely areas with up to approximately 0.7 to 0.8% carbon, but overall constituting a medium-carbon steel with a carbon content of about 0.4% (FIGS 71 and 72).

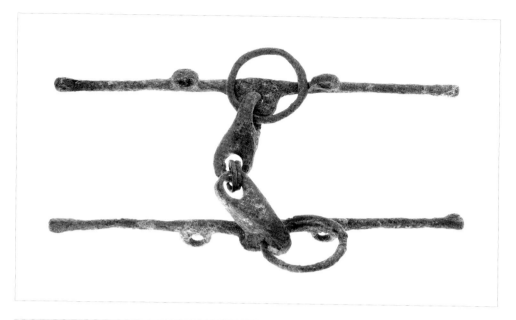

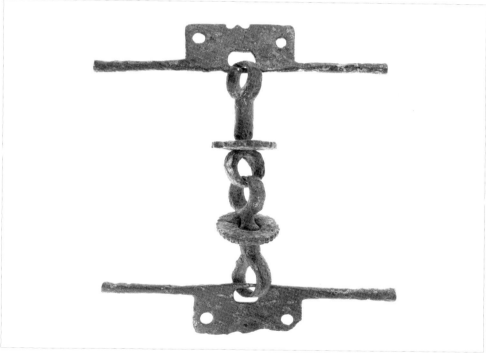

R.4 Horse bit, l. 25 cm; early 1st millennium BC; no.515
R.5 Horse bit, l. 18 cm; 4th–6th century AD; no.516

Medieval objects (11th to 15th centuries)

The earliest of the 11 medieval objects examined was a two-part flint-striker (P.1), dated by inscription on the striker plate to the 11th century. Perhaps surprisingly, both parts of this flint-striker were found to consist of what appears to be a quenched, very high-carbon steel. A fairly dense and evenly distributed scattering of small, mid-to-pale grey non-metallic inclusions was visible across the areas examined. These were mainly spheroidal in shape although there was a much smaller proportion of more elongated inclusions, of an otherwise similar appearance. These were aligned parallel to the outside surface, which must represent the direction this piece of steel was forged. These inclusions look most typical of manganese sulphides.

The outer part of this flint-striker was found to have the typically acicular (needle-like) martensitic structure of a fully quenched medium- to high-carbon steel. The striker plate, however, showed a rather different quenched appearance, this time consisting of a martensitic structure (FIG.73) which was found to be mixed in some places with an irresolvable dark-etching constituent, possibly bainite. At higher magnification a fairly even scattering of tiny white particles was also visible, these most probably consisting of cementite (iron carbide). This indicates the steel to be hypereutectoid, possibly with a carbon content of about 1–1.2%, although this is difficult to estimate from the quenched structure. The steel for both parts of this object would, however, seem to be very similar, apart perhaps from some variation in carbon content, and is most probably of crucible origin.

A different pattern of results was obtained from seven of the other objects, all flint-strikers, which were dated stylistically to the period of the 11th to the 15th centuries. Five of these were composite copper alloy and steel objects although the ferrous metal striker plate that was originally inserted into the lower edge of the copper alloy body of one (FIG.63) was missing. In the case of the other four (FIGS 61, 62, 64 and 65), the striker plates all appeared to be made of crucible steel although the ferrous insert of one (FIG.61) was found to consist of a curious mixed white cast iron and steel structure (FIGS 74 and 75).

Although as yet it is not clear how this structure was achieved, it does at least show that white cast iron was sometimes used directly in the manufacture of objects, and may be an example of the type of white cast iron used as part of the crucible charge as described in medieval and post-medieval accounts of Iranian crucible steel-making.[5] The direct use of cast iron in another Iranian object of this period has also been noted recently.[6]

5. Referred to as *dus/asteh/ru* by al-Biruni (1989) p.248.
6. As part of a routine analysis in the British Museum: Paul Craddock, personal communication.

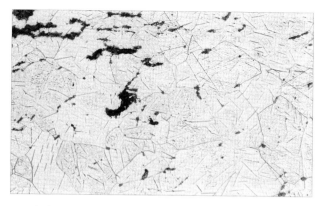

FIG.70 Photomicrograph showing many needle-like carbo-nitrides across the large grain ferrite structure of an armlet or bracelet (R.2). Magnification x 110; etched 2% nital.

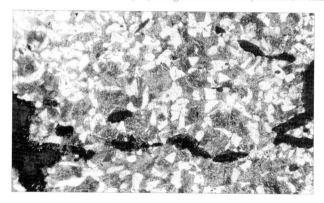

FIG.71 Medium-carbon steel of the shaft of a lynch pin (R.3), showing lamellar pearlite and ferrite (pale areas) plus large irregular corroded areas. Magnification x 110; etched 2% nital.

FIG.72 High-carbon steel of a horse bit (R.5), showing a spheroidised pearlite structure. Magnification x 450; etched 2% nital.

Of the other three inserted ferrous flint-striker plates, one (FIG.62) has been more comprehensively investigated both by metallography and electron-probe microanalysis (EPMA) and found to consist of a low-alloy crucible steel (the carbon content of which was found to be in the range approximately 1.5–2%) with significant quantities of several minor elements, in particular (in descending order of approximate overall concentration by weight) chromium, 1.2%; nickel, 0.3%; manganese, 0.3%; sulphur, 0.1%; phosphorus, 0.08%; vanadium, 0.05%; and silicon, 0.03%. The distribution of these elements was uneven, with the scattering of free cementite particles containing an average of 3.2% chromium and 0.2% vanadium, whereas the concentrations of these elements in the background steely matrix was found to be 0.7% and 0.02% respectively. By contrast there was more nickel and phosphorus in the background matrix and almost no silicon in the cementite, with most of the manganese and sulphur combined as small manganese sulphide inclusions with the residue distributed fairly evenly.

These results make it clear that not only was this ultra high-carbon steel produced by a crucible process, but more particularly that it must have been produced by the mixed cast iron/plain bloomery iron process: the levels of chromium, manganese, vanadium and silicon are far too high for any of the steels produced by bloomery iron and direct carburisation processes. This indicates that it is a product of the branch of the crucible steel-making industry in which the crucible charge consisted of a mixture of cast iron and bloomery iron. The very high chromium content suggests the use of chromium-containing magnetite iron ores from the Zagros mountain region which may in turn indicate crucible production of this steel in southwestern Iran, possibly as part of the industry in Fars hinted at in the 9th century by al-Kindi (see below).

In this flint-striker the contrast in size between the very large blocky cementite particles, up to 100 microns (0.1 millimetres) across, and the much more numerous and smaller sub-rectangular cementite particles was especially noticeable in section (FIGS 76 and 77). This and the comparitively high concentration of the carbide-promoting elements chromium and vanadium would appear to provide fairly strong support for the recent proposal that differential cementite growth – which is not usually quite as pronounced as this – is a direct result of thermal recycling (i.e. successive heating and cooling) during the forging of an object.[7]

A more obvious layered structure reflecting the dendritic inhomogeneities of these minor elements in the original cast (*wootz*) ingot might also have been expected, for it is clear that the dendritic spacing within a cast steel must be an important factor in the eventual spacing of the layered effect which gives rise to the

7. Verhoeven (1996).

FIG.73 Ultra-high carbon steel of striking plate of P.1, showing elongated manganese sulphide inclusions in a barely resolved matrix, mainly of martensite. Magnification x 450; etched 2% nital.

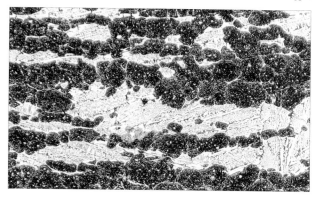

FIG.74 Mixed steel and white cast iron structure of the striker plate inserted into one of the copper-alloy bodied flint-strikers (no.351, FIG.61). Magnification x 60; etched 2% nital.

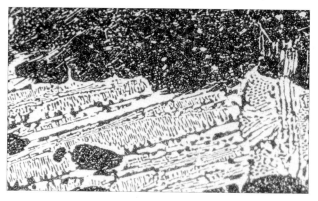

FIG.75 Detail of the same striker plate (no.351, FIG.61) showing the irresolvable, dark pearlitic steel matrix and one of the areas with a white cast-iron structure. Magnification x 450; etched 2% nital.

typical watered patterns seen on many objects, particularly swords. The extent to which an ingot is forged (i.e. the degree of deformation) is clearly another important factor; the layered structure typical of watered-steel objects seems to have been partly developed during the very extensive forging that some of them must have undergone. Research by John Verhoeven and others – partly experimental and partly based on the study of some post-medieval swords – suggests that a typical ingot might be expected to show an inter-dendritic spacing of approximately 500–600 microns, with the layer spacing within a typical sword of approximately 30–60 microns. This means that, at least in some cases, a reduction in thickness of approximately 10–20 times might be expected as a result of forging. So far no surviving Iranian crucible-steel ingots have been reported but a section through part of an Indian *wootz* ingot has shown an inter-dendritic spacing varying from approximately 1000–2000 microns (FIG.8d). This would suggest that the coarseness of the dendritic structure, and hence the inter-dendritic spacing, is likely to be rather more variable, at least across the approximate range 500–2000 microns.

In the case of this flint-striker there was no well-developed layered structure: in fact there was only a slight tendency for the large blocky cementite particles to congregate in lines along the direction of forging, and as far as it was possible to judge from the etched section (FIG.77) the inter-dendritic spacing appeared to be approximately 100–150 microns. This seems most likely to mean that the extent of forging was too little to produce a more pronounced layered structure. As the dendritic structure will also vary depending on the overall cooling rate of the furnace/crucible as well as differences in composition, gauging the size and shape of the original crucible-steel ingot used to forge the metal for this flint striker plate from the dendritic spacing is virtually impossible.

The inserted ferrous striker plates of the remaining two medieval flint-strikers with copper-alloy bodies (nos 80 and 81, FIGS 64 and 65) both showed quenched martensitic structures and both appeared to be of crucible origin, as (in most other cases) indicated by the presence of small, elongated non-metallic inclusions most probably of manganese sulphide, and the absence of almost any other non-metallic inclusions (FIG.78).

The final two medieval flint-strikers were each made of one piece of steel, and again both appeared to be of crucible origin (P.2 and P.3). They had largely martensitic structures indicating hardening, probably by quenching in water, although in P.3 the effectiveness of the quenching is clearly slightly uneven, with the pale martensitic areas interspersed with darker, roughly linear patches running at right-angles to the sides of the flint-striker (FIG.79). At higher magnification the acicular appearance of the paler martensitic areas is visible, and the darker areas have the characteristic nodular appearance of a radial form of pearlite, a typical intermediate

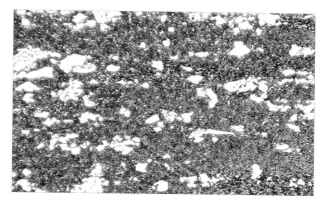

FIG.76 Ultra-high carbon steel structure of no.352 (FIG.62), with large irregularly shaped and small pale cementite particles visible against a dark pearlitic matrix. Magnification x 110; etched 2% nital.

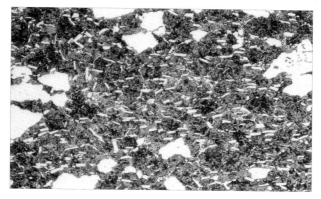

FIG.77 Detail of part of the steel structure in FIG.76 showing the two main sizes of cementite particles against a pearlitic matrix irresolvable at this magnification. Magnification x 450; etched 2% nital.

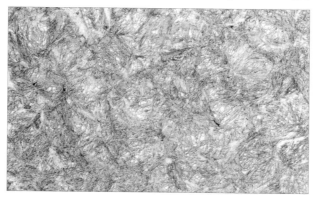

FIG.78 Martensitic structure of the steel insert in no.81 (FIG.64), with some small elongated manganese sulphide inclusions also visible. Magnification x 450; etched 2% nital.

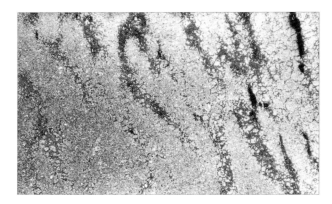

FIG.79 Mixed quenched structure of the striking edge of P.3. Magnification x 60; etched 2% nital.

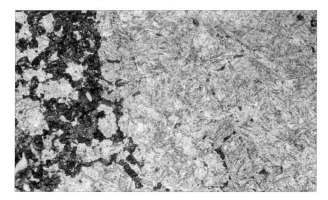

FIG.80 Detail of P.3 showing broad martensitic areas and narrower, darker areas of radial pearlite, with some small, elongated manganese sulphide inclusions. Magnification x 450; etched 2% nital.

quench product of an area within a steel with a relatively low carbon content (FIG.80). Quenched structures like this prevent any reliable visual estimate of carbon content from being made although a rough estimate of about 1% is suggested for these two objects. In the case of P.3 the inclusions were unusually numerous and elongated in appearance.

The other three objects dated tentatively to this period were all mirrors of a similar late 15th-century date (Q.17–19). All three mirrors were made of steel with a high-carbon, hypo-eutectoid composition (carbon content approx 0.6–0.8%) and their largely pearlitic microstructures indicate that these objects were probably air-cooled after the final heating cycle used in their manufacture. The non-metallic slag inclusions in one (Q.17) would appear to identify it as a bloomery product (FIG.81) and the relatively low carbon content of the other two might suggest a similar origin, although this is uncertain without more detailed analytical work. One of the mirrors

FIG.81 Edge of Q.17, showing lamellar pearlite in a more or less eutectoid structure. Small, elongated slag inclusions show the direction of forging parallel to the surface. Magnification x 450; etched 2% nital.

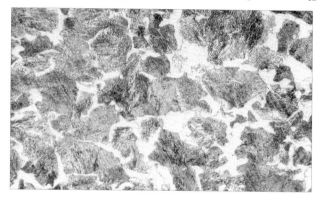

FIG.82 Edge of Q.18, showing darker areas of lamellar pearlite contrasting with much paler ferrite. Magnification x 450; etched 2% nital.

(Q.18) had a particularly clearly defined medium-grain, well-resolved lamellar pearlite structure and the apparent absence of any non-metallic inclusions is notable (FIG.82). It seems quite clear that these mirrors, like all the other objects examined here, were forged to shape even though details of style, particularly the twist decoration on the handles, would seem more suited to being cast in a mould. Their pearlitic structure shows that after the heating and forging cycle was completed these objects were finally air-cooled.

Post-medieval objects (probable 16th- to 17th-century date)

Most of the remaining 58 objects belonged to the post-medieval period and of these only four are tentatively placed within the 16th and 17th centuries. Only one (A.10), a knife or dagger (*kard*), was dated by inscription, in this case to AD 1615–16. Its blade showed up a distinctive inhomogeneous layered structure in section (FIG.83) which

suggests that it may once have had a watered surface, now lost, probably through over-cleaning. The blade was examined at the (slightly damaged) tip and was found to be made of a hypereutectoid steel (carbon content approximately 1.5–1.8%), almost certainly of crucible origin, consisting of pale cementite particles in a dark matrix, partially resolvable as a granular steely structure. This indicates that, before any surface finishing was carried out, the blade was quenched and tempered following the final heating cycle.

One intricately decorated pair of scissors (K.23) was also found to have been made of a hypereutectoid crucible steel, again with a carbon content visually estimated at approximately 1.5–1.8%. This time, however, instead of a layered macrostructure, at low magnification an inhomogeneous blotchy or mottled effect was visible (FIG.84) which would not have produced much, if any, of a watered pattern on the surface. The paler areas of this consisted of a fairly heavy concentration of small white cementite particles visible against a pale grey iron/iron carbide matrix (FIG.85). The darker areas were similar but had a much lower density of cementite particles and a correspondingly higher proportion of the iron/iron carbide matrix, which showed up darker but was very difficult to resolve at higher magnification: this would appear to represent an intermediate heat-treated structure, suggesting this object might have been slack- or slow-quenched in a liquid with low thermal capacity such as oil. The mottled effect seen at low magnification seems most likely to be the result of inhomogeneities in the original (perhaps egg-shaped) cast-steel ingot from which these scissors were made. What is not at all clear is why the mottled effect should have persisted when this object was forged out, rather than having become flattened to give a structure more like the layered effect normally seen in objects like these which must have been extensively forged, where there is a marked segregation of areas of cementite particles.

The late Safavid stirrup (C.1) was found to consist of plain iron, very much to be expected for this type of utilitarian object. In this stirrup the variable grain structure and related uneven but low carbon content indicate that this is a typical plain bloomery iron. The more even-grained carbon-free iron of the pair of stirrups (C.2) could have been the product of a finery hearth (i.e. made indirectly from cast iron) although this is very unlikely so early in this region and a bloomery origin for both the horse fittings is most probable.

The remaining object from this group, the spearhead (A.44) was found to be made of crucible steel with a carbon content of approximately 1.5%. At low magnification the structure of the spearhead looked interesting and slightly uneven, with a tendency towards layering, or at least linear clustering, though possibly not enough to produce a recognisable watered pattern (FIG.86). At higher magnification some linear clustering of cementite particles was visible against a largely irresolvable

TECHNOLOGICAL INVESTIGATION

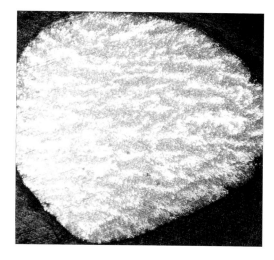

FIG.83 A layered macrostructure near the tip of A.10, consisting of pale, spheroidal particles of cementite in a dark pearlitic matrix. Magnification x 60; etched 2% nital.

FIG.84 An irregular, blotchy macrostructure showing across the tip of one of the blades of K.23. Magnification x 60; etched 2% nital.

FIG.85 Detail of the blade in FIG.84 showing a dense but even scattering of small spheroidal cementite particles in a darker matrix of spheroidised pearlite. Magnification x 450; etched 2% nital.

dark carbide matrix with a slightly granular appearance (FIG.87). Paler, decarburised areas around the cementite clusters suggest that, after the final heating cycle, this spearhead was quenched and then underwent what appears to have been a fairly prolonged tempering treatment. It is unclear whether or not any sort of watered surface effect was intended.

Objects of probable 18th- to 19th-century date

Forty-four of the remaining 52 objects examined here have been dated to the 18th or 19th centuries, mostly on stylistic grounds although two are dated by inscriptions. While it is tempting to conclude that objects identified as having been made of non-homogeneous crucible steel must be pre-20th century, there is as yet no clear indication that the manufacture of objects from the native form of crucible steel (*fulad* or *wootz*) had definitely ceased in Iran – and elsewhere – by the 20th century, although we are fairly certain that this was the case.

Of these 44 objects, 25 appear to have been made of crucible steel and 11 of plain bloomery iron. Of the remaining eight objects, one flint-striker (P.11) was found to be made of bloomery steel, and two pairs of charcoal tongs (P.27 and P.28) and a spring hook (B.17) were made of plain iron of either bloomery or finery origin – precisely which could not be determined from the micro-structure. One horse-bit (C.6) was found to be made of several dissimilar pieces of low-carbon iron, probably of bloomery origin, unevenly welded together, and a second horse-bit (C.9) was made in much the same way, although this time at least one piece of bloomery steel had been included. The way these two horse-bits have been made strongly suggests the use of recycled iron. Finally, two objects, a vambrace (A.2) and a heavy ceremonial axe-head (G.12), were made of high-carbon steel although its method of manufacture and more precise carbon content have not yet been determined.

The 25 crucible-steel objects of this period included two flint-strikers. One, an elegant one-piece flint-striker in the shape of a swan (P.6), has a very distinctive, if rather diffuse, wavy, layered macrostructure, the alignment of which varies across its width, which coincides with a single flaw towards one side (FIG.88). This flaw would appear to be consistent with the single flaw which, from Abbot's description,[8] as well as the flaws visible on the backs of many otherwise high-quality sword blades of this period, can be expected for more or less any object made from an egg-shaped or disc-shaped ingot of crucible steel. At higher magnification it becomes clear that the layered effect in this case has nothing whatever to do with any linear cementite segregation, as none is visible.

Instead a typical hypereutectoid steel microstructure shows up, consisting of an

8. Abbott (1847) p.417.

FIG.86 The macrostructure of A.44 at its tip, showing a tendency towards layering. Magnification x 60; etched 2% nital.

FIG.87 The same area as in FIG.86, showing linear clusters of pale, spheroidal and angular cementite particles in a pearlitic matrix. Magnification x 450; etched 2% nital.

austenitic grain boundary network of cementite together with needle-like formations of cementite oriented along the crystal planes of the iron, showing up against a dark pearlitic background matrix (FIG.89). This is similar to that seen in the crucible steel (*wootz*) ingot from the group of related 19th-century material collected by Thomas Holland from Tamilnadu in southeast India and for which a carbon content of 1.34% has been calculated (FIG.7). A few free cementite particles are visible and a carbon content of approximately 1.3–1.5% can probably be assumed for this flint-striker. Rather than being quenched as part of a final heat treatment, like most of the earlier crucible-steel flint-strikers examined in this study, this one appears to have been air-cooled.

Rather different in method of manufacture is the composite steel flint-striker (P.5), in which thin sheets of watered steel with a clear, layered macrostructure formed the surface on either side, disguising a thicker, plain steel core piece which formed the

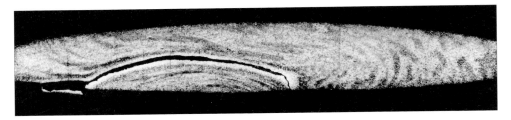

FIG.88 Lower, front tip of P.6 showing a diffuse, wavy macrostructure and a welding flaw, a typical by-product of forging a small crucible-steel ingot. Magnification x 30; etched 2% nital.

FIG.89 Detailed microstructure of the area in FIG.88, a pale grain boundary network and needle-like cementite formation and a darker pearlitic background matrix. Magnification x 450; etched 2% nital.

striker plate (FIG.90). Both the surface pieces and core appear to have been made of crucible steel. The striker plate, in this case largely hidden from view, was found to be made of a hypereutectoid steel with a uniform, non-layered structure consisting of a network of fine cementite particles in a pearlitic matrix, a structure incapable of producing a watered surface effect (FIG.91). Its structure and the presence of a few tiny non-metallic inclusions, probably manganese sulphides, strongly indicate a crucible origin for this steel, with a carbon content of approximately 1.2%. Very different were the watered-steel side pieces, with an unusually high carbon content (estimated at between about 1.8 and 2.0%), which consisted of dense lines of relatively coarse, spheroidal particles separated by areas with finer spheroidal cementite particles in a largely ferritic matrix (FIG.92). This structure suggests that these pieces were quenched, followed by a possibly over-prolonged tempering treatment – the steel may have been left too long unintentionally, for the background matrix has lost its darker etching quality and therefore the contrast in the pattern is not as good as it might have been.

With few exceptions most of the rest of the later post-medieval objects divide up neatly into those made from crucible steel, either watered or unwatered, and those

FIG.90 Lower part of P.5, contrasting the layered macrostructure of one of the watered-steel sides (top) with the non-layered hypereutectoid steel of the core. Magnification x 60; etched 2% nital.

FIG.91 Detail of the structure of the main striker plate of P.5, with a network of fine cementite particles visible against a dark, pearlitic background matrix. Magnification x 450; etched 2% nital.

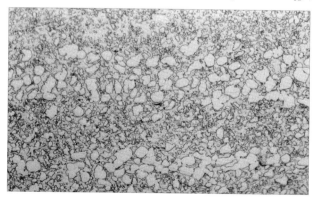

FIG.92 Lower edge of one of the side pieces of P.5, with layers of relatively coarse cementite particles and of finer particles, dispersed in a ferritic matrix. Magnification x 450; etched 2% nital.

of plain iron, mostly of bloomery origin, according to the type of object. All six weapon-related objects from this period, the lance head (A.42), pommel cap (A.47), two sword suspension fittings (A.46 and B.21), helmet (A.3) and a small hammer (L.49) that may be a gun accessory or jeweller's tool, were identified as being made of crucible steel. The hammer appeared to have been quenched, probably in water, but not tempered.

In the lance head (A.42) the structure consisted of a fairly even dispersion of small cementite particles which, at low magnification, gave a white speckled appearance against the darker steely background matrix (FIG.93). At higher magnification this dark background matrix was partially resolvable as a degraded pearlitic structure (FIG.94), suggesting that the lance head was annealed but not quenched after the final heating and forging cycle. The structure had no hint of layering and was much too even to have produced any surface pattern; the lance head seems, therefore, to be a clear example of a non-watered crucible-steel object.

The same is clearly not the case for the sword suspension fitting (A.46), one of a pair, in which the original surface watering survives. This object, which also appears to have been quenched and heavily tempered, does have a distinctive layered macrostructure which is clearly responsible for the watered pattern. The structure is unusual in that the linear segregations of cementite run at right-angles to the main observed surfaces rather than being more or less parallel with them (FIG.95). This would, however, appear to represent only the structure of the end part that was examined, at the end of the fitting, rather than the wider, flatter part of the suspension mount where a layered structure running parallel to the main watered surface would be expected. At higher magnification the linear clusters of cementite are clearly visible against a darker background matrix consisting of a largely granular form of iron carbide dispersed in ferrite (FIG.96), suggesting that this mount was quenched and heavily tempered following the final forging and heating cycle. Apart from the overall structure of this ultra-high carbon steel, a crucible origin is also indicated by an even scattering of very small non-metallic inclusions, probably manganese sulphides. Its overall carbon content was estimated at approximately 1.5–1.8%.

The pommel cap (A.47), however, was quite different. This time the structure was quite even with no hint of layering and clearly would never have produced a watered effect however the surface was treated. At higher magnification a fine, very even dispersion of very small, pale cementite particles was visible against a darker iron/iron carbide background matrix (FIG.97), difficult to resolve optically, but with a slightly granular appearance suggesting again that the sword fitting was quenched and tempered. It too was made of an ultra high-carbon steel with a carbon content estimated at approximately 1.5%. Without detailed micro-analysis it is impossible to

TECHNOLOGICAL INVESTIGATION

FIG.93 Structure at the tip of A.42: an even dispersion of pale cementite particles produces a speckled appearance against the darker pearlitic background matrix. Magnification x 60; etched 2% nital.

FIG.94 Detail near the centre of the area in FIG.93, with pale cementite particles in a darker matrix of pearlite, partially resolved in lamellar form; two apparent inclusions may represent corrosion penetration in from the tip. Magnification x 225; etched 2% nital.

say why this chape has such an even microstructure compared to the sword suspension fitting (A.46), although the lack (or homogeneous distribution) of certain critical carbide-promoting minor or trace elements such as chromium or vanadium might be one reason, another being an over-prolonged anneal of the steel sometime after the casting of the ingot from which it was made. Possibilities such as these will have to await future analytical investigation.

The junction mount (B.21) was made of crucible steel with a clear layered macrostructure indicating that it once had a watered surface, now lost, probably through overcleaning, and its structure suggests that it was quenched and heavily tempered. A very similar crucible steel was used for the helmet (A.3), which also showed a layered macrostructure suggesting that the surface of the helmet was originally watered. Again this object appears to have been quenched and heavily tem-

FIG.95 Segregated macrostructure visible at one end of A.46, with pale, linear clusters of cementite particles visible against darker areas between. Magnification x 60, etched 2% nital.

FIG.96 Detail of area in FIG.95; linear clusters of sub-rectangular cementite particles in a darker matrix of a granular form of iron carbide dispersed in ferrite. Magnification x 450; etched 2% nital.

pered. Both these objects contained about 1.5% carbon. In contrast the crucible steel of the small hammer (L.49) appears to have been air-cooled, its structure being much more homogeneous with no sign of layering within the mass of cementite particles present, these indicating a carbon content within the range 1.5–2.0%.

Two cosmetic instruments (Q.12 and Q.13), a surgical knife (M.6) and a penknife (L.16) were all found to consist of what would appear to be crucible steel of a more even, non-layered structure, that could not have produced a watered pattern. These four objects contain free cementite particles indicating that they are made of hypereutectoid steel that has been extensively forged, although in each case the proportion of cementite varies, indicating a different carbon content for each, within the range 1.0–1.5%. One of the cosmetic implements (Q.13) appeared to have been slack- or slow-quenched, possibly in oil, whereas Q.12, M.6 and L.16 appeared to have been quenched and then tempered to differing degrees, producing microstruc-

FIG.97 Detail of A.47, with a fine, very even dispersion of very small cementite particles in a darker iron/iron carbide background matrix. Magnification x 450; etched 2% nital.

FIG.98 Area near the tip of M.6, showing an even scattering of very fine cementite particles in an unresolved darker steely matrix. Magnification x 450; etched 2% nital.

tures consisting of even dispersions of very fine cementite particles in a dark grey steely matrix, difficult to resolve optically but all with much the same rather granular appearance, such as is visible near the tip of the surgical knife (FIG.98).

Another 19th-century cosmetic instrument (Q.8) and a pair of paper scissors (K.18) appear to have been made of crucible steel with a carbon content estimated to be within the range 1.2–1.5%. The second of these, a pair of scissors with a surviving watered surface pattern (K.18), has a characteristic layered microstructure consisting of parallel lines of very small, sub-rectangular cementite particles in a dark, irresolvable steely matrix possibly indicative of slow- or slack-quenching (FIG.99). By contrast the pair of tweezers (Q.8) were found to have a fairly uniform structure, with no tendency towards a layered effect, a structure, therefore, which could not have produced a watered surface effect. This object also appears to have been cooled in air after the final forging/heating cycle.

All seven specialised tools of this period (L. 3, L. 14, L. 18, L. 19, L. 25, L. 27 and K.22) would appear to have been made of hypereutectoid crucible steel. In two of these, the jeweller's stake (L. 3) and double-ended file (L. 14), the structures were quite uniform, and again these two objects could never have been watered. Both consisted of a high-carbon steely matrix with an even dispersion of white particles of cementite. The carbon content of the jeweller's stake was estimated at approximately 1.0–1.2% whereas the double-ended file was found to have an unusually dense concentration of small cementite particles, mostly measuring about 4–6 microns (0.004–0.006 millimetres) across, from which a carbon content of approximately 1.8–2.0% was estimated (FIG.100). In this case the contrast between the pale cementite particles and the steely matrix was not so great as the background material, which was found to be partially ferritic. It would appear likely that this object was quenched and then tempered or annealed for long enough for the unstable quench products to decompose and leave a partially ferritic metal matrix. This may have been quite deliberate as this structure would have meant that the file was not at all brittle while the high density of very hard cementite particles would have ensured that it was effective as a file.

Of the remaining five objects in this group of tools, the decorated saw (L. 25) had a well-preserved watered surface and both the folding knives (L. 18 and L. 19) appeared to have surviving traces of surface watering. Both the saw and the blade of one of the folding knives (L. 18) had inhomogeneous macrostructures typical of watered-steel objects, with layers of small, pale cementite particles visible against a slightly granular darker steely background matrix. The other folding knife (L. 19) was more of a puzzle. It was found to have one of the highest densities of cementite particles of any of the objects examined in this study (FIG.101); many of these particles were also unusually large, measuring up to about 50 microns (0.05 millimetres) across. The cementite density suggests an unusually high carbon content of around 2%, and in the macrostructure shown here there is only the very slightest tendency towards a linear clustering of the cementite particles, although this seems to have been enough to produce a watered effect in this case. Although no trace of watering survived on the surface of the other two objects, a leather-cutting tool (L. 27) and a highly decorated pair of scissors (K. 22), the layered macrostructure of both suggests that they are likely once to have had watered surfaces now lost through overcleaning.

The largest and most unusual object of this group of watered crucible-steel tools was the saw (L. 25), dated by inscription to AD 1817–18. The steel for this object, with a carbon content estimated at 1.3–1.5%, had been forged extensively both sideways and lengthwise to give quite a thin but flexible, non-brittle piece of sheet metal for the blade, out of which the saw-teeth were cut. After the final forging/heating cycle this blade appears to have been quenched followed by prolonged tempering which

FIG.99 Detail near one of the blade tips of K. 18 with a watered surface pattern, showing parallel lines of sub-rectangular cementite particles in a darker steely matrix. Magnification x 450, etched 2% nital.

FIG.100 End of L. 14; cementite particles evenly dispersed in a matrix of ferrite and a mainly granular carbide; tiny non-metal inclusions, probably manganese sulphide. Magnification x 450, etched 2% nital.

has resulted in the linear clusters of white cementite particles being visible against a darker background carbide matrix with a granular appearance (FIG.102). The other crucible-steel tools of this group were variously air-cooled or quenched and tempered after the final heating cycle (see Table 2).

Two medical instruments, both lancets, were almost certainly made of crucible steel. One (M. 3) still had a well-preserved watered surface even though the structure of the steel of the blade had only a comparatively slight tendency towards layering, with widely varying sizes of pale cementite particles, up to 60 microns (0.06 millimetres) across, visible against a partially spheroidised pearlitic background suggesting that this object was partially annealed but not quenched (FIG.103). A second lancet (M. 7) had no surviving trace of watering and was found to have what appeared at low magnification to be a fairly homogeneous structure with no sign of any linear segregation and was therefore unlikely ever to have had a watered surface. At

FIG.101 Detail of L. 19; cementite particles of varying size in a matrix of partially spheroidised pearlite; spheroidal non-metallic inclusions, probably manganese sulphide. Magnification x 110; etched 2% nital.

FIG.102 Structure at the end of L. 25, showing up as linear clusters of small, pale cementite particles in a darker, partially granular carbide matrix. Magnification x 60; etched 2% nital.

higher magnification an even dispersion of very small pale cementite particles, measuring approx 2–4 microns (0.002–0.004 millimetres) across, was visible against a darker, carbide matrix with a granular appearance suggesting that this lancet was both quenched and tempered (FIG.104). Small grey, spheroidal non-metallic inclusions, probably of manganese sulphide, evenly scattered across the field of view, are indicative of the crucible origin of this hypereutectoid steel.

Of the remaining objects which appear to be made of crucible steel, the bazuband (G. 2) had a well-preserved watered surface clearly linked to its distinctive layered macrostructure. The chisel (L. 44), which has no surviving surface watering, has a distinct but unusual layered macrostructure consisting of parallel fuzzy pale bands visible against a darker background (FIG.105). At higher magnification it became obvious that this banding not only looked different but was unrelated to the linear segregations of cementite responsible for the watered pattern in most steels of

FIG.103 Tip of M. 3, showing the slight linear tendency of the variously sized cementite particles in a darker, partially spheroidised pearlitic background matrix. Magnification x 110; etched 2% nital.

FIG.104 Tip of M. 7; cementite particles distributed in a granular carbide matrix with spheroidal inclusions. Larger 'inclusions' are corrosion penetration from the tip. Magnification x 450; etched 2% nital.

this type. In this case, instead of lines of cementite particles, a fairly even microstructure was visible as a pale, fine grain-boundary network of cementite contrasting with a darker, barely resolvable steely carbide matrix with a slightly granular appearance (FIG.106) indicating that this chisel has been heat-treated, probably quenched and heavily tempered. A fuzzy, banded macrostructure of this unusual form has been noted recently on a watered Indian dagger, where the layering was found to match a banded enrichment or segregation of phosphorus. It would seem likely that linear phosphorus enrichment may also be responsible for the fuzzy pale banded effect seen in the chisel (L. 44) reported here although this chisel requires more detailed investigation, in the form of micro-elemental mapping, for a more confident identification to be made.

Of the remaining three steel objects, the flint-striker (P. 11) was made of bloomery steel, identifiable by its very variable carbon distribution and slag content, with an

FIG.105 Distinctive macrostructure visible at the tip of L. 44, with fuzzy parallel pale lines showing up clearly against a fine, generally dark microstructure. Magnification x 60; etched 2% nital.

FIG.106 Microstructure of L. 44, showing a fine grain boundary network of pale cementite particles in a darker, mainly granular carbide, background matrix. Magnification x 225; etched 2% nital.

overall carbon content of approximately 0.4%. The identification of the high-carbon steels of both the vambrace (A. 2) and the large ceremonial axe-head (G. 12) – dated AD 1786–87 is still uncertain.

In contrast to the steel objects of this period 14 objects made of plain iron were also found. Much as might be expected, generally these were less specialized objects and ten of them would appear to have been made more specifically of bloomery iron to judge from their more inhomogeneous structures, often with small amounts of carbon present. These objects include a standard (E. 7) dated to AD 1711; a lancet (M. 8), presumably of poor quality; three horse fittings (C.4, C.5 and C.7); one belt fitting (B.18); and three tweezers or tongs (J.20, J.21 and Q.9). Two horse fittings (C.6 and C.9) would appear to have been made of recycled iron, consisting of at least three pieces of iron, probably all probably of bloomery origin, irregularly welded together; one of these, the horse bit (C.9), included a piece of medium-

FIG.107 Recycled steel used in C.9, showing typical hypo-eutectoid structure: a pale network of ferrite, partly dispersed along the crystal planes of the iron, the darker parts partially lamellar pearlite. Small ribbon-like inclusions near the centre, probably iron silicate. Magnification x 225; etched 2% nital.

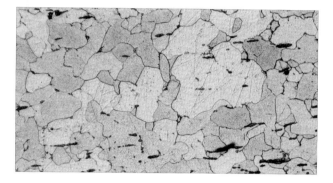

FIG.108 Near one blade tip of P.27; medium grain ferrite (plain iron) with uneven scatter of non-metallic inclusions of pale iron oxide and darker iron silicate or a glassy phase. Magnification x 60; etched 2% nital.

carbon steel (FIG.107).

The more even-grained ferrite (more or less carbon-free iron) of the pair of stirrups (C.2) and the spring hook (B.17) could have been the product of a finery hearth (i.e. made indirectly from cast iron), although this is unlikely this early in this region and a bloomery origin for both these horse fittings is most probable. Likewise, all three sets of charcoal tongs (P.27, P.28 and P.30) were made of very similar iron which, from its slaggy, more or less carbon-free structure could be either of bloomery or finery origin, both of which are possible during this period when small-scale bloomeries are likely still to have been widespread in this region (FIG.108).

Objects of probable late 19th- or 20th-century date

The remaining eight post-medieval objects are dated approximately to the first half of the 20th century, two on stylistic grounds and the other six because they were found to have been made wholly or partially of mild steel, which is unlikely to have been available in Iran or the surrounding region much before 1900. Unlike the artefacts of previous periods, which demonstrate a fairly clear tendency, at least, to use steel or plain iron for specific types of object, the same choices in the use of materials seems no longer to apply to these more modern objects.

Six of the seven objects made of mild steel include a nibbing block (K.26), toilet set (Q.10), horse bit (C.8), awl (L.29), swivel hook (B.12), and a double-ended file (L.13), which all showed a typical fine, even grain structure with no slag present (FIG.109), the only non-metallic inclusions encountered being very small spheroidal particles most probably of manganese sulphide or a similar constituent typical of mild steel but not of low-carbon iron, which characteristically has a larger and more uneven grain structure and at least some residual entrapped slag left over from the production processes. The carbon content of these six objects was approximately 0.1% or less, typical for mild steel. The seventh object, a strap end (B.24), was made of a front and back plate of very high-carbon steel, possibly recycled metal of non-crucible origin, which had been brazed to two side strips of mild steel (FIG.110). Apart from the horse bit and swivel hook, all these objects would in earlier periods have been expected to be made of crucible steel to judge from the other results presented here.

Mild steel was also used in a buckle (B.9), although here it was mixed with a different low-carbon iron, one which could have been of either bloomery or finery origin. This mixture would suggest the use of scrap metal for this object. The other object, another horse bit (C.6) was thought to be 20th-century on stylistic grounds and was made of plain iron with no sign of mild steel having been used, although its composition was a mixture of two different irons, one most probably bloomery metal while the other could have been of either bloomery or finery origin, again suggesting the likely use of recycled or scrap metal.

It would seem that during the 20th century there has been less discrimination about the type of iron or steel used for different objects. This may reflect a change in the availability of different – more modern and cheaper – types of iron or steel which in turn must have been a major factor in the collapse of the traditional crucible-steel industry, which appears to have ceased production, both in Iran and India, by the end of the 19th century.

CONCLUSIONS

One of the most interesting overall results from this study was that more than half of

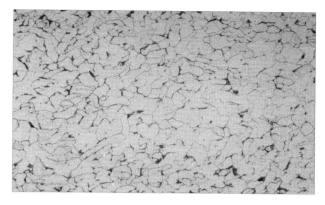

FIG.109 Mild steel structure near one end of L.13, typically fine grain, low-carbon iron with random tiny spheroidal inclusions, probably of manganese sulphide. Magnification x 225; etched 2% nital.

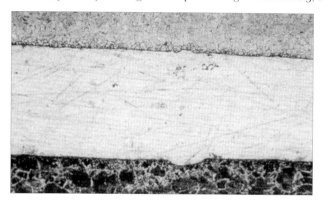

FIG.110 Brazed junction between front and sides at the inner end of B.24: high-carbon, hypoeutectoid front plate, carbon content approximately 0.7% (bottom); fine grain, low-carbon mild steel side strip (top); unetched brazing metal, a high zinc brass (middle). Magnification x 100; etched 2% nital.

the objects examined were found to be made of an ultra high-carbon (hypereutectoid) steel. This would appear to be consistent with the cast crucible steels described in historical sources at various times from the 3rd century AD onwards, but which, before now, have hardly been recognised as having been used for objects apart from swords, daggers and some armour. A more unexpected finding was the quite clear division of this crucible steel, at least in the form it was found in the finished objects, into two types. One type produced a characteristic layered structure in section, a structure which was clearly responsible for the watered patterns that still survive on some of the objects examined (and which is much better known as the decorative effect exploited for sword manufacture from at least the 9th century AD, when it was described by al-Kindi). In most, if not all, the examples in which a layered microstructure was found, the decorative style of the object suggests that a watered

finish is highly likely to have been present, even it has subsequently been lost due to over-cleaning, corrosion or both. Of particular interest was the second type of crucible steel, in which no layered microstructure was found and which could not have produced a watered pattern on the surface of those objects for which it was used. While these results are still provisional and bound by the limitations on the present metallographic investigations outlined above, they go some way to bearing out the evidence of the written sources on whom we are still almost entirely reliant for information about the early production of steel in Iran and southern Asia.

The likelihood that steel may have been produced by a non-crucible process in southern Asia in the 1st millennium AD, possibly on a significantly large scale, has been shown by the recently discovered evidence of the early Sri Lankan iron-smelting industry, discussed elsewhere (see p.49). We might speculate that the Sri Lankan ironworkers were, like their modern counterparts operating the surviving *tatara* furnace of Japan, skilled at separating the higher carbon, more steely parts of the bloom.[9] The steel portions of the blooms must still have been of a fairly mixed composition, with a variable carbon content and at least some residual fayalitic slag content from the smelting process.

The recent findings would suggest that the Sri Lankan furnaces were part of an industry that was already well established when al-Kindi was writing in the 9th century AD, although we still have no clear idea of what the Sri Lankan steel reported by al-Kindi as being imported into Iran and Pakistan for swordmaking actually consisted. Al-Kindi included it among the different types of *fulad*, which he defined as 'unmined iron', by which he clearly meant crucible steel. He describes Sri Lankan steel as being of medium quality but whether or not it was reprocessed in some way – possibly as part of a secondary crucible process – that would justify its description as *fulad* is not known for certain. If al-Kindi was correct in his report of the crucible origin of all the swords he describes as being made of *fulad* then there is at least a possibility that the mixed products of the Sri Lankan furnaces (which may have ranged from low-carbon iron to ultra high-carbon steel or even cast iron) may have been used to supply raw materials for a secondary crucible processing industry aimed at producing steel with a more even and reliable composition. The recent finding at Merv of crucible remains and pieces of steel – most likely of crucible origin – dated by radiocarbon determination to the 9th to 11th century, is at least an indication that this was the case.

Al-Kindi says that swords made of *fulad* were being made in Sri Lanka as well as

9. The sought-after *tamahagane* steel used by Japanese swordmakers was produced by this process. Its carbon content was usually within the range 1–1.2% before initial forging and controlled partial decarburisation, although it was uneven and could vary, even over quite small distances, typically between 0.6 and 1.5%; Kapp and Yoshihara (1987) pp.9, 65 and fig.39.

in Iran, Pakistan, Iraq and the Yemen, using Sri Lankan steel, but until any of these blades is identified and analysed we cannot even be sure that he was necessarily correct in all his identifications of these weapons as crucible-steel products. Up till now no iron or steel objects of this period from Iran, Sri Lanka or India have been analyzed and, with the possible exception of two sword blades and an adze from Taxila, no analyses have yet been reported which might relate to crucible-steel objects from the 10th century or earlier (and there is very little for the next few centuries either). Nevertheless, a crucible origin for the steel used to make these swords is strongly suggested by the fact that, in all cases, the weapons are referred to as having a watered surface pattern (*ferend*), by which their quality was judged. Recent research has confirmed that the the formation of the watered pattern is dependent on the segregation of certain carbide-controlling impurities during the freezing of a liquid steel in a crucible (see above),[10] supporting a-Kindi's identification of *fulad* as an indirectly produced, crucible steel.

Al-Kindi's reference to watered-steel sword production in Sri Lanka suggests that crucible-steel production may have taken place there as well, in addition to and possibly supported or supplied by the iron smelters. So far, it is impossible to say in what form Sri Lankan steel was imported to the coastal Iranian province of Fars for sword production there, although al-Kindi's remark that *fulad* swords were also made from locally produced iron (*arkazmat*), described as square-section bars, an arm's length on each side,[11] suggests the local Farsian production of crucible steel as, perhaps, would the manufacture of another *fulad* type of sword in Fars, those called *baid* ('white'). Al-Kindi also notes that a Sri Lankan type of steel sword was made in the inland, eastern Iranian province of Khurasan and implies the use of locally made crucible steel, which is described as having a pure white (perhaps cast iron) essence.[12]

By the time al-Biruni was writing in the 11th century AD crucible-steel production was clearly well established in Iran. He stressed the importance of Herat as a centre for the manufacture of *fulad* and describes the steel being made as a liquid in crucibles by the mixing of plain bloomery iron (*narmahan*) and its water, which must mean cast iron, the final product being egg-shaped ingots (*baidat*). The discovery of two different types of crucible steel among many of the objects in this study and the use of the non-watered crucible steel mainly for the less decorative objects, such as files and other tools, mirrors al-Biruni's comments on the making and use of two different types of crucible steel. He described the non-watered type being made in a crucible by the melting and equal mixing of *narmahan* with cast iron (*dus*) so that one

10. Verhoeven 1996.
11. al-Kindi p.30.
12. al-Kindi p.29.

was indistinguishable from the other (i.e. it did not produce a watered pattern or *ferend*), in which state it was good for files and the like. Of watered steels he said that the melting qualities of the different types of iron in the crucible vary and that the incomplete mixing of these is the reason for the appearance of the watered pattern.[13] From these descriptions it is clear that, probably before the 9th century and certainly by the early 11th century AD, this eastern part of Iran was a well-known producer of crucible steel of two varieties, only one of which appears to have been capable of producing a watered pattern on the polished and etched surface of a finished object. It would appear that the crucible steel capable of being watered was favoured for swords whereas the plain variety was used for a selection of more specialized tools.

Non-crucible steel (*shaburqan*) was also recorded during this period, but seems to have been best known for its use in the manufacture of Russian or Western swords, whether pattern-welded or not: neither al-Kindi nor al-Biruni mention *shaburqan* as having been used to make anything in Iran. Nor do they describe the manufacture of *shaburqan* although al-Kindi is quite specific about its origin as 'mined' (i.e. directly smelted iron), and he adds that swords made from this steel are brittle and do not quench evenly because they contain veins of *narmahan*. Both *narmahan* and *shaburqan* are described by al-Kindi as having been forged since ancient times and says that they are both 'single invariable metals without anything ever having been introduced into their essence that would change them for better or worse'.[14] This is an unambiguous description by al-Kindi of bloomery metal, and as far as *shaburqan* is concerned he clearly means that this steel was not produced by any secondary carburisation treatment.

It seems highly likely from these descriptions that the crucible process (however it might have been carried out) was the favoured method for making steel in this region, and the fact that it was still an established industry when mentioned by European travellers from the 17th to 19th centuries (by which time it may already have been in decline) is borne out by the metallographic analyses of the later pieces examined.

It should also not be forgotten that the results of the present study suggest that directly smelted or bloomery iron production is likely to have continued in Iran and the surrounding region until well into the 19th century, if not later. The white cast iron produced as a raw material for the secondary crucible process may have been made as part of a more specialized production at some of these same bloomery sites: the one detailed analysis done during the present study (of no.3522, FIG.62) indicated the likely late medieval production of white cast iron, as well as crucible steel, in the

12. al-Biruni p.252. 14. al-Kindi p.8.

area of the Zagros mountains in western Iran. Historical sources also suggest this to be the case but much more work needs to be done before anything like a coherent picture of the early Iranian iron and steel industry can be worked out.

The results given here, while not complete or detailed enough to be conclusive, at least suggest that the variations in crucible-steel making described by al-Biruni can be taken as a basic description of much of the specialized Iranian industry. Micro-analytical results from datable surviving objects (as well as additional archaeological finds from sites like Merv) should enable us to work out the details of the relevant crucible production processes in the future, and to form a clearer idea of when and how particular steels were being used for particular objects. It is hoped that the present study will help to provide a framework for these future investigations, besides indicating the variety of results, often unexpected, that might be encountered.

TABLE 2. OBJECTS EXAMINED BY METALLOGRAPHY

Cat. no.	Analysis no.	Description	Date	Iron/steel type	Comments
Pre-Islamic: circa 12th century BC–7th century AD					
R.4	AM1128	Horse bit	Early 1st millennium BC	Bloomery iron	Ferrite
R.1	AM1165	Armlet or bracelet	Early Iron Age (10th–8th century BC)	Bloomery iron	Ferrite: fine grained
R.2	AM1166	Armlet or bracelet	Early Iron Age (10th–8th century BC)	Bloomery iron	Ferrite with carbo-nitrides
R.3	AM1167	Lynch pin? or upper part of mace	7th century BC –3rd century AD)	Bloomery steel	Carbon content variable
R.5	AM1129	Horse bit	4th–6th century AD	Bloomery steel	Carbon content variable
Later medieval: 11th–15th centuries					
P.1	AM949	Flint-striker	11th century	Crucible steel	Not watered
350 (FIG.63)	AM1162	Flint-striker	11th/12th century		Steel insert missing
351 (FIG.61)	AM952	Flint-striker	12th/13th century	White cast iron/steel	Layered macro-structure; insert in copper-alloy body (possibly cast on)
352 (FIG.62)	AM1164	Flint-striker	12th/13th century	Crucible (low alloy) steel	Up to 3.7% Cr, 0.3% Mn and 0.2% V in the cementite particles; striker plate insert in copper alloy body
Q.15	AM1138	Mirror	Late 15th century	Bloomery steel	Hypoeutectoid; 0.6–0.8% carbon
80 (FIG.65)	AM1163	Flint-striker	15th century	Crucible steel	Insert in copper alloy
Q.17	AM1001	Mirror	Late 15th century	Bloomery steel	Hypo-eutectoid; 0.6–0.8% carbon
81 (FIG.64)	AM1007	Flint-striker	15th century	Crucible steel	Quenched, martensitic structure;

TECHNOLOGICAL INVESTIGATION

					insert in copper-alloy body
Q.16	AM1139	Mirror	Late 15th century	Bloomery steel	Hypo-eutectoid; 0.6–0.8% carbon
P.2	AM1161	Flint-striker	15th century	Crucible steel	One-piece striker with a quenched, martensitic structure; not watered
P.3	AM1006	Flint-striker	15th century	Crucible steel	One-piece striker with a quenched, martensitic structure; not watered
Earlier post-medieval: 16th–17th centuries					
K.23	AM1045	Scissors	16th–17th century	Crucible steel	Not watered
C.1	AM1119	Stirrup	Late 17th–early 18th century	Bloomery iron	Variable grain size; with a little pearlite at grain boundaries in places
A.10	AM1005	Knife	AD 1615–16	Crucible steel	Most probably once watered
C.2	AM1120	Pair of stirrups	18th century	Bloomery iron	
Later post-medieval: 18th–19th centuries					
A.3	AM1168	Helmet	Late 18th century	Crucible steel	Probably once watered
A.42	AM1059	Lance head	18th/early 19th century	Crucible steel	Not watered
A.45	AM1060	Pommel cap	19th century	Crucible steel	Not watered; part of same set as 502
A.48	AM1059	Scabbard suspension fitting	19th century	Crucible steel	Watered; part of same set as 503
A.44	AM1080	Lance head	17th/18th century	Crucible steel	Possibly once watered
P.6	AM948	Flint-striker	19th century	Crucible steel	Possibly watered
P.11	AM1443	Flint-striker	19th century	Bloomery steel	

B. 17	AM1065	Spring hook	18th/early 19th century	Bloomery or finery iron	
E. 7	AM1027	Standard	AD 1711	Bloomery iron	
G. 12	AM1170	Ceremonial axe-head	1785–86	High-carbon steel	?Crucible or bloomery steel
B. 18	AM1066	Sword suspension hook	19th century	Bloomery or finery iron	
K. 22	AM1083	Scissors	Late 18th century	Crucible steel	Probably once watered
G. 2	AM1000	Bazuband	17th–19th century	Crucible steel	Watered; one of a pair with 311
A. 2	AM1169	Vambrace	18th/early 19th century	High carbon steel	?Crucible or bloomery steel
C. 7	AM1114	Horse-bit	18th/19th century	Bloomery or finery iron	
L. 25	AM1041	Saw	AD 1817–18	Crucible steel	Watered blade
P. 5	AM1010	Flint-striker	19th century	Crucible steel (core and side pieces)	Watered and gilded steel side pieces, homogeneous steel core, separate back
K. 18	AM947	Scissors	19th century	Crucible steel	Watered
Q. 7	AM1133	Tweezers	19th century	Crucible steel	Not watered
L. 49	AM1063	Hammer	18th/19th century	Crucible steel	Not watered
Q. 10	AM1082	Cosmetic instrument	18th/19th century	Crucible steel	Quenched; not watered
Q. 11	AM1084	Cosmetic instrument	18th/19th century	Crucible steel	Not watered
M. 6	AM1086	Surgical knife	19th century	Crucible steel	Not watered
L. 16	AM1085	Penknife	19th century	Crucible steel	Not watered
L. 3	AM1050	Jeweller's stake	17th–19th century	Crucible steel	Probably not watered
L. 14	AM1048	Double-ended file	17th–19th century	Crucible steel	Not watered
L. 19	AM1081	Folding knife	circa 1825–1850	Crucible steel	Appears to be watered; carbon content ~2%
L. 18	AM1042	Folding knife	Early 19th century	Crucible steel	Watered blade

TECHNOLOGICAL INVESTIGATION

L. 27	AM1044	Half-moon knife	Early 19th century	Crucible steel	Watered blade
M. 3	AM1046	Lancet	19th century	Crucible steel	Watered blade
M. 7	AM1087	Lancet	19th century	Crucible steel	Probably not watered
L. 44	AM1043	Chisel	18th/19th century	Crucible steel	Possibly watered
M. 8	AM1088	Lancet	19th century	Bloomery iron	Two halves hammer-welded
C. 4	AM1127	Pair of stirrups	18th/19th century	Bloomery or finery iron	
C. 5	AM1118	Horse-bit	18th/19th century	Bloomery iron	
B. 21	AM1062	Junction mount	18th century	Crucible steel	Probably once watered
J. 21	AM1136	Tweezers	19th century	Bloomery iron	
J. 20	AM1137	Tweezers	19th century	Bloomery iron	
C. 9	AM1115	Horse-bit	18th/19th century	Bloomery iron plus medium carbon steel	Brass insert with red pigment inlay; iron/ steel body, ? recycled
C. 6	AM1116	Horse-bit	19th century	Bloomery iron	
Q. 8	AM1135	Tweezers	18th/19th century	Bloomery iron	
P. 28	AM1130	Charcoal tongs	19th century	Bloomery or finery iron	
P. 27	AM1131	Charcoal tongs and pin	Late 19th century	Bloomery or finery iron	
P. 30	AM1132	Charcoal tongs	19th century	Bloomery or finery iron	

Modern: very late 19th–20th centuries

B. 12	AM1068	Swivel hook	Late 19th/ 20th century	Mild steel	
K. 26	AM1067	Nibbing block	Late 19th/ 20th century	Mild steel	
B. 24	AM1061	Strap-end	Late 19th/ 20th century	Mild steel/ crucible steel	Crucible steel ?recycled; a pair with 101
Q. 9	AM1134	Toilet set	Late 19th/ 20th century	Mild steel	

515

C. 8	AM1117	Horse-bit	Late 19th/20th century	Mild steel	
L. 29	AM1047	Awl	Late 19th/20th century	Mild steel	
L. 13	AM1049	Double-ended file	Late 19th/20th century	Mild steel	
B. 9	AM1064	Buckle	Late 19th/20th century	Mild steel plus bloomery iron	Probable mix of recycled iron

Appendices

Appendix One

LIST OF STEEL-WORKERS BY NISBA

Large numbers of steel-workers are recorded on surviving objects, and a few of them, together with a number of other craftsmen, are mentioned in texts. This appendix is not intended to provide a listing of them all but to provide a list by *nisba*, as a resource for evaluating the comparative roles of different steel-working centres in Iran. *Nisba*s of course have a literature of their own,[1] and the interpretation of the evidence is far from straightforward. Readers who wish to follow up all possible steel-working craftsmen should use this list in conjunction with Mayer's rolls of swordsmiths and metal-workers. In addition, it should be noted that there are many other craftsmen known who may have, or indeed did, hail from Isfahan, but did not use an Isfahani *nisba* on their signed pieces. An obvious example is Haji 'Abbas (see p.93).[2] In the following list, 'n.d.' stands for 'no date'.

Ardabili

Muhammad Ardabili: n.d.; dagger, Historisches Museum, Bern, Moser collection; Mayer (1962) p.58, Zeller and Rohrer (1955) no.410 pl.LXXIX. (From the shape of the dagger this craftsman was almost certainly working in the Caucasus.)

Muhammad Ardabili (Haji): n.d.; *'alam* strut; Tanavoli collection E.4.

Bukhara'i

'Ali Khudgar Bukhara'i (Ustad Shaikh): AH 817 (AD 1414–15), grille doors, Museum of the Shrine of the Imam Riza, Mashhad; Mashhad (n.d.) pp.31–33, no.59; *Arts of Islam* (1976) no.245.

Isfahani

'Abdallah Isfahani: AH 1115 (AD 1703); sword, Porte de Hal Museum, Brussels; Mayer

1. See, for example, Allan (1979) pp.54–55; Melikian-Chirvani (1982) pp.72–73.

2. For further discussion of Asadallah Isfahani and his two sons, see pp.96–99. See also Allan (1994).

(1962) p.13.

'Abdallah Isfahani: n.d.; *khanjar*, Metropolitan Museum of Art, New York, acc. no.36.25.677a,b; Mayer (1962) p.15, pl.I.[3]

Abdal-Vahhab Isfahani: AH 1137 (AD 1725); *'alam* shaft, Sotheby's, 16 April 1986, lot 184.

'Ali Isfahani: n.d.; sword, Oruzheynaya Palata, Moscow; Mayer (1962) p.24.

'Ali Isfahani: n.d.; sword, Historisches Museum, Dresden; Mayer (1962) p.24.

Asadallah Isfahani (see above pp.102–105)

Bahram Isfahani: n.d.; sword; *Splendeur des Armes Orientales* no.241. (Made for Mir Fath Ali Khan Talpur.)

Faizallah Isfahani (see Shushtari)

Ghulam Isfahani: n.d.; sword, Salar Jung Museum, Secunderabad; Mayer (1962) p.33.

Isma'il ibn Asadallah Isfahani: AH 1186 (AD 1772); sword, Royal Collection, Windsor, no.1788; Mayer (1962) p.44; Kalus (1980) pp.46–49, no.20.

Isma'il valad-e Asadallah Isfahani: n.d.; sword, private collection; unpublished.

Kalb'ali ibn Asadallah Isfahani (see above pp.102–105))

Kazim Isfahani: n.d.; *tulwar*, Wallace Collection, London, no.1503; Mayer (1962) p.48; Laking (1964) pp.30–31. (The owner's name is Mir Murad 'Ali Khan Talpir. The maker's name is uncertain, for the inscription is ambiguous. Inside the cartouche, above, is the name Muhammad Shirazi, while below is the name Kazim Isfaha[ni]. The word *'amal-e* is directly alongside the flat sweep of the '*ni*' of 'Isfahani' which divides the cartouche horizontally. It is thus uncertain to which name *'amal-e* applies, and it could be to both. A swordsmith by the name of Muhammad Kazim Shirazi is also known – see below.)

[3]. According to Mayer's informant, this is a sword, but in fact it is a *khanjar*.

APPENDICES

Muhammad Isfahani; n.d.: gun block; Tanavoli collection A.15.

Muhammad 'Ali Isfahani: AH 1213 (AD 1799); enamelled body armour, Tower of London; Mayer (1962) p.57. (Made for Ghulam 'Ali Khan.)

Muhammad (Ustad Haji) ibn Ustad Husain Isfahani: AH 1264 (AD 1848); *ziyarat nameh*, Museum of the Shrine of the Imam Riza, Mashhad; Mashhad (n.d.) pp.78–79 no.61.[4]

Muhammad ibn Ja'far Isfahani: n.d.; sword, Oruzheynaya Palata, Moscow; Mayer (1962) p.59.

Muhibb 'Ali Isfahani: n.d.; sword, Dresden; Mayer (1962) p.62.

Muhibb 'Ali Isfahani: n.d.; sword, private collection; Mayer (1962) p.63.

Muhibb 'Ali Isfahani: n.d.; sword, Royal Collection, Windsor, no.1802; Mayer (1962) p.63.

Muhibb 'Ali Isfahani: n.d.; sword, Royal Collection, Windsor, no.1803; Mayer (1962) p.63.

Muhibb 'Ali Isfahani: n.d.; sword; Oruzheynaya Palata, Moscow; Mayer (1962) p.63.

Muhibb 'Ali Isfahani: n.d.; sword; Wallace Collection, London, no.1871; Mayer (1962) p.63.

Muhibb (or Mukhtar) Isfahani: n.d.; sword, whereabouts unknown, Russia; Mayer (1962) p.63. (Perhaps the same as Muhibb 'Ali Isfahani.)

Muqim Isfahani: AH 1193 (AD 1779); dagger, National Museums of Scotland, Edinburgh; Mayer (1962) p.64 and pl.XIII.

Muqim Isfahani: n.d.; sword, Maharaja of Jaipur's collection; Mayer (1962) p.64.

4. In this publication it is wrongly dated 1294 – a postcard on sale at the Shrine has the correct date of 1264.

Muqim ibn Muhammad Isfahani: n.d.; sword, Wallace Collection, London, no.1762; Mayer (1962) p.64.

Nawruz Isfahani: n.d.; sword, Tsarkoye Selo Museum, St Petersburg; Mayer (1962) p.67.

Rajab 'Ali Isfahani: n.d.; four swords, Oruzheynaya Palata, Moscow; Mayer (1962) pp.69–70; Loukonine and Ivanov (1996) no.216.

Rajab 'Ali Isfahani: n.d.; sword, Metropolitan Museum of Art, New York; Mayer (1962) p.70.

Sadiq Isfahani (Mulla): n.d.; sword, Figiel collection, PS18; Figiel (1991) pp.82–83.

Sadiq ibn Muhibb 'Ali Isfahani: n.d.; sword, British Museum; Mayer (1962) p.71 pl.XVI.

Sulaiman Isfahani: n.d.; sword, whereabouts unknown; Mayer (1962) p.73.

Zaman Isfahani, pupil of Asad Allah?: 1836?; sword, Kabul?; Mayer (1962) p.78.

Zaman Isfahani, pupil of Asad Allah?; n.d.; sword, Copenhagen; Mayer (1962) p.78 pl.XVII.

Kashghari
Haj Sa'd al-Din Kashghari, working in Bukhara: AH 1265 (AD 1848–49); sword, private collection; Haase *et al.* (1993) no.130, pp.192–93.

Khurasani
Ahmad Khurasani: n.d.; sword, Benaki Museum, Athens; Mayer (1962) p.20 pl.II.

Ahmad Khurasani: n.d.; sword, Metropolitan Museum of Art, New York, acc. no.32.75.303; Mayer (1962) p.20 pl.II. (Also inscribed *shahinshah anbiya Muhammad*, referring to Muhammad Shah [1834–48]).[5]

Kalb'ali Khurasani: n.d.; sword, Salar Jung Museum, Secunderabad; Mayer (1962) p.48.

5. Rabino di Borgomale (1945) p.70.

Lari

Muhammad Lari: n.d.; dagger, Victoria and Albert Museum, London, acc. no.814-1893; Mayer (1962) p.59.

Mashhadi

Baqir Mashhadi: AH 1162 (AD 1748–49); sword; Mayer (1962) p.31.

Baqir Mashhadi: AH 1162 (AD 1748–49); sword, Metropolitan Museum of Art, New York, acc. no.36.25.1304; Mayer (1962) p.31; Alexander (1992) p.139. (Made for Safdar Jang Bahadur, vizier of the Mughal Muhammad Shah, and Mughal governor of Avadh, 1739–56.)[6]

Muhammad Baqir: AH 1122 (AD 1710–11); dagger; Ricketts and Missilier (1988) no.136; mentioned by Alexander (1992) p.139.

Muhammad Baqir Mashhadi: AH 1163 (AD 1748–49); sword; Alexander (1992) no.82. (Made for Safdar Jang Bahadur, vizier of the Mughal Muhammad Shah, and Mughal governor of Avadh, 1739–56.)

Muhammad Baqir Mashhadi: AH 1163 (AD 1749–50); sword; Alexander (1992) no.81.

Qazvini

'Ali Qazvini: n.d.; sword, formerly in Sarre collection; Mayer (1962) p.25.

Shirazi

Abu'l-Hasan Shirazi: n.d.; *kard*, Historisches Museum, Bern, Moser collection; Mayer (1962) p.16; Zeller & Rohrer (1955) no.169, pl.XLIV. (Abu'l-Hasan signs his work on the bolster, and must be the original craftsman. However, at a later date the signature of Kalb 'Ali Isfahani has been added to one side of the blade, with the unlikely date AH 999 [AD 1590–91] on the other side.)

'Ali Muhammad Shirazi: n.d.; sword, Victoria & Albert Museum, London, acc. no.3328; Mayer (1962) p.25 pl.III.

Muhammad Shirazi – see Kazim Isfahani (above)

Muhammad Shirazi: n.d.; *tulwar*, private collection; Haase *et al.* (1993) no.129 pp.192–93.

Muhammad Kazim: AD 1109 (AH 1697–98) or AH 1119 (AD 1707–8); *qalamdan*, Museum of the Shrine of the Imam Riza, Mashhad; Ardalan and Inanlu (1988) pp.22–23; Mashhad (n.d.) no.29 pp.54–56 gives the maker's name as Kamal al-Din Mahmud. (Made for Sultan Husain [1694–1722].)

Muhammad Kazim Shirazi: AH [1]128 (AD 1715–16); sword, Figiel collection PS19; Figiel (1991) pp.84–85.

Muhibb Hasan ibn 'Ali Shirazi: n.d.; sword, Oruzheynaya Palata, Moscow; Mayer (1962) p.63.

Shushtari
Faizallah: AH 1119 (AD 1707–8); two groups of three steel door plaques, Museum of the Shrine of the Imam Riza, Mashhad; Mashhad (n.d.) p.34 no.198, 193, and p.35 no.192.[7] (Made by order of Shah Sultan Husain.)

Faizallah: n.d.; a piece of steel bearing an inscription, Museum of the Shrine of the Imam Riza, Mashhad; Mashhad (n.d.) p.44 no.78.

Faizallah: n.d.; mace, Victoria and Albert Museum, London, acc. no.742-1889; Mayer (1962) p.32 and pl.VII. (Also inscribed *bande-ye shah-e vilayat 'abbas*; *nasr min allah wa fath qarib*.)

Faizallah Isfahani: n.d.; sword, Prince of Wales Museum, Bombay, acc. no.22.3603; Mayer (1962) p.32 and pl.XVII.

Faizallah Shushtari: AH 1119 (AD 1707–8): small steel orange, Museum of the Shrine of the Imam Riza, Mashhad; Mashhad (n.d.) p.44 no.65. (Gift of Shah Sultan Husain to the Shrine.)

Faizallah Shustari: AH 1120 (AD 1708-9); pair of vambraces, Royal Armouries, Leeds, acc.no.XXVIA.242-3.

6. David Alexander maintains that this sword is signed by Muhammad Baqir Mashhadi, but Wiet's entry in Mayer does not mention Muhammad, nor could I see Muhammad on the inscription when I studied the piece in New York. It is possible that Baqir Mashhadi and Muhammad Baqir Mashhadi are the same person. In either case, the craftsman or craftsmen worked for at least some time in India: see Muhammad Baqir Mashhadi below.

7. The comment in Mashhad (n.d.) p.53 under no.94 that these three are the work of Faizallah was confirmed by the author when he visited the Museum in 1992.

APPENDICES

Faizallah Shushtari: AH 1127 (AD 1715); ewer, Museum of the Shrine of the Imam Riza, Mashhad; Bahrami (1949) p.21 no.46; Mayer (1959) p.41; Mashhad (n.d.) p.53–54; Ardalan and Inanlu (1988) pp.24–25. (Made by order of Shah Sultan Husain for the Shrine.)

Faizallah Shushtari: AH 1146 (AD 1733–34); helmet, Tsarkoye Selo Museum, St Petersburg; Mayer (1962) p.32; Egerton (1968) pl.V and p.52.

Faizallah Shushtari: n.d.; helmet, Victoria and Albert Museum, London, acc. no.778-1888; Mayer (1962) p.32 pl.VI.

LIST OF STEEL-WORKERS OF KNOWN PROVENANCE

Isfahan

See also p.99 above.

'Abbas (Ustad Haji Mirza) Bayaz ibn 'Abd al-Vahhab *'alamatsaz*, died AH 1380 (AD 1960–61); Shafiq (1372/1992) pp.46–47.[8]

'Abbas (Haji): AH 1292 (AD 1875); *qalian* body, Iran Bastan Museum, Tehran, acc. no.21862; unpublished.

'Abbas (Haji): AH 1296 (AD 1879); *kashkul*, Museum of Oriental Art, Moscow; Maslenitsyna (1975) pl.70.

'Abbas (Haji): AH 1307 (AD 1889–90); *kashkul*, Hermitage, St Petersburg, acc. no.VS-804; *Masterpieces of Islamic Art in the Hermitage Museum* (1990) no.118.[9]

(According to Muhammad Bayazi, Haji 'Abbas and Muhammad Hasan (q.v.) were both involved with Yadallah (q.v.) in the making of the steelwork for the shrine of Sayyid Muhammad Shafti in Isfahan in AH 1322 [AD 1904–5].)

'Abd al-Vahhab: father of Haji 'Abbas; Allan (1994).

Ahmad Isfahani: cutler famous for penknives in Safavid times; Mirza Husain

8. For objects by Haji 'Abbas in addition to those listed below see Mayer (1959) pp.19–20; Allan (1982b; and Allan (1994).

9. The date is also given here as AH 1207 (AD 1792–93).

10. Floor (1971) p.111.

525

Khan.[10]

Bahman family: three brothers headed by Ustadh Haj Akbar Bahman *alamatsaz*; Allan (1994) p.146.

Fuludgar family: last member of the family died *circa* 1985; Allan (1994) p.146.

Ghulam'ali Mubashshir 'Abd al-Baqi (Haji): AH 1260 (AD 1844); door of the grille in the shrine of Sayyid Muhammad Shafti in Isfahan; unpublished.

Muhammad Bayazi (Haj) ibn Haj Karim ibn Haji 'Abbas ibn 'Abd al-Vahhab *'alamatsaz*: contemporary steel-working craftsman in Isfahan; Allan (1994) p.145.

Karim (Haj) ibn Haji 'Abbas ibn 'Abd al-Vahhab *'atiqsaz*: father of Muhammad Bayazi; Allan (1994) p.145.

Mahmud: cutler in the time of Fath 'Ali Shah; Mirza Husain Khan.[11]

pusar-i ('son of') Haji 'Abbas: n.d.; *kashkul*, Ethnographical Collection, National Museum, Copenhagen, acc. no.E.671; Mayer (1959) p.47 and pl.IVb.

Tahir (Haj); employee of Haji 'Abbas; Allan (1994) p.146.

Muhammad Hasan (Haj): employee of Haji 'Abbas; Allan (1994) p.146. (According to Muhammad Bayazi, Muhammad Hasan and Haji 'Abbas were both involved with Yadallah (q.v.) in the making of the steelwork for the shrine of Sayyid Muhammad Shafti in Isfahan in AH 1322 [AD 1904–5].)

Muhammad Sadiq Shirani (Haj) *'alamatsaz*: trained by Fuludgar; Allan (1994) p.146.

Yadallah (Ustad): AD 1322 (AH 1904–5); top part of grille work in the shrine of Sayyid Muhammad Shafti in Isfahan; unpublished.

Shiraz
Haji Asad: AH 1255 (AD 1839–40); swordsmith, recorded by Hasan-e Fasa'i as taking part in a rebellion in Shiraz.[12]

11. Floor (1971) p.111. 12. Busse (1972) p.265.

Appendix Two

INSCRIPTIONS TRANSLATED BY MANIJEH BAYANI

A.32 HALF OF A PRIMER

Our [my] intention is to leave an impression behind us [me];
For I cannot see our [my] existence as eternal.
In the year 1217 (1802–3)

غرض نقشي ست کز ما باز ماند
که هستي را نمي بينم بقائي
في سنه ١٢١٧

B.3 BELT BUCKLE

From the side of the meadow blew the breath of good fortune
From the rose bush of hope blew the rose of benevolence
... which is from fair destiny and an auspicious horoscope
Your royal patent of favour for all arrived.

از طرف چمن نسيم اقبال وزيد
وز گلبن اميد گل لطف دم [يد]
..... که ز حسن طالع و بخت سعيد
پروانه التفات عام تو رسي[يد]

D.1 HAWK STAND

The work of Muhammad Husayn 1[0]37 (1627–28)

عمل محمد حسين ١[٠]٣٧

D.2 HAWK STAND

As the falcon of the kingdom of Ilkhan
Sits on top of the [bird] stand
The end of the [bird] stand will then
Sit on the eyes of his enemy.

چه باز دولت ايلخان
بر سرنشينه نشيند
بچشم دشمنش آنگه
بن نشينه نشيند

G.1 PILGRIMAGE PRAYER PLAQUE

In the lobed panel at the top:
The *mutlaqa* invocation to His Holiness Imam Husayn, may peace be upon him.

زيارت مطلقه حضرت امام حسين عليه السلم

In the top corners of the main panel:
He is the God Who suffices me and He is the best Disposer of affairs.

هو الله حسبي / و نعم الوكيل /

In the narrow panel above the main text:
In the name of God, The Compassionate, The Merciful.

بسم اله الرحمن الرحيم

In the main panel:
Peace be upon you, O servant of God. Peace be upon you, O son of the Messenger of God. Peace be upon you, O son of the Commander of the Faithful. Peace be upon you, O son of Fatima the Radiant One, mistress of the women of the two worlds. Peace be upon you, O father of guiding and rightly guided imams. Peace be upon you, O quick to shed tears. Peace be upon you, O one possessed of allotted misfortunes. Peace be upon you, and upon your grandfather, and your father, and your mother, and your brother, and on the imams among your descendants. I testify that God has made the earth [of burial] sweet from you, and has clarified the Book through you, and has given religious merit liberally through you, and has made you and your father and your grandfather and brother and mother and descendants an example to those who are intelligent. O son of the fortunate, the good, who recite upon the Book, I have directed my greetings to you, may God's blessing and peace be upon you, and He has filled the hearts of some men with love towards you. He shall not be lost who holds onto you and takes refuge in you.

السلام عليك يا / ابا عبدالله السلام عليك يابن رسول / الله السلام عليك يابن امير المومنين السلام عليك يابن فاطمه الزهراء سيدة نساء العالمين / السلام عليك يا ابا الائمه الهادين المهدين / السلام عليك يا سريع الدمعة الساكبه السلام / عليك يا صاحب المصيبه الراتبه السلام عليك و على جدك و ابيك و امك و اخيك و / على الائمه من بنيك اشهد لقد طيب الله بك التراب و اوضح بك الكتاب و اجزل بك الثواب و / جعلك و اباك و جدك و اخاك و امك و بنيك / عبرة لاولي الإلباب يابن الميامين الاطياب / التالين الكتاب وجهت سلامي اليك / صلوات الله سلامه عليك و جعل افئده / من الناس تهوي اليك ما خاب من تمسك / بك و لجاء اليك /

APPENDIX TWO

In the lower corners:

Muhammad 'Ali ibn Abu'l-Qasim, the year 1197 (1782–82).

محمد علي بن / ابوُلقاسم سنه ۱۱۹۷

G.12 AXE-HEAD

On one side, in the lobed cartouche:

God, Muhammad, 'Ali, Fatimah, Hasan and Husayn, 'Ali, Ja'far, Musa

الله / محمد علي فاطمه / حسن و حسين علي / جعفر موسي /

In the panels:

This axe was endowed to the offspring [of 'Ali?] out of respect
So that [this] second [object] to be remembered [is there as a sign] of [the donor's] nobility and honour.

وقف اولاد اين تبرزين را نمود از احترام
تا كه باشد يادگار ثاني از خير شرف

On the other side, in the lobed cartouche:

God, 'Ali, Muhammad, 'Ali, 1201 (1786–87), Hasan, Muhammad. Through your mercy,
O You who is the best of those who show mercy.

الله / علي محمد علي ۱[۰]۰۲۰۰۱ /
حسن محمد برحمت[ك] / يا ارحم
الراحمي[ن] /

In the panels:

For Isma'il, the victim[?], through affection and love
Haji Muhammad, the follower of the King of Najaf, endowed this.

بهر اسمعيل قربان از سر شوق شعف
وقف كرد حاجي محمد شيعه شاه نجف

O 'Ali, help!
O 'Ali …

يا علي مدد
يا علي

… the intercessor …

....شافع

On the edge:

… Be cursed …

.... [با] شد بلعنت

… Haji Muhammad 'Ali ibn 'Ali

.... حاجي [م] حمد علي ابن علي

529

G.13 KASHKUL

On the top:

Our [my] intention is to leave an impression behind us [me];
For I cannot see our [my] existence as eternal,
Perhaps one day a man of piety through compassion
Will offer prayers for the dervishes.

غرض نقشیست کز ما باز ماند
که هستی را نمی بینم بقائی
مگر صاحبدلی روزی برحمت
کند در حق درویشان دعائی

In cartouches:

[This] rare *kashkul*, which is full of gold and watering
As you observe, is like a precious stone
Whoever drank a mouthful from it, said:
It is a thousand times better than that of *tasnim* and *kawthar*
It was completed by the efforts of the learned master
'Abbas, who is celebrated in every city and country.

کشکول طرفه که پر از زر و جوهر است
چون بنگری تو چه یک دانه گوهر است
نوشید هر که جرعه ای ازین بگفت
خوشتر هزار باره ز تسنیم و کوثر است
از سعی استاد خردمند شد تمام
عباس آنکه شهره بهر شهر و کشور است

May [whatever is drunk from it] be wholesome.

وش باد

I.1 MEAT CLEAVER

From the eye-brow of the cruel [flows] the blood of the bier
From the dissection of the meat, [comes] a tingling sigh.

ز ابروی دل[۱] زار خون ز سریر
ز هوش فلذا طنون دمش

J.1 BALANCE

In cartouches on the bar:

As our [my] book of sins was folded
It was taken to be measured against our [my] deeds
Our [my] sins were more than anybody else's, but
We were [I was] forgiven for our [my] love of 'Ali.

چون نامه جرم ما پهم بپیچیدند
بردند بمیزان عمل سنجیدند
بیش از همه کس گناه [ما] بود ولی
ما را بمحبت علی بخشیدند

O heart, take the world according to your own wishes
In it, take what has been resting for a thousand years

ای دل بکام خویش جهانرا دیده گیر
در وی هزار سال چنان آرمیده گیر

Take all the riches which are in this world as bits
Take every pleasure which is in this world as dust
Every moon-faced one who is in this clime of beings
Entreat her soothingly, and rest her next to yourself
It would be a thousand … and inlaid …
Take it [as] worthy (?), take it as stitched, take it as torn
The kingdom of Alexander, and the gold of Korah, and the life of Noah
No one has [ever] seen this iron [scales], but you take a look
Your face 'Abd al-Nabi, and your eyes are like a cage
One day break the cage and let its bird fly.

هر نعمتي كه هست بدنيا تو خورده گير
هر عشرتي كه هست بدنيا تو گرده گير
هر ماهرو كه هست در اقليم كائنات
آنرا بناز در بر خود آرميده گير
.... باشد هزار و زرنگار
سزيده (؟) گير و دوخته گير و دريده گير
ملك سكندر و زر قارون عمر نوح
اين آهنرا كس نديد وليكن تو ديده گير
روي تو عبدالنبي و چشم تو چون قفس
روزي قفس شكسته مرغش بريده گير

In cartouches under the scales:
O King of Najaf, you are the water of life for all
Brought to memory for clemency, at the time of death, for all
Noah has brought … of the refuge for man,
That is to say, You are the rescue ship for all.

يا شاه نجف آب حيات همهء
خاطر ز كرم وقت ممات همهء
آورده پناه آدم نوح
يعني كه سفينت النجات همهء

The scales are in the hands of the butcher, and I, astonished at his face
Come, O Purchaser! Look at the Moon in the house of balance.

ترازو در كف قصاب من در صورتش حيران
بيا اي مشتري بنگر قمر در خانه ميزان

O King of Najaf! These hands of mine, a totally destitute one
I fear will not reach the hem of your cloak on the day of retribution
In accounting for my sins, at the last judgement
If you desist from [judgment?], only you and God will know.

يا شاه نجف دست من بي سر پا
ترسم نرسد بدامنت روز جزا
در بحر (كذا) [بهر] كناهان من اندر محشر
كوتاهي اكر كني تو داني و خدا

In smaller cartouches:
O 'Abbas, the son of 'Ali.

يا عباس علي

N.24 SHRINE PADLOCK
By the truth of 'I testify that there is no god but God'. May this threshold be ever open in felicity.

بحق اشهد ان لا اله الا الله
گشاده باد بدولت هميشه اين درگاه

P.27 EMBER TONGS AND PRICKER

On one side:

My soul burned like a candle because of separation from you

My bone marrow burned because of sorrow for you

… your command is … on the top of a place

… and burned my house and its belongings.

همچو شمع از فراق جانم سو / خت /
از غمت مغز استخوانم سوخت /
..... حکم تو بر سر آنجائیست /
....... و خان مانم سوخت /

On the other side:

We [I] asked for the description of your face. He said:

Along with the flame, my tongue burned

The flame spread and the fire burned my tongue

It burned everything of mine from the earth to the sky.

وصف روی تو خواستیم گف[ت] /
هم ره شعله اش زبانم سوخت /
زد شعله آتش زبانم سوخت /
از زمین تا به آسمانم سوخت /

At the ends:

In the name of God, the Compassionate, the Merciful.

بسم الله الر / حمن الرحیم /

Appendix Three

FIRMANS RELATING TO MINING IN IRAN

The following translations are taken directly from Fowler (1841) pp.324–26.

Firmaun relative to the Mines in Persia, from the Shah to his Son, Abbas Meerza

In the year of the Hegira, 1245 (AD 1830)
'The royal and auspicious command of his Majesty was issued (to wit) that the keys of the gates of prosperity, and the brilliancy of the soul of royalty – the accomplished and distinguished son – the deputy of this everlasting sovreignty, Abbas Meerza, may he be blessed and happy. And be it known to him, that according to what has been represented to our illustrious presence, that incomparable son has granted to the sagacious, faithful, and highly distinguished servant, his Excellency —, the important affairs of the mines of Azerbaijan, and has committed the execution of that important service to the charge of the endeavours of the above-mentioned distinguished gentleman; and since the manners of the sagacity, and the intellectual power of the above-mentioned gentleman has become manifest to the presence of his Majesty. We have from the beginning of the year 1244, and the time to come, granted the execution of that important affair to the above-mentioned gentleman, that according as it suits that distinguished gentleman's natural talent, he may employ his skill and services towards that concern, he may bring the well-informed miners from whatever country he may find out, and employ according to his own management and sagacity; so that he may prove the manifestation of his services in procuring the fruits of the mines. And we further command that that son, according to what he had agreed, will confine the execution of that important science to the above-mentioned gentleman, and all the necessary helps on your part should be stored upon him, and to establish him in his important service, and heal him with your royal favour. We further command that their Excellencies, the distinguished nobles of the Court of Exchequer, and the Ministers of the supreme Court of Royalty should preserve copy of this royal Firmaun in their respective registers, and preserve them from any alteration or forgery.'

(Sealed with his Majesty's imperial seal, and registered and sealed by the grand Vizier and twelve other Ministers of State).

Firmaun from Abbas Meerza, relative to the Mines

'The royal command is issued, viz., that the object of our illustrious mind is this – that the mines which are in the country of Azerbaijan, as far as are under our dominion, should not remain useless nor unproductive – nay, they should be useful and profitable; and as his Excellency —, &c. &c., on whose learning and the high degree of his service we have great confidence, and are sensible of. He in the auspicious presence of his Royal Highness, requested that he should be appointed to execute this important service, and have committed to his charge the mines of the above-mentioned countries. We have granted for the space of twenty-one years, that he may procure miners from England whensoever he should approve them to be learned and distinguished in this art, to open the mines; and by the help of God, they should employ all their endeavours and efforts, that this important affair should be terminated with success, and so may be the means of the increase of the royal favour towards him,' &c.

(The grant was confirmed by the eldest son of the Crown Prince of Persia).

Firmaun from Mahmoud Meerza, the present Shah of Persia (Son of Abbas Meerza)

'This royal order denotes, that since the powerful and penetrating command of his Royal Highness the superior and my Lord of Bounty, the mighty deputy of sovereignty to whom my life is devoted, has established the honour of working the mines,' &c. &c. (recapitulating as before).

'We, therefore, obediently to the royal commands, according to its contents, it having been commanded and ordered to us, who are the most obedient of servants, that we should also pass and order agreeably to the royal command. We, therefore, obediently to the royal commands of his Royal Highness (our father), in the manner that that royal order has passed, from the beginning of the present year until the time above mentioned, having granted that important affair to the above mentioned distinguished gentleman, in order that without interruption or interference of any one, he should work the above mentioned mines. We further command that the great marshals and the superior nobles, the governors of the different districts of Azerbaijan, shall obey this command, and consider all the requisites and necessaries therein confined exclusively to him; their excellencies the secretaries of the blessed state should register and preserve the contents of the royal firmauns, and having preserved it from the guile of any alterations, and obey it necessarily.'

Appendix Four

PREPARATION OF DAMASCENE STEEL IN PERSIA

Extract from the account by Second Captain Massalski published in *Annuaire du Journal des Mines de Russie*, 1841, pp.297–308 (plate V, Figs 2, 4, 5, 6, 7 and 8)
Translation by Graham Cross

The proportion of elements constituting damascene steel varies according to the quality of the metals used in its preparation. These metals are: iron, cast iron and a little silver. The first should be old, already worked (nails, sheets, etc.), but free from rust. The cast iron isto be chosen from the best qualities of white iron. The steel should be of very high purity. The normal proportion is 1 of cast iron to 3 of iron by weight.

After the iron and the cast iron have been reduced to small pieces, and as good a mixture of the two as is possible has been prepared, it is then placed in refractory crucibles (Pl.V, fig.3), the height, upper diameter and lower diameter of which are in the ration of the numbers 5, 4 and 3 respectively. The size of the crucibles depends on the quantity of metal which is to be prepared. This quantity is normally between one quarter and 1 bacheman in Persia [one bacheman is equivalent to 6 pounds (2.46 kg)]; the base of the crucible is slightly concave. The mixture which is to be fused occupies one third of the capacity of the crucible.

The melting furnace consists (Pl.V, Fig.4 and 5) of a cubic box of brick ABCD, with a flat base and with four corners where openings C are left to receive the nozzles of the bellows; a door made in the middle of one of the sides of the box allows charcoal to be added, if necessary, while the operation is in progress. The box is spanned by a double bottom of bricks mn pierced by round holes o, having the diameter of the crucible at $^{2}/_{3}$rds of its height. This double bottom is supported at the necessary height within the box by means of iron or brick feet p. It is normally placed at $^{3}/_{4}$ of the height of box ABCD. The holes o are made in such a way that the crucibles are 2 inches apart (0.051 m from each other); each of the holes is surrounded by four small holes q, through which the flame passes through the base mn and thus envelops the crucibles on all sides. The furnace is closed by a lid of iron or bricks, sealed with clay, which is moved using a simple lever. Several holes made in

FIG.III Sketches by Massalski relating to the steel-making process: Fig.3, proportions of crucibles; Fig.4, schematic diagram of furnace; Fig.5, section and plan view of structures supporting crucibles

the cover provide a passage for the draught.

Sufficient charcoal is first placed in the furnace to reach the base of the crucibles; the latter are housed in the holes o in the base nm, which is placed as horizontally as possible, and the space between base mn and the lid of the furnace is completely filled with charcoal; the lid is carefully sealed with clay; fire is applied to the four corners C, and the bellows operated. When the metal begins to melt, which takes place after 5 or 6 hours, a boiling noise can be heard, which increases as the metal melts, and ceases once melting is complete. Once the boiling has ceased the lid is removed; the crucibles are freed from the charcoal covering them; 3 or 4 zol. (0.013kg or 0.017 kg) of divided silver is placed in each and stirred rapidly with a metal rod, the crucibles are again covered with charcoal; the lid is replaced; all the holes of the furnace are sealed up with clay, and it is allowed to cool for about 3 days.

Once the furnace has completely cooled, the crucibles are removed, and the cakes are taken out. These cakes are cleaned and any grains of silver which may remain on their surface are removed. In this condition they are known as Damascus

steel. They then merely have to be tested. One of them is tested for this purpose. If it shows little mottling, the cast iron is considered to be unsatisfactory, and it is improved by annealing. This operation is performed in an ordinary draught furnace; the cakes are lined up in rows 2 inches (0.051 m) apart, and they are heated to a light red colour; they are then cooled in the furnace itself, if the test cake only has traces of mottling, or in air, if the steel does not require strong annealing.

If the mottling does not appear satisfactorily after the second test, another annealing is performed, and so on. The makers state that everything here depends on chance. Sometimes they are so unsuccessful that the entire melt fails to provide a single good cake. Thus Damascus steel is quite expensive. A cake 3 $1/2$ inches (0.09 m) in diameter may cost as much as a ducat, and is never worth less than 5 roubles.

A good cake should have a firm surface, with as few holes as possible. Above all it should have neither roughness nor bosses. The presence of the latter indicates a poorly fused metal which will break into pieces the first time it is hit with a hammer.

Cakes of Damascus have the shape of disks of different diameters, but a thickness of at least a $1/2$ inch (0.013 m). When it is desired to make blades, they are stretched out into bars in such a way that the underside of the disk, which is the better knitted of the two, forms the cutting edge, while the other side forms the back, and the external circumference forms the flat of the blade.

To draw out a cake in this way it is placed on the hearth with the top down, and heated, turning it in the fire, to a light red colour. This heat lasts about seven and a half minutes. The steel is then removed from the fire and struck with a 6 pound (2.45 kg) hammer, to give a uniform thickness throughout. This first working requires great care. If the steel withstands the first hammer blows, then the success of the remainder of the work is assured.

Without allowing time for the piece of steel to cool, it is replaced in the fire and heated a little more than the first time. A start is then made on drawing out the blade using the conventional method, taking care not to make a mistake about which side is intended to form the cutting edge.

As an example of the ease with which the cakes of Damascus burst under the first blows of the hammer, I would quote a fact of which I myself was an eye witness. Out of six exactly similar cakes, three burst into pieces after the first heat. The other three were drawn out in 1 $1/2$ hours into bars 6 verch (0.27 m) long, one verch (0.044 m) wide and one quarter verch (0.011 m) thick. The bar is gradually cooled, first keeping it close to the fire, and then taking it further and further away, until it can be held in the hand. The soft iron which forms on the surface is then cleaned off, first with the file, and then with shears of best English steel. This operation frequently disappoints the maker's hopes, and sometimes in order to be able to bare the Damascene he has to file down the bar in such a way that instead of obtaining the blade

from it, all he can make is a knife.

The fact that the soft iron has been completely removed from the bar can be recognised either by the resistance which is experienced to the file, or above all by the lack of the metallic lustre of the iron on the black background of the Damascus. Again a small portion of the bar can be polished, cleaned with emery and chalk, wiped dry and coated with a solution of iron sulphate. If this test does not make the mottling appear on the bar, it can be concluded that there is still iron on the surface of it. In order to clean a polished bar, a small piece of partly efflorescent ferrous sulphate is taken, and dissolved over the fire in a small dish. A minute later the water takes on a dark orange colour. The solution is allowed to cool a little, a cloth is soaked in it and wiped over the bar several times, and finally the bar is wiped clean.

Sometimes soft iron forms on the surface of the bars which can be cut into pieces. In this situation the bars take on a very irregular shape, and requires a great deal of working to even them up and draw them out into a thin blade. This working is performed using ordinary forging techniques. Then the soft iron is removed once again, the bar is reheated, and is given the shape of the object which it is desired to obtain, keeping it at a strong red heat.

If a sabre is required, only one of the sides of the bar is slightly cleaned up, in particular the one which will form the back of the sabre. Cakes which have many pores on their top surface should be avoided. Otherwise these pores will form deep holes in the back of the sabre. These the manufacturer well knows how to plug, but they greatly reduce the value of the sabre. The Persians fill up these holes by pushing ordinary needles into them. They perform this operation with great skill, but without great firmness.

When the blade has cooled, it is quenched in boiling hemp seed oil. Some armourers add a little grease and bone marrow. The wooden tub which contains the oil is sufficiently large for the blade to go in easily. The oil is heated by plunging two or three pieces of red hot iron into it. During this time the blade is given a heat between red and white hot, and then plunged into the bath. If it is a dagger it is held flat; if it is a sabre, it is quenched little by little, beginning by the end of the cutting edge, holding the latter towards the bath. This manoeuvre is repeated until the oil stops smoking, which proves that the blade has cooled. After quenching the blade is always soiled with burnt oil. This dirt is removed by heating it enought to set light to a piece of wood, and by rubbing with a rag from a bedsheet. It is at this time too that imperfections are corrected and the blade is straightened if it is out of true. After 5 or 6 heats the blade leaves the fire quite ready, i.e. it then only has to be cleaned with sand, polished with emery and mottled by pickling in iron sulphate.

The tools which the Persians use are very simple, but also very inconvenient. They also make the work slow and therefore costly. Hardwood charcoal is used for

preference. To give the mottling of the blade greater variety small transverse notches which are not more than 1 quarter of a line (0.0005 m) deep are cut with a file into the bar which has been cleared of its soft iron, and already fashioned into a regular shape. Figure 6, Pl.v, shows various possible arrangements of these notches. An effort is made to make them exactly identical on both sides. These notches appear later, after working, in the form of transverse lines with a hard sharp lustre.

Major General Anosov is of the opinion that the purpose of this working is to imitate artificially blades with natural patterns whose method of manufacture is now lost. But the Persians know no other way of making patterned blades, and as we know nothing of the procedures used by ancient armourers, it is highly likely that their methods do not differ at all from the present method. It is however difficult to believe that the very regular patterns on ancient damascene blades are but a caprice of chance.

Armourers frequently use the remains of old damascened sabres to make new ones which they sell at a great profit. Through being repeatedly sharpened the blades eventually become worn, become too narrow and thus lose three quarters of their value. It is these old sabres which skilled armourers make use of. To do this they heat them and draw them out into a thin blade having the width of a good sabre and the length of two. They then prepare a blade of ordinary iron, cover it precisely with the blade of Damascus, and weld the whole together. A good armourer performs this operation very skilfully. However close examination will almost always reveal where the steel blades have been welded to the iron blade.

Good Damascus steel should have coarse, dark, uniform and sharp mottling, with a transverse pattern. A good sabre is roughly two fingers broad. It is heavy, with a good sound. Its back should have no plugged holes. Its surface should not be blemished with any residual soft iron. The blade should have a uniform width over its entire length.

Glossaries

GLOSSARY OF IRON AND STEEL PRODUCTION TERMS

Accelerator radiocarbon dating
Radiocarbon dating is a technique for determining the age of materials based on their content of the radioisotope carbon-14. Carbon-14 decays to the isotope nitrogen-14 with a half-life (the time taken for half of the atoms to decay) of 5730 years. Measurement of the amount of radioactive carbon remaining in the material thus gives an estimate of its age. A mass spectrometer records and measures the types of isotope present in a material and their relative amounts, rather than counting the radioactive decay. This method involves much smaller samples than the usual radiocarbon method and for this reason is generally suitable for dating steel or cast-iron objects, except where fossil fuel (coal or coke) has been used in their production.

Acicular
Needle-like

Annealing
A general term applied to several softening operations affecting the grain size and cementite (q.v.) structures within a particular steel. Full annealing is carried out with forging (q.v.) on modern steels in order to obtain grain refinement in combination with high ductility. Hypo-eutectoid steels (q.v.) are heated to about 50°C above the upper critical point (q.v.) and hyper-eutectoid steels (q.v.) 50°C above the lower critical point (FIG.112b). The steel is held for a while at this temperature, depending on its thickness, followed by very slow cooling, usually in the furnace. This produces a softer steel than normalising (q.v.). Microscopy of a sample of the metal will reveal which operation has taken place.

Archaeo-metallurgy
The archaeological study and reconstruction of early metallurgy, which can include any aspect of metal production and use up to the introduction of modern industrial processes.

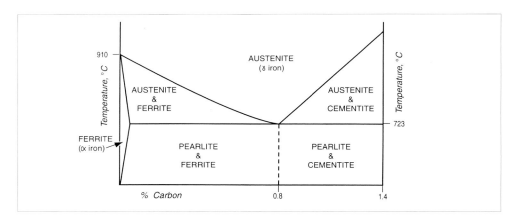

FIG.112a Expanded steel portion of the iron–iron carbide phase diagram

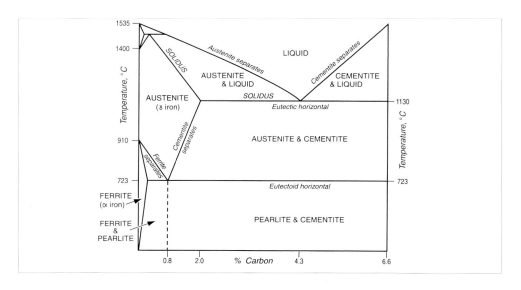

FIG.112b The complete iron–iron carbide phase diagram.

Austenite

The face-centred cubic lattice (gamma) form of iron (q.v.) which can contain up to 2% carbon in solid solution.

Austenite range

The range of temperatures at which austenite is the stable form of iron (see FIG.112a).

Bainite

A range of microconstituents found in ancient steels, the formation of which is dependent both on the composition of the steel and the size and shape of the object, as well as how rapidly it has been cooled. It can be observed in alloy steels or carbon steels that have been rapidly cooled from the austenite range (q.v.), but not rapidly enough to form martensite (q.v.). In some instances bainite is found in early steels subjected to intermediate continuous cooling condition (such as slack quenching, q.v.) although the reasons for this are not clear. One form – upper bainite – has a feathery appearance which is also laminated and so resembles pearlite (q.v.), whereas another form – lower bainite – has a dark, acicular (q.v.) appearance similar to lightly tempered martensite, although bainite is less hard. Structures such as bainite suggest that early ironsmiths had the specific intention of producing a steel of intermediate hardness and brittleness.

Bloomery iron

The product of the single-stage method of directly smelting (q.v.) or reducing iron from its ores using charcoal as the fuel and reducing agent. Reduction from ores to give a mixture of iron particles and waste products, mainly non-metallic slag (q.v.) and cinders, is possible as low as 800°C, but the production of iron in this way is not practicable until a large proportion of the slag can be separated from the iron in the furnace, only possible when the free-running temperature of the slag (in most cases, approximately 1100–1200°C) is reached. During reduction solid particles of iron are formed and after the slag has run to the bottom of the furnace or been tapped away these gradually coalesce to form a semi-congealed, porous or spongy mass of iron, the 'bloom'. (The term derives from the Old English word *bloma*, meaning a flower: Anglo-Saxon iron-makers presumably thus described the appearance of the mass of metal in the furnace.) The bloom is still mixed with much slag which must be mostly removed by bloom consolidation (q.v.). Most of the impurities present in the ore, such as the oxides of manganese, magnesium, calcium and aluminium, will be lost in the slag since they are far less readily reduced than the iron oxides, although some impurities such as phosphorus are readily reduced.

Bloomery steel

The direct production of steel from iron ore by making the conditions in a bloomery smelting furnace more reducing than is necessary to produce plain or low-carbon iron (q.v). A higher charcoal to ore ratio is required and control over the air blast is more critical, factors which make the production of bloomery steel a more difficult and expensive operation than that of plain iron. In practice, the difficulty of maintaining even reducing conditions in early bloomery furnaces probably resulted in

the production of blooms with varying carbon content.

Calculation of carbon content
In a hypo-eutectoid steel (q.v.) that has been cooled in still air, or normalised (q.v.), the visible proportion of ferrite (q.v.) to pearlite (q.v.) can be used to estimate its carbon content by applying the following formula:

% carbon = % pearlite x 0.008

A similar visual estimate of carbon content can be obtained for hyper-eutectoid steels (q.v.).

Carburisation
The process by which carbon atoms are made to diffuse in from the surface of a piece of iron. Under reducing conditions carbon monoxide gas is produced which on decomposition forms nascent carbon atoms which are absorbed at the surface of iron. The process is slow and sufficiently reducing conditions (a minimum temperature of 900°C) have to be maintained throughout: even carburisation is difficult to achieve in a smithy and would only have been possible with quite small pieces of iron. The heat and carburising medium may sometimes have been separated, for instance, by packing of pieces of iron and charcoal (or plain iron and cast iron) in sealed containers that were placed in the hearth. This is a basic description of how crucible steel was made in Iran, India and parts of the surrounding region during much of the 1st and 2nd millennia AD. As far as we know, carburisation methods for making steel were not used in the West until the post-medieval introduction of methods such as pack-carburising. It is not known to what extent the process was used in earlier times although it is mentioned in the 12th century by Theophilus, who was probably referring to case-carburising which only affects a thin surface layer. In more recent times this process was exploited in the process of case-hardening (q.v.). Occasionally referred to as carbonisation.

Cast iron
Iron–carbon alloys containing approximately 2–5% carbon are classed as cast irons. Much of the carbon is present either in its combined form, iron carbide or cementite (q.v.) – white cast iron or white iron – or as free carbon, graphite flakes in a matrix consisting of varying proportions of the eutectoid pearlite or ferrite (q.v.) – grey cast iron or grey iron. When liquid cast iron solidifies, white cast iron will form if the cooling rate is sufficiently rapid, grey cast iron if the cooling rate is slower. The cooling rate is dependent on the presence of quite small quantities of certain impurities in the metal. For instance, silicon promotes the formation of graphite, whereas phosphorus (above 0.1%) promotes the formation of cementite. An intermediate

cooling rate can result in mottled iron, which has a white iron matrix with roughly spheroidal patches of grey iron dispersed within it.

Cast steel

A term sometimes used to refer to steel in the as-cast condition, i.e., before any subsequent heat treatment or forging (q.v.). In the context of the present study this would usually mean disc- or egg-shaped ingots of steel removed from clay crucibles after they have cooled, but also could refer to objects (or billets) made of crucible steel cast into moulds, although it is not known to what extent steel might have been moulded in this way.

Cementation

A largely obsolete term referring to the carburisation of iron (q.v.).

Cementite (iron carbide)

A white, very hard, brittle compound of iron and 6.7% carbon (Fe_3C).

Charge

The mixture of raw materials (mainly ore and fuel) loaded into a furnace for smelting (q.v.), or the mixture of materials placed in the crucible (q.v.) for a secondary process such as crucible steel-making. The term is also used to refer to the actual loading of these materials into the furnace or crucible.

Co-fusion

A term introduced by Joseph Needham in 1958 to describe a Chinese steel-making process involving the carburisation of wrought iron (q.v.) with liquid cast iron (q.v.): wrought-iron bundles and small pieces of cast iron were packed together, covered in a mixture of clay and straw, and heated in a furnace. The technique was reported as early as the 6th century AD and described in the 17th century, and documentary sources refer to *guan'gang* or 'irrigated steel', although the use of liquid cast iron has yet to be identified in archaeological material.

Colour estimation of temperature

Early ironsmiths estimated the correct temperature from which to forge or quench (q.v.) a steel by gauging its colour. This becomes a just visible dull red at 500–600°C, reaches its brightest red at approximately 900–950°C, and goes through stages of orange and lemon yellow before reaching white heat at 1200–1300°C. A different effect is used to gauge the correct, and much lower, temperature at which a steel can be tempered. Gently heating the steel produces a thin film of oxide the colour of which

varies depending on the temperature: pale yellow at approximately 220°C, through brown/purple at approximately 265°C, to dark blue at approximately 315°C.

Consolidation
The removal of most of the slag still present in a bloom by gentle hammering while the bloom is still hot or after re-heating (above about 1050°C) until the slag becomes fluid enough to be squeezed out. A bloom carefully consolidated in this way can result in a clear iron, relatively low in slag, although the care taken over consolidation by early smiths could be rather variable.

Crucible
A vessel in which substances are heated to high temperatures. Before the development of modern steel-making the crucible was a vessel made of refractory clay.

Crucible steel
In the context of pre-Industrial Revolution processes, the hyper-eutectoid steel (q.v.) made as a liquid in closed clay crucibles (q.v.). It was usually, if not always, the product of a secondary carburising process in which at least some of the raw material in the crucible charge (q.v.) consisted of iron that had already been reduced from its ores by a primary process, smelting (q.v.).

Damascening
A misleading term which has been used to refer to, amongst other things, a variety of decorative processes linked to the production of iron and steel objects, in particular those made of crucible steel (see the discussion elsewhere, pp.76–80).

Decarburisation
Loss of carbon from the surface of a piece of steel or cast iron by oxidation, either accidental or deliberate.

Dendritic structure
A firtree- or fern-like formation of microconstituents that occurs during the first stages of solidification of a liquid metal or slag. In a liquid alloy, these formations are localised in the areas with a higher melting-point, which tend to solidify first. The dendritic patterns characteristic of a cast metal are revealed by polishing and etching a flat specimen and examining it under a relatively low-power lens. Dendritic formations can be seen in a slag where two or more constituents or phases (q.v.) – typically wüstite (iron oxide) and fayalite (iron silicate) – are present, and are revealed by polishing a flat section without the need for etching.

Eutectoid
For a steel this refers to the laminated structure pearlite, and is also used to describe a steel containing approximately 0.8% carbon, where the entire micro-structure consists of pearlite.

Fayalite
One of a series of iron silicates (Fe_2SiO_4)

Ferrite
The body-centred cubic lattice (alpha) form of iron (q.v.), stable at lower temperatures.

Fining
An obsolete process for removing carbon from cast iron to produce wrought iron (q.v.). Molten cast iron (pig iron) is oxidised by blowing air through it or by the addition of iron oxides in the form of ore, or a combination of both. By these means steel and carbon-free iron can be indirectly produced. See decarburisation.

Flux
Material added to a furnace or crucible charge to aid in the melting and removal of unwanted waste products (or gangue) such as silica, and to prevent further oxidation. Iron oxide, for example, reacts with silica (and other minerals) to form a glass-like slag, consisting mainly of fayalite (with a free-running temperature about 1170°C), which either rises to the top of the iron or steel in a crucible, or can be run or 'tapped' off. There seems to be little evidence before the late medieval period for the use of additional fluxing agents such as lime to lower the free-running temperature and improve the yield of iron.

Forging
Working or hammering a metal while it is still hot. Unlike copper, iron cannot be cold-worked to any great extent as it soon becomes hard and brittle.

Fuel
Until the development of the coking of coal, during the 18th century, the chief source of fuel for the reduction of iron ore was charcoal. Alternative fuels must have been tried but found unsatisfactory – raw wood because of its oxygen content and the need to mix it with the ore in small pieces, coal because of its sulphur content – although peat has been used to a limited extent, for example, in Scotland.

Gradient quenching
The protection of part of a steel object from the effects of a quenching medium (q.v.), and thus from rapid cooling, usually by covering it with clay. Medieval and later Japanese swordsmiths, for example, might coat a blade with a mixture of wet clay and charcoal, then scrape most of this away along the edge which was to be hardened. The blade was then heated above the upper critical temperature, and quenched in water, producing a blade with a hardened edge and a tough unhardened back.

Hammer-welding
The compressing and fusing together of separate pieces of white-hot iron or steel by hammering, without the metal becoming liquid, an extension of what happens during bloom consolidation (q.v.). The process is often referred to as hammer-welding or forge-welding.

Hyper-eutectoid steel
Term used for a steel containing more than 0.8% carbon. For a plain carbon steel this is an alloy of iron containing up to approximately 2.0% carbon.

Hypo-eutectoid steel
An iron–carbon alloy containing up to about 0.8% carbon. This can be subdivided into two categories which are very important in the study of early ferrous artefacts. What is now termed a modern low-carbon or mild steel (q.v.) contains up to 0.3% carbon and cannot be hardened by heating and quenching (q.v.). Medium- to high-carbon steels (those containing 0.3–0.8% carbon) can be quenched although the effect varies depending on the proportion of carbon present. In the present study, iron containing up to 0.3% is referred to as low-carbon iron (q.v.).

Iron
Iron exists as a solid in different crystalline forms (allotropes). The most important are alpha (α) iron and gamma (γ) iron. The crystal lattice arrangement of alpha iron is body-centred – with a lattice point at the centre of each unit cell as well as at the corners – whereas that of gamma iron is a face-centred cubic arrangement – with a lattice point at the centre of each face of each unit cell, as well as at the corners – (FIG 113). The iron–carbon equilibrium diagram (technically the iron–iron carbide diagram) shows the temperature ranges in which each form of iron is most stable as well as the effect of different proportions of carbon (FIG.112b).

The importance of the two crystalline forms of iron for steel-making lies in the difference of the solubility in solid solution of carbon between the two. Carbon is virtually insoluble in the body-centred alpha form, the lattice structure of which will accept a maximum of only 0.04% carbon. The face-centred cubic lattice of gamma iron will accept carbon atoms more readily and up to about 2.0% carbon is soluble in gamma iron. Alpha iron is also known as ferrite (q.v.) and that of carbon in gamma iron as austenite (q.v.).

FIG.113 Allotropic forms of iron: body-centred (α) and face-centred (γ) cubic lattice structures in iron, stable at different temperature ranges (see FIG.112a)

Low-carbon iron

In this study, a term used to refer to low-carbon or mild steel, with less than 0.3% carbon, which cannot be quenched. See also hypo-eutectoid steel.

Martensite

A supersaturated solution of carbon in gamma iron (q.v.), produced by very rapid cooling such as is obtained by quenching (q.v.) a steel in water. The carbon present does not have time to separate as pearlite (q.v.) and the distorted lattice structure of martensite results. Its structure means that it is very hard and non-ductile: the higher the carbon content, the greater the distortion to the lattice structure and the greater the hardness of the martensite. The hardness increases most markedly for steels with a carbon content of up to about 0.7% but the effect is rather less thereafter. The cooling rate above which martensite will be formed is known as the critical cooling rate and differs for steels of different carbon content. In practice, steels with less than 0.3% carbon cannot be hardened effectively (see hypo-eutectoid steel). Martensite appears acicular (q.v.) as a result of the diffusionless precipitation of carbon as plates or laths along certain crystal planes.

Metallographic analysis

The examination of a flat, polished and etched area of metal with a microscope and

Mild steel
A form of low-carbon iron made as a liquid, only possible with the introduction of the Bessemer converter and the Siemens open-hearth process, both *circa* 1860. It is characteristically more homogeneous than low-carbon iron produced by earlier methods (e.g. bloomery, finery) and contains fewer non-metallic inclusions but is usually recognisable by the presence of impurities such as manganese sulphides.

Nodular pearlite
See radial pearlite

Normalising
Normalising is related to annealing (q.v.) but involves heating both hypo- and hyper-eutectoid steels (q.v.) to about 50°C above the upper critical point, for a period depending on the thickness of the steel, and then allowing the metal to cool in still air. This will produce maximum grain refinement and consequently the steel is slightly harder and stronger than fully annealed steel.

Pattern-welding
A method of hammer-welding or forging (q.v.) designed to produce patterns on the surface of an object after it has been polished and chemically etched. In this sense it refers to effects seen on certain, usually composite iron objects, particularly swords. The term may also be used (as pattern-welded) to refer to the overall structure of an object like a sword, or at least, specific parts of it.

Pearlite
A very regular, laminated structure, consisting of alternate plates of cementite (q.v.) and ferrite (q.v.) giving a characteristic mother-of-pearl appearance. Its formation is greatly affected by the rate of cooling. It is most commonly or easily visible in early steel objects cooled in air.

Phase
A general term referring to the metallurgical structure of a metal. In most earlier iron/steel objects more than one phase (i.e. structure) is usually found to be present.

Piling
The extensive forging (q.v.) of a piece of iron will usually result in a long rod or bar.

This can be folded, welded and forged out again to the same length and this procedure repeated a number of times. This process is sometimes known as piling (or faggotting) and may result in a layered structure even in objects consisting of fairly homogeneous low-carbon iron. Piling is still used for the production of steel for Japanese sword blades as part of a surviving medieval tradition.

Plain iron

The simplest form of iron found in early objects and largely consisting of ferrite (q.v.) plus small, irregular proportions of non-metallic impurities – slags, present as inclusions drawn out along the main direction of forging (q.v.) – and small proportions of alloying constituents, typically carbon (below about 0.1%), phosphorus, nickel, copper and arsenic. Plain iron is often referred to as wrought iron (q.v.) although the term 'wrought' is usually associated more particularly with iron which has been produced from cast iron by a secondary oxidising process.

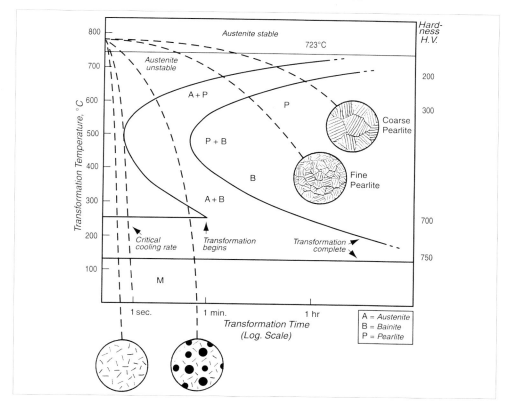

FIG.114 Time/temperature transformation (TTT) diagram overlain with continuous cooling curves to show the transformation effects of different cooling rates for eutectoid (0.8% carbon) steel.

Quenching (or quench hardening)
The process of rapidly cooling a re-heated metal object by plunging it in water or another liquid, such as oil. Steels can be hardened to varying extents depending on their carbon content and the rate or speed at which the quench occurs, which varies with the thermal capacity of the quenching liquid as well as the mass of shape of the object being quenched. In an air-cooled steel the cooling rate is sufficiently slow to allow the structure of the steel to transform to one at least partly made up of pearlite (q.v.). When this critical cooling rate is exceeded, the transformation to pearlite no longer has time to take place and, depending on the rate of cooling, one of several less stable structures is the result. The more efficient the quench the less stable and correspondingly harder and more brittle is the resultant structure. When the rate of cooling is rapid enough a fully quenched structure of martensite is the result.

Radial pearlite
A form of pearlite (q.v.) with a distinctive nodular appearance at low magnification which can be seen at much higher magnification to consist of laminations of cementite and ferrite radiating from a central nucleus. Above the upper critical cooling point pearlite of increasing coarseness is formed (FIG.114). Very close to the critical point a mixed formation of martensite and radial pearlite can occur. Radial pearlite is easily recognizable in early steels, including edged weapons. In earlier textbooks it is called troostite.

Slack- or slow-quenching
Quenching (q.v.) carried out using a cooling liquid, such as oil, with a lower thermal capacity than a fast-cooling liquid like water. Depending on the carbon content of a steel quenched in this way, an intermediate transformation product such as bainite (q.v.) will be formed, rather than the fully quenched, much harder and more highly stressed transformation product, martensite (q.v.). More gentle quenching can avoid excessive distortion or even breakage, although an insufficiently well-quenched steel might be too soft and perhaps too easily blunted or bent.

Slag
The glassy waste by-product of smelting (q.v.).

Smelting
To obtain iron from its ore, the iron oxide in the ore must be reduced to metal. The lowest temperature at which this can be achieved is about $800\,°C$,; the melting-point of pure iron is about $1535\,°C$.

Solid-phase welding
See hammer-welding.

Steel
Carbon steel is usually referred to as an alloy of iron and carbon containing up to about 2% carbon. For convenience, in the present work steel is defined as that alloy of iron and carbon which can be hardened by quenching, which means a practical lower limit for carbon content of approximately 0.3%. An iron–carbon alloy with less carbon than this would normally be referred to as a low-carbon or mild steel, but here is referred to as low-carbon iron (q.v.). See also hyper-eutectoid steel and hypo-eutectoid steel.

Sub-critical annealing
A low-temperature treatment carried out on modern steels to soften the metal and to relieve internal stresses caused by cold-working. The steel is heated to approximately 500–650°C, just below the temperature at which pearlite (q.v.) re-dissolves as austenite (q.v.). It is held for a time, up to several hours, within this temperature range during which time the pearlite lamellae 'ball up' or spheroidise. The ferrite (q.v.) grains also gradually increase in size. The longer this process is continued the greater the ductility of the steel with a corresponding decrease in tensile strength and hardness. Similar structures found in early steel indicate that this was a secondary heat treatment that may often have been applied to early artefacts in order to soften the steel parts.

Tempering
A process carried out on fully hardened martensitic steel, which is very hard but also brittle and liable to cracking, in order to relieve the internal stresses caused by quenching and to toughen the steel. This is carried out by warming the steel for a time between approximately 100 and 300°C. A temperature of 100–200°C is sufficient to relieve internal stressses while leaving the martensite in an acicular (q.v.) and slightly less hard form, called tempered martensite. Although it resembles lower bainite, it is much harder. Between 200 and 300°C further decomposition to bainite takes place and above this and up to about 450°C decomposition into a precipitation of fine iron carbide particles in ferrite takes place. This structure is tougher but less hard than martensite. At even higher temperatures, 450–650°C, annealing (q.v.) takes place, when the carbide particles coalesce to produce fewer, larger particles in a spheroidal form often known as sorbite. In this condition the steel is yet tougher but less hard. A similar sub-critical annealing treatment (q.v.) is sometimes found to have been used on steels which have been air-cooled. The temperature

ranges used to be gauged by colours (see Colour estimation of temperature).

White cast iron (or white iron)
See cast iron

Widmanstatten effect
A cause of brittleness in steel, the result of overheating or maintaining the correct heat for too long. Under these conditions austenite (q.v.) grain growth occurs, and upon cooling, ferrite is deposited first at the grain boundaries and then along certain crystallographic planes. Upon further cooling pearlite will form around the ferrite. The resulting structure has a very distinctive columnar or acicular appearance. It derives its name from the man who first observed the structure in meteorites. In early artefacts it usually occurs only in patches, indicating localised overheating and reflecting the difficulty in controlling the temperature of the furnace.

Wrought iron
Plain iron produced indirectly from its ore by the decarburisation (q.v.) of cast iron, either by fining (q.v.) or puddling.

Wüstite
Iron oxide (FeO).

ISLAMIC TERMS IN IRON- AND STEEL-MAKING

Ard
A term used by the 9th-century commentator al-Kindi to refer to the darker background matrix visible on a watered-steel sword blade.

Baidat
This word, meaning 'eggs', is often used by al-Biruni and found in other medieval Islamic references to describe the lump of solidified steel produced by one or more of the crucible-steel making processes.

Bulat
A corruption of *fulad* (q.v.) or pulad found further north, towards Russia.

Dus
A term used by al-Biruni, probably to refer to white cast iron.

Firind

A term often used by al-Kindi to refer to the watered pattern seen on many swords of crucible-steel origin. These are almost invariably found to have an inhomogeneous layered macrostructure, which gives rise to the pattern on polishing and etching. Also found as *ferend*, *farand* and *barand*.

Fulad

Steel, described by al-Kindi, al-Biruni and others as being an 'unmined' form of iron, in this case a steel indirectly produced from its ores by a secondary process). This was steel produced as a liquid in small clay crucibles and variations in the manufacturing process are known from number of medieval 'recipes' and one earlier description (see pp.56–57).

Jauhar

'A jewel', a reference to the watered pattern seen on some swords. See also *firind*.

Narmahan

'Soft' iron, one of the products of direct or bloomery iron production referred to by al-Kindi, al-Biruni and others as 'mined', i.e. produced directly from its ores.

Palawud

A variant or misspelling of *pulad* (see *fulad*).

Poulad (jauderder)

See *fulad*.

Shaburqan

'Hard iron', which is referred to by both al-Kindi and al-Biruni as a particular form of 'mined iron', which seems to be a clear reference to bloomery steel, the only type of steel directly produced from its ores. *Shaburqan* is reported to have been used in the manufacture of what must be European swords (which made extensive use of steel from about the 8th century onwards) and is defined in such a way as to differentiate it from *fulad*.

Wootz

A very high-carbon steel produced by a crucible process in which the charge consists of bloomery iron and organic materials or bloomery iron and cast iron. The term, a corruption of *ukku* (pronounced 'wukku'), a word meaning steel in Telangu-Kannada, a language of central southern India, became attached to the product in

18th century, but *wootz* was produced in southern India, Sri Lanka, and to a lesser extent in Iran, from at least the 11th century.

Zaj/zag/zagh

An acid etching solution, probably used from ancient times to bring out or make visible the watered pattern inherent in the structure of many objects, especially swords, made of wootz (q.v.). A sample zaj was analysed in 1816 by Jacquin, who found it to consist of a naturally occurring basic ferric sulphate and could have been formed by the natural or intentional weathering and oxidation of any of the many mineral deposits containing iron sulphide or pyrites.

GLOSSARY OF SECONDARY METAL-WORKING TECHNIQUES

Bluing

Turning steel a blue-black colour by heating it over a bed of charcoal and then quenching (q.v.) when the required colour has been reached. Steel can also be blued, browned, blacked or greyed by chemical processes. Bluing was widely used in India to provide contrast to the silver inlay or overlay used to decorate steel objects, but its use in Iranian steelwork remains to be researched.

Background colouration

The use of a substance, such as niello, or a colouring of the steel to set off an inlaid or chiselled inscription. For other colouration see bluing, brass, brazing, inlaying, overlaying and red foil.

Brass

An alloy of copper and zinc which, when used as a solder (see brazing), can have a decorative effect. Brass is also sometimes used as an inlay, presumably as a cheap substitute for gold.

Brazing

A method for joining separate pieces of iron and steel. Like forging, brazing is done when the metal is hot (typically at a dull red to cherry-red heat, 500–700°C), using copper or brass solder (q.v.). Brass solder melts at approximately 800–900°C. Sometimes the technique can be used for decorative effect. The use of brass solder by steel-workers reflects the way crafts interlocked in earlier times.

Burnishing

Rubbing metal with a hard, smooth tool to make its surface smooth and glossy.

Case-hardening
Hardening the surface of iron or steel by covering the metal with a mixture of salt and horn-meal, heating it till it is bright red, sprinkling on further applications of the mixture, and then quenching (q.v.) it. This produces a hard, durable surface without affecting the physical properties of the softer iron of the rest of the object. The method is particularly used in the manufacture of files.

Chasing
Decorating the surface of a steel object using an appropriate tracing or engraving tool, of harder steel than the object itself.

Chiselling
Removing background areas of a design from the surface of an object by the use of a chisel (see also relief work).

Cutting
Shaping a piece of steel by cutting, *cf.* chiselling.

Drilling
Drilling small holes into, but not through, a steel object for decorative purposes. Drilling is also the first step in the piercing process (q.v.).

Etching
A technique used either to bring out the watered pattern (q.v.) on a steel object, or instead of chiselling (q.v.) in the production of a relief (q.v.) design on the surface of the steel. Its history in Iran in the latter context is uncertain. Most etched objects appear to be 19th- or 20th-century.

Incising
Decorating the surface of an object by engraving or tracing. It is used here for large objects with crudely incised marks, where the fineness of workmanship associated with the word 'chasing' is inappropriate.

Inlaying
A decorative process in which grooves are cut into the steel and filled with gold or silver wire. The steel is first warmed, then the design is engraved into it, leaving rough edges the better to give purchase to the inlaid material. The wire is pressed into the groove and either flattened by hammering or left in relief. It might then be reheated to restore the colour, or burnished (q.v.). In spatial inlaying, the background of the

design is chiselled away and filled with gold foil, leaving the design itself black against the gold ground.

Overlaying
Another decorative technique using wire. In this case the surface of the metal to be decorated is roughened, and the pattern is engraved with a fine pointed tool. Very fine gold wire is laid along the line of the design and hammered into place with a hammer and a punch. Once this process is finished the article is then heated, polished and cleaned. The gold stands above the surface, and was described as being very durable. Modern imitations of this kind of work were done with gold leaf, and lasted less well.

Piercing
Producing an openwork design by drilling (q.v.) holes in sheet steel with a bow-drill, and then filing away the areas between the drill holes. The rough edges left by the initial filing have then to be smoothed off, though often this is done only on the front of the object to save time and effort. In such cases the remains of the small circular holes made by the bow-drill bit are usually visible.

Punching
A method of surface decoration done using steel punches with differently shaped ends, depending on the effect desired.

Red foil
A material used as a background to pierced designs by inserting it between the pierced sheet and its steel backing sheet. Its composition is unknown. It is found in only a small number of objects in the Tanavoli collection but seems to have been popular in India. The technique may have spread eastwards from Europe – where cut-out designs in precious metal were sometimes superimposed on red velvet – perhaps via Turkey.

Relief work
An effect achieved where the background for a design is chiselled away, leaving the design itself in relief. Inlaying (q.v.) may also produce a relief design.

Rivets
Short metal pins, sometimes of brass, used to join different pieces of steel in a composite object. Rivets are also normally used to fix a piece of pierced steelwork onto a background sheet.

Solder

Usually refers to soft solder, typically a lead-tin alloy, used to join non-ferrous metals at low temperatures, approximately 150–250°C. A variety of hard, mainly 'silver' solders contain varying proportions of silver, copper, zinc and tin (not all have silver) and most have melting points approximately in the range 700–800°C.

Tinning

Plating or coating steel with tin, to avoid rusting. The technique is the same as for tinning copper: a mixture of pure tin and sal-ammoniac is applied to the object with an extremely hot pad; the vapourizing sal-ammoniac produces a metallically clean surface; and by continuous rubbing with the pad the craftsman distributes the molten tin evenly over the surface.

Turning

Shaping a material on a lathe. There is no documentary evidence for steel being turned, but one or two of the cylindrical shafts or handles on Tanavoli pieces are so finely cut that some sort of turning technique seems likely.

Watering

Patterns visible on the surface of a steel object, comparable to the ripples or shimmering on the surface of otherwise still water. It occurs in crucible steels (q.v.) with a slightly uneven, inhomogeneous layered structure.

GLOSSARY OF TERMS FOR ARMS AND ARMOUR

Aventail Pendant mail defence attached to a helmet

Barding Armour or ornamental covering for a horse

Brigandine Body defence in the form of a coat of silk or velvet reinforced with canvas and lined with metal plates

Camail Mail attached to the helmet protecting the neck and shoulders

Chamfron Armour for a horse's head

Char-aineh Iranian cuirass of four plates buckled round the wearer's body over a mail shirt

Corselet Body armour

Crinet Part of the barding of a horse covering the ridge of its neck and its mane

Cuirass Body armour

Greave Armour for the leg below the knee

Housing Another word for barding (q.v.)

Lamellar armour Armour constructed of small rectangular metal plates, laced together both horizontally and vertically

Laminated armour Armour built up of horizontal metal strips (*cf* splint armour)

Mail Armour constructed of interlocking metal rings

Nasal Strip of armour for the nose, attached to the helmet

Poitrel Chest armour for a horse

Scale armour Armour constructed of small metal scales laced to a backing material and horizontally to one another

Spangenhelm German term for a conical helmet built up of segments of metal

Splint armour Armour built up of vertical metal strips (*cf.* laminated armour)

Targe/target Buckler, small shield

Trapper Another word for barding (q.v.)

Vambrace Plate armour for the arm

Zertsala Russian equivalent of the Iranian *char-aineh*

Concordances

CONCORDANCE BY CATALOGUE NUMBER

A.1	16	A.29	179	B.7	298
A.2	17	A.30	218	B.8	314
A.3	15	A.31	222	B.9	315
A.4	14	A.32	371	B.10	380
A.5	155	A.33	25	B.11	312
A.6	224	A.34	204	B.12	348
A.7	83	A.35	168	B.13	353
A.8	144	A.36	166	B.14	354
A.9	145	A.37	404	B.15	355
A.10	345	A.38	356	B.16	279
A.11	146	A.39	341	B.17	379
A.12	196	A.40	342	B.18	95
A.13	529	A.41	20	B.19	96
A.14	346	A.42	18	B.20	280
A.15	528	A.43	62	B.21	135
A.16	395	A.44	19	B.22	505
A.17	13	A.45	503	B.23	101
A.18	383	A.46	500	B.24	102
A.19	216	A.47	501	B.25	374
A.20	217	A.48	502	B.26	397
A.21	282	A.49	164	C.1	12
A.22	281	A.50	165	C.2	11
A.23	219	B.1	162	C.3	9
A.24	51	B.2	313	C.4	10
A.25	223	B.3	525	C.5	5
A.26	220	B.4	163	C.6	3
A.27	221	B.5	159	C.7	1
A.28	428	B.6	311	C.8	4

C.9	2	J.2	270	K.18	246
C.10	328	J.3	43	K.19	248
C.11	160	J.4	273	K.20	317
C.12	6	J.5	278	K.21	247
C.13	7	J.6	275	K.22	182
D.1	526	J.7	71	K.23	181
D.2	21	J.8	276	K.24	364
E.1	58	J.9	70	K.25	365
E.2	59	J.10	68	K.26	236
E.3	65	J.11	67	K.27	237
E.4	60	J.12	66	K.28	340
E.5	61	J.13	274	L.1	24
E.6	148	J.14	69	L.2	26
E.7	57	J.15	277	L.3	27
E.8	332	J.16	271	L.4	385
F.1	174	J.17	506	L.5	195
F.2	23	J.18	272	L.6	357
F.3	22	J.19	296	L.7	211
F.4	152	J.20	257	L.8	194
F.5	56	J.21	255	L.9	384
G.1	301	J.22	142	L.10	368
G.2	180	J.23	143	L.11	530
G.3	316	K.1	239	L.12	364
G.4	189	K.2	429	L.13	360
G.5	420	K.3	238	L.14	361
G.6	158	K.4	378	L.15	362
G.7	306	K.5	249	L.16	426
G.8	310	K.6	376	L.17	513
G.9	307	K.7	251	L.18	184
G.10	136	K.8	377	L.19	424
G.11	4	K.9	389	L.20	199
G.12	82	K.10	375	L.21	423
G.13	529	K.11	390	L.22	347
H.1	44	K.12	193	L.23	231
H.2	344	K.13	250	L.24	30
I.1	303	K.14	242	L.25	304
I.2	302	K.15	244	L.26	171
I.3	225	K.16	183	L.27	187
J.1	40	K.17	245	L.28	266

L.29	265	M.12	34	N.38	109
L.30	405	M.13	35	O.1	54
L.31	267	N.1	531	O.2	172
L.32	333	N.2	202	O.3	173
L.33	512	N.3	124	O.4	178
L.34	409	N.4	321	O.5	55
L.35	406	N.5	322	O.6	226
L.36	63	N.6	123	O.7	41
L.37	64	N.7	118	O.8	50
L.38	33	N.8	119	O.9	91
L.39	507	N.9	120	O.10	84
L.40	416	N.10	121	O.11	87
L.41	207	N.11	318	O.12	89
L.42	253	N.12	132	O.13	93
L.43	45	N.13	100	O.14	86
L.44	46	N.14	133	O.15	88
L.45	209	N.15	131	O.16	92
L.46	290	N.16	129	O.17	268
L.47	208	N.17	288	O.18	32
L.48	210	N.18	192	O.19	261
L.49	504	N.19	117	O.20	200
L.50	94	N.20	293	O.21	201
L.51	359	N.21	122	O.22	510
L.52	206	N.22	116	O.23	511
L.53	28	N.23	291	P.1	349
L.54	29	N.24	107	P.2	73
L.55	358	N.25	324	P.3	74
L.56	233	N.26	104	P.4	75
M.1	185	N.27	285	P.5	527
M.2	325	N.28	98	P.6	425
M.3	299	N.29	292	P.7	76
M.4	329	N.30	320	P.8	78
M.5	335	N.31	286	P.9	197
M.6	411	N.32	134	P.10	77
M.7	399	N.33	112	P.11	72
M.8	415	N.34	115	P.12	79
M.9	327	N.35	111	P.13	343
M.10	326	N.36	108	P.14	188
M.11	241	N.37	110	P.15	198

P.16	177	P.29	227	Q.11	382
P.17	176	P.30	235	Q.12	48
P.18	401	P.31	392	Q.13	49
P.19	427	Q.1	386	Q.14	240
P.20	170	Q.2	387	Q.15	149
P.21	423	Q.3	388	Q.16	150
P.22	37	Q.4	269	Q.17	31
P.23	36	Q.5	407	R.1	518
P.24	38	Q.6	414	R.2	519
P.25	39	Q.7	256	R.3	517
P.26	421	Q.8	367	R.4	515
P.27	422	Q.9	398	R.5	516
P.28	234	Q.10	381		

CONCORDANCE BY TANAVOLI COLLECTION NUMBER

1	C.7	23	F.2	46	L.44
2	C.9	24	L.1	48	Q.12
3	C.6	25	A.33	49	Q.13
4	C.8	26	L.2	50	O.8
4	G.11	27	L.3	51	A.24
5	C.5	28	L.53	54	O.1
6	C.12	29	L.54	55	O.5
7	C.13	30	L.24	56	F.5
9	C.3	31	Q.17	57	E.7
10	C.4	32	O.18	58	E.1
11	C.2	33	L.38	59	E.2
12	C.1	34	M.12	60	E.4
13	A.17	35	M.13	61	E.5
14	A.4	36	P.23	62	A.43
15	A.3	37	P.22	63	L.36
16	A.1	38	P.24	64	L.37
17	A.2	39	P.25	65	E.3
18	A.42	40	J.1	66	J.12
19	A.44	41	O.7	67	J.11
20	A.41	43	J.3	68	J.10
21	D.2	44	H.1	69	J.14
22	F.3	45	L.43	70	J.9

CONCORDANCES

71	J.7	121	N.10	180	G.2
72	P.11	122	N.21	181	K.23
73	P.2	123	N.6	182	K.22
74	P.3	124	N.3	183	K.16
75	P.4	129	N.16	184	L.18
76	P.7	131	N.15	185	M.1
77	P.10	132	N.12	187	L.27
78	P.8	133	N.14	188	P.14
79	P.12	134	N.32	189	G.4
82	G.12	135	B.21	192	N.18
83	A.7	136	G.10	193	K.12
84	O.10	142	J.22	194	L.8
86	O.14	143	J.23	195	L.5
87	O.11	144	A.8	196	A.12
88	O.15	145	A.9	197	P.9
89	O.12	146	A.11	198	P.15
91	O.9	148	E.6	199	L.20
92	O.16	149	Q.15	200	O.20
93	O.13	150	Q.16	201	O.21
94	L.50	152	F.4	202	N.2
95	B.18	155	A.5	204	A.34
96	B.19	158	G.6	206	L.52
98	N.28	159	B.5	207	L.41
100	N.13	160	C.11	208	L.47
101	B.23	162	B.1	209	L.45
102	B.24	163	B.4	210	L.48
104	N.26	164	A.49	211	L.7
107	N.24	165	A.50	216	A.19
108	N.36	166	A.36	217	A.20
109	N.38	168	A.35	218	A.30
110	N.37	170	P.20	219	A.23
111	N.35	171	L.26	220	A.26
112	N.33	172	O.2	221	A.27
115	N.34	173	O.3	222	A.31
116	N.22	174	F.1	223	A.25
117	N.19	176	P.17	224	A.6
118	N.7	177	P.16	225	I.3
119	N.8	178	O.4	226	O.6
120	N.9	179	A.29	227	P.29

231	L.23	280	B.20	335	M.5
233	L.56	281	A.22	340	K.28
234	P.28	282	A.21	341	A.39
235	P.30	285	N.27	342	A.40
236	K.26	286	N.31	343	P.13
237	K.27	288	N.17	344	H.2
238	K.3	290	L.46	345	A.10
239	K.1	291	N.23	346	A.14
240	Q.14	292	N.29	347	L.22
241	M.11	293	N.20	348	B.12
242	K.14	296	J.19	349	P.1
244	K.15	298	B.7	353	B.13
245	K.17	299	M.3	354	B.14
246	K.18	301	G.1	355	B.15
247	K.21	302	I.2	356	A.38
248	K.19	303	I.1	357	L.6
249	K.5	304	L.25	358	L.55
250	K.13	306	G.7	359	L.51
251	K.7	307	G.9	360	L.13
253	L.42	310	G.8	361	L.14
255	J.21	311	B.6	362	L.15
256	Q.7	312	B.11	364	K.24
257	J.20	313	B.2	364	L.12
261	O.19	314	B.8	365	K.25
265	L.29	315	B.9	367	Q.8
266	L.28	316	G.3	368	L.10
267	L.31	317	K.20	371	A.32
268	O.17	318	N.11	374	B.25
269	Q.4	320	N.30	375	K.10
270	J.2	321	N.4	376	K.6
271	J.16	322	N.5	377	K.8
272	J.18	324	N.25	378	K.4
273	J.4	325	M.2	379	B.17
274	J.13	326	M.10	380	B.10
275	J.6	327	M.9	381	Q.10
276	J.8	328	C.10	382	Q.11
277	J.15	329	M.4	383	A.18
278	J.5	332	E.8	384	L.9
279	B.16	333	L.32	385	L.4

386	Q.1	416	L.40	507	L.39
387	Q.2	420	G.5	510	O.22
388	Q.3	421	P.26	511	O.23
389	K.9	422	P.27	512	L.33
390	K.11	423	L.21	513	L.17
392	P.31	423	P.21	515	R.4
395	A.16	424	L.19	516	R.5
397	B.26	425	P.6	517	R.3
398	Q.9	426	L.16	518	R.1
399	M.7	427	P.19	519	R.2
401	P.18	428	A.28	525	B.3
404	A.37	429	K.2	526	D.1
405	L.30	500	A.46	527	P.5
406	L.35	501	A.47	528	A.15
407	Q.5	502	A.48	529	A.13
409	L.34	503	A.45	529	G.13
411	M.6	504	L.49	530	L.11
414	Q.6	505	B.22	531	N.1
415	M.8	506	J.17		

Bibliography

PRIMARY ARABIC, PERSIAN AND TURKISH SOURCES

Abd al-Karim (1797)	'Abd al-Karim, *Voyage de l'Inde à la Mekke par A'bdoûl-Kérym*, trans. L. Langlès (Paris 1797)
Abu'l-Fazl (1894)	Abu'l-Fazl, *The Ain i Akbari by Abul Fazl-i-Allami*, trans. by H.S. Jarrett, 3 vols (Calcutta 1894)
al-Biruni (1936)	Muhammad ibn Ahmad al-Biruni, *Kitab al-jamahir fi ma'rifat al-jawahir*, ed. F. Krenkow, (Hyderabad 1936); trans. H.M. Said, *Al-Beruni's Book on Mineralogy. The Book Most Comprehensive In Knowledge On Precious Stones* (Islamabad 1410/1989)
al-Dimashqi (1866)	Muhammad ibn Abi Talib al-Dimashqi, *Nukhbat al-dahr fi 'aja'ib al-barr wa'l-bahr*, ed. M.A.F. Mehren (St Petersburg 1866)
Eskandar Beg Monshi (1978)	Eskandar Beg Monshi, *History of Shah 'Abbas the Great*, trans. R.M. Savory, 3 vols (Boulder, CO, 1978)
Fakhr-i Mudabbir (1346/1967)	Fakhr-i Mudabbir, *Adab al-harb wa'l-shaja'a*, ed. A.S. Khvansari (Tehran 1346/1967)
Hafiz-i Abru (1936)	Hafiz-i Abru, *Chronique des Rois Mongols en Iran*, ed. and trans. K. Bayani (Paris 1936)
al-Hamdani (1968)	al-Hasan ibn Ahmad al-Hamdani, *Kitab al-jawharatain al-'atiqatain*, ed. and trans. C. Toll (Uppsala 1968)
Hudud al-'alam (1937)	*Hudud al-'alam*, text ed. M. Sutuda (Tehran 1962), trans. and commentary V. Minorsky (London 1937)
Ibn al-Balkhi (1962)	Ibn al-Balkhi, *Fars nama*, ed. G. Le Strange and R.A. Nicholson (Cambridge 1962), trans. G. Le Strange, 'Description of the province of Fars', *Journal of the Royal Asiatic Society* (1912) pp.1–30, 311–339, 865–89
Ibn Battuta (1958–71)	Muhammad ibn 'Abdallah Ibn Battuta, *The Travels of Ibn Battuta*, translated by H.A.R. Gibb, 4 vols (Cambridge 1958–71)
Ibn al-Faqih (1885)	Ahmad ibn Muhammad Ibn al-Faqih, *Kitab al-buldan*, ed. M.J. de Goeje, *Bibliotheca Geographorum Arabicorum* vol.5 (Leiden 1885)
Ibn Hawqal (1938–39)	Abu'l-Qasim Ibn Hawqal, *Kitab surat al-'ard*, ed. J.H. Kramers (Leiden 1938–39), trans. J.H. Kramers and G. Wiet, *Configuration de la terre* 2 vols (Beirut and Paris 1964)
al-Jahiz (1932)	'Amr ibn Badr al-Jahiz, *Kitab al-tabassur bi'l-tijara*, ed. H.H. 'Abd al-Wahab, *La Revue de l'Académie arabe*, 12 (1932) pp.321–51
Jabbir ibn Hayyan (1686)	Jabir ibn Hayyan, *The Works of Geber*, trans. R. Russell (London 1686)
al-Jahiz (1366/1947)	Abu 'Uthman 'Umar al-Jahiz, *al-Bayan wa'l-tabyin*, ed. H. al-Sundubi,

	3 vols (Cairo 1366/1947)
al-Juzjani (1864)	al-Juzjani, *Tabaqat-e Naseri*, ed. Lees (Calcutta 1864)
Kashani (1345/1966)	Abu'l-Qasim 'Abd Allah Kashani, *'Arayis al-jawahir wa nafayis al-ajayib*, (Tehran 1345/1966)
al-Kindi (1952)	Ya'qub ibn Ishaq al-Kindi, *al-Suyuf wa ajnasuha*, ed. A.R. Zaki, *Bulletin of the Faculty of Letters, Fouad I University*, 14 part 2 (1952) pp.1–36
al-Mas'udi (1861–77) and (1962–71)	'Ali ibn Husain al-Mas'udi, *Kitab muruj al-dhahab wa ma'adin al-jawhar*, text and transl., C. Barbier de Meynard and Pavet de Courteille, 9 vols (Paris 1861–77), revised trans. C. Pellat, 3 vols (Paris 1962–71)
Mirza Husain Khan (1342)	Mirza Husain Khan, *Jughrafiya-yi Isfahan*, ed. M. Setudeh (Tehran 1342)
al-Muqaddasi (1877)	Muhammad ibn Ahmad al-Muqaddasi, *Ahsan al-taqasim bi ma'rifat al-aqalim* ed. M.J. de Goeje, *Bibliotheca Geographorum Arabicorum*, vol.3 (Leiden 1877)
al-Narshakhi (1892)	Muhammad ibn Ja'far al-Narshakhi, *Tarikh-i Bukhara*, ed. C. Schefer (Paris 1892), trans. R.N. Frye (Cambridge, MA, 1954)
Nasrabadi (1317)	Mirza Muhammad Tahir Nasrabadi, *Tadhkira-yi Nasrabadi*, ed. Wahid Dastgirdi (Tehran 1317)
Pliny (1952)	Pliny [the Elder], *Natural History*, trans. H. Rackham (1952)
Pseudo-Aristotle (1912)	Pseudo-Aristotle, *Kitab al-ahjar*, ed. J. Ruska, *Das Steinbuch des Aristoteles* (Heidelberg 1912)
Qalqashandi (1331/1913)	Qalqashandi, *Kitab subh al-a'sha*, vol.2 (Cairo 1331/1913)
al-Qazvini (1848)	Zakariyya al-Qazvini, *Athar al-bilad*, ed. F. Wüstenfeld, 2 vols (Göttingen 1848)
Qumi (1984)	Shaikh Abbas Qumi, *Mafatih al-jinan*, with translations by E. Qumshe-i (London 1984)
Sa'di (1371)	Sa'di, *Gulistan* (*Kulliyyaat-i Sa'di*), ed. M.'A. Foroughi (Tehran 1371)
al-Tha'alibi (1968)	Abu Mansur al-Tha'alibi, *Kitab lata'if al-ma'arif*, ed. P. de Jong (Leiden 1867), trans. by C.E. Bosworth, *The Book of Curious and Entertaining Information. The Lata'if al-ma'arif of Tha'alibi* (Edinburgh 1968)
Tiflisi (1337/1957)	Habish ibn Ibrahim ibn Muhammad Tiflisi, *Bayan al-sana'at*, ed. Iraj Afshar, *Farhang-e Iran-e Zamin*, vol.5 (Tehran 1337/1957)
Tusi (1348/1969)	Nasir al-din Tusi, *Tansukh namayi ilkhani* (Tehran 1348/1969)
Yaqut (1861) and (1866–73)	Yaqut, *Mu'jam al-buldan*, ed. F. Wüstenfeld, 6 vols (Leipzig 1866–73), trans. M. Barbier de Meynard, *Dictionnaire de la Perse* (Paris 1861)
Yazdi (1723)	Sharaf al-Din 'Ali Yazdi, *Zafar-nama*, trans. J. Darby, *The History of Timur-Bec* 2 vols (London 1723)

EUROPEAN AND SECONDARY SOURCES

Abbott (1847)	J. Abbott, 'Process of Working the Damascus Blade of Goojrat', *Journal of the Asiatic Soiety of Bengal*, vol.16, 1 (May 1847) pp.417–23
Abdullayev, Fakhretdinova and Khakimov (1986)	A. Abdullayev, D. Fakhretdinova, A. Khakimov, *Pesn' v metalle* (*Song in metal*) (Tashkent 1986)
Ådahl (1981)	K. Ådahl, *A Khamsa of Nizami of 1439* (Uppsala 1981)
Adamova (1996)	A.T. Adamova, *Persian Painting and Drawing of the 15th–19th centuries from the*

BIBLIOGRAPHY

	Hermitage Museum (St Petersburg 1996)
Akimushkin (1994)	O.F. Akimushkin, *Murakka di San Pietroburgo* (Milan 1994)
Albuquerque (1875–84)	A. Albuquerque, *The Commentaries of the Great Afonso Dalboquerque, Second Viceroy of India. Translated from the Portuguese Edition of 1774 with Notes and an Introduction by Walter De Gray Birch*, 4 vols (London 1875–84)
Al-e-Dawud (1992)	'A. Al-e-Dawud, 'Coffee', *Encyclopaedia Iranica* vol.5 (1992) pp.893–96
A'lam (1990)	H. A'lam, 'Baz', *Encyclopaedia Iranica* vol.4 (1990) pp.17–20
Alexander (1983)	D.G. Alexander, 'Two Aspects of Islamic Arms and Armor', *Metropolitan Museum Journal*, vol.18 (1983) pp.97–109
Alexander (1992)	D.G. Alexander, *The Arts of War*, The Nasser D. Khalili Collection of Islamic Art, vol.21 (London 1992)
Alexander (1996)	D.G. Alexander (ed.) *Furusiyya*, 2 vols (Riyadh 1996)
Alexander (1984)	J. Alexander, 'The Swords of Damascus', *Waffen- und Kostumkunde. Zeitschrift der Gesellschaft für historische Waffen- und Kostumkunde*, Heft 2 (1984) pp.131–38
Alexander (1827)	J.E. Alexander, *Travels from India to England; comprehending a visit to the Burman Empire ... in the years 1825–26* (London 1827)
Alfieri *et al.* (1974)	B.M. Alfieri, L. Lanciotti, G. Mantici, A. Tamburello, M. Tosi, *Armi e armature asiatiche* (Milan 1974)
d'Allemagne (1911)	H.-R. d'Allemagne, *Du Khorassan au Pays des Backhtiaris*, 4 vols (Paris 1911)
Allan (1971)	J.W. Allan, *Medieval Middle Eastern Pottery*, Ashmolean Museum (Oxford 1971)
Allan (1979)	J.W. Allan, *Persian Metal Technology 700–1300 AD* (Oxford 1979)
Allan (1982)	J.W. Allan, *Nishapur. Metalwork of the Early Islamic Period*, Metropolitan Museum of Art (New York 1982)
Allan (1982a)	J.W. Allan, *Islamic Metalwork. The Nuhad Es-Said Collection* (London 1982)
Allan (1982b)	J.W. Allan, 'Haji 'Abbas', *Encyclopedia Iranica*, vol.1 fasc.1 (1982) pp.76–77
Allan (1991)	J.W. Allan, *Islamic Ceramics*, Ashmolean Museum (Oxford 1991)
Allan (1991a)	J.W. Allan, 'Metalwork of the Turcoman dynasties of Eastern Anatolia and Iran', *Iran*, vol.29 (1991) pp.153–59
Allan (1994)	J.W. Allan, 'Hajji 'Abbas', *Iran*, vol.32 (1994) pp.145–47
Allan (1994a)	J.W. Allan, 'On the trail of Haji 'Abbas', *The Ashmolean* no.26 (Summer 1994) pp.10–11
Allan (1995)	J.W. Allan, 'Silver-faced doors of Safavid Iran', *Iran*, vol.33 (1995) pp.123–37
Allan (1996)	J.W. Allan, 'Muhammad ibn al-Zain: Craftsman in Cups, Thrones and Window Grilles?', *Levant*, vol.28 (1996) pp.199–208
Allan (forthcoming)	J.W. Allan, 'Oljaitu's Oranges: the grilles of the Mausoleum of Sultan Oljaitu at Sultaniyya', in ed. R. Hillenbrand, *Proceedings of the Symposium on the Art of the Mongols held in Edinburgh July 1995* (forthcoming)
Allen (1980)	M. Allen, *Falconry in Arabia* (London 1980)
Allgrove McDowell (1989)	J. Allgrove McDowell, 'Textiles', in Ferrier (1989) pp.157–70
Anatolian Civilisations 1983	*The Anatolian Civilisations*, Topkapi Palace Museum, 3 vols (Istanbul 1983)
Anderson (1961)	J.K. Anderson, *Ancient Greek horsemanship* (Berkeley/Los Angeles, CA, 1961)

Andrews (1981)	P.A. Andrews, 'The Turco-Mongol context of some objects shown in the Istanbul Album pictures', *Islamic Art* vol.1 (1981) pp.110–20
Anoçoff (1841)	Anoçoff, 'Mémoire sur l'acier damassé', *Annuaire du Journal des Mines de Russie* (1841) pp.192–286
Anon (1910–1911)	Anon., 'Mirror: Medieval and Modern; Manufacture', *Encyclopaedia Britannica*, 11th edition (1910–1911) vol.18, pp.576–77
Anon (n.d.)	Anon., *Rahnama-yi muza-yi astan-i quds-i rizavi* (Mashhad n.d.)
Islamic Period Art (1996)	*An Anthology from the Islamic Period Art*, Iranian National Museum (Tehran 1996)
Arasteh (1961)	R. Arasteh, 'The character, organization and social role of the *Lutis (Javan-Mardan)* in the traditional Iranian society of the 19th century', *Journal of the Social and Economic History of the Orient*, vol.4 (1961) pp.47–52
Arberry et al. (1959–62)	A.J. Arberry et al., *The Chester Beatty Library. A Catalogue of the Persian Manuscripts and Miniatures*, 3 vols (Dublin 1959–62)
Ardalan and Inanlu (1988)	S.A. Ardalan and D. Inanlu, *A Glimpse at The Central Museum of Astan Quds Razavi* (Mashhad 1988)
Arnold (1877)	A. Arnold, *Through Persia by caravan*, 2 vols (London 1877)
Arnold (1928)	T.W. Arnold, *Painting in Islam* (Oxford 1928)
Art from the World of Islam (1987)	*Art from the World of Islam 8th–18th century*, *Louisiana Revy*, vol.27 no.3 (Copenhagen, March 1987)
Arte islamico (1994)	*Arte islamico del Museo Metropolitano de Arte de Nueva York*, Colegio de San Ildefonso, septiembre de 1994 – enero de 1995 (Mexico City 1994)
Arts of Islam (1976)	*The Arts of Islam*, Arts Council (London 1976)
Askeri Müz (1993)	*Askeri Müze / Military Museum* (Istanbul 1993)
Atasoy (1970)	N. Atasoy, 'Four Istanbul Albums and some Fragments from Fourteenth-Century Shah-Namehs', *Ars Orientalis*, vol.8 (1970) pp.19–48
Atıl (1973)	E. Atıl, *Ceramics from the World of Islam* (Washington, DC, 1973)
Atıl (1978)	E. Atıl, *The Brush of the Masters: Drawings from Iran and India* (Washington, DC, 1978)
Atıl (1981)	E. Atıl, *Renaissance of Islam. Art of the Mamluks*, Smithsonian Institution (Washington, DC, 1981)
Atıl (1990)	E. Atıl (ed.), *Islamic Art and Patronage. Treasures from Kuwait* (New York 1990)
Atıl, Chase and Jett (1985)	E. Atıl, W.T. Chase and P. Jett, *Islamic Metalwork in the Freer Gallery of Art*, (Washington, DC, 1985)
Augustin (1997)	B. Augustin, 'Sawavidische Metallarbeiten', in ed. H. Spielmann and J. Drees, *Gottorf im Glanz des Barock* vol.1, *Kunst und Kultur am Schleswigen Hoff 1544–1713*, Schleswig-Holsteinisches Landesmuseum (Schleswig 1997) pp.122–30
Awad (1980)	H.A. Awad, 'The surgical heritage of early Islamic Egypt', *Islamic Archaeological Studies* vol.2 (1980) pp.1–21
Babelon and Blanchet (1895)	E. Babelon and J.-A. Blanchet, *Catalogue des bronzes antiques de la Bibliothèque Nationale* (Paris 1895)
Bahrami (1949)	M. Bahrami, *Iranian Art. Treasures from the Imperial collections and museums of Iran* (New York 1949)
Bahrami (1952)	M. Bahrami, 'A gold medal in the Freer Gallery of Art', in G.C. Miles (ed.),

Archaeologica Orientalia in memoriam Ernst Herzfeld (New York 1952) pp.5–20

Baker (1997)	P.L. Baker, 'Wrestling at the Victoria and Albert Museum', *Iran* 35 (1997) pp.73–78
Baldwin-Brown (1915)	G. Baldwin-Brown, *The Arts in Early England. Vol.III: Saxon Art and Industry in the Pagan Period* (London 1915)
Balsiger and Kläy (1992)	R.N. Balsiger and E.J. Kläy, *Bei Schah, Emir und Khan* (Schaffhausen 1992)
Barker (1816) and (1818)	J. Barker, 'Method of Renewing the *Giohare* of Flowery Grain of Persian Swords Commonly Called Damascus Blades', *Fundgraben des Orients*, vol.5 (1816) pp.40–43; reprinted under the name S. Barker in the *Annual Register* (1818), pp.599–602
Barrett (1949)	D. Barrett, *Islamic Metalwork in the British Museum*, British Museum (London 1949)
Bassett (1887)	J. Bassett, *Persia, the land of the Imams* (London 1887)
Bates (1984)	M. Bates, 'Islamic and South Asian [accessions], *Annual Report of the American Numismatic Society* (New York 1984) pp.17–20
Baur and Rostovtzeff (1931–36)	P.V.C. Baur and M.I. Rostovtzeff (ed.), *The excavations at Dura-Europos* (New Haven 1931–36)
Bauer (1979)	W.P. Bauer, 'A scientific examination of the applied decoration on two Indian swords', in ed. R. Elgood, *Islamic Arms and Armour* (London 1979) pp.1–4
Beazeley (1903)	C.R. Beazeley (ed.), *The texts and versions of John de Plano Carpini and Wm. de Rubruquis* (London 1903)
Belenitski and D'yakonov (1953)	A.M. Belenitski and M.M. D'yakonov, *Trudi Tadzhikskoy Arkheologicheskoy Ekspeditsii*, vol.2, *Materiali'i issledovaniya po arkheologii SSSR* no.37 (Moscow/Leningrad 1953)
Belenitski and Piotrovski (1959)	A.M. Belenitski and B.B. Piotrovski, *Skul'ptura i Zhivopis drevnego Pyandzhikenta* (Moscow 1959)
Belaiew (1918)	N. Belaiew, 'Damascene Steel', *Journal of the Iron and Steel Institute*, vol.97 (1918), pp.417–39
Bell (1788)	Bell, *Travels from St Petersburgh in Russia to various parts of Asia* 2 vols (Edinburgh 1788)
Benjamin (1887)	S.G.W. Benjamin, *Persia and the Persians* (London 1887)
Bennion (1979)	E. Bennion, *Antique medical instruments* (London 1979)
Bennion (1986)	E. Bennion, *Antique dental instruments* (London 1986)
Beny and Nasr (1975)	R. Beny and S.H. Nasr, *Persia: Bridge of Turquoise* (London 1975)
Bernard (1964)	P. Bernard, 'Une pièce d'armure perse sur un moment lycien', *Syria* vol.41 (1964) pp.195–212
Berthelot (1888)	M. Berthelot, *Collection des Anciens Alchimistes Grecs*, 3 vols (Paris 1888)
Binnning (1857)	R.B.M. Binning, *A journal of two years' travel in Persia, Ceylon etc.*, 2 vols (London 1857)
Binyon, Wilkinson and Gray (1933)	L. Binyon, J.V.S. Wilkinson and B. Gray, *Persian Miniature Painting* (London 1933)
Bivar (1955)	A.D.H. Bivar, 'The stirrup and its origins', *Oriental Art*, N.S., vol.1, no.2 (Summer 1955) pp.61–65
Bivar (1972)	A.D.H. Bivar, 'Cavalry equipment and tactics on the Euphrates frontier',

	Dumbarton Oaks Papers, vol.26 (1972) pp.273–91
Blair (1984)	S.S. Blair, 'Ilkhanid Architecture and Society: an Analysis of the Endowment Deed of the Rab'-i Rashidi', *Iran* vol.22 (1984) pp.67–90
Blair (1986)	S.S. Blair, 'The Mongol Capital of Sultaniyya, "the Imperial"', *Iran* vol.24 (1986) pp.139–52
Blair (1992)	S.S. Blair, *The Monumental Inscriptions from Early Islamic Iran and Transoxiana*, Supplement to Muqarnas vol.5 (Leiden 1992)
Blair (1995)	S.S. Blair, *A Compendium of Chronicles. The Jami' al-Tawarikh of Rashid al-Din*, Nasser D. Khalili Collection of Islamic Art, vol.27, London, 1995.
Blair and Bloom (1991)	S.S. Blair and J.M. Bloom, *Images of Paradise in Islamic Art*, exhibition catalogue, Hood Museum of Art (Hanover, NH, 1991)
Bodenheimer and Rothenberg (1996)	J. Bodenheimer and B. Rothenberg, 'High-Tech in Talmudic Times' in *Jerusalem College Times* (September 1996) pp.10–11
Bodur (1987)	F. Bodur, *Turk maden sanati. The art of Turkish metalworking* (Istanbul 1987)
Bosch (1952)	G.K. Bosch, *Islamic Bookbindings: twelfth to seventeenth centuries*, D.Phil thesis, University of Chicago (1952)
Bosch, Carswell and Petherbridge (1981)	G.K. Bosch, J. Carswell and G. Petherbridge, *Islamic Bindings and Bookmaking* (Chicago, IL, 1981)
Bosworth (1963)	C.E. Bosworth, *The Ghaznavids* (Edinburgh 1963)
Bosworth (1993)	E. Bosworth, 'misaha', *Encyclopaedia of Islam* new edition, vol.7 (1993) pp.137–38
Brandenburg (1982)	D. Brandenburg, *Islamic Miniature Painting in Medical Manuscripts* (Basle 1982)
Bronson (1986)	B. Bronson, 'The making and selling of wootz, a crucible steel of India', *Archeomaterials* vol.1 no.1 (Fall 1986), pp.13–51
Brooks (1937)	J.E. Brooks, *Tobacco. Its History Illustrated by The Books, Manuscripts and Engravings in the Library of George Arents, Jr.*, 4 vols (New York 1937)
le Brun (1718)	C. le Brun, *Voyages de Corneille le Brun par les Muscovis, en Perse, et aux Indes Orientales*, 2 vols (Amsterdam 1718)
Brydges (1834)	Sir H.J. Brydges, *An Account of the Transactions of His Majesty's Mission to the Court of Persia in the Years 1807–11* (London 1834)
Buchanan (1807)	F. Buchanan, *A Journey from Madras through the Countries of Mysore, Canara and Malabar*, 3 vols (London 1807)
Bumiller (1993)	M. Bumiller, *Typologie Früislamischer Bronzen. Flügelschalen und Flakons. Bumilller-Collection* (Panicale/München 1993)
Burnes (1835)	A. Burnes, *Travels into Bokhara*, 3 vols (London 1835)
Burton (1852)	R.F. Burton, *Falconry in the Valley of the Indus* (London 1852)
Busse (1972)	H. Busse, *The history of Persia under Qajar rule* (New York/London 1972)
CVB (1820)	'CVB', 'Method of Making Steel in Mysore', *Asiatic Journal*, vol.9 (1820) pp.441–42
Cacciandra and Cesati (1996)	V. Cacciandra and A. Cesati, *Fire Steels* (Turin 1996)
Cahen (1947–48)	C. Cahen, 'Un traité d'armurie composeé pour Saladin', *Bulletin d'Études Orientales*, 12 (1947–48) pp.103–163
Caldwell (1967)	J.R. Caldwell, (ed.) *Investigations at Tal-i-Iblis* (Springfield, IL, 1967)

Calmeyer and Peck (1990)	P. Calmeyer and E.H. Peck, 'Belts', *Encyclopaedia Iranica*, vol.4 (1990) pp.130–36
Canby (1992–92)	S. Canby, 'Portraits from Persia & Mughal India in the British Museum', *Eastern Art Report*, vol.3 no.6 (1991–92) pp.20–23
Canby (1993)	S. Canby, 'Depictions of Buddha Sakyamuni in the *Jami' al-Tavarikh* and the *Majma' al-Tavarikh*', *Muqarnas* 10 (1993), pp.304–305 and fig.5
de Plano Carpini (1903)	J.de Plano Carpini, *The texts and Versions of John de Plano Carpini and William de Rubruquis*, ed. C.R.Beazley (London 1903)
Casson (1989)	L. Casson, *The Periplus Erithraei* (Princeton 1989)
Chakrabati (1992)	D.K. Chakrabati, *The Early Use of Iron in India* (Delhi and Oxford 1992)
Chamerlat (1987)	C.A. de Chamerlat, *Falconry and art* (London 1987)
Chardin (1735)	Sir John Chardin, *Voyages ... en Perse, et autres lieux d'Orient*, 4 vols (Amsterdam 1735)
Chardin (1811)	J. Chardin, *Voyages du Chevalier Chardin en Perse*, ed. L. Langlès, 10 vols (Paris 1811)
Chardin (1988)	J. Chardin, *Travels in Persia 1673–1677* (New York 1988)
Chijs (1887–1931)	Chijs, J.A.V. (ed.), *Dagh-Register gehouden int Casteel Batavia vant passerende daer ter plaetse als over geheel Nederlandts India: 1624–1682* (Batavia/The Hague, 1887–1931)
Christy (1903)	M. Christy, 'Concerning tinder-boxes', *Burlington Magazine*, vol.1 (1903) pp.55–62, cont. vol.3 (1903) pp.321–26.
Christy (1926)	M. Christy, *The Bryant and May Museum of Fire-Making Appliances* (London 1926)
Clark (1982)	F. Clark, *Hats* (London 1982)
Clavijo (1928)	Clavijo, *Clavijo. Embassy to Tamerlane 1403–1406*, trans. G. Le Strange (London 1928)
Clough (1984)	R.E. Clough, 'The bloomery process', in ed. B. Scott and H. Cleere, *The crafts of the blacksmith* (Belfast 1984) pp.19–27
Coghlan (1956)	H.H. Coghlan, *Notes on prehistoric and early Iron in the Old World* (Oxford 1956)
Collins (1896)	E.T. Collins, *In the Kingdom of the Sha*h (London 1896)
Colnaghi (1976)	P. & D. Colnaghi & Co. Ltd., *Persian and Mughal Art* (London 1976)
Coomaraswamy (1908)	A. Coomaraswamy, *Medieval Sinhalese Art* (London 1908)
Correia-Afonso (1990)	J. Correia-Afonso (ed.), *Intrepid Itinerant: Manuel Godinho and his Journey from India to Portugal in 1663*, trans. from the Portuguese by V. Lobo and J. Correia-Afonso (Bombay 1990)
Cortesao (1944)	A. Cortesao (ed. and trans.), *The Suma Oriental of Tome Pires and the book of Francisco Rodrigues*, 2 vols (London 1944)
Craddock (1995)	P.T. Craddock, *Early Metal Mining and Production* (Edinburgh 1995)
Craddock (1998)	P.T. Craddock, 'New Light on the Production of Crucible Steel in Asia', *Bulletin of the Metals Museum of Japan Institute of Metals*, vol.29 (July 1998) pp.41–66
Curzon (1892)	G.N. Curzon, *Persia and the Persian Question*, 2 vols (London 1892)
Crawshay Williams (1907)	E. Crawshay Williams, *Across Persia* (London 1907)

Curtius Rufus (1954)	Q. Curtius Rufus, *Geschichte Alexanders des Grossen* (Munich 1954)
Dale (1994)	S.F. Dale, *Indian merchants and Eurasian trade 1600–1750* (Cambridge 1994)
Dames (1918–21)	M.L. Dames, *The Book of Duarte Barbosa*, 2 vols (London 1918, 1921)
Danespazuh (1990)	M-T. Danespazuh, 'Baz-nama', *Encyclopaedia Iranica* vol.4 (1990) pp.65–66
de Baghdad à Ispahan (1994)	*de Baghdad à Ispahan*, Musée du Petit Palais (Paris 1994)
Denison Ross (1933)	Sir E. Denison Ross (ed.), *Sir Anthony Sherley and his Persian Adventure* (London 1933)
Dexel (1991)	T. Dexel, *Handwerk und Kunst in Persien* (Brauschweig 1991)
Diba (1999)	L. Diba, ed., *Royal Persian Paintings. The Qajar Epoch 1785–1925* (London/New York 1999)
Dickson (1949)	H.R.P. Dickson, *The Arab of the desert* (London 1949)
Dickson and Welch (1981)	M.B. Dickson and S.C. Welch, *The Houghton Shahnameh*, 2 vols (Cambridge, MA, 1981)
Donaldson (1935)	D.M. Donaldson, 'Significant mihrabs in the Haram at Mashhad', *Ars Islamica*, vol.2 (1935) pp.118–27
Dreaming of Paradise (1993)	*Dreaming of Paradise. Islamic art from the collection of the Museum of Ethnology, Rotterdam* (Rotterdam 1993)
Drouville (1825)	G. Drouville, *Voyage en Perse, fait en 1812 et 1813*, 2 vols (Paris 1825)
Duhamel du Monceau (1767)	H.-L. Duhamel du Monceau, *Art du Serrurier* (Paris 1767)
Dunlop (1930)	H. Dunlop, *Bronnen tot de qeschiedenis der Oostindische Compagnie in Perzie. [Eerste Deel 1611–1638]* ('S-Gravenhage 1930)
Durand (1902)	E.R. Durand, *An Autumn Tour in Western Persia* (London 1902)
Dyson (1960)	R.H. Dyson, 'The death of a city', *Expedition*, vol.2, no.3 (1960)
Eastwick (1864)	E.B. Eastwick, *Journal of a diplomate's three years' residence in Persia* 2 vols (London 1864)
Edwards (1960)	E.C. Edwards, *The Persian carpet* (London 1960)
Egerton (1968)	Lord Egerton of Tatton, *Indian and Oriental Armour* (London 1968)
Elgood (1970)	C. Elgood, *Safavid Medical Practice* (London 1970)
Elgood (1979)	R. Elgood (ed.), *Islamic Arms and Armour* (London 1979)
Elgood (1994)	R. Elgood, *The Arms and Armour of Arabia* (London 1994)
Elgood (1995)	R. Elgood, *Firearms of the Islamic World in the Tareq Rajab Museum, Kuwait* (London/New York 1995)
Elwell-Sutton (1979)	L.P. Elwell-Sutton, 'Persian armour inscriptions', in Elgood (1979) pp.5–19
Enderlein and Sundermann (1988)	V. Enderlein and W. Sundermann, *Schahname. Das persische Königsbuch. Miniaturen und Texte der Berliner Handschrift von 1605* (Berlin 1988)
Eras (1957)	V.J.M. Eras, *Locks and Keys throughout the Ages* (Lips' Manufacturing Company, USA 1957)
Eredità dell'Islam (1993)	*Eredità dell'Islam. Arte islamica in Italia*, ed. G. Curatola, exhibition catalogue, Venezia, Palazzo Ducale, 30 ottobre 1993–30 aprile 1994 (Venice 1993)
Etem (1936)	H. Etem, 'Madenden üç Türk eseri', *Türk Tarih, Arkeologya ve Etnografya Dergisi*, 3 (1936), pp.137–50, précis in French pp.151–53

Ettinghausen (1962)	R. Ettinghausen, *Arab Painting* (Geneva 1962)
Falk (1973)	T. Falk, *Un catalogue de peintures qajar* (Tehran 1973)
Falk (1985)	T. Falk (ed.), *Treasures of Islam* (Geneva 1985)
Fateh (1926)	M.K. Fateh, *The Economic Position of Persia* (London 1926)
Fatimi (1964)	S.Q. Fatimi, 'Malaysian weapons in Arabic literature: a glimpse of early trade in the Indian Ocean', *Islamic Studies*, vol.3, 2 (1964) pp.199–233
Fawcett (1936–55)	C. Fawcett, *The English factories in India* 4 vols (Oxford 1936–1955)
Fehérvári and Safadi (1981)	G. Fehérvári and Y.H.Safadi, *1400 years of Islamic art* (London 1981)
Ferrier (1857)	J.P. Ferrier, *Caravan journeys and wanderings in Persia, Afghanistan, Turkistan and Baloochistan* (London 1857)
Ferrier (1976)	R.W. Ferrier, 'An English view of Persian trade in 1618. Reports from the Merchants Edward Pettus and Thomas Barker', *Journal of the Economic and Social History of the Orient* 19 (1976) pp.182–214
Ferrier (1986)	R.W. Ferrier, 'Trade from the mid-14th century to the end of the Safavid period', in P. Jackson and L.Lockhart (eds), *The Cambridge History of Iran*, vol.6, *The Timurid and Safavid Periods* (Cambridge University Press 1986) pp.412–90
Ferrier (1989)	R.W. Ferrier (ed.), *The Arts of Persia* (London 1989)
Ferrières-Sauveboeuf (1790)	Comte de Ferrières-Sauveboeuf, *Mémoires historiques, politiques et géographiques des voyages du Comte de Ferrières-Sauveboeuf faits en Turquie, en Perse et en Arabie, depuis 1782, jusqu'en 1789*, 2 vols (Paris 1790)
Figiel (1991)	L.S. Figiel, *On Damascus Steel* (New York 1991)
Flinders Petrie (1911)	W.M. Flinders Petrie, 'Weights and Measures', *Encyclopaedia Britannica*, 11th edition, vol.28 (Cambridge 1911)
Flindt (1979)	T.W.Flindt, 'Some nineteenth-century arms from Bukhara', in ed. R.Elgood, *Islamic Arms and Armour* (London 1979) pp.20–29
Floor (1971)	W.M. Floor, *The Guilds in Qajar Persia*, doctoral dissertation submitted to Rijksuniversiteit, Leiden (1971)
Floor (1987)	W.M. Floor, 'The Iranian navy in the Gulf during the eighteenth century', *Iranian Studies*, 20 (1987) pp.31–53
Floor (1993)	W.Floor, 'Cˆopoq', *Encyclopaedia Iranica* vol.6 (1993) p.258
Fogg (1875)	W.P. Fogg, *Arabistan or the Land of the Arabian Nights* (London 1875)
Foley (1984)	A. Foley, 'The invention of the wheellock', *Journal of the Arms and Armour Society*, vol.11, no.4 (December 1984) pp.207–248
Foley and Canganelli (1990)	A. Foley and S. Canganelli, 'Proposal for a new Earliest Matchlock', *Journal of the Arms and Armour Society*, vol.13, no.3 (March 1990) pp.161–72
von Folsach (1990)	K. von Folsach, *Islamic art. The David Collection* (Copenhagen 1990)
Foster (1896–1902)	W. Foster (ed.), *Letters received by the East India Company from its Servants in the East*, 6 vols (London 1896–1902)
Foster (1906–27)	W. Foster, *The English Factories in India 1618–1669* 12 vols (Oxford 1906–27)
Fowlet (1841)	G. Fowler, *Three years in Persia; with travelling adventures in Koordistan*, 2 vols (London 1841)
Frähn (1836)	M. Frähn, 'Erklärung der arabischen Inschrift des eisernen Thorflügels zu

	Gelathi in Imerethi', *Mémoires de l'Académie Impériale des Sciences de St. Pétersbourg*, vɪme série. *Sciences politiques, histoire et philologie*, vol.3 (1836) pp.531–46
Francklin (1788)	W. Francklin, *Observations made on a tour from Bengal to Persia in the years 1786–7* (Calcutta 1788)
Fraser (1825)	J.B. Fraser, *Narrative of a Journey into Khorasan in the years 1821 and 1822* (London 1825)
Fraser (1826)	—, *Travels and Adventures in the Persian Provinces* (London 1826)
Fraser (1834)	—, *An historical and descriptive account of Persia* (Edinburgh and London 1834)
Fraser (1838)	—, *A Winter's Journey (Tatar) from Constantinople to Tehran*, 2 vols (London 1838)
Fraser (1840)	—, *Travels in Koordistan, Mesopotamia &c.*, 2 vols (London 1840)
Frembgen (1995)	J.W. Frembgen, 'Schiitische Standartenaufsätze', *Tribus*, vol.44 (1995) pp.194–207
Fryer (1698)	J. Fryer, *A new account of East India and Persia being nine years travel 1672–1681*, 3 vols (London 1698)
Fu *et al.* (1986)	S. Fu *et al. From Concept to Context*, Freer Gallery of Art, Smithsonian Institution (Washington, DC, 1986)
Fukai and Horiuchi (1969–72)	S. Fukai and K. Horiuchi, *Taq-i-Bustan*, 2 vols (Tokyo 1969–72)
Gandy (1995)	C.T. Gandy, 'Inscribed Silver Amulet Boxes', in J.W. Allan (ed.), *Islamic Art in the Ashmolean Museum*, Oxford Studies in Islamic Art, vol.10, (1995) part 1, pp.155–66
Ghirshman (1938–39)	R. Ghirshman, *Fouilles de Sialk*, 2 vols (Paris 1938–39)
Ghirshman (1962)	R. Ghirshman, *Iran: Parthians and Sassanians* (London 1962)
Ghirshman (1963)	—, 'Notes iraniennes XIII, trois épées sassanides', *Artibus Asiae*, vol.26 (1963) pp.293–311
Ghirshman (1966)	—, *Tchoga-Zanbil*, vol.1 *La Ziggurat* (Paris 1966)
Ghirshman (1971)	—, V. Minorsky and R. Sanghvi, *Persia. The Immortal Kingdom* (London 1971)
Giggal (1966)	K. Giggal, 'The blueing and browning of guns and gun barrels', *Journal of the Arms and Armour Society* vol.5 (1966) pp.314–18
Gilbar (1976)	G.G. Gilbar, 'Demographic developments in late Qajar Iran, 1810–1906', *Asian and African Studies* 2 (1976) pp.125–56
Gilbar (1978)	G.G. Gilbar, 'Persian agriculture in the late Qajar period, 1860–1906', *Asian and African Studies* 12 (1978) pp.312–65
Gilbar (1979)	G.G. Gilbar, 'The Persian economy in the mid 19th century', *Die Welt des Islams* 19 (1979) pp.177–211
Gilmour (1991)	B.J.J. Gilmour, 'The Technology of Anglo-Saxon Edged Weapons', University College London, unpublished PhD thesis (London 1991)
Gilmour (1996)	B.J.J. Gilmour, 'The patterned sword in medieval Europe and southern Asia', *Proceedings of the Forum for the Fourth Conference on the Beginnings of the Use of Metals and Alloys – BUMA IV* (Shimane, Japan 1996) pp.113–31
von Gladiss and Kroger (1985)	A.H. von Gladiss and J. Kroger, *Islamische Kunst. Loseblattkatalog unpublizierter Werke aus deutschen Museen*, Band 2 Berlin. Staatliche Museen Preussischer Kulturbesitz. Museum für Islamische Kunst. Metall, Stein, Stuck, Holz, Elfenbein, Stoffe (Mainz/Rhein 1985)

Gluck and Gluck (1977)	J. and S.H. Gluck (eds), *A survey of Persian handicraft* (Tehran 1977)
Godard (1938)	A. Godard, 'Muhammad Rida al-Imami', *Athar-e Iran* vol.3 (1938) pp.267–76
Goldsmid (1879)	F.J. Goldsmid, 'Persia; and its military resources', *Journal of the United Service Institution* 23 (1879) pp.149–72
Goodman (1964)	W.L. Goodman, *The History of Woodworking Tools* (London 1964)
Gordon (1988)	R.B. Gordon, 'Strength and structure of wrought iron', *Archeomaterials*, vol.2, no.2 (Spring 1988) pp.109–137
Gordon (1896)	T.E. Gordon, *Persia Revisited* (London 1896)
Gorelik (1979)	M.V. Gorelik, 'Oriental armour of the Near and Middle East from the eighth to the beginning of the seventeenth centuries as shown in works of art', in R. Elgood (1979) pp.30–63
Grabar and Blair (1980)	O. Grabar and S. Blair, *Epic images and contemporary history. The illustrations of the Great Mongol Shahnama* (Chicago, IL, 1980)
Grancsay (1963)	S.V. Grancsay, 'A Sasanian chieftain's helmet', *BMMA*, n.s., vol.21 (1963), pp.253–62
Gray (1961)	B. Gray, *Persian Painting* (Geneva 1961)
Gray (1979)	B. Gray (ed.), *The Arts of the Book in Central Asia* (UNESCO 1979)
Grohmann (1967–71)	A. Grohmann, *Arabische Paläographie*, 2 vols (Vienna 1967–71)
Grube (1967)	E. Grube, 'The Language of the Birds. The Seventeenth-Century Minatures', *Bulletin of the Metropolitan Museum of Art* (May 1967) pp.339–52
Grube and Sims (1989)	E. Grube and E. Sims, 'Painting', in Ferrier (1989) pp.200–224.
Guest (1949)	G.D. Guest, *Shiraz Painting in the Sixteenth Century* (Washington, DC, 1949)
Guyot, Le Tourneau and Paye (1935)	R. Guyot, R. Le Tourneau and L. Paye, 'La corporation des tanners et l'industrie de la tannerie à Fès', *Hespéris*, vol.21 (1935) pp.167–240
Gyuzal'yan (1968)	L. Gyuzal'yan, 'The bronze qalamdan (pen-case) 542/1148 from the Hermitage collection (1936–1965)', *Ars Orientalis*, vol.7 (1968) pp.95–119
Haase, Kröger and Lienert (1993)	C.-P. Haase, J. Kröger, U. Lienert, *Oriental Splendour. Islamic Art from German Private Collections*, Museum für Kunst und Gewerbe (Hamburg 1993)
Hackin, Carl and Meunié (1959)	J. Hackin, J. Carl, and J. Meunié, *Diverses recherches archéologiques en Afghanistan* (Paris 1959)
Haider (1991)	S.F. Haider, *Islamic Arms and Armour of Muslim India* (Lahore 1991)
Hakluyt (1903)	R. Hakluyt, *The Principal Navigations, Voyages, Traffiques and Discoveries of the English Nation*, vol.3 (Glasgow 1903)
Haldane (1983)	D. Haldane, *Islamic Bookbindings* (London 1983)
Hambly (1991)	G.R.G. Hambly, 'The traditional Iranian city in the Qajar period', in P. Avery, G. Hambly and C. Melville (eds), *From Nadir Shah to the Islamic Republic*, The Cambridge History of Iran, vol.7 (Cambridge University Press 1991) pp.542–89
Hambly (1988)	M. Hambly, *Drawing Instruments 1580–1980* (London 1988)
Hammer-Purgstall (1854)	J. Hammer-Purgstall, 'Sur les lames des orientaux', *Journal Asiatique*, 5th ser., 3 (1854) pp.66–80
Hammond (1995)	N. Hammond, 'Silk Road city smelted steel first', *The Times* (London 23 August 1995)
Hanway (1754)	J. Hanway, *An historical account of the British trade over the Caspian Sea*, 2 vols

	(London 1754)
Harrison (1968)	J.V. Harrison, 'Minerals' in ed. W.B.Fisher, *Cambridge History of Iran*, 1, *The Land of Iran* (Cambridge 1968) pp.489–516.
Hassan (1978)	A.Y. al-Hassan, 'Iron and steel technology in medieval Arabic sources', *Journal for the History of Arabic Science*, vol.2, 1 (1978) pp.31–52
Hassan and Hill (1986)	A.Y. al-Hassan and D.R. Hill, *Islamic Technology: An Illustrated History* (Cambridge 1986)
Hawley (1978)	R. Hawley, *Omani silver* (London/New York 1978)
Hayes (1983)	J.H. Hayes (ed.), *The Genius of Arab Civilization. Source of Renaissance* (Henley-on-Thames 1983)
Heikamp (1966)	D. Heikamp, 'La Medusa del Caravaggio e l'armatura dello Scià 'Abbâs di Persia', *Paragone*, N.S., 19, Anno 17, Numero 199/19 (settembre 1966) pp.62–76
Hendley (1892)	T.H. Hendley, *Damascening on steel or iron, as practised in India* (London 1892)
Herbert (1677)	Sir T. Herbert, *Some yeares travels into Africa and Asia the Great* (London 1677)
Hermann (1989)	G. Herrmann, 'Parthian and Sasanian saddlery', in L. de Meyer and E. Haerinck (eds), *Archaeologica Iranica et Orientalis Miscellanea in honorem Louis Vanden Berghe*, vol.2 (Ghent 1989) pp.757–810
Hermann, Masson, et al. (1993)	G. Herrmann, V.M. Masson et al., 'The International Merv Project. Preliminary Report on the First Season', *Iran* 31 (1993) pp.39–43
Hermann, Kurbansakhatov et al. (1994)	G. Herrmann, K. Kurbansakhatov et al., 'The International Merv Project. Preliminary Report on the Second Season', *Iran* 32 (1994) pp.53–75
Hermann, Kurbansakhatov et al. (1995)	G. Herrmann, K.Kurbansakhatov et al., 'The International Merv Project. Preliminary Report on the Third Season', *Iran* 33 (1995) pp.31–60
Hermann, Kurbansakhatov et al. (1996)	G. Herrmann, K.Kurbansakhatov et al., 'The International Merv Project. Preliminary Report on the Fourth Season', *Iran* 34 (1996) pp.1–22
Herzfeld (1936)	E. Herzfeld, 'A bronze pen-case', *Ars Islamica*, vol.3 (1936) pp.35–43
Heyne (1814)	B. Heyne, *Tracts Historical and Statistical on India* (London 1814)
Higuera (1994)	T.P. Higuera, *Objetos e imagenes de al-Andalus* (Madrid/Barcelona 1994)
Hillenbrand (1986)	R. Hillenbrand, 'The Symbolism of the Rayed Nimbus in Early Islamic Art', *Cosmos* 2 (1986) pp.1–52
Hillenbrand (1986a)	R. Hillenbrand, 'Safavid Architecture', in P. Jackson and L. Lockhart (eds), *The Cambridge History of Iran*, vol.6 *The Timurid and Safavid Periods* (Cambridge 1986) pp.759–842
Himsworth (1953)	J.B. Himsworth, *The story of cutlery* (London 1953)
Hinz (1955)	W. Hinz, *Islamische Masse und Gewichte* (Leiden 1955)
Hinz (1965)	W. Hinz, 'dhira'', *Encyclopaedia of Islam* new edition, vol.2 (1965) pp.231–32
Hoare (1987)	O. Hoare, *The Calligraphers' Craft*, Ahuan Gallery of Islamic Art (London 1987)
Holland (1892)	T.H. Holland, 'Preliminary Report on the Iron-Ores and Iron-Industries of the Salem District', *Records of the Geological Survey of India*, vol.25, 3 (1892) pp.135–59

Holland (1893)	T.H. Holland, 'Iron Resources and Iron Industries of the Southern Districts of Madra Presidency', *Imperial Institute Handbook of Commercial Products*, 8 (Calcutta 1893)
Holmes (1910–11)	E.M. Holmes, 'Opium: Opium Smoking', *Encyclopaedia Britannica* 11th edition (1910–11) vol.20, pp.136–37
Holstein (n.d.)	P. Holstein, *Armes Orientales*, 2 vols (Paris n.d.)
Hommaire de Hell (1854–60)	X. Hommaire de Hell, *Voyage en Turquie et en Perse*, 4 vols (Paris 1854–60)
Honarfar (1344/1966)	L. Honarfar, *Ganjine-yi athar-i tarikhi-yi Isfahan* (Isfahan 1344/1966)
Hopkins (1928)	A.A. Hopkins, *The Lure of the Lock* (New York 1928)
Houtum-Schindler (1881)	A. Houtum-Schindler, 'Notes on Marco Polo's Itinerary in Southern Persia, *Journal of the Royal Asiatic Society*, n.s. vol.13 (1881) pp.490–97
Houtum-Schindler (1896)	A. Houtum-Schindler, *Eastern Persian Irak* (London 1896)
Houtum-Schindler (1910–11)	A. Houtum-Schindler, 'Hormuz', *Encyclopaedia Britannica* 11th edition (1910–11) vol.13, pp.694–95
Hoyland, Gilmour and Allan (forthcoming)	R. Hoyland, B. Gilmour and J. Allan, *Of swords and their kinds, a treatise of Ya'qub ibn Ishaq al-Kindi* (forthcoming)
Huff (1977)	D. Huff, 'Takht-i Suleiman. Vorläufiger Bericht über die Ausgrabungen im Jahre 1976', *Archaeologische Mitteilungen aus Iran* N.F.10 (1977) pp.211–30
Hughes (1877)	A.W. Hughes, *The Country of Balochistan* (London 1877)
Hunter (1875)	A. Hunter, 'Metal-Work among the Hindus', *Journal of the Iron and Steel Institute*, vol.9 (1875) pp.245–6, 617–18
Huntingford (1980)	G.W.B. Huntingford, *The Persian Periplus of the Erythraean Sea* (London 1980)
Indian Heritage (1982)	*The Indian Heritage. Court Life and Arts under Mughal Rule*, exhibition catalogue, Victoria and Albert Museum 21 April–22 August 1982 (London 1982)
Ipşiroğlu (1976)	M.S. Ipşiroğlu, *Siyah Qalem* (Graz 1976)
Ipşiroğlu (1980)	M.S. Ipşiroğlu, *Masterpieces from the Topkapi Museum* (London 1980)
Hommes du vent, gens de terre (1971)	*Iran: hommes du vent, gens de terre*, Muséum national d'histoire naturelle, Musée de l'homme (Paris 1971)
Islamic Art in Cairo (1969)	*Islamic Art in Cairo 969–1517*, Ministry of Culture (Cairo 1969)
Islamic art in Egypt 969–1517 (1969)	*Islamic art in Egypt 969–1517*, Ministry of Culture, U.A.R., exhibition (Cairo 1969)
Islamic Calligraphy (1988)	*Islamic Calligraphy*, catalogue of the exhibition 'Islamic Calligraphy, Sacred and Secular Writings' held at the Musée d'Art et d'Histoire, Geneva (Geneva 1988)
Islamic World (1987)	*The Islamic World*, Metropolitan Museum of Art (New York 1987)
Islamische Kunst (1986)	*Islamische Kunst. Verborgene Schätze*, Ausstellung des Museums für Islamische Kunst (Berlin 1986)
Islamiske Våben i dansk privateje (1982)	*Islamiske våben i dansk privateje. Islamic Arms and Armour from private Danish Collections*, Davids Samling (Copenhagen 1982)
Issawi (1971)	C. Issawi, *The Economic History of Iran, 1800–1914* (Chicago, IL, 1971)
Issawi (1991)	C. Issawi, 'European economic penetration, 1872–1921', in P. Avery, G. Hambly and C. Melville (eds), *From Nadir Shah to the Islamic Republic,*

	The Cambridge History of Iran, vol.7, (Cambridge University Press 1991) pp.590–607
Ivanov (1976)	A.A. Ivanov, *The Art of Kubachi* (Leningrad 1976)
Ivanov (1979)	A.A. Ivanov, 'A group of Iranian daggers of the period from the fifteenth century to the beginning of the seventeenth, with Persian inscriptions', in R. Elgood (1979) pp.64–77
Ivanov, Lukonin and Smesova (1984)	A.A. Ivanov, V.G. Lukonin and L.S. Smesova, *Yuvelirnie izdeliya Vostoka* (Moscow 1984)
Jackson (1894)	A.V.W. Jackson, 'Herodotus VII.61, or the arms of the ancient Persians', *Classical Studies in honour of Henry Drisler* (London 1894) pp.95–125
Jacquin (1816) and (1818)	J. Jacquin, 'Chemische Versuche mit dem Sagh', *Fundgraben des Orients*, vol.5 (1816) p.44; reprinted under the name A. Jacquin, 'Chemical observations on the sagh', *Asiatic Journal and Monthly Register* vol.5 (1818), pp.571–72
Jacob (1975)	A. Jacob, *Les armes blanches de l'Atlantique à l'Indus* (Paris 1975)
Jacob (1985)	A. Jacob, *Les armes blanches du monde islamique* (Paris 1985)
Janneau (1948)	G. Janneau, *Henry-René d'Allemagne. La maison d'un vieux collectionneur* 2 vols (Paris 1948)
Jenkins (1983)	M. Jenkins (ed.), *Islamic Art in the Kuwait national Museum. The al-Sabah Collection* (London 1983)
Johnson (1818)	J. Johnson, *A Journey from India to England through Persia, Georgia, Russia, Poland and Prussia in the year 1817* (London 1818)
Juleff (1996)	G. Juleff, 'An ancient wind-powered iron smelting technology in Sri Lanka', *Nature*, vol.379, no.6560 (4 January 1996) pp.60–63
Juleff (1998)	G. Juleff, *Early Iron and Steel in Sri Lanka: a study of the Samanalawewa area* (Mainz 1998)
Kaempfer (1977)	E. Kaempfer, *Am Hofe des persischen Grosskönigs 1684–1685*, ed. W. Hinz (Tübingen/Basel 1977)
Kalter (1984)	J. Kalter, *The Arts and Crafts of Turkestan* (London 1984)
Kalter (1987)	J. Kalter, *Linden-Museum Stuttgart* (Stuttgart 1987)
Kalus (1980)	L. Kalus, 'Inscriptions arabes et persanes sur les armes musulmanes de la Tour de Londres', *Gladius*, vol.15 (1980) pp.19–78
Kalus (1986)	L. Kalus, *Catalogue of Islamic seals and talismans*, Ashmolean Museum (Oxford 1986)
Kapp, Kapp and Yoshihara (1987)	L. Kapp, H. Kapp and Y. Yoshihara, *The Craft of the Japanese Sword* (Tokyo, New York and London 1987)
Karimzadeh Tabrizi (1985–91)	M.A. Karimzadeh Tabrizi, *The Lives and Art of Old Painters of Iran* (in Persian) 3 vols (London 1985–91)
Kealle (1993)	E.J. Keall, 'One man's Mede is another man's Persian; one man's coconut is another man's grenade', *Muqarnas*, vol.10 (1993) pp.275–85
Keddie (1972)	N.R. Keddie, 'The Economic History of Iran, 1800–1914, and Its Political Impact: An Overview', *Iranian Studies* 5 (1972) pp.58–78
Kemp (1959)	P.M. Kemp (trans. and ed.) *Russian travellers to India and Persia [1624–1798]. Kotov. Yefremov. Danibegov* (Delhi 1959)
Keyvani (1982)	M. Keyvani, *Artisans and Guild Life in the later Safavid period* (Berlin 1982)

Khalegi-Motlagh (1994)	Dj. Khalegi-Motlagh, 'Derafš-e Kavian', *Encyclopaedia Iranica* vol.7 fasc.3 (1994) pp.315–16
Khalili, Robinson and Stanley (1996)	N.D. Khalili, B.W. Robinson and T. Stanley, *Lacquer of the Islamic Lands*, The Nasser D. Khalili Collection of Islamic Art, vol.23 in 2 parts (London 1996)
Khan (1999)	I.A. Khan, 'Nature of Gunpowder Artillery in India during the Sixteenth Century – a Reappraisal of the Impact of European Gunnery', *Journal of the Royal Asiatic Society*, series 3, vol.9 part 1 (1999) pp.27–34
Kinneir (1818)	J.M. Kinneir, *Journey through Asia Minor, Armenia, and Koordistan in the years 1813 and 1814* (London 1818)
Kisch (1965)	B. Kisch, *Scales and Weights – A Historical Outline* (New Haven/London, 1965)
Kleiss (1990)	W. Kleiss, 'Hufeisen aus Iran', *Archaeologische Mitteilungen aus Iran*, vol.23 (1990) pp.299–310
Korom and Chelkowski (1994)	F.J. Korom and P.J. Chelkowski, 'Community Process and the Performance of Muharram Observances in Trinidad', *The Drama Review*, 38, 2 (1994) pp.150–75
von Kotzebue (1819)	M. von Kotzebue, *Narrative of a Journey into Persia in the suite of the Imperial Russian Embassy in the Year 1817* (London 1819)
Kürkman (1991)	G. Kürkman, *Ottoman weights and measures*, Türk ve Islam Eserleri Müzesi (Istanbul 1991)
Ladame (1945)	G. Ladame, 'Les ressources métallifères de l'Iran', *Schweizerische mineralogische und petrographische Mitteilungen*, 25 (1945) pp.167–303
Laking (1964)	G.F. Laking, *Wallace Collection Catalogues. Oriental Arms and Armour* (London 1964)
Lambton (1953)	A.K.S. Lambton, *Landlord and Peasant in Persia* (London/New York/Toronto 1953)
Lambton (1954)	A.K.S. Lambton, *Islamic Society in Persia*, an inaugural lecture delivered on 9 March 1954, School of Oriental and African Studies, London University (London 1954)
Landor (1902)	M.S. Landor, *Across coveted lands*, 2 vols (London 1902)
Lane (1957)	A. Lane, *Later Islamic Pottery* (London 1957)
Lang, Craddock and Simpson (1998)	J. Lang, P.T. Craddock and St. J. Simpson, 'New evidence for early crucible steel', *Journal of the Historical Metallurgical Society*, vol.32, 1 (1998) pp.7–14
Laufer (1914)	B. Laufer, 'Prolegomena on the history of defensive armour', *Field Museum of Natural History Publications* no.177, Anthropological series, vol.13 no.2, (Chicago, IL, 1914)
Lawton and Lentz (1998)	T. Lawton and T.W. Lentz, *Beyond the Legacy. Anniversary Acquisitions for the Freer Gallery of Art and the Arthur M. Sackler Gallery*, Smithsonian Institution (Washington, DC, 1998)
Lefebvre des Noette (1931)	Ct. Lefebvre des Noettes, *L'Attelage et le cheval de selle à travers les ages* (Paris 1931)
Lentz and Lowry (1989)	T.W. Lentz and G.D. Lowry, *Timur and the princely vision*, Los Angeles County Museum of Art (Los Angeles, CA, 1989)
Lewis (1976)	B. Lewis (ed.), *The World of Islam* (London 1976)
Littauer (1969)	M.A. Littauer, 'Bits and pieces', *Antiquity*, vol.43 (1969) pp.289–300.

Littauer (1981)	M.A. Littauer, 'Early stirrups', *Antiquity*, vol.55 (1981) pp.99–105
Littauer and Crouwel (1984)	M.A. Littauer and J.H. Crouwel, 'Ancient Iranian Horse Helmets?', *Iranica Antiqua*, vol.19 (1984) pp.41–52
Littauer and Crouwel (1988)	M.A. Littauer and J.H. Crouwel, 'A new type of bit from Iran?', *Iranica Antiqua*, vol.23 (1988) pp.323–27
Lockhardt (1938)	L. Lockhardt, *Nadir Shah* (London 1938)
Loukonin and Ivanov (1996)	V. Loukonin and A. Ivanov, *Lost Treasures of Persia. Persian Art in the Hermitage Museum* (Washington, DC, 1996)
Lowe (1988)	T.L. Lowe, 'Solidification and the Crucible Processing of Deccani Ancient Steel', *Proceedings of the Indo-US Conference on Solidification and Materials Processing* (Hyderabad, Andhara Pradesh 1988) pp.729–40
Lowe (1990)	T.L. Lowe, 'Refractories in High-Carbon Iron Processing: A Preliminary Study of the Deccani Wootz-Making Crucibles', *Ceramics and Civilization IV: Cross-craft and Cross-cultural Interactions in Ceramics* (Westerville, OH, 1990) pp.237–51
Lowe (1995)	T.L. Lowe, 'Indian Iron Ores and the Technology of Deccani 'Wootz' Production' in P. Benoit and P. Fluzin (eds), *Paléométallurgie et Culture. Actes du Symposium International du Comité pour la Sidérurgie ancienne de L'Union Internationale des Sciences Préhistorique et Protohistoriques* (Sevenans, Belfort 1995) pp.119–29
Lowry (1988)	G.D. Lowry, *A jeweler's eye*, Smithsonian Institute (Washington, DC, 1988)
Lowry and Beach (1988)	G.D. Lowry and M.C. Beach, *An Annotated and Illustrated Checklist of the Vever Collection*, Smithsonian Institution (Washington, DC, 1988)
Lukens (1967)	M. Lukens, 'The Language of the Birds. The Fifteenth-Century Minatures', *Bulletin of the Metropolitan Museum of Art* (May 1967) pp.317–38
Lumsden (1822)	T. Lumsden, *A Journey from Merut in India to London through Arabia, Persia, Armenia, Georgia, Russia, Austria, Switzerland and France during the years 1819 and 1820* (London 1822)
Luschey-Schmeisser (1981)	I. Luschey-Schmeisser, 'A Safavid tile spandrel with hunting scene in the Brooklyn Museum', in A. Daneshvari (ed.), *Essays in Islamic Art and Architecture in Honor of Katharina Otto-Dorn* (Malibu 1981) pp.109–111
Macdonald (1859)	R. Macdonald, *Personal Narrative of Military Travel and Adventure in Turkey and Persia* (Edinburgh 1859)
Mahmud (1988)	S.J. Mahmud, *Metal technology in medieval India* (Delhi 1988)
Maksimov (1986)	V. Maksimov, *Kirkizskii uzor* (Kirgizstan 1986)
Malcolm (1827)	Sir J. Malcolm, *Sketches of Persia* 2 vols (London 1827)
du Mans (1890)	R. du Mans, *Estat de la Perse en 1660*, ed. Ch. Schefer (Paris 1890)
Maqami (1969)	J. Qa'im Maqami, *'mohr ha va toghra ha va tawqi' ha-ye padeshahan-e iran as ilkhani ta payan-e qajariyyeh'*, *Majalleh-ye barresiha-ye tarikhi*, serial nos 20–21, June–September (1969) pp.123–62
Margulan (1986)	A.Kh. Margulan, *Kazakhskoe narodnoe prikladnoe iskusstvo* (Alma-Ata 1986)
Marshall (1951)	J. Marshall, *Taxila*, 3 vols (Cambridge 1951)
Martin (1996)	V. Martin, 'An evaluation of reform and development of the state in the early Qajar period', *Die Welt des Islams*, 36, 1 (1996) pp.1–24
Maryon (1948)	H. Maryon, 'A Sword of the Nydam Type from Ely Fields Farm, Near Ely', *Proceedings of the Cambridge Antiquarian Society*, vol.41 (1948) pp.73–76

Maryon (1960)	H. Maryon, 'Pattern-welding and Damascening', *Studies in Conversation*, vol.5 (1960) pp.25–36 and 52–59
Maslenitsyna (1975)	S. Maslenitsyna, *Persian Art in the collection of the Museum of Oriental Art, Moscow* (Leningrad 1975)
Massalski (1841)	'Préparation de l'acier damassé en Perse', *Annuaire du Journal des Mines de Russie* (1841) pp.297–308
Masterpieces of Islamic Art (1990)	*Masterpieces of Islamic Art in the Hermitage Museum*, exhibition catalogue, Dar al-Athar al-Islamiyyah (Kuwait 1990)
Maveety (1979)	P. Maveety, *Opium pipes, prints & paraphernalia*, exhibition catalogue, Stanford University Museum of Art (Stanford 1979)
Maxwell-Hyslop and Hodges (1966)	K.R. Maxwell-Hyslop and H.W.M. Hodges, 'Three Iron Swords from Luristan', *Iraq*, vol.28 (Autumn 1966) pp.164–76
Mayer (1959)	L.A. Mayer, *Islamic metalworkers and their work* (Geneva 1959)
Mayer (1962)	L.A. Mayer, *Islamic armourers and their work* (Geneva 1962)
Meen and Tushingham (1968)	V.B. Meen and A.D. Tushingham, *Crown Jewels of Iran* (Toronto 1968)
Melikian-Chirvani (1970)	A.S. Melikian-Chirvani, 'Le roman de Varqe et Gulsah', *Arts Asiatiques*, vol.22 (1970)
Melikian-Chirvani (1973)	A.S. Melikian-Chirvani, *Le bronze iranien* (Paris 1973)
Melikian-Chirvani (1976)	A.S. Melikian-Chirvani, 'Four pieces of Islamic metalwork: some notes on a previously unknown school', *Art and Archaeology Research Papers*, vol.10 (1976) pp.24–30
Melikian-Chirvani (1979)	A.S. Melikian-Chirvani, 'The tabarzins of Lotf'ali', in Elgood (1979) pp.116–35
Melikian-Chirvani (1981)	A.S. Melikian-Chirvani, 'Notes sur la terminologie de la metallurgie et des armes dans l'Iran musulman', *Journal of the Economic and Social History of the Orient*, vol.24, no.3 (1981) pp.310–16
Melikian-Chirvani (1982)	A.S. Melikian-Chirvani, *Islamic metalwork from the Iranian world, 8th–18th centuries* (London 1982)
Melikian-Chirvani (1983)	A.S. Melikian-Chirvani, 'The westward journey of the Kazhagand', *Journal of the Arms and Armour Society*, vol.11 (1983) pp.8–35
Melikian-Chirvani (1984)	A.S. Melikian-Chirvani, 'Le *Shah-Name*, la gnose soufie et le pouvoir mongol', *Journal Asiatique*, vol.272, nos 1–2 (1984) pp.149–338
Melikian-Chirvani (1986)	A.S. Melikian-Chirvani, 'State Inkwells in Islamic Iran', *Journal of the Walters Art Gallery*, vol.44 (1986) pp.70–94
Melikian-Chirvani (1987)	A.S. Melikian-Chirvani, 'Asadullah Isfahani', *Encyclopaedia Iranica* vol.2 fasc.7 (1987) pp.698–99
Melikian-Chirvani (1988)	A.S. Melikian-Chirvani, 'Bargostvan', *Encyclopaedia Iranica* vol.3 fasc.8 (1988) pp.795–96
Melikian-Chirvani (1991)	A.S. Melikian-Chirvani, 'From the royal boat to the beggar's bowl', *Islamic Art*, vol.4 (1991) pp.3–112
Melikian-Chirvani (1993	A.S. Melikian-Chirvani, 'Le *kashkul* safavide, vaisseau à vin de l'initiation mystique', in J.Calmard (ed.), *Etudes Safavides* (Paris/Tehran 1993) pp.165–94
Membré (1993)	M. Membré, *Mission to the Lord Sophy of Persia (1539–1542)*, trans. with

	Introduction and Notes by A.H. Morton (London University 1993)
Meshkati (1974)	N. Meshkati, *A list of the historical sites and ancient monuments of Iran* (Tehran 1974)
Miles (1965)	G.C. Miles, 'Dinar', *Encyclopaedia of Islam* new edition vol.2 (1965) pp.297–99; 'Dirham' pp.319–20
Miller (1979)	Y.A. Miller, 'Iranian swords of the seventeenth century with Russian inscriptions in the collection of the State Hermitage Museum', in ed. R. Elgood, *Islamic Arms and Armour* (London 1979) pp.136–48
Minorsky (1943)	V. Minorsky, *Tadhkirat al-Muluk* (London 1943)
Misugi (1981)	T. Misugi, *Chinese Porcelain Collections in the Near East*, 3 vols (Hong Kong 1981)
Mitford (1884)	E.L. Mitford, *A Land March from England to Ceylon Forty Years Ago*, 2 vols (London 1884)
Momtaz (1995)	I. Momtaz, *A perspective of unity* (London 1995)
Moore (1915)	B.B. Moore, *From Moscow to the Persian Gulf* (New York/London 1915)
Moorey (1971)	P.R.S. Moorey, *Catalogue of the Ancient Persian Bronzes in the Ashmolean Museum* (Oxford 1971)
Moorey (1974)	P.R.S. Moorey, *Ancient Persian Bronzes in the Adam Collection* (London 1974)
Moorey (1982)	P.R.S. Moorey, 'Archaeology and Pre-Achaemenid Metalworking in Iran: A fifteen-year Retrospective', *Iran*, vol.20 (1982) pp.81–101
Moorey (1991)	P.R.S. Moorey, 'The decorated ironwork of the early Iron Age attributed to Luristan in western Iran', *Iran*, vol.29 (1991) pp.1–12.
Moreland (1931)	W.H. Moreland, *Relations of Golconda in the early seventeenth century* (London 1931)
Morier (1812)	J. Morier, *A Journey through Persia, Armenia and Asia Minor to Constantinople in the years 1808 and 1809* (London 1812)
Morier (1818)	J. Morier, *A second journey through Persia, Armenia and Asia Minor to Constantinople in the years 1810 and 1816* (London 1818)
Morton (1974)	A.H. Morton, 'The Ardabil Shrine in the reign of Shah Tahmasp I', *Iran* vol.12 (1974) pp.31–64
Morton (1975)	A.H. Morton, 'The Ardabil Shrine in the reign of Shah Tahmasp I (concluded)', *Iran* vol.13 (1975) pp.39–58
Moser (1912)	H. Moser, *Collection H. Moser-Charlottenfels: Oriental Arms and Armour* (Leipzig 1912)
Mostafavi (1978)	S.M.T. Mostafavi, *The Land of Pars (The Historical Monuments and Archaeological Sites of the Province of Fars)*, trans. R.N. Sharp (Chippenham 1978)
Mounsey (1872)	A.H. Mounsey, *A Journey through the Caucasus and the Interior of Persia* (London 1872)
Moxon (1703)	J. Moxon, *Mechanick Exercises: Or the Doctrine of Handy-Works* (London 1703)
Murdoch Smith (1885)	R. Murdoch Smith, *Persian Art* (London 1885)
Muscarella (1988)	O.W. Muscarella, *Bronze and Iron*, Metropolitan Museum of Art (New York, 1988)
Mushet (1805)	D. Mushet, 'Experiments on Wootz', *Philosophical Transactions*, vol.95 (1805) pp.163–75
Mushet (1840)	D. Mushet, *Papers on Iron and Steel, Practical and Experimental* (London 1840)
Naqvi (1987)	S. Naqvi, *Qutb Shahi 'Ashur Khanas of Hyderabad City* (Hyderabad 1987)
Nashat (1981)	G. Nashat, 'From Bazaar to Market: Foreign Trade and Economic Develop-

ment in Nineteenth-Century Iran', *Iranian Studies* 14 (1981) pp.53–85.

Nasr (1976) — S.H. Nasr, *Islamic Science. An Illustrated Study* (London 1976)

Needham (1958) — J. Needham, *The Development of Iron and Steel Technology in China* (London 1958)

Needham (1965) — J. Needham, *Science and Civilization in China* vol.4, part 2, section 27 (1965)

Needham (1980) — J. Needham, 'The Evolution of Iron and Steel Technology in East and Southeast Asia', in T.A. Wertime and J.D. Muhly (eds), *The Coming of the Age of Iron* (New Haven and London 1980) pp.507–41

Nesbitt and Powell (1910–11) — A. Nesbitt and H.J. Powell, 'Glass: History of Glass manufacture', *Encyclopaedia Britannica*, 11th edition (1910–11) vol.12, pp.97–105

Nickel (1973) — H. Nickel, 'About the sword of the Huns, and the "Eurepos" of the Steppes', *Metropolitan Museum Journal*, vol.7 (1973) pp.131–42

Nicolle (1976) — D. Nicolle, *Early Medieval Islamic Arms and Armour* (Madrid 1976)

Nikolycheva (1970) — E.P. Nikolaycheva, 'Opisanie kollektsionneikh predmetov po shiitskomu kultu', in *Akademiya Nauk SSSR, Chornik Muzeya Antropologii i Etnografii* vol.26, *Traditsionnaya Kultura Narodov Perednei i Srednei Azii* (Leningrad 1970) pp.367–83

Norden (1928) — H. Norden, *Under Persian skies: a record of travel by the old caravan routes of western Iran* (London 1928)

Norgren and Davis (1969) — J. Norgren and E. Davis, *Preliminary Index of Shah-nameh Illustrations*, University of Michigan, Center for Near Eastern and North African Studies (Ann Arbor 1969)

Norman (1968) — A.V.B. Norman, 'Ornate weapons of the Orient', *Country Life* (November 1968) pp.1245–48.

Norman (1982) — A.V.B. Norman, 'Some Princely Arms from India and Persia in the Wallace Collection', *Islamiske våben i dansk privateje. Islamic Arms and Armour from private Danish Collections*, Davids Samling (Copenhagen 1982) pp.7–16

North (1985) — A. North, *Islamic Arms*, Victoria and Albert Museum (London 1985)

O'Dea (1964) — W.T. O'Dea, *Making Fire*, HMSO (London 1964)

Ogilby (1673) — J. Ogilby, *Asia, the First Part being An Accurate Description of Persia* (London 1673)

d'Ohsson (1834–35) — A.C.M D'Ohsson, *Histoire du Mongols*, 4 vols (The Hague and Amsterdam 1834–35)

Okasha (1981) — S. Okasha, *The Muslim Painter and the Divine* (London 1981)

Olearius (1669) — A. Olearius, *The Voyages and Travels of the Ambassadors*, trans. J. Davies (London 1669)

Orbeli and Trever (1935) — I. Orbeli and C. Trever, *Orfèvrerie sasanide* (Moscow/Leningrad 1935)

Oriental Splendour (1993) — *Oriental Splendour. Islamic Art from German Private Collections*, Museum für Kunst und Gewerbe (Hamburg 1993)

Orsolle (1885) — E. Orsolle, *Le Caucase et la Perse* (Paris 1885)

Osborne (1975) — H. Osborne (ed.), *The Oxford Companion to the Decorative Arts* (Oxford 1975)

Osborne (1745) — T. Osborne, *A collection of voyages and travels, compiled from the curious and valuable library of the late Earl of Oxford*, 2 vols (London 1745)

Overlaet (1998) — B. Overlaet, 'Sasanian Bronze Sculptures in the Werner Abegg Collection', in K. Otavsky, ed. *Entlang der Seidenstrasse: Frühmittelalterliche Kunst zwischen Persien und China in der Abegg-Stiftung, Riggisberger Berichte*, no.6

	(Riggisberg 1998)
Ouseley (1819–23)	Sir W. Ouseley, *Travels in various countries of the east, more particularly Persia etc.*, 3 vols, (London 1819–23)
Pakdaman (1983)	N. Pakdaman, Preface to *Iranian Studies* 16 (1983) pp.125–35
Panseri (1965)	C. Panseri, 'Damscus steel in legend and in reality', *Gladius* vol.4 (1965), pp.5–66
Papachristou and Swertschkow (1993)	O.A. Papachristou and L.M. Swertschkow, 'Eisen aus Ustruschana und Tiegelstahl aus dem Fergana-Becken. Forschungen zur mittelalterlichen Eisenproduktion in Mitttelasien', *Der Anschnitt. Zeitschrift für Kunst und Kultur im Bergbau*, vol.45, 4 (1993) pp.122–31
Pearson (1795)	G. Pearson, 'Experiments and Observations to Investigate the Nature of a Kind of Steel … Called Wootz', *Philosophical Transactions* (1795) pp.322–46
Pedersen (1984)	J. Pedersen, *The Arabic Book* (Princeton 1984)
Percy (1864)	J. Percy, *Metallurgy* (London 1864)
Persian Art (1931)	*Persian Art. An illustrated souvenir of the Exhibition of Persian Art at Burlington House, London 1931* (London 1931)
Persian and Mughal Art (1976)	*Persian and Mughal Art*, Colnaghi & Co.Ltd (London 1976)
Peterson, Baker and Verhoeven (1990)	D.T. Peterson, H.H. Baker and J.D. Verhoeven, 'Damascus Steel, Characterization of One Damascus Steel Sword', *Materials Characterization*, vol.24 (1990) pp.355–74
Peterson (1979)	S.R. Peterson, 'Painted tiles at the Takieh Mu'avin ul-Mulk (Kirmanshah)', *Akten des VIII. Internationalen Kongresses für Iranische Kunst und Archäologie, München 7.–10. September 1976* (Berlin 1979) pp.618–28
Peterson (1979)	S.R. Peterson, 'The Ta'ziyeh and related arts', in ed. P. Chelkowski, *Ta'ziyeh. Ritual and Drama in Iran* (New York 1979) pp.64–87.
Petrasch (1991)	R. Petrasch, *Die Karlsruhe Türkenbeute* (Munich 1991)
Petrie (1917)	F. Petrie, *Tools and weapons* (London 1917)
Philipp (1984)	T. Philipp, 'Isfahan 1881–1891: A Close-up View of Guilds and Production', *Iranian Studies* 17 (1984) pp.391–411
Phillips (1969)	E.A. Phillips, *The Mongols* (London 1969)
Phillpott (1908)	D.C. Phillpott (trans.), *The Baz-nama-yi Nasiri. A Persian treatise on falconry* (London 1908)
Pinkerton (1808–14)	Pinkerton, J. (ed.) *A general collection of the best and most interesting voyages and travels in all parts of the world*, 17 vols (London 1808–14)
Piotrovsky and Vrieze (1999)	M.B. Piotrovsky and J. Vrieze, *Earthly beauty, heavenly art*, Die Nieuwe Kerk, Amsterdam (London 1999)
Pitt-Rivers (1883)	Lieut-General Pitt-Rivers, *On the Development and Distribution of Primitive Locks and Keys* (London 1883)
de Planhol (1988)	X. de Planhol, 'Bandar-e 'Abbas(i)', *Encyclopaedia Iranica* vol.3 fasc.7 (1988) pp.685–87
Pleiner (1971)	R. Pleiner, 'The Problem of the Beginning Iron Age in India', *Acta Praehistorica et Archaeologica*, vol.2 (1971) pp.5–36
Pleiner (1993)	R. Pleiner, *The Celtic Sword* (Oxford 1993)

Polak (1865)	J.E. Polak, *Persien, das Land und seiner Bewohner* (Leipzig 1865)
Pollington (1867)	Viscount Pollington, *Half Round the Old World. Being some account of a tour in Russia, the Caucasus, Persia, and Turkey, 1865–66* (London 1867)
Polo (1929)	Marco Polo, *The Book of Ser Marco Polo*, trans. and ed. Sir H. Yule, 3rd edition revised by H. Cordier, 2 vols (London 1929)
Pope (1938–39)	A.U. Pope (ed.), *A Survey of Persian Art*, 6 vols (Oxford 1938–39)
Pope (1960)	A.U. Pope, *Masterpieces of Persian Art* (London 1960)
Porter (1821–22)	Sir R. Ker Porter, *Travels in Georgia, Persia, Armenia, Ancient Babylonia &c. &c. during the years 1817, 1818, 1819, and 1820*, 2 vols (London 1821–22)
Potratz (1966)	J.A.H. Potratz, *Die Pferdetrensen des Alten Orient* (Rome 1966)
Pottinger (1816)	H. Pottinger, *Travels in Beloochistan and Sinde* (London 1816)
Price (1983)	P. Price, *Bells and Man* (Oxford 1983)
Price (1825)	W. Price, *Journal of the British Embassy to Persia* (London 1825)
Probst (1993)	S.E.L. Probst, *Sproni, morsi e staffe*, Musei Civici di Modena (Modena 1993)
Purchas (1625)	Purchas, *Purchas his Pilgrimes* (London 1625)
Qaddumi (1987)	G.H. Qaddumi, *Variety in Unity. A Special Exhibition on the Occasion of the Fifth Islamic Summit in Kuwait* (Kuwait 1987)
Qaddumi (1989)	G.H. Qaddumi, *Science in the Arab-Islamic Civilization* (Kuwait 1989)
Rabino di Borgomale (1945)	H.L. Rabino di Borgomale, *Coins, Medals, and Seals of the Shahs of Iran, 1500–1941* (London 1945)
Rabino di Borgomale (1951)	H:L. Rabino di Borgomale, *Album of Coins, Medals, and Seals of the Shahs of Iran, 1500–1948* (Oxford 1951)
Raby (1999)	J. Raby, *Qajar Portraits* (London/New York 1999)
Ragib and Fluzin (1997)	Y. Ragib and P. Fluzin, 'La Fabrication des Lames Damassés en Orient', *Journal of the Social and Economic History of the Orient*, vol.40, 1 (1997) pp.30–71
Rehder (1989)	J.E. Rehder, 'Ancient carburization of iron to steel', *Archeomaterials* vol.3 no.1 (Winter 1989), pp.27–37
Rehder (1991)	J.E. Rehder, 'The decorated iron swords from Luristan: their material and manufacture', *Iran* vol.29 (1991) pp.13–20
Remple and Gross (1993)	D. Remple and C. Gross, *Falconry and birds of prey in the Gulf* (London 1993)
Rice (1950)	D.S. Rice, 'The blazons of the "Baptistère de Saint Louis"', *Bulletin of the School of Oriental and African Studies*, vol.13, part 2 (1950), pp.367–80
Rice (1951)	D.S. Rice, *Le Baptistère de St. Louis* (Paris 1951)
Rice (1961)	D.S. Rice, 'A Seljuq Mirror', *Communications Presented to the First International Congress of Turkish Arts, Ankara, 1959* (Ankara 1961) pp.288–90
Rich (1836)	C.J. Rich, *Narrative of a residence in Korrdistan*, 2 vols (London 1836)
Richardson (1934)	H. Richardson, 'Iron, prehistoric and ancient', *American Journal of Archaeology*, vol.38, 4 (1934) pp.555–83
Ricks (1973)	T.M. Ricks, *Towards a Social and Economic History of Eighteenth-Century Iran*, *Iranian Studies* 6 (1973) pp.110–26
Riefstahl (1931)	R.M. Riefstahl, *Turkish Architecture in Southwestern Anatolia* (Cambridge 1931)
Robinson (1949)	B.W. Robinson, 'The Sword of Islam', *Apollo Annual* (1949) pp.56–59

Robinson (1958)	B.W. Robinson, *A descriptive catalogue of Persian paintings in the Bodleian Library* (Oxford 1958)
Robinson (1972)	B.W. Robinson, 'Shah Abbas and the Mughal Ambassador Khan 'Alam: The pictorial record', *Burlington Magazine* vol.114 (1972) pp.58–63
Robinson (1976)	B.W. Robinson, *Persian Paintings in the India Office Library* (London 1976)
Robinson (1980)	B.W. Robinson, *Persian Paintings in John Rylands Library* (London 1980)
Robinson (1988)	B.W. Robinson (ed.), *Islamic art in the Keir collection* (London 1988)
Robinson (1989)	—, 'Painting in the Post Safavid Period', in R.W. Ferrier (1989), pp.225–31.
Robinson (1992)	B.W. Robinson, *Jean Pozzi. L'Orient d'un collectionneur*, Musée d'art et d'histoire (Geneva 1992)
Robinson (1995)	—, 'Lacquer in the University of Oxford', in J.W. Allan (ed.), *Islamic Art in the Ashmolean Museum*, Oxford Studies in Islamic Art, vol.10, (1995), Part 2, pp.45–62
Robinson (1967)	H.R. Robinson, *Oriental Armour* (London 1967)
Rochechouart (1867)	J. de Rochechouart, *Souvenirs d'un voyage en Perse* (Paris 1867)
Rogers (1986)	J.M. Rogers, *The Topkapi Saray Museum. The Albums and Illustrated Manuscripts* (London 1986)
Rogers (1987)	—, *The Topkapi Saray Museum. The Treasury* (London 1987)
Rogers and Ward (1988)	— and R. Ward, *Süleyman the Magnificent*, British Museum (London 1988)
Rollason (1973)	E.C. Rollason, *Metallurgy for Engineers*, 4th edition (London 1973)
Rosenthal (1971)	F. Rosenthal, *The Herb. Hashish versus medieval Muslim society* (Leiden 1971)
Rostoker (1986)	W. Rostoker, 'Troubles with Cast Iron Cannon', *Archeomaterials* vol.1 no.1 (Fall 1986), pp.69–90
Rostoker and Bronson (1990)	W. Rostoker and B. Bronson, *Pre-Industrial Iron. Its Technology and Ethnology*, Archaeomaterials Monograph No.1 (Philadelphia 1990)
Rostoker and Dvorak (1990)	W. Rostoker and J. Dvorak, 'Wrought irons: distinguishing between processes', *Archeomaterials* Vol.4 no.2 (Summer 1990), pp.153–66
Saadat (1976)	B. Saadat, *The Holy Shrine of Imam Reza, Mashhad* (Shiraz 1976)
Sachse (1994)	M. Sachse, *Damascus Steel: Myth, History, Technology, Applications*, trans. P. Knighton (Düsseldorf 1994)
Safadi (1978)	Y.M. Safadi, *Islamic calligraphy* (London 1978)
Safrani (1992)	S.H. Safrani, *Golconda alums* (Golconda and Hyderabad 1992)
Sainsbury (1913)	E.B. Sainsbury, *A Calendar of the Court Minutes of the East India Company 1650–1654* (Oxford 1913)
Sajjadi (1996)	S. Sajjadi, 'Dentistry', *Encyclopaedia Iranica* vol.7 (1996) pp.292–96
St John, Lovett and Smith (1876)	O.B. St John, B. Lovett and E. Smith, *Eastern Persia. An account of the journeys of the Persian Boundary Commission 1870–71–72* (London 1876)
Sakisian (1929)	A.B. Sakisian, *La Miniature Persane du XIIe au XVIIe siècle* (Paris/Brussels 1929)
Salaman (1975)	R.A. Salaman, *Dictionary of tools used in the woodworking and allied trades c.1700–1970* (London 1975)
Salaman (1986)	R.A. Salaman, *Dictionary of leatherworking tools c.1700–1950* (London 1986)
Salter (1997)	C.J. Salter, 'Bloomery Steel – an Overlooked Material' in P. Crew and S. Crew (eds), *Abstracts: Early Ironworking in Europe, archaeology and experiment Plas*

BIBLIOGRAPHY

	Tan y Bwlch (1997) pp.102–103 (full proceedings forthcoming)
Samuels (1980)	L.E. Samuels, *Optical Microcopy of Carbon Steels*, American Society for Metals (Ohio 1980)
Sanders (1936)	J.H. Sanders (trans.) *Tamerlane or Timur the Great Amir, from the Arabic Life of Ahmed ibn Arabshah* (London 1936)
Sarre (1906)	F. Sarre, *Erzeugnisse Islamischer Kunst* (Berlin 1906)
Sarre and Martin (1911)	F. Sarre and F.R. Martin, *Die Ausstellung von Meisterwerken Muhammedanischer Kunst in München 1910* (Munich 1911); reprinted (London 1984)
Scerrato (1971)	U. Scerrato, 'Oggetti metallici di eta islamic in Afghanitan. III – Staffe ghaznavidi', *Annali dell'Istituto Orientale di Napoli*, vol.31 (N.S. XXI) (1971), pp.455–66
Schmidt (1957)	E. Schmidt, *Persepolis* (Chicago, IL, 1957)
von Schwartz (1899)	C. von Schwartz, 'Correspondence on Syed Ali Bilgrami's Iron Industry in Hyderabad', *Journal of the Iron and Steel Institute*, vol.56, 2 (1899) pp.88–89
Schwarzer (1988)	J.K. Schwarzer, 'A Medieval Arsenal', *The Glass Wreck: An 11th-Century Merchantman, INA Newsletter*, vol.5 no.3 (1988) pp.26–27
Schwarzer and Deal (1986)	J.K. Schwarzer and E.C. Deal, 'A sword hilt from the Serce Liman shipwreck', *MASCA Journal*, vol.4 no.2 (1986) pp.50–59
Scott-Scott (1986)	M. Scott-Scott, *Drawing instruments 1850–1950* (Princes Risborough 1986)
Scott Waring (1804)	E. Scott Waring, *A Tour to Sheeraz* (Bombay 1804)
Schwarzlose (1886)	F.W. Schwarzlose, *Die Waffen der alten Araber* (Leipzig 1886)
Shahbazi (1994)	A.Sh. Shahbazi, 'Derafs', *Encyclopaedia Iranica*, vol.7 fasc.3 (1994) pp.312–15
Shadman (1944)	S.F. Shadman, 'A review of Anglo-Persian relations, 1798–1815', *Journal of the Royal Central Asian Society* 31 (1944), pp.23–39
Sheil (1856)	Lady Sheil, *Glimpses of life and manners in Persia* (London 1856)
Sherby and Wadsworth (1985)	O. Sherby and J. Wadsworth, 'Damascus Steels', *Scientific American*, vol.252, 2 (1985) pp.94–99
Sievernich and Bude (1989)	G. Sievernich and H. Bude (eds), *Europa und der Orient 800–1900* (Berlin 1989)
Sims (1985)	E.G. Sims, 'A'ina-kari', *Encyclopaedia Iranica* vol.1 (1985), pp.692–94
Smith (1960)	C.S. Smith, *A history of metallography* (Chicago, IL, 1960); second edition (MS 1988)
Soucek (1975)	P. Soucek, 'An Illustrated Manuscript of al-Biruni's *Chronology of Ancient Nations*', in P.J. Chelkowski (ed.), *The Scholar and the Saint* (New York 1975) pp.103–168
Soudavar (1992)	A. Soudavar, *Art of the Persian Courts* (New York 1992)
Sourdel-Thomine (1971)	J. Sourdel-Thomine, 'Clefs et serrures de la Ka'ba. Notes d'épigraphie arabe', *Revue des Etudes Islamiques* 39 (1971), pp.29–86
Sourdel-Thomine and Spuler (1973)	J. Sourdel-Thomine and B. Spuler, *Die Kunst des Islam, Propylaen Kunst Geschichte* (Berlin 1973)
Sözen (1981)	M. Sözen, *Anadolu'da Akkoyunlu Mimarisi* (Ankara 1981)
Spink and Lewis (1973)	M.S. Spink and G.L. Lewis, *Abulcasis. On Surgery and Instruments* (London 1973)
Splendeur des Armes Orientales (1988)	*Splendeur des Armes Orientales*, exhibition catalogue, Galérie ART, 4 Mai–31 Juillet 1988 (Paris 1988)

Srinivasan and Griffiths (1997)	S. Srinivasan and D. Griffiths, 'Crucible steel in south India – preliminary investigations on crucibles from some newly identified sites' in P.B. Vandiver, J.R. Druzik, J.F. Merkel and J. Stewart (eds), Materials Issues in Art and Archaeology V, Materials Research Society Proceedings, vol.462 (Pittsburgh 1997) pp.111–25
Stack (1882)	E. Stack, *Six months in Persia*, 2 vols, (London 1882)
Stanley (1997)	T. Stanley, 'Locks, padlocks and tools', in F. Maddison and E. Savage-Smith, *Science, tools and magic*, The Nasser D. Khalili Collection of Islamic Art, vol.12, (London 1997) Part 2, pp.356–405
Stanley (1866)	W.F. Stanley, *A descriptive treatise on mathematical drawing instruments* (London 1866)
Stchoukine (1954)	I. Stchoukine, *Les Peintures des Manuscrits Timurides* (Paris 1954)
Stchoukine (1959)	I. Stchoukine, *Les Peintures des Manuscrits Safavis* (Paris 1959)
Stchoukine (1964)	I. Stchoukine, *Les Peintures des Manuscrits de Shah 'Abbas* (Paris 1964)
Stocqueler (1832)	J.H. Stocqueler, *Fifteen Months' Pilgrimage through Untrodden Tracts of Khuzistan and Persia*, 2 vols (London 1832)
Stein (1989)	D. Stein, 'Three Photographic Traditions in Nineteenth-Century Iran', *Muqarnas*, vol.6 (1989) pp.112–30
Stöcklein (1934)	H. Stöcklein, 'Die Waffenschätze im Topkapı Sarayi Müzesi zu Istanbul', *Ars Islamica*, vol.1 (1934) pp.200–218
Stone (1934)	G.C. Stone, *A glossary of the construction, decoration and use of arms and armour* (Portland, ME, 1934)
Struys (1684)	J. Struys, *The Voyages and Travels of John Struys*, trans. J. Morrison (London 1684)
Stuart (1854)	C. Stuart, *Journal of a Residence in Northern Persia and the Adjacent Provinces of Turkey* (London 1854)
Sykes (1898)	E.C. Sykes, *Through Persia on a Side-Saddle* (London 1898)
Sykes (1910)	P.M. Sykes, 'Historical Notes on Khurasan', *Journal of the Royal Asiatic Society* (1910) vol.2, pp.1113–54
Sykes and Khan (1910)	P.M. Sykes and A.D. Khan, *The glory of the Shi'a world* (London 1910)
Tafazzoli (1974)	A. Tafazzoli, 'A list of trades and crafts in the Sassanian period', *Archaeologische Mitteilungen aus Iran*, N.S. 7 (1974) pp.191–96
Talbot Rice (1976)	D. Talbot Rice, *The illustrations to the 'World History' of Rashid al-Din* (Edinburgh 1976)
Tanavoli (1985)	P. Tanavoli, *Lion Rugs* (Basel 1985)
Tanavoli (1985a)	P. Tanavoli, *Shahsavan. Iranian Rugs and Textiles* (New York 1985)
Tanavoli (1994)	P. Tanavoli, *Kings, Heroes & Lovers* (London 1994)
Tanavoli (1998)	P. Tanavoli, *Horse and Camel Trappings from Tribal Iran* (Tehran 1998)
Tanavoli and Wertime (1976)	P. Tanavoli and J.T. Wertime, *Locks from Iran*, exhibition catalogue, Smithsonian Institution (Washington, DC, 1976)
Tavernier (1970)	J.-B. Tavernier, *Voyages en Perse* (Geneva 1970)
Tezcan and Tezcan (1991)	H. and T. Tezcan, *Türk Sancak Alemlari* (Ankara 1991)
Qashqa'i of Iran (1976)	*The Qashqa'i of Iran*, Whitworth Art Gallery (Manchester 1976)
de Thevenot (1686)	*The travels of Monsieur de Thevenot into the Levant*, trans. A. Lovell (London 1686)

Thomas and Roy (1873)	W. Thomas and S.A. Roy (trans.), *Travels to Tana and Persia by Josafa Barbaro and Ambrogio Contarini* (London 1873)
Titley (1977)	N.M. Titley, *Miniatures from Persian Manuscripts*, The British Library (London 1977)
Titley (1983)	N.M. Titley, *Persian Miniature Painting*, The British Library (London 1983)
Torre (1989)	P. Torre, *Lucchetti Orientali. Funzione, simbolo, magia*, Palazzo Brancaccio (Rome 1989)
Treasures of the Kremlin (1998)	*Treasures of the Kremlin. Arsenal of the Russian Tsars*, Royal Armouries (Leeds 1998)
Unity of Islamic Art (1405/1985)	*The Unity of Islamic Art*, an exhibition of Islamic art at the Islamic Art Gallery, the King Faisal Center for Research and Islamic Studies (Riyadh 1405/1985)
Untracht (1968)	O. Untracht, *Metal Techniques for Craftsmen* (London 1968)
Ussher (1865)	J. Ussher, *A Journey from London to Persepolis* (London 1865)
Validi (1936)	A.Z. Validi, 'Die Schwerter der germanen, nach arabischen Berichten des 9–11 Jahrhunderts', *ZMDG*, N.S.,15 (1936) pp.19–37
della Valle (1663–70)	P. della Valle, *Les fameux voyages de Pietro della Valle*, 4 vols (Paris 1663–70)
Verhoeven (1987)	J.D. Verhoeven, 'Damascus Steel, Part I: Indian Wootz Steel', *Metallography*, vol.20 (1987) pp.145–51
Verhoeven (1990)	J.D. Verhoeven, 'Analysis of Decarburization of Hypereutectoid Fe-C Alloys and Its Application in Evaluating the Processing Steps Used to Make Damascus Steel Swords', *Materials Characterization*, vol.25 (1990) pp.221–39
Verhoeven, Baker et al. (1990)	J.D. Verhoeven, H.H. Baker, D.T. Peterson, H.F. Clark and W.M. Yater, 'Damascus Steel, Part III: The Wadsworth-Sherby Mechanism', *Materials Characterization*, vol.24 (1990) pp.205–27
Verhoeven and Pendray (1992)	J.D. Verhoeven and A.H. Pendray, 'Experiments to Reproduce the Pattern of Damascus Steel Blades', *Materials Characterization*, vol.29 (1992) pp.195–212
Verhoeven and Pendray (1992)	J.D. Verhoeven and A.H. Pendray, 'A Reconstructed Method for Making Damascus Steel Blades', *Metals, Materials and Processes*, vol.4, 2 (1992) pp.93–106
Verhoeven and Pendray (1993)	J.D. Verhoeven and A.H. Pendray, 'Studies of Damascus Steel Blades: Part I – Experiments on Reconstructed Blades', *Materials Characterization*, vol.30 (1993) pp.175–86
Verhoeven, Pendray and Berge (1993)	J.D. Verhoeven, A.H. Pendray and P.M. Berge, 'Studies of Damascus Steel Blades: Part II – Destruction and Reformation of the Pattern', *Materials Characterization*, vol.30 (1993) pp.187–200
Verhoeven, Pendray and Dauksch (1998)	J.D. Verhoeven, A.H. Pendray and W.E. Dauksch, 'The Key Role of Impurities in Ancient Damascus Steel Blades', *Journal of Metals*, vol.50, 9 (1998) pp.58–64
Verhoeven, Pendray and Gibson (1996)	J.D. Verhoeven, A.H. Pendray and E.D. Gibson, 'Wootz Damascus Steel Blades', *Materials Characterization*, vol.37 (1996) pp.9–22
Verhoeven and Peterson (1992)	J.D. Verhoeven and D.T. Peterson, 'What is Damascus Steel?', *Materials Characterization*, vol.29 (1992) pp.335–41
Vernoit (1997)	S. Vernoit, *Occidentalism. Islamic art in the 19th century*, The Nasser D.Khalili Collection of Islamic Art, vol.23 (Oxford 1997)

Vianello (1966)	G. Vianello, *Armi e Armature Orientali* (Milan 1966)
Vianello (1966a)	G. Vianello, *Armi in Oriente* (Milan 1966)
Vienna (1895)	*Sammlung von Abbildungen Türkischer, Arabischer, Persischer, Central Asiatischer under Indischer Metallobjecte*, K.K. Österreichischen Hnadels-Museum (Vienna 1895)
Vigneron (1968)	P. Vigneron, *Le cheval dans l'antiquité gréco-romaine* (Nancy 1968)
van Vloten (1892)	M.G. van Vloten, 'Les drapeaux en usage à la fête de Huçeïn à Téhéran', *Internationales Archiv für Ethnographie* vol.5 (1892) pp.105–111
Voysey (1832)	H.W. Voysey, 'Description of the Native Manufacture of Steel in Southern India', *Journal of the Asiatic Society of Bengal* 1 (1832) pp.245–47
Wagner (1993)	D. Wagner, *Iron and Steel in Ancient China* (Leiden 1993)
Wagner (1856)	M. Wagner, *Travels in Persia, Georgia and Koordistan*, 3 vols (London 1856)
Walravens (1979)	H. Walravens (ed.) *Kleinere Schriften von Berthold Laufer*, 2 vols (Wiesbaden 1979)
Walser (1980)	G. Walser, *Persepolis* (Tubingen 1980)
Ward (1993)	R. Ward, *Islamic Metalwork*, British Museum (London 1993)
Ward (1996)	R. Ward, 'Stirrups from the Islamic World', in Alexander (1996) vol.1 pp.84–91
Warmington (1974)	F.H. Warmington, *The Commerce between the Roman Empire and India* (London and New York 1980)
Warzée (1913)	D. de Warzée, *Peeps into Persia* (London 1913)
Welch (1973)	A. Welch, *Shah 'Abbas and the Arts of Isfahan* (New York 1973)
Welch (1979)	A. Welch, *Calligraphy in the Arts of the Muslim World*, exhibition catalogue, Asia House Gallery (New York 1979)
Welch (1972)	S.C. Welch, *A King's Book of Kings* (London 1972)
Wellesz (1959)	E. Wellesz, 'An early al-Sufi manuscript in the Bodleian Library in Oxford', *Ars Orientalis* 3 (1959) pp.1–26.
Wertime (1962)	T.A. Wertime, *The Coming of the Age of Steel* (Chicago, IL, 1962)
Wertime and Muhly (1980)	T.A. Wertime and J.D. Muhly (eds), *The Coming of the Age of Iron* (New Haven and London 1980)
Weyman (1998)	M. Weyman, 'Report on the analysis of two crucible steel ingot fragments and other metal artefacts', Appendix D in G. Juleff, *Iron and Steel in Sri Lanka: A Study of the Samanalawewa Area* (Mainz 1998) pp.387–403
White (1962)	L. White, *Medieval technology and social change* (Oxford 1962)
Whitehouse and Williams (1973)	D. Whitehouse and A. Williams, *Sasanian Maritime Trade*, Iran, vol.11 (1973), pp.29–49
Wiedemann (1911)	E. Wiedemann, 'Zur Chemie bei den Arabern, Beiträge zur Geschichte der Naturwissenschaften no.24', *Sitzungsberichte der physikalisch-medizinischen Sozietät in Erlangen* vol.43 (1911) pp.72–113
Wiest (1979)	F.K. Wiest, 'The Sword of Islam. Edged Weapons of Mohammedan Asia', *Arts of Asia* (May–June 1979) pp.73–82
Wiet (1935)	G. Wiet, *L'épigraphie arabe de l'exposition d'art persan du Caire*, Mémoires présentés à l'Institut d'Egypte, vol.26 (Cairo 1935)
Wilkinson (1987)	C.K. Wilkinson, *Nishapur. Some Early Islamic Buildings and Their Decoration*, Metropolitan Museum of Art (New York 1987)

Williams (1991)	A.R. Williams, 'Slag inclusions in armour', *Journal of the Historical Metallurgy Society* 24 no.2 (1991) pp.69–80
Williams (1935)	H.W. Williams, 'A sixteenth-century German treatise, *von Stahel und Eysen*, translated with explanatory notes', *Technical Studies* vol.4 no.2 (October 1935) pp.64–92
Wills (1883)	C.J. Wills, *In the Land of the Lion and the Sun* (London 1883)
Wills (1886)	C.J. Wills, *Persia as it is* (London 1886)
Wilson (1986)	S.G. Wilson, *Persian Life and Customs* (Edinburgh and London 1896)
de Windt (1891)	H. de Windt, *A ride to India across Persia and Baluchistan* (London 1891)
Wood (1893)	C. Wood, 'Discussion of Turner's Paper on the Production of Iron in Small Furnaces in India', *Journal of the Iron and Steel Institute*, vol.44, 2 (1893) pp.177–80
Wright (1944)	D. Wright, 'Trebizond and the Persian transit trade', *Journal of the Royal Central Asian Society*, 31 (1944) pp.299–301
Wright (1977)	D. Wright, *The English Amongst the Persians* (London 1977)
Wulff (1966)	H.E. Wulff, *The traditional crafts of Persia* (Cambridge, MA, 1966)
Wyndham Hulme (1937/8)	E. Wyndham Hulme, 'Prehistoric and Primitive Iron Smelting. Part I: From Meteoric Iron to 1000 BC', *Transactions of the Newcomen Society*, 18 (1937/8) pp.181–92
Wyndham Hulme (1940/1)	E. Wyndham Hulme, 'Prehistoric and Primitive Iron Smelting. Part II: The Crucible Processes of the East', *Transactions of the Newcomen Society*, 21 (1940/1) pp.23–30
Yakubovski et al. (1954)	A. Yu. Yakubovski et al., *Zhivopis' drevnego Pyandzhikenta* (Moscow 1954)
Yang (1984)	Hong Yang, 'The discovery of ancient Chinese horse equipment and foreign influences' [in Chinese], *Wen Wu* (no.9, 1984), pp.45–54 and p.76
Yarshater (1983)	E. Yarshater (ed.), *The Cambridge History of Iran*, vol.3 (1) *The Seleucid, Parthian and Sasanian Periods* (Cambridge 1983)
Yater (1982)	W.M. Yater, 'The Legendary Steel of Damascus. Part I: a review of the literature', *The Anvil's Ring*, vol.10, 1 (1982) pp.3–8
Yater (1983)	W.M. Yater, 'The Legendary Steel of Damascus. Part II: How it was made in the East', *The Anvil's Ring*, vol.11, 2 (1983) pp.3–13
Yater (1983–4)	W.M. Yater, 'The Legendary Steel of Damascus. Part III: Forging, pattern development and heat treatment', *The Anvil's Ring*, vol.11, 4 (1983–4) pp.3–17
Zaki (1955)	A.R. Zaki, 'Islamic Swords in the Middle Ages', *Bulletin de l'Institut d'Égypte* 36 (1955) pp.364–79
Zaky (1961)	A.R. Zaky, 'Introduction to the Study of Islamic Arms and Armour', *Gladius*, 1 (1961) pp.17–29
Zaky (1979)	A.R. Zaky, 'Medieval Arab Arms', in R. Elgood (1979) pp.202–212
Zchokke (1924)	B. Zchokke, 'Du Damasse et des lames de damas', *Revue de Metallurgie*, 21 (1924) pp.635–69
Zeller and Rohrer (1955)	R. Zeller and F. Rohrer, *Orientalische Sammlung Henri Moser-Charlottenfels*, Bernisches Historisches Museum (Bern 1955)
Żygulski (1979)	Z. Żygulski, 'Islamic weapons in Polish collections and their provenance', in R. Elgood (1979) pp.213–38

Żygulski (1986)	Z. Żygulski, *Broń Wschodnia* (Warsaw 1986)
Żygulski (1989)	Z. Żygulski, *Sztuka Islamu* (Warsaw 1989)
Żygulski (1992)	Z. Żygulski, *Ottoman Art in the Service of the Empire* (New York/London 1992)

Index

Abarquh, padlock production 31
Abbas Mirza (Qajar Prince) 22, 24, 80; and armaments 159; arsenals 84, 143; and imports 88; and Iranian army 186; sends craftsmen to Europe 160; sword 191
Abbas I, Safavid Shah 33, 81–82, 100, 102, 108, 120, 287; and falconry 248; gift of armour 131–33, 229, 246; miniature of 308; sword 190
Abbot, 68; on mining 88; on Nur iron works 26–27
Abd al-Karim, on grilles 286
Abd al-Malik, and system of weights 334
Abd al-Vahhab Isfahani (craftsman) 96, 99, 277
Abu 'Ali 160
Abu Bakr (locksmith) 105, 417
Abu'l-Fath Gilani 454
Abu'l-Fazl (Mughal statesman and author), *Ain-i Akbari* 14–15
Abu'l-Hasan Shirazi 150
Abu'l-Qasim ibn 'Abd al-'Aziz (historian) 344
Achaemenid period 8, 43, 44
Agha Muhammad Khan (Qajar ruler) 27, 32, 83; sword 190–91
Ahmad Isfahani (cutler) 104–105
Albucasis, *On surgery and instruments* 398
Albuquerque, Alfonso 154
Alburz mountains, iron resources 19, 25–28
d'Alessandri, Vincentio 155
Alexander, David 233
Alexander the Great 44
Alexander II, Tsar 197
Ali Akbar (swordsmith) 109, 151, 152
Ali (first Imam) 8–9
Ali Khudgar Bukhara'i, Ustad Shaikh 286
Ali Quli Jabbadar 250
Ali Riza 'Abbasi (calligrapher) 295
Ali Riza Nazuk 298
Allan, Prof. James 9
d'Allemagne, Henri 31, 35, 36, 100, 106; on attention to detail 110–11; on barbers 394–95; on belt fittings 211, 214, 219; on daggers 147; on dentistry 400; on dervish axe 316; on drawing equipment 342, 350, 351; on falconry 250; on flint-strikers 435, 448; on guns 171; on imitations 91–92; on locksmiths 303, 416–17; on opium-smoking 456–57; tool illustrations 369–71
Amir Kabir 23; and imports 88
Amul, armoury 143; arsenal 84; foundry 158, 244
amulet boxes 311, 312

An-hsi (Persia) 48
anvils and stakes 358–59, 360
apprenticeship system 95, 98, 100
Arab conquests 226
arabesque designs 136–38, 149, 152; on drawing equipment 356; on standards 254, 255
Ardabil, Indian steel in 115; shrine of Shaikh Safi 11, 259, 261, 269, 273–74, 307; steel-working 24, 273–74
Ardashir 126
armour, centres of production 141–44; decline of 85; decorative use 136, 143–44; earliest evidence 125, 126; early Islamic 127–29; for elephants 128; for horses 126–27, 128, 129, 130–31, 141; imports of 143; introduction of circular plates 133–36; Mongol 128–29; pre-Islamic 125–27; study of 11; Timurid 1 129–31 armouries 32–33, 81, 84 arms, study of 11
arms manufacturing 21, 22, 23
arquebus 153–54
artisans, in royal workshops 81
Asadallah Isfahani (swordsmith) 33, 34, 82, 95–96, 102–104, 196; use of name on work 107, 109
Asbijab, iron manufacturing 21
Astarabad, gunpowder factory 158
Aus ibn Hajar (poet) 47
Avar migration (6th century) 226
Avesta (sacred book) 7
awls, leather-working 376–77
axes 144–46; bird's head design 222; ceremonial 317–19; dervish 144, 313, 316–19; military or ceremonial 144–46; sugar 424, 427–29
Azarbaijan, iron resources 19, 21–25, 80; mines 88

Baghdad 293
Bahman, Bahram (steel-worker) 261
Bahman family 98; standard-making 261–63
Bahman, Husain (steel-worker) 261–63
Bahman, Majid (steel-worker) 261, 262
Bahman, Ustad Haj Akbar 261–63
balances and scales 331
Banyans (money-changers and brokers) 121
Baqir (swordsmith) 152
Barbaro 82, 130, 253; on armour production 142; on camel bells 323
barbers 393–401
Barker, Thomas 25, 67–68, 122; on Indian steel 117–18

bazaar, itinerant workers 82
bazubands (armbands) 8–9, 307–310; for wrestlers 310
bells 323–27; cage bells 324, 325–26; decorating animals 323; in gymnasia 325; open-mouth 326–27; worn by dervishes 323–24
belt fittings 211–25; buckles 211–15, 216, 217; spring catches 218–25; swivel hooks 215–18
Bihzad (painter) 239, 255
Bilal 'Ali (swordsmith) 204
Binning, Robert 34, 87, 107, 115, 122, 197; on daggers 146; on door knockers 302; on fire implements 449; on guns 161, 163; on Indian steel 117; on powder holders 176–77; on sword manufacture 198
bird's head, on axes 222; on belt fittings 214, 219–20; on flint-strikers 446; on knives 367–69
Birjand, steel manufacture 40
*bismar*s (balances) 331–32
bits (horse fittings) 235–44
al-Biruni 38, 44–45, 54, 55, 60–63, 69; on crucible-steel making 75; on Indian steel 113; *Mineralogy* 202; recipes for steel 61–63; on swords 202, 205, 206
bloomery steel 42, 50n., 57
bookbinding 369, 376, 379–80; designs 302
Boyle, Robert 78–79
brass 11; and steel-working 15
braziers 449
bridles 236, 238
bronzes 11
Buchanan, Francis, on *wootz* production 70
buckles 211–15
Bukhara, palace of Bidun Mukhar Khudah 292
Bundahishn 7
butcher's implements 328–30, 421

calligraphy 93–94, 104, 110, 111; equipment 341–56; and family tradition 98; knives 365, 367
candle-snuffers 426, 430
candlesticks 430
cannons 23n., 154–55
Carpini 128, 129
carpets 433; comb-beaters 381–83
Cartwright 30, 33, 142
chafing dishes 449
Chal Shutur, locksmithing centre 36, 90, 405
Chaldiran, Battle of (1514) 187, 190, 267–72
Chang Ch'ien 48
Chardin, Jean 25, 32–33, 36, 72, 78, 81, 100, 101, 102, 122; on barbers 393; on court fashion 323–24; on

guns 155–56; on Indian steel 114, 117; on locks 402; on mirrors 471; on spring catches 218; on textile measures 339; on weights 334
China, iron and steel production 48; trade with Iran 48, 48–49
chisels 381
clamps (cramps) 359–62
Clavijo 81, 286; on armour production 141
Clement of Alexandria, on Indian steel 113
coffee-drinking 421–22
compasses, Roman 348
compasses and dividers 348–51, 380
copper, use in weapons 22
coppersmiths 85
cosmetic implements 460–65
craftsmen 519–27; day labourers 100–101; titles used by 110; variety of products 85–86
crucible-steel making, pre-Islamic 46–47; process described 57–60, 70–76
crutches, dervish 314–15
cups, coffee 421–22

daggers, manufacture 25, 146–53; social significance 150
daggers *see also* knife production
damascene/damasked steel *see* Damascus steel
Damascus steel 12, 32, 76–79
dating of items 13
Delhi, wrought-iron pillar 44
dental instruments 399–400, 401
dervish paraphernalia 304, 313–20; bells 324; symbolism 315
Deve Huyuk (Syria), spearhead 43–44
al-Dimashqi 40, 206
dividers 349–51
doors and door plaques 292–302; hooks 300, 303; knockers 299, 302–303; types 296–302
dragon heads, on belt fittings 214, 219, 221; on flint-strikers 446, 447, 448; on knives 32; on standards 254–55, 256, 257, 258, 263, 270–72
Drouville, Gaspard 22, 24, 27, 37, 158, 162–63; on flints 177; on horse fittings 229; on Iranian army 186, 188, 235; on standards 261
Duarte Barbosa 120; on Iran-India trade 114
Dutch East India Company 12, 82–83, 115–17, 118, 120, 121, 346, 421

East India Company 82–83, 115–17, 118, 120, 121, 122, 346

597

embossing 14
enamelling 148
Eskandar Beg Monshi (author) 154–55, 197, 258
etching, knives 328; of standards 262–63; steel 15
etuis (instrument holders) 398–99, 400
ewers and basins 430

Faizallah Shushtari Isfahani (steel-worker) 101, 104, 138, 210, 287
Fakhr-i Mudabbir 69; on swords 206
falconry 247–52; blocks 248–50; literature on 248; perches 248, 250–52, 381
family businesses 95–99
farand (mixed colour) steel 62–63
Farghana, iron resources 19; medieval steel-making 50
Fars 49, 57; iron manufacture 28–31; Persian settlement 41; swordsmithing 193–94
Fath 'Ali Shah (Qajar ruler) 83–84, 84, 121, 136, 164, 197; court fashions 309; gift of body armour 136; miniature of 233; palace 284; standard 261
Fath Allah (calligrapher) 94
Ferdinand I, Grand Duke, gift of armour 131, 229
figurines 430, 433
files 362–64
Firdausi, *Shah-nameh* 7
fire-tongs 449–50, 455
flint-strikers 85, 87, 112, 182, 220, 435–49, 437–41; composite 444–45, 447–48; dating 436, 448; decline 448–49
flints 177
foreign trade, and economic development 86; with Europe 84, 120–21, 346; with India 113–22; Iranian merchants 120–21; iron and steel exports prohibited 122; lack of infrastructure 84; and preservation of craft industries 86–87; quality of steel 118
forgeries 105–109, 197, 319–20; swords 195
forgeries *see also* import substitution
Fraser, James Baillie 25, 27, 31, 32, 39, 87, 115, 158, 190, 286; on grilles 290; on Shiraz 148; on specialisation of products 93
fulad (crucible steel) 5–7, 49, 55; process described 61–62, 63–64; sword-making 77, 78
Fuladgar family (standard-makers) 98, 99
Funduqistan (Afghanistan), wall-painting 191

Ghazan Khan 81
Ghulam 'Ali 454
Ghur, armour production 141; iron production 37–38
Gilan, iron production 25; specialisation of products 93

Golconda, Kingdom of 114–16
grease boxes 185, 186
grilles 283–92; locks 403; manufacture 291–92; and secrecy of shrines 284, 285–86
guilds, entry to 387–89; exemption from taxation 102–103; Isfahan 33–34, 35, 82, 94–95, 100–103; in towns and villages 101–102; use of standards 260
guns 153–72; accessories 172–86; breech-loaded 170–71; European imports 159–60; flintlocks 156, 157–58, 163–64; local production 160–68; manufacture of 158; matchlocks 156–57, 158; percussion system 169–70; wheel-locks 157
gunsmithing 85, 361; forgeries 106; significance 112

haberdashery sellers 85–86
Haithon 129
Haj Akbar Bahman, Ustad (steelworker) 97, 99, 110
Haj Karim (steel-worker) 96; as 'maker of antiques' 106
Haj Muhammad Hasan (steel-worker) 96, 99
Haj Muhammad ibn 'Ali Hafiz al- Isfara'ini (craftsman) 93
Haj Muhammad Sadiq Shirani (steel-worker) 97, 98, 99
Haji 'Abbas (steelworker) 93, 96, 98, 99, 107, 319–20, 454
Haji Asad (craftsman) 31
Haji Ghulam'ali Mubashir 'Abd al- Baqi (craftsman) 94, 290, 291
Haji Isma'il Khan (merchant) 121
Haji Mirza Muhammad Tajir-i Tabrizi 88
Haji Muhammad (craftsman) 101, 305
Haji Muhammad Haft Khan (craftsman) 161
Haji Mustafa (gunsmith) 164, 168
Hamadan, iron manufacture 32, 37; Medes in 41
al-Hamdani 38
hammer-welding 41, 42
hammers, for jewellery 381, 382
harness, steel 9
hats, Western 424
hawk stands 247–52
Haydar Mirza, Sultan 190
heat treatments 65–66, 67–69
helmets (*khuds*) 7, 138–40
Herat, *fulad* production 61–62, 63; steel production 38, 39, 54, 80
Herbert, Sir Thomas 154; on horse fittings 241; on surgical instruments 398
Heyne, Benjamin, on *wootz* production 70
hooks and catches 215–25; leather-working 376; mouse-shaped 421
horse armour 126–27, 128,
129, 130–33, 141
horse fittings 226–46; bits 235–44; hoof knives 246; nosebands 236–37, 246; saddles 226–27, 229, 246; shoes 244–46; spurs 235;stirrups 226–35; tethers 246
horse shoes 244–46
household objects 421–34; ornaments 430–34; steel 9
Hudud al-'alam (anon.) 25, 38
Hurmuz, iron resources 19
Husain (gunsmith) 163–64
Husain Mirza, Sultan, *Majalis al-'Ushshaq* 313, 314, 341, 342
Husain, Shah Sultan 387; gifts by 287
Husam al-Daula Taymur Mirza, *Baz-nameh-yi Nasiri* (on falconry) 248, 249
Husayn Shirazi (swordsmith) 196

Ibn al-Balkhi 30
Ibn al-Faqih 30, 37; on mirrors 466
Ibn Battuta 15; on grilles 283, 286
Ibn Hawqal 19
Ibn Hodeil 114
Ibrahim (craftsman) 354
Ibrahim ibn 'Uthman ibn 'Ankawayh (smith) 292
Ibrahim Kashani (craftsman) 447
Ibrahim (standard-maker) 274, 275
Ibyas ibn Yusuf ibn Ahmad al- Makki (locksmith) 419
al-Idrisi 69, 114
Imam Husein 8
import substitution *see also* forgeries 89, 91–92, 161
imports, European mass-produced goods 87; from India 87, 92; from Russia 87, 92; iron 88; and price of raw materials 87–88
Imru'ulqais (poet) 47
India, British rule 346; fashion for *bazuband*s 308; iron production 116; iron and steel work in 14–15, 50; standard-making 253; steel trade with 31, 35, 44, 47, 82, 92, 113–22; *wootz* production 70–76
ink scoops 356, 357
Iran Bastan Museum 11
iron, difference from steel 7; identification of 13
Isfahan, armoury 32–33, 142; bazaar 85–86; camel sacrifice 318–19; capture by Afghans (1722) 34, 82; craftsmen 11; dagger production 147; Darb-i Imam 297; decline in trade 82–83, 90; guilds 33–34, 35, 82, 94–95, 100–102; gunsmithing 162; Hasht Behesht Palace 250; Imamzadeh Isma'il (tomb) 291; import substitution 89, 91–92; knife-making 426; locksmiths 405, 410; Lutfullah Mosque 33, 101,

358; Maidan-i Shah 33, 85–86, 100–101; Masjid-i Shaikh Lutf Allah 260; metal manufacture 32–36, 81; penknives 369; religious celebrations 259; shrine of Sayyid Muhammad Shafti 94, 288, 289, 291; standard-making 274; tool sets 389–90
Isma'il I, Shah 23, 30, 96, 131, 154; belt fittings for 211; defeat by Ottomans 267;Haydari sword 190
Isma'il ibn Asadallah (swordsmith) 108
Isma'il Isfahani (swordsmith) 104

Jabir al-Hayyan, *Kitab al-hadid* ('Book on Iron') 52, 55, 57–60, 75
Jami'al-Tawarikh manuscript 239
al-Jahiz 38, 226
Jamshid 7
javelins 188
Jawhari, Mr (steelworker) 97, 98, 99
jewellery, bracelets 7–8; dapping blocks 381; hammers 381, 382; pendants 381; tools for 380, 381, 382; use of iron in 7–8
al-Jildaki 52, 57–60
John III Sobieski, sword 196
al-Juzjani 141

Kaempfer, Engelbert 33, 38, 81, 142, 155; on dervishes 313
Kakuwayhid brothers 292
Kalb'ali Isfahani (swordsmith) 33, 96, 102–104, 150
Kamal al-Din Mahmud Nazuk (steel-worker) 93–94, 264, 291, 298
*kamar-band*s (belts) 8–9
Karadagh district, iron resources 19, 21–22; mines 22–23
Karim Khan Zand (ruler) 30–31, 83; sword 190
*kashkul*s (boat-shaped vessels) 319–20
Kazim Sharif (calligrapher) 94
Kerbala, shrine of Imam Husain 280, 304–305
Khalil, Sultan 30, 154
Khamseh of Nizami 254, 255, 260, 314, 446
khud (helmet) 7
Khura (craftsman) 328
Khurasan 49, 57; armour production 141; iron resources 19, 21, 88; specialisation of products 93; steel production 19, 21, 37–40, 80; swordsmithing 192, 193, 206–207
Khusrau II 126
Khusrau and Shirin manuscript 229
Khwaju Kirmani, *Diwan* 228
al-Khwarizmi 206
al-Kindi 30, 49, 50, 55, 56–57, 60; on Indian steel 113; on polishing and etching 66–67; on

INDEX

quenching 65; *Risalat* 194; on swords 77, 78, 80, 192–94, 200, 202–203, 204–205
Kirind, firearms and locksmithing industries 37, 405
Kirman, iron manufacture 28–32, 79, 81, 83, 89
Kirmanshah, gunsmithing 162; iron manufacture 32, 37; Takyeh Mu'avin al-Mulk 318, 324
Kiyumars 7
knives 365–69; butchers' 328–30; circumcision 396, 398, 399; folding 365, 366, 368, 369, 380; hoof knives 246; hunting 365; for leather-working 372–80; manufacture of 85; penknives 85, 104–105, 366, 369; reed-cutting 365, 367; surgical 396–98; table 426
knives *see also* daggers
Ko-Ku-Yao 56
kohl bottles 459–60
kohl sticks 460–61
Kotov 33, 36, 277–78, 285; on dervishes 313; on use of standards 259
Kuli (smithing gypsies) 102

lances 186–88
lancets, for blood-letting 396, 397
Language of the Birds manuscript (Herat) 315
leather-working tools 372–80
locks and padlocks 85, 105, 402–20, 411–15, 416–17; brass 419–20; dating 410, 419–20; extent of trade 405; fish shape 402, 404; goat shape 405, 409; Isfahan shrine 403, 447; Ka'aba 418–19; keys 410, 416; pre-Islamic 419–20; symbolic importance 403
Luristan, analysis of iron swords 41–43; bronze horse bits 236; evidence of standards 253; iron bracelets 7–8
Lutf'ali Ghulam (axe-maker) 109–110, 135, 146, 222
luxury goods, steel used for 80

maces 189–90; symbolism 315
Mahmud of Ghazneh, mace 189
Mahmud, Ustad (craftsman) 93
Malaysia, pattern-welding 77
al-Malik al-'Adil Tumanbay 197
du Mans, Rafael 101; on barbers 394, 396; on daggers 146, 147; on drawing equipment 342, 352
Maragheh, dagger manufacture 25
Marco Polo 31–32, 468
Marsmanda, iron resources 19, 21
Mashhad, grille 286; iron manufacture 39–40, 81; shrine of Imam Riza 11, 93, 95, 101, 284, 285, 286–87, 295–96, 305–307
Massalski 68; on crucible-steel manufacture 72–75, 535–39; on manufacture of gun barrels 164–66; on sword manufacture 197, 198–200, 203
Mas'ud (Ghaznevid ruler), mace 189
Matafih al-Janan 305
Maulana Ustadh Nuri Quflgar (locksmith) 417
Mawlana Shams (craftsman) 93
Mawlana Ustad Nuri Quflgar (locksmith) 105
Mazandaran, iron mines 25–26, 88
Mazyad ibn 'Ali of Damascus (al- Dimashqi) 55, 61, 78
measurement, textiles 339–40
measurement *see also* balances; weights
Mehr (Mithra), chariot of 7
Membré, Michele 258; on bells 324; on torches 449
Mertz, Martin, and spring catches 218
Merv, International Merv Project 38, 50–55; medieval steel-making 50–55; steel production 38, 80
Minak, iron resources 19, 21
miniature paintings, *bazubands* in 308; belt fittings in 211; depiction of guns 155; depiction of standards 253, 254; depictions of armour 129–30; doors and door plaques in 294; drawing equipment in 341, 342; evidence of sword design 200; falconry in 247; stirrups in 228–29
mining 88; foreign concessions 89
Mir Karam 'Ali Khan Talpar 103
mirrors, brass 465–66; frames 470–71; glass 470; on stands 430; steel 87, 92, 466–70; survival 12–13
Mirza 'Ali (steel-worker) 94
Mirza Amin (merchant) 121
Mirza Baba (smith) 336
Mirza Husain Khan, *Jughrafiya-yi Isfahan* 25, 35, 36, 83–84, 85, 90, 93, 102, 104–105, 144, 147, 150, 163–64, 318–19, 328, 354, 367, 369, 410, 422, 426, 449
Mirza Isma'il (steel-worker) 96, 94
Mirza Ma'sum (merchant) 121
Mirza Muhammad Tahir Nasrabadi 121
Mongols, influence on horse fittings 239; invasion 128–29
Morier, James 21–22, 22, 24, 34, 159, 160, 163; on grilles 290
al-Mubarrad 226
al-Muhallab 226
Muhammad 'Ali (swordsmith) 34
Muhammad 'Ali (calligrapher) 94
Muhammad 'Ali son of Abu'l-Qasim (smith) 304, 36
Muhammad 'Ali (wood-worker) 371–72
Muhammad Baqir (swordsmith) 389–90
Muhammad Bayazi (steel-worker) 96
Muhammad Beg Muslutar 286
Muhammad Hadi (swordsmith) 152
Muhammad Hasan (spear maker) 188
Muhammad Husain (steel-worker) 252
Muhammad ibn Abu Ishaq al-Isfahani (craftsman) 292
Muhammad Ibrahim (artist) 471
Muhammad Isfahani (gunsmith) 164, 170
Muhammad Karim (craftsman) 150
Muhammad Kazim Shirazi (swordsmith) 30, 204, 287
Muhammad Nishan Saz (craftsman) 94
Muhammad Qasim-i Tabrizi (painter) 452–53
Muhammad Riza (calligrapher) 94, 137
Muhammad Sadiq (painter) 390
Muhammad Shah (Qajar ruler), present of flints to 177
Muhammad Taqi (smith) 146, 317
Muhammad Zaman Isfahani (swordsmith) 196
Muhibb 'Ali (swordsmith) 96
Mu'in Musavvir (craftsman) 344
Mulaim Beg 119
Multanis (merchants) 121
multi-purpose instruments 183, 184–86
al-Muqaddasi 21, 29, 38
Muqim (swordsmith) 34
Murdoch Smith 27, 35, 39; on guns 162; on horse fittings 234; on *kashkuls* 320; on tobacco 453–54
Nadir Shah 25, 82, 83; adoption of artillery 158; armouries 158, 244
Najaf 'Ali (painter) 390
Naqshi-i Rustam, standards depicted 253
al-Narshakhi, on door plaques 292
Nasir al-Din Shah 88, 89, 92, 197, 430, 471–72; portrait of 309, 471
Nasrabadi 104
Nazuk, 'Ali Riza (steel-worker) 95; Kamal al-Din Mahmud 107, 108
Nazuk family 95, 298
Nazuk, Kamal al-Din Mahmud (steel-worker) 95
Nazuk, Kamal al-Din Mahmud Yazdi (steel-worker) 95
Nazuk, Shafi' (steel-worker) 95
nibbing-blocks 356, 357
Niriz 40; iron manufacture 28–29; steel production 36–37
Niriz area, iron resources 19
Nishapur, horseman fresco 238–39, 247; sword found at 54; wall-painting of horseman 195
Nur 'Ali Shah (dervish) 313, 317–18
Nurabad, Imamzadeh-yi Darb-i Ahanin 293
Nurullah (belt-maker) 211
nutcrackers 426, 431

Olearius, Adam 25, 27, 29, 36; on Ardabil shrine 307; on barbers 393–94; on grilles 285; on mirrors 470; on standards 259, 273
Oljeitu, Sultan, mausoleum 24; *see also* Sultaniyya
opium-smoking *see* tobacco- and opium-smoking equipment
Ottomans 8, 23; conquests 267–68; standard-making 253

padlocks *see* locks and padlocks 93
paint boxes 343, 344–45
Pakistan, sword-making 68–69
palms (thimbles) 378
Panjikent (wall painting) 191–92, 226
Pao Tsang Lun 48
paper-scissors 352, 354
Parpa (iron mine) 29
Parthian period 8
patronage, and armour production 142–143; by governors 82; royal 32–33, 81–82, 387; without payment 84
pattern-welding 43–44, 47, 76–77
pen-boxes 341–45, 389; brass 341
pens and styli 345–47; for ruling 346–47
Periplus of the Erithraean Sea (anon.) 46, 113
Persian Gulf, iron from 40
pestles 424, 425; leather-working 377–78
pilgrimage prayer plaques 304–307
pincers, leather-working 378
plaques, decorative 433–34; door *see* doors and door plaques
Pliny, on "Seric" iron 45–46
Polak, Jakob Eduard 31, 39, 87–88, 115; on cutlery 369; on guns 162; on imitations 91
polishing and etching 66–67
Portuguese, early use of guns in Iran 154
powder horns (flasks) 176–82
primers (powder holders) 176–82
Prince Regent (George IV), gift of body armour 136
profit margins 120
pulad/damascened steel 34–35, 39
punches 381, 382

599

Qadi Ahmad 98
Qajar period (1779–1924) 9, 24–25, 83
Qal'ah, *fulad* swords 77; as trading centre 49
al-Qalqashandi (historian) 341, 342–44
Qasr al-Hayr al-Gharbi, floor-painting 227
Qazvin 27
al-Qazvini 21, 25, 30, 32, 206; on Shiraz 148; *Aja'ib al-Buldan* 32
quenching 43, 65–66
Quintus Curtius Rufus 44
Qum, iron manufacture 32, 36–37, 81; shrine of Fatima 284, 290–91
Qur'an, in amulet boxes 311; inscriptions on armour 135, 136, 138; inscriptions on doors and door plaques 293, 300–301, 302; inscriptions on scissors 354; inscriptions on standards 274, 277, 278; inscriptions on weapons 148, 151–52, 207; references to falconry 247; references to iron and steel 44–45

Rafi' al-Din Muhammad (steel-worker) 328
Rajab 'Ali Isfahani (swordsmith) 196, 200
Ramadan Talakub Isfahani, Ustad (craftsman) 94
ramrods 172, 173
Rashid al-Din, on armour production 141; *Jami' al-tawarikh* ('Universal History') 129, 283, 293
Rasht, iron working 25
Rayan, iron and steel products 89–90
Rayy, iron manufacture 37; scissor-making 354
razors 395–96
religious tradition, use of armour 136, 143–44
religious traditions, iron and steel products for 8, 90; use of grilles 283; use of standards 259–61, 281
religious traditions *see also* amulet boxes; *bazubands*; dervish paraphernalia; pilgrimage plaques
Riza (craftsman) 31
Riza Shah, and gun production 171–72
Riza-i 'Abbasi (calligrapher and artist) 155, 156
Roberts, Allen (miner) 22–23
de Rochechouart 27, 92; on daggers 150; on swords 200, 201, 206–207
Rochester, Earl of 196
Rukh, Shah (Timurid ruler) 254, 286, 287
rulers 347–48
Russia, imports from 35, 92; influence of design of primers 180; Iranian craftsmen in 88; war with 84
Rustam 105–106

Sabzavar, spade manufacture 92–93
saddles 226–27, 229, 246
Sa'di, *Gulistan* 182
Sadiq (steel-worker) 96
Safavid period (1502–1722) 8–9, 23–24, 80–82
Safi, Shah (Safavid ruler) 121
Safi, Shaikh 11, 23
Salih (craftsman) 375–76
Sam Mirza (Safavid prince) 105, 417
Samar, iron production 25
Sasanian period 8, 44, 49
saucers 422, 423
saws 370, 371–72
Sayyid Mirza (painter) 250
scissors 351–56, 367; circumcision 398; cloth-cutting 369–71; cutting metal 371; production 85
screwdrivers 447
Sevruguin, Antoine (photographer) 318
Shah-nameh, references to iron and steel 7, 45, 80; references to maces 189; manuscripts 129, 130, 138, 228–29, 231, 239, 241, 250, 251, 254, 258, 283, 293–34
Shahdi (craftsman) 341
Shaikh 'Ali Khudgar Bukhara, Ustad (steel-worker) 93, 101
Shapur I 126
Shash, iron resources 21
shields 140–41
Shir'Ali (cutler) 369
Shiraz, arsenal 84; dagger production 148; gun-smithing 162; import substitution 91–92; patronage of Karim Khan Zand 83; shrine of Shah Tahmasp 297; standard designs 258; steel manufacture 30–31, 81; sword manufacture 207
shoe horns 426, 431
shot measures 172–76
signatures, on sword and dagger blades 104
silk, state monopoly abolished 120–21
Silk Route 48, 55
Siyah Qalam (painter) 231, 239, 308, 371; standard design 255
smelting techniques 7
solid-state carburisation 41n., 42
spears 187, 188–89
specialisation, based on products 93, 101
speculum 388, 390
spoons 422–23, 425; sherbet 424
spurs 235
Sri Lanka 57; iron and steel production 48, 49–50; processing methods 65n.
Ssuma Chhien 48–49
stakes and anvils 358–59, 360
stamping of iron 14
standards 253–82, 433; etching 262–63; in form of hand 261; manufacture 261–63; religious use 259–61, 281; symbolism 260–61; types 263–81
steel, cutting of 14; difference from iron 7

steel-workers, depictions of 13; skills 14 steel-working, relationship with other crafts 110–12
steelyards (balances) 331–32; bronze 332
stirrups 226–35
Struys, Jan Janszoon 24, 33, 36–37, 285; on Indian steel 114, 115
Sufism 304
Sulaiman I (Safavid shah) 301
Sultan Husain (Safavid shah) 101, 104, 108, 109
Sultaniyya, mausoleum of Oljeitu 24, 115, 283, 284–85
surgical instruments 389, 396–99
swordmaking 24, 27, 30–31, 198–200; characteristics 200–207; decline of 85, 87; early Islamic 192–95; fittings 207–10; later Islamic 195–98; mixed colours (*farand*) 62–63; monetary value 92, 201; Nishapur blade 54–55; pattern-welded 60; pre-Islamic 191–92; sabres 63, 192–95, 200; *shamsir* ('lion's tail') 195, 200; significance of Asdallah 102–104; symbolic value 112, 190–91; types of 57; watered-steel 76–79, 201–207

al-Tabari, *Annals* 45
Tabriz 90, 93; armoury 142, 143; arsenals 84; gates of bazaar 293; iron- and steel-working 22, 23, 24–25; Ottoman attacks 142, 267–68; standard-making 274
Tadhkirat al-Muluk 81
Tahmasp, Safavid shah 23, 45, 190, 197, 258; *Shah-nameh* manuscript 24, 250, 251, 255, 256, 257, 274, 294, 323; shrine 297
Tal-i Iblis expedition 29
Talmud, on iron trading 47
al-Tarsusi 61, 63–64; on crucible-steel making 75; on quenching 65–66
Tavernier, Jean-Baptiste 33, 39, 78, 100, 101; on Indian steel 114–15, 117; on tool craftsmen 358; on weights 334
Taxila, crucible-steel making 46
Tehran 27, 28, 90; Arg (Shah's palace) 294; armoury 143; arsenals 84, 89, 171; gunsmithing 162
textile measures 339–40
al-Tha'alibi 354
de Thevenot, Jean 259; on horse shoes 244–46; on Safavid court 387
thimbles 378–79
Timur, armoury 81, 141; imagery of 260
tinned iron and steel 15
tinsmiths 85
tobacco- and opium-smoking equipment 451–58; tongs 453, 455, 457–58; types of pipe 453–54, 456–57
tools and implements 9, 357–90; dating 387; for farrier/saddle maker 389;

sets of 383–90; surgical 389
torches 449
tourism, and forgeries 106; iron and steel products for 90, 91, 389
Transoxiana, armour production 141; iron resources 19, 21; sword-smithing 192–93
transport, difficulties in 86–87, 89
Turkistan, steelwork 92
Turkomanchai, Treaty of (1828) 86
Tus, iron production 37–38
tweezers 362; cosmetic 461–62, 463; used with weights 336, 338, 339

Uzun Hasan (Akkoyunlu ruler) 81, 82, 154

della Valle, Pietro 259
Varqueh and Gulshah manuscript 227, 228, 229, 239
vases 430
vices, hand 361–62, 364
da Vinci, Leonardo 218

watch-cases 426
watered-steel, in swords 201–207
weights 332–38; dating 338; standardisation 334–35; surviving examples 335–36; varying standards 334
welding, hammer- 41, 42; pattern- 43–44, 47, 76–77
Wills, Charles James 91, 290–91; on barbers 394; on daggers 146–47; on dervishes 313; on drawing equipment 356; on family monopolies 96; on horse fittings 242; on opium-boxes 458; on weights 334
wootz (crucible-steel ingots) 48, 50, 69–70; process described 70–74; prohibitions on production 122
worms (gun accessories) 172, 173
wrestlers 325
wrought iron, stamping 14

Xenophon, on early armour 125, 126

Yadallah, Usad (craftsman) 94, 290, 291
Ya'qub (Turkoman sultan) 154
Yaqut 38, 105, 417
Yazd, chain manufacture 246; Khatir gate 292

zaj (etching compound) 67
Zand dynasty 148
Zanjan region 11, 27–28; iron resources 19
zereh (body armour) 7
Zosimos (alchemist) 46–47, 56, 64
Zu'l-Faqar (sword of 'Ali) 190